— THE —

DEATH

of Aztec
Tenochtitlan,

— THE —

LIFE

of Mexico City

JOE R. AND TERESA LOZANO LONG SERIES IN LATIN AMERICAN AND LATINO ART AND CULTURE

THE
DEATH
of Aztec
Tenochtitlan,
THE
LIFE
of Mexico City

BARBARA E. MUNDY

UNIVERSITY OF TEXAS PRESS ⌄ AUSTIN

Printed in China by Four Colour Print Group,
Louisville, Kentucky

First edition, 2015

Requests for permission to reproduce material from this work
should be sent to:

 Permissions

 University of Texas Press

 P.O. Box 7819

 Austin, TX 78713-7819

 http://utpress.utexas.edu/index.php/rp-form

♾ The paper used in this book meets the minimum requirements
of ANSI/NISO z39.48-1992 (R1997) (Permanence of Paper).

LIBRARY OF CONGRESS CATALOGING-IN-PUBLICATION DATA

Mundy, Barbara E.

 The death of Aztec Tenochtitlan, the life of Mexico City /
by Barbara E. Mundy.

 pages cm. — (Joe R. and Teresa Lozano Long series
in Latin American and Latino art and culture)

 Includes bibliographical references and index.

 ISBN 978-0-292-76656-3 (cloth : alkaline paper)

1. Mexico City (Mexico)—History—To 1519. 2. Mexico City
(Mexico)—History—16th century. 3. Nahuas—Mexico—
Mexico City—History. 4. Aztecs—Mexico—Mexico
City—History. 5. Power (Social sciences)—Mexico—Mexico
City—History. 6. Mexico City (Mexico)—Social life and
customs. 7. Sacred space—Mexico—Mexico City—History.
8. Architecture—Mexico—Mexico City—History. 9. Water-
supply—Mexico—Mexico City—History. 10. Mexico City
(Mexico)—Environmental conditions. I. Title.

 F1386.3.M86 2015

 972′.5302—dc23

 2014026617

doi:10.7560/766563

Contents

Illustrations

TABLES

Acknowledgments

Many books are journeys; this one unfolded as I walked the streets of Mexico City, often side by side with other scholars whose passion for the place fed my own. Sharing ideas and observations with them has enriched this book. Memorable walks in search of the sixteenth-century city included those with María Castañeda de la Paz and Carlos González González around Moyotla in March of 2009; two months later, María, Clementina Battcock, and Saúl Pérez Castillo and I crisscrossed Cuepopan; John F. López, Rosario and Luis Fernando Granados, Kristopher Driggers, and Sara Ryu hunted down the city's water systems with me in March of 2011; in May of 2012, over nine hours, Jonathan Truitt, William Connell, and I explored three of the four colonial parishes, or *parcialidades*; in January of 2013, Gibran Bautista y Lugo, Aaron Hyman, Sara Ryu, and Lynda Klitch braved the blazing sun with me in Moyotla; and most recently, Byron Hamann and I covered the southern cities (on bike, not on foot). I thank all of my fellow walkers for sharing their company and their ideas. Very much with us in spirit on all those walks (although not in person) was Edward Calnek, whose work on the sixteenth-century city and generosity with material have benefited us all.

Those walks, like this book, had their antecedent in research carried out for a volume on the Beinecke Map, now at Yale's Beinecke Rare Book and Manuscript Library, and in April of 2007 Pablo Escalante, Saeko Yanaguisawa, Alejandro Alcántara, and I went in search of Atlixocan. My particular thanks go to Mary Miller and Dennis Carr, who first invited me to speak at the conference that resulted in the volume on the Beinecke Map. In addition to them, María, Pablo, Diana Magaloni Kerpel, and Gordon Whittaker contributed to that book, and my understanding of sixteenth-century Mexico City has been enriched by ongoing conversations with all of them. Thanks also to Linda Arnold, Elizabeth Boone, Jeffrey Collins, Patricia Connelly, Gustavo Coronel, Jordana Dym, María Teresa García García, Salvador Guilliem, Gerardo Gutiérrez, Patrick Hajovsky, Leonardo López Lujan, Xavier Noguez, Michel Oudijk, Dorothy Tanck de Estrada, Emily Umberger, and Olga Vanegas, as well as to the two anonymous reviewers for the press, whose suggestions helped make this a better book. While in Mexico City, I have been indebted to the hospitality and generosity of James Oles, Roberto Mayer, Laura Palazuelos, Miguel Legaria, and Cuca Valero. It has been a privilege to work with so many talented students during the course of research, including Kristopher Driggers, Jorge Gómez Tejada, Sarah Hetherington, Aaron Hyman, Sara Ryu, and Lauren Toole. I also thank the staff at the Archivo General de la Nación in Mexico City, especially Guillermo Sierra Araujo, and at Mapoteca Orozco y Berra, especially Carlos Vidali Rebolledo. My wonderful art historian colleagues at Fordham, both past and present, have been keen readers of the work in progress, and they include Kimberly Bowes, Andrée Hayum, Kathryn Heleniak, JoAnna Isaak, Nina Rowe, and Maria Ruvoldt. Fordham University faculty grants also gave me necessary time off and resources to complete the book. Friendships have sustained me, particularly those with Jennifer Egan and Titia Hulst. The manuscript is a better work for passing through the careful scrutiny of Gloria Thomas, its copyeditor. But my deepest thanks go to Byron Hamann and Dana Leibsohn, who carefully read the manuscript, in Dana's case twice, and offered excellent suggestions for improvement.

My husband, Gerry Marzorati, has lived patiently with me and this work, as have our two sons, Guy and Luca Marzorati, giving me support and encouragement through it all: it is to these men in my life that I dedicate this book.

A Note on Spelling and Translations

In the text, Nahuatl words are spelled without diacritics to mark glottal stops and vowel lengths, a common convention in scholarly literature. I am using the conventional spelling "Moteuczoma" for the rulers' name, and the spelling adopted by Moteuczoma II's legitimate children, "Moctezoma," when referring to his descendants.

All translations from Spanish are mine, unless a published English translation is cited. All translations from Nahuatl are from the English or Spanish of the cited text, unless my translation is noted.

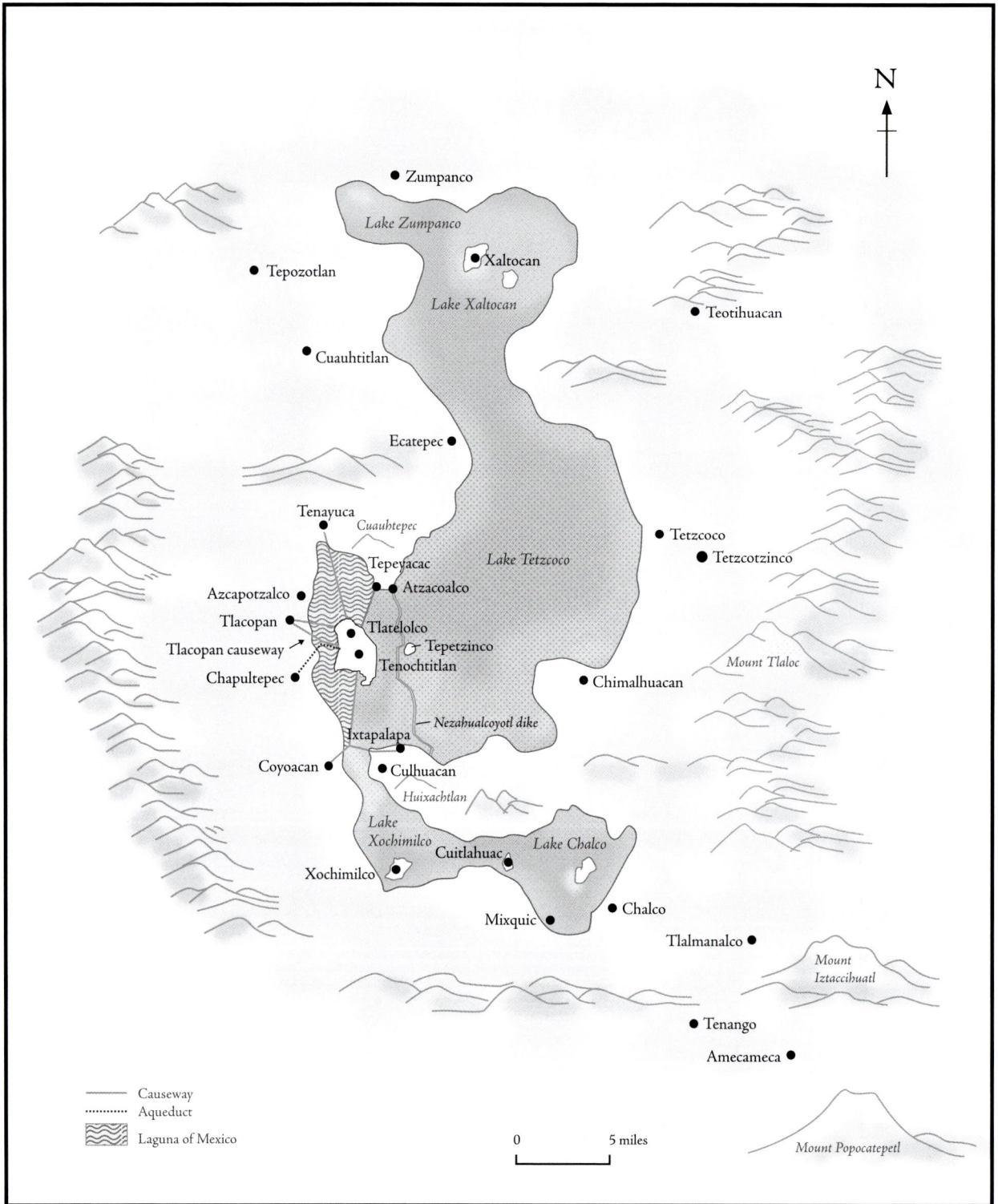

N

● Zumpanco

Lake Zumpanco

● Tepozotlan

● Xaltocan

Lake Xaltocan

● Teotihuacan

● Cuauhtitlan

● Ecatepec

● Tenayuca
Cuauhtepec

● Tepeyacac

Lake Tetzcoco

● Tetzcoco

● Tetzcotzinco

● Azcapotzalco
● Atzacoalco

● Tlacopan
Tlatelolco

Tlacopan causeway

○ Tepetzinco

● Chapultepec
Tenochtitlan

Mount Tlaloc

● Chimalhuacan

— Nezahualcoyotl dike

Ixtapalapa

● Coyoacan
● Culhuacan

Huixachtlan

Lake Xochimilco

● Cuitlahuac

Lake Chalco

● Xochimilco

● Mixquic

● Chalco

● Tlalmanalco

Mount Iztaccihuatl

● Tenango

● Amecameca

Causeway
Aqueduct
Laguna of Mexico

0 5 miles

Mount Popocatepetl

FIGURE I.I. *Map of the Valley of Mexico, by Olga Vanegas.*

CHAPTER I

Introduction

Todo ella en llamas de belleza se arde,
y se va como fénix renovando . . .
(All of it blazes in flames of beauty,
and renews itself like a phoenix . . .)

BERNARDO DE BALBUENA, *LA GRANDEZA MEXICANA*

In 1518, the Aztec capital of Tenochtitlan was one of the world's largest cities. Built on an island in the middle of a shallow lake, its population numbered perhaps 150,000.[1] It was the hub of an urban network clustered around the lake whose total population was perhaps half a million, as well as the cynosure of an indigenous empire that held power over much of central Mexico (figure 1.1). The collective size of these lakeshore cities exceeded European contemporaries: in the early sixteenth century, Paris had about 260,000 residents, Naples about 150,000, Seville and Rome, 55,000 each, and that of the latter would ebb to about 25,000 following the Sack of 1527.[2]

In 1521, the Aztec capital of Tenochtitlan died. In 1521, Mexico City was born, and it lives today.

The death of Tenochtitlan is documented in the Third Letter of the Spanish conquistador Hernando Cortés to Charles V of Spain, where it is equated with the city's physical destruction. The letter was written after the siege and the surrender of the city's rulers, and Cortés, in describing his own victory, recounts how even distant indigenous rulers in Mexico had heard that Tenochtitlan had been "destroyed and razed to the ground," and later in his account, he claims "it was completely destroyed."[3] Cortés's letter gives eyewitness evidence of the demolishment of Tenochtitlan, the reduction of this city to a field of rubble in the wake of his siege and the sack of vengeful armies in 1521. He is echoed by Bartolomé de las Casas, the Dominican firebrand, who decries the physical destruction of this city and the execution of its political leaders in 1521 in his widely read *Brevísima relación* of 1552: "There followed the

battle for the city, the Christians having returned in full strength and they created great havoc. In this strange and admirable kingdom of the Indies, they slew a countless number of people and burned alive many great chiefs. Later when the Spaniards had inflicted extraordinary abominations on the city of Mexico [i.e., Tenochtitlan] and the other cities and towns, over a surface of fifteen or twenty leagues, killing countless Indians, they pressed forward to spread terror and waste the province of Pánuco, where an amazing number of people were slain."[4] Such representations would have profound implications for the shape of later historical narratives.

If the death of Tenochtitlan can be metered via physical destruction and political decapitation, its death as an indigenous city can also be traced in the disappearance of its name, not an imprecise index given how loaded the name was to early residents, who more commonly called themselves the "Mexica," a term preferred here, comparable to the more recognizable moniker "Aztecs."[5] In Nahuatl, the indigenous language of central Mexico spoken by the Mexica, "Tenochtitlan" roughly means "next to the nopal cactus fruit of the rock," from the Nahuatl *nochtli*, for "nopal cactus fruit," and *tetl*, for "rock." Residents of the city held that their great migrations of the eleventh and twelfth centuries were brought to a close by their tribal deity, Huitzilopochtli (hummingbird of the south), in 1325, when he sent the Mexica tribal leaders a potent sign. Taking on the form of an eagle, he flew to a perch on top of a nopal cactus where the exhausted and harried tribe was resting, on a rocky outcrop in the center of the great lake

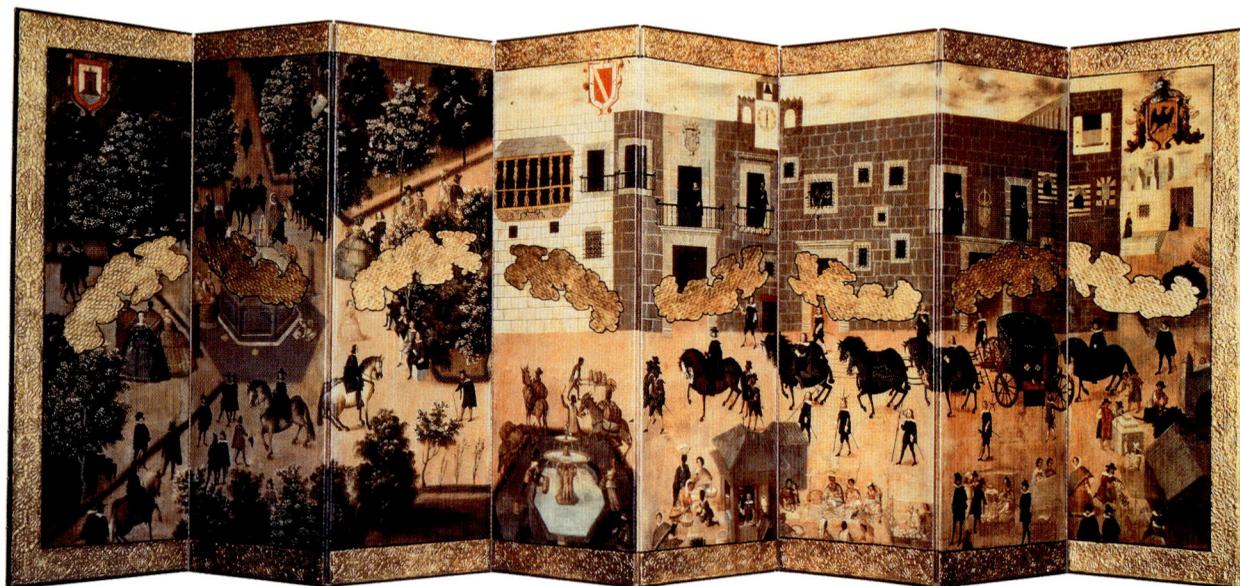

FIGURE 1.2. *Unknown creator,* Biombo *Portraying a View of the Palace of the Viceroy in Mexico City, late seventeenth century. Museo de América, Madrid.*

of Tetzcoco. These leaders founded their island city on this spot and gave it the name Tenochtitlan, a name drawn from the topography of the site of this miraculous event. Thus the name is not just a descriptive toponym but the location where Huitzilopochtli, a powerful warrior deity, chose Tenochtitlan as the island home for the Mexica, confirming their sense of themselves as his chosen people.

But this name, central to the history of the Mexica city from its foundation, was erased by the name of the city that was founded upon it after its conquest in 1519–1521. When the Spanish-born Bernardo de Balbuena published his well-known epic poem about the city in 1604, he called it "la famosa Ciudad de México" (the famous city of Mexico) and made no mention of Tenochtitlan.[6] The city Balbuena wrote about seemed to have little connection to its Aztec forebear. It stood at the pivot of a new, now global, empire. It was home to the viceroy of New Spain, second only in power to the Habsburg king himself, and was the hub of a vast trading network that threaded out to ports in Antwerp and Seville and reached as far as China. Because of these networks, Chinese merchants would pay their debts with silver coins minted in Bolivia, natives in the Valley of Mexico would plant grafted peaches from Spain, and courtiers in Nuremberg would decorate their salons with Japanese folding screens. The American center of this empire was Mexico City's great Plaza Mayor, one of the largest urban plazas in the world, dominated by the red-roofed Parián, a market named after the one in Manila, another Habsburg domain. In Mexico City's Parián, one

could buy silk and porcelain from China, wool from Spain, and wines from Portugal.

A painting created at the end of the seventeenth century captures, in both form and format, the early global empire that Balbuena had known some two or three generations earlier (figure 1.2). This work is a *biombo*, a Japanese-inspired folding screen popular among painters and their patrons in Mexico City, who encountered such Asian works firsthand because of the brisk transpacific traffic of goods on the Spanish fleet known as the Manila galleon. It is an eight-paneled work (perhaps two central panels are missing, which would originally have made a screen of ten panels), and the five panels on the right show us the eastern side of the Plaza Mayor with the palace where the viceroy lived as its backdrop, one of the many such nodes of royal power across the empire. Its architecture was comparable to other Habsburg seats built in the seventeenth century, a reminder of the centralizing pull that Spain exerted on its far-flung domains. A carriage approaches the door of the palace, as black-garbed courtiers watch from second-story windows at the approach of the viceroy; golden clouds, inspired by Japanese works, float lazily over the surface of the scene.[7] In this pictorial space, the world of indigenous Tenochtitlan has vanished.

The death of Tenochtitlan and, with it, the destruction

of the Aztec world has been an enduring topos of both New World and urban history. The Spanish historical narratives about the "abominations" inflicted on the city, the killing of its political leaders and the dispersal of its residents, might allow us to read the first clause of this book's title, "the death of Aztec Tenochtitlan," as a simple historical fact. The brutal war of conquest of 1519–1521 included a crippling siege led by Spanish forces on the island city, and after the Mexica emperor Cuauhtemoc surrendered, he ordered an evacuation. Its death was confirmed when a new city, this one called Mexico City, was founded within the island space it once occupied. But while Tenochtitlan as an indigenous imperial capital certainly came to an end with its conquest, the death of Tenochtitlan as an indigenous city is a myth. This book will argue that while the Conquest changed an indigenous New World capital, and it was remade into the hub of the global empire of the Habsburg kings in the sixteenth century, it did not destroy indigenous Tenochtitlan, either as an ideal, as a built environment, or as an indigenous population center. Instead, indigenous Tenochtitlan lived on. Looking beyond the triumphant accounts of Cortés and the despairing accounts of Las Casas to other representations of the city, and focusing on ones created by and about its indigenous occupants, will reveal the endurance of the indigenous city once known as Tenochtitlan within the space of Mexico City.

CITIES AS METAPHOR

In my first forays into the city's past, I carried with me the assumption—as do many others—that the great city of Tenochtitlan had died with the surrender of its Mexica ruler Cuauhtemoc to Hernando Cortés in 1521, its rulers in chains and its population dispersed. Its successor, Mexico City, was founded within a year or two by Spanish political leaders, a new city laid out on the purportedly vacant island, soon to be populated by the Spanish conquistadores, Cortés included, who had laid waste to Tenochtitlan. The Spanish ruling elite of Mexico City certainly promoted this view in subsequent centuries by commemorating the 1521 founding of Mexico City on August 13 of every year. By the beginning of the seventeenth century, Balbuena would liken the city to a phoenix, a mythical bird in Ovid that was believed to die in fire and then be miraculously reborn from the ashes. Balbuena's choice of metaphor also implies the city's death as a result of the siege of 1521, after which the phoenix-like city was reborn in the decades following

the war. But just as many other certainties pixilate upon close view, the notion of the death of Tenochtitlan with the Conquest did too when I began to read historical narratives and look at images of this great city. It was not just that the sharp edges of historical facts (death and birth) tend to blur when one sees the competing and conflicting accounts that comprise them. Instead, the very idea of rebirth seemed to be founded on an even more fundamental ontological error. Can cities die?

Our idea that they can rests on the idea of the city as a biological entity, capable of both birth and death, a notion spurred in modern times by the title of Jane Jacob's famous book, *The Death and Life of Great American Cities*, of 1961. In the case of Aztec Tenochtitlan, where the city's "death" was coincident with its physical destruction and, more importantly, the overthrow of its political leadership, it also rests on another biological metaphor. This is the idea of the city as a body, a politically constituted one, at whose head are its leaders, whose capitulation or decapitation brings the death of the whole. In a European context, such a notion of the city corresponds to emergent early-modern ideas of the state, where the political nation was closely identified with the body of the king. We even know of maps that show the spatial expanse of the realm in the form of the monarch's body. But Tenochtitlan's death is also indebted to indigenous political philosophy, which traditionally understood a charismatic and semidivine supreme leader, the *tlatoani* (plural *tlatoque*), as a metonym for the larger community or city-state, the *altepetl* (plural *altepeme*); in the case of Tenochtitlan, the identification of this leader with the city was particularly potent, the result of a successful strategy of imperial propaganda engineered by the city's ruling elite before its conquest.

The annealing of the figure of the ruler to the city of Tenochtitlan is clear from the opening image of the Codex Mendoza.[8] This book was created by native scribes in Mexico City about a generation after the Conquest and contains a pictorial history of the city almost certainly drawn from pre-Conquest indigenous manuscripts that recorded the officially sanctioned history of the city. The manuscript's name was affixed only around 1780, reflecting the idea that it was created at the behest of the powerful Spanish viceroy Antonio de Mendoza, who arrived in the city to shore up the authority of the Spanish Crown in 1535.[9] Whether or not the work was Mendoza's commission, it was undoubtedly a high-status project, with expert native scribes clustering over unbound folios to draw up

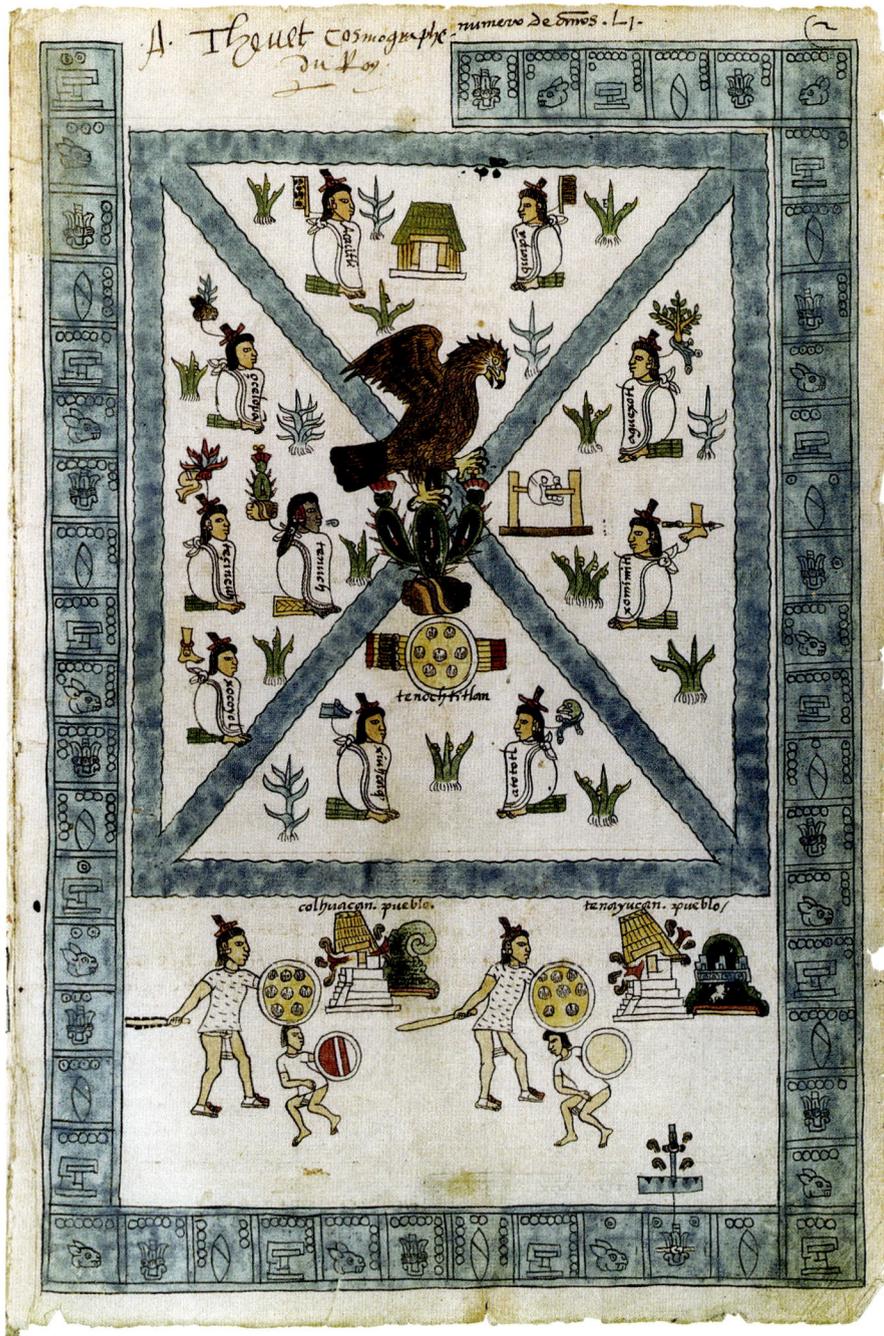

FIGURE I.3. *Unknown creator, the foundation of Tenochtitlan, Codex Mendoza, fol. 2r, ca. 1542. Bodleian Libraries, University of Oxford, Ms. Arch. Selden A1.*

an ambitious three-part history of the Mexica rulers and the empire they had built over two centuries. These artists worked in tandem with Spanish-language scribes to translate the visual information into alphabetic form; thus their images are accompanied by explanatory texts written in Spanish. From its inception, the Codex Mendoza was a work of translation, mediating between two writing systems (indigenous pictography/Spanish alphabet) and two concepts of the book.

Folio 2r is one of the two pages of the book that are dominated by a single image, and so are visually distinctive within the larger volume (figure 1.3). Its Mexica creators, who could draw on a long tradition of indigenous bookmaking wherein one could find important full-page statements like this one, were likely to have also been influenced by the illustrated frontispieces of printed European books that had been imported into the country. These too offered visual introductions to the content that followed. Thus the

Mendoza folio 2r serves as both an introductory statement and an opening scene, a painted preamble to the history on the pages that follow. It shows in simplified graphic form the city of Tenochtitlan, not as the full-grown city of ca. 1542 that its makers knew firsthand, but as the city at the moment of its foundation in 1325. It is a simple settlement, a small island surrounded by a rectangular band of blue water, with canals dividing the space of the nascent city into four triangular plots. Rudimentary architecture is included: a little green thatched-roof hut is at top, while a skull-rack (*tzompantli*), where a skull is pinioned at center right, shows the residue of ritual sacrifice. The early city is unlikely to have had such an ordered appearance; instead, the artists employed the quadripartite scheme because it was conceptually and aesthetically important within the larger world of Nahuatl speakers, whom modern scholars call the Nahua. They held that quadripartite arrangements in politics and architectural design, as well as urban spaces, were conducive to harmony in those entire arenas. At the center of the page, we find a concise icon of the city's foundation. Here the eagle of Huitzilopochtli is seen alighting on the nopal cactus to tell his people to found their city on that spot. Thus, as told by the Codex Mendoza, the history of the Mexica people began only with their establishment as an urban people in a carefully manipulated space, this city brought into being through being named: Tenochtitlan, whose distinctive glyph, combining the symbols for "rock" and "prickly-pear cactus," is set at the center of the page.

This city's political elites figure prominently in the image. In the quadrants, the ten tribal leaders of the Mexica cluster, each marked with a pictographic or hieroglyphic name written in the iconic script developed in the pre-Hispanic period. The black-faced figure at the center left is named with a hieroglyph whose central component is the nopal cactus. The nopal rises from the glyph for "stone," an oval shape with foliate ends painted yellow and gray. Together, these hieroglyphs (for *te* and *noch*) yield the name of Tenoch, the tribal leader and priest who was the leader of the ethnic chiefs shown here as city founders. As such, Tenoch would lend his name to the city itself. This connection is made clear by the central icon of the page that anchors the page's whole design at the crossing canals. Here, in the same horizontal register as Tenoch's name, we find another, similar name comprising a nopal and stone written in iconic script, and that is the name of the city, Tenochtitlan. To emphasize that this is indeed a

place-name, one of the scribes who worked on the manuscript has written the name in the Latin alphabet below. The name of Tenoch, the tribal leader, is one with the emergent city. His reign is also set into a near-ideal cycle of time. Around the edge of the page is a band made of fifty-one small squares, all colored a brilliant turquoise, each one representing a year in the native calendar; Tenoch's rule falls one short of the auspicious Nahua century of fifty-two years.

On the most basic level, the page, with its encircling turquoise band, points to the Mexicas' own historical tradition, wherein they kept written records in a time-line presentation, or annals format.[10] The brilliant band of turquoise years introduces another point: that the writer of this history has chosen to divide the continuous and seamless flow of time into even units of solar years and then to group those years irregularly, according to the lifespan of a seated ruler. Such division enables the imposition of a particular narrative shape and limit to the potentially infinite number of events a history could include. Here, its arc is determined by a ruler's life. As the subsequent pages of the Codex Mendoza show, the focus of Tenochtitlan's history falls almost exclusively on the figure of the ruler and his conquests.

Folio 15v is the first of three pages to document the reign of Moteuczoma II (r. 1502–1520), whom the Codex Mendoza presents as the last ruler, the end of the series of nine who followed Tenoch (figure 1.4). This page is like the other pages that chronicle these rulers in format and information: the figure of the ruler, contained within the general grid-like schema of the page, is seen at the middle left. He is distinguished by seat and crown, and a glyph for his name is attached to his head. In this case, the leftmost band of the page gives us the count of the first sixteen years of his reign, the bright blue year symbols corresponding in the Gregorian calendar to 1502–1518 CE. In front of Moteuczoma is a round shield decorated with seven tufts of eagle down, with four spears visible behind it, a symbol of his prowess as a warrior. His abilities are further attested to by the sixteen icons of temples on this page—their yellow-gold thatched roofs set ajar and flames emerging from the right—that show Moteuczoma's conquests (they continue on the pages that follow). Each one of them is attached on the left to a place-name that identifies it as a distinct city or town, once independent but now being brought under the sway of Tenochtitlan and its ruling lords.

On this page as on others previous, the death of a ruler

FIGURE I.4. *Unknown creator, the reign and conquests of Moteuczoma II, Codex Mendoza, fol. 15v, ca. 1542.*
Bodleian Libraries, University of Oxford, Ms. Arch. Selden A1.

is marked by the cessation of the year symbols. Once all a ruler's conquests have been registered, a new page begins with the newly inaugurated *tlatoani* and the temporal count picks up again. It hardly needs saying how much the narrative structure and scale chosen by the historian determine our understanding of past events, what moment is chosen as a beginning and what is chosen as its close.[11] This part of the Codex Mendoza, which begins with the founding of Tenochtitlan by Tenoch in 1325 and ends with the death of Moteuczoma, offers a neat historical package of 16 folios and 196 years, and fuses the history of the city with the lifespans of it rulers. Given the close alliance the Codex Mendoza forges between Tenochtitlan and its Mexica rulers, it would appear, from a Mexica perspective, that with the death of a monarch and the shutting down of the ruling line, the city and empire of which he was the embodiment would die with him. Or so it would seem. Because if we turn to the bottom of the neat band of turquoise years on this page, we see a prevarication, an uncertainty on the part of its artists about this tidy narrative linkage between city and political leadership promoted by the official history (figure 1.5). The artist painting the dates in black ink ended the count with the date 1 Reed, which is 1519, to show that Moteuczoma's reign ended with the arrival of the Spaniards. But the artist coloring the pages subsequently must have disagreed, considering only the years before the

Spanish arrived as part of Moteuczoma's reign, for he or she extended the precious turquoise pigment only to 13 Rabbit (1518). And then another of the manuscript's scribes countermanded these as end dates; one can see how the count has been extended to the right as an uncertain hand has added two more years: 2 Flint (1520) and 3 House (1521). The presence of the year 2 Flint is explained with a gloss in Spanish that reasserts the connection between the city and the living ruler: "Fin y muerte de Motecçuma" (End and death of Moteuczoma), and wrapping around the final glyph of 2 House (the year in which Tenochtitlan fell to the Spanish) is a line of text that reads: "paçifiçaçion y conquista de la nueva españa" (pacification and conquest of New Spain).

While we could dismiss these added year dates as simply the by-product of the rushed circumstances of this manuscript's creation, from my view, the ambiguous presentation of these dates is highly significant. The scribes creating this manuscript were living in Mexico City, the city whose history the book laid out, around 1542. They well knew of the death of Moteuczoma in 1520. But they also knew, firsthand, that the city it purported to chronicle had not ended, given that they had (likely) been born in it and walked its streets daily. This tiny moment of irregularity on the page registers the scribes' crucial uncertainty about the actual subject of this historical section, and brings us back to the ontological question. If indeed this history of the city and its empire was fully embodied by rulers, then there should have been no uncertainty about its end with the death of Moteuczoma in 1520, and with the

FIGURE 1.5. *Unknown creator, the reign and conquests of Moteuczoma II, detail, Codex Mendoza, fol. 15v, ca. 1542. Bodleian Libraries, University of Oxford, Ms. Arch. Selden A1.*

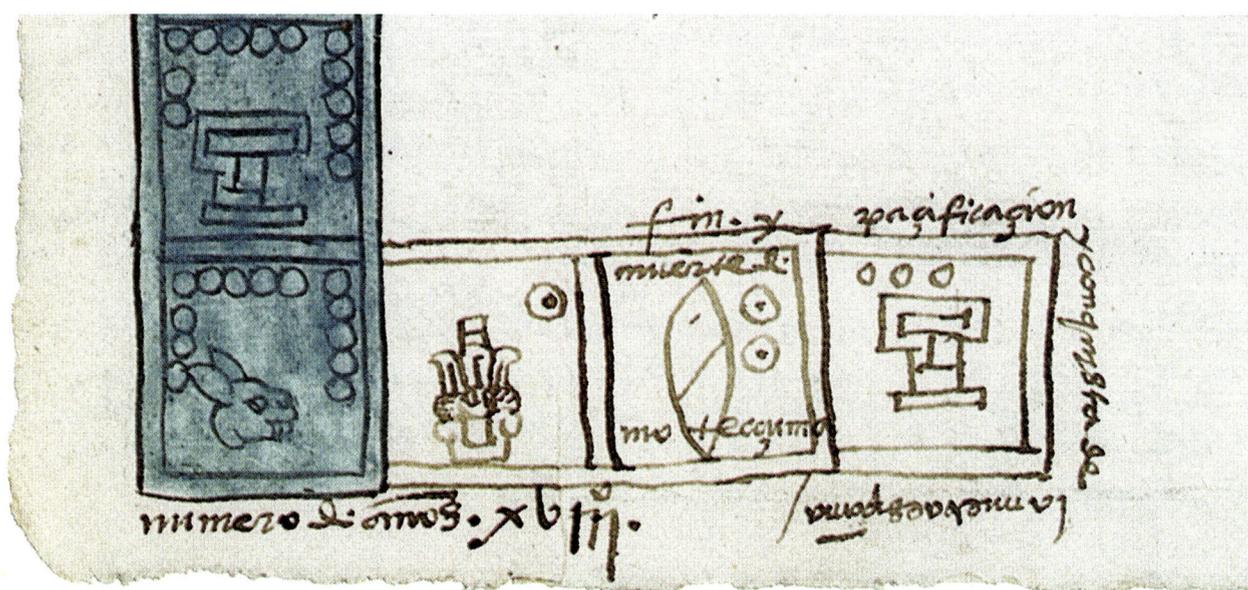

FIGURE 1.6. *Unknown creator, the death of Cuitlahua and the Conquest's aftermath, Codex Aubin, fols. 44v–45r, ca. 1576–1608. © Trustees of the British Museum.*

cessation of an indigenous ruling line. The gloss in Spanish seems to offer a definitive answer to the question, the words "y conquista" blocking the count from proceeding any further; the placement of the text suggests that the end of the political regime is also the end of the history of the city that begins on folio 2r. But if this is the history of an empire as embodied by its principal city, irrespective of the political class, then the scribes themselves seem to be grappling with a version of our ontological question: if the history of the city is *not* simply the history of its political elites, contingent upon their being seated in power, but instead is something else, perhaps the history of the Mexica as a people, then can it so neatly end?

In considering another history of Tenochtitlan produced, like the Codex Mendoza, in Mexico City by indigenous scribes, the death of the city seems, as in the humorist's quip, exaggerated. The Codex Aubin, named after a nineteenth-century owner of the manuscript, offers an annals history of Tenochtitlan and Mexico City. Like the Codex Mendoza, the backbone of this history is a count of the years, but its text is written in Nahuatl, rather than in Spanish.[12] This native-language text that was written between 1576 and 1608 does not insist that the history of the city is absolutely coincident with that of its rulers;

instead, its writers were keenly attuned to the experiences of the urban populace: its images and text chronicle the famines, the plagues, the consecration of new buildings, the building of new waterworks. Opening the book to pages 44v–45r reveals 2 Flint and 3 House, the same years that Codex Mendoza folio 15v shows us ambiguously as the years of the death of Moteuczoma (figure 1.6). In the Codex Aubin, however, the even count of the years has not been ruptured by the Conquest. Instead, these years are followed by 4 Rabbit, 5 Reed, 6 Flint, 7 House, and so on in the following folios. While the dense text on folio 44v registers an indelible remembrance of the Conquest year, the Codex Aubin refuses to break the temporal count into the periodization of pre- and post-Conquest; moreover, its writers link the city with the experiences of its populace, not just its rulers. The writer (or writers) of the Codex Aubin has unwittingly pointed us to the origin of our ontological error. While Mexica rulers tried to forge an unbreakable relation between their presence as a political class and the city of Tenochtitlan, city dwellers after



Moteuczoma's death were clearly not so convinced. They show in a work like the Codex Aubin that the city is not embodied by its ruler and thus cannot simply arrive at a mortal end, no matter how much the Mexica rulers themselves would have liked to convince their people of this point. Instead, the flow of history across the pages of the Codex Aubin, one that seems not to proclaim the city's death, compels us to locate the city elsewhere, beyond its ruling elite.

LOCATING THE CITY

In the case of Tenochtitlan, Cortés describes the city as "destroyed and razed to the ground," and it would be fair to equate total physical destruction with the city's death, if we were to understand the city as coterminous with the built environment. Ironically, Cortés probably did not understand the city as this; to him, as to other Spaniards of his era, the city was both a physical entity and a collection of citizens.[13] However, Cortés's immediate circumstances, most of all his aspirations to consolidate *Spanish* political control of territory, made it expedient to claim that Tenochtitlan had been destroyed, and with it, indigenous political power. His claim is echoed by traditional architectural history, with its focus on the built environment, and within its terms, the erasure of a city's built environment *is* its death. The death of Tenochtitlan, along with other indigenous cities, as measured by its built forms, figures in many conventional histories of Mexico's built environment, which posit its destruction or nonexistence. Consider Robert Mullen's architectural history of the viceregal period, in which he writes, "Soon after the Conquest, however, the need for both civil and religious architecture became imperative as new cities were founded and native communities were urbanized. . . . Administrative centers, schools, hospitals, water supplies, defenses and above all, churches were needed *where none had ever existed*" (italics mine).[14] While Mullen's claim is true for a newly founded city like Puebla, most of the post-Conquest cities in the population-dense Valley of Mexico had deep temporal roots, continuing to employ long-established transport networks, aquatic infrastructure, and building technologies after the Conquest, as they had done before; most changes that resulted from the Conquest were registered in monumental architecture alone. In other words, cities endured. The question of just how much of the built environment

of Tenochtitlan survived in the wake of the Conquest will be explored in the following chapters, but using destroyed temples—pre-Hispanic monumental architecture—as an index of the city's death is, I think, as limiting as equating the death of a ruler with the death of a city. So how *should* we think of the city?

If we turn to an early page of the Codex Aubin, which offers a history of the city seen from the bottom up, unlike its top-down counterpart, the Codex Mendoza, and look at the page that marks the beginning of a new fifty-two-year period in the year 2 Reed, the glyph in the upper right, we see one way the Mexica thought of cities (figure 1.7). Here, we see the green bell-shaped hill (*tepetl*), and streaming from it is a flow of blue water (*atl*); at the top is the grasshopper (*chapolin*) that serves as a logograph for the place named Chapultepec, where the Mexica once lived. And below is a shield and club, the necessary instruments for Mexica expansion. Like other Nahuatl-speaking peoples

FIGURE 1.7. *Unknown creator, the arrival at Chapultepec, Codex Aubin, fol. 19r, ca. 1576–1608.* © *Trustees of the British Museum.*

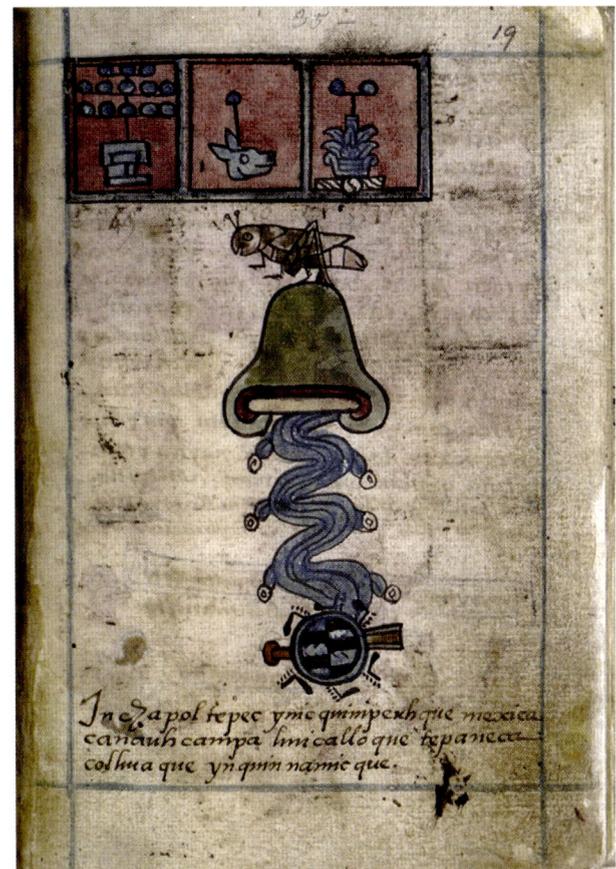

of central Mexico, Mexica identified the city with the term *altepetl*, a word that translates directly as "water hill." The *altepetl* rather than the larger state was the primary focus of affiliation and loyalty; recently, Federico Navarrete has pointed out that "the concept of the altepetl makes direct allusion to two elements essential to any Mesoamerican political entity: a sacred hill that was considered to be the residence of the patron deity, and often ancestors, as well; the spring or other source of water, which permitted the subsistence and agriculture of its residents."[15] In addition, but not exclusively, an *altepetl* was closely identified with its ruler, whose own political positions were solidified by such a connection, as we saw in the Codex Mendoza. Such identification helped clarify the rules of the political life of central Mexico, particularly in the conquest state that the Mexica led. The death or capitulation of the ruler meant the defeat of the *altepetl*, which would then be required to pay tribute to conquering overlords.

So how can we account for the city in a way that takes into account these sometimes competing, sometimes complementary vantages—the city as a political domain and the city as an ethnic community, bound by descent from a common ancestor? It is useful to remember that, in addition to the ways its historians described it in political or ethnic terms, the city of Tenochtitlan was also a space, and a very unusual geographic one at that, an island set in a shallow, salty inland sea, connected to the surrounding lakeshore by causeways. And while rulers can die, spaces cannot. And while ethnic communities are conquered or ravaged by disease, spaces endure. Shifting our focus to the city *as a space* allows us a critical vantage onto this city that will be productive on a number of fronts. First, treating the space of Tenochtitlan and Mexico City will allow us a temporal continuity that is denied us if we imagine the city as simply the political domain of a ruling class: by these lights, Tenochtitlan—ruled by an indigenous *tlatoani*—did die, and Mexico City—ruled by a Spanish town council— *was* born. Secondly, as an interpretive category, space has the capacity to contain both of these culturally specific political ideologies of the city, the Nahua *altepetl* and the Spanish *ciudad*, just as the spatial expanse of the island contained them both after the Conquest. It also allows us to bring together the different historical narratives that fundamentally disagree about the definition of the city (Cortés's letters vs. the Codex Aubin) and treat them as different vantages onto a single entity, the island space called

Tenochtitlan in the fifteenth century, and Mexico City by the seventeenth.

LEFEBVRE AND DE CERTEAU

To treat the city as a space demands that we define what interpretive approach we are to take, given the nearly infinite number of meanings that "space" can have, both concrete and metaphorical, an elasticity that can render it shapeless. In his attempt to rescue space from the natural and transparent position to which the Western philosophical tradition had relegated it, Henri Lefebvre argued for the social construction of space, "at once a precondition and a result of social superstructures." Such a position seems unconsciously sympathetic to Mexica understandings of their city, where the *altepetl* was the result of actions of both a ruler and an ethnic group. Moreover, approaching the city, which is a geographic space, as a socially created product allows us entry into some of its complications. "The city of the ancient world," Lefebvre wrote, "cannot be understood as a collection of people and things in space; nor can it be visualized solely on the basis of a number of texts and treatises on the subject of space. . . . For the ancient city had its own spatial practice: it forged its own—appropriated—space. Whence the need for a study of that space which is able to apprehend it as such, in its genesis and its form, with its own specific time or times (the rhythm of daily life), and its particular centres and polycentrism (agora, temple, stadium, etc.)."[16] His invitation is compelling: not just to think of the city as a collection of people, or buildings, but also to focus on those daily practices as fundamental to that creation of the social space that constitutes the city.

It is taken up in Michel de Certeau's essay "Walking in the City." In this short work, the French Jesuit philosopher begins as his narrator looks over Manhattan from the vantage point of the 110th floor of one of the towers of the (then-standing) World Trade Center. To see the city from the distance that the building provides "is to be lifted out of the city's grasp. . . . [The viewer is] an Icarus flying above these waters, he can ignore the devices of Daedalus in mobile and endless labyrinths far below. His elevation transfigures him into a voyeur." But Certeau sees the limits of this seemingly omnipotent position: the city is experienced only as an image, an "optical artifact," captured and bounded by "the imaginary totalizations produced by the

eye."[17] The city from afar, separated from lived experience, is turned into a mental representation akin to a bird's-eye-view map that offers us, like the gaze of Icarus, a similarly voyeuristic view.

In contrast to the city as representation or mental image is the city as experienced by a walker on its streets. Certeau continues, "The ordinary practitioners of this city live 'down below,' below the thresholds at which visibility begins. They walk—an elementary form of this experience of this city; they are walkers, *Wandersmänner*, whose bodies follow the thicks and thins of an urban 'text' they write without being able to read it. . . . The networks of these moving, intersecting writings compose a manifold story that has neither author nor spectator, shaped out of fragments of trajectories and alterations of spaces: in relation to representations, it remains daily and indefinitely other."[18] In turning his focus to the city as a lived practice, constituted not by urban planners or by the built environment, but by the inchoate and quotidian actions of its inhabitants, Certeau posits the city as also being located in the daily practices of its dwellers.

Certeau's way of conceptualizing the city in this essay sets up a tension between two poles: the representations of the city on one hand, like maps or the urban planner's schema, and the lived experience of its "walkers," urban residents whose own daily trajectories define what the city is, on the other. His identification of the latter—who could be nameless and politically powerless—as constituting the city was written to counter the ideas of Michel Foucault, whose focus was on "the structures of power" that arose in the wake of the Enlightenment and the rise of the modern centralized and bureaucratic state, which exercises a "disciplinary" control over its citizens. By turning attention to "multiform, resistance, tricky and stubborn procedures that elude discipline," that is, individual human action within the urban space, Certeau was able to allow for individual agency within Foucault's totalizing theories about the structure of power.[19]

In Manhattan, close to where I write now, one need only walk down 43rd Street near Times Square to see the dichotomy in action. On a grid laid out by the maps of nineteenth-century urban planners, commercial buildings follow legally prescribed street setbacks, and surveillance cameras set on façades track the movements of every passerby. But the actions of those contained by such spaces are often uninhibited: office workers jaywalk; West African immigrants create illicit shops-without-walls by setting out knockoff goods on the sidewalk; and tourists film their own personal on-the-spot experience of their singular New York.

The two spheres that Certeau suggests constitute the city—on one hand, the representations of the city, be they maps or urban plans, those "imaginary totalizations," and on the other hand, the itineraries and practices of urban dwellers—provide useful conceptual categories to study urban spaces of the past like Tenochtitlan, allowing us to move, when possible, beyond the static representations that are the urban historian's principal archive (like folio 2r of the Codex Mendoza) to take into account the lived practices and experiences of the streets. Lefebvre, in fact, offers an equivalent schema for the study of space, contrasting "representations of space" with spatial practice. To him, the former draws on a wide body of precedents. About the medieval city, he explains, "As for representations of space, these were borrowed from Aristotelian and Ptolemaic conceptions, as modified by Christianity: the Earth, the underground 'world,' and the luminous Cosmos, Heaven of the just and of the angels, inhabited by God the Father, God the Son, and God the Holy Ghost. A fixed sphere within a finite space, diametrically bisected by the surface of the Earth; below this surface, the fires of Hell."[20] But by this dualistic approach, the dynamism of those representations is unaccounted for; the tourist walking into Times Square along 43rd Street for the first time undoubtedly carries in his or her head memories of TV images of everything from brilliant neon billboards to the grainy tape from surveillance cameras used to track crime along the square, and these images inflect what Times Square is as a lived space.

It is Lefebvre who offers a third sphere, as he sketches out a "conceptual triad" to aid in the analysis of space. Together this triad will be invaluable to us in looking at Tenochtitlan and Mexico City. In addition to "representation of space" and "spatial practice," Lefebvre posits a sphere of what he calls "representational spaces," and by this he means actual spaces in or features of the urban fabric (a church, a market, a graveyard). In the traditional sphere of architectural or urban history, this category would envelop what we call the built environment—streets, buildings, plazas, and parks. But Lefebvre insists that such spaces cannot be treated separately from the "representations of space" that have been formed of them (those "imaginary

totalizations" of Certeau). In Lefebvre's schema, "representations of space" contain ideologically coded, and culturally specific, ideas about space that are articulated in both objects and ideas, from an urban planner's exact scale map to the medieval cosmic schema. And what he calls "representational spaces" (at whose base is the built environment) are deeply colored by representations of space. In turn, the built environment cannot be bracketed off from the practices of urban dwellers (those walkers of Certeau). So this third sphere, "representational spaces," postulated by Lefebvre triangulates the dualism defined above (image vs. walker), encompassing the built environment, but also holding that the built environment is not a static physical entity, but one inflected both by representation and by practices. Lefebvre would use somewhat different words to discuss the spheres defined by Certeau, as he wrote of the equivalent of Certeau's walker, using the term "spatial practice," a term used throughout this book. For Certeau's "imaginary totalizations," he uses the term "the representation of space," the second term used throughout. He calls these two categories "the perceived, the conceived" and then adds a third category: "the lived," which he calls "representational space."[21]

For my readers, who will encounter this triad frequently in the pages that follow, I ask forgiveness in advance for departing in one instance from Lefebvre's terms: "representational space." Although useful because it is so carefully defined, it has proven cumbersome to both eye and ear in the writing of this book, and so I will modify the third term of our triad and call the category "lived space." For the initial purposes of urban analysis, we can take the spheres as separate entities, but as we will see in the chapters that follow, they intersect and inflect each other.[22]

To see how these three spheres, the perceived (called "spatial practice" by Lefebvre), the conceived ("representations of space"), and what we will call "lived space," operate, let us turn to a space in Tenochtitlan's southwest corner that on a map of the city in 1500 might appear largely as a void or might be marked with the symbol for *tianquiztli*, or "market" (figure 1.8). This symbol, one representation of space, is itself significant. It is composed of concentric circles, one of them filled with smaller disks. These disks connoted preciousness: when colored blue-green, they are the symbol for "jade," the most valuable gemstone of the Americas; appearing on the entablature of a building, disks representing jade marked it as the dwelling of a lord. Inflecting the sphere of lived space, this symbol conveyed

ideas of the market as being a place of preciousness (indeed, precious items were for sale in indigenous markets) and a space of lordly authority; its concentric circles also connoted origin and order (we find them also in symbols of navels, that biological sign of origins). Moreover, another representation of the market space was to be found in the heavens. Residents of Tenochtitlan called an important constellation *Tianquiztli*—it may be what we know as the Pleiades—and its closely observed passage in the night sky marked the moment that a new fifty-two-year cycle would begin.[23] Within the city of Tenochtitlan, of course, it was the quotidian and unremarkable actions of urban dwellers that consecrated this space called *tianquiztli* as the market, as they came by foot or in low-slung canoes across the lake, carrying baskets laden with greens plucked out from an urban plot, or pitch-pine torches harvested from the surrounding forests, to buy and sell: our second sphere of spatial practice.[24] The physical space of the market itself is the third sphere. Created out of the actions of urban dwellers, its meaning and character inflected by the ideologies encoded in the symbol, the market was not a mere physical expanse, a void in the urban fabric, but what Lefebvre would call "representational space," and what we will call "lived space," given how it carried in it the larger ideologies of the marketplace as well as the traces of its own historical creation and existence.

Lefebvre's triad, these intersecting spheres, gives us purchase on the complex and messy matter of urban space, and this interpretive framework will guide us in the

FIGURE 1.8. *Symbol for* tianquiztli, *"marketplace." Author drawing after Codex Mendoza, fol. 67r.*

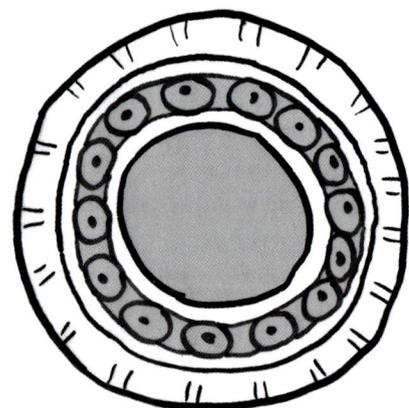

chapters that follow. As an art historian, I will be dealing most frequently with the first sphere, what Lefebvre would call "representations of space"—and the reader will see this in the strong focus on maps, plans, and other images that run through the book. The emphasis on the image is also necessary in dealing with Tenochtitlan and Mexico City, because through the sixteenth century the peoples of central Mexico expressed themselves through images and a largely pictographic script, as they had before the Conquest; one can see in the pages of the Codex Mendoza the central role that the images play. The alphabetic text, a post-Conquest introduction, is at times meant only to explain the images to its assumed European reader. In order to reencounter the heretofore occluded history of the indigenous city, I turn frequently in the pages that follow to a group of rare pictographic-alphabetic manuscripts produced in the city in the sixteenth century: the Codex Mendoza (ca. 1542), the Codex Aubin (ca. 1576–1608), the Map of Santa Cruz (ca. 1537–1555), Genaro Garcia 30 (1553–1554), the Codex Osuna (ca. 1565), the Tlatelolco Codex (ca. 1565), and the Florentine Codex (ca. 1575–1577). While these alphabetic-pictorial manuscripts are crucial to understanding sixteenth-century representations of urban space, alphabetic texts also offer us descriptive representations, and I will be drawing on period texts written in both Spanish and Nahuatl selectively, often as complement to the image, to discuss the nature and history of this city in the fifteenth and sixteenth centuries.

But representations of space, of course, *represent* something, and my real quarry is that elusive referent. On the simplest level, it is the built environment, actual spaces in the urban fabric. But Lefebvre reminds us that the built environment is just one component of the category of lived spaces of the city, as the built environment is defined by quotidian practice and inflected by ideologies supplied by representations of space; we will see that our three spheres, when in use, are not like hard-edged solids, but more like radiant bodies emitting colored light—blue and yellow and pink—their appearance changing as they mingle, touch, and intersect. Thus, in dealing with the built environment, I will also be attentive to these mutually constituting inflections. In using representations of the city to better understand the city's lived spaces, we will find that historical continuities, rather than ruptures, reveal themselves. That is to say, if the powerful master narrative of "death" and "birth" as coincident with its political leadership is lodged in the representations of the city's space, lived spaces offer

countering—and abundant—evidence of the city's continuities before and after the Conquest, irrespective of who claimed political authority. I suspect that a close-grained analysis of urban practices would reveal even more such continuities. But since practice—so quotidian, so ephemeral—is often best encountered through archeology and in the historical archive, an archive that is highly fragmentary in the case of indigenous Tenochtitlan and Mexico City, the present study is just a first step toward understanding the lived spaces of the city. If Lefebvre's spheres can be imagined in order of visibility as we look back in time to the historical city, the representations of the city ("the conceived") loom large in the foreground, with lived spaces in the blurred midground, and practice ("the perceived") hovering at the horizon line.

How are these lived spaces to be encountered, given the looming endurance and historiographical primacy that representations of the city's space have had? I would contend that, often, their traces are hidden in plain sight. Let us return to the marvelous *biombo*, with its scene of palace and plaza, and bring our gaze closer to the bottom of the work (figure 1.2). Here, we see the city's original residents: Nahuatl-speaking women wearing traditional clothing, selling food, which might include the leaves and fruit of the nopal cactus, avocados, and pomegranates. Their husbands and sons work nearby, selling freshwater from wooden barrels or transporting goods on their backs. While this painting does include these residents, it shows them as the city's underclass, the visual hierarchy echoing a social one, with popular classes at the base and the ruling class, in the form of the royal palace and viceroyal retinue, above. Nonetheless, their inclusion in this representation of space points to their practices that shaped the urban fabric, practices that took them beyond the frame of this particular image as they followed their daily routines, inflecting other lived spaces in the city. The daily paths of the female sellers set into the *biombo*'s foreground may have led to the city's indigenous markets, where Nahua women sold beans, corn, and chile to provision the teeming city. In the *biombo*, the Habsburg palace that dominates the background is the only urban palace that made its way into this representation of space, but it was one of two such palaces in the city. The other, never pictured, as far as I know, by a *biombo* painter, sat in the city's southwest, and within its walls gathered the indigenous men who also served as the city's rulers—an indigenous government would exercise power in the city, along with the city's Spanish *cabildo*, "town council," until

around 1820.[25] Thus, using representations of space as a starting point, and amplifying what they show (and sometimes, what they omit) and drawing on other data, can lead us to the lived spaces of the city.

MEMORY

While I have treated the three intersecting spheres, representations of space, lived spaces, and spatial practices, in a largely synchronic fashion, it is worth underscoring their diachronic nature, and what a conservative force a relationship to past representations and practices can be. For instance, a city map, that representation of the space par excellence, is indebted to earlier models of maps for inspiration to its creator and for legibility to its audience. A volume by one of Mexico City's leading historians, Sonia Lombardo, serves to make the point. Her *Atlas histórico de la ciudad de México* discusses major maps of the city in chronological sequence, and on its pages one can see visual connections between many of the maps reproduced therein, like links in a chain, as their makers updated previous maps to better conform to the expectations of their audiences about what a map should be, as well as to changes in the urban form itself.[26] In other words, each map of the present is indebted to a map of the past.

On an individual level, it is the capacity for memory that ties urban dwellers to the city's past, often through habitual memory (this is the place to which I return to buy beans and corn), an aspect of memory that has its greatest impact on practices. But the past might also be drawn into the present as urban dwellers remember specific occurrences via mental retrieval and revival. This kind of memory might be activated by an encounter with a specific place—thus engaging the capacity of memory that Aristotle called "anamnēsis"—the effort to recall.[27] In fact, in elaborating on the ways that memories are constructed and reinforced, scholars have emphasized the key role that spaces have.

While one's first field of associations might be created through deeply personal experience and lodged in individual memory, like those one might have of the childhood home or of the landscape of adolescent wanderings, other place memories are shaped by collective social practices and shared by a wider body of people.[28] One trigger for place memory is the commemorative monument or marker, which declares a particular spot as the place where something happened. Place memory goes beyond the physical monument; the sociologist Maurice Halbwachs

FIGURE 1.9. *Street sign, Puente de Alvarado, Mexico City, 2009. Author photograph.*

underscored the role of commemorative rituals in shaping a sense of the past, as did Paul Connerton.[29] Such collective rituals make their mark on lived space and contribute to the social nature of space, as underscored by Lefebvre: "Itself the outcome of past actions, social space is what permits fresh actions to occur, while suggesting others and prohibiting yet others."[30] Much of this capacity of spaces to shape future action has to do with the memory of urban dwellers.

The complex relation between representation, practice, and memory can be seen in a street sign in today's Mexico City that names the spot as the "Puente de Alvarado," after a bridge that no longer exists, once standing at the site of the "Salto de Alvarado" (Alvarado's leap, figure 1.9). This event occurred during the first phase of the city's conquest, at the end of June 1520; when the Spaniards were first routed from Tenochtitlan, Cortés's second-in-command made a daring leap to safety across a canal. The name on the street sign is a representation of the space, installed and maintained by Mexico City's government. Well-schooled residents of the city today who take note of the sign might carry its meaning downward into the lived space of this street's edge, drawing from an internal cache of memories of a lesson learned in a history class. In post-Conquest Mexico City, however, a practice in the form of a procession also shaped the space, as on August 13th, the feast of San Hipólito, the city's residents marched toward this spot from the Plaza Mayor to celebrate the day on which Cuauhtemoc was defeated and Mexico City was founded. Thus, individual memories—of participation in this parade or of viewing it as a spectator—also play a

role in shaping the meanings of lived spaces. The theme of memory will reoccur later in the book.

PAST STUDIES

When representations of the city's spaces are probed with an eye to indigenous presences, they yield a different understanding of the city's sixteenth-century history. By emphasizing indigenous presence, rather than assuming its absence, in representations of space and lived spaces, this book makes a novel contribution to both the history of Mexico City and early modern urbanism. It draws inspiration from a slim volume and map that the architect Luis González Aparicio published in 1973 on the pre-Hispanic city, in which he laid out the extensive environmental manipulation—the building of dikes and causeways, roads and aqueducts—undertaken by the peoples of the Valley of Mexico to make their highland lacustrine environment habitable, paralleling a similar study of the hydraulic environment published by Ángel Palerm the same year.[31] González Aparicio posited that the pre-Hispanic builders of the valley cities consciously connected the urban nuclei—the urban network clustered around the lake—with great visual axes that tied together the built environment and in turn connected urban dwellers to the sacred mountain peaks that surrounded the valley. In doing so, he underscored both the genius of indigenous hydraulic engineers as well as the ideological drives behind their great urbanistic feats, as they created a built environment in harmony with the natural one, particularly the mountains and bodies and currents of water. His work has been confirmed and amplified by others. Archeologists working on the Templo Mayor, the main temple of the Mexica that was revealed in the center of Mexico City in 1978, have underscored the manifold ways that the ideal concept of the *altepetl* (a word that means the ideal sociopolitical community and translates literally as "water hill") was given expression in the architecture and urban design of pre-Hispanic Tenochtitlan, discussed in chapter 2. The geographer Alain Musset has explored the ideologies of water and the manipulation of the lacustrine landscape in the Valley, as has the anthropologist Gabriel Espinosa Pineda, among others.[32]

A decade before the publication of González Aparicio's work, Charles Gibson's masterful history of 1964, *The Aztecs under Spanish Rule*, looked at the social and political history of the post-Conquest valley and underscored the enduring presence and practices of indigenous peoples in the Valley of Mexico.[33] Gibson's enterprise was furthered by James Lockhart, particularly in *The Nahuas after the Conquest*, of 1992; Lockhart worked through the vast archive of documents written in Nahuatl to construct a new history about the indigenous past, one that underscored indigenous agency in the colonial period.[34] More recently, historians have homed in on Mexico City and given us a better picture of the workings of the indigenous city and its government in the post-Conquest period. William Connell's *After Moctezuma* looked at the history of the indigenous government that was set up in the capital in the wake of the Conquest, a government that was structured similarly to the Spanish *cabildo* that ruled over the center of the city: publications by María Casteñeda de la Paz, Emma Pérez-Rocha, Perla Valle, and Rafael Tena have focused on the actions of indigenous elites, bringing to light new understandings of these key players and new documentary sources.[35] Ethelia Ruiz Medrano, who has studied the role of Crown officials in shaping the early economy of the region around Mexico City, has also turned her attention to the role of indigenous elites in the city, revealing the complicated political currents among them, Franciscans and Spanish *encomenderos* (who held Crown grants of indigenous labor); a recent collection edited by Felipe Castro Gutiérrez, including essays by him, Rebeca López Mora, and Margarita Vargas Betancourt, has focused attention on the indigenes of Tenochtitlan and Tlatelolco, as well as their counterparts in other cities of New Spain.[36]

Yet these two avenues of study have not yet come together: archeologists and architects have amply revealed the extraordinary feats of the Mexica in creating the pre-Hispanic city and the compelling ideologies that drove them; at the same time, historians have brought new understanding of the actions and agency of indigenous peoples, particularly elites in the post-Conquest city. But to date, no one has focused extensively on the role of indigenous peoples in shaping the built environment and lived space in sixteenth-century Mexico City. In order to fully understand the lived space of the indigenous city, this book avoids a periodization that posits a definitive break between the pre-Hispanic and post-Conquest city—a corrective to the trope of the death of Tenochtitlan—and treats the creation of the indigenous city as an ongoing process that spans the fifteenth and sixteenth centuries, with new challenges—but not insurmountable ones—introduced

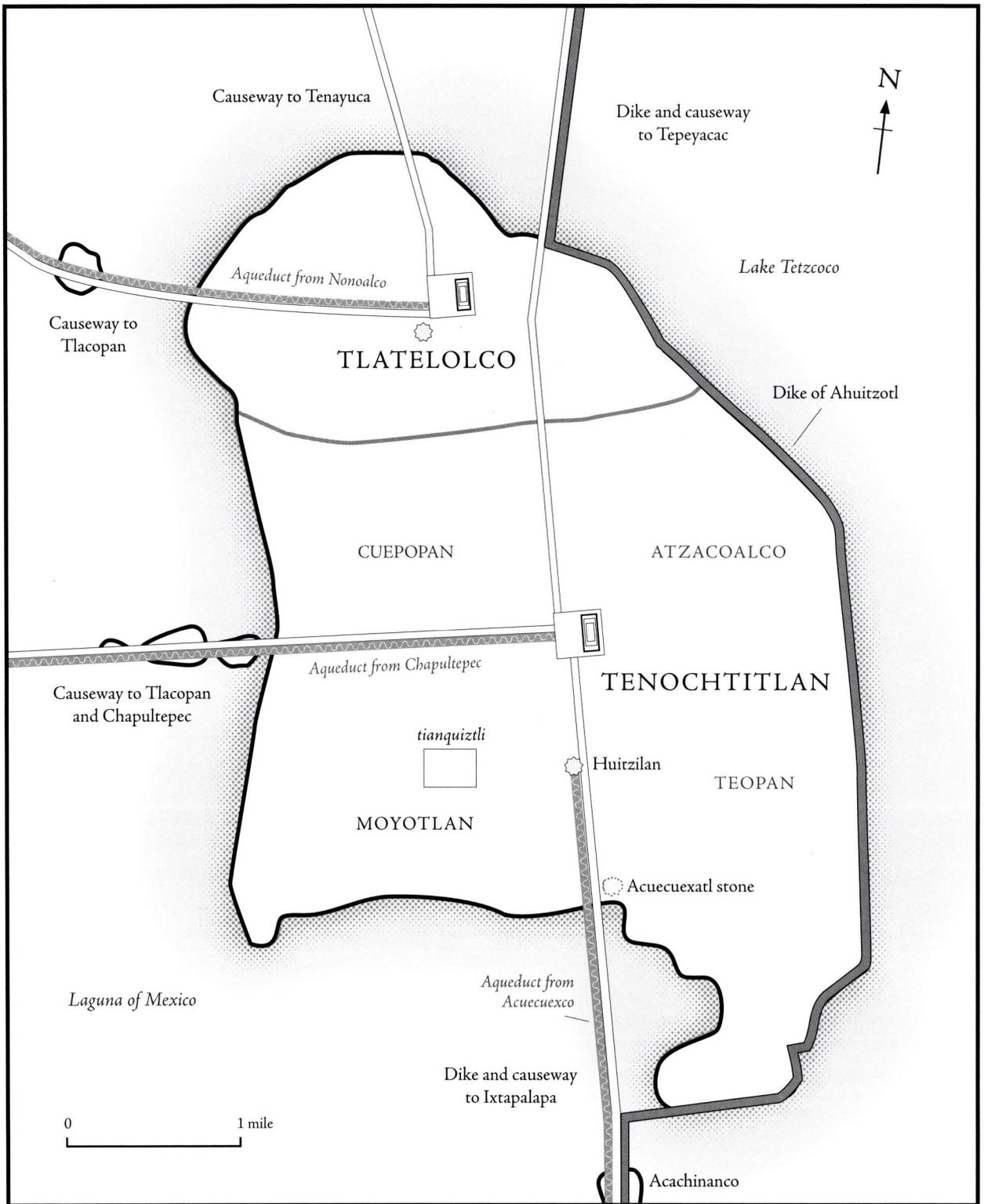

Causeway to Tenayuca

Dike and causeway
to Tepeyacac

N

Lake Tetzcoco

Aqueduct from Nonoalco

Causeway to
Tlacopan

TLATELOLCO

Dike of Ahuitzotl

CUEPOPAN

ATZACOALCO

Aqueduct from Chapultepec

Causeway to Tlacopan
and Chapultepec

TENOCHTITLAN

tianquiztli

Huitzilan

TEOPAN

Acuecuexatl stone

MOYOTLAN

Laguna of Mexico

*Aqueduct from
Acuecuexco.*

0 1 mile

Dike and causeway
to Ixtapalapa

Acachinanco

FIGURE I.IO. *Map of pre-Hispanic Tenochtitlan and Tlatelolco, by Olga Vanegas.*

by the occupation of the center of the city by Spaniards beginning in the 1520s. There are precursors to such an approach in the work of Edmundo O'Gorman, who brought up the question of spatial continuities between the pre-Hispanic and sixteenth-century city in an article published in 1938; Alfonso Caso also offered strong evidence for the colonial continuities of the pre-Hispanic spatial and social categories in the city in his landmark study of its neighborhoods.[37] Caso's interest was not in the sixteenth-century city, but in the quotidian spaces of pre-Hispanic Tenochtitlan, and to this end he identified the locations of the *tlaxilacalli* (neighborhoods) that were the component elements of the city. However, all of his supporting data was drawn from post-Conquest sources, some of it directly describing the post-Conquest city. As a result, Caso's article and accompanying map (see figure 7.3) underscored continuities of indigenous lived space before and after the Conquest, particularly in the arrangement of sixteenth-century religious buildings and other features of the built environment.[38] And the work of Edward Calnek has, over decades, contributed immeasurably to our understanding of Mexico City as an indigenous city.[39]

Evidence of continuity is revealed by the map in figure 1.10, which shows how pre-Hispanic Tenochtitlan was divided by roads that radiated from the central temple precinct. These were practical conduits: the ones running south, west, and north led to the great, wide causeways that connected the city to the lakeshore. Another map of the city, this one published in 1524 with Cortés's Second Letter, shows much the same. It is the earliest European printed map of the city and offers a bird's-eye view of the valley, oriented to the west, with a separate map of the Gulf Coast, oriented to the south, included at left (figure 1.11). The 1524 maps were created by a European artist, but the city view at right was likely drawn from a Mexica source, and shows us Tenochtitlan at center, as a porous disk surrounded by a larger ring of water of the lake; canals thread through the city and once served to irrigate raised fields called *chinampas* that supplied food to city's residents.[40] The blocks of houses that appear to float on the water may be the artist's imaginative evocation of these urban atolls. The ceremonial precinct at the center of the city is pictured as a walled

FIGURE 1.11. *Unknown creator, map of Tenochtitlan (at right) and schema of the Gulf Coast (at left), from Hernando Cortés's Second Letter,* Praeclara Fernandi Cortesii de Noua Maris Oceani Hyspania Narratio . . . *(Nuremberg, 1524). Courtesy of the Newberry Library, Chicago, Ayer 655.51.C8 1524d.*

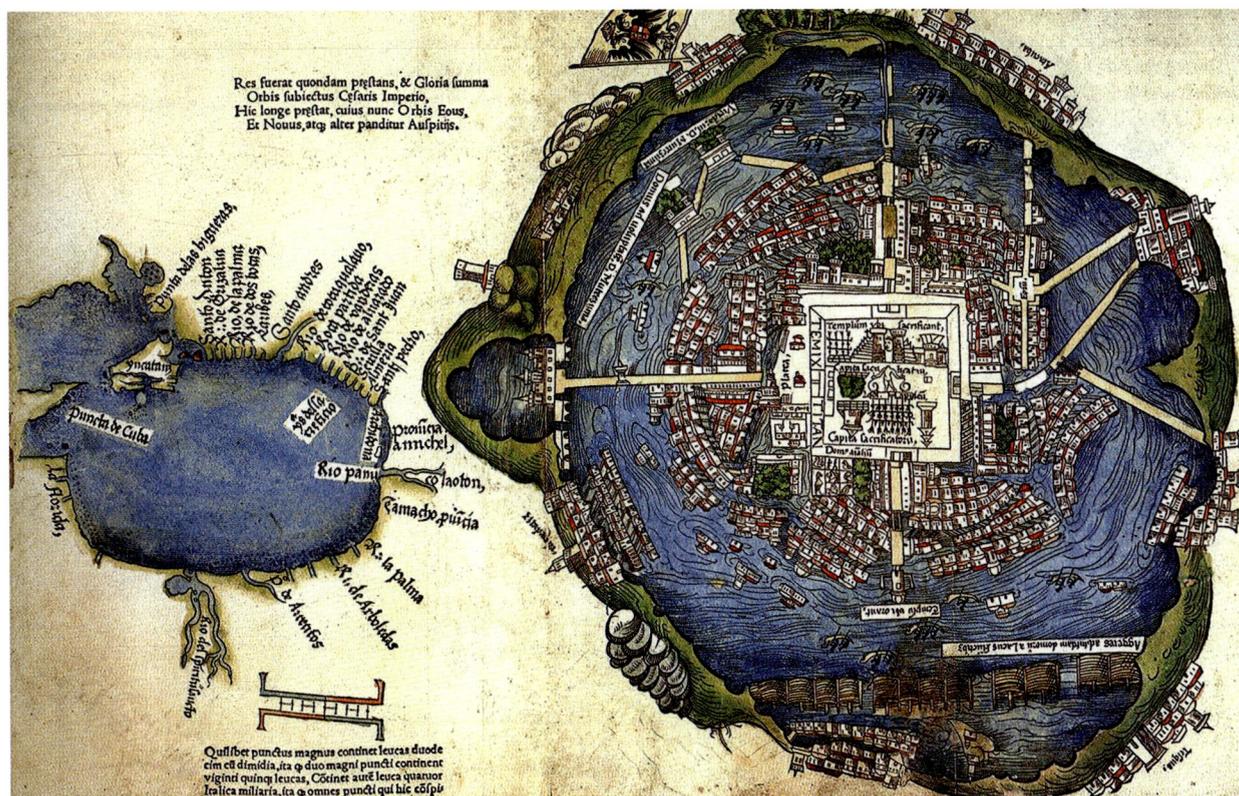

square, and from the center of each of its four sides, one can see the starting points of four broad causeways, three of them (to the west, south, and north) connecting the city to the encircling lakeshore. Along the western causeway, running vertically upward from the city, one can even see the bridges spanning the breaks in the causeways that allowed the lake water to circulate. The four causeways that cut through the city also divided it politically, and the resultant four parts—Moyotlan, Teopan, Atzacoalco, and Cuepopan—were each a distinct sociopolitical entity, or *altepetl*. In the pre-Hispanic period, each seems to have had its own ruling lineage and its own religious complex dedicated to the *altepetl*'s particular deity; Lockhart describes the larger city of Tenochtitlan as a "complex altepetl" comprising these four component *altepeme*, which in turn had one *huei tlatoani* (supreme leader) and a central sacred complex in the Templo Mayor, seen as the square at the center of the map.[41]

Despite the destructions of the Conquest, the causeways remained, as did the quadripartite sociopolitical arrangement of the indigenous city. Tenochtitlan's post-Conquest inhabitants divided themselves into four *parcialidades*, "parts" (also called *barrios*, "neighborhoods"), of Mexico City, which largely respected the preexisting arrangements of the quadripartite city, including the nomenclature of places and the placement of sacred architecture. An indigenous government ruled over these areas, headed, through the sixteenth century, by members of the Mexica ruling family. And a number of pre-Hispanic Mexica monuments—including ones that proclaimed the cosmic centrality of the Mexica state—were publicly visible in Mexico City into the seventeenth century, adding another provocative counter to the widely held notion of the erasure of the indigenous city.[42]

While there is a mounting tide of evidence supporting continuities in representations of space and lived space of indigenous Tenochtitlan and Mexico City across the fifteenth and sixteenth centuries, spatial practices, those quotidian actions that both create and give meaning to cities' lived spaces, are both the most important sphere in which to look for more such evidence of continuity and the one of most difficult access to the urban historian. Fortunately, new work being done by historians on Mexico City's Nahuatl-speaking community promises to further enrich our understanding of the city's lived spaces: Alejandro Alcántara Gallegos has focused on the spatial configuration of indigenous lands; Jonathan Truitt's dissertation on

San José de los Naturales has looked particularly at the role of Nahua confraternities in creating the post-Conquest city's religious spaces; and while Richard Conway's work focuses on Xochimilco, it does shed light on the indigenous market practices within the urban hub, all part, as is this work, of the spatial turn of the humanities.[43]

METHOD

Let us begin with an exercise in the method of the book, that is, begin with a representation of the space of the city and examine it for the evidence it offers of lived space, as an introduction both to the history of the city as well as to the themes of the chapters that follow. Today, Mexico City has some 8.85 million inhabitants (this is the official count for just the Distrito Federal, as the central urban zone is known; inclusion of the entire urbanized area of the valley pushes the population as high as 23 million), and perhaps the representation of the city that most encounter today is the map of its metro system, whose passengers made 1,606,865,117 trips in 2012, some 4,402,370 trips a day, along a system of 140,733 miles of tracks.[44] Metro maps are framed in every station, greeting those who enter, and are set along the platforms (figure 1.12). The metro was designed by urban planners in the 1960s to bring a contemporary system of transport to the city under President Gustavo Díaz Ordaz. It was then, and is now, a marker of Mexico City's urban modernity, still one of the most efficient systems of urban transport ever created. The metro map is a representation of space par excellence; its spidery lines index what happens aboveground, in the fresh air of lived space. In the first phase of the system, opening in 1969, the longest of these lines was route 2, which now stretches over 12 miles, cutting into the city's broad middle from the west, taking a turn at the center of the city, and then heading south. New lines added in 1999 and in 2012 track the recent expansion of the urban populace to the city's northeast and southeast. Looking at the map of the system, one can also see traces of the city's historical development. Five of the fourteen lines (1, 2, 3, 8, and B) thread around the Zócalo, once known as the Plaza Mayor and seen in the *biombo* painting, the core of the city and one of the world's largest urban plazas, a plaza that was first shaped by the city's Mexica founders and is seen at the center of the 1524 map of Tenochtitlan. A few stops away to the left, or west, four of these lines converge around the Alameda, another great open space, this one an urban park whose

FIGURE 1.12. *Map of the Mexico City metro, "Sistema de Transporte Colectivo:*
Red de Metro." © Sistema de Transporte Colectivo. Ciudad de México.

orderly paths still follow its late eighteenth-century plan, a park that once marked the western edge of what was an island city. A bundle of lines press toward the south, tracing the surge of urban development as once-independent cities—Coyoacan, Culhuacan, Tlahuac—were absorbed into the modern megalopolis.

The names of the stations that mark the map open like windows onto the city's history. Each of them is designated by a related icon (designed by a team under Lance Wyman), useful in a city with still-high illiteracy rates, and most of the names were chosen because they relate to an aboveground feature or toponym, or a historical figure or event, often one that happened close to the location of the metro station. Appropriately, the map sets them along the lines following their spatial order, but we could easily rearrange them, like playing cards on a table, to follow a different order, this one chronological. Near the contemporary end of our timeline would be "Universidad," the stop at the National Autonomous University (UNAM), relocated from the center of the city to a rocky outcropping in the south in 1954, or "Instituto de Petroleo," built in 1965 as a research arm for the national petroleum industry (PEMEX), whose profits have underwritten many of Mexico's public services, including the UNAM. Somewhere in the middle of our metro-station timeline would be those stations with names relating to the city's tumultuous nineteenth-century history, when this former capital of the viceroyalty of New Spain wrested itself from Spain's control and shaped itself into a nation: the "Hidalgo" stop recalling Miguel Hidalgo, the priest whose rallying cry in 1810 triggered the Mexican War of Independence from Spain; "Juárez" after Benito Juárez, who was born to a peasant Zapotec family and later became president, helping transform Mexico under the liberal constitution of 1857. Clustered in the city's center, where millions pass through them daily, these stations are as central to the transport hub as they are to Mexico's own historical narrative, where independence and nation building have pride of place.

At the beginning of our timeline, we would set a small number of stations that bring us even further back in time, to the city's sixteenth-century history. The city's violent conquest by Spanish and allied indigenous troops in 1519–1521 has produced a number of traces in the metro map: the station named "Villa de Cortés" is after Hernando Cortés, the great conquistador, whose deadly siege from May to August of 1521 brought the Mexica city to capitulation; "Cuauhtemoc" is named after the last Mexica

emperor, who took the throne of the imperiled city in 1520, surrendered to Cortés the following year, and was executed by him in 1525; "Cuitlahuac" is after Cuauhtemoc's predecessor, Cuitlahua, who ruled for only eighty days as Aztec emperor in 1520 before dying, likely a victim of smallpox, a European-introduced pathogen whose rapid and terrifying death-sweeps through the indigenous population were the Spanish conquistadores' most effective avant-garde. And then, of course, there is the station named "Moctezuma."

The icon of this station is evocative and provocative (figure 1.13). It shows us, in simplified form, the great fan made of resplendent green quetzal feathers that, in the popular imagination, Moteuczoma II was believed to have worn as a headdress (figure 1.14). The fan, probably made right before the arrival of the Spaniards in 1519, is one of the great works of Mexica art to survive. The feathers making up the headdress were brought to the city by long-distance traders whose journeys knitted the imperial center to far-flung peripheries in places like Guatemala, six hundred miles to the south. As such, it was a material reminder of the large empire cobbled by Moteuczoma's forebears, mostly in the wake of the Triple Alliance of 1428, begun when the *altepetl* of Tenochtitlan joined with two other *altepeme* in the Valley of Mexico, Tetzcoco and Tlacopan. The triumvirate began to wage brief wars against other

FIGURE 1.13. *Icon of the Mexico City metro station "Moctezuma."* © *Sistema de Transporte Colectivo. Ciudad de México.*

altepeme, who upon their defeat were required to render tribute—often in the form of feathers or feathered costumes like the headdress—as often as five times a year to their new valley overlords. The geographic expanse of this tribute empire is captured in a modern map in figure 1.15. Upon the arrival of Hernando Cortés, this empire revealed itself to be an unstable one, given that the component *altepeme* retained a good degree of autonomy after conquest, with none of the nationalist ideologies that would help fragmentary European states adhere.

Material evidence of the successful tribute empire, feathers were both beautiful and highly symbolic to pre-Hispanic viewers. They were appropriate for Moteuczoma's garb, not only because they signaled his role as imperial cynosure of a far-flung and materially diverse empire, but also because their deep green color was that of freshly sprouted maize, the stuff of life. Jade and greenstones carried similar meanings, and the emperor's body was often hung with carefully worked jade earrings, necklaces, belts,

and bracelets. Feathers were worn in large devices like this one and decorated enormous fans that were carried in public processions, the iridescent feathers of the quetzal being a sign and a reflection of the imperial presence.

But the location of the station "Moctezuma" is, at first glance, perplexing. It sits outside the old urban core, where this powerful emperor lived in grand style in a palace flanking what is today the Zócalo, ruler of a populous city as well as the larger empire beyond. It bears no relation to the site where, in November of 1519, he and a bevy of lords and retainers processed along one of the city's great causeways to meet and welcome Cortés, that stranger from afar who was treated with great courtesy and hospitality, welcomed into the palace, and given wine and women. Nor does it mark the sites of any of the extraordinary urban features that Moteuczoma constructed: his great zoo, which featured a

FIGURE 1.14. *Unknown creator, feather headdress, ca. 1520. Museum für Völkerkunde, Vienna.*

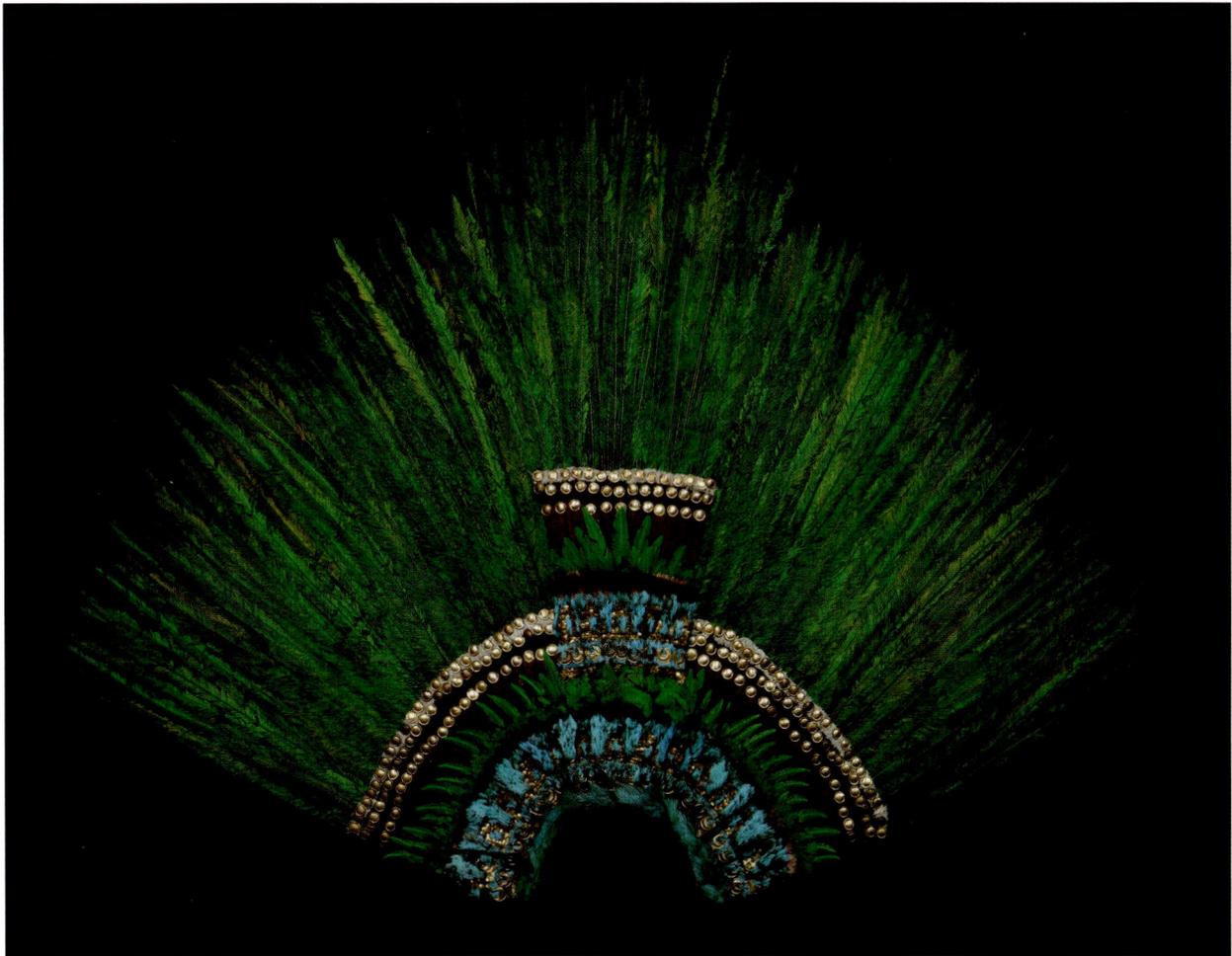

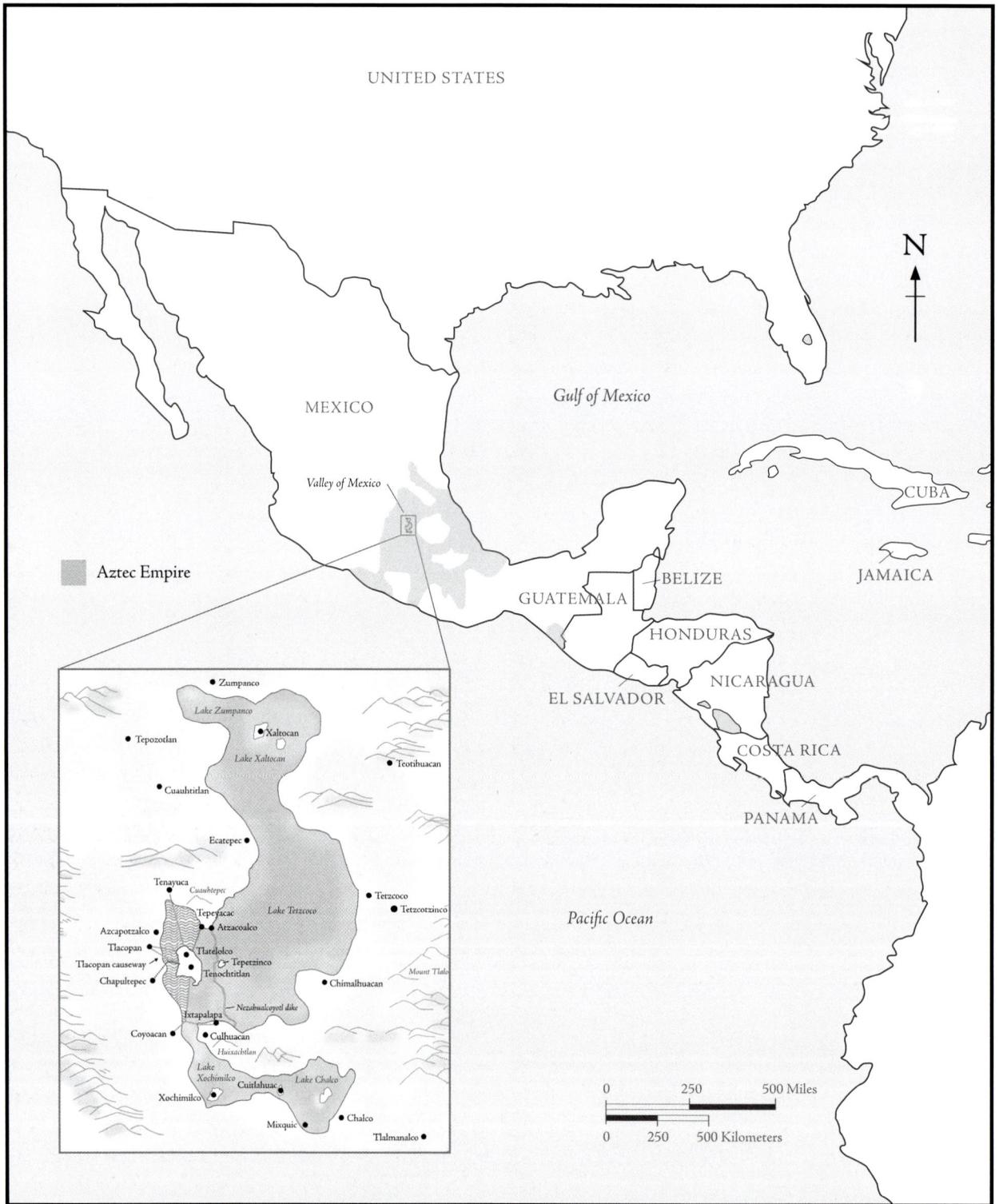

United States

Gulf of Mexico

N

MEXICO

Valley of Mexico

CUBA

Aztec Empire

JAMAICA

GUATEMALA ─ BELIZE

HONDURAS

NICARAGUA

EL SALVADOR

COSTA RICA

Pacific Ocean

PANAMA

Zumpanco

Lake Zumpanco

Tepozotlan

Xaltocan

Lake Xaltocan

Teotihuacan

Cuauhtitlan

Ecatepec

Tenayuca

Cuauhtepec

Tepeyacac

Atzacoalco

Lake Tetzcoco

Tetzcoco

Tetzcotzinco

Azcapotzalco

Tlacopan

Tlatelolco

Tepetzinco

Tlacopan causeway

Tenochtitlan

Chapultepec

Mount Tlalo

Chimalhuacan

Ixtapalapa

Nezahualcoyotl dike

Coyoacan

Culhuacan

Huixachtlan

Lake Xochimilco

Cuitlahuac

Lake Chalco

Xochimilco

Mixquic

Chalco

Tlalmanalco

0 250 500 Miles

0 250 500 Kilometers

FIGURE I.15. *Map of the Aztec Empire, in relation to modern political boundaries, by Olga Vanegas.*

special section of albino animals; his aviary, which may have occupied an enormous city block; his "house of women," presumably housing the overflow from his palace of secondary wives, concubines, and their children. Instead, the station "Moctezuma" marks what was once the water's edge, the limits of his watery city, created through spectacular engineering feats of this ruler and his predecessors.

Along the same metro line where this station is set, two other stations with similar connections to the extensive manipulation of the aquatic environment are to be found: Chapultepec and Pantitlan. On our imagined timeline made of metro stations, these would be the second and third. (The first would be Copilco, a rocky volcanic outcrop in the southern valley that was settled as early as 800 BCE.) When the future city was little more than nubs of high ground in the middle of a vast, shallow, salty lake measuring some forty miles north to south, within the enormous volcano-ringed basin that we know as the Valley of Mexico, Chapultepec was a solid hill that rose at its western littoral (figure 1.1). Visible for miles around, it was a life-giving place, its rocky outcrops dripping and oozing with freshwater, the unstoppable gift of internal springs, the physical embodiment of *altepetl*, water hill. Probably around the eleventh century, that group of nomadic Nahuatl-speakers who called themselves the Mexica had come into the valley, and they first settled here, in Chapultepec. By the thirteenth century, they had moved from the shore and were occupying the outcrops in the middle of the salty lake, and later enshrined the year 1325 as that of their city's foundation. By the middle of the fifteenth century, they headed a large tribute state. Despite their military and economic successes, the Mexica in their island city remained perpetually tethered to Chapultepec, the site of their early settlement across the lake, as they were dependent upon its freshwater, which they carried across the lake via an ingenious system of double aqueducts. Early emperors had their portraits carved on the rocky outcrops of the hill, and today, vestiges of the portrait of the last Mexica emperor, Moteuczoma, carved directly into the live rock, are still visible. Chapultepec's life-giving water would provision the city until the nineteenth century.

Chapultepec was the place where tamed, potable water was available to the island's residents, and if we travel along the same metro line in the other direction, past the "Moctezuma" station, we arrive at "Pantitlan," and we encounter water's other face. The great salt lake that surrounded the city was seasonally fickle; technically speaking, it was an inland sea, with no natural outlets. During the summer rainy season, torrential rains in the valley and surrounding mountains would pour into the lake; then this swollen monster would threaten to engulf the island city. During the winter dry season, lake levels would drop precipitously, suturing the flow into vital arteries of canals that crisscrossed the valley and allowed provisioning canoes to reach large urban populations. Pantitlan was a site in the middle of the lake, and it seemed to be a concentrated microcosm of the lake's temperamental ebbs and flows. The large, shallow canoes that plied the lake would avoid it because even on calm, sunny days, when the lake surface could glisten like a mirror, Pantitlan could generate enormous waves that would swallow a boat and its crew. At other times, it seemed to turn into a great drain, generating a huge whirlpool that could suck boats and men down to the depths. The Mexica emperors were eager to mitigate its effects, and so they closely attended to the water deities ultimately responsible for such calamities. Their high priests went to Pantitlan like ambassadors on one of the religious feast days that fell early in the year. During the month of Atlcahualo, they headed out in canoes to Pantitlan to negotiate a favorable relationship with the needy and powerful water deities with offerings of food and vessels. Also included in the gifts to the deities were young children, carefully chosen for the sacrifice. Decorated with jade jewelry that was green, the color of new life, the children were like maize kernels that needed to be buried to ensure the sustenance of all. Throats slit, their small and precious bodies were gently committed into Pantitlan's watery depths.[45]

Thus even the map of the city's great metro system, that hallmark of the city's modernity, carries us, riders and readers, back to the past. Our voyage through the metro has allowed us to glimpse two principal themes of this book, seen as if from the windows of the train speeding in dark tunnels: the figures of the indigenous Mexica monarchs ("Moctezuma," "Cuitlahuac," and "Cuauhtemoc") and the city's relationship with its watery environment ("Chapultepec" and "Pantitlan"). The book's chapters are arranged in rough chronological order, beginning in the fifteenth century in chapter 2, "Water and the Sacred City," to explore the city as it was created and engineered by the Mexica, who took the rocky outcropping in the middle of a shallow lake and transformed it over generations into a densely built island city; as we shall see, they not only engineered the environment, but also articulated their feats of environmental control in their representations of

the city. The Codex Mendoza, as we have seen, posited a close identification between the figure of the ruler and the city itself, and chapter 3, "The *Tlatoani* in Tenochtitlan," focuses first on Ahuitzotl (r. 1486–1502), the *huei tlatoani* preceding Moteuczoma II, and then on Moteuczoma himself to demonstrate connections between the flow of water and the figure of the ruler. It also shows how he both functioned as a representation of the city as well as embedded himself in urban spaces, and connected himself to all-important temporal cycles; we will look fleetingly at practices, as the figure of the ruler threaded together the urban fabric. Chapter 4, "The City in the Conquest's Wake," takes up the city in the wake of the Conquest, or the trope of Tenochtitlan's "death" as Mexico City was formally founded within its space in 1522. While Spanish narratives about the city emphasize the destruction of visible monuments of pre-Hispanic religion—the manuscripts, the "idols," and the temples—we will instead look at the crucial role that indigenous peoples, and the Mexica elite, played in the rebuilding of the city. Chapter 5, "Huanitzin Recenters the City," continues to look at the role of the indigenous elite as they imagined the new city, focusing on one of the early governors, don Diego de Alvarado Huanitzin (r. 1537/1538–1541), and on a seminal representation of the city crafted out of feathers under Huanitzin's patronage. Chapter 6, "Forgetting Tenochtitlan," turns to Huanitzin's urban partners, the Franciscans, the mendicant order chosen to evangelize the city's indigenous population, to encounter their complex and ambivalent project as they sought in the 1530s and beyond to both preserve and erase indigenous Tenochtitlan. Their implied analogy of the city to the human mind—with urban erasure akin to forgetting—allowed them to destroy, but mostly preserve, the lived spaces of the city. At the same time, they attempted to fill those spaces with new meanings, creating from old Tenochtitlan a new Rome. Chapter 7, "Place-Names in Mexico-Tenochtitlan," takes up one of the

primary, but often overlooked, representations of the city, its place-names, and through them looks at the city under the successors of Huanitzin, particularly don Diego de San Francisco Tehuetzquititzin (r. 1541–1554). Above, we noted how important urban practices are in defining the city, and also how difficult these ephemeral traces are to track in the historical record; in an attempt to better understand the city's lived spaces in the mid-sixteenth century, chapter 8, "Axes in the City," looks to urban processions and their role in creating lived spaces, with particular focus on the late 1560s and the 1570s. Chapter 9, "Water and *Altepetl* in the Late Sixteenth-Century City," returns to the themes of water and the indigenous ruler in its discussion of the construction of a new urban aqueduct under the auspices of the indigenous city's great late-century ruler, don Antonio Valeriano (r. 1573–1599), underscoring his role in the maintenance of the ancient *altepetl* of Tenochtitlan, both as an ideal and as a reality.

If we return again to our *biombo* painting (figure 1.2), we will encounter an image that dovetails nicely with seventeenth-century Mexico City as represented in Spanish sources, centering on orderly urban life around the plaza and the palace, that emblem of Habsburg rule. But such an image can assign the viewer to the role of Icarus, whose daring plumage allowed him to be "lifted out of the city's grasp" at the same time that his ability to see everything from above deprived him of the experience of being on the ground. By the end of this book, I hope readers will have a greater understanding of the role of the indigenous residents in the creation of this extraordinary place across the fifteenth and sixteenth centuries and will come, as I have, to appreciate what the view from the ground has to offer, as we trace canals and walk through markets, raising our heads at times to glimpse the spectacular figure, quetzal-plumed or wrapped in embroidered mantle, of the indigenous ruler as he made his way through the island capital that the world now knows as Mexico City.

Water and the Sacred City

A painting in Mexico City's Museo Nacional de Antropología by Luis Covarrubias imaginatively captures the relationships between the pre-Hispanic city of Tenochtitlan and its surrounding environment (figure 2.1). Seen from a bird's-eye view from the west, the island city dominates the surrounding lake, anchored to its shores by the thin filaments of the causeways. At the city's center are the imposing buildings of the sacred precinct, with temples rising from spacious plazas; a secondary center of Tlatelolco is visible at left, on the northern part of the island. Around the lake are spent volcanic cones, and beyond them the great mountains of the Valley of Mexico dominate the eastern horizon line, their snowcapped peaks jutting into the sky. This ring of mountains, whose jagged profiles can be seen on particularly clear days in today's city, was well known from a distance to city residents, many of the peaks known by their Nahuatl names: Cuauhtepec, Popocatepetl, Iztaccihuatl. They were seen not only on the horizon but also at the heart of the city, since the massive, rubble-filled temples that rose up in every city center across the valley and beyond were conceived of as smaller versions of the surrounding mountains: the great pyramid of the city

FIGURE 2.1. *Luis Covarrubias (Mexico, 1919–1987), View of the Valley of Mexico, ca. 1955. Museo Nacional de Antropología, Mexico City. Archivo Digitalización de las Colecciones Arqueológicas del Museo Nacional de Antropología.* CONACULTA-INAH-CANON. *Reproduction authorized by the Instituto Nacional de Antropología e Historia.*

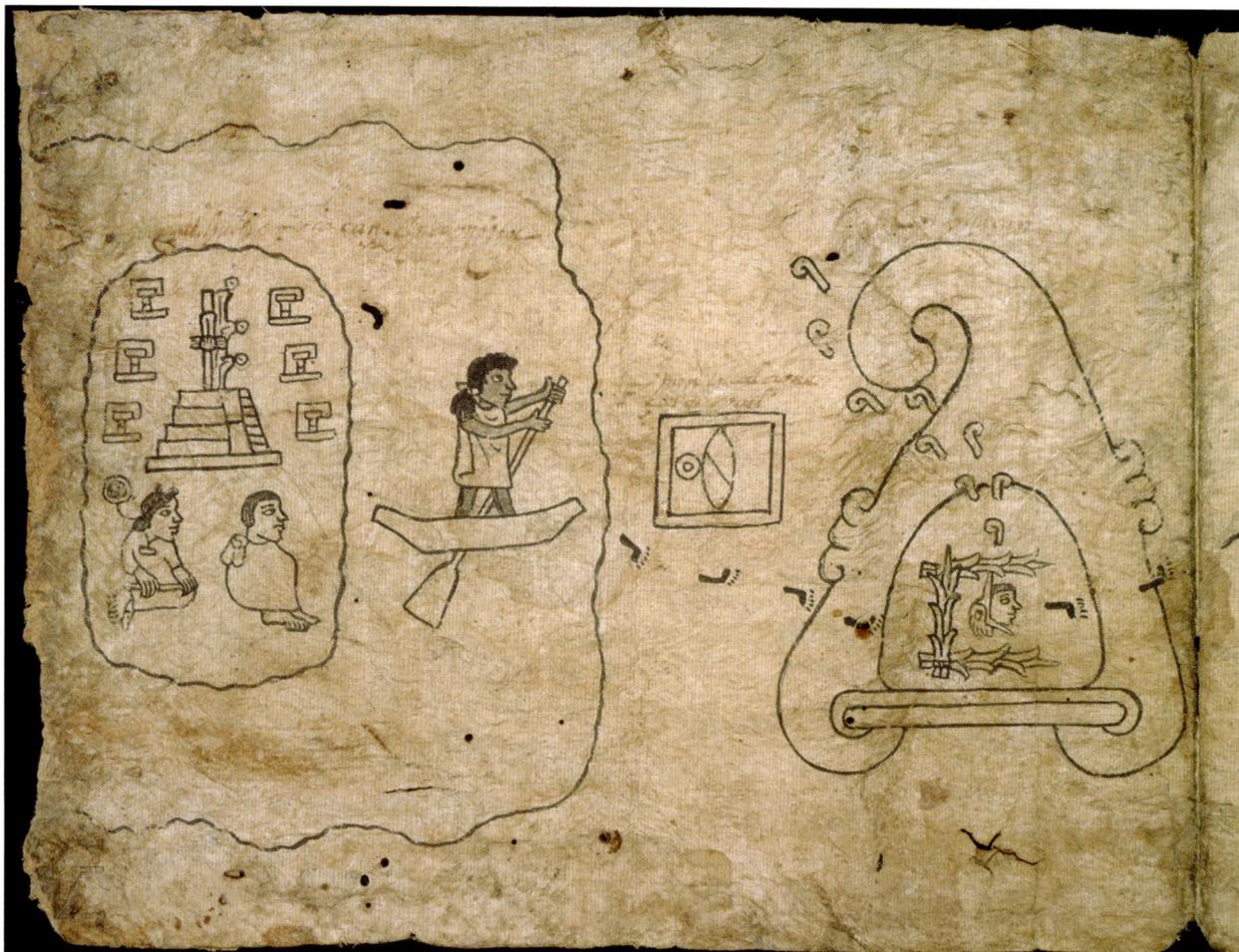

FIGURE 2.2. *Unknown creator, departure from Aztlan, Tira de la Peregrinación, ca. 1530. Biblioteca Nacional de Antropología e Historia, Mexico. Reproduction authorized by the Instituto Nacional de Antropología e Historia.*

of Cholula, outside the valley, was Tlachihualtepetl, which means "created hill," and the main pyramid at Tenochtitlan was Coatepec, or "serpent hill." Thus, from a distance, a key organizing principle of the city is visible: the mirroring of the man-made environment, its lived space, to that of the natural and therefore sacred one.[1]

The creation of the great island metropolis that dominates the painting—made of the twin cities of Tenochtitlan to the south and Tlatelolco to the north—was a hard-won victory over the surrounding lake for its residents, who distinguished themselves and their *altepetl* from other Nahuatl-speaking groups who were resident in the valley. Their persistence in the face of adversity was enshrined in their tales of origin, records written in iconic script that told of their departure from the mythic city of Aztlan, another water-ringed place, in the year 1 Flint, correlating to 1063, carrying with them the sacred bundle of their special deity, Huitzilopochtli, worshipped by them alone and the divine representative of their *altepetl* who directed them in their travels.[2] This history was well

known to pre-Hispanic residents of the city, and we find it represented in the early sixteenth century in the Tira de la Peregrinación (sometimes called the Codex Boturini), a manuscript of great graphic simplicity and clarity (figure 2.2). This screenfold manuscript was painted on a strip of native *amate* paper, measuring eighteen feet long, and then folded to create twenty-one pages, each of them representing some part of the great peregrination that took the Mexica out of their island of origin. On the first page, the island of Aztlan appears at left, delineated by a simple ovoid shape, containing a stepped temple in profile within. Around the temple are six small houses in profile, symbolizing the early settlement. Below, a couple sitting within the island watches a man, his skin painted black, in a canoe rowing across the surrounding lake; the

footprints that lead from his landing place show that he travels to a hill with a curved top, and they pass below a date, 1 Flint, in a rectangular cartouche. Within the hill, the unnamed rower will encounter Huitzilopochtli, who is shown as a profile face wearing a hummingbird head-dress within a three-sided enclosure of bundled reeds. The speech scrolls shaped like little candy-canes that emerge from above Huitzilopochtli indicate that he is command-ing the Mexica, and the footsteps that lead out of his shrine toward the right edge of the page signal the long migra-tion the Mexica are about to undertake, one that will lead them out of Aztlan. Note the representation of Aztlan as an island settlement surrounded by a circular lake, which reflects how the Mexica conceived their place of origin. It also provided a template for the city of Tenochtitlan, which they would build at the end of their journey—as this repre-sentation of space impressed itself upon lived space.

The unusual watery environment of the valley within which Tenochtitlan was built and the means of control-ling it have been a source of wonder and puzzlement in all its histories, from the letters of Hernando Cortés, who described it as "built on a salt lake" that "rises and falls with its tides as does the sea,"[3] to the writings of Karl Wittfogel, who saw the waterworks as the key to understanding the Mexica state. In his *Oriental Despotism*, he argued that the leaders who masterminded massive feats of environmen-tal engineering were "uniquely prepared to wield supreme political power"; within such societies, he argued, lay the precursors of the twentieth-century totalitarian state. It was Wittfogel who pointed out the close relation between the conquest state and the hydraulic state, as "organized control over the bulk of the population in times of peace gives the government extraordinary opportunities for coor-dinated mass action in times of war."[4]

Centuries earlier, the Mexica themselves made a similar linkage, twisting together the glyphs for "stream of water" (*atl*) and "burnt thing" (*tlachinolli*), which refers to the out-come of warfare, into a single symbol. This opposition is the kind that Nahuatl speakers were so fond of in their literary tradition, called in Spanish a *difrasismo*, or doubled phrase. It is explained in the dictionary of the Nahuatl lan-guage compiled by the Franciscan Alonso de Molina and published in 1571. He tells us that the couplet *atl, tlachinolli* is a metaphor for "battle or war" (as is another paired cou-plet, "arrow, shield" [*mitl, chimalli*]).[5] While many scholars have looked to one side of the *atl, tlachinolli* couplet with studies of Aztec warfare, it is surprising that no one has

turned attention to the place of water in representations of pre-Hispanic Tenochtitlan. This chapter does so. To consider the interplay between those spheres of represen-tation and lived space, it sets representations of the watery environs of Tenochtitlan, to be found in both images and texts, alongside a discussion of the engineering feats that brought the city into being. It argues that water—often shown as a violent or unruly woman—was an enduring trope in representations, and by the end of the fifteenth century, it was shown to be defeated or mollified by the ruler of the *altepetl* of Tenochtitlan. At the same time, the construction of waterworks linked to rulers carried these ideas into the lived spaces of the city. Wittfogel argued for the worldwide similarities between what he termed "hydraulic societies," be they in China, India, or the Valley of Mexico, a broad-brush picture. Here, we will see how, in fact, ideologies of both water and the ruler, and the link-ages between them, were products of a unique time and place, and in later chapters, we will see how the historical endurance of the linkage between the control of water and the indigenous ruler carried into the colonial period.

WATER AND *TEOTL*

By the thirteenth century, according to the Tira de la Pere-grinación and other histories, the Mexica had reached the valley. Tenochtitlan, the city that they would transform into one of the greatest metropolises of the world, began, as archeology has revealed, as little more than a series of low-lying atolls in the shallow and swampy saltwater of Lake Tetzcoco, bearing only the slightest resemblance to the ideal of Aztlan. By the fifteenth century, a new Aztlan had been created: the work of human hands, it had been wrested from the surging waters of the surrounding lakes, as generation after generation of Mexica scooped up lakebed mud and tramped to higher ground with their loads, building up the dry land, basketful by basketful, into the verdant island. These quotidian actions would be registered in the Nahuatl description of the city as *cem anahuac tenochca tlalpan*, the "water-ringed land of the Tenochca peoples."[6]

The Tira de la Peregrinación shows the special status of those called out from Aztlan by showing their election by the calls of Huitzilopochtli. And to those who lived in the city modeled on Aztlan, proof of Tenochtitlan's special status was embedded in the material reality of the city, from the measured flow of waters through the capillaries of

ditches and canals to the rhythms between temples and the surrounding landscape of volcanic mountains. The Mexica identified the sacred quality of the natural world as *teotl*, a word that expresses, as Richard Townsend put it, "the notion of a sacred quality, but with the idea that it could be physically manifested in some specific presence—a rainstorm, a lake, or a majestic mountain." *Teotl* was a central concept of the belief system shared by a broad spectrum of the people of central Mexico, wherein natural forces and presences were manifestations of the sacred world; the concept of *teotl* (often compared to the Polynesian concept of *mana*) expresses this view of the world as a hierophany, "perceived as being magically charged, inherently alive in greater or lesser idea with this vital force."[7] The sacredness of the world could be expressed in many forms, and thus *teotl* and *teo-* are frequent components of the names and terms that the Mexica, like other Nahuatl-speaking peoples of central Mexico, used for deities and sacred places, like Tlazolteotl, for a female deity, or *teocalli* (*calli* means "house"), for "temple."[8]

Covarrubias's twentieth-century image drew on a representation from the European-made map accompanying Cortés's account of the city (see figure 1.11), but inflecting that original map was a Mexica understanding of this city. We can never aspire to capture the intimacy with which residents knew this city through practice as they trekked out in ritual pilgrimages toward the sacred shrines that lay on the peaks or in the folds of the surrounding ranges or dredged out island soil to allow the insistent water to pass. But we find its representation in the poetry written in the sixteenth century in Nahuatl, a heavily metaphoric language, where the water and the lakes are a central figure. The poet of one work included in a compilation known as the *Cantares Mexicanos* seems to anticipate the blue-green expanse that Corrarubias's brush would produce centuries thence: "Creating circles of emerald, the city stretches out: / radiating brillance like the quetzal feather, here Mexico extends outward."[9] And yet another captures the wonders of this watery paradise at ground level:

> *Mexico Tenochtitlan Atlitic*
> *Among the rushes and the reeds*
> *Where the rock cactus stands*
> *Where the eagle stops and rests*
> *Where the eagle shrieks and pipes*
> *Where the eagle relaxes and takes pleasure*
> *Where the eagle dines and gorges itself*

> *Where the snake hisses*
> *And the fish glides*
> *Where the blue-green and yellow waters*
> *Merge and seethe*
> *At the water's center*
> *Where the waters enter.*
> *Where the rushes and the reeds whisper*
> *Where the white water-snakes*
> *And the white frogs dwell*
> *Where the white cypress*
> *And the white leafy willow stand*
> *There it is declared*
> *That sweat and toil have come to be known.*[10]

In its tranquil disposition, the picture by Covarrubias masks the lurking ecological violence in the valley, but it is there in the landscape of the poem: the lake that could seethe and swallow the city during the rainy season, the volcanoes, hissing like snakes, whose steamy plumes could erupt in molten lava, the ground itself that could buckle and rupture during earthquakes. Even the sun was inconsistent, a vagrant wandering from north to south along the horizon during the course of the year—indeed, the Mexica held that this era, the fifth "sun," or epoch of creation, *nahui olin*, 4 Movement, would end as the earth seized up in a cataclysm of seismic violence, much like the one that today's city, Mexico City, experienced in 1985. The natural world was an alternately wonderful and fearsome place, and the residents of Tenochtitlan knew it.

SPATIAL MODELS OF THE COSMOS

Representations of space, as Henri Lefebvre anticipated, are modeled on foundational beliefs or worldview, which scholars of Mesoamerica have termed "cosmovision." Alfredo López Austin has argued that a shared cosmovision has deep historic roots and extended widely across Mesoamerica, a geographic region extending from modern Mexico through Central America whose inhabitants shared common cultural traits across millennia. In a recent encyclopedia entry on the topic, he defined the term as a "hard nucleus" existing from the beginnings of civilization in Mesoamerica. At the core of this nucleus, "a complex of fundamental ideas was integrated to form the core of a common body of thought shared by many different ethnic groups."[11] The main element of this "common body" was a "cosmos shaped by complementary opposites," overseen

by a set of immortal deities who "possess reason, will, passions, and faculties of communication among themselves and with humans" and are able to "modify . . . the world." This cosmos had a specific geography, divided into levels and directions; the world moved in cycles that echoed the agricultural cycle of maize; but finally, it was the human body that was "one of the most important sources for the formulation of ideas about the cosmos." López Austin also understood it to have a dialectical quality. For him, the elaborate architecture of cosmovision had its foundations in human experience: "Humans assimilated their experiences, confronting and abstracting them to form bodies of congruent concepts; this allowed them, conversely, to construct a reality in which their perception of the world and action facing that world acquired a particular meaning. . . . Cosmovision served as a guide for action" at the same time that action and experience then continued to shape the understanding of the cosmos.[12] Such a model dovetails neatly with the spatial model proposed by Lefebvre, where the sphere of the representation of space, which in the case of Mesoamerica would include cosmovision—a systematic and integrated body of thought—inflects both lived spaces and practice.

The space of the Mesoamerican cosmos was structured along the principle of "opposing and complementary forces," perceived in the alternation between the wet summer and the dry winter of the tropics, which added a temporal dimension to spaces, which were transformed from light and dry (October–April) to dark and wet (May–September). The geography of this cosmos was composed of nine underworld layers of a place Nahuatl speakers called Mictlan, the underworld, and thirteen heavenly ones of the place they called Omeyocan, a heavenly place of creation. This multilayered cosmos was also divided into four quadrants and a center. This representation of cosmic space was imprinted on the lived space of architecture, as Eduardo Matos Moctezuma has argued for the Templo Mayor, the great twin temples that rose from the heart of Tenochtitlan's ceremonial precinct, which can be clearly seen in the Covarrubias view (figure 2.1). In Matos's view, "the principal center, or navel, where the horizontal and vertical planes [of the cosmos] intersect, that is, the point from which the heavenly or upper plane and the plane of the Underworld begin and the four directions of the universe originate, is the Templo Mayor of Tenochtitlan. Moreover, the structure itself represents the totality of the vision the Mexica had of the universe."[13]

At the center of Tenochtitlan, and the pivot of the cosmic order, the lived space of Templo Mayor carried in it proof of the victories of the principal Mexica deity, Huitzilopochtli, over his enemies, in particular, his principal female enemy, his half sister Coyolxauhqui. As told in the Florentine Codex, the great encyclopedia of the Mexica world written in parallel columns in Spanish and Nahuatl by native intellectuals working under the auspices of the Franciscan Bernardino de Sahagún, a woman named Coatlicue was sweeping at a sacred place called Coatepec when she placed an errant ball of feathers for safekeeping in her dress, only to find herself impregnated. This miraculous conception infuriated her daughter, Coyolxauhqui, and her sons for the dishonor it brought; Coyolxauhqui incited her brothers to murder their pregnant mother. But one of them slipped away to give warning to the unborn child. When the angry siblings charged up the hill of Coatepec, the Florentine Codex continues, Huitzilopochtli burst forth, fully armed and dressed in war costume, from the body of his mother, Coatlicue, and proceeded to slay his wrathful half siblings.[14]

As represented in an image in the Florentine Codex, the scene of battle takes place in Coatepec, which means "serpent hill," shown as a hill at whose top is a fork-tongued serpent; Huitzilopochtli, with striped face and body paint and wearing a crown of feathers, stands on the right of the hill and battles his half brothers (figure 2.3). The lower half of the central axis of the image is dominated by the dismembered body of one of his half brothers: his head lies upon the slope of Coatepec, and his bloody torso, with arms and one leg chopped off, lies at its base. At the Templo Mayor site itself, the designers of the building brought this representation to bear by setting undulating serpent balustrades and serpent heads upon the main pyramid to designate it as a Coatepec in miniature; the bundle representing Huitzilopochtli was cached in the upper reaches of the temple, and a disk-shaped relief sculpture of his half sister Coyolxauhqui, shown with head, arms, and legs severed from her central torso, was set below, at its base. This victory of (male) Huitzilopochtli over (female) Coyolxauhqui was reflected in a daily cosmic event happening in the skies over the *templo*, in the contest between Huitzilopochtli, a solar deity, and Coyolxauhqui, a lunar deity, every time the brilliant solar orb rose up and blotted out the weaker lunar one.

Representations of cosmic space were thus powerful models for the lived spaces of Tenochtitlan, particularly

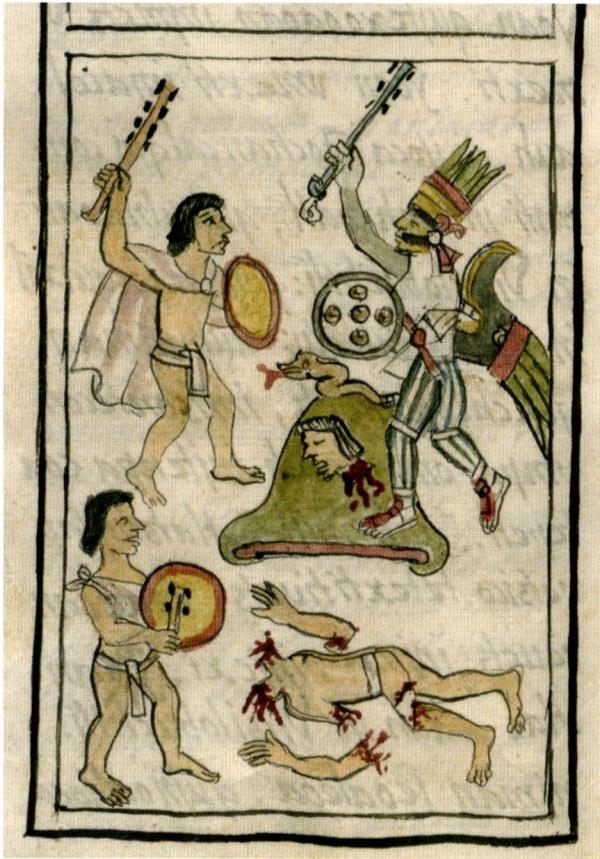

FIGURE 2.3. *Unknown creator, birth of Huitzilopochtli at Coatepec, Florentine Codex, bk. 3, ch. 1, fol. 3v, ca. 1575–1577. Florence, Biblioteca Medicea Laurenziana, Med. Palat. 218, c. 204v. By concession of the Ministry for Heritage and Cultural Activities; further reproduction by any means is forbidden.*

the monumental architecture. But for the Mexica, the current may have run the other way as well, with lived spaces determining cosmic ones. Twin-templed at its top, the Templo Mayor's right (or southern) side was dedicated to the deity Huitzilopochtli, and its left (or northern) side was dedicated to Tlaloc. Archeologists have shown that its earliest architects (of Phase II) carefully aligned the building to the east, so the cleft between the two buildings seemed to precisely channel the rising sun into the sky on the important days of the equinoxes. Successive rebuildings (Phases III and IV), which increased the height of the building, threw off the solar alignment. So important was the relationship between the building and the movement of the sun that beginning in Phase V, successive generations of Mexica architects reoriented the building with every rebuilding, carefully skewing the axis of the building to preserve the relationship, even at the cost of

a somewhat irregular trapezoidal footprint.[15] Thus, upon the autumnal equinox in late September, at the beginning of the dry season, a season associated with Huitzilopochtli because it was the season to wage war, the sun rose between the cleft in the two shrines at the top of the pyramid. It then moved south along the horizon with every successive sunrise on its gradual voyage to the terminal point along the horizon, falling on the winter solstice. It then journeyed back along the horizon again, and every sunrise until the spring equinox continued to appear behind Huitzilopochtli's side of the temple. In contrast, in the wetter and darker summer months, the sun rose behind the side of the temple dedicated to Tlaloc, the rain and agricultural deity. Considered from the perspective of the earth-bound observer, this building had agency—that is, lived spaces determined cosmic ones. The slipping of the sun along the horizon provoked anxiety; should the sun continue moving on its southbound course after December 22, appearing for a shorter and shorter period day by day, until it would not appear at all, the world would end. But this cosmic collapse was prevented (or at least forestalled) by the double-templed building, which *made* the sun rise through its cleft twice yearly, or so it appears from the ground. In doing so, the building actualized a cosmic model where solar darkness (conceived of as the cloudy rainy season) battled against solar brightness (the sunny dry season); by serving as a permanent horizon marker, the building brought this contest into clear visibility. And every time the sun moved back to its expected position of rising from the cleft at the equinoxes, the Templo Mayor of Tenochtitlan confirmed its capacity to make things happen, exerting its force on the solar orb like the slow and inexorable pull of a gravitational field.

THE SEARCH FOR THE IDEAL ALTEPETL

If one key nexus of Mexica spatial thought was the victory of the rising sun, Huitzilopochtli, over his cast-down (and often female) enemies, another was the *altepetl*, which was both an ideal physical and an ideal political space. The search for the ideal *altepetl* also dominates Mexica historical narratives. As pictured in the Tira de la Peregrinación, the Mexica endured years of wandering around the lake, shown by the year count embedded in the squares on the page. But in the year 1279, or 8 Reed, they arrived at a hill called Chapultepec, which lay on the Laguna of Mexico, the swampy western edge of the salty Lake Tetzcoco (figures

1.1 and 2.4). Abundant freshwater springs flowed from the base of the hill, and the hilltop site was easily defensible. Its ideal nature is made clear by the glyph the artist of the Tira used to show Chapultepec, which can be compared to a similar glyph in the Codex Aubin, discussed in chapter 1 (see figure 1.7). It appears as a grasshopper (*chapolin*) on top of the bell shape that was the symbol for *tepetl*, "hill." When combined with the glyph for "water" (*atl*), which can be seen flowing out of the hill's base, it also conveys *altepetl*, the word used to designate the human collective that was the primary group affiliation, after kin, of peoples in central Mexico. The *altepetl* was more than just a grouping of people; additionally it was an ideal environment within which people flourished. The Florentine Codex tells us that mountains like those surrounding the valley "were

only like ollas (vessels) or like houses; that they were filled with water . . . and hence the people called their settlements altepetl."[16] Chapultepec thus figures in this account as a kind of original paradise, an easily defensible site, a mountain filled with water. The Mexica respite in this ideal *altepetl* lasted twenty years. Like the representation of the space of the island settlement, Aztlan, that begins the Tira de la Peregrinación, an image that would provide a template for what the Mexica would come to construct in Tenochtitlan, so too would Chapultepec, this sacred *altepetl*, serve as a conceptual model for other lived spaces.

The pacific idyll in the perfect *altepetl* of Chapultepec came to a violent end when an enemy of Huitzilopochtli, his nephew Copil, raised armies against the Mexica to extract vengeance for Huitzilopochtli's abandonment of Copil's mother, another female enemy, a sorceress named Malinalxochitl. In the ensuing battle, Copil was captured by the Mexica and met a gruesome end at the hill of Tepetzinco, a rocky outcropping rising from Lake Tetzcoco (see figure 1.1). As told by the *Codex Chimalpahin*, a

FIGURE 2.4. *Unknown creator, arrival at Chapultepec, Tira de la Peregrinación, ca. 1530. Biblioteca Nacional de Antropología e Historia, Mexico. Reproduction authorized by the Instituto Nacional de Antropología e Historia.*

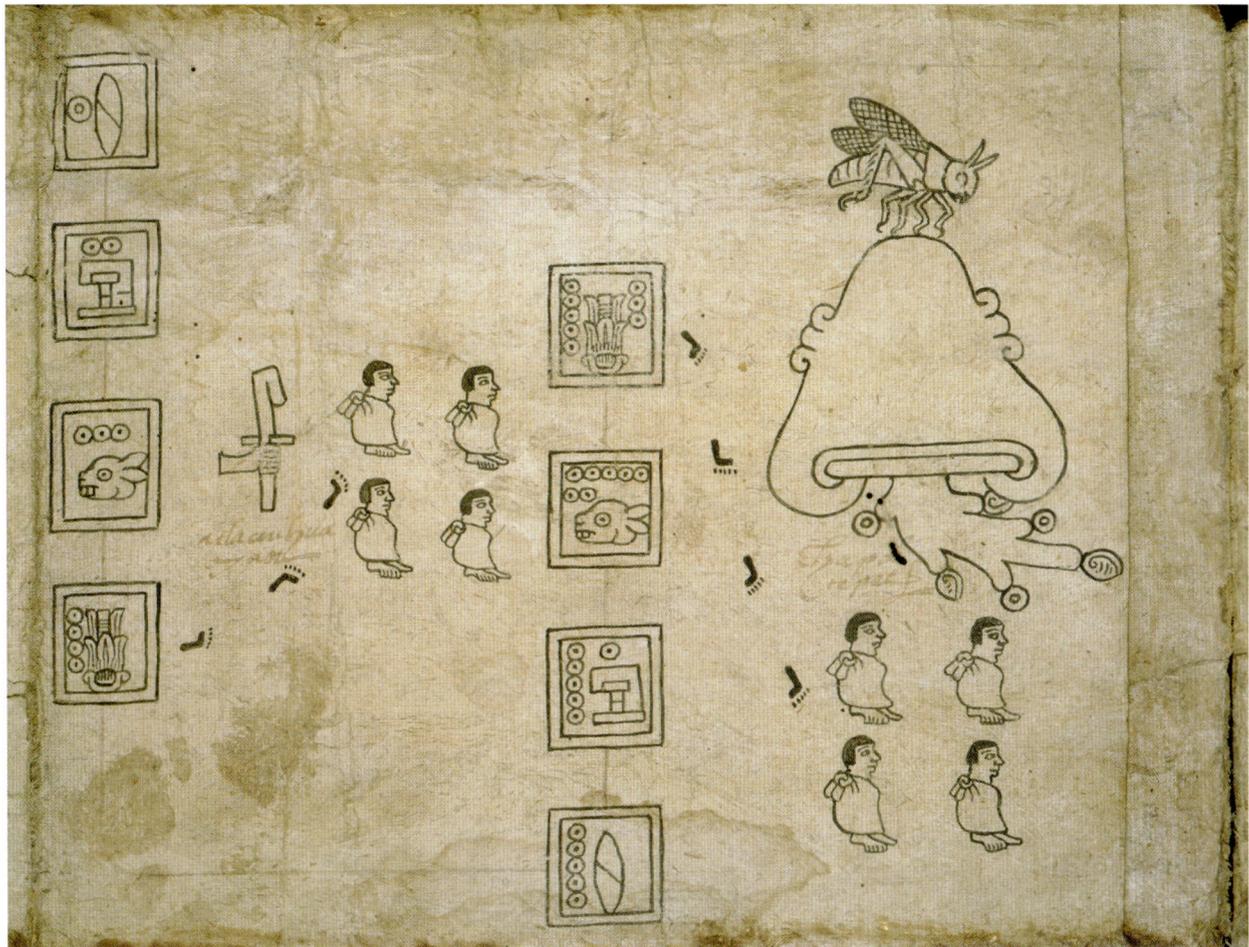

history of the Mexica written in Nahuatl at the beginning of the seventeenth century, "Then they overtook Copil at Tepetzinco. And when he had died then [Huitzilopochtli] cut off his head and cut open his breast. When he had cut open his breast he took his heart from him. And he placed his head on top of Tepetzintli, a place now named Acopilco, [for] there Copil's head died."[17] Despite Copil's defeat and dismemberment (another narrative tells us his heart was cast into the depths of the lake), the Mexica were routed by his forces, who chased them out of Chapultepec, taking women as slaves.[18] This happened in the year 2 Reed in the native calendar, a year that correlates to 1299.[19] Their ensuing exodus took the Mexica from one inhospitable place in the valley to another, all the choice grounds being occupied and carefully guarded by other *altepeme*.

Eventually they were allowed to settle in Tizaapan by the ruler of one of the lake cities, Culhuacan, but this too was a marginal and uninviting place, far from the ideal *altepetl* they were seeking. Nonetheless, they survived, and in 1323, the Mexica leaders asked the ruler of Culhuacan for the hand of his daughter to marry to their deity.[20] The unsuspecting monarch sent his daughter to them, only to arrive at the wedding feast to find that she had been sacrificed. Her flayed skin was draped over a priest in her new incarnation as "goddess." This female sacrifice led her horrified father to expel these Mexica from Culhuacan, and so they began their peregrinations again. But Huitzilopochtli never abandoned them and kept them going by promising to send them a sign when he found them a home.

That sign arrived in 1325, the year 2 House, when Huitzilopochtli sent an eagle, a bird associated with him, to land on the top of a prickly-pear cactus (a nopal) growing on a rocky outcropping in the middle of the lake; some accounts say that the nopal tree had sprouted from Copil's sacrificed heart.[21] It was here that the Mexica leaders were told to settle (see figure 1.3). The topography of this place is carefully described in a number of sources, both pictorial and textual, and in the motif of abundant flowing water, it conforms to the ideal *altepetl*. For instance, the *Codex Chimalpahin* records the Mexica leaders seeing the sign of Huitzilopochtli's eagle thus:

Then they saw the white cypresses [*ahuehuetl*], the white willows that stood there, and the white reeds, the white sedges; and the white frogs, the white fish, the white snakes that lived in the water there. And then they saw the intersecting crags and caves. The first crag and cave faced the sunrise, [with a stream] named the Fiery Waters [*tleatl*], Where the Waters Burn [*atlatlayan*]. And the second crag and cave faced north; the place where they intersected [were streams] named Blue Waters [*matlallatl*] and Yellow Waters [*toxpallatl*]. And when the ancient ones saw this, they wept.[22]

Just as the image of Aztlan seen in the Tira de la Peregrinación provided a template of the city surrounded by water that would be replicated in Tenochtitlan, the verbal representation of the city evokes a cosmic model. Across pre-Hispanic central Mexico, people understood that a great world tree supported the heavens; in the Mexica version, it is a pair of trees, an *ahuehuetl*, the great cypress that could live a thousand years, and a willow, both of them water-seeking plants. At the base of the world tree was a cave, and from this cave, like an earthly womb, human beings had once emerged. The Tenochtitlan version of this template includes another significant element: streams of water emerge from the caves, composed of complementary elements: fiery water and burning water, blue water and yellow water. But instead of being violent, as their names would suggest, the streams are peacefully flowing ones. These streams were connective axes between the human world of the earth's surface and the underworld, whose entrance was marked by caves.[23]

Having arrived at the ideal space of an *altepetl*, Huitzilopochtli addressed his chosen people, the Mexica, and his speech in this history underscores their sense of being embattled and surrounded by enemies: "Thus shall we find all who lie surrounding us, all whom we shall conquer, whom we shall capture."[24] These enemies included the hostile surrounding environment. During their migration, the Mexica often lived in marginal areas in and around the salty lake, and had to subsist on a diet of snakes and frogs; one of their settlements at Tizaapan, adjacent to the lake near Culhuacan, was "occupied only by vipers and poisonous snakes."[25]

Despite its representation as the ideal *altepetl*, the rocky outcrop was hardly a ready-made paradise, and it was only in conquering the surrounding lake that the Mexica made it so. Archeology has revealed how the city was once formed of small atolls that rose from the salty Lake Tetzcoco; lower-lying areas were underwater during the rainy season.[26] Over generations, residents filled in around these atolls to reclaim more land from the lakebed, gradually filling in a larger landmass (albeit one with swampy

depressions and edges). Just as their human enemies continually threatened the Mexica, so too did their watery one, their *altepetl* always subject to flooding by the tempestuous lake during the dark rainy season, when it was swollen by rain waters.

But those gentle streams bubbling up in the rocky outcrop where the eagle landed would be the reason for the Mexica to persist. These were freshwater springs, which nurtured two freshwater-loving trees, the willow and the *ahuehuetl*. And as late as the end of the sixteenth century, residents of Tenochtitlan were still making use of the freshwater provided by numerous springs in their island. The springs and other sources of freshwater would eventually convert this island into the ideal *altepetl*, a cornucopia, because they would make possible the growth of maize, that sacred grain of Mesoamerica that allowed the Mexica to move from a spare diet of "snakes and frogs" and begin to eat tortillas and other delicious and sustaining food. Thus the representation of space that Mexica historical narratives and architecture offer not only contains Huitzilopochtli's military victory over his enemies, symbolized by the sacrifices of Coyolxauhqui and Copil, where they are

FIGURE 2.5. *Unknown creator, diagram of the four directions of the world, Codex Fejérváry-Mayer, p. 1, fifteenth to early sixteenth century. Courtesy National Museums Liverpool.*

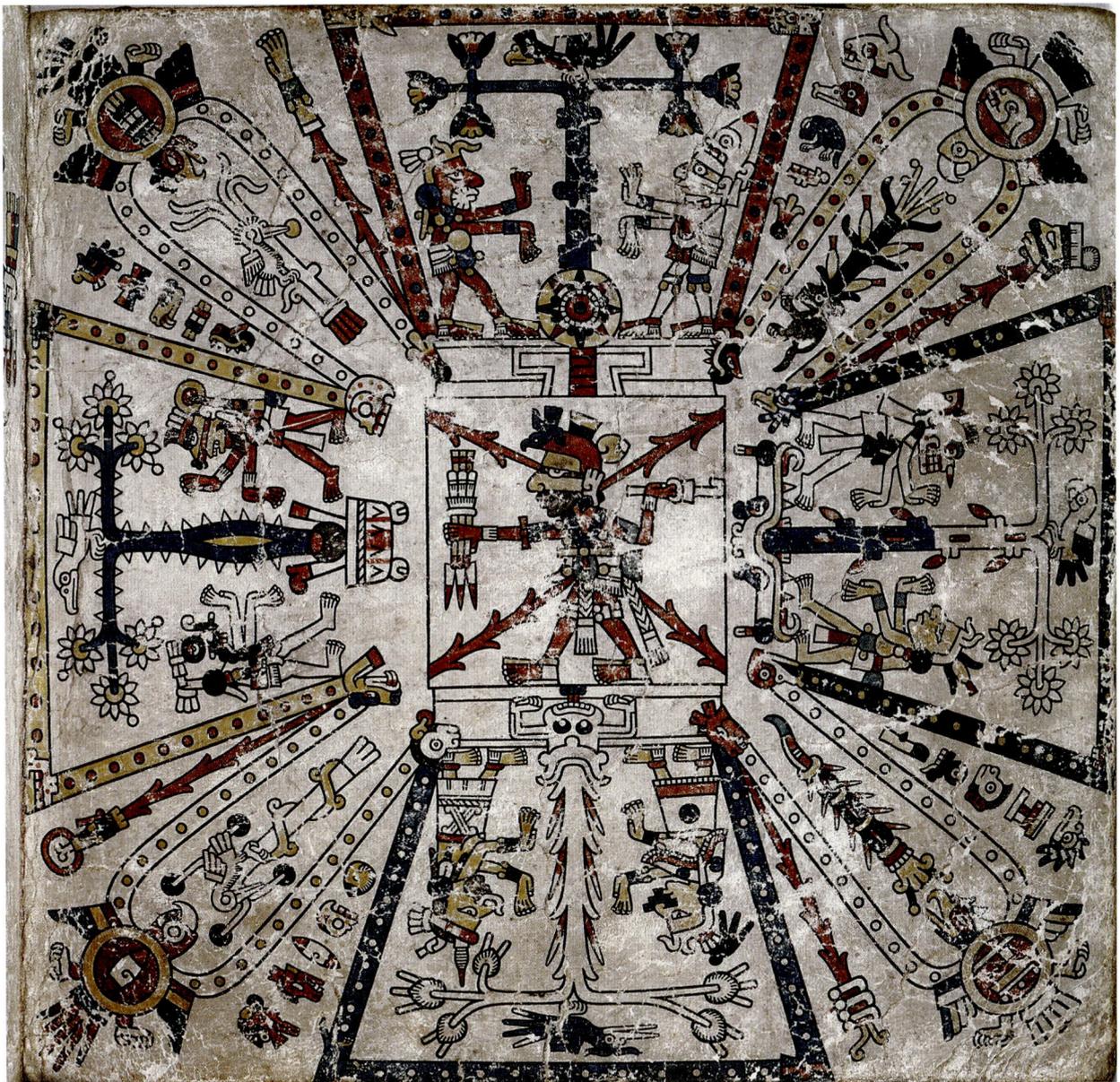

cast down and out to the periphery as the solar orb rises along the central east–west world axis, but also sets this in relation to the representation of the ideal *altepetl*, a rising landmass marked by abundant freshwater provided by gentle, crossing streams, spatial ideologies that would prove tenacious both in the pre-Hispanic city and after the Conquest as well.

This representation of the ideal *altepetl*, with its crossing streams of pacific freshwater, is expressed on folio 2r of the Codex Mendoza, which begins with a map-picture of Tenochtitlan at the moment of its official foundation in 1325 (see figure 1.3), discussed in the introduction. At the center of the page, the eagle of Huitzilopochtli lands on the cactus tree and four streams of water flow out from, or cross, near this tree, like those four streams described in the *Codex Chimalpahin*. Registering yet another important spatial template, the artist rendered the newly founded city as a quincunx, a visual motif that also opens the Codex Fejérváry-Mayer, a pre-Hispanic religious manuscript. The frontispiece of this sacred book offers us a map of cosmic geography, a pattern to which the Codex Mendoza artist would adhere (figure 2.5). The surface of the sacred earth is rendered in the form of a Maltese cross. At the center of each trapezoidal quadrant is a T-shaped tree that holds up the skies, represented by the celestial bird that perches in its branches, and each trunk rises from a base that serves as a directional marker. East is at the base of the blue tree in the top quadrant, shown by a rayed solar disk rising over a low temple, just as the sun rises in the east. At the center of these quadrants is a square space within which we see the solar deity Xiuhtecuhtli, identifiable by his striped face paint, a blue bird set above his forehead, and his red body paint. So when the artist of the later Codex Mendoza evoked this pattern of four quadrants with a deity at the center (in the Mexica's case, the eagle of Huitzilopochtli, another deity associated with the sun), he or she meant to show the city's space in alignment with that of the divinely created world.

In the Codex Mendoza, the space that the city would come to occupy is pictured on the page as bordered by a simple blue rectangle of water (see figure 1.3). While this codex likens the layout of Tenochtitlan to that of the sacred cosmos, of note on this page is the quality of the water. I have frequently read the framing rectangle as an abstracted version of the surrounding lake (see figure 1.1), but the water of the surrounding Lake Tetzcoco was almost always represented as frothy, surging, uncontrolled—qualities also

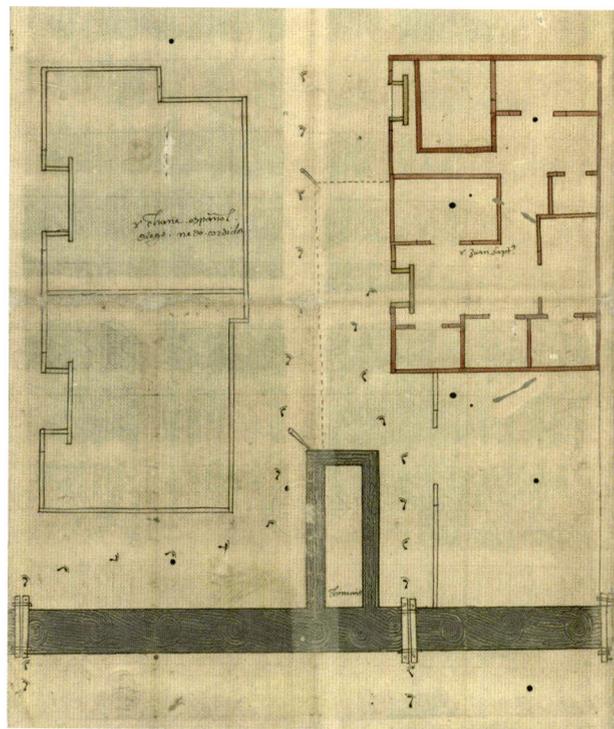

FIGURE 2.6. *Unknown creator, map of household properties showing chinampas, mid-sixteenth century. Archivo General de la Nación, Mexico, Bienes Nacionales, legajo 1147. Mapoteca 4743.1.*

noticed by Spanish residents in the sixteenth century, who spoke fearfully about the huge waves of the lake. Instead, what frames the newly born city are the gentle, tamed waters of a canal, rendered similarly to canals surrounding the raised-bed plots called *chinampas* that we find pictured in quotidian land documents produced in Tenochtitlan in the sixteenth century. In the map of a house plot shown in figure 2.6, the more turbulent water of a supply canal that runs across the bottom of the page is filled with spiraling eddies. In contrast, the ditch that flows around the rectangular *chinampa* (identified here in Nahuatl as a *chinamitl*) is marked with parallel lines to show its calm nature. It was these raised irrigated beds and their development that would prove crucial to the development of the Mexica and their city in the fourteenth and fifteenth centuries. Thus it is to the great feats of water management that we now turn.

WATER CONTROL IN TENOCHTITLAN

The Valley of Mexico was once dominated by five shallow lakes; while separate in the dry season, during the rainy season, when water flooded into the system, they could

combine into one enormous lake. However, they were carefully manipulated over centuries to turn the high-altitude valley into a hospitable environment for agriculture (figure 2.7).[27] The southern lakes, named for the main cities on them, Chalco and Xochimilco, were certainly the most important, as they were freshwater lakes fed by springs and rivers, allowing for agriculture around their shores; the largest of the other three lakes, Tetzcoco, was saline, providing an abundance of edible flora and fauna, such as fish and those algae patties, "small cakes made from a sort of ooze which they get out of the great lake," that the Spanish conquistador Bernal Díaz del Castillo praised as tasting like cheese—as well as salt.[28] By the thirteenth century, the Nahuatl-speaking residents of the southern lakes had a fully functioning system of intensive agriculture, building rows of raised beds out of the nutrient-rich muck of the lake bed, which would be dredged out and piled into rectangular plots, the sides secured with deeply rooted trees.[29] These chinampas were, and still are, marvels of ecological engineering and intensive agriculture. The dredged areas around them created a system of canals, providing both constant irrigation and transport to markets in the cities around the lake. Intensely productive, the chinampas that the southern peoples created provided the basic foodstuffs of the Mesoamerican diet: squashes and chilies, greens and fragrant herbs, and of course, maize; even today, the chinampas of the Chalco region produce flowers and vegetables for the Mexico City market. By the fifteenth century, these verdant gardens of Chalco and Xochimilco were supplying the markets of Tenochtitlan with their abundant goods.

The freshwater of these southern lakes was protected by two phenomena: the southern lakes are at slightly higher altitudes than the rest of the system, meaning the freshwater from these lakes would drain downward into the saltwater Lake Tetzcoco. In addition, a natural bottleneck created by the rising flanks of the hill of Huixachtlan (later known as Cerro de la Estrella) on the east and the Pedregal, a rocky lava flow to the west of the town of Coyoacan, further protected the inlet to these lakes. Normally, excess freshwater flowed through this bottleneck into Lake Tetzcoco. But during the rainy season, the swelling salty lakes in the north threatened the chinampas; if a large volume of water poured into the system from the north, it would reverse its normal flow, surging back through the bottleneck to flood Lakes Xochimilco and Chalco with salt water. By the 1420s, residents of the southern lakes had protected their precious freshwater zone by building a raised

causeway that served, as would all the causeways in the system, as a dike; it spanned a natural bottleneck, running nearly two miles from the base of the hill of Huixachtitlan, at the town of Mexicaltzinco, across to Huitzilopochco, which lay adjacent to the Pedregal.[30] This causeway/dike of Mexicaltzinco may have had removable barriers in it to allow the southern lakes to follow their normal drainage patterns into Lake Tetzcoco, as well as for canoes to pass through; during flooding season, these openings would have been closed to protect the chinampa zone.

So, capturing a moment in 1325, the page of the Codex Mendoza registers both cosmic templates and the lived spaces of the valley. Well to the south of Tenochtitlan, those industrious residents of Chalco and Xochimilco were constructing the most ambitious program of land reclamation and water control ever seen in the valley (see figures 1.1 and 1.3).[31] The construction of thousands of hectares of raised-bed chinampas and the harnessing of the agricultural potential of the lakebed allowed for a population explosion in the subsequent centuries.[32] From their rocky island in salty Lake Tetzcoco, the Mexica of Tenochtitlan were well aware of this, making the conquest of the Chalco region the centerpiece of the military campaigns of the emperor Moteuczoma I (r. 1440–1468). By the sixteenth century, when the Codex Mendoza was painted, the nascent Mexica city at the moment of origin, a year identified as being 1325, was remembered as a large chinampa, the fertile plot made by human hands that made the survival of the altepetl possible; the Codex Mendoza page shows that the familiar chinampa and its carefully controlled canalized waters, life-giving, abundant, were the microcosm of the city itself.

But even before, in the early fifteenth century, the residents of Tenochtitlan witnessing the "Chalco miracle" to the south understood that they could harness equivalent ecological phenomena to create a similar freshwater zone in their western corner of Lake Tetzcoco, which is called the Laguna of Mexico (figure 2.7); modern scholars in the wake of Wittfogel, including Ángel Palerm, Luis González Aparicio, Teresa Rojas Rabiela, and Perla Valle, have reconstructed the workings of this system.[33] Like the southern lakes, this western part of the valley holding the laguna sits at a slightly higher elevation than the east, and this phenomenon would be quite visible during the dry season, when the laguna would dry up to swampy conditions. The laguna is also fed by numerous rivers and springs flowing in from the west, meaning that its water is sweeter

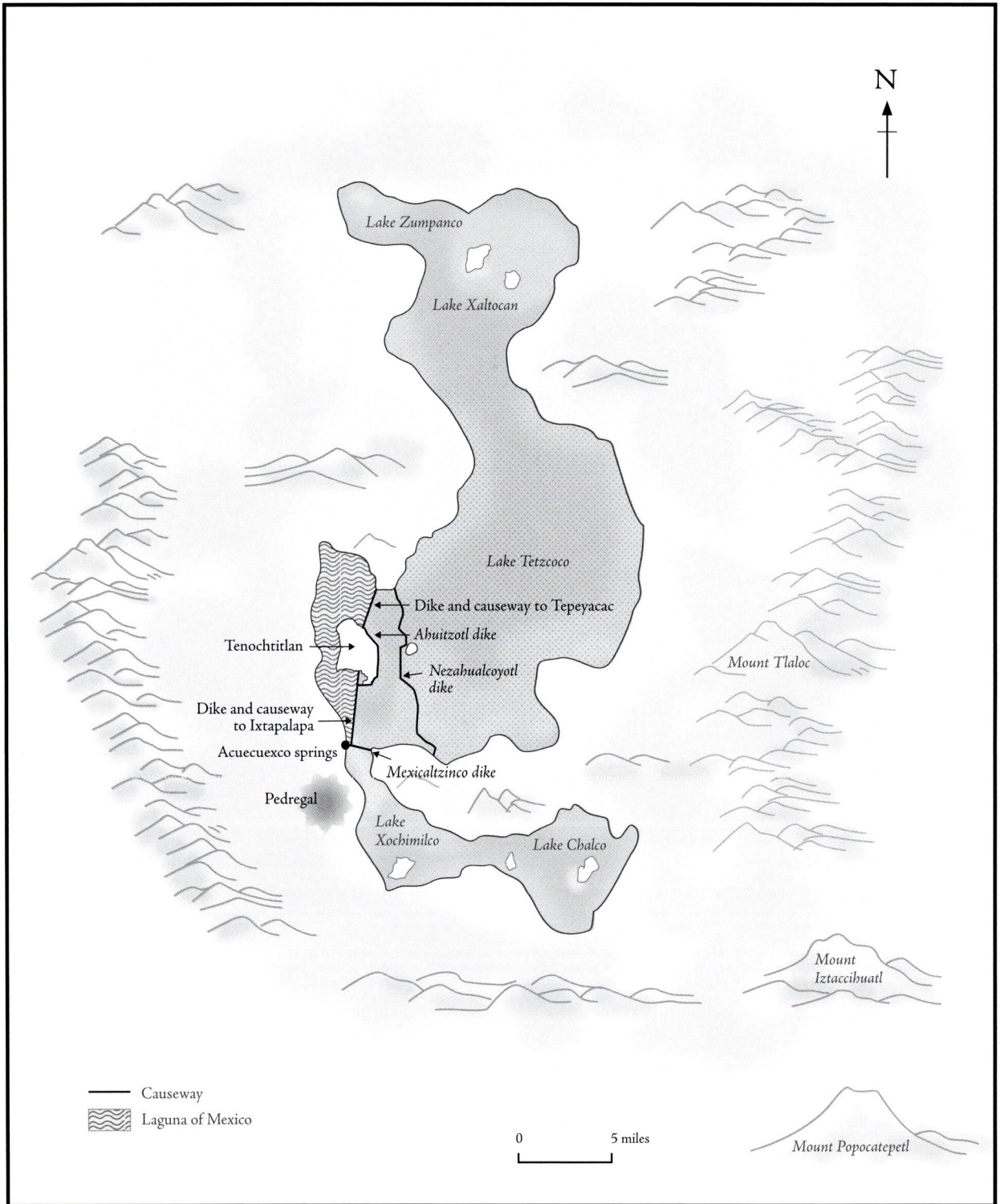

Labels on map:
- Lake Zumpanco
- Lake Xaltocan
- Lake Tetzcoco
- Dike and causeway to Tepeyacac
- Ahuitzotl dike
- Tenochtitlan
- Nezahualcoyotl dike
- Mount Tlaloc
- Dike and causeway to Ixtapalapa
- Acuecuexco springs
- Mexicaltzinco dike
- Pedregal
- Lake Xochimilco
- Lake Chalco
- Mount Iztaccihuatl
- Mount Popocatepetl

Legend:
- —— Causeway
- Laguna of Mexico

0 — 5 miles

FIGURE 2.7. *Map of the major dikes of the Valley of Mexico, ca. 1500, by Olga Vanegas, with information from Gerardo Gutiérrez.*

than in zones further east. By sealing off the laguna with a dike and preventing it from draining naturally into the lower Lake Tetzcoco, the Mexica would be able to create a kind of reservoir, a relatively sweet zone of water fed by the springs and freshwater rivers entering from the western mountains. During the rainy season, the abundant freshwater would sluice eastward, and openings in the dikes would allow it to flush out the salt into Lake Tetzcoco. And when rain waters and runoff rushed into Lake Tetzcoco from the northern lake zones, closing up the dikes could prevent these undesirable salty waters from washing back into the protected western enclave of the laguna. In the course of the fifteenth century, a set of roughly parallel dikes was built, running north to south, to create a barrier between the ever-sweeter Laguna of Mexico and the salty Lake Tetzcoco, as seen in figure 2.7.[34]

The waterworks, those lived spaces of the city, were represented in accounts of the city written in sixteenth- and seventeenth-century histories as the outcome of the actions of a pair of valley rulers, specifically Nezahualcoyotl of Tetzcoco and Ahuitzotl (r. 1486–1502) of Tenochtitlan. The linkage follows what we have seen in indigenous histories like the Codex Mendoza that represent the *altepetl* of Tenochtitlan as the project of its rulers, beginning with the naming of the city after Tenoch, the tribal chief, and continuing with the expansive growth of the *altepetl*'s tributary regions with his successors. These indigenous histories are echoed in those authored by Spaniards, usually because their source material is derived from earlier indigenous histories; such is the case in a work like the Dominican friar Diego Durán's *Historia de las Indias de Nueva España e islas de la tierra firme*, finished in 1581, a res gestae centered on the Mexica rulers, with its chronicle of events structured by a framing account of the successive reigns. Durán's work is one of the key historical sources on the waterworks, and its insistent linkage of waterworks to ruler points to those indigenous representations of the city that served as its sources as doing the same.

According to Durán, the great waterworks of the fifteenth century developed in tandem with the swift rise to power of three new *altepeme* in the valley. In 1427, a valley-wide war broke out as the Acolhuas of Tetzcoco and the Mexica of Tenochtitlan and Tlatelolco attempted to free themselves from the control of the Tepanec in Azcapotzalco, under the ruler Maxtla. In the wake of Maxtla's defeat in 1428, the political structure in the valley was realigned, this eclipse of Azcapotzalco as the major power

in the valley leading to the rise of Mexica and Tetzcocan fortunes. A new alliance was created by the Acolhuas in Tetzcoco, the Mexica in Tenochtitlan, and the dissident Tepanec of Tlacopan, the Triple Alliance, a triumvirate that would adhere even beyond the arrival of the Spaniards into the valley in 1519. Each of these polities was supported by an ever-growing network of tributary states, captured during the relentless military campaigns that the Triple Alliance launched in and around the valley, to create an empire that eventually reached as far south as Guatemala (see figure 1.15). While these conquered tributary city-states continued to act with no small degree of local autonomy, they were obliged to pay tribute to the Triple Alliance as often as five times a year.

As Durán tells it, the creation of the Laguna of Mexico by the building of retaining causeways began in tandem with the creation of the Triple Alliance and its military victories. The first project was launched under the Mexica ruler Itzcoatl (r. 1427–1440), under whose rulership the Mexica state expanded dramatically; the Codex Mendoza lists him as making twenty-four conquests. In the wake of the military defeat of neighboring Xochimilco, he commanded that this conquered *altepetl* build a great causeway (which functioned as both roadway and dike) from their city northward to Tenochtitlan. This so-called causeway of Ixtapalapa began at the causeway of Mexicaltzinco and reached the city of Tenochtitlan. It thereby provided direct access between Tenochtitlan and the southern agricultural regions, which were gradually being brought into the Mexica tributary orbit, completed with the conquest of Chalco in 1465.[35] This causeway had the secondary effect of protecting the southern laguna from salty inflow from Lake Tetzcoco, but it did not seal off the system completely.

This nascent system would be further developed shortly after 1432, when Nezahualcoyotl took the throne of Tetzcoco and a fight broke out between him and Itzcoatl. The Tetzcocan historian Fernando de Alva Ixtlilxochitl presents the Tetzcocan side of the story, and tells us that the fight was occasioned over Itzcoatl's unjustified use of the honorary title "chichimeca teuctli," one until then claimed by Tetzcocan leaders. This small irritant served as a catalyst within a larger political contest between Tenochtitlan and Tetzcoco as they battled for preeminence in the valley. To attack Tenochtitlan, writes Ixtlilxochitl, "Nezahualcoyotl mustered his soldiers for the purpose, creating an army of some 50,000 men and they advanced to Tenochtitlan which they entered via Tepeyacac, today the shrine of the

Virgin of Guadalupe, and he, Nezahualcoyotl, was the first to make that causeway."[36] By giving the ruler credit for building the Tepeyacac causeway in this historical representation, the ruler was thereby imbedded in one of the key lived spaces of the city, a causeway that linked the island city to the northern shore (figure 2.7). This causeway served as one of the main arteries of the city through the sixteenth century and beyond. Archeology has revealed some of the actual practices that its construction entailed: it required legions of workers to haul the retaining wooden pylons and the stone fill to the site. Indeed, many of those 50,000 soldiers—a number that was almost certainly inflated by the partisan historian—that Nezahualcoyotl mustered may have begun the campaign by helping build the causeway that would give them access to the city.[37]

Thus, as represented in the city's histories, particularly Durán's *Historia*, two rulers were responsible for the key works that protected the city from floods and enabled a freshwater zone to gradually establish itself along the city's western flank. Nezahualcoyotl is credited with the northern causeway of Tepeyacac, which ran from the northern shore to the island of Tenochtitlan; Itzcoatl with the causeway of Ixtapalapa, which ran from Tenochtitlan to the southern edge of the lake. Together these dikes effectively sealed off the Laguna of Mexico from salty Lake Tetzcoco, as can be seen in figure 2.7; this effect was noted by colonial observers who described the "laguna dulce" (sweetwater laguna) to the west and the saltwater lake to the east.[38]

The island itself functioned as the middle part of this great dike, but it was a necessarily porous link. While those great works of engineering, the causeways, that were specifically attributed to rulers were being constructed, a corresponding system of east–west canals was likely being dug within the city to allow canoe traffic to pass through it, as well as allowing the waters flowing into the system from the west to sieve through the city and flow out into the eastern Lake Tetzcoco. As the laguna grew less and less saline, so too the canals into the city that it fed; while they were never a source of drinking water, the canals and ditches did sustain urban agriculture.

Despite the engineering feats sponsored by Nezahualcoyotl and Itzcoatl, this north–south barrier using the island of Tenochtitlan-Tlatelolco as its middle bulwark proved insufficient. In 1449, Tenochtitlan was the victim of terrible floods. The reigning monarch, Moteuczoma I, turned to his Tetzcocan counterpart, Nezahualcoyotl, now an old man, to create another dike, this one vastly

more ambitious than the causeway to Tepeyacac. The construction of this dike, which probably occurred during the dry season of 1449–1450, is recorded by the Franciscan chronicler Juan de Torquemada, who wrote how rulers of neighboring cities in the valley contributed to this massive engineering feat, which he calls the "albarrada vieja" (old dike): "It was made heroically, with brave hearts attempting, because it went almost three-quarters of a league [from the shore] into the lake, which in parts was very deep and it was four brazas [about sixteen feet] wide and almost three leagues [about eight miles] long."[39] The archeologists Margarita Carballal Staedtler and María Flores Hernández tried to excavate along this dike but were unable to do so due to the intensive urbanization of the area. However, they mined ethnohistorical sources, particularly maps and aerial photographs, to trace its route.[40] They convincingly argue that the so-called dike of Nezahualcoyotl ran some ten miles from the shoreline at Atzacoalco (adjacent to Tepeyacac) across Lake Tetzcoco, passing along the slopes of Tepetzinco to the town of Ixtapalapa, closing off the Laguna of Mexico and increasing the size of the freshwater enclave around the island city of Tenochtitlan by about a third.[41] Torquemada confirms its function: "so that the salty waters didn't meet the sweet waters upon which was founded this city of [Tenochtitlan]."[42] The positive effects of this dike are registered in the annals section of the Codex Telleriano-Remensis, an indigenous book created ca. 1553–1563, which notes that 2 Reed (or 1455–1456, some five years after the dike was finished) was "a fertile year and thus are painted the green stalks [of maize]."[43]

Successful components of the dike system were thereby created by a succession of Mexica leaders, Itzcoatl, Moteuczoma, and finally Ahuitzotl, each of them also successful military leaders. The last piece of the causeway-and-dike system was completed near the end of Ahuitzotl's reign, in ca. 1499–1500, and it was in this state that the Spanish conquistadores found it in 1519 (figure 2.7, and see figure 1.10). It was built following a disastrous campaign to bring more freshwater into the city, described at length in the next chapter. After the inundation of the city in 1499 (7 Reed), Ahuitzotl sponsored the building of another short dike, this one linking up the causeways of Tepeyacac and Ixtapalapa, those already existing north–south barriers, to create a protective border along the eastern shore of the city, running roughly parallel to the outer dike of Nezahualcoyotl.[44] The Ahuitzotl dike ran about four miles and began in the north, at the intersection with the

causeway of Tepeyacac, looping outward toward the east to run along the city's littoral and then joining with the causeway of Ixtapalapa.

The creation of this shorter dike, called the dike of Ahuitzotl, after its patron, most likely served to protect the city from freshwater, that is, floodwaters coming from the Laguna of Mexico.[45] Had Ahuitzotl faced saltwater inundations from Lake Tetzcoco, the solution would have been to raise the level of the Nezahualcoyotl dike. Instead, it seems as though within this (now) freshwater system, too much water flowing in from the higher, southern lakes of Chalco and Xochimilco washed into the Laguna of Mexico, which now had a restricted capacity because of the bulwark of the dike of Nezahualcoyotl. Thus, these freshwaters flooded eastern Tenochtitlan, no doubt entering the city via back-flooding of the very east–west canals that were supposed to guide water out from the urban core. Construction of this second dike probably began in 1500, or as early as the fall of 1499, when the dry season began and the waters receded. It achieved two goals. First, it created a more secure system to maintain lake levels in the Laguna of Mexico, because of the double band of protection between it and Lake Tetzcoco. The inner band was created by the causeway of Tepeyacac, the dike of Ahuitzotl, and the causeway of Ixtapalapa, and the outer band by the dike of Nezahualcoyotl. The distance between these retaining roads and dikes was barely a third of a mile at its narrowest point, right off the shore of Tenochtitlan (around where the Archivo General de la Nación now sits). Farther to the south, the distance between the Ixtapalapa causeway and the dike of Nezahualcoyotl was about one and one-fourth miles (figure 2.7). The second function of the causeways and dikes was to create more arable land within Tenochtitlan itself. Protected by the dike of Ahuitzotl, the eastern edge of the city was safely reclaimed from threats from the salty waters of Lake Tetzcoco; this pattern of building outward into the lake from terra firma has a long history, as archeology and the present-day expanse of Mexico City demonstrate.[46]

LIVED SPACES IN THE MAP OF SANTA CRUZ

While the *tlatoque* (supreme leaders) of Tenochtitlan were quick to connect themselves to works of successful aquatic engineering, as reflected in later histories, many residents of the city would have understood the waterworks close up, in their experiences of building and maintaining them, since the process would have drawn on thousands of men and women to haul tree trunks, break stones, dig postholes, and make tortillas for workers. The exploratory archeology by Carballal Staedtler and Flores Hernández could not include excavations along this long dike of Nezahualcoyotl to determine how it was constructed, but they suggested a comparison to the causeway of Tepeyacac, along which they did excavate. They found that this causeway was constructed by using large tree trunks as pylons to secure the sides of the causeway by forming retaining walls, which were then filled in with stone; Torquemada also mentions the great *estacas*, "pylons," that were brought from the lakeside cities as well as the large and heavy stones used in the dike's construction.[47] If we look again at the 1524 map of the city from Cortés's Second Letter, we can see that its artist has represented the dike as a horizontal fence set below the city within the lake, and it looks as if it were made of woven wicker (see figure 1.11). This rendering may have as its source an earlier drawing of the dike that showed these vertical wooden pylons woven with horizontal saplings to hold the fill.

By the eighteenth century, when the lake waters had receded, the ruins of this dike appear in a 1768 map showing fields to the west of the city. At that point, few remains were left of the wooden pilings, and the dike was little more than a long wall of piled stone.[48] In a nineteenth-century record, also cited by Carballal Staedtler and Flores Hernández, the ruined dike, after centuries of erosion and pillaging for stone, still measured between twenty-six and thirty-three feet thick and over three feet high, which points to the initial extent of this protective earthwork, which they suggest was once twenty-three feet thick.[49] The amount of labor required to construct these dikes was enormous, even greater than the mobilization for warfare; in the 1555–1556 reconstruction of the inner dike, the shorter of the two, historian Charles Gibson reports that while the viceroy summoned six thousand indigenous laborers, another, unofficial account calculated that two million men were employed over several months for the same work.[50]

If residents of the city knew these dikes intimately as products of their labor, they also knew the happy effect of these parallel barriers, which was registered in one of the most important representations of the city's space, created some years after the Conquest. The magnificent Map of Santa Cruz shows a bird's-eye view of the entire valley oriented to the west at top, with the island city

appearing as the slightly darker brown ground at center, and it was rendered by a native artist, perhaps as early as 1537 (figure 2.8).[51] The map is an enormous work, measuring thirty-one by forty-five inches, painted on skin. While we know very little about why exactly the map was made or how it arrived at the University of Uppsala, where it is found today, the skin support points to its being an elite commission, perhaps created by native painters working out of the Franciscan monastery in Tlatelolco, since this monastery dominates the urban fabric in the image, depicted in a much larger scale than other buildings of the city in the city's upper right.[52] But even more salient is the attention it pays to the water systems of the valley, both the streams and the rivers that supplied the lakes, which appear as fine capillaries on the large map, as well as the systems of dikes that protected the island city. While the date of the map will be discussed further in chapter 5, in rendering the dike system, the artists show them as they functioned right before the Conquest, that is, fully operative, and in this, present a utopian view of the city.

As seen in figure 2.9, a detail from the map's lower horizontal quadrant, the dry land of the city is colored brown at top, and ringing the city's perimeter, the dike of Ahuitzotl appears as a wall of light yellow-brown stonework. Somewhat farther to the east (toward the upper part of the image) is the dike of Nezahualcoyotl, appearing in much the same fashion, as an undulating band of yellow-brown; it is wide enough for some of the figures to walk upon it. The artist has used careful gradations of pigment to show the quality of the water depicted: while the salty water in Lake Tetzcoco, which dominates the bottom of figure 2.9, is painted a darker blue with an admixture of green, the area above it, between the dikes, is a much more pure blue, showing how the dikes effectively separated the salty water from the sweet. The slight difference in pigments used by the artist is highly important. In recent scientific studies of another indigenous map from Mexico City, the Beinecke Map of ca. 1565, as well as the Florentine Codex, Diana Magaloni Kerpel has argued that indigenous artists used different pigments not for visual effect alone, but to capture differences among the objects they were representing;

FIGURE 2.8. *Unknown creator,* Map of Santa Cruz, *ca. 1537–1555. Uppsala University Library, Sweden.*

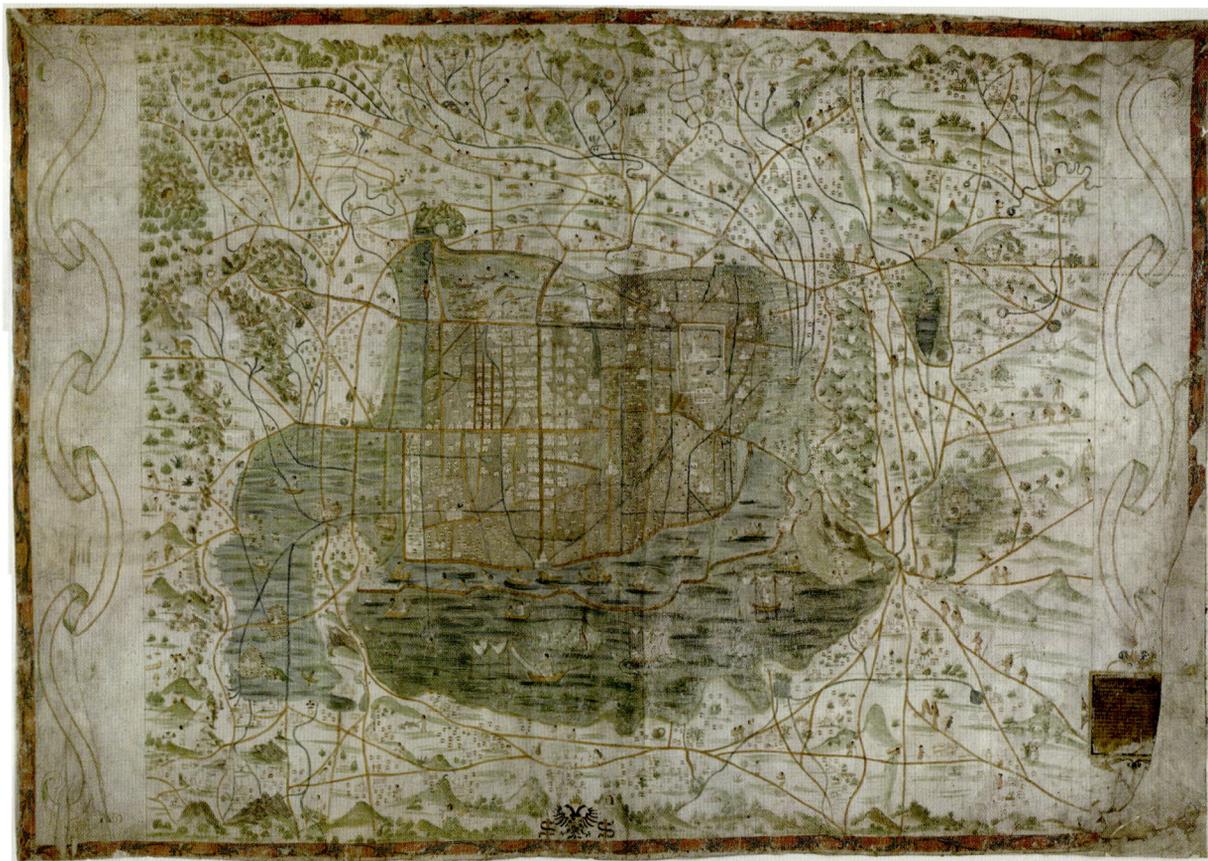

FIGURE 2.9. *Unknown creator, dikes of Ahuitzotl and Nezahualcoyotl, detail, Map of Santa Cruz, ca. 1537–1555. Uppsala University Library, Sweden.*

thus, on the Beinecke Map, the gray pigments used to represent muddy earth at the edge of a waterway contained an admixture of Maya blue, a precious pigment imported into the Valley of Mexico from southern Mexico. In the Beinecke Map, Maya blue was used to convey the presence of water in the earth, even though its blue color was not visible to the naked eye. In contrast, gray pigments that were used to show elements like a wall with no watery element lacked Maya blue. Magaloni's findings suggest that such a careful use of pigments corresponding to the nature of the thing represented was part of the longer painting tradition of central Mexico, one that the painters of the Map of Santa Cruz would have participated in.[53] Thus, the Santa Cruz artist's (or artists') use of the different, greenish pigment—which had not only a different color but a different composition, as revealed by the craquelure over its surface—was likely an effort to capture the lakes' salty nature, whereas the pure blue (likely to be Maya blue, although no studies have been made of the composition of the map's pigments) was the material used to represent sweet water.

The Map of Santa Cruz is one of the rare representations of the city to show the complex system of waterworks; the compelling vignettes of daily life and interactions between Spaniards and indigenous peoples that one can see along the roads in the landscape surrounding the island city have attracted the most attention of researchers, but the waterworks and the transport system that they enabled were clearly of equal, if not greater, interest to its

creators. In figure 2.8, the artists have carefully limned darker blue lines that cross the lakes on the left (Lakes Chalco and Xochimilco) to show the canals that were maintained in the shallow lakes, allowing rowers to pass with canoes in the dry season. Freshwater rivers, streams, and springs fed many of them, so they appear the deep blue of freshwater. Others appear as the watery continuation of roads that reach the lakeshore; these points were the small ports where goods would be loaded onto boats for quicker passage by lake. The importance of this sweet water between the two dikes is signaled in the Map of Santa Cruz by the number of fishermen, seen in figure 2.9 as they cast their rods and pull out fish, with others standing on the dike itself and casting nets into the water, showing how the dikes could function as a pathway through the water as well as a protective barrier. Below, in the salty lake, bird trappers set up their nets to catch ducks and other water-loving birds.

Representations of space like the Map of Santa Cruz reflected the lived spaces of the city, like those great waterworks and networks of roads and canals that we see on the map, and the artists' attentiveness to the dikes and understanding of the separations of water indicate how widespread knowledge and appreciation of this infrastructure

were. We have seen how histories emphasize the role of the rulers in building the dikes that controlled the water. But we have also seen how daily experience and practice taught the Mexica that they lived in an environment of lightning, thunder, drops of rain, and flows of streams. The idea of *teotl* held that the world around was animated by divine forces. As such, all these elements were alive, and provided another cosmic model for the watery environment of Tenochtitlan.

TEOTL AND THE WATER DEITY CHALCHIUHTLICUE

The pluralism of *teotl* led Spanish observers to marvel at the expanse of the Mexica pantheon that was the focus of the devotional life of the people of Tenochtitlan, envisioning it to be a thickly peopled one, even more expansive than that of Olympian gods. One wrote that "they had many idols, so many that it seemed as if there was one for each thing."[54] These deities dwelt in a vertically stratified universe composed of a thirteen-tiered sky and a nine-layer underworld, these upper and lower levels intersecting upon the terrestrial plane. Modern scholarship has clarified the enormous and nebulous pantheon recorded by sixteenth-century chroniclers, showing that the large number of central Mexican deities are simply different expressions of just three fundamental themes: celestial creation; rain/moisture/agriculture; war/sacrifice/solar nourishment.[55]

Perhaps the most important of these "deity complexes," because of their vital necessity to agricultural life, were those associated with water, particularly Tlaloc and Chalchiuhtlicue. Water coming from the sky as well as electrical storms and lightning were associated with the agricultural deity Tlaloc, who also caused water to be stored within mountains, spaces with which he was intimately associated, which were like great water-filled vessels. Correspondingly, he was linked to rainfall and mountain cults (for rain was born of cloudy mountaintops); his temple was the northern half of the Templo Mayor.[56] Because of his association with both mountains and life-giving water, Tlaloc was worshipped in every *altepetl*. The Florentine Codex gives us this account: "To him was attributed the rain; for he made it, he caused it to come down, he scattered the rain like seed, and also the hail. He caused to sprout, to blossom, to leaf out, to bloom, to ripen, the trees, the plants, our food. And also by him were made floods of water and thunder-bolts."[57] Among the Mexica, images

of Tlaloc often decorated hollow vessels, analogies of his watery capacities, as well as monumental sculpture. One major work found in the Templo Mayor is a *chacmool*, a reclining figure, wearing the mask of Tlaloc with standard iconography (figure 2.10). He has round, goggle eyes and a mouth that appears fanged as it sports curling barbules. He is laden with jade jewelry, in the form of a beaded necklace and wrist- and ankle-bands. In other examples, he wears a crown-like headdress of serrated paper or one carved out of pieces of precious greenstone, its surface rendered smooth and shiny like the surface of water.

In contrast, once water emerged from spaces of the hollow mountains, it became "the property of" the female deity Chalchiuhtlicue.[58] Like her frequent companion, Tlaloc, Chalchiuhtlicue was a deity associated with water, particularly lakes and streams. Cults to her were celebrated at the Templo Mayor (it was here that many of the activities of the four monthly, or *veintena*, festivals [Cuahuitlehua, Tozotontli, Etzalcualiztli, and Tecuilhuitontli] centered on her were carried out). There exist a multiplicity of stone images of this deity, in which she can be identified by the butterfly-shaped double fan of paper at the nape of her neck (the *amacuexpalli*, a fan shared by other water and fertility deities as well) and the headdress with two large tassels over her ears (figure 2.11). Around her head, a cap of stacked coils decorated with small tassel-like spheres runs above her eyebrow line.[59] Like other female deities, she wears the *quechquemitl*, a triangular upper-body garment. She is frequently represented in small sculptures carved

FIGURE 2.10. *Unknown creator,* chacmool *with Tlaloc mask, ca. 1500. Museo Nacional de Antropología, México. Archivo Digitalización de las Colecciones Arqueológicas del Museo Nacional de Antropología.* CONACULTA-INAH-CANON. *Reproduction authorized by the Instituto Nacional de Antropología e Historia.*

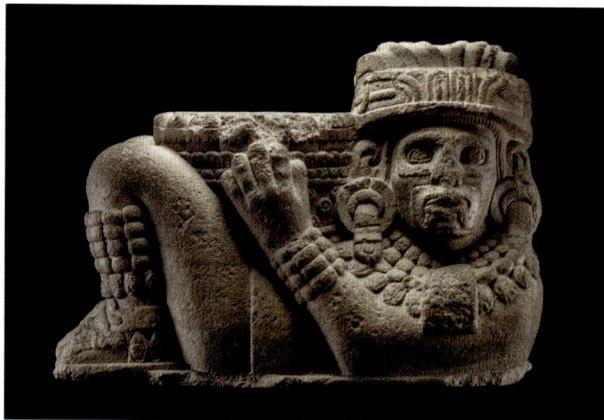

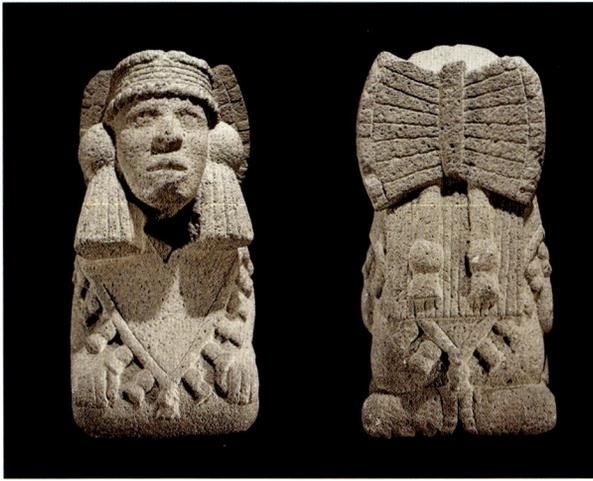

FIGURE 2.11. *Unknown creator, stone sculpture of Chalchiuhtlicue, front and back views, late fifteenth to early sixteenth century. 14.5 × 8 in. (37 × 20 cm). Christy Collection. © Trustees of the British Museum.*

out of stone, and the number and small size of these works suggest that the locus of her worship was decentralized, taking place in the numerous neighborhood temple precincts around the city as well as in the regions around. The ubiquity of these rather humble sculptural representations is an index of her hold on the Mexica sacred imagination, but while she appears calm and ordered in her stone manifestation, other representations show her to be dangerous and unpredictable.

The informants of Sahagún's Florentine Codex associated Chalchiuhtlicue with the *movement* of groundwater, most perceptible when it was most violent. Their description runs thus:

> The goddess named the Jade-skirted, who was [goddess of] the waters.
>
> She was considered a god[dess]; her likeness [*quixiptla*] was that of a woman. It was said that she belonged among the rain-gods, as their elder sister.
>
> Hence she was esteemed, feared, and held in awe; hence she terrified men. [For] she killed men in water, she plunged them in water as it foamed, swelled and formed whirlpools about them; she made the water swirl; she carried men to the depths.
>
> She upset the canoe, she emptied it; she lifted it, tossed it up and plunged it in the water.
>
> And sometimes she sank men in the water; she drowned them. The water was restless: the waves roared; they dashed and resounded. The water was wild....

And when (there was) no wind, it was calm; the water spread like a mirror, gleaming, glittering.[60]

The Florentine's description captures some of the Mexica understanding of this deity, particularly her violence toward human beings (the "men" of the translation is genderless in the Nahuatl original), and its designation of her likeness (*quixiptla*) as a woman (*cihuatl*) suggests an anthropomorphic being. The Codex Borbonicus, a manuscript containing a ritual calendar, shows us an image of Chalchiuhtlicue as the patron of one of the *trecenas*, or ritual "weeks" of thirteen days (figure 2.12). She appears in the large square in the page's upper left, a seated female, elaborately garbed in blue and green clothes, the color of water, with a number of offerings set in front of her. Around her head is her diagnostic headdress, wrapped bands of blue and white decorated with small spheres at top and bottom and tied with an elaborate double tassel that hangs behind her right ear. Her face is painted bright red, edged in yellow, and a black stripe appears on her cheek. An enormous pleated fan is attached to the nape of her neck, just as in her stone representations. Her clothes are decorated with small doughnut-shaped gems, carved of jade. She is seated on a small red stool, and from it, a great gush of flowing water emerges, carrying within it images of two small human figures; the one closest to the deity is her human counterpart, with the same face paint, the red extending down her torso. They are swept up the stream of water as if in a flood. Indeed, both the visual descriptions of the deity in the Codex Borbonicus and the verbal one in the Florentine Codex seem to be colored by the experience of flood ("sometimes she sank men in the water; she drowned them. The water was restless: the waves roared; they dashed and resounded. The water was wild"), for despite the careful manipulations of causeways and dikes, Tenochtitlan did flood both before the Conquest and after, with one particularly bad flood sweeping through the city in 1499.

From the perspective of lived experience, Chalchiuhtlicue *was* a terrifying presence in the city; in the rainy summer months, Chalchiuhtlicue's waters could break like an uncontrollable surge of amniotic fluid, invading the city, rushing down its streets, uprooting the carefully planted *chinampas*, washing away the adobe buildings that many called home. In the Florentine passage quoted above, Chalchiuhtlicue is fairly static at the beginning ("the goddess named the Jade-skirted"), but as the passage proceeds, she becomes more and more like a force that animates the

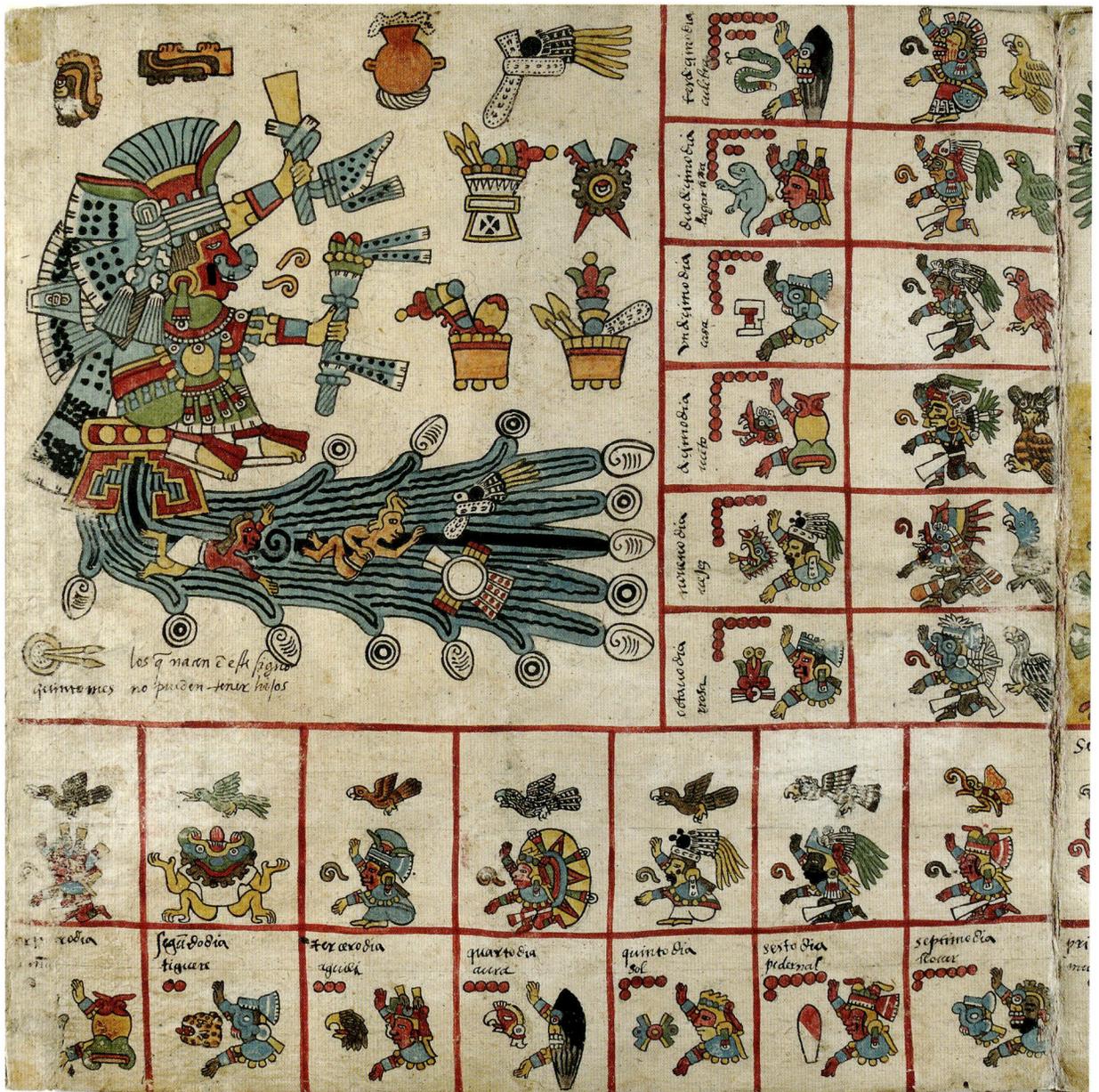

FIGURE 2.12. *Unknown creator, Chalchiuhtlicue with ritual objects and surrounding thirteen-day calendar, Codex Borbonicus, p. 5, ca. 1525. Bibliothèque de l'Assemblée nationale, France.*

water itself, the force that makes the foam and whirlpools and eddies. If we turn to the gush of water flowing from beneath Chalchiuhtlicue in the Codex Borbonicus, we can see that the Mexica artist has limned its edges with shells and circular jade disks, alternating one after the next. But the visual emphasis falls on the striations of wavy black lines, the central straight heavy line breaking into a swirl in front of the tiny female figure. The artist seemed intent

on capturing this animating force behind the movement of the water as it was perceptible to human senses.

But the Mexica did not represent all water to be the same, and the writers of the Florentine Codex's pages provide a longer taxonomy to show that there were different kinds of water, dependent upon origin and hydrography. They had different smells, colors, and tastes; thus the "fiery water" of the foundation of Tenochtitlan was perceptibly different from the "yellow water" there. But all of them were manifestations of Chalchiuhtlicue, whose unpredictable violence lay right beneath her calm, mirrorlike surface.[61]

Her violent potential in the world is also represented

in central Mexican origin histories. The Nahua believed that the world had existed in four previous incarnations, each called a "sun" and each ending in calamity. One of these worlds, or suns, had come to an end in a great watery flood, and it was named for the day it ended: 4 Rainstorm, or *nahui quiyahuitl*. Its patron was none other than Chalchiuhtlicue. Tlaloc was the patron of the sun that ended in a great rain of fire, a sun named for the day on which it ended, 4 Water, or *nahui atl*. The present world, 4 Movement, or *nahui olin*, it was believed, will come to an end at the future date of 4 Movement, in a great earthquake.

We have seen how, on one hand, Chalchiuhtlicue's association with watery violence grew out of daily experience within Tenochtitlan, as over the years the Mexica encountered floods that threatened to wash away their island city. On the other hand, Mexica rulers, who often dressed as Huitzilopochtli to show their close identification with the Mexica tribal deity, connected themselves to the water-controlling hydraulic works necessary for the stable *altepetl*. The need for male deities to dominate and tame a dangerous female space finds echoes in a Mexica story of origins. In the Histoyre du Mechique, a history of the beginning of the earth written down in the sixteenth century (and surviving through a French translation), the creation of the habitable world is made possible only through the violent sacrifice by dismemberment of Tlaltecuhtli, the earth deity who is presented as a female, by two male deities, Quetzalcoatl and Tezcatlipoca, who transform themselves into serpents and rip her apart to create the earth. "After this was done, to repay this earth goddess for the damage that the two gods had done to her, all the gods descended to console her and they commanded that from her all the fruits of the earth necessary for mankind should come."[62] Similar sacrifices mark other creation stories from central Mexico, as the Mexica well understood that fundamental acts of violence underlay the creation of their world. However, for the Mexica, it was particularly the conquest of female deities like Tlaltecuhtli and Coyolxauhqui that brought about an ordered world. And these templates would be extended to Chalchiuhtlicue and her physical manifestation, the surrounding lake.

THE TEOCALLI OF SACRED WARFARE

Understanding the cosmic templates that the Mexica drew on to conceptualize the surrounding environment allows us to reconsider one of the most important pre-Hispanic representations of the city of Tenochtitlan, the back face of the throne of Moteuczoma II, the Mexica ruler who greeted Cortés in 1519 (figures 2.13, 2.14, and 2.15). Upon its discovery in 1926, the work was christened the "Teocalli [temple] of Sacred Warfare" by Alfonso Caso, a name still in common use today; writing a half century later, Emily Umberger rechristened it "Moteuczoma's Throne." These names given to the work reflect the interpretive frame that each of these authors constructed for the sculpture, briefly summarized here. Caso saw in the carved images a unifying statement of Mexica religious practices, arguing that they expressed two entwined ideas: a solar cult and sacred warfare. In believing that the sun demanded human sacrifices in order to rise and set every day, the Mexica were compelled to provide the offerings that propelled the sun across the sky; their quest for sacrificial victims led them to continually engage in warfare.[63] The sun's presence is seen by the solar disk at the top of the monument, and the practice of this "sacred warfare" is made manifest in the lower iconography, of whose bellicose nature Caso left little doubt: on each of its lateral sides are arrayed two seated deities in martial garb, holding spines to pierce themselves in ritual bloodletting; the twisting symbol streaming from their skeletal mouths combines *atl* (water) with *tlachinolli* (burnt thing) to convey "war." The iconography bears up Caso's argument that the Teocalli's main iconographic theme is sacred warfare, which, not incidentally, allowed the Mexica to keep up a juggernaut imperial expansion.

Certainly, for any Mexica viewer of this symbol, the *tlachinolli* symbol would be easily associated with warfare. After all, the sign of capitulation of a polity conquered by the Mexica was the burning of its temple. In the Codex Mendoza's account of the history of conquests of the Mexica emperors, the pages are filled with images of temple structures with their thatched roofs pushed off their supports and emitting red- and yellow-tipped flames (see figure 1.4). The roof-burning of the principal temple of an *altepetl* was not only a symbol for conquest on the manuscript page, but a lived event as well. When a temple roof was burnt it would send out a smoky plume that would make the *altepetl*'s defeat visible for miles around.

Umberger's more recent interpretation of the Teocalli shifts emphasis from the general practice of warfare by the Mexica to the particular role of the ruler among them. She argues that the work, which is forty-eight inches high, served as a seat, or throne, for the ruler. It took the form of the Templo Mayor, which had a steep staircase running

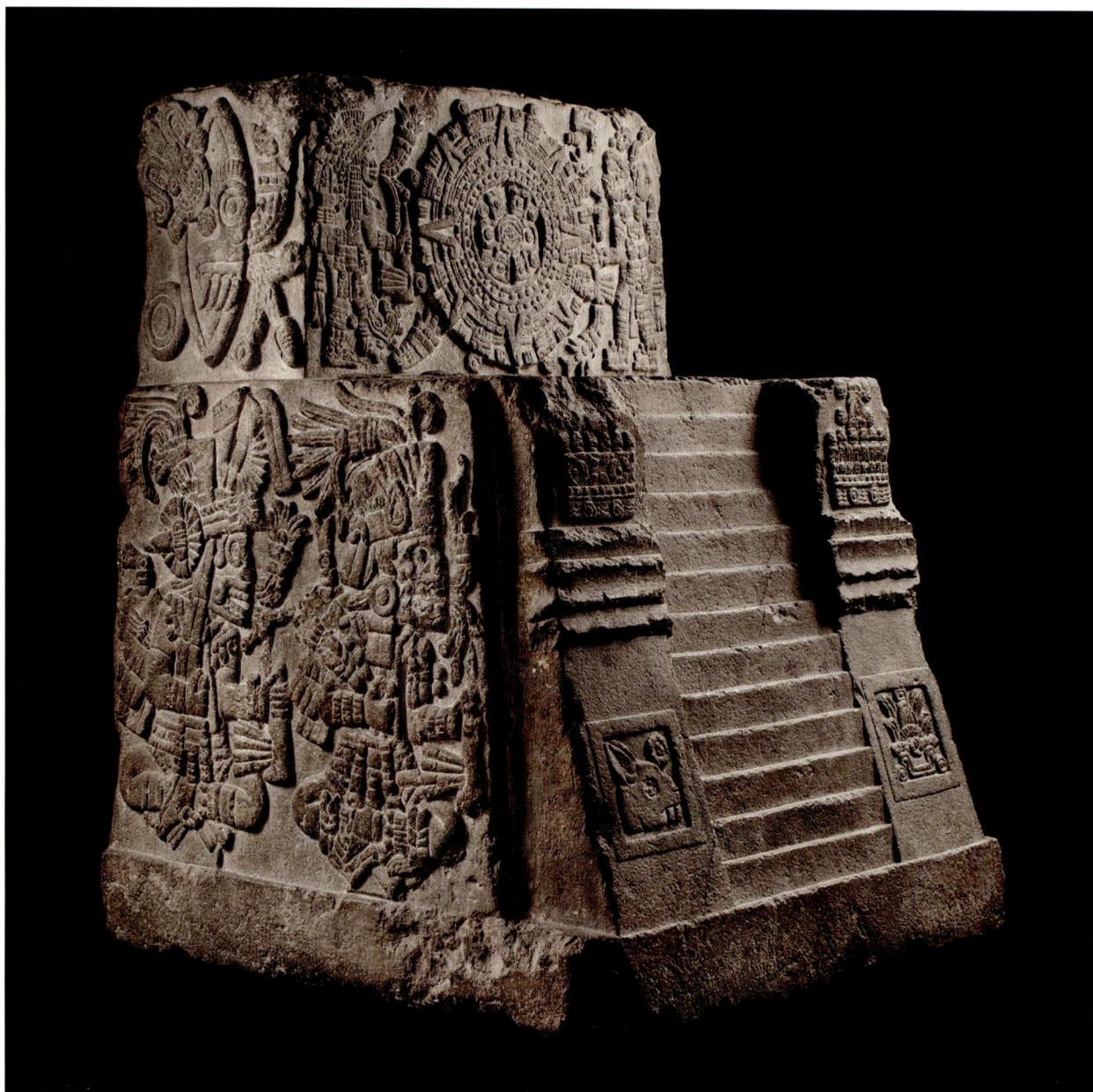

FIGURE 2.13. *Unknown creator, Teocalli of Sacred Warfare, also known as Moteuczoma's Throne, oblique view, ca. 1507. Museo Nacional de Antropología, Mexico City. Archivo Digitalización de las Colecciones Arqueológicas del Museo Nacional de Antropología.* CONACULTA-INAH-CANON. *Reproduction authorized by the Instituto Nacional de Antropología e Historia.*

down its front. At the top of the sculpture's "stairs" is the image of the sun, flanked by two figures who also engage in ritual bloodletting (figure 2.13). To the upper right of the solar orb is a *teuctli* ("lord") glyph (a miter-like headdress). Umberger identifies this as the name glyph of the ruler Moteuczoma II (r. 1502–1520), establishing his patronage.[64] Recently, William Barnes has suggested that the throne was carved also to resemble the upright stone upon which sacrifices were carried out.[65]

None of the scholars' arguments about the Teocalli of Sacred Warfare focused on the back face of the monument, perhaps because in contrast to the complicated and often obscure imagery on the front and lateral sides of the sculpture, the image on the reverse face of the throne seems absolutely straightforward (figures 2.14 and 2.15). It illustrates the history of the foundation of Tenochtitlan, which we encountered on folio 2r of the Codex Mendoza

FIGURE 2.14. *Unknown creator, Teocalli of Sacred Warfare, also known as Moteuczoma's Throne, back view, ca. 1507. Museo Nacional de Antropología, Mexico City. Archivo Digitalización de las Colecciones Arqueológicas del Museo Nacional de Antropología.* CONACULTA-INAH-CANON. *Reproduction authorized by the Instituto Nacional de Antropología e Historia.*

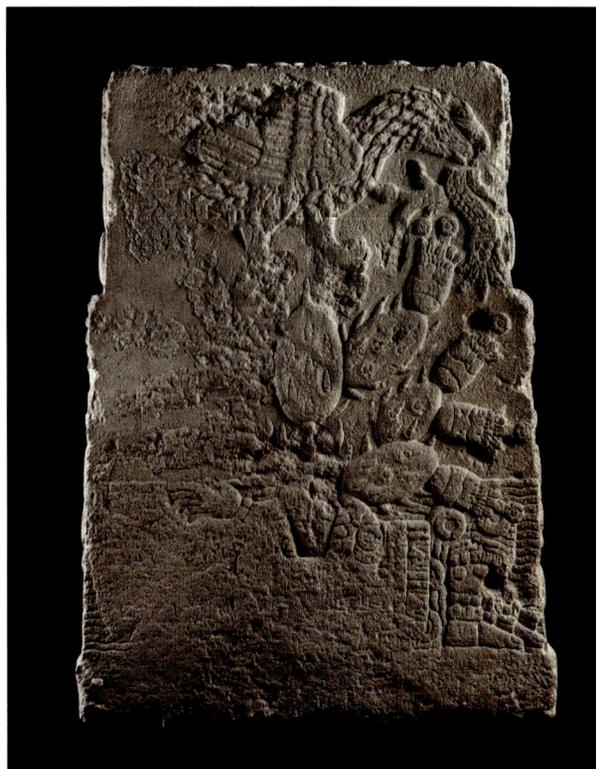

FIGURE 2.15. *Drawing of the Teocalli of Sacred Warfare, back, also known as Moteuczoma's Throne, by Emily Umberger. Base shows Chalchiuhtlicue: her paper-fan headdress (A); water behind her figure (B); jade beads on her skirt (C); and her sandals (D).*

(see figure 1.3). At the center of the flat, carved-stone face is the eagle, which represents the solar god Huitzilopochtli, its wings slightly arched open as it completes its landing on the top of a nopal cactus, ripe with fruit. In contrast to the other surfaces of the monument, which are densely carved at different scale, this one seems open, easy, with little in the way of background. The back face of the monument also includes yet another *atl, tlachinolli* glyph, this one streaming out of the eagle's mouth. We recall that some accounts of the mythic history of the foundation of the city tell us that the tossed-away heart of the sacrificed Copil gave rise to the cactus tree upon which Huitzilopochtli's eagle landed. Thus we would expect to find the heart of Copil at the base of the nopal cactus. But we do not.

Instead, the monument celebrates the defeat of Chalchiuhtlicue, the deity of lakes and streams. She is shown on her back with her knees drawn in toward her body, the tips of her two sandaled feet touching the right edge of the sculpture (D on figure 2.15).[66] While much of her headdress, which would have occupied the left side of the sculpture, is eroded, some of it, taking the shape of a folded-paper fan (A), is discernible, as is her skirt (C), a series of undulating bands that represent water (B), and a visual representation of her Nahuatl name, the glyphs for "jade-skirted." Most known representations of Chalchiuhtlicue in stone show her as an upright, columnar figure (figure 2.11), but here the sculptor has fit her body into a narrow horizontal register at the bottom of the work, and it appears, although difficult to make out given the erosion, that the cactus grows out of an open cavity in her chest.

Figures lying on their backs are rare in Mexica art, and when seen in manuscripts, figures adopting this position are victims of heart sacrifice, stretched out upon the sacrificial plinth to expose the cavity of their chests, where the heart would have been extracted. A sculptural parallel to this Chalchiuhtlicue, a figure on its back with knees drawn

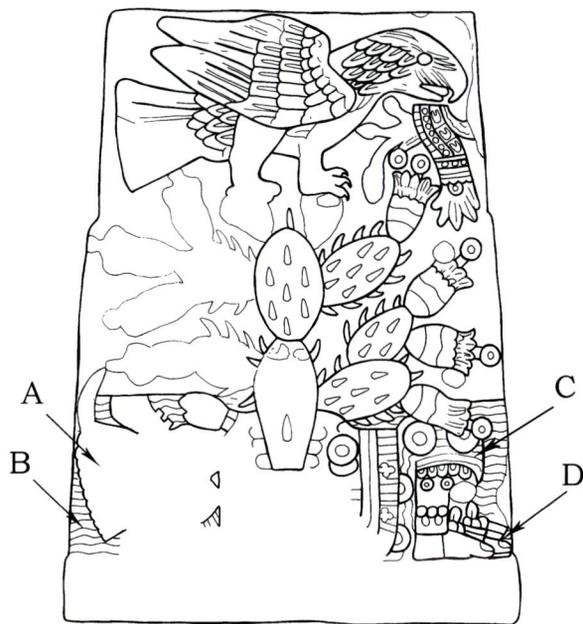

in toward its body, is to be found in *chacmool* figures, a sculptural type known from the earliest constructive phases of the Templo Mayor. The *chacmool* seen in figure 2.10 was found near the *templo,* and, like other *chacmools* this three-dimensional sculpture is a humanlike figure, shown on its

FIGURE 2.16. *Unknown creator, world tree with sacrificed deity at base, detail, Codex Borgia, p. 52, ca. fourteenth to early fifteenth century. Biblioteca Apostolica Vaticana.*

back, knees drawn up, holding a bowl for sacrificial offerings on its chest. In this case, the *chacmool* is very much alive, staring out from behind an elaborate goggle-eyed face mask of Tlaloc and gripping the offering bowl with puffy hands. However, the lively *chacmool* was not always so. Mary Ellen Miller has traced the origin of the *chacmool* form to depictions of sacrificial captives, set at the base of Maya stelae, and the figure of Chalchiuhtlicue carved into the back face of the Teocalli of Sacred Warfare can be understood as returning to this prototype.[67]

Thus, the imagery of the back of the Teocalli draws on long-standing spatial diagrams with cast-down females. It is like the Templo Mayor, which had a sculpture of the sacrificed Coyolxauhqui set at its base. It follows the mythic template found in the Histoyre du Mechique, where the female earth deity, Tlaltecuhtli, is sacrificed at the origin of the world, as male deities fly through and above her

body. And it even more closely adheres to the image of a sacrificed female deity depicted in the Codex Borgia, a comparison first suggested by Caso (figure 2.16). In one scene from this important religious manuscript from central Mexico, the female earth deity lies on her back at the base of the image and is identifiable by her clawed hands and feet. She wears the mask of Tlaloc, showing her watery associations. Just like Chalchiuhtlicue on the Teocalli, her sacrificed body gives rise to a spiny cactus tree arising from her chest. This is not any tree, but a world tree, holding up the heavens, like the four depicted in the Codex Fejérváry-Mayer (figure 2.5). And just like on the Teocalli, an eagle, that solar bird, sits in its upper branches.[68] The back image

of the Teocalli shows us, then, that Mexica artists drew on long-standing and widespread spatial templates, but in their particular case, it was the sacrifice not of a female earth deity but of Chalchiuhtlicue that gives rise to an axis mundi, a world tree. As expressed in the Teocalli, it was the sacrifice of Chalchiuhtlicue that made the foundation of the city possible, much as on the experiential plane, it was the taming of the lakes in the fifteenth century that allowed the city to survive.

PLACE-NAMES AND MYTHIC HISTORY

If the world—including the spaces of Tenochtitlan—came about because of the dismemberment of Tlaltecuhtli, her presence was marked in place-names, a key representation of space that we will return to again in the chapters that follow. The creation story told in Histoyre du Mechique tells us that after the sacrifice of Tlaltecuhtli, "from her eyes [came] springs and fountains and little caves, from her mouth, rivers and huge caves, from her nose, mountain valleys, mountains from her shoulders."[69] The constant presence of this earth deity, welling up in the groundwater and lurking at the base of all earthly spaces, is felt in the way place-names were written using the iconic script of central Mexico. In the Codex Mendoza, for example, the place-name for the town of Xico (from *xictl*, "navel") is represented in circular form with a ropelike umbilicus emerging from its puckered center (figure 2.17, left). The area around the cord is yellow, and this is encased in a red ring. If we compare the Xico sign to the familiar glyph for

"hill" (*tepetl*) in the same manuscript, here as part of the place-name Pochtepec, which means "smoking hill," the artist has used the same yellow and red colors at the base of the hill symbol, but here they appear as bands; that is, they are being seen from the side, and the umbilicus is hidden on the underside of the glyph (figure 2.17, center). Thus hills are visually likened to body parts, each with its own umbilicus. The symbol for "cave" (*oztotl*) reiterates that caves are the open mouth of the earth deity, and we see this in the place-name Oztoma, which means "cave of the hand," where the cave is depicted as the open mouth of the earth deity, and here, the red band surrounding a yellow center is used for the mouth (figure 2.17, right). In indigenous land maps created as late as the 1570s, like one from the state of Veracruz in figure 2.18, *tepetl* signs, seen at the left and right edges, still retained traces of the diamond-patterned skin of Tlaltecuhtli, who was believed to resemble a spiny caiman, and water, the snaky rope cutting across the center of the map, was shown with a pattern of alternating spirals, rectangles, and chevrons that show us the movements that marked the presence of Chalchiuhtlicue. Thus, manuscript art reminds us that all places come from these primordial deities, and many retain traces of their presence.[70]

But most residents of the city did not encounter the traces of these cosmic templates and historical events on

FIGURE 2.17. *Place-names revealing the presence of the earth deity, Tlaltecuhtli. From left, Xico (navel place), Poctepec (smoking hill), and Oztoma (cave of the hand). Author drawing after Codex Mendoza, fols. 20v, 17v, and 18r.*

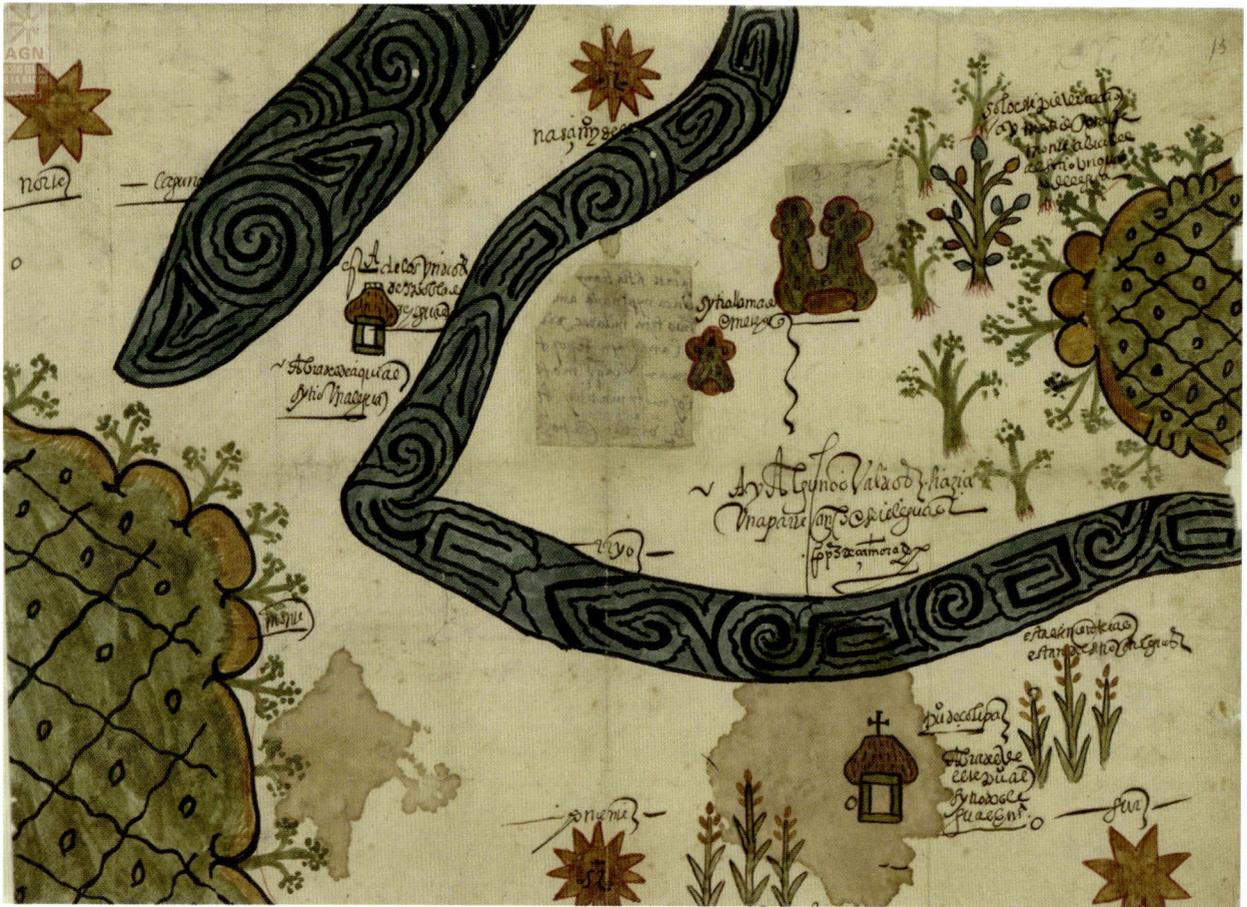

FIGURE 2.18. *Unknown creator, map whose features still retain traces of the crocodilian skin of the earth deity in the hill symbols and the animate nature of water in the river, from Zolipa, Misantla, Veracruz, 1573. Archivo General de la Nación, Mexico, Tierras 2672, 2nd pte., exp. 18, fol. 13. Mapoteca 1535.*

the pages of a book. Instead, these events were more often commemorated (and thus remembered) within the collective sphere in the most pedestrian of registers, the spoken place-name. The tales of Mexica migration began as oral ones, and they (as we know them from their later written forms) are quite concrete in setting the history in very specific and well-known places, like Chapultepec or the island outcropping of Tepetzinco or the place known as Tlacocomulco within the larger island of Tenochtitlan.[71] Sometimes names conveyed specific events: through the colonial period, a small atoll off Tepetzinco was called Aco-pilco, "place of Copil," to mark the place where the heart of this enemy of Huitzilopochtli was tossed. Coatepec, as seen above, was the place of Huitzilopochtli's violent birth, and the Templo Mayor, with its wide serpent balustrades,

was also represented (and perhaps was even named as) Coatepec. These examples introduce us to a wider Mexica practice of annealing the known world together to its past through proper nouns, inscribing history on particular (and real) spaces, none of which lay more than two miles from the center of Tenochtitlan. Thus the landscape in and around the city functioned as a mnemonic for this sacred history of the defeat of Copil/Chalchiuhtlicue, invoking its memory in a broader and more persistent way than the singular image carved on the Teocalli.

CONCLUSION

In the works discussed above, from folio 2r of the Codex Mendoza to the Teocalli of Sacred Warfare, we have seen how Mexica artists were intent on providing small, organized models that reflected both the cosmic template as well as the specifics of Tenochtitlan's extraordinary landscape, particularly its hydrographic profile. This drive to use sculpture and architecture to model the surrounding world included the Templo Mayor, which served as a

microcosm of the larger cosmic order, as Eduardo Matos Moctezuma's work has revealed. In addition, the Templo Mayor also served as a model for the ideal *altepetl*, a mountain at whose base tamed water flowed. There is abundant evidence for Chalchiuhtlicue's presence in the caches that were buried within the Templo Mayor, although we know little of her visible sculptural representations at that site, given the widespread post-Conquest destruction.[72] We also find evidence that the primordial landscape at the foundation of Tenochtitlan —that is, those streams called Tleatl (fiery water), Atlatlayan (burning water), Matlallatl (blue water), and Toxpallatl (yellow water)—was re-created at the Templo Mayor.[73] The Florentine Codex lists, among the buildings and features of the temple precincts, four pools, the first three used for bathing rituals of the priests: Tlilapan (upon the black water); Tezcaapan (upon the mirror water); and Coaapan (upon the serpent water). The fourth was fed by a spring with the same name as that of the foundation account: Toxpallatl.[74] These four pools may have been oriented to the cardinal directions, and two of them bear colors associated with those directions (black and yellow).[75] Like the pyramid itself, which re-created the birthplace of Huitzilopochtli at Coatepec, these four pools with their distinct waters evoke the four streams that flowed out from the caves at the site of the city's foundation.[76]

But since Chalchiuhtlicue's presence was seen in the way that water moved, it is worth attending to the quality of the water at the Templo Mayor and where its sources may have been. Three of the pools have no noted origin point, but they were certainly calm water, allowing the priests to bathe in them. More vivacity was to be found in the pool of Toxpallatl, whose source was identified in the Florentine Codex as flowing springwater that was captured in some kind of public fountain, described as where "the common folk drank water."[77] While underground springs may have fed this pool, by the fifteenth century its source was more likely the freshwater aqueduct from Chapultepec that ran down the Tlacopan (later bastardized as "Tacuba") causeway, which ran east to west to connect to the western lakeshore and brought a current of water into the site (see figure 1.10); it too was described as "provid[ing] drink, refreshment to the Mexican nation."[78] Thus in the pools at the Templo Mayor, one encountered Chalchiuhtlicue in her most desirable state, calm and constant, providing for the priests and the people of the *altepetl* alike. If we are to return to the Teocalli of Sacred Warfare and understand that one of its many meanings was to serve as a replica of the larger Templo Mayor, with the shallow "steps" cut into its front and the receding crowning "temple" at its top and at its base, the body of the female sacrifice on its back face was to be found in the pool of "tamed" water also associated with Chalchiuhtlicue (figures 2.14 and 2.15).

In both the Templo Mayor and the Teocalli, we find a towering temple over a calm body of water. Given that temples were conceived of as man-made mountains, we confront once again the image of the *altepetl*, the harmonious human collective, the site of unstinting natural bounty that the rulers of Tenochtitlan were engineering, again and again, for the benefit of their peoples, in sculpture, in architecture, and in the city itself. By the beginning of the sixteenth century, the Mexica rulers of Tenochtitlan had created *altepetl* models, or maquettes, expressing the idealized water hill not only at the Templo Mayor, but in other sites they controlled around the valley, in Tepetzinco and Chapultepec and beyond. These and other sites, like that in Tetzcotzinco, created by the rulers of Tetzcoco, gave a series of ambitious dynastic rulers in the fifteenth and early sixteenth centuries an opportunity to show themselves in relation to the idealized *altepetl*, but they are largely beyond the scope of this study. Instead, it is to the presence of the Mexica rulers in the urbanscape that we will now turn.

The *Tlatoani* in Tenochtitlan

In the second half of the fifteenth century and in the wake of the creation of the Triple Alliance between the Mexica, the Acolhua, and the Tepanec, the Mexica rulers of Tenochtitlan grew wealthy in their island capital. The successful wars of conquest waged inside and outside the Valley of Mexico led to tribute of foodstuffs, cloth, and luxury goods like feathers and jade, which flowed into the capital as often as five times a year. In addition, nearby conquered towns provided the labor that Mexica rulers needed to build the elaborate waterworks that protected the city from floods. At the same time, the "taming" of the Laguna of Mexico by creating a relatively sweet water enclave to the west of Lake Tetzcoco allowed more areas to be converted into *chinampas*, yielding greater agricultural productivity on and around the island. More of the city's residents turned to specialized trades, creating featherworks, gold jewelry, pottery, and textiles. Better provisioned, the people of Tenochtitlan prospered.

And so did their rulers. City residents—like all members of *altepeme*—were expected to support the local nobility and the local temple with tribute goods and labor, to hold up their end of the social contract. Rulers, in turn, safeguarded and cared for the *altepetl* at large. The city's political stability was enhanced in this period by long-ruling *huei tlatoque*, many holding office for a dozen years or more: Moteuczoma Ilhuicamina (Moteuczoma I) ruled for twenty-eight years (1440–1468); Axayacatl ruled for thirteen years (1468–1481); Tizocic's short reign (1481–1486) was the anomaly; Ahuitzotl (1486–1502) ruled for sixteen years; and the eighteen-year reign of Moteuczoma

Xocoyotzin (Moteuczoma II; 1502–1520) was ended by the arrival of the Spaniards. In the last chapter, we saw how these leaders set representations of themselves and the feats of their rule within the city's built environment, a strategy to broadcast their presence widely and publicly by setting themselves within, and adding to the valences of, the city's lived spaces. They reshaped the built environment through the construction of protective dikes and causeways around the city that kept the salt water of Lake Tetzcoco at bay and allowed urban residents to transform the laguna into a freshwater reserve. And then they represented the spaces around them in sculpture, such as in the Teocalli of Sacred Warfare, in which, as we saw in the last chapter, Moteuczoma's artists drew on cosmic templates wherein the male solar deity triumphs over his female opponent to shape the image of Tenochtitlan. The steady uptick in the number of large monolithic (and therefore largely immobile) monuments that can be ascribed to rulers from Moteuczoma I onward offers further evidence of the Mexica *huei tlatoque*'s interest in setting themselves and the events of their rule into the spaces of the city.

Sculpture, however, existed in tandem with performance, and in truth, the Mexica ruler was better known to a pre-Hispanic public through performances that served to make him visible to a wide spectrum of people—and this quality of being "made visible" was crucial in the larger construction of the ruler's authority. As Louis Marin pointed out about Louis XIV, a ruler known far and wide to his subjects via representations, "the king *is* his image."[1] For the Mexica *huei tlatoani*, it was through being seen,

both by members of the elite and then by a larger public, that the ruler and his associated authority was made tangible within specific urban spaces. At the same time, as an analysis of ruler costume below will show, the Mexica *huei tlatoani* used costume to bring representations of distant spaces to the urban core. By wearing costumes fashioned of feathers, he represented the geographically peripheral spaces of the tributary empire, and by costuming himself as specific deities, he brought the usually separate levels of the otherworldly realms, particularly those twelve upper layers of the sky and their inhabitants, down to the earthly plane, the first layer of the multitiered universe.

Not just any spaces were marked with the presence of the *huei tlatoque*, and after discussing the means by which, and the spaces in which, rulers were visible in the city, we turn to a triad of Mexica rulers, Moteuczoma I, Ahuitzotl, and Moteuczoma II, who marked their presence, both through ephemeral performance and in permanent sculpture, in spaces that were associated with the harnessing of freshwater for the city. While in the last chapter we looked at the enormous projects meant to control the lakes that surrounded Tenochtitlan, in this one we will turn our attention to two important sources of fresh, potable water—aqueducts coming from Chapultepec in the west of the city and the springs at Acuecuexco to the south—and the performances and sculpture that attended their creation. Delving into these inaugural rituals that took place in the streets and along the canals of Tenochtitlan allows us better insight into urban practices, that third constituent sphere of space that so often lies beyond the recoverable horizon of the urban historian but that inflects urban spaces with so much of their meaning. In doing so, we will encounter again the idea of *teotl*, introduced in chapter 2, and the *teixiptla*, a costumed person who was understood to be the living representative, or delegate, of a deity, a figure whose performances marked urban spaces and endowed them with meaning.[2]

THE SPATIAL RULER

One of the few eyewitness accounts of the last Mexica emperor, Moteuczoma II, written by the conquistador Bernal Díaz del Castillo, mentions the ruler's visual inaccessibility: "Not one of these chieftains dared even to think of looking at him in the face, but kept their eyes lowered with great reverence, except those four relations, his nephews, who supported him with their arms."[3] Given

the ruler's frequent public appearances, such a prohibition only served to heighten the importance of his visibility, and for those who encountered him, this unseeable ruler would have left an even keener mental impression of both himself and the particular location of his appearance. Perhaps because of this quality of memorability, the informants of the Dominican historian Diego Durán, some of whom may have seen the ruler firsthand as youths, were able to provide many descriptions full of fresh detail about Moteuczoma. Those Nahuatl-speaking intellectuals who wrote the Florentine Codex were able to do the same. Since it is unlikely these elite Mexica invented such remembrances out of whole cloth, the vivid descriptions in these histories suggest that the ruler was often fully visible among the elite class (from whom the Florentine writers and Durán's informants descended) and that he was at times also visible to a larger public.

Cloaked as they were in the rhetoric of unseeability, Moteuczoma II's appearances would have been memorable, as they were to both Cortés and Bernal Díaz, who were so impressed by what they saw that they offered lengthy descriptions of Moteuczoma and his retinue upon their first encounter in 1519. This took place along the Ixtapalapa causeway, one of the first great earthworks built under Itzcoatl (r. 1427–1440) nearly a century before, and they described his jade-laden costumes and the four lords who held up a canopy over his head.[4] For a viewer at any distance, as Bernal Díaz would have been, the most prominent feature of the ruler was this feathered and jeweled canopy—whose green color suggests that it was composed of nothing less than the most precious of all feathers, those of the quetzal bird, a bird not native to the valley but imported as part of the tribute demanded of conquered provinces, a bird whose feathers were featured in the famed headdress of Moteuczoma II, whose nearly six-foot expanse gives us some notion of the visual spectacle that feather costumes offered (see figure 1.14). A page from the Codex Mendoza, a sixteenth-century book whose image of the foundation of Tenochtitlan and depiction of the conquests of Moteuczoma was discussed in chapter 1, also includes one of two extant lists of the tribute that the Mexica rulers in the valley demanded from conquered provinces. Figure 3.1 shows the goods expected from Tochtepec, which lay to the east of the valley, along the Gulf Coast (see figure 1.15). While many of the tribute provinces in the empire were expected to deliver rather prosaic items, like the beans and corn that were the mainstay of the diet,

FIGURE 3.1. *Unknown creator, tribute goods from the province of Tochtepec, Codex Mendoza, fol. 46r, ca. 1542. Bodleian Libraries, University of Oxford, Ms. Arch. Selden A1.*

Tochtepec and its surrounding towns were called upon to produce a wealth of exotic goods, many made from raw materials that did not exist in the cool, high-altitude Valley of Mexico. Most of the goods on the page were destined for ritual use: in the second register from the bottom is the ceramic pot holding the liquidambar used as incense, and on the center right edge are two balls of rubber, used in painting the deities and their impersonators as well as in the ballgame. But most importantly, the page is dominated by feathers: finished products made of feathers, like shields, backracks, and suits, in the upper third. On the lower left part of the page are the bundles of feathers required as tribute, and the quantities are staggering: eight thousand turquoise feathers, eight thousand scarlet feathers, eight thousand green feathers. The source for the most valuable of these feathers, whose color echoes the precious jade necklaces that appear above them, is also pictured, in the upper left quadrant of the page: it is a backrack in the form of the male quetzal bird. The bird's long tail feathers were particularly prized, so much so that the native writers of the Florentine Codex would wax eloquent about the "glowing, shimmering" of these feathers.[5]

Trapped and shot down with blowguns by the Maya and others in Guatemala and Costa Rica, the birds would yield feathers that were carefully sorted and bundled, as pictured here, then sold to long-distance traders or to neighboring regions to use for the finished tribute goods. These precious cargos of feathers were carried by *tameme* (from Nahuatl *tlamama*, "someone who bears a load") following the routes and roadways that connected south to north, and they eventually threaded their way through mountain passes to the high Valley of Mexico to enter Tenochtitlan by canoe or causeway.[6] Sold in the markets of Tenochtitlan[7] or ushered into the workshops of the city's featherworkers to be made into ritual paraphernalia, feathers were exotic goods. They were expressly marked and known as the products of the peripheral conquests of the empire—the Florentine Codex authors tell us, for instance, that the prized quetzal feathers arrived in the time of Moteuczoma I, specifically linking the appearance of these feathers to a round of fifteenth-century imperial expansion.[8]

Feathers were thus part of a spatial imaginary, that is, one of the ways that distant space found expression before the eyes of residents of the pre-Hispanic city. Not only were they exotic—not from the cool, high-altitude valley—but also acquiring them was a goal and an outcome

of the Mexica military forays to the regions outside of the valley. Feathers, more than any flat image like a map, were the physical evidence of the expanse of an empire, made possible by the military prowess of its ruler. And feathered costumes brought to the center as part of this imperial booty were worn, in turn, by the armies that marched out of Tenochtitlan to extend the empire, or to subdue any rebellions within.[9] Thus the feathers worn by the ruler allowed him to represent on his person the spatial expanse of the conquered empire and his role in that expansion. Not only a vivid complement to the rather static iconography of conquest found in other sculptural works, they also allowed geographic peripheries to be brought to the center.[10]

Feathers also formed an important part of the ruler's battle dress, as known from painted manuscripts created after the Conquest. One exquisite rendering of a ruler in such battle dress is to be found in the Codex Ixtlilxochitl, in which a great Tetzcocan ruler, Nezahualcoyotl, appears in battle pose (figure 3.2).[11] As presented here, the Tetzcocan ruler wears the suit of feathers and carries feathered accouterments that only highest-status warriors would be eligible to wear and carry: a close-fitting jerkin (called an *ehuatl*, meaning "skin" or "husk") covers his body, this version made for rulers and created out of rich turquoise feathers. His kilt is also made of feathers—long pink and yellow plumes are bordered at top and bottom by shorter green feathers. Flame-colored orange-red feathers are on the lower borders of his shield, carried on his left arm, while his right hand holds the obsidian-bladed *macuahuitl*, deadly in combat at close quarters. (Given the position of right and left hands and feet, we are to read the body as opening away from us, but the easy naturalism is slightly marred by the artist's positioning of Nezahualcoyotl's right foot low down in the picture plane, whereas one-point perspective would call for it to be higher up.) He appears as if shifting his weight as he makes ready to strike an unseen opponent with a crushing overhead blow by the *macuahuitl*—the portrait thus reinforcing Nezahualcoyotl's status as a warrior, fully appropriate for the Acolhua leader who helped forge the Triple Alliance. On his tour of valley cities after the successful war waged against Tehuantepec in the Isthmus of Mexico, the Mexica ruler Ahuitzotl was connected to the successful conquest of outlying territories by the elaborate feather costumes he wore along with his courtiers. Additionally, dwarfs in the retinue carried "skins of jaguars and ocelots that had been brought back from the

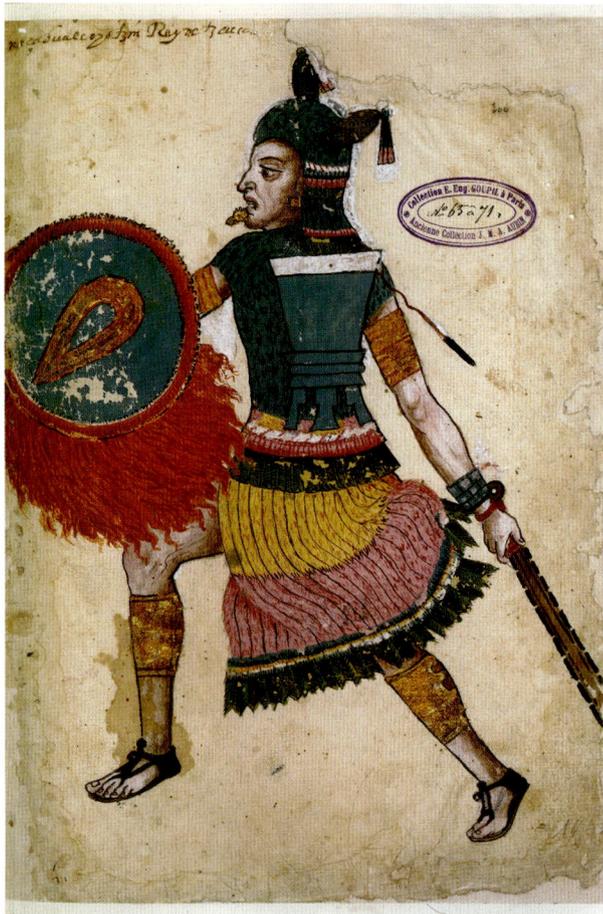

FIGURE 3.2. *Unknown creator, portrait of Nezahualcoyotl, Codex Ixtlilxochitl, fol. 106r, ca. 1580. Ms. Mexicain 65–71, Bibliothèque nationale de France, Paris.*

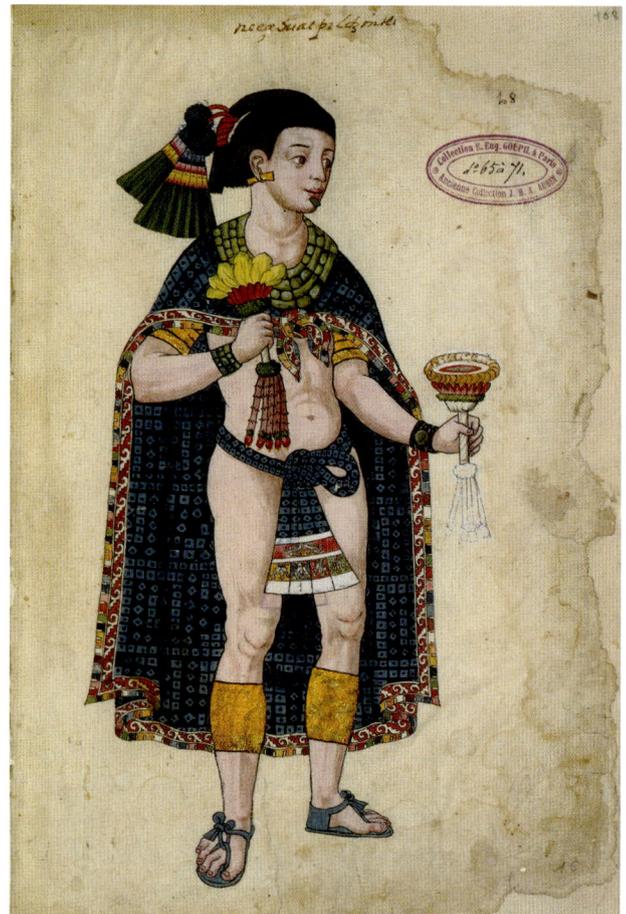

FIGURE 3.3. *Unknown creator, portrait of Nezahualpilli, Codex Ixtlilxochitl, fol. 108r, ca. 1580. Ms. Mexicain 65–71, Bibliothèque nationale de France, Paris.*

conquest of Tehuantepec, as well as other objects that were part of the spoils of war."[12]

If battle dress was associated with faraway places, the court dress of valley rulers often referenced the nearby, particularly the skills of urban women, who were master dyers, spinners, weavers, and embroiderers. In Tenochtitlan, women of the royal court were particularly important creators of luxury cloth. We see an example of their art in another page from the Codex Ixtlilxochitl, this one presenting a portrait of Nezahualcoyotl's son, Nezahualpilli (figure 3.3). He wears an elaborate version of the basic clothing that most men of central Mexico wore: an elegant blue cloak, or *tilmatli*, over his shoulders, this turquoise-patterned cloak with a distinctive shell border worn only by high-status rulers and called the *xiuhtilmatli-techilnahuayo*, and a coordinated embroidered loincloth, or *maxtlatl*, around

his middle.[13] The exquisite embroidery along the borders, both patterned and figural (the open maw of the earth deity appears on his *maxtlatl* over his groin) was almost certainly the handiwork of his female court.[14]

While the associations of feathers allowed the *huei tlatoani* to bring the periphery to the center, and court costume put the skills of nearby urban women on display, the ruler's frequent adoption of deity costumes for ceremonial occasions also allowed him to represent the forces that existed in other layers of the universe on the terrestrial plane. Both in public appearances and in sculptural representations, rulers wore the garb of particular deities. But this was more than mere surface costuming; instead, the ruler took on the identity of that deity, as if transubstantiated. In both written and visual representations of Mexica kingship, we find the *huei tlatoani* acting as a deity delegate.

In a prayer recorded in the Florentine Codex, recited on the death of a ruler, supplicants address Tezcatlipoca, the great creator deity. Their words suggest that the ruler is a kind of vessel for the deity: "Briefly, for a while, N. [the ruler] hath come to assume thy troubles for thee on earth . . . and he came to reap reward on thy reed mat, thy reed seat, there he came to await thy spirit, thy word." The prayer also concerns itself with the liminal period between the death of a ruler and the appointment of the next. Anxiety during these periods ran high, particularly about the fate of the *altepetl*, always subject to attack by other *altepeme* and even more so when it lacked a designated leader. The prayer continues: "And the altepetl, will it perhaps here in his absence be mocked? Will it divide? Will it scatter? . . . Will the altepetl lie abandoned, will it lie darkened?" The prayer goes on to implore the deity Tezcatlipoca's aid in selecting a successor, to "concede, reveal, designate which one will guard for thee, will govern, will fortify, will gladden the altepetl, which one will place [*contlatlalitiez*] the city upon his thigh, will fondle it [*in conahuiltiz*], will dandle it?"[15] In this passage, the joyful (even sexual) nature of the *tlatoani*'s duties is heightened—the word *ahuiltia* (found in "fondle") was translated in the sixteenth century as "to amuse someone with an enjoyable game"; additionally, *ahuiya* had connotations of sexual pleasure, with *ahuiyani* (literally, "a giver of pleasure") translated into Spanish as the equivalent of "prostitute." However, another current in the idea of *tlatoani* would have been audible to speakers of Nahuatl—that of order. Understood by the use of the root word *tlalia* (used in the agglutinative word *contlatlalitiez*) was "to place"; thus the Florentine's translators render it in the question, "Which one will place the city upon his thigh?" Given that *tlalia* also means "to set things in order," the prayer neatly exposes that a key element of Mexica kingship was the ruler's role as delegate of Tezcatlipoca, and it additionally identifies him as the protector (even sexual partner) and organizer of the *altepetl*, the figure who keeps it from military assault and from disorder. On reading more of the passage, we find that the ruler is not only a stand-in for Tezcatlipoca, but also a delegate of the line of male rulers who came before him, and he will go to rejoin them on his death. Because rulers were understood to be delegates of immortal deities, costume was crucial in revealing the "altered" identity of the ruler, made manifest in his role as the delegate of a divine authority. Such transient costumes

had a more enduring life when they were reworked into stone on monumental sculptures.

MARKING THE URBAN SPACE

The costumes that Mexica rulers wore in public helped forge a visible bond between them and the otherworldly deity cults whose worship was shared by all sectors of society; by dressing as deities such as Tezcatlipoca, Huitzilopochtli, or Xipe Totec in public and by commissioning works in stone of himself in which he was wearing their costumes, a ruler thereby established himself as the conduit between the sacred spaces of the otherworld and the quotidian plane of the known earth, the medium through which these representations of sacred spaces came down to earth. And the costumed ruler, as the center of a spectacle, moved through very particular pathways in the city. Thus, rulers, as they represented spaces of the empire both near and far and the layered spaces of the cosmos, were aligned with specific nodes at the city's ceremonial centers and axes both inside and outside of the urban fabric.

What were these nodes and axes? We know something of the lived space of the city and the valences that some of these spaces carried through time. On the eve of the Conquest, Tenochtitlan was a four-part city, so large that its component parts were themselves *altepeme*, with rulers and internal bureaucracies, the whole being a "complex altepetl" (see figure 1.10).[16] These component *altepeme*, Moyotlan, Teopan, Atzacoalco, and Cuepopan, seem to have been separated by the causeways (to the north, west, and south) and main street (to the east), and thus occupied the intercardinal spaces of the city. Tlatelolco, which filled the northern part of the island, was also an *altepetl*, having been conquered by Tenochtitlan in 1473, but was never fully integrated into the four-part system. Each of these *altepeme* had its own ceremonial center; we know little about these urban centers, and assume that they were smaller versions of the temple-and-plaza complex of the main ceremonial center, at whose heart was the Templo Mayor, because each contained districts called *teocalli* or *teocaltecpan*—Nahuatl words meaning "temple" from combining *teotl*, "divinity," and *calli*, "house"; and from *teotl*, *calli*, and *tecpan*, "palace."[17] This four-part city was in turn subdivided into smaller neighborhoods called *tlaxilacalli* (known elsewhere as *calpolli*), whose residents traced descent to a common ancestor. We currently understand the *tlaxilacalli*

to have had both a social and a spatial dimension.[18] Even in the enormous sixteenth-century city after the Conquest, residents of a number of the extant *tlaxilacalli* located their origins in the clans of the initial migrants. While different histories offer differing accounts of the number of early settling clans, the Codex Mendoza shows us ten clan leaders settling Tenochtitlan in 1325, and histories connect some of these leaders to specific places in the pre-Hispanic city.[19] For instance, the tribal leader Xomimitl (arrow foot), who is to be found in the right-hand quadrant of folio 2r in the Codex Mendoza, was the leader of the *tlaxilacalli* of Yopico in Moyotlan (see figure 1.3).[20]

Fragmentary evidence from the colonial period suggests that members of the colonial elite were affiliated with particular quadrants within the city—that is, they may have seen themselves as members of the *altepetl* of Moyotlan or the *altepetl* of Teopan first and foremost, even before they saw themselves as Mexica.[21] The affiliations with one of the four quadrants of the city may have pertained to the pre-Hispanic rulers as well. The 1524 map that accompanied Cortés's Second Letter labels the urban complexes of Moteuczoma II with long texts—the pleasure houses where concubines lived, his gardens—and they are set within Moyotlan, the quadrant that appears in this western-oriented map between nine o'clock and twelve o'clock on the map's surface, suggesting that this ruler belonged to this part of the city and marked his presence in that quadrant with extravagant architectural works (see figure 1.11). One of Moteuczoma's sons reportedly lived along the Tlacopan causeway right between Moyotlan and Cuepopan, but at present the evidence is too scarce to definitely assign pre-Hispanic rulers to the different parts of the city.[22]

The ruler was able to link himself with places through architecture, thereby availing himself of, and adding to, the embedded meanings of lived spaces. By moving along axes during public processions and ritual within the city, he was also able to imbue these spaces of the city with his presence. These same axes also could extend through space to connect the great cities of the valley, stretching from temple-top to temple-top.[23] Post-Conquest histories at times reveal where rulers moved, and many emphasize the movement along the causeways and roads that extended from the central ceremonial precinct where the royal palaces lay. Causeways, which had the double function of dikes, connected the city to the surrounding lakeshore; as we saw in the last chapter, the principal ones were the Tepeyacac causeway to the north, the Ixtapalapa causeway to the south, and Tlacopan to the west (see figures 1.10 and 2.7). The causeways were raised above the lakebed and in their extension into the city were set above the city streets, an effect still visible along the Tlacopan (now known as the Tacuba) causeway today, which is called San Cosme in its western extension and still rises slightly above the surrounding streets. Leading into the central ceremonial precinct, these causeways created long and narrow raised platforms within the city on which the ruler could display himself. The open plazas of the precinct served as stages for ritual. So did the stepped façades of the pyramids, dozens of which rose in the precinct, providing ladderlike stages upon which processions could array themselves vertically and be visible throughout the low city. In these consciously designed spaces, the ceremonial life of the city unfolded, brilliantly, with the monarch at its center.

To greet the Spanish conquistadores, for instance, Moteuczoma traveled along the century-old causeway leading south toward Ixtapalapa. Other reconstructions of the ruler's movements are somewhat conjectural: Moteuczoma almost certainly visited the hot springs of Tepetzinco for ritual bathing or en route to make pilgrimages to Teotihuacan, and his passage would have taken him along the main eastern street to the docks on the city's eastern littoral to complete the rest of the journey, about nineteen miles, by canoe (see figure 1.1).[24] But the most important axis within the city would have been the causeway of Tlacopan, which stretched across the western laguna to link to Chapultepec. It would have been this road where the public caught their first glimpse of the newly anointed *huei tlatoani*. During a ruler's coronation rites, he spent days kept from public view in the central precinct, but then was made visible in the last phases of the rites, when he visited two shrines, the first, Tlillan, a temple to the female deity Cihuacoatl on the north side of the Templo Mayor.[25] His visit to the second shrine, the Temple of Yopico, dedicated to Xipe Totec, an important patron deity of the Mexica rulers, would have brought him into public view. The Yopico temple has been suggested through excavations by Carlos González González as having been located in the southwest quadrant of the city in the *tlaxilacalli* of Yopico in Moyotlan; the *tlatoani*'s most likely route to reach this temple would have him move from the Templo Mayor out to the Tlacopan causeway to the west, along the route of the aqueduct of Chapultepec, as it flowed inward to the temple precinct.[26] Thus this principal axis in the city, the one that carried its

vital supply of freshwater, would have been the axis of the new *tlatoani*'s inaugural procession.

This western axis out of the city was also the one used when the ruler returned as victorious conqueror after a military campaign. When Ahuitzotl returned home from his scorched-earth campaign of the rebellious Teloloapan, he first stopped at Chapultepec, where he was greeted by a joyous procession of priests and elders.[27] To enter the city, Ahuitzotl would have traced the route of the Chapultepec aqueduct that linked the lakeshore site to the Tlacopan causeway, thereby following the route of freshwater. No doubt Ahuitzotl entered the city dressed in battle regalia, making public the spoils of battle as well as revealing himself to the public. But the victorious *tlatoani* was not seen just on the Tlacopan causeway; Ahuitzotl, flush with his Tehuantepec victory, "then visited the temples of the different gods that were in the city, going to one each day."[28] Since these main temples of Tenochtitlan's component *altepeme* lay outside the temple precinct, with their sacred precincts set roughly on the intercardinal points, Ahuitzotl might head out in a different direction on each of the days. This four-day period was followed by a visit to the southern lake districts, which took the victorious emperor and his glittering court along the Ixtapalapa causeway.

So, despite the rhetoric of unseeability, Mexica rulers *were* very visible within the city, usually as triumphant military victors. The *tlatoani*'s movement through the city in colorful and noisy processions would have reinforced the importance of the principal axes, particularly the ones to the south and the west. This latter one linked to Chapultepec, the ruler's ceremonial entrance to the city. One could argue that the representations of the *tlatoani*'s power via these public presentations were most closely shaped by elite concerns. But in their encounter with spaces, they could not be so hermetic, because the spaces of the city had their own, independent public life. Thus, Chapultepec was a particularly strategic point for ritual event, because it was well known to the city's populace (who manned the work gangs to build and clean the canals) as the source of life-giving freshwater.

Another important practice that served to inflect the lived spaces within the city were the *mitotes* (from *itotia*, "to dance"), or ritual dances, and we will encounter these again in discussing the post-Conquest city in chapter 8. These were a key feature of ruler accessions; Durán, who offers the fullest account of the coronation of Ahuitzotl, says that the feasting and dancing lasted for four days; such

four-day dances were repeated as part of the coronation rituals of Moteuczoma II.[29] The coronation *mitotes* were held within the palace walls and thus did not spill out into public spaces, but the insistent beating of the loud drums certainly did, as the sonic effect of the coronation permeated every corner of the surrounding area.

The guest lists reveal something of their function, although they were often secret, since many guests were rulers of surrounding polities and thus officially "enemies." During the days of dancing, the guests were given rich gifts of jewels, feathers, and cloth. In such an asymmetrical exchange of gifts, the richness of the Mexica state was meant to overwhelm rather than show affection, the kind of gifting that Marcel Mauss would describe among chiefs of the Canadian Northwest, where "the only way to demonstrate his fortune is by expending it to the humiliation of others, by putting them 'in the shadow of his name.'"[30] The eating of mushrooms followed, to induce an altered, hallucinogenic state, reserved for only the most sacred of events. But dances were not just for coronation, as they were part of almost any sacred event; priests and celebrants sang and danced to welcome the victorious ruler into the city; city dwellers sang and danced at almost every one of the important *veintena*, or monthly feasts, happening every twenty days, most likely filling the plazas of their *altepetl* temple. In these dances, the unified and disciplined movement of a large body of people gave a tactile presence to ritual and social cohesion, as well as marked the spaces in which they occurred.

SPATIAL AGENCY

In the introduction, we saw the three intersecting spheres that constituted the city's space; one way of envisioning them was to view them like a landscape captured in a painting: the dominant foreground filling the view (representations of space), the midground (the lived space that includes the built environment), and the dimly perceived background (practice), much of it lying beyond the horizon line. But this metaphor rests on the idea that it is *our* gaze, as we stand outside of our imagined picture of a past landscape, that perceives this triad and *our* minds that make sense of the relationship between the three spatial strata or spheres. But, of course, Mexica dwellers of the city did not stand outside these spaces as we do, and from their vantage within the landscape, these spatial spheres intersected and interpenetrated into a seamless whole.

But what knitted these spaces together? Whose agency—that is, the ability through will or intent to make something happen—made it possible for the Mexica to perceive an inert building like the Templo Mayor (lived space) as carrying in it the imprint of the larger design of the cosmos (a representation of space)? On the most quotidian level, it was the daily practices of the urban population that imbued lived spaces like the *tianquiztli*, "market," with much of their meaning, but we also see the Mexica rulers assuming a key role in the public spectacles, themselves engaging in a kind of practice that carried representations of space into the built environment. The Mexica at large perceived the *tlatoani*'s agency to be greater than that of a normal human being, and this enhanced agency was proclaimed in some of the public spectacles described above. When Ahuitzotl returned from his successful war, for instance, the victory celebrations, the processions and dancing at Chapultepec and as he moved down the causeways and into the temples of the city, were a way of marking his prowess, his active role in shaping and extending the empire to spaces beyond the valley, and at the same time the feathers that he and his retinue of warriors and courtiers wore carried this representation of the tributary empire into urban spaces. Because those parts of Tenochtitlan that were marked by his presence, like the western causeway and the four *altepetl* temple complexes, continued to carry that association through time, we can think of the Mexica *tlatoani* as having had a leaky agency, which left a residue in the spaces where he commemorated those acts long after the fact—his spectacular practice leaving a mark on lived space. And in turn, Mexica artists used sculpture—often fixed and immovable—to reiterate the *huei tlatoani*'s actions within specific spots of the city.

It is easy for us to see Mexica rulers as having had agency to carry meanings from one spatial sphere to another, since we live in a world animated by human agency and our belief in human agency is foundational. But Mexica also held that nonhuman agencies were at work that allowed spaces to take on meaning. Sculptural representation, that translation into stone, also seems to have allowed the efficacy of original acts to survive though time. In other words, by setting a monument in a particular place and having its imagery register ritual actions, the work of art extended the agency of that ritual action. Mexica sculpture, long admired for its perceived "stoniness," its inert, monolithic grandeur, seems to have carried the capacity to shape the world around it.

This escape of human agency from the (strictly defined) human domain is the subject of a study by the anthropologist Alfred Gell, who writes:

We can accept that the causal chains which are initiated by intentional agents come into being as states of mind, and that they are orientated towards the states of mind of social "others" (i.e., "patients": see below)—but unless there is some kind of physical mediation, which always does exploit the manifold causal properties of the ambient physical world (the environment, the human body, etc.), agent and patient will not interact. Therefore, "things" with their thing-ly causal properties are as essential to the exercise of agency as states of mind. In fact, it is only because the *causal milieu* in the vicinity of an agent assumes a certain configuration, from which an intention may be abducted, that we recognize the presence of another agent. We recognize agency, *ex post facto*, in the anomalous configuration of the causal milieu—but we cannot detect it in advance, that is, we cannot tell that someone is an agent before they *act as an agent*, before they disturb the causal milieu in such a way as can only be attributed to their agency. Because the attribution of agency rests on the detection of the effects of agency in the causal milieu, rather than an unmediated intuition, it is not paradoxical to understand agency as a factor of the ambience as a whole, a global characteristic of the world of people and things in which we live, rather than as an attribute of the human psyche, exclusively.[31]

Our consideration of the space of Tenochtitlan has given pride of place to the ruler's agency, and we have seen how a ruler like Moteuczoma I made his agency manifest by "disturbing the causal milieu" as a kind of chief engineer: by building a canal or constructing an aqueduct, his agency was given material testament (the piled stone and packed earth of the aqueduct). But Mexica understandings of agency were clearly more complex on two fronts: they granted a ruler an enhanced agency beyond that of a normal human being (seen when he presented himself as a deity-delegate), and they seem to have given agency to inanimate objects, like architecture and sculpture. To explain these phenomena from a Mexica perspective, we turn to two entwined Nahua concepts that allowed for rulers to have expanded agency and endowed even an inert object or substance with its own agency: first, the idea of *teotl*, introduced in chapter 2, that "sacred quality

... physically manifested in some specific presence—a rainstorm, a lake, or a majestic mountain,"[32] and second, the *teixiptla*. Both are key to understanding the ways that space was inflected with meaning, and we will draw on them both to understand two essential freshwater sources of Tenochtitlan in Chapultepec and Acuecuexco.

CHAPULTEPEC

Chapultepec, as we saw in the last chapter, was a key site on the Mexica migration, a prominent hill in the valley landscape that was filled with natural springs that oozed out of its bottom (see figures 1.7 and 2.4). Its importance as a water source was designated on the map that accompanied Cortés's Second Letter with the text set at the very top of the map, "ex isto fluuio conducut aguā in ciuitatem" (from here a stream of water flows into the city; see figure 1.11). This fortuitous combination of hill and water allowed it to serve as an *altepetl* maquette, a small-scale representation of space that expressed the idealized relationship between the flow of water and the human community.[33] This world-in-miniature was similar to Mexica architecture, seen in the way the Templo Mayor was conceived as a model of Coatepec, its sculptural program recasting the events and sacrifices that marked the birth of Huitzilopochtli, and other *altepetl* maquettes are found at other sites in the valley, such as Tetzcotzinco and Tepetzinco.[34]

Mexica rulers had long associated themselves with Chapultepec, and the importance of their provisioning of the nascent Tenochtitlan with freshwater is underscored in the historical representations of the place. The drive to bring freshwater into the city from Chapultepec's springs was the antecedent to the formation of the Triple Alliance in 1428. As told in Durán's *Historia*, in the 1420s, the Mexica had settled in Tenochtitlan but were still required to pay tribute to the ruler of nearby Azcapotzalco, the *altepetl* at that point in control of much of the valley. After seeing his people subsisting on brackish water, the third ruler of the Mexica, Chimalpopoca (r. 1417–1427), who was also the grandson of the Azcapotzalco ruler Tezozomoc, asked his grandfather for the right to build an aqueduct from the springs at Chapultepec, on the western littoral of the lake (see figure 1.1). Request granted, the Mexica built a conduit upon the causeway that linked their island city to the western lakeshore. Water in the raised aqueduct flowed from west to east through the city, as non–potable water did in the extensive ground-level canal system, which allowed easy passage for canoes through the city (see figure 1.10).[35] This orientation was fundamental to the Mexica sense of order in the city, and they expressed the alignment in their carefully arranged cached offerings set into the Templo Mayor, wherein the objects made of worked stone representing lightning bolts and streams of water were set on an east–west orientation.[36] As Durán's *Historia* tells it, "Very soon, with the aid of stakes and canes, earth and other materials, the water began to come into the city." However, the new aqueduct proved to be an imperfect one, as Durán continues: "It was a difficult task because the aqueduct was built on the lagoon and constantly crumbled due to the great impact of the water; also the conduit was built of clay." Durán goes on to recount how, soon afterward, the ambitious Mexica, "desiring that matters with Azcapotzalco come to a head so they could be free of their vassalage," sent a bold message to Tezozomoc, demanding the materials for a better aqueduct. The council of Azcapotzalco would have none of it: "We cannot permit this; it is not our will. We would rather lose our lives. . . . Chimalpopoca has no right to command us in this despotic way."[37] The council overrode the opposition of old and ailing Tezozomoc, arranged for Chimalpopoca's midnight assassination, and rallied the Tepanec people into a fever pitch against their Mexica neighbors.

Although their ruler had been violently assassinated, the hotheaded Mexica kept their anger in check; Tezozomoc died shortly after his grandson, and the infighting between his two sons led to a civil war in Azcapotzalco, this *altepetl* falling victim to the same divisions and scattering that the Florentine prayer quoted above so pointedly abjured. On the island of Tenochtitlan, meanwhile, the Mexica took a different path, coming together to elect a new ruler, Itzcoatl, who organized an army to launch a violent retributive assault on Azcapotzalco, "devastat[ing] the city, burn[ing] the houses, and spar[ing] neither young nor old, men nor women."[38] With this victory, the subsequent formal establishment of the Triple Alliance with Tetzcoco and Tlacopan, a Tepanec city that opposed Azcapotzalco, the great Mexica expansion of the fifteenth century began.

So initial control of the springs of Chapultepec had a unique role in early Mexica history, and some forty years later, in 1466, after a devastating famine had visited the city in the year 1 Rabbit (1454), Moteuczoma I rebuilt the aqueduct.[39] This work was more substantial than the earlier earthwork built in Chimalpopoca's time; to create it, Moteuczoma turned to his counterpart Nezahualcoyotl of

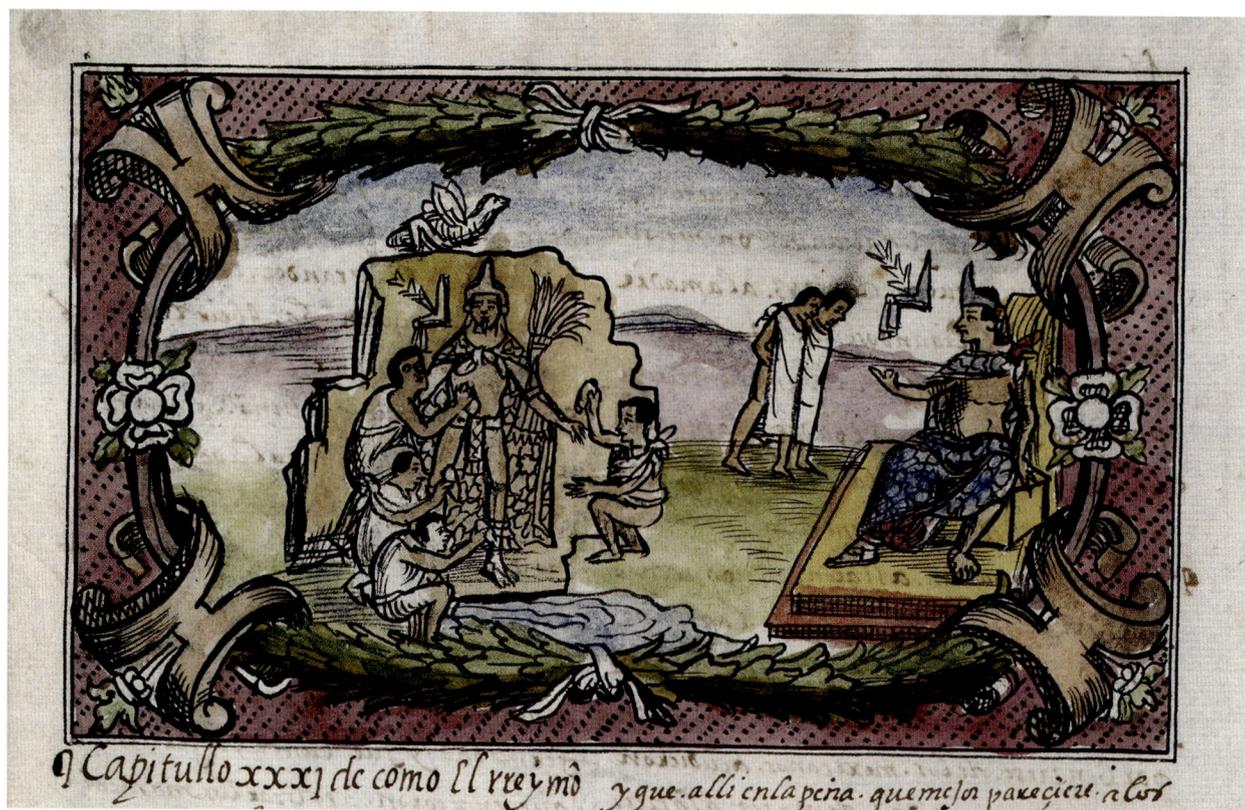

q Capitullo xxxj de como El rrey mõ y que.alli en la peña. que mejor paxeçieu a Lor

FIGURE 3.4. *Unknown creator, Moteuczoma I's portrait being carved on Chapultepec hill, from Diego Durán,* Historia de las indias de Nueva España e islas de la tierra firme, *bk. 3, fol. 19v, ca. 1570. Biblioteca Nacional de España, Madrid.*

Tetzcoco for engineering know-how.[40] After the end of the famine and the completion of the aqueduct, Moteuczoma I had himself memorialized by the carving of his portrait onto the live rocks of Chapultepec hill, probably one of the first such sculptural portraits the Mexica created.[41] The Moteuczoma portrait exists today only as an illustration in Durán's *Historia*, the original long since destroyed. As envisioned by a sixteenth-century indigenous artist who illustrated the work, the seated ruler appears at right, his distinctive name glyph (the turquoise miter, or *xiuhhuitzolli*), in the air in front of his face (figure 3.4). The cloak he wears is similar to the turquoise-patterned cloak worn by his cousin Nezahualpilli in his portrait in the Codex Ixtlilxochitl (figure 3.3). Moteuczoma points with his upturned hand, a particular gesture showing command. Four sculptors cluster around the rock face at left; that it is the hill of Chapultepec is signaled by the grasshopper at the top and the stream of springwater that flows copiously from its base. The four sculptors work with a variety of stones and tools for chiseling and grinding. Emerging out of their labors is the portrait of the ruler, shown frontally, with his elegant patterned *tilmatli* and *xiuhhuitzolli*, capturing the image of the living ruler who watches on the right.

Durán also recounts that the portrait of Tlacaelel was created alongside that of his brother Moteuczoma I, although he does not represent it in his manuscript. This important figure in Mexica history served as co-ruler with Moteuczoma, upon whose accession he had been named as *atempanecatl*, or "field or lagoon marshal."[42] He also enjoyed the title "cihuacoatl" (woman serpent), a title that would survive into the colonial period. Tlacaelel's presence at Chapultepec marks his importance to Tenochtitlan, and bearing the title "atempanecatl," he was likely in charge of the functioning of the vast and growing system of waterworks. Other actions attributed to Tlacaelel reveal more of his role as a majordomo in the functioning of the city, negotiating with ward leaders, for instance, in preparing the city for the coronation rites of Ahuitzotl.[43] The portrait thus linked Moteuczoma and his brother to the source of Tenochtitlan's freshwater, adding a new layer to the already-existing associations of the site of Chapultepec.

These portraits focused attention on the Mexica rulers, eclipsing the extraordinary feats of their engineers, which

stood nearby. Salvage archeology carried out by Rubén Cabrera C. in 1975 has brought light to the achievements of Mexica engineers at Chapultepec.[44] Water oozed from the natural springs within the hill and normally would flow downward into the nearby laguna. The Mexica intervened in this process by creating tanks at the base of the hill, fed by the springs. These thick-walled tanks allowed water pressure to build up, enough so the water would propel itself down the Chapultepec aqueduct, which ran along the lakeshore in a northeasterly direction before joining with the causeway running from Tlacopan (see figure 1.1). Along the causeway, the water flowed in an ingenious system of a double set of pipes, where one was always functioning while the second was being cleaned and repaired.[45] Cabrera's excavations revealed one part of the system of retaining tanks; since these same springs fed the city through the nineteenth century, the system had been continually rebuilt, and most of the tanks he found dated to the colonial and modern periods.[46] But a small part of the pre-Hispanic piece of the system was revealed, identifiable as such by a thick coating of stucco on the outside

of the buildings, typical of pre-Hispanic structures. Two low structures, parallel and adjacent, about eight feet high, carefully finished with a thick stucco coat, were constructed with a sloping talud, topped by a thick entablature, the conventional architectural signature of sacred buildings (figure 3.5). In the aperture between these buildings, water once flowed, where a small dam could regulate its force. In the early 1970s, off the southwestern corner of this complex, electrical workers made an accidental find (leading to the salvage project) of pre-Hispanic sculptures, including a sculpted image of the rain deity Tlaloc. The presence of this cache led the archeologists to posit that there might have been some kind of temple structure adjacent to the water dam to house the sculptures of water deities. This temple stood in a grove of great *ahuehuetl* trees, which may

FIGURE 3.5. *Map of structures at the foot of Chapultepec to supply water to the aqueduct, by Olga Vanegas. After Rubén Cabrera C., María Antonieta Cervantes, and Felipe Solís Olguín, "Excavaciones en Chapultepec, México, D.F." Diario del Campo, Suplemento 36 (October–December, 2005), 34.*

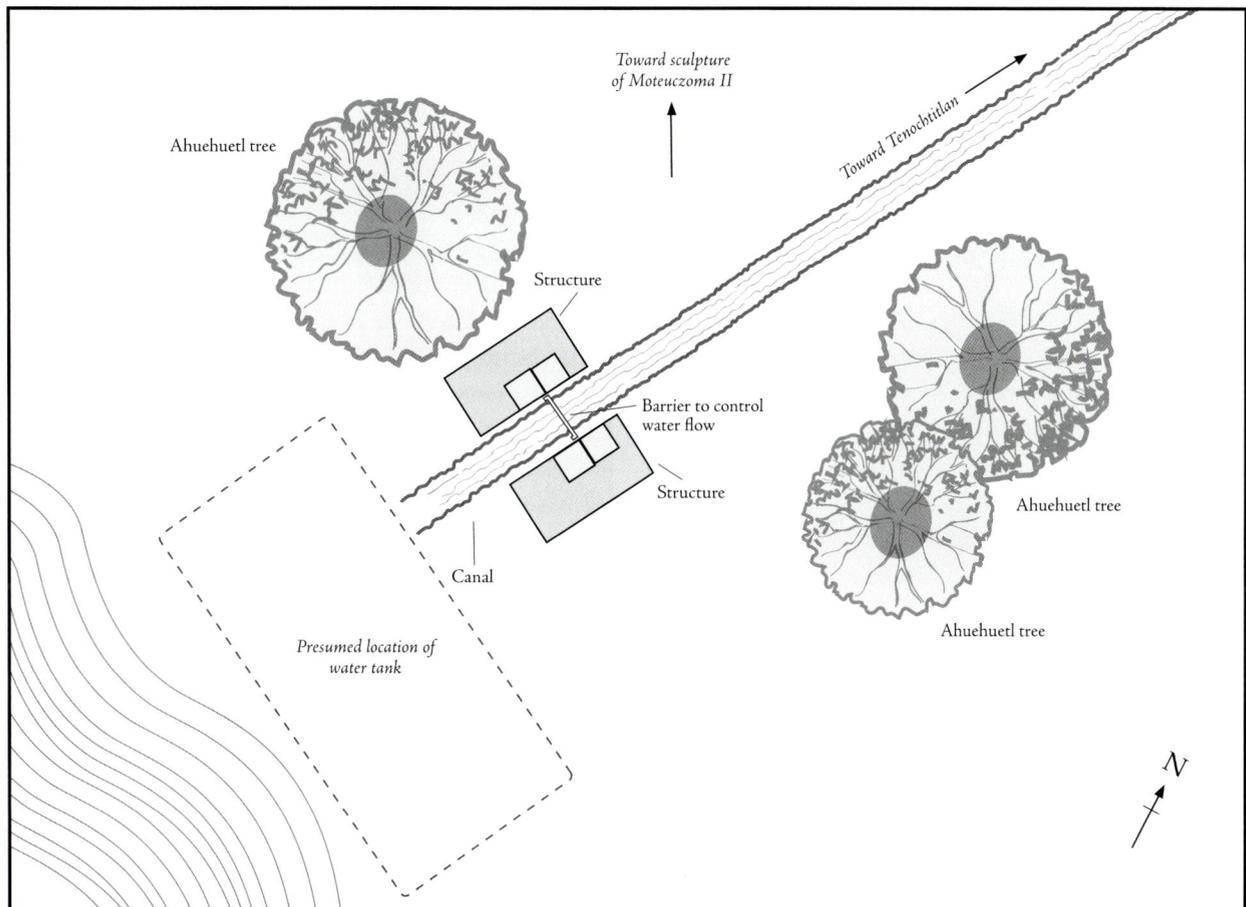

have predated the foundation of the city. Years later, near this site, Moteuczoma II would install his own portrait.[47] While we tend to privilege the artistic representation alone, the meaning of the portraits was clearly dependent upon the adjacency to both waterworks and tree grove, as Mexica rulers linked their sculptural representations to control over the surrounding environment.

THE ACUECUEXCO AQUEDUCT

In the decades that followed the building of the elaborate Chapultepec aqueduct in 1466, the desalinization and control of the Laguna of Mexico added to urban growth. Under Ahuitzotl, the residents of the city "had planted gardens and orchards, that provided a pleasant freshness. Here they had sown maize, chia, squash, chilies, amaranth, tomatoes and many kinds of flowers." Nonetheless, as Durán's *Historia* underscores, it was a precarious paradise, dependent upon rainfall to feed the rivers that in turn ran into the lake. "With all these plants the city was greatly beautified, but their freshness would be lost should they lack water. They would dry up and wither away." Drought affected not only the laguna, but the entire lake system, important because the city increasingly depended upon canoes to bring foodstuffs such as maize from outlying regions as well as move it through the city, and "in the dry season the water in the canals of Tenochtitlan was so low that the canoes could barely pass."[48]

Because of the growing population in the city and the evident insufficiency of the freshwater coming into the city over the Chapultepec aqueduct, Ahuitzotl hatched a plan to build another aqueduct into the city, one that would tap five springs that lay close to the city of Huitzilopochco and were under the jurisdiction of the southern city of Coyoacan; the aqueduct would be named Acuecuexco, after one of them (see figure 2.7).[49] Its ruler, Tzutzumatzin, objected to the plan and issued a Cassandra-like warning to Ahuitzotl of the dangers the unleashed waters might cause, because had he not, "then the Aztecs would complain that he had not warned them." Instead of taking Tzutzumatzin's counsel to heart, Ahuitzotl raged at the objection, swearing "that he would destroy Tzutzumatzin and erase his entire family from the face of the earth," and dispatched assassins to murder the Coyoacan ruler.[50] Realizing the peril, Tzutzumatzin tried a number of sorcerer's tricks, turning himself into an eagle and then a jaguar, a serpent and a flaming chamber, but then realized that resisting the Mexica would

bring calamity on all of Coyoacan. He gave himself up to the Mexica assassins, who strangled him on the spot.

With his opponent's death, Ahuitzotl went forward with construction. The springs were dammed up with "a strong mortar dam which made the water surge up with great force," very much like the dam we know to have existed at Chapultepec, from both before and after the Conquest, which allowed the springwater to fill a tank and achieve the necessary elevation to enter and flow through the aqueduct with force. From the dammed springs, the waters flowed along a raised aqueduct, probably made of stone and packed earth, and then joined the existing Ixtapalapa causeway, the main southern route into the city. It was very similar to the Chapultepec aqueduct, which, likewise, carried the water from the springs before joining with the Tlacopan causeway (see figure 2.7).[51] This southern causeway had originally been built under Itzcoatl in the wake of the Triple Alliance. It passed across a small island called Acachinanco before reaching the island at a site known in Durán's time, as today, as San Antonio Abad. Here, at the edge of the lake, residents could approach via canoe, and aqueduct water was sluiced off to fill a freshwater reservoir. At Huitzilan, a little farther north into the city (at the present-day Hospital de Jesús, along the Ixtapalapa causeway), there was another collection point, followed by one at Pahuacan; Durán does not tell us where the aqueduct ended, but given its utility to agriculture, any excess freshwater may have been channeled toward urban *chinampas*. The opening of the aqueduct was celebrated with great fanfare in 7 Reed (1499).[52]

The celebrations around the opening of the Acuecuexco aqueduct were memorable ones—Durán's account, written almost a century after the fact, includes pages devoted to celebrations remarkable for their novelty and for the range of participants as well as spatial expanse. Far from marking a feat of successful engineering, they were religious in character, led by priests and punctuated by human sacrifices. But unlike the highly orchestrated *veintena* festivals that were centered in Tenochtitlan's main temple precinct, these celebrations of 1499 spread through the city, as "the entire city turned out, dancing and singing" to welcome the life-giving water as it entered the city.[53] Some of the attention of the throng that turned out into the streets of the city was certainly focused on the priests, immediately recognizable by their black-painted bodies and matted hair, who performed sacrifices of four young boys at the main culvert. But other city residents crowded along the route to

collect some of the water as it came surging through, with members of the royal court joining Ahuitzotl at the end of the course to celebrate the glorious excess of freshwater. Durán's account captures the joyous spontaneity of the crowds—most of them at least part-time agriculturalists, well aware of the liquid life-rescue that awaited them. It is likely that even the lowest Mexica peasant who lifted her terracotta vessel to catch the streaming water would have understood it to be a source of *teotl*, and when she and her neighbors pressed up against the newly built conduit in 1499 to collect its precious flow, they were perhaps availing themselves of the *teotl* of the water itself.

But specific manifestations of *teotl* were often assigned the name of a deity, and it is clear that the Acuecuexco aqueduct of 1499 was linked to the *teotl* of Chalchiuhtlicue, a deity perceived as the animating force of water. This linkage between water's animate qualities and the deity endured for more than two generations and was captured by the indigenous artist working for Durán, who shows us how the event was imagined in the early 1580s, when his *Historia* was finished (figure 3.6). In an inset illustration that accompanied the beginning of the chapter devoted to the opening of the aqueduct, the artist shows three priests within the rectangular frame. The first wears a water-patterned skirt and has a blue-painted forehead and rubber-striped cheeks, his head is adorned with a spray of feathers, and he burns incense and shakes a rattle staff; the second blows a conch; the third sacrifices a bird. They approach a rushing spring at left, depicted

with a circular blue disk to suggest the whirlpool, a marker used in representations of Chalchiuhtlicue, the spiral form making her animating force visible. From this spring flows a wide blue band, representing the water in the aqueduct, which traverses the bottom of the page before encircling the base of the glyph for the city of Tenochtitlan, a cactus growing from the glyph of a rock, which we saw in the Codex Mendoza as well as the Teocalli of Sacred Warfare. The stream of water, presumably canalized, receives the priests' recent offerings: a decapitated bird floats on its surface, as does a sacrificed child with an open and bloodied chest cavity. It flows across the image from left to right, as if to trace the south-to-north flow of water up the new aqueduct into the city. The flow depicted here resembles the flow of water on the page of the sacred *tonalamatl* calendar contained in the Codex Borbonicus showing the thirteen-day period (a *trecena*) devoted to Chalchiuhtlicue (see figure 2.12). The parallel to the image in Durán is unmistakable, as emerging from the seated figure above on the page of the Borbonicus is a stream of water, fringed with shells and jade, holding offerings within to the deity. That the Acuecuexco aqueduct in Durán's text shares the vital qualities that were taken as evidence of the presence of Chalchiuhtlicue and that it receives the same offerings as the deity suggest that they possessed the same animate

FIGURE 3.6. *Unknown creator, dedication of the Acuecuexco aqueduct, from Diego Durán,* Historia de las indias de Nueva España e islas de la tierra firme, *fol. 143r, ca. 1570. Biblioteca Nacional de España, Madrid.*

(Capitullo. xlix. decomo El aqua entro Chroyano auia Rememedio y que lo mejor era

quality, and were both thought to share in the *teotl* of Chalchiuhtlicue.

If *teotl* expresses this view of the world as a hierophany and was made present to the residents of Tenochtitlan through the motion or force that animated the natural world and had agency within it, another Nahuatl word was used to describe its expression or manifestation in perceptible, concrete form. *Teixiptla*, those performed images that were transubstantiations of the deities themselves, are best known as the richly garbed "deity performers" who played a central role in all Mexica ceremonies, as they did in the opening of the Acuecuexco aqueduct in 1499. Here, the most important presence was the *teixiptla* of Chalchiuhtlicue, a priest costumed as this deity, who stood at the aqueduct accompanied "by all the priests of the temples," who played flutes and blew on conch-shell horns to welcome the water into the city.[54] His costume is carefully detailed in Durán's account:

> As [the water] began to run toward the city, a man disguised as the goddess of the waters and springs appeared, dressed to impersonate the deity, in a blue garment over which was a surplice similar to a scapulary. This last was covered with costly green and blue stones. He also wore a diadem made of white heron feathers and his face was stained with liquid rubber. His forehead was covered blue, in his ears were two green stones, another on his lower lip, and on his wrists he wore strings of blue and green beads. In his hands he carried rattles shaped like turtles and a bag filled with the flour of blue maize. His legs were painted blue and he was wearing blue sandals, signifying the color of water.[55]

The priest was, in essence, a living manifestation of the deity Chalchiuhtlicue; his presence, as he danced in neat, measured steps, was meant to "welcome" the *teotl* of the deity, as manifest in the current of water. Costume played a key role in effecting this identification. In the image of Chalchiuhtlicue from the sacred calendar represented in the Codex Borbonicus, the figure's costume is similar to Durán's description of the priest's garb—she too wears blue and green garments and a heron-feathered headdress, her face and costume spotted with black rubber. More of the relationship between the priest/*teixiptla* and the deity he represented is revealed in the speech quoted by Durán:

> Once in a while the man who was impersonating the deity took some of the water in his hand and drank it, then spilled it on both sides of the canal and, with great reverence, spoke to the water: "O precious lady, welcome to your own road! From now on you will follow this course and I, who represent your image [*semejanza*], have come here to receive you, to greet you and to congratulate you for your arrival. Behold, lady, today you must come to your own city, Mexico-Tenochtitlan."[56]

The use of the imperative form by the speaking *teixiptla* suggests not supplication, but the idea that control over water was afforded when the *teixiptla* moved within the ritual context created by the movements of the dance and the music. In addition, the *teixiptla* made possible a "real physical interaction" between the community of believers and the deity.[57] And as old men threw fish and water snakes and other amphibious creatures into the water along the aqueduct before it entered the city, they spoke directly to the deity, "telling the canal to carry them into Tenochtitlan in order that they might reproduce there."[58]

As we envision the elaborately dressed human *teixiptla* of Chalchiuhtlicue standing at the edge of the newly built aqueduct and welcoming the water into the city and directing the flow through the aqueduct ("from now on you will follow your own course"), we witness the human *teixiptla*'s agency "disturbing the causal milieu," in Gell's words, making itself known through the construction of the aqueduct and the resultant change in Tenochtitlan's aquatic profile. This transfer of agency between deity and its *teixiptla* allows me to venture that the stone sculptures that dominate the known corpus of Mexica art were perceived to have a similar agency. In their ornament-filled surfaces, or evidence of ritual dressing, they share many of the same features that transformed human actors, such as rulers and priests, into deities. And the accounts of the feeding of the "idols" on the part of Spanish observers all point to sculptures as also animate beings, that is, possessing the same agency that both human performers and sacred architecture did—to the point that they could bring death. In the testimony offered in an idolatry trial of 1539, one Mateo revealed that his father, a confidant of Moteuczoma II, had been entrusted with an "idol," almost certainly the sacred bundle of Huitzilopochtli, to save during the war of conquest. This sacred figure was described and pictured to be little more than a bundle of cloth. Nonetheless, Mateo described his father as having "a bundled idol that he worshipped, very heavy, and that he never unwrapped it, just worshipped it, and that no noble would ever unwrap

it because of the reverence they had, saying that *whoever unwrapped it would die*" (italics mine).[59] Mateo's testimony revealed that inert objects, like the bundle, had the potential for powerful agency, like bringing death to the impious. Given the agency of these bundle-idols, as well as the evidence that the ritual actions of costumed *teixiptla* also had measurable effect in the world, it is not improbable that other monuments, ones sometimes treated as merely commemorative, possessed a similar ability to effect change in the spaces in which they were embedded, as we will see in the work commissioned by Ahuitzotl at the time of the completion of the aqueduct.

THE ACUECUEXATL STONE

In the same year that he completed the freshwater aqueduct, 1499, the emperor Ahuitzotl had a commemorative stone carved, and this work exists today in a fragmentary state—it is a long, rectangular monolith, once about 9.2 feet long but today measuring 5.4/5.6 feet long, 2 feet wide, and 1 foot deep (figures 3.7 and 3.8).[60] While about a third of the stone is missing, the relative cleanness of the cut, like taking a slice from a stick of butter, suggests that its destruction came about not as part of an idolatry campaign, as the surface imagery is untouched, but rather for pragmatic reasons, probably for colonial architectural use, when its iconography no longer mattered and the neatly cut stone could serve as a lintel or a doorstep. A number of scholars have discussed the Acuecuexatl stone and connected it to the building of the aqueduct, given that it is dated on the year of the aqueduct's completion: in a square cartouche one can see the glyph of 7 Reed, or 1499, clearly visible in the upper left of side B (see figure 3.8).[61] Despite its truncated state today, much of the iconography is visible on four of the six sides. The images on the two largest faces of the stone (sides A and B) are similar: a seated, cross-legged figure is engaged in ritual bloodletting from his ears. He is identified as Ahuitzotl on side B by the glyph carved right in front of his head, an *ahuitzotl* with a stream of water flowing down its back, an animal thought to have been a nutria or some small dog; on side A, this same glyph appears behind him, in the upper left corner of the sculpture. Behind Ahuitzotl on both sides is a serpent. On side A, the coiled serpent creates a dramatic backdrop to the penitential figure; on side B, the serpent is neatly confined to the space behind Ahuitzotl. On both sides, Ahuitzotl faces an altar, the central icon of the monument,

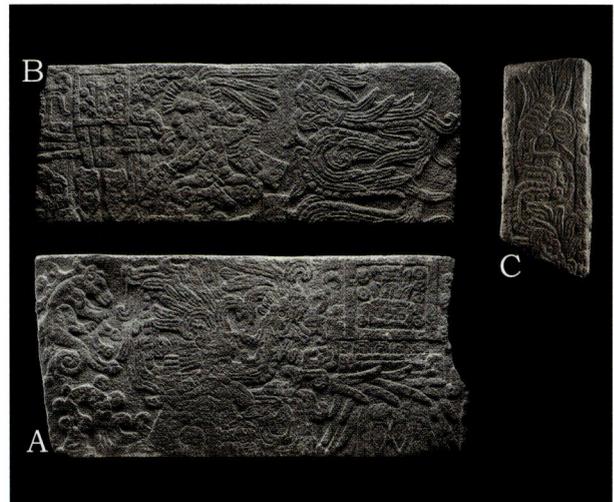

FIGURE 3.7. *Unknown creator, the Acuecuexatl stone, ca. 1499. Museo Nacional de Antropología, Mexico. Archivo Digitalización de las Colecciones Arqueológicas del Museo Nacional de Antropología.* CONACULTA-INAH-CANON. *Reproduction authorized by the Instituto Nacional de Antropología e Historia.*

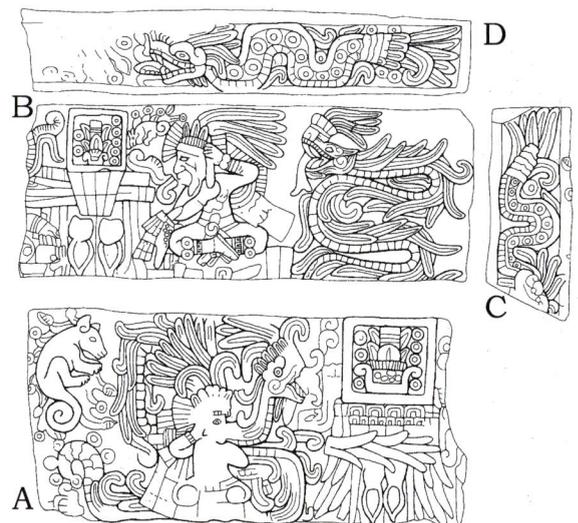

FIGURE 3.8. *Drawing of the Acuecuexatl stone, by Emily Umberger.*

along with the date glyph, which is set above it. Since Mexica sculpture has a tendency to be bilaterally symmetrical, we assume that an equivalent figure sat on the other side of the altar, also engaged in a ritual act.

The iconography shows us Ahuitzotl costumed as the *teixiptla* of Chalchiuhtlicue.[62] As William Barnes has noted, the Mexica ruler wears the pleated paper fan of the rain/water deities, the *amacuexpalli*, on the back of

his headdress (seen also in the Codex Borbonicus image); like the priest that Durán describes, he wears "a diadem made of white heron feathers," and on side B, the marking around his mouth may be the "liquid rubber" that stained Chalchiuhtlicue and her *teixiptla*. Also like the priest, he wears "strings of blue and green beads" on his wrists, as well as on his legs. In his perceptive work on the iconography of Mexica sculpture, Barnes has further identified the fan-and-flap back ornament as one worn by celebrants in the feast of Ochpanitztli, as well as the pouch hanging from his arm (visible on side B) as the turquoise-colored pouch held by Chalchiuhtlicue's *teixiptla* containing the blue-maize flour used for scattered offerings.[63]

Ahuitzotl's choice to show himself as the *teixiptla* of this water deity is unusual, because in other monuments, Mexica rulers dressed as martial figures, like Tezcatlipoca or Huitzilopochtli. He is shown on the stone piercing his ears with a maguey spine, one of the principal acts of consecration carried out by rulers. We cannot say what consecration is being effected by the offering—whether it is the final phase of Ahuitzotl's ritual transformation into a *teixiptla* or an offering made to complete the aqueduct. On side B of the stone, where more of the imagery is visible, the remains of another figure lie to the left of this altar, and Barnes has identified a set of hands pouring water from a jug, an action that Tlaloc impersonators frequently carry out to call forth the arrival of water.[64]

Durán's account tells us that the presence of the *teixiptla* of Chalchiuhtlicue at the opening of the aqueduct was to "welcome" the deity into the city, but also to control her behavior, her often-too-violent movement. This animate icon fell under the control that elaborately planned rituals imposed on the passage of time; her unpredictable movements became the measured steps of dance, which kept time with the rhythm of music, which made audible and measurable the flow of the minutes. The stone of Acuecuexatl presents us with a related scene, as we see Ahuitzotl dressed as Chalchiuhtlicue in an act of consecration. His actions seem to have a visible effect, measured by the imagery of the work. The imagery of the two sides of the stone is certainly very similar, with the same basic elements of penitent Ahuitzotl, central altar, and feathered serpent. That they appear to be distinct not only shows two hands at work, but suggests different moments and/or places, as if each side shows different moments in a longer ritual, with the events on side B happening first. The reason for the sequence follows from the iconography: while on side B is

a bundle of four maguey spines, used in ritual bloodletting, the central altar on side A features a *cuauhxicalli*, "eagle vessel," to receive those blood sacrifices after blood had been let. Reading the Acuecuexatl stone as a temporal sequence allows us to see the feathered serpent, a representation of the deity Quetzalcoatl, quiescent on side B, leaping out to fill the pictorial space on side A, as Ahuitzotl shrinks in size.[65] While feathered serpents are strongly associated with wind, on this monument they are also associated with water. On side B, the twisting feathered body forms a spiral at its center, looking very much like the whirlpool sign that was associated with Chalchiuhtlicue; on the A side, the tip of the serpent's tail bears round beads of jade, which also mark streams of water. The visible difference between the snakes seems to register the effect of Ahuitzotl's ritual action: in phase one, shown on side B, where the four maguey spines are still in place, suggesting the beginning of ritual activity, the serpent is contained in the right quadrant of the sculpture, whereas on side A, where the *cuauhxicalli* serves to collect the offered blood, the feathered serpent expands to fill much of the space, almost overwhelming the human figure in front of it. In other words, the sculpture shows us one of those "disturbances of the causal milieu," like the built aqueduct itself, revealing the effects of Ahuitzotl's ritual actions as the feathered serpent expands and springs into action.

The format of the narrowest face of the monument (side D in figure 3.8) is the same as that of the larger faces, with figures arranged symmetrically (presumably, given the loss of stone) around a central cult image. This central image is eroded, but enough can be made out of the figure to see the remains of a disk of water; it is a representation of a spring, similar to the way it is pictured in Durán's *Historia* (figure 3.6). Moving toward it is a water serpent carved in shallow relief, whose body is filled with the circular symbols for jade/water; another may have flanked the spring on the missing side, as well. Unlike the windy serpent of Quetzalcoatl of the lateral sides, this serpent is fit inside a constrained space, carefully defined by a carved frame of a few inches across—just as the snaking water was confined within the open aqueduct, its movement visible on its surface, as in this stone. A similarly framed jade-filled serpent is carved on the end of the stone, side C. The four distinct but related faces suggest that the stone was meant to be read as a narrative, where cosmic events are set into motion by the sacrifices performed by Ahuitzotl, unleashing the feathered serpent. The top and end surfaces show

us the watery serpent, contained on the narrowest sides, the proper behavior of the canalized water.

The physical relationship of this work to the 1499 aqueduct has been somewhat obscured by its vagrant history. When the historian César Lizardi Ramos became aware of its existence, it was in the northeast corner of the Botanical Garden of Chapultepec, where it had been since at least 1933, according to one of his informants. But this was not its original site, because when it was originally identified as a Mexica work, in 1924, it was being used as the lintel of the city's slaughterhouse, which sat on the Plaza San Lucas, a site adjacent to the ancient aqueduct from Acuecuexco (see figure 1.10).[66] A long rectangular prism, it was originally the shape and size appropriate for an architectural element. Its iconography makes it clear that it was set horizontally, rather than as an upright post. Since places like Chapultepec reveal that there were ceremonial buildings adjacent to aqueducts, this work could have been set as a ceremonial lintel or at the frieze level or perhaps served as a cornice of the structure built to contain the water coming off the aqueduct.[67]

The placement of this elaborately worked sculpture, probably set at or near the aqueduct, commemorates the acts of auto sacrifice that Mexica tlatoani engaged in at such moments of building consecration; by costuming themselves as the teixiptla of a deity, they were transformed into this being and as her, had some control over her behavior. The serpent on the top of the monument, its body marked with jade, whose color and transparency were associated with water, evokes the water in the aqueduct itself. The verdant feathers that adorn the serpent on its side signify the new growth of green maize shoots. The active ruler, who is either adjacent to or dominant next to the feathered serpent, controls these unruly natural forces through his own action of self-sacrifice. Thus, the sculpture does not present us with the portrait of Ahuitzotl, but makes clear that we are witnessing Ahuitzotl-as-Chalchiuhtlicue. The evanescent performance of the teixiptla becomes permanent, as if to guarantee that the effects of ritual action set into a particular space will endure as long as the stone itself.

Despite the anticipatory representation of the water serpents on the Acuecuexatl stone, Ahuitzotl's engineers failed to foresee the quantity of the flow of water, or its effects. So much water came through the aqueduct, Durán reports, that after forty days the laguna that captured the aqueduct's overflow was swollen, and the city began to flood with the freshwater welling up from the surrounding laguna. Ahuitzotl, in desperation, had the strong mortar dams that had been so carefully built around the spring destroyed and allowed the water to flow back into its normal course. To stop the backwash, he had a long dike built along the eastern littoral of the city, linking the causeways of Tepeyacac and Ixtapalapa, the final link of the inner dike to protect the city, but to no avail (see figure 2.7). "The more they tried to stop the water, the more damage it caused." The surging Chalchiuhtlicue refused to be restrained.[68]

In response, Ahuitzotl sent sculptors to the city of Tula, a sacred city in the Valley of Mexico, to carve a shallow relief on a rock face overlooking the site, showing Quetzalcoatl—or Ahuitzotl costumed as this deity supplicating himself in front of the deity Chalchiuhtlicue—requesting to have the overabundant waters cease.[69] Carving deity images into semimodulated surfaces of live rock on hills has other parallels in the valley, and in all cases, the presence of these sculptures, both in the iconography and in the ritual action they registered, imbued each place with new meanings. Understanding the Mexica ideas of teotl and teixiptla and the particular agency that they possessed allows us to better understand how the Mexica themselves understood these transfers of meaning to happen between the different spheres of space.

FRESHWATER AND MOTEUCZOMA

Ahuitzotl's reign was tarnished by his failure to win the battle with water; he died in 1502, shortly after the fiasco of the aqueduct. His successor, his nephew Moteuczoma II, had thus witnessed firsthand his uncle's humiliating battle with the forces of freshwater. In one of the early monuments of Moteuczoma's reign, the Teocalli of Sacred Warfare, there is no supplication to the powerful water deity. Instead, another visual strategy was employed in commemorating Chalchiuhtlicue's defeat in the iconography on its back (see figures 2.14 and 2.15). Again, its placement would have been important, in both taking meaning from and lending meaning to its spatial context. The throne was discovered at the end of July 1926 in the southwest corner of the Palacio Nacional, under a small projecting spur of the south tower, quite close to two other major monuments unearthed in 1790 in the adjacent southeast corner of the Plaza Mayor, the Calendar Stone and the massive sculpture of Coatlicue. Since the Palacio Nacional was built on the foundations of the palace of Moteuczoma and the throne shows very little surface damage through dragging

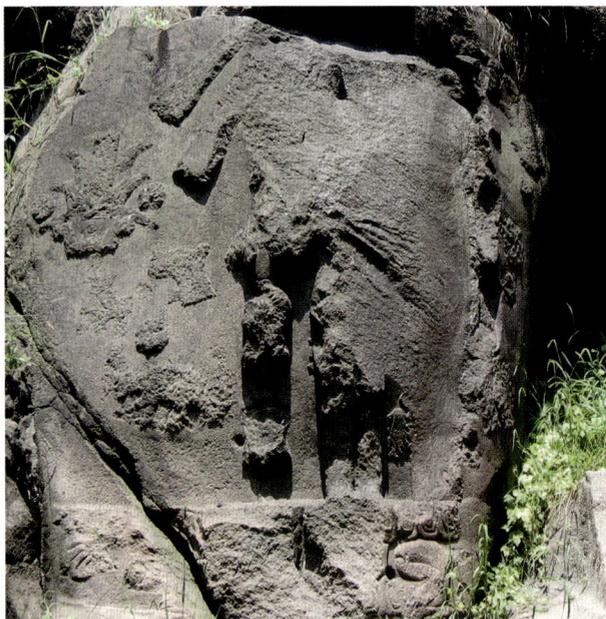

FIGURE 3.9. *Unknown creator, portrait of Moteuczoma II, ca. 1507, Chapultepec Park, Mexico City. Photograph by Patrick Hajovsky. Reproduction authorized by the Instituto Nacional de Antropología e Historia.*

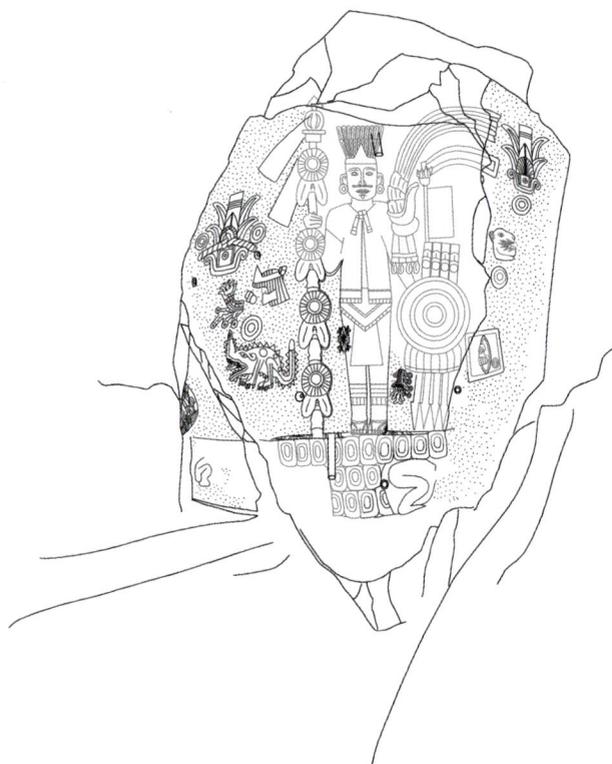

FIGURE 3.10. *Reconstruction drawing of the portrait of Moteuczoma II, by Patrick Hajovsky.*

or defacement, it is probable that it was buried close to where it was originally set.[70] Running along the south side of the palace, from west to east, was the main canal that ran through the Mexica city, known as the *acequia real* in the colonial period. Given the careful placement of Mexica sculpture in other sites in Tenochtitlan, the Teocalli, with its image of the tamed Chalchiuhtlicue, may have been meant to work in tandem with the adjacent canal. If this reconstructed placement near a canal is correct, it would underscore the meaning of the iconography, which announces that the foundation was made possible by the sacrifice and the visual taming of the deity of the lake.

If we conceive of the Teocalli of Sacred Warfare as a victory monument over water, Moteuczoma II would carry the same idea into the iconography of his portrait statue. It was carved on the flanks of the hill of Chalpultepec like the earlier portrait of his namesake, Moteuczoma I, marking his relation to that reliable source of freshwater for the city, upon which the Mexica continued to depend after the disaster of the Acuecuexco aqueduct. Today, this portrait survives but in damaged form, cut into the live rock some 110 yards to the north of the water tanks that supplied the aqueduct system (figure 3.9).[71] A reconstruction by the art historian Patrick Hajovsky is reproduced in figure 3.10. To create it, the sculptors did little to smooth the escarpment, working with the irregular contours of the rock face. Moteuczoma II stands on a low platform, defined by a strong horizontal step that runs along the bottom of the work. Within the platform under the portrait on the far right, the distinctive back legs of a grasshopper are visible, with their particular back-turned foot also seen in other renderings of grasshoppers (see figure 2.4), to show that the figure "stands" upon Chapultepec. Enough of the image remains in the rock face to allow one to discern the legs of the almost life-sized ruler, frontal to the viewer, and costume elements, particularly the ruler's distinctive staff and the large plumed headdress that once decorated his head. Hajovsky's work shows the collection of symbols carved in the rock around the ruler's figure, which, following his and other excellent iconographical studies, reveal that Moteuczoma costumed himself not as Chalchiuhtlicue, but as Xipe Totec, a deity of springtime and regeneration; still clearly visible are Xipe's rosette with four notched ribbons that Moteuczoma wears on his right thigh, and his staff with its four rosettes. This was not the first time Moteuczoma costumed himself as Xipe; he did the same after a victory over neighboring Toluca in 1501, and garbing himself as

military victor would be entirely consistent with the earlier establishment of Chapultepec as the site where the victorious *huei tlatoani* was welcomed back into the city.[72] Xipe is an ancient deity, best known for the gruesome costume of flayed skin of his *teixiptla*. Worn over days, the skin would split off its wearer like the splitting of the outer skin of a seed before sprouting, a signifier of Xipe's power to make things grow—he was celebrated in important springtime rituals. The Mexica rulers connected themselves to this life force by making offerings at his temple at Yopico in Moyotlan as the last phase of their coronation rituals.[73]

In addition to being a freshwater source, Chapultepec was the last stopping point of the Mexica migration before the founding of Tenochtitlan, the end of one chapter of the Mexica history of peregrination and the beginning of the next. By placing his image at the site, Moteuczoma II conveyed his crucial ability to bridge liminal temporal periods, as he did with the celebration of New Fire in 1507, when a new era was ushered in. He thus further inflected the place with traces of his own presence, now known through the surviving half-legible sculpture. At the same time, he was able to draw on age-old conceptions of the ruler as the controller and protector of the variable and dangerous forces of nature to give added meaning to the site. Near the waterworks, archeologists found the remains of the trunks of two great *ahuehuetl* (cypress) trees, which flanked the aqueduct (figure 3.5). Only yards away still stands the trunk of another great *ahuehuetl* tree, which survived into the twentieth century and would have been a large tree in the fifteenth. In formal speeches, the ruler was likened to a great tree; consider the oration that Nezahualcoyotl is believed to have delivered to Moteuczoma: "You well know, great prince, that all your subjects, nobles as well as the common people, are under your shade for you have been planted here like a great cedar tree under which men wish to rest in order to take pleasure in the freshness of your friendship and love."[74] Thus in landscape works like Chapultepec, the ruler reiterated his control over the natural world, linking his presence to charged sites through indelible sculptural works as well as natural features.

CONCLUSION

The control of the surrounding environment, particularly the flow of water, preoccupied Mexica rulers in fifteenth-century Tenochtitlan. The building of great dikes, causeways, and aqueducts was parallel to the military campaigns through which the Mexica expanded the reach of their tributary empire beyond the valley, since the freshwater system that provisioned the growing city of Tenochtitlan was of equal importance. In certain monuments created under Ahuitzotl and Moteuczoma II, these rulers commissioned representations of themselves that showed their control over the surrounding environment, embedding the ideologies of ruler as master of the aquatic environment in lived spaces of the city and its environs. Our exploration of the ideas of *teotl*, which allowed inanimate forces like the flow of water to be accorded an agency, particularly agency within the spaces of the city, and the *teixiptla*, wherein costumed priests and rulers could take on the identity of deities, has allowed us to better understand the way the Mexica themselves understood the three spheres of space to inflect each other. The pluralistic nature of the *teixiptla*—which could be animate performers or stone bundles—has led us to posit that sculptural works could also exert some of *teotl*'s efficacious agency, particularly those sculptures set in important sites, like the entry of the Acuecuexco aqueduct into the city or the hill of Chapultepec.

The potent combination of performance and artwork marked key sites within the city of Tenochtitlan, imbuing spaces themselves with certain valences, particularly those of the ruler's efficacious actions of environmental control. When the Spanish entered Tenochtitlan from the south, they saw Moteuczoma II gloriously arrayed and surrounded by a nimbus of green quetzal feathers, but had little idea that the ground beneath their feet was the great causeway of Ixtapalapa, that first successful attempt of the Mexica rulers of Tenochtitlan to control the watery environment, built by Moteuczoma's great-grandfather Itzcoatl. Its construction had been made possible by the defeat of Xochimilco, one of the *chinampa*-rich cities to the south, whose conquered peoples provided the labor. Nor did they understand that at this moment, Moteuczoma showed himself as master of distant territories that were the sources of his feathers and his gold, as well as controller of the immediate environment by the massive earthwork that stretched beneath his feet. At that moment, his power—and that of the city that he had helped shape—was at its height.

CHAPTER 4

The City in the Conquest's Wake

Only twenty months after Moteuczoma II paraded down the causeway of Ixtapalapa in the regalia that conveyed the sweep of his imperial power, in the city over which he once ruled, corpses littered the streets and choked the fitful canals, while the doorways of empty houses looked out over abandoned *chinampas* and an overpowering stench filled the once-clear air. The city the Mexica had so carefully built out of the lake was nearly unrecognizable and Moteuczoma himself dead at the hands of an assassin.

The apocalypse began in 1520, as the Spaniards turned on their Mexica hosts, who repelled them from the city midyear. After regrouping and massing their indigenous allies, the Spaniards returned to the Valley of Mexico and inaugurated their deadly siege of the city on May 13, 1521, with Cristóbal de Olid breaking the water pipes that supplied Tenochtitlan from Chapultepec. Three months later to the day, Cuauhtemoc, Moteuczoma's successor, surrendered.[1] In the days following, the joined cities of Tenochtitlan and Tlatelolco were at first like any war booty, up for grabs by the looting armies, who had their way with their women and any remaining wealth. The Anales de Tlatelolco records: "Once the lords [including Cuauhtemoc] were imprisoned, the people began to leave, they went looking for a place to escape, they had hardly a rag to tie around their waist. But the Christians looked everywhere, ripping the clothes off women to search between their legs, looking in their ears, in their mouths and in their hair."[2] The victorious soldiers soon left—there was nothing to eat in the city anyway—and Cuauhtemoc was allowed to give the command to evacuate the city, so flooding out along the

causeways were the surviving Mexica who could muster some desperate connection to relatives or contacts in the lakeside cities, where there was water and the possibility of a daily tortilla or bowl of gruel. Bernal Díaz del Castillo, who witnessed the scene, wrote, "During three days and nights they never ceased streaming out and all three causeways were crowded with men, women and children, so thin, yellow, dirty and stinking that it was pitiful to see them."[3] A native account follows that trail of tears along the causeways: "Thus was the manner in which the common people left, when they scattered among the surrounding cities, when they went for shelter in corners and between houses."[4] And in the once-glorious city, only a skeleton crew remained.

Many histories of the Conquest close here, with the scene of the defeated and vacant Tenochtitlan. They thereby contribute to the myth of its death.[5] And subsequent historical representations have perpetuated this myth by zeroing in on the initial settlement by conquistadores. It began as Hernando Cortés stood on the ruined grounds of the ceremonial precinct of the Mexica capital in 1522 and began to parcel out lands to his men-at-arms. By 1524, the streets of the *traza* (grid plan) were being laid out by Alonso García Bravo (one of the conquistadores).[6] The rectilinear streets that composed the traza began to extend outward from the center of the former sacred ceremonial precinct, and the pyramids and other works of monumental architecture were quickly decapitated of their topmost shrines, in time-honored fashion. Consider figure 4.1, from George Kubler's influential *Mexican Architecture*

of the Sixteenth Century. The map features the streets around the Plaza Mayor, where the Spanish population clustered. An imaginary line is set on the map, thereby delimiting an interior of the city, with streets laid out under Spanish auspices, and an exterior, where unplanned (and largely indigenous) zones were to be found. In contrast, figure 4.2 offers a more complete view of the city, showing all the lands that stretched to the littoral of the island, and includes the city's indigenous neighborhoods, the four *altepeme* of Moyotlan, Teopan, Atzacoalco, and Cuepopan. These were oriented to the intercardinal directions, and were bordered by the once-independent *altepetl* of Tlatelolco. After the Conquest, names of Catholic patron saints were added to the Nahuatl names, and the *altepeme* became known as San Juan Moyotlan, San Pablo Teopan, San Sebastián Atzacoalco, and Santa María Cuepopan, with Santiago Tlatelolco to the north. However, as social and spatial entities, these *altepeme* endured across time.

In this chapter, I examine the rebuilding of the city in the 1520s and 1530s, picking up the thread of the city's history in the wake of the wars of conquest. As a counter to urban histories emphasizing the role of a small group of Spanish residents, I focus on the role of its indigenous residents to reveal that, in its built environment, the post-Conquest island shared essential features with pre-Conquest Tenochtitlan. Certainly, new monumental architecture, like the new palaces that would be built for Cortés and other conquistadores on and around the Plaza Mayor, marked Spanish presences and employed European architectural vocabularies. It was the construction of these works—and the wanton deaths that resulted—that the Franciscan friar Motolinia would call the "seventh great plague" to visit the city's indigenous people, demanding more laborers than the great Temple of Jerusalem.[7] However labor intensive and physically impressive they may have been, these constructions occupied only a small area of the city. In contrast, the Mexica still occupied large expanses of the city. The architectural masses of the Spanish mansions and Catholic churches that were built in the 1520s and 1530s were certainly important to the nature of the city, but so were its great spatial axes and voids—plazas, causeways, and the great markets, or *tianguises* (the Hispanicization of the Nahuatl *tianquiztli*). Established in the pre-Hispanic period, they were extensive, and these lived spaces were primarily used by the city's Mexica residents and shaped by their daily, and ephemeral, routines.

Central to my reinterpretation of the space of the city

FIGURE 4.1. *The new Spanish* traza, *or grid plan, in Mexico City, from George Kubler,* Mexican Architecture of the Sixteenth Century *(New Haven: Yale University Press, 1948), figure 17, facing p. 72. Reproduced courtesy of the Kubler family.*

are the practices that created habitable spaces and endowed them with meaning, as well as the continuities of the role of indigenous elites in shaping the city's spaces. By the mid-1520s, this indigenous city, forming a ring around its new Spanish center, had its own indigenous government, called a *cabildo*, like its Spanish counterpart. It was headed not by a *tlatoani*, but by a *gobernador*, who was supported by tribute goods and the labor of *altepetl* residents, as before the Conquest. And this *gobernador* and his *cabildo* oversaw a city built by indigenous laborers, who employed time-tested indigenous technologies in aquatic engineering and basic principles of architecture in the soft-soiled city; it was indigenous agriculture that, in these early years, fed the city; and most of all, it was indigenous people whose daily, unrecorded actions made it a city. If one were to walk through the streets of the city's southwest quadrant of Moyotlan in 1530, not even a decade after the Conquest, one could enter a great market, named for an indigenous lord, where hundreds of women sellers, all speaking Nahuatl, would be

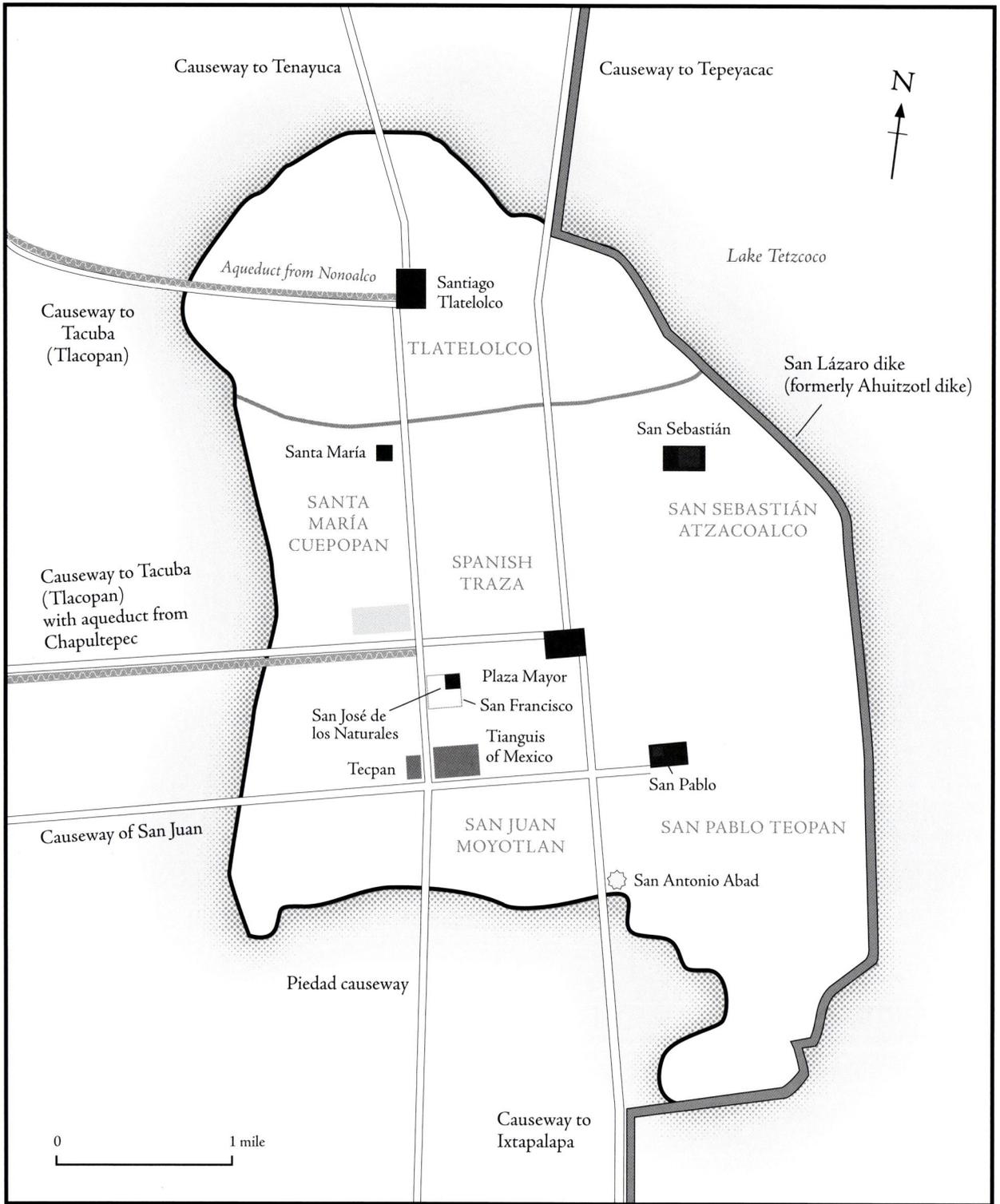

FIGURE 4.2. *Map of sixteenth-century Mexico City, ca. 1556, by Olga Vanegas.*

selling maize dough, cotton mantles, and foaming drinks, and demanding cacao beans in payment—a scene very similar to a city market there in 1500.

This is not to say that all was unchanged. In the latter part of this chapter, I look at the ways that in two important symbolic registers, the civic celebration and place-names, the new Spanish ruling class was asserting its vision of the city onto its spaces. And in the same way that we go about our lives in the midst of long-term ecological changes, so too did the residents of Mexico City. So as not to lose sight of the ways in which the valley was undergoing slow and irretrievable changes, I begin by surveying some of these larger environmental and demographic shifts.

WATERWORKS AND THE CONQUEST

The fall of Tenochtitlan was precipitated by the uprising of longtime enemies and resentful vassal states who joined with the Spaniards and waged a deadly war against the island-bound Mexica; for many of the warriors, it seemed like just another cycle in the indigenous power plays that shifted power from one *altepetl* to the next, perhaps not much different from the Triple Alliance's defeat of Azcapotzalco a century before. Few could have foreseen the apocalyptic effects of the epidemic diseases that were unleashed by previously unknown Old World pathogens and that began their deadly creep through the unsuspecting population even before the arrival of the conquistadores. Epidemic diseases would reduce the New World populations in 1600 to one tenth of what they had been in 1500.[8] In addition to carrying deadly pathogens, the Spanish unwittingly put into motion a dramatic and devastating long-term realignment of the delicate balance between the city and the lake, the kind of *longue durée* change impossible to register in the moment.

While Cortés initially wrote admiringly of the city in his letters to Charles V, his attitude and those of his fellow conquistadores would change dramatically when they attempted to capture the watery city. The surrounding lake functioned like a great moat protecting the island city, and the bridges spanning the breaks in the causeways, which allowed the flow of water from one part of the system to another, could be removed to further isolate the island capital. When the Spaniards did battle within the city, as during the Noche Triste on June 30, 1520, when Mexica warriors ejected them, they found that their enemies used the urban canals as transport routes for canoes filled with

as many as sixty armed warriors each. Slogging across the canals slowed the conquistadores in their retreat, and when, exhausted, they fled on foot along the causeways, those raised roads served to organize them into a neat firing line for the Mexica sharpshooting archers gathered alongside in the lake in their canoes. Small wonder that they emerged from the war with little appreciation of the role that these causeways and dikes played in protecting the city from the scourges of floods.

And once the conquistadores understood it, Tenochtitlan's fragile interdependence with the surrounding waters helped deliver it to its enemies. After Cortés had regrouped and rebuilt his army, he reentered the valley and laid siege to the city, beginning in May of 1521. Key to the strategy were the city's vital aqueducts supplying Tenochtitlan with freshwater from the springs of Chapultepec. They were cut on the thirteenth of that month. The Mexica were left dependent upon water from springs within the city, which were soon exhausted, and then only salty groundwater remained to drink. And although the city's surrounding lake made it quite defensible from soldiers on foot, it proved more vulnerable once Cortés could use brigantines to carry troops and munitions. The ships were assembled at Tetzcoco, and in order for them to reach Tenochtitlan, the great dike of Nezahualcoyotl needed to be breached, which allowed the brigantines to travel from Tetzcoco to reach the eastern shores of the city; to approach the city from the south, they would also have needed to breach the dike of Ahuitzotl (see figure 2.7). The effect of the broken dikes on the delicate equilibrium of the system was not immediately apparent. But in the years after the Conquest, Spanish observers noticed a dramatic (and to them, inexplicable) drop in lake levels. This was partially the result of a long drought that gripped the valley in the two decades after the Conquest, and it also seems that the once carefully husbanded freshwater in the Laguna of Mexico resumed its natural flow into the lower-lying Lake Tetzcoco.[9] While water-suspicious Spaniards welcomed less water around Mexico City, perceiving it to be less likely to flood, the opposite was true. Their failure to repair the dike of Nezahualcoyotl meant that the eastern side of the city was vulnerable to salty backflows from Lake Tetzcoco, as was the once-freshwater laguna; the Spanish inclination to protect the city by bottling up the southern lake system meant that crucial *chinampa* zones were imperiled. The long-term effects of this distrust of water will be picked up in chapter 9.

In the days after their victory, Spanish conquerors withdrew with their plunder to the southern city of Coyoacan, where Cortés had set himself up in a palace, along with a bevy of Mexica nobles held captive, among them Cuauhtemoc, who had ordered the evacuation of the city. At first, Cortés seemed to want nothing more than to have the city disappear into the lake out of which it had been born, even declaring that any indigenous resident moving back would be executed, setting up a gallows in the main plaza for the task. The history of Tenochtitlan might have ended here; many of Cortés's soldiers argued that Coyoacan was a better place to build the capital, a healthy, defensible spot, with drainage.[10] But Cortés, perhaps still enchanted by his memories of the glittering capital, decided that Tenochtitlan would rise again, this time as *his* city.[11]

A map of the center of the city created around 1563 would seem to record the triumph of Cortés's ambition some four decades later (figure 4.3). It shows us the heart of the city, the Plaza Mayor, once dominated by the great twin temples dedicated to Tlaloc and Huitzilopochtli, but no trace of that past remains. Instead, we see entirely new architecture modeled on European examples. To the east, at the bottom right side of the map, the palaces of Moteuczoma II have been replaced by the royal palace, a secondhand palace bought from the Cortés family in 1562; to the west, on the left side of the map, where the palaces of Axayacatl once stood, are the fortresslike residences of the Cortés family. They overwhelm the rather diminutive building on the north side of the plaza, roughly in the center of the map, labeled as "iglesia mayor" (main church), also known as the Cathedral of Mexico. It served the city's Spanish population and was the seat of the Bishop of Mexico, with the first bishop, Juan de Zumárraga, arriving in 1534. After the Conquest, the Spanish population was small in relation to the indigenous population of the city, but around the time the map was created in the 1560s, it had grown to about 3,000 *vecinos* (property-owning residents who were recognized by the town council, almost

FIGURE 4.3. *Map of the Plaza Mayor of Mexico City, ca. 1563. Top is oriented to the north. Spain, Ministerio de Educación, Cultura y Deporte, Archivo General de Indias, MP-Mexico, 3.*

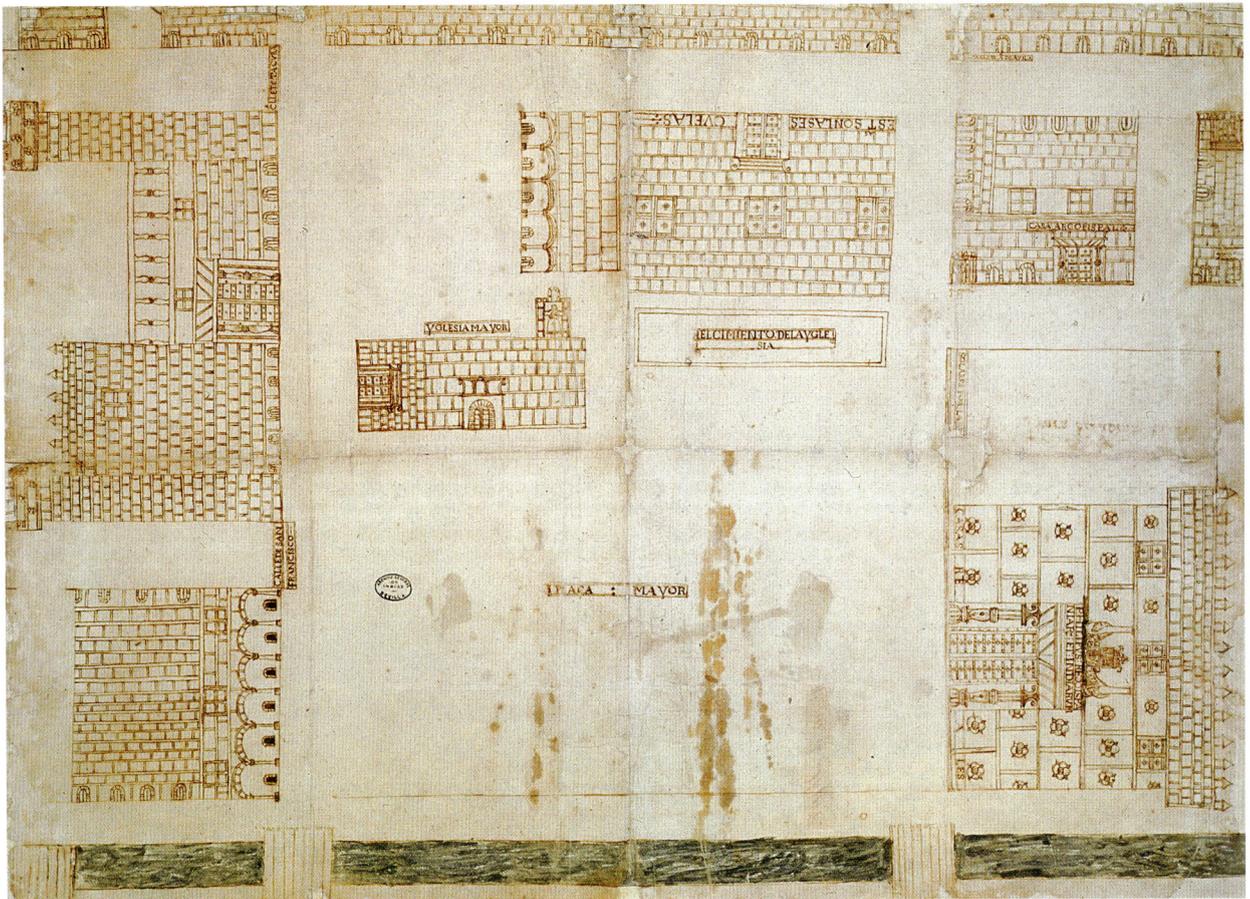

all men of Spanish descent) and plans for a new cathedral building were being drawn up, a building that would finally be dedicated in 1656.[12] Not seen on this map is the *ayuntamiento*, "city hall," where the Spanish town council, or *cabildo*, of the city met. It rose behind the canal at the bottom edge; but visible are the arcaded spaces, the *portales* along the plaza's west side that this *cabildo* rented out for income. Stretching out from the large plaza at the center are straight streets, the grid plan that the city follows today. As this map shows it, the erasure of the indigenous city and the triumph of the Spanish city are complete.

THE SURVIVAL OF THE INDIGENOUS CITY

But spaces have a way of refusing to give up their pasts. The brash new palaces set at the upper left and lower right of this map depended upon the solid foundations of the Mexica palaces beneath them to bear up the weight of their heavy stone towers and cornices. Buried in the foundation of the royal palace at lower right, close to the canal that runs across the bottom of the map, the Teocalli of Sacred Warfare rested, facedown, waiting for its rediscovery seven indigenous centuries, or 364 years, later. The canal is empty of canoes in this rendering, but it would have been filled by indigenous boats trafficking goods around the city. If we were to step into one of them and ask the oarsmen to take us to the outskirts of the city, perhaps heading to the northwest, we would find ourselves in a very different space.

It would look something like the map reproduced in figure 4.4, which is the Plano Parcial de la Ciudad de México, one of the most remarkable sixteenth-century maps from the valley, one perhaps made in the city or its immediate environs around 1565, that is, two years after the Plaza Mayor map (figure 4.3).[13] It shows a great expanse of productive *chinampas*, the rectangular plots separated by a grid of canals. We see almost no trace of Spanish authority here; instead, the right edge of the map is marked by a line of successive indigenous rulers, beginning with Itzcoatl (r. 1427–1440), that run from bottom to top. As reproduced in figure 4.5, the list appears in two details, one from the map's lower part on the left, on which are seen (A) Itzcoatl, (B) Moteuczoma I, (C) Axayacatl (effaced), (D) Moteuczoma I (second appearance), (E) Ahuitzotl, and (F) Moteuczoma II; at right are (G) Cuitlahua and (H) Cuauhtemoc. Notably, the list does not end with Moteuczoma II, or even Cuauhtemoc, the

rulers who died under Cortés, but continues upward to include the Mexica elite who were named as *gobernadores* of the indigenous city after the Conquest: (I) don Pablo Xochiquentzin (r. 1530–1536), (J) don Diego de Alvarado Huanitzin (r. 1537/1538–1541), (K) don Diego de San Francisco Tehuetzquititzin (r. 1541–1554), (L) don Esteban de Guzmán (r. 1554–1557), (M) don Cristóbal de Guzmán Cecetzin (r. 1557–1562), and (N) don Luis de Santa María Cipactzin (r. 1563–1565). Omitted on this map are don Juan Velázquez Tlacotzin, who was named *gobernador* in 1524 but died shortly thereafter, and don Andrés de Tapia Motelchiuhtzin, who ruled 1526–1530. The presence of this lineage suggests that the map may have been used as documentary support in the fierce battles waged by the indigenous rulers of the city to hold on to tributary land in and around the city. The role of this elite will concern us in the next chapters.

What is remarkable about the work is how few marks of Spanish presence are to be found on the larger landscape depicted on the map some forty years after the Conquest. The map's location has yet to be securely determined, but it shows some expanse of the island, or an area that pre-Hispanic Tenochtitlan possessed near the opposite littoral of the lake. Other than a church glossed as "S. María," we see acre upon acre of *chinampas*, those highly productive plots, each one labeled with the pictographic name of its owner and a symbol for a house, with great diagonal canals cutting through the space, feeding the smaller arteries between the fertile plots. A total of over four hundred plots spread out over the map's large surface.

If the 1564 map of the Plaza Mayor shows us one view of the city, the Plano Parcial de la Ciudad de México shows us the region's other face: Nahuatl-speaking agriculturists living in organized communities under the control of their traditional lords in a landscape carefully created by the harnessing of water. It reveals an ordered and (it seems) fully functioning indigenous community and impels us to construct a bridge between this image and that of the chaos and destruction of forty years earlier. What really needed to happen to get the city to function again? Who were the key agents in the process? The act of laying the streets out was merely marking lines on the ground, but getting a city—a vast collective of people as well as a particular geographic space—to function in the immediate wake of the war was another matter altogether.

Because after the war was over, the city's evacuated residents did come back. The city's population has been

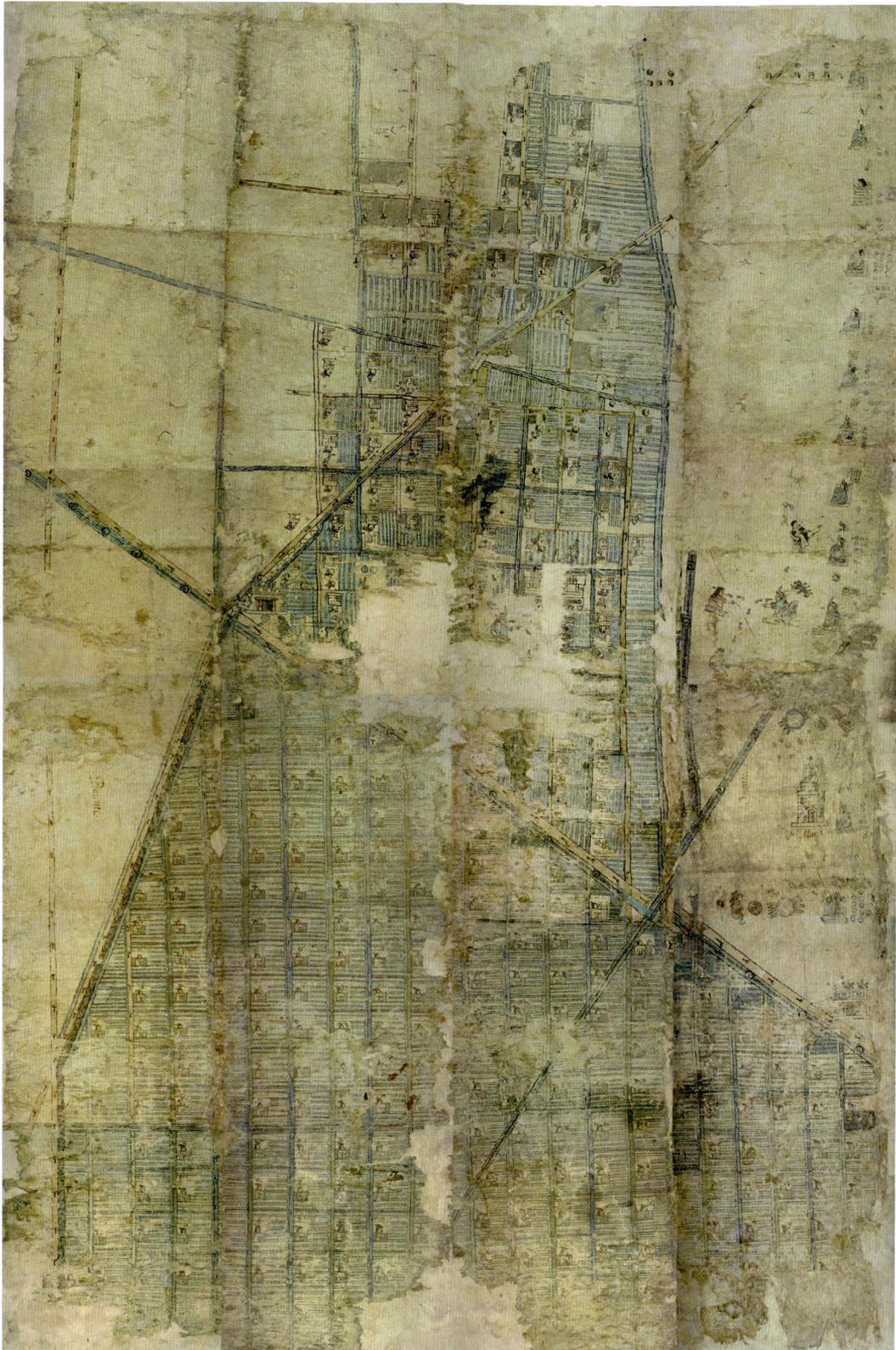

FIGURE 4.4. *Unknown creator, Plano Parcial de la Ciudad de México, ca. 1565. Biblioteca Nacional de Antropología e Historia, Mexico. Reproduction authorized by the Instituto Nacional de Antropología e Historia.*

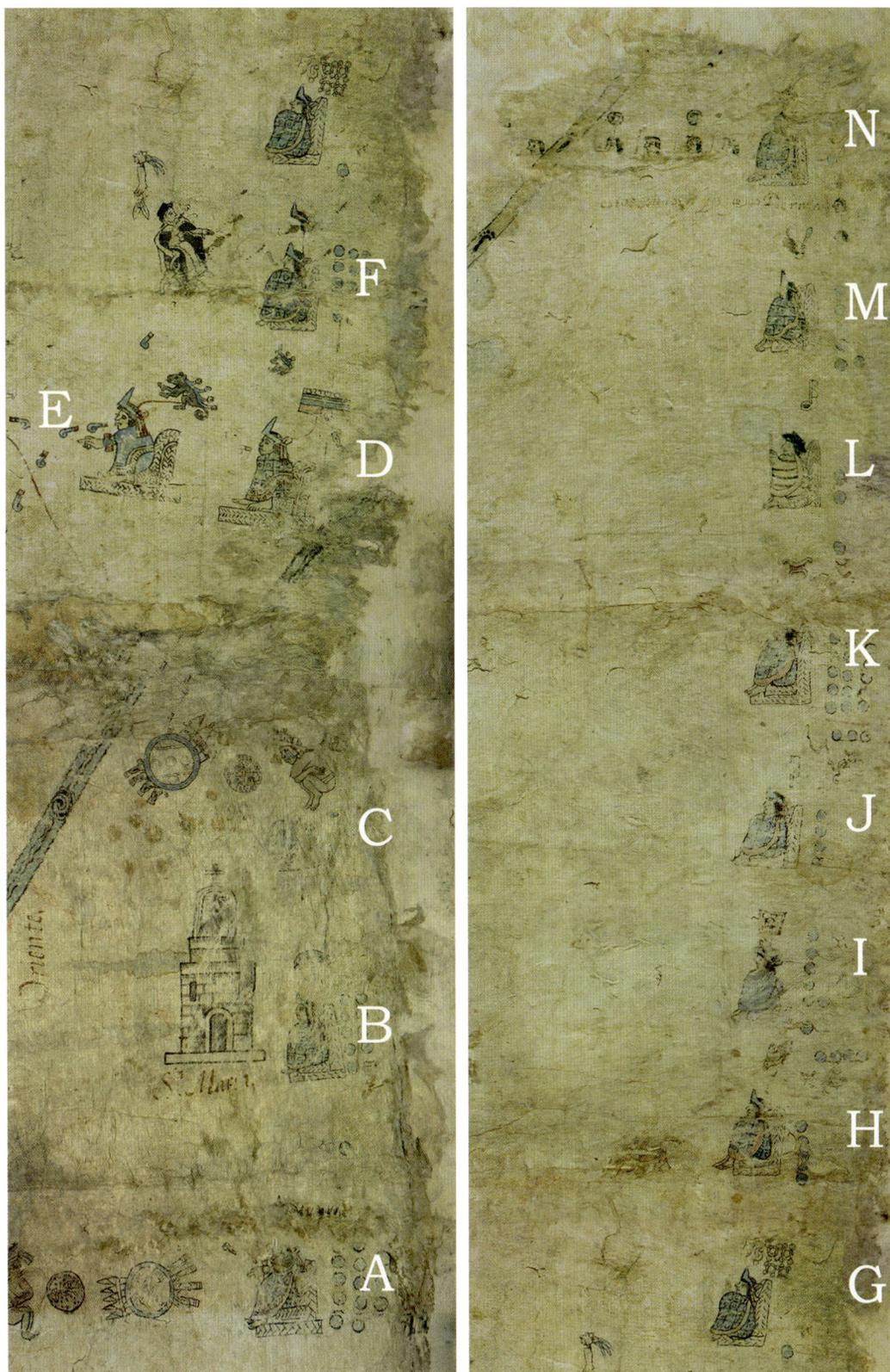

FIGURE 4.5. *Unknown creator, rulers of Tenochtitlan, two details of right side, lower part at left, upper part at right, Plano Parcial de la Ciudad de México, ca. 1565. Biblioteca Nacional de Antropología e Historia, Mexico. Reproduction authorized by the Instituto Nacional de Antropología e Historia.*

estimated at 150,000 people before the Conquest, and we have no very reliable census figures for the city until the 1560s, when the indigenous population was about 75,000.[14] Taking into account the effect of the deadly epidemic of 1545–1548, the city may have had more than 100,000 indigenous people in the years after the Conquest. And while the residents grew maize, squash, and greens in backyard plots, Mexico City was not a city that could feed itself, nor had been the earlier Tenochtitlan; it depended on the agricultural products brought in from outside, many of them coming in from tributary zones around the southern lake, the heart of the *chinampa* zone. The system of urban distribution had two keys: the first was a functioning canal system to transport goods, particularly from the south, and the second was an urban marketplace for the traffic of locally manufactured products, like the ceramic vessels and woven mats of everyday use, and foodstuffs from both within the city and outside of it.

Markets, in short, were essential to the survival of the city. While it is Tlatelolco's pre-Hispanic market that is often written about, Tenochtitlan had one of equal size.[15] The markets of Tenochtitlan and Tlatelolco were marvelous places, and their size and the wealth of the goods in them were riveting to early Spanish observers. Cortés's biographer Francisco López de Gómara, after noting that Tlatelolco had a large market, goes on to describe the market of Tenochtitlan, which after the Conquest was known as the Tianguis of Mexico:

> The marketplace of Mexico is wide and long, and surrounded on all sides by an arcade; so large is it, indeed, that it will hold seventy thousand or even one hundred thousand people who go about buying and selling, for it is, so to speak, the capital of the whole country, to which people come, not only from the vicinity, but from farther off.

After hundreds more words of description, López de Gómara finally concludes, "I should never finish if I were to list all the things they offer for sale."[16] The markets were first and foremost distribution points for foodstuffs and quotidian items like building materials and fuel, but we should also be aware of the quantities of exotic goods being brought into them. Bernal Díaz lists the "skins of tigers and lions, of otters and jackals"; Cortés describes the "ornaments of gold and silver, lead, brass, copper, tin, stones, shells, bones and feathers . . . [and] as many colors for painters as may be found in Spain and in excellent hues."[17] Bernardino

de Sahagún's Florentine Codex, created by native scribes, or *tlacuiloque*, interested in such matters, provides an even larger list of the *tlapalli*, or different colors of pigment, that were available to them. The codex sets the exotic pigments like *xochipalli* and *achiotl*, pigments from "the hot lands," into lists alongside *tlilli*, local carbon black, and *tecozehuitl*, ochre or yellow stone, beginning with pure pigments and then moving on to composite pigments, offering a conceptual framework for categorizing the known and absorb the new.[18] Markets in the city were similar, highly structured and ordered spaces that provided the framework and the opportunity for the encounter with new and often exotic goods. For such reasons, markets are now appreciated for their role in the formation and transformation of visual and material cultures.

This market of Mexico in the years right after the Conquest has escaped the attention of many historians of the city, but it helps us understand how the early city came to be rebuilt. Before the Conquest, as we will see, Tenochtitlan's great market sat in the southwestern quadrant of the city, accessible from the southern lakes via canals coming in from the south, as well as the causeway of Ixtapalapa by foot. But this market was abandoned during the Conquest, and during the rebuilding of the city a new market was set up on the western side of the city, right off the causeway from Tacuba, the city's main artery, allowing direct access by foot traffic along that causeway in a zone that coincides with today's Alameda park. Freshwater, an essential commodity in the city, reached this market directly, as the aqueduct from Chapultepec, newly restored after the Conquest and running along the causeway from Tlacopan, later Tacuba, reached here.[19] Boat traffic may have reached it via the western Laguna of Mexico.

The early market appears in a number of the records of the Spanish *cabildo*, and they call it the "Tianguis de Juan Velázquez." No one of this name appears among the names of the city's early Spanish residents, and the only high official to bear that name was don Juan Velázquez Tlacotzin. He was the grandson of Tlacaelel, who served as *cihuacoatl* under his brother Moteuczoma I and whose portrait was carved along with his brother's on the cliff at Chapultepec.[20] And like his grandfather, Tlacotzin too served as *cihuacoatl*, under Moteuczoma II. His biography shows him to be one of the most important and underappreciated figures during and immediately after the Conquest. The powerful "Tlacotzin Cihuacoatl" was remembered, decades after his death in 1525, as "very close to Moteuczoma [II]"

and a "very feared man."[21] During the siege of the city, he emerged as the key negotiator between the increasingly embattled Mexica and the conquistadores.[22] After the Conquest, he was a person trusted by Cortés, who put him in charge of "people and construction," and appointed him head of one of the city's four parts, probably the largest polity of Moyotlan.[23] The other parts were entrusted to other indigenous elites, and these partitions would have irksome political consequences, as we will see in chapter 7. When Tlacotzin was christened, he took on the new Spanish name of Velázquez, a name he gave to the marketplace. This new *tianquiztli* was built adjacent to his house, offering confirmation of who was doing the work of reconstructing the post-Conquest city—the old elites, who knew how to run things.[24]

Most histories have neglected Tlacotzin, but he is an important figure in native annals. Consider his depiction in the Codex Aubin (see figure 1.6). He appears at the center of folio 45r, adjacent to the year 5 Reed (1523), and his title, "cihuacoatl," appears written in pictographic script above his head, a serpent (*coatl*) with the head of a woman (*cihuatl*). As in the images on the previous page of Cuitlahua, who ruled for a mere eighty days in 1520 before dying of smallpox, and of Cuauhtemoc, who succeeded Cuitlahua and whose image appears above him, Tlacotzin wears the turquoise miter, the *xiuhhuitzolli*, a symbol of high authority, and sits on the *tepotzoicpalli*, the high-backed throne; however, he does not wear the brilliant blue *tilmatli* of the *huei tlatoani*, instead wearing a deep-red cloak decorated with black curves and dots, evocative of the ocelot pattern made out of feathers worn by pre-Hispanic Mexica warriors into battle.[25] Nor is he numbered in the list of Mexica rulers, as were his predecessors Cuitlahua and Cuauhtemoc. The text reads, "Here, Cihuacoatl Tlacotzin, was seated as ruler; during his rule there was an eclipse of the sun," an astronomical event of immense importance.[26]

While it is true that he and other elites were quick to collaborate with a colonial regime, at the same time, we must appreciate not only that managing the ecology and economy of the refounded city was a complex endeavor, as it had been in Tenochtitlan, but also that the lives of tens of thousands of Mexica depended upon its continued functioning. The new conquistadores, for all of their brash confidence, had no understanding of the complex economic and ecological balance of the urban prize that the Mexica city of Tenochtitlan was during the war of conquest. Tlacotzin did, and the title "atempanecatl," or "field or lagoon marshal," given to the earlier *cihuacoatl* suggests that one of the roles of office was the maintenance of the city's infrastructure, especially those great dikes made of stone and adobe that kept the water in check.[27] The Humboldt Fragment II, a map created sometime before 1564–1565, showing lands either owned by or worked for high-ranking Conquest-era Mexica nobles, lists the owners' pictographic names within their respective fields on the right side of the map, which is reproduced here (figure 4.6). On the right edge of this work, Tlacotzin is set among other high-ranking Mexica elites, and is identified by an alphabetic gloss that reads "Jua Velazque Tlacotzin." His "cihuacoatl" title appears written pictographically as the image of a serpent (*coatl*) out of whose mouth a female (*cihuatl*) face appears. A short staff with an angled top appears to the right of the *cihuacoatl* glyph, and the Codex Mendoza (on folio 64r) assigns this particular symbol of authority to the lord responsible for "repairing the streets and bridges" that led to an adjacent temple pyramid, further suggesting that Tlacotzin played a lead role in maintaining the city's infrastructure.

Cortés wrote that the city's marketplace was reestablished "among where the Spanish lived," but it was in fact also adjacent to Tlacotzin's house, a placement not without benefits for Tlacotzin.[28] In the chaotic aftermath of the Conquest, the larger system of imperial tribute collection was being overhauled by the Spanish, who sought ways to funnel the stream of goods that flowed to local native lords and into imperial centers like Tenochtitlan into their own coffers. A handful of indigenous elites, like a few of the children of Moteuczoma, were eventually granted *encomiendas*—assignments of entire indigenous towns for their labor—by the Crown. However, most other elites in the city were left out of this golden circle and needed to find ways to support themselves and their extended families, especially as they competed with a new class of Spanish overlords for goods and services that commoners were obliged to provide to their rulers. The reallocation of lands within the city to themselves and their dependents was one way to support themselves. Another was availing themselves of the traditional taxes that indigenous commoners were used to paying in the market. Overseeing the market was one method of procuring this income stream, a key resource for the indigenous elites in the early colonial period, as tax collection on marketed goods was a pro forma feature of urban life, almost certainly a pre-Hispanic holdover.[29]

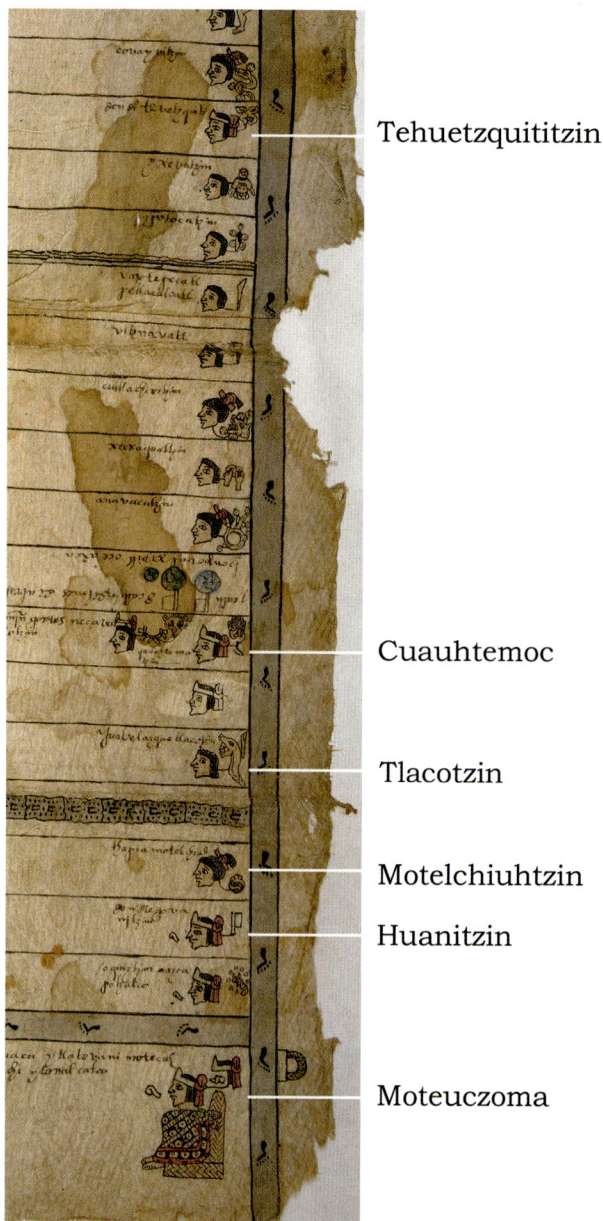

Tehuetzquititzin

Cuauhtemoc

Tlacotzin

Motelchiuhtzin

Huanitzin

Moteuczoma

FIGURE 4.6. *Unknown creator, map of property held by Mexica elites, detail, Humboldt Fragment II, ca. 1565, Ms. Amer. 1, fol. 1, Staatsbibliothek zu Berlin. Pbk, Berlin/Staatsbibliothek zu Berlin, Stiftung Preußischer Kulturbesitz, Berlin, Germany/Art Resource, New York.*

And not to be discounted is the symbolic value of an association with the market. The glyph for "market," discussed in chapter 1, was linked to the preciousness of jade beads, the same markers of the surging green force of new life that the *huei tlatoani* wore on his person. The disk-like forms of the symbol were similar to the architectural markers that lordly houses carried on their entablatures. Sahagún's description shows the market as a place where

the foreign was introduced and then domesticated. So barely two years after the Conquest, we are beginning to glimpse patterns of lived spaces and practices that carried forth the indigenous city of before the Conquest—as traditional elites again assumed roles of power and reconstructed the city according to its pre-Hispanic patterns—as well as taking it into the future, where elites needed to find new ways, in cooperation with Spanish authorities, of maintaining their status. In this respect, the indigenous elite of Mexico City were no different from those of other polities, sensitively documented by Robert Haskett, Susan Kellogg, Ethelia Ruiz Medrano, and others.[30]

Don Juan Velázquez Tlacotzin was, like the market named after him, an evanescent force in the city; in October of 1524, when Cortés set out toward Honduras to capture the rival conquistador Cristóbal de Olid, he decided to take the Mexica *huei tlatoani* Cuauhtemoc and other indigenous elites with him "so that they might not disturb the country and rebel in his absence."[31] Among the ranks of the "very powerful men, who, if left behind, would have been capable of staging a rebellion," was "Xihuacoa" ("Cihuacoatl," Tlacotzin's title).[32] We also know something of the other men on this trip, many of whom would come to play prominent roles in the city. Accompanying Tlacotzin was Moteuczoma's nephew don Diego de Alvarado Huanitzin and Huanitzin's second cousin, don Diego de San Francisco Tehuetzquititzin.[33] Once out of the city, Cortés accused Cuauhtemoc of conspiracy and had him hanged early in 1525. He quickly appointed Tlacotzin *gobernador*, a sign that he intended to bring him back to Mexico City and have him permanently installed in the stead of Cuauhtemoc. Tlacotzin's premature death during the campaign brought the plan to an end.[34]

THE CITY'S INDIGENOUS RULERS, 1526–1535

If he was a fearless invader, Cortés was never very effective in governance, his weaknesses more on display as he attempted to consolidate himself as the royal representative after his return from Honduras to the city in June 1526 within the territory that he had christened "New Spain." Since Tlacotzin had died en route, Cortés needed to name a new indigenous governor, and his selection for the office reveals a blindness to the Mexica regard for sacred kingship that is picked up, like discordant signals from a radio, in native histories.[35] They emphasize that the handpicked

men after Tlacotzin lacked even his pedigree and were less than palatable to the surviving Mexica elite. In 1526, Cortés named don Andrés de Tapia Motelchiuhtzin, who like his predecessor was a member of the Honduras campaign, but was not a direct descendant of earlier *huei tlatoque*.[36] The native historian don Domingo Francisco de San Antón Muñón Chimalpahin Quauhtlehuanitzin, writing at the beginning of the seventeenth century, suggested his lack of credentials in calling him "only a Mexica eagle-noble."[37] Native pictorial histories likewise show Motelchiuhtzin without the traditional regalia. Motelchiuhtzin's rule (1526–1530) coincided with a chaotic period in Mexico City's history. Charles V, more aware of the vast riches that the New World promised and increasingly wary of the quarrelsome leader's pretensions, recalled Cortés to Spain, and he was there from 1528 to 1530. But Cortés left behind a large conquistador class that could easily impinge on royal authority, so in lieu of the government that Cortés had established, the Crown mandated that a panel of judges called the Real Audiencia (royal court) govern New Spain in late 1527. At the head of this first *audiencia* sat Nuño Beltrán de Guzmán, who was brought in as a check to Cortés's power but turned out to be a man of unparalleled ruthlessness, particularly toward the indigenous population; quite soon, conflict broke out between him and the newly arrived Bishop Juan de Zumárraga, a Franciscan, over these abuses. When word reached Charles that Guzmán was doing more damage than good to royal interests, he swept out the first *audiencia*, appointing Guzmán as governor of the northern province of Nueva Galicia. Upon leaving the city with troops to subdue the frontier Chichimec tribe, Guzmán took Motelchiuhtzin and other city leaders with him. Motelchiuhtzin was hit by an enemy arrow and died far outside the city in 1530, like so many of his immediate predecessors.[38] He left behind a son, Hernando de Tapia, who would come to be a powerful force in the city.

Guzmán's inept government was replaced by the second *audiencia*, headed by the bishop of Santo Domingo, Sebastián Ramírez de Fuenleal, between January 1531 and April 1535. Ramírez de Fuenleal was sympathetic to the Franciscans and worked to protect native peoples from excessive abuse. Recognizing the immense challenges that ruling a native population entailed, he developed informal policies to employ native institutions when it served the long-term interests of the Crown. Thus, Ramírez de Fuenleal supported the recognition of the de facto native

government in the city, in no small part as a counter to the abusive inclinations of the conquistadores.[39] At the same time, he must have been wary about putting any of the surviving Mexica high nobles into power, because in 1532, he appointed to the governorship of the city don Pablo Tlacatecuhtli Xochiquentzin, another lesser noble who had proved his loyalty to the Crown by joining Guzmán on the northern campaign.[40]

While the slowly congealing royal government, led by the second *audiencia*, seems to have been perfectly satisfied with any sympathetic native ruler, the strenuous objections to these rulers that colored native histories written after the fact (Chimalpahin called Xochiquentzin "only a nobleman-steward" and said Motelchiuhtzin was merely an "interim ruler") remind us that the native elite were still a powerful one in the city and to them, the divine election of these rulers still mattered; indigenous chroniclers, writing in Nahuatl, have given these elites an enduring voice.[41] While Chimalpahin was likely an educated commoner, another prominent Nahua chronicler, whose manuscripts Chimalpahin knew, was don Fernando Alvarado Tezozomoc, Moteuczoma's grandson on the maternal side and Huanitzin's son, who thus traced his descent on both sides back to pre-Hispanic *huei tlatoque*. Thus, the native intellectual class who had an interest in the authority of rulers spanned strict class lines.

While disapproval of the three "illegitimate" rulers of 1525–1532 could be passed off as self-interest of the high Mexica elite and self-styled elites like Chimalpahin, it extended to artists and scribes in the city, who carefully employed visual symbols to distinguish "truly" legitimate rulers from the three "interim" ones. On Humboldt Fragment II, a number of these rulers appear (figure 4.6). The *huei tlatoani* Moteuczoma is represented as a full figure at the bottom of this list, with typical sartorial splendor: his cloak is the distinctive *xiuhtilmatli-techilnahuayo* that his cousin Nezahualpilli also wore (see figure 3.3). He sits on the *tepotzoicpalli* and wears the *xiuhhuitzolli*. Above Moteuczoma appear many of the post-Conquest rulers up through 1554, including Cuauhtemoc (1520–1524) and Motelchiuhtzin (named as Thapia [for Tapia] Motelchiuh). Notably, Tlacotzin and Motelchiuhtzin, who were not descended from *huei tlatoque*, do not wear the *xiuhhuitzolli*, while Cuauhtemoc, Huanitzin, and Tehuetzquititzin do (figure 4.7).

Such interest in marking the legitimacy of the Mexica rulers extends across a broad spectrum of manuscripts

Acamapichtli
r. 1376–1395

Itzcoatl
r. 1427–1440

Huitzilihuitl
r. 1396–1417

Tezozomoc

Moteuczoma I
r. 1440–1468

Chimalpopoca
r. 1417–1427

m.

Atotoztli

Axayacatl
r. 1468–1481

Tizocic
r. 1481–1486

Ahuitzotl
r. 1486–1502

Tezozomoc
Acolnahuacatl

Moteuczoma II
r. 1502–1520

Cuitlahua
r. 1520

Tezcatlpopoca

Cuauhtemoc
r. 1520–1525

son

don Francisco de
Alvarado
Matlaccohuatl

don Diego de
Alvarado Huanitzin
r. 1537/1538–1541

m.

doña Francisca
Moteuczoma

don Diego de San Francisco
Tehuetzquititzin
r. 1541–1554

don Luis de Santa María
Cipactzin
r. 1563–1565

don Antonio Valeriano
r. 1573–1599

m.

doña Isabel de
Alvarado Moteuczoma

don Cristóbal de
Guzmán Cecetzin
r. 1557–1562

son

don Antonio Valeriano
the younger
r. 1620s

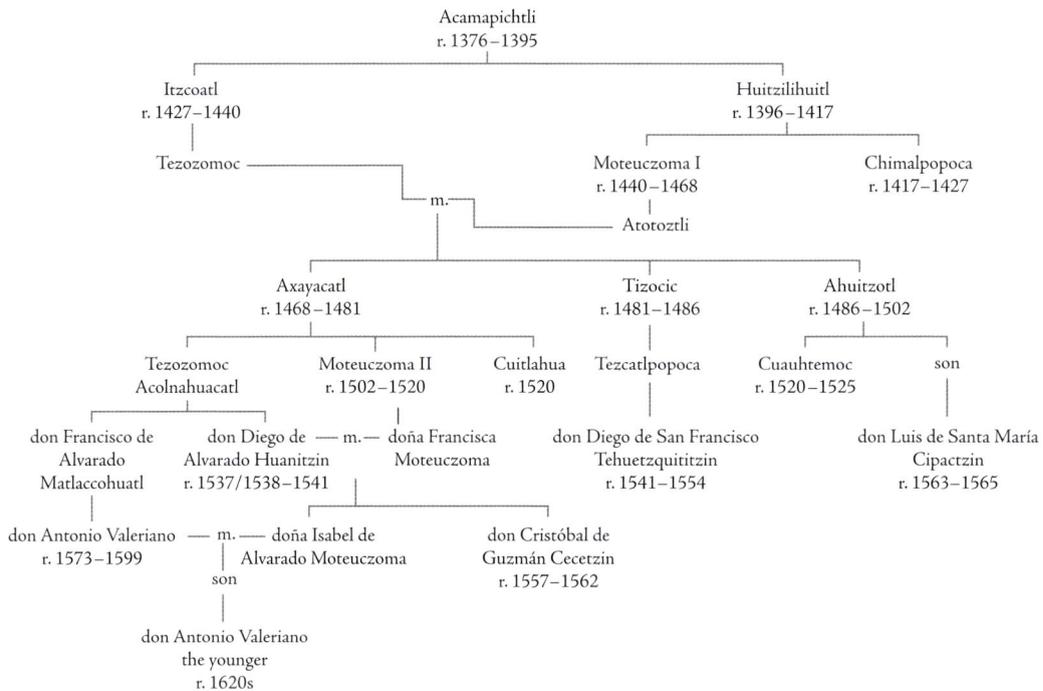

created in and around the city. Since many of them date to the 1560s or after, we see in them later historical consolidation; nonetheless, the authority of their rulers continued to preoccupy Mexica elites, intellectuals, and scribes, evidence that the careful ideological construction by pre-Conquest Mexica rulers of their centrality—a centrality hinging on their semidivine status—was not completely dismantled over the course of the century. Just as native manuscripts concur in showing an interregnum of rulers of dubious legitimacy up to 1532, many of them agree on their aftermath: a new leader was chosen who again merited being crowned with the *xiuhhuitzolli* and garbed with the *xiuhtilmatli-techilnahuayo*. He was Huanitzin, one of the highest-ranking members of the Mexica royal family, a survivor of Cortés's march to Honduras, a ruler who was a pivotal figure in the creation of post-Conquest Mexico City, much as Tlacotzin, the first post-Conquest ruler, had been, and his vision for the city will be the subject of the next chapter.

THE TIANGUIS OF MEXICO

Despite their dubious legitimacy, the *gobernadores* who followed Tlacotzin were all involved in shaping the city's great *tianguis*. Under Xochiquentzin, the market was relocated in 1533 to a site farther to the south from where it had been under Tlacotzin, where it would remain through

FIGURE 4.7. *Genealogy of the indigenous rulers of Mexico-Tenochtitlan belonging to the Mexica royal house, 1376–1620s. Diagram by Olga Vanegas after María Castañeda de la Paz, "Sibling Maps, Spatial Rivalries: The Beinecke Map and the Plano Parcial de la Ciudad de México."* In Painting a Map of Sixteenth-Century Mexico City: Land, Writing, and Native Rule, *edited by Mary E. Miller and Barbara E. Mundy (New Haven: Beinecke Rare Book and Manuscript Library, 2012), 54.*

the seventeenth century. A contemporary document makes it clear that this relocation actually served to bring the Tianguis *back* to its original, pre-Hispanic site. The Spanish *cabildo*, responding to Xochiquentzin's petition not to move the market, in turn requested of the Real Audiencia that "it not move the Tianguis of Mexico to where it once was," whereas, in the view of the *audiencia*, one of the advantages of the new market was that it would be returned to "where it *was*" (italics mine).[42] A detail from the Map of Santa Cruz shows us a signal advantage of this original site in revealing the deep blue lines of canals cut into the lakebed and wending through the city that led to the *tianguis*, which is identified on the map as "el mercado" (figure 4.8). These water routes allowed goods and produce to be brought in via canoes even in the dry season, the most efficient and favored means of transport in the valley. The water route between the post-1533 Tianguis of Mexico and the southern *chinampa* regions, the area's breadbasket, was direct; on this detail of the western-oriented map, they lay

off the left edge, reached by the roadway-canal that stems horizontally across the top edge of the market. In contrast, the main artery leading to the short-lived Tianguis of Juan Velázquez was the causeway of Chapultepec, a more circuitous land route that required the use of oxen (expensive and scarce in indigenous communities) or equally inefficient and expensive porters.

By the middle of the sixteenth century, this great market was sometimes called the Tianguis de San Juan, taking the name of San Juan Moyotlan, or was referred to as the Tianguis of Mexico, the name preferred here.[43] By then, it was one of three indigenous markets in the city. Its main competitor was that of Santiago Tlatelolco, which also was

of pre-Hispanic origin and lay adjacent to that *altepetl*'s *tecpan*, or palace of the indigenous government, and the monastery. The third was the Tianguis of San Hipólito, which had been established under Viceroy Antonio de Mendoza in the 1540s and sat at the western edge of the city, north of today's Alameda park, close to the site of the old Tianguis of Juan Velázquez.[44] In the colonial period, a *tianguis* was understood as a market that trafficked primarily in foodstuffs, as opposed to *pariáns*, where one would

FIGURE 4.8. *Unknown creator, the Tianguis of Mexico and surrounding area, oriented to the west, detail, Map of Santa Cruz, ca. 1537–1555. Uppsala University Library, Sweden.*

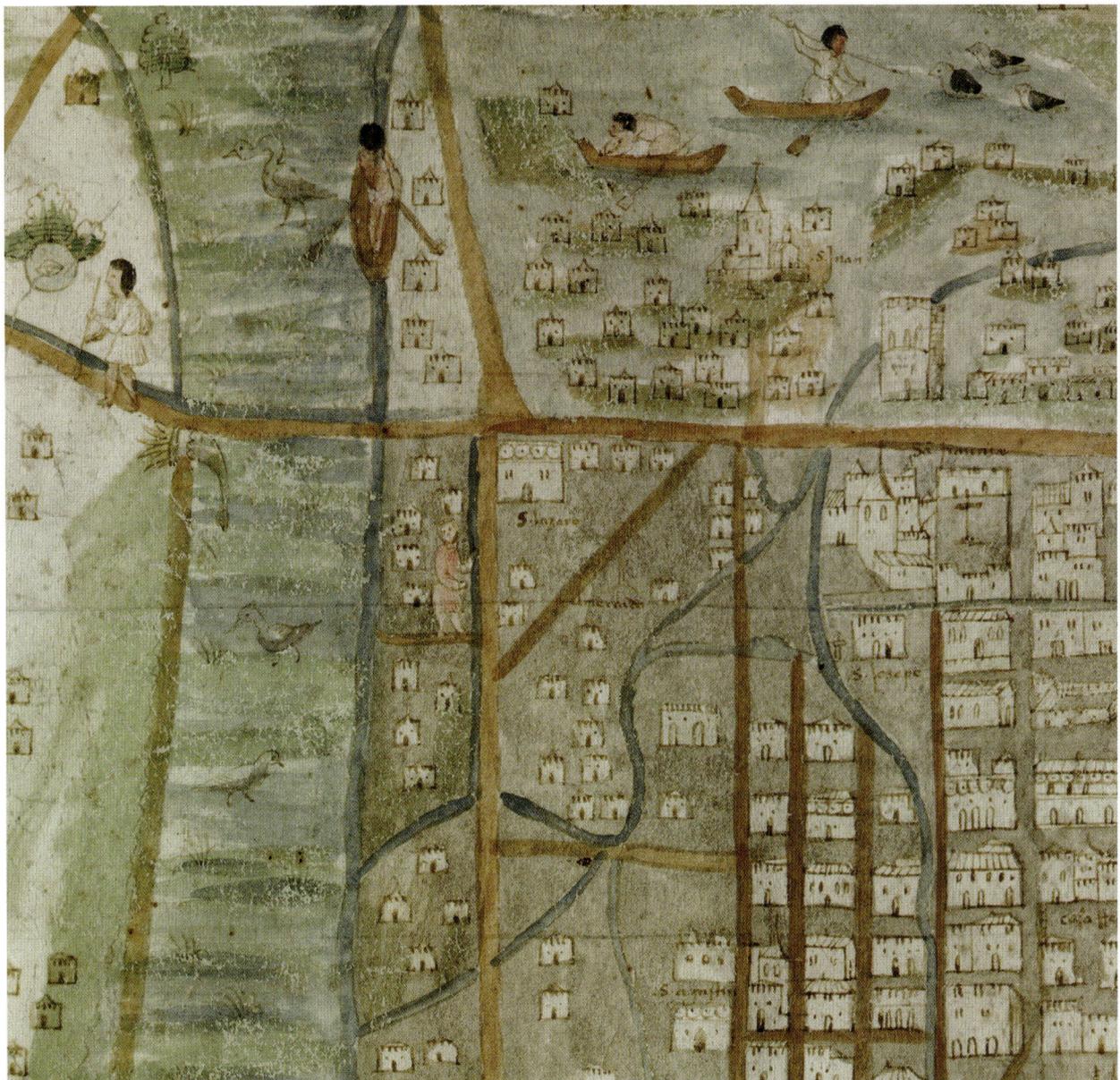

eventually find commodities from the far reaches of the empire. The market on the Plaza Mayor was such a *parián*, and seems to have been of minor importance to indigenous marketers in the sixteenth century, but grew in importance in the seventeenth after floods forced sellers in the other markets to the high ground of the plaza, which is why the *biombo* reproduced in figure 1.2 shows indigenous marketers on the Plaza Mayor.[45] While the markets of Tlatelolco and Mexico seem to have operated every day, each of the three markets had its major selling day; as reported by the English traveler Henry Hawks, "The one of these Faires is upon the Munday, which is called S. Hypolitos faire, and S. James [Santiago Tlatelolco] his faire is upon the Thursday, and upon Saturday is S. Johns [Tianguis of Mexico] faire."[46] Hawks would have witnessed the Saturday "faire" in the Tianguis of Mexico in the 1560s while living in Mexico. He thus saw it in the wake of orders issued by the *audiencia* midcentury, which commanded that all indigenous towns within a twenty-league radius come to this *tianguis* on Saturday to sell food, thereby ensuring that the city was properly provisioned. Such directives vexed indigenous peoples in the valley, who claimed that they were forced to sell their turkeys, chickens, and eggs well below cost, and no doubt reminded some communities of their burdensome pre-Hispanic tribute obligations to Mexica lords; the Franciscan Pedro de Gante, in his role as indigenous advocate, jumped to the defense of the sellers.[47] In any event, such an influx of marketers would have swollen the already large market on that day.

When it was founded, this great indigenous market likely occupied an urban void that had once contained the earlier pre-Hispanic one, and in the first half of the sixteenth century, it was marked as an indigenous space, dominated by indigenous marketers and organized by the indigenous governors. The native government had jurisdiction over these markets, a fact confirmed by Ramírez de Fuenleal, president of the second *audiencia*, who wrote to the queen in 1533, the year of the *tianguis*'s move, to recommend that the native judges, the *mixcatlaylutla*, retain their powers of "light coercion" in the *tianguis* so as to maintain its well-established order.[48] Through the mid-sixteenth century, when the Spanish population of the city was still small, control of the market was relatively uncontested, but by the 1560s, as we shall see, the Spanish *cabildo*, which ruled over the Spanish-occupied center of the island, came to see it as part of the city under their control.

If the daily movement of goods, like the path of

processions, establishes relations of center to periphery, the Tianguis of Mexico was at the hub of both the daily market economy and the indigenous city. As such, it was connected to both the city and the larger valley by important arteries, some of which can be seen in figures 4.2 and 4.8. The southern limit of the *tianguis*, seen in figure 4.8 as its left border, was defined by the causeway of San Juan, which ran from Chapultepec across the city to San Pablo and was the city's major east–west axis south of the causeway of Tacuba. This road had been extended westward across the lake to reach Chapultepec in 1532, around the time the *tianguis* was refounded at the site.[49] The construction of this causeway was not difficult: lake levels had fallen precipitously after the Conquest, and the area it spanned was mostly shallow swamp. The minutes of the meetings held by the Spanish cabildo, the *Actas de cabildo*, an essential source for the early city, called this roadway the "calzada nueva de Chapultepec" (new Chapultepec causeway). Names given to streets in the sixteenth-century city were highly situational, often changing block to block, and the part of this road that penetrated the city was often called in the sixteenth-century *Actas de cabildo* "calzada que va del Hospital Real al Tianguis" (causeway that goes from the Royal Hospital to the Tianguis); today it is the Calle José María Izazaga, but for consistency, this book refers to it as the causeway of San Juan. Another urban axis defined the western side of the Tianguis of Mexico. By the 1540s, it would link the market and the *tecpan*, the palace of the indigenous governors, with the newly built monasteries of San Francisco and, to the north, Santiago Tlatelolco; it also had a southern extension (known as the Calzada [Causeway] de la Piedad in the colonial period), which ran parallel to the causeway of Ixtapalapa (eventually renamed Calzada de San Antonio Abad) and reached Coyoacan in the south. This is seen as the horizontal roadway running across the top of the market in figure 4.8. But more importantly, it led from the market to water routes coming in from the southern lakes, where canoes from the rich agricultural zones in the south could dock.

Other than the Map of Santa Cruz, we have no early maps of the Tianguis of Mexico, and faced with this lack, I turn to two maps created later in the century to add more details of its physical features. A map of 1588 by the *cabildo*'s *alarife mayor* (director of public works), Cristóbal de Carvallo, offers pertinent details about the appearance of the *tianguis* later in the century (figure 4.9). This map, created to resolve a long-simmering jurisdictional dispute, shows

FIGURE 4.9. *Cristóbal de Carvallo, map of the Tianguis of Mexico, oriented to the west, 1588. Archivo General de la Nación, Mexico, Tierras 35, exp. 2. Mapoteca 280.*

the space of the *tianguis*, oriented to the west, as in figure 4.8, which would mean that the causeway to Chapultepec ran along its left edge, and a main north–south axis along its upper edge. Despite the arteries that fed into it, the *tianguis* is represented as a highly contained space, bordered on all sides by walls; the southern wall, on the left-hand side of the map, had only one narrow entrance, blocking easy access from the adjacent causeway. Another wall defined the west perimeter of the *tianguis*, with two small entrances leading out to this causeway. Stores may have defined the northern side of the *tianguis*, and at the northeast corner are the "Portales de Tejada," the arcade marked by small circles showing the footprint of its round columns. This building, constructed by an *oidor* (judge) of the Real Audiencia, Lorenzo de Tejada, was perhaps the earliest permanent market structure, whose front was a covered arcade within which marketers could display their wares and which gave them protection from the elements; it was attached to two-story dwellings for shopkeepers.[50] The eastern side, along the lower edge of the map, had three blocks of buildings on it, and two streets cut between them, one thirty feet wide, the other thirty-six; if one followed them out of the *tianguis*, one would quickly arrive at the convent of Nuestra Señora de Regina Coeli, founded in 1553, which stood beyond the east end of the *tianguis* and whose building was considered "new" in 1588.[51]

Today, the location of the great Tianguis of Mexico is often mistakenly assigned to that of another, much later market, the Mercado de San Juan, which occupies a site a few blocks away,[52] perhaps because much of the old *tianguis* site is filled with the eighteenth-century building of Las Vizcaínas. Figure 4.10 is a detail from an 1867 map of Mexico City, oriented to the west so it better corresponds to the 1588 map drawn by Cristóbal de Carvallo. The space once occupied by the great Tianguis of Mexico is highlighted, and dominating its upper right corner is the complex of Las Vizcaínas, with many interior courtyards, marked as "75." The northeast corner, at the lower right, is designated as "Portal de Tejada," suggesting that the covered arcade stood there into the nineteenth century. It no longer stands today, but the abrupt narrowing of what is now Mesones Street follows the street line established by the outer limit of the sixteenth-century arcade. The three streets leading into the highlighted space, seen at the bottom of the map, correspond directly to the three streets at the bottom of the 1588 map, as does their somewhat irregular spacing. The 1588 map gives measurements of some of the internal divisions

FIGURE 4.10. *Luis Espinosa and J. M. Alvarez, Plano de la Ciudad de México, detail showing the tecpan of Mexico-Tenochtitlan (A), with the area of the former Tianguis of Mexico highlighted and "Portal[es] de Tejada" visible at lower right; map oriented to the west, 1867. Mapoteca Manuel Orozco y Berra, 1230-CGE-725-A, Servicio de Información Agroalimentaria y Pesquera, SAGARPA.*

of this enormous market. Cross-checking these with modern maps reveals that the *tianguis* measured approximately 270 varas, or 250 yards, across its north–south axis, and was somewhat longer on the east–west axis, perhaps 330 yards. This great space was therefore larger, by about 15 percent, than the Plaza Mayor in the center of the city (which measures about 260 yards square), itself the second-largest plaza in the world today. Thus, when founded, the Tianguis of Mexico was one of the largest open urban spaces in any European or American city.

Enormous, packed with vendors and buyers, the Tianguis of Mexico was the commercial hub of the city, and the small transactions that took place here—in an era without refrigeration, fresh food would need to be bought frequently—were the mainstay of the economic life of the city's indigenous people, particularly women: orders issued by the viceroy in the late sixteenth and early seventeenth centuries often identify the sellers as female "indias."[53] Another map, which exists only as a later copy now at the Bibliothèque nationale de France, reveals what was sold at the late sixteenth-century *tianguis* and thus offers an index to consumption in the city as well as to the kind of hybrid products that were being sold (figures 4.11 and 4.12 and table 4.1).[54] In this map, we see a highly ordered urban

space, oriented to the south. The upper left is dominated by the *tecpan*, the palace of the indigenous government built in the 1540s and discussed in the next chapter, and it appears as a façade only, with an arched doorway and four doughnut-shaped rings across the entablature. Estimating from the scale of the 1588 map, the street façade of this building would have been about ninety yards long.

The perimeter of the *tianguis* is dominated by structures, likely shops, with doorways, but it corresponds to the 1588 map in showing very few entrances; like the 1588 map, on the lower right appear the circles to show the bases of the arches of the Portales de Tejada. While the 1588 map shows only a circle marked as *fuente* (fountain), in the otherwise unmarked space of the interior of the market, the map of figure 4.11 gives us more physical details. Within the bounded space of the *tianguis*, there was an open square

around the central octagonal fountain or cistern, and eight straight streets or passages radiated out from the corners, dividing the space of the market into eight blocks. The great corner blocks contain spaces for twenty marketers, while the inner blocks, oriented to the cardinal directions, contain ten, a grid that is diagramed in figure 4.12. The large open square at the southwest corner was left unoccupied by sellers, and was likely designed so that carts could unload and turn around, the heaviest loads, those of *ocotl*, "pitch pine," quickly dispatched to an adjacent stall.

Many of these rectangular market spaces are identified by small hieroglyphs or images of the goods sold,

FIGURE 4.11. *Unknown creator, map of the Tianguis of Mexico, oriented to the south, ca. 1580s, nineteenth-century copy. Ms. Mexicain 106b, Bibliothèque nationale de France, Paris.*

TECPAN

North toward
San Francisco

Portales de Tejada

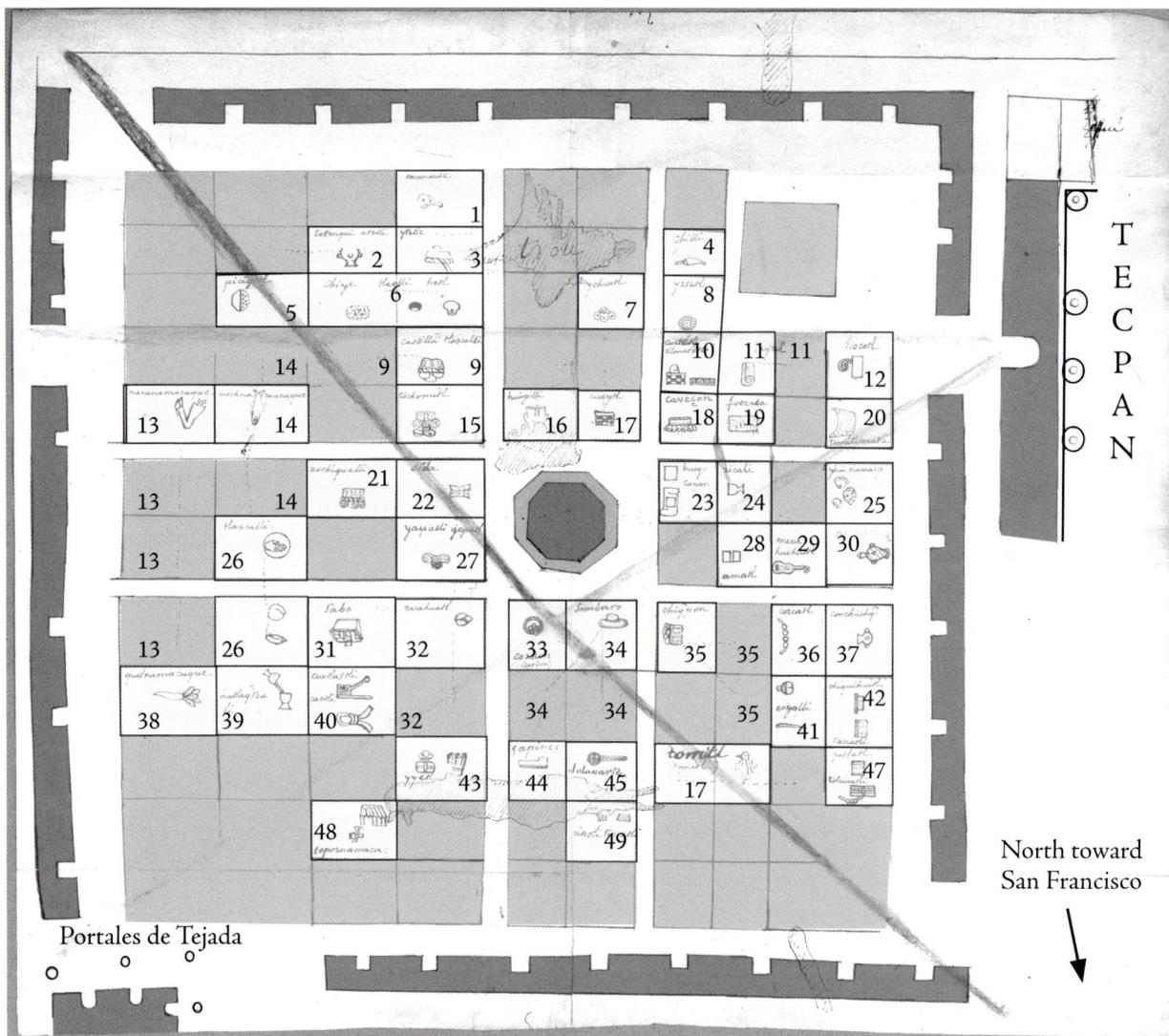

accompanied by glosses in Nahuatl (see table 4.1). Tiny dotted lines were the artist's (or perhaps the copyist's) convention to show that one class of good extended into several market spaces; for instance, the small hat (labeled with the Spanish word *sombrero*) has two dotted lines attaching it to spaces below it to show that hats were sold in three adjacent locales. In figure 4.12, the stalls with glyphs are unshaded and numbered to correspond to table 4.1; stalls connected by dotted lines are numbered correspondingly, but shaded. Most foodstuffs were found on the eastern side of the market, the left half of this map; notable among them are the four stalls for the meat sellers (*nacanamacaque*) and three stalls for fishmongers (*michnamacaque*). The former underscores the abundance of meat in the indigenous diet after the great plains of pasture, virgin until the arrival of the Spaniards, were turned over to raise sheep and cattle.

FIGURE 4.12. *Diagram of the Tianguis of Mexico, after Ms. Mexicain 106b. Numbers correspond to table 4.1. By Olga Vanegas.*

These great bounties of meat in the sixteenth century led to the ecological devastation that followed in the centuries thereafter.[55] Their location on this side of the *tianguis* made sense in the larger layout of the city, because it put them in proximity to the slaughterhouses where animals were butchered, which lay yet farther to the east in the city, so these stalls were the closest to their suppliers. While we know that poultry was a frequently demanded tribute item and sold at the market, only one glyph for a duck appears; the scarcity of spaces for poultry vendors may simply be due to the poor state of preservation of the original map at the time it was copied.

While it boasted an abundance of foods—chilies, chia,

TABLE 4.1. *Goods in the Tianguis of Mexico*

	GLOSS	NORMALIZED SPELLING, SPANISH LOANWORDS IN ITALICS	ENGLISH TRANSLATION	DESCRIPTION OF IMAGE
1	cacanautli	cacanauhtli	duck	duck head with beak
2	totonqui atolli	totonqui atolli	hot atole	vessel
3	ytztic [atolli]	itztic atolli	cold atole	?
4	chilli	chilli	chili pepper	chili pepper
5	piciyetl	picietl	tobacco	bowl with dotted substance
6	chiye tlaolli hetl	chiy[antli] tlaoli etl	chia, dried maize, beans	circle of small dots (chia), black bean, maize kernel
7	ychcatl	ichcatl	cotton	inverted three-lobed shape, the glyph for "cotton"
8	yztatl	iztatl	salt	circle with black dots inside
9	*Castilla* tlascalli	*Castilian* tlaxcalli	Castilian tortilla, i.e., bread	basket with round objects
10	cuetetli tilmatetli	cuetentli tilmatentli	skirt border, cloak border	checkerboard cloak with border with the tenixyo design
11	*sayal*	*sayal*	baize	roll of fabric
12	hocotl	ocotl	pine torch	rectangular shape with black curvilinear element
13	nacanamacaque	nacanamacaque	meat vendors	animal leg with hoof and bone joint revealed
14	michnamacaque	michnamacaque	fish vendors	fish
15	tochomitl	tochomitl	rabbit fur	rabbit head over a twisted hank of thread and square of cloth
16	huipilli	huipilli	woman's dress	dress
17	cueytl	cueitl	woman's skirt	skirt with checkerboard pattern
18	coneçon or caveçon	?	?	bracelet edged with shells or jingle bells
19	*frezada*	*frazada*	blanket	rectangle with small stippling
20	tomitilmatli	tomitilmatli	fur cloaks	curved object with small dots
21	zochiqualli	xochicualli	fruit	basket with round objects
22	*seda*	*seda*	silk	rectangle marked with a cruciform shape
23	huey *capan*	huei *capa*	large cloak	rectangle and glyph for "cloak"
24	xicali	xicalli	gourd vessel	chalice-shaped cup
25	yhui [tapachtli?] namaco	[tapachtli?] namaca	[?] vendor	three bivalve shells
26	tlaxcalli	tlaxcalli	tortilla	round object with the outline of a hand within

TABLE 4.1. *Goods in the Tianguis of Mexico (continued)*

	GLOSS	NORMALIZED SPELLING, SPANISH LOANWORDS IN ITALICS	ENGLISH TRANSLATION	DESCRIPTION OF IMAGE
27	yaualli ycpatl	yahualli icpatl	round thread	hank of thread
28	amatl	amatl	amate paper	two small rectangles
29	meca huehuetl	mecahuehuetl	corded upright drum [guitar]	guitar
30	[illegible]	?	?	vase-shaped vessel with internal cross-hatching
31	sabo	?	?	inverted box with internal rectangles or cubes
32	cacahuatl	cacahuatl	cacao	three-lobed shape
33	*cozton*	*cordon*	cordage	circle with internal round shapes
34	*sombrero*	*sombrero*	hat	hat
35	chiq~pan	chiquihuitl	basket	woven basket filled with round objects
36	cozcatl	cozcatl	jewel	beads on a string or cord
37	conchiuhq~	conchiuhque	pottery vessels	small vase-shaped vessel with side handles
38	quilnamacaque	quilnamacaque	greens vendors	carrot-shaped root with a leafy top
39	hatlaq~tzali	atlaquetzalli	foamy chocolate	two chalice-shaped vessels, with liquid pouring from one to the other
40	cuetlaxtli cactli	cuetlastli	leather shoes	sandal in profile, a knotted loop of leather
41	coyolli	coyolli	small bell	jingle bell and a thin tusk-shaped object
42	chiquihuitl tanatli	chiquihuitl tanatli	basket, basket with handle	two woven baskets with no handles
43	yyetl—	ichcatl or ihuitl?	cotton or feathers?	bundle of cotton, bundle of feathers?
44	çapines	?	?	lazy-L shape
45	dolavarte	?	?	round object with a long, projecting handle and internal cross, like an incense burner
46	tomitl	tohmitl	fur or fleece	no image
47	petlatl tolcuextli	petlatl, tolcuextli	woven reed mat, mat made of long thick rushes	rectangle with stippling to show a woven mat, a bundle of reeds tied with a twisted cord
48	tepoznamaca	tepoznamaca[que]	metal vendor[s]	house shape and an unidentifiable object
49	pinoli tenextli	pinolli, tenextli	powdered lime [pinolli is also wheat flour]	two baskets?

NOTE: *Numbers correlate to figure 4.12. Glosses and images appear in figure 4.11. Normalized spellings, translations, and descriptions are author's.*

maize, beans, greens, fruit, meat, fish, and tortillas—this *tianguis* was not just a food market. Indigenous luxury goods were to be found here, in the western stalls nearest the palace of the indigenous rulers: *cozcatl*, or jewels (identified with a necklace likely of jade beads), are seen, as well as shells (used to decorate clothing and for other adornments); that an entire square is devoted to bells suggests their extensive use as sonic elements for dress, or perhaps for music in processions. Textiles of different varieties were abundant, and it is this class of objects that shows the greatest influence of Spain. Of the seven loan words identifiable in the glosses, six of them refer to textiles or clothing—*sayal, seda, frazada, cordon, sombrero, capan*—and the seventh, Castilla *tlaxcalli*, is used to distinguish wheat bread from the native maize tortilla. Indigenous makers were almost certainly creating fine clothes for Spanish consumers in the city, and native elites were wearing them as well, at the same time that indigenous makers were adopting textiles of once-foreign origin.[56] Note how silk—a material introduced soon after the Conquest and produced locally—was being sold next to hanks of thread labeled as *yahualli icpatl*, "round thread," as well as *tochomitl*, "rabbit fur," which was spun and woven into luxury fabric or made into the *tomitilmatli* (fur cloaks) sold in another market plot.[57]

So while markets in general were places where buyers could encounter imported and exotic goods, where they could look at, touch, and smell the material traces of far-off peoples, what is remarkable about the *tianguis* is how conservative the material culture was—the *tianguis* was dominated by the same foods, beverages (*atole* and foamy cocoa), and stimulants (tobacco) that would have been sold here in its pre-Hispanic incarnation, the same reed mats and pottery vessels.[58] Given the strong smells of chilies, fish, and tropical fruits, the *tianguis* also carried forth a similar smellscape, another powerful connection it offered to its pre-Hispanic counterpart. As did sound—we can imagine the hawkers (speaking in Nahuatl) and the bell sellers pushing their products and promoting one introduced item, the Spanish guitar, by its Nahuatl name, *mecahuehuetl*, meaning "corded upright drum."

THE CONTESTED SPACE OF THE *TIANGUIS*

Because of its centrality to the economy of the city, the Tianguis of Mexico was a contested space, and both the city's indigenous *cabildo* and the city's Spanish *cabildo*, whose spatial jurisdiction did not extend to indigenous lands, laid claim to it. Battles surface in the lawsuits that were fought in the city's *audiencia*, or royal court, which often mediated cases between Spaniards and indigenes. For a dispute to reach the court, it meant that it was not resolved in any of the informal ways (face-to-face negotiation) or formal ones (appeal to market authorities) that people could use, and we can only surmise that for every contest that reached the court, there were many other disputes that never reached that level.

One of the rights that Spanish *cabildos* in the New World exercised was the ability to grant land within their cities, established by royal decrees of 1532 and 1563; the Spanish *cabildo* of Mexico City had also been given this right as the outcome of a lawsuit of 1530, when the Council of the Indies confirmed that they could "apportion lots in order to build houses."[59] In the early *actas*, the Spanish *cabildo* underscored that land grants were to be made on the *traza*—by which it meant not a bounded "Spanish" space, but rather along the planned grid that was being rolled out to regulate future development of the city. Constructions that impinged on the *traza* by violating the straight lines of planned streets were ordered to be torn down. For instance, although initially, in 1524–1526, the *cabildo* had made grants within what would become the Plaza Mayor, it decided after 1526 to allow for a larger public space in the center of the city, and revoked these grants; the large plaza we see in figure 4.3 was this cleared-out space.[60] With the creation of this large plaza, the *cabildo*, both in theory and in practice, established an important public space within the city, one it controlled, whose land was thenceforth not granted to private individuals.

But the *tianguis* was not the same kind of public space as the Plaza Mayor because the same royal directives that established the *cabildo*'s right to grant land and control communal goods also gave express protection to indigenous lands. Thus the indigenous *gobernadores* understood the *tianguis* to be *their* space. For support, they could point to royal directives that stated that Spanish *cabildos* were to "leave Indian properties alone."[61] They could (and would) draw on pre-Hispanic precedent (where the market was overseen by native judges), early colonial customs (which continued the offices of indigenous judges), and the Spanish laws defining the rights of *cabildos*, all to justly exercise control over the land of and activities in the *tianguis*, as they did over indigenous land in other parts of the city. For instance, in 1533, the indigenous governor don Pablo

Xochiquentzin ordered indigenous houses to be torn down to clear land in the city. Later lawsuits make clear that the indigenous *cabildo* granted land in the indigenous areas of the city.[62] But while indigenous jurisdiction over most of the indigenous zones and properties elsewhere in the city was largely tolerated by the Spanish *cabildo* in the first half of the sixteenth century, it was at issue within the *tianguis* as early as the 1520s.

The Spanish *cabildo* made its first move to control the Tianguis of Mexico with the appointment of an *alguacil de tianguis* (who was something like a sheriff) in 1526.[63] However, the efficacy of this lone officeholder at such an early date is questionable. He was likely aided or perhaps enabled by his indigenous peers in the oversight of this enormous market because when later edicts went out about market activities, they were often directed to native government.[64] In the early years after its reestablishment in 1533, as seen in the early Map of Santa Cruz, the great Tianguis of Mexico is shown as a vague open space with a somewhat desultory collection of houses and structures at its eastern edge, as well as the church of San Lázaro to the west, identified as "S. Lazaro" above "el mercado" (figure 4.8). Since by 1535 the Spanish *cabildo* had made no grants in this area, the houses in the Map of Santa Cruz were almost certainly occupied by indigenous residents.[65] The Spanish *cabildo*'s official records make no mention of monies spent in regular maintenance of this space, so its upkeep and improvement were the responsibility of the native governors, as court cases from later in the century, discussed in chapter 9, also reveal. The ordered spaces seen in figure 4.11 were almost certainly created under the auspices of the native government, and as we shall see, the indigenous government continued to claim control of the *tianguis* lands through the sixteenth century.

PROCESSIONAL ROUTES IN THE NEW CITY

Thus far, we have seen how crucial the indigenous governors and residents were in the reconstruction and the functioning of the lived spaces of the island city, particularly the zones outside of the *traza* around the Plaza Mayor. The example of the Tianguis of Mexico reveals the extent of quotidian practices in shaping urban spaces, and complementary to these were ceremonial practices, like the spectacular processions of the *huei tlatoani* seen in the last chapter. And just as quotidian spaces like the *tianguis* were

contested, so were the meanings of the major ceremonial route in the city, the causeway of Tlacopan, which carried vital freshwater from Chapultepec and had been the principal axis for the display of the Mexica *huei tlatoani*.

Quickly after the refoundation of the city, its Spanish residents began to occupy the lots around the Plaza Mayor, with Cortés beginning construction of his palaces and other leading conquistadores following his lead by constructing their urban houses close to the Plaza Mayor or along the causeways. As more residents moved into the city, the streets of the initial cruciform Spanish core gradually pushed out into the lands around it, as Spaniards bought up land from pressured Mexica residents. Simply waiting for land to become vacant was another quite effective strategy for Spanish residents of the city because the epidemics that swept through the city in the following decades cleared urban lands with efficient regularity. Concurrently, the Spanish *cabildo* began to organize the ceremonial life of the city, through which lived spaces would absorb the meanings that ritual practice imbued them with. Moreover, a sense of collective identity and purpose would be forged among the urban residents. Two ritual cycles determined city life. The first was the set festivals of the Catholic Church, most of them dedicated to remembering and reenacting events in the life of Christ on a yearly cycle, events that climaxed in Holy Week, which commemorated the last week of Jesus's life, leading up to his crucifixion on Good Friday, and Easter, marking Jesus's miraculous resurrection from the dead. Such reenactments "recall the religious past and make it present" for urban residents.[66] In Mexico City, in the years after the Conquest, such collective celebrations by the city's Spanish residents took on the added valence of being performed in a still-pagan land; recall that many of them were soldiers before they were city dwellers, so joining in the collective processions and expressions of piety at great civic masses evoked the consolidation of the troops on the battlefield.

The second set of rituals that punctuated the even rhythms of city life were the civic rituals marking events in the life of the royal family, the deaths of kings (infrequent in the sixteenth century, which was marked by the long reigns of Charles V [1519–1557] and Philip [1557–1598]) and queens (more frequent, as Philip had four wives), the births of heirs, and the *jura*, the swearing of an oath of loyalty to a newly anointed monarch. These were celebrated with fervor in the colonies and were a principal way that Spaniards maintained their status as a separate

and distinct class through their connection to the Spanish monarchy. Such festivals would take on an even larger role in the city's collective life with the arrival of a viceroy in 1535, himself a direct representative of the king and the cynosure of royal power in New Spain. But even before the city's Spanish *cabildo* would develop the protocols for celebrating the royal person, it would create a festival that celebrated the conquistadores, many of whom were *cabildo* members, and their achievements. This climax of Mexico City's festival year came with the feast of San Hipólito, dedicated to a minor saint in the church's festival calendar whose feast day coincided with the day that Mexica forces under Cuauhtemoc surrendered and Cortés took charge of the city, August 13. By 1528, preparations for sponsoring this feast were being recorded in the *cabildo* records, along with preparation for the feasts of San Juan (June 24), Santiago (July 25), and the Assumption of the Virgin ("Santa María de Agosto," on August 15), but it was always San Hipólito that most absorbed the *cabildo*'s energy and funds.[67]

In commemorating the feast of San Hipólito, the *cabildo* designed a ritual of reenactment, following the age-old patterns set by Holy Week celebrations, this one stretching over two days, thereby allowing it to bleed into the important Marian festival of the Assumption. Although the battle itself was not replayed, we can still see in the way the event was choreographed the *cabildo*'s attempt to consolidate the messy and brutal history of the Conquest into a singular compressed narrative, enacted by city residents and foregrounding the presence of the city's civic government. The festival began the evening before the feast, as Spanish residents in their ceremonial best mustered in the Plaza Mayor in front of the *cabildo*'s building on the plaza's south edge. The *cabildo* had paid for special elements, like the dozen trumpets to announce the parade, and the high-pitched brass melodies were distinctly different from the low beat of the drums that marked indigenous celebrations in the city. The great velvet *pendón*, or scarlet battle standard, was an object of special expense, and every year it was carefully entrusted to a *regidor*, or councilmember of the *cabildo*, who would host a midday banquet for celebrants.[68] This *regidor* went on horseback and was preceded by many other residents with a mount; the participation of the conquistadores, at least in the early years, and the battle garb of the *regidor*'s horse would have lent a martial character to the event. So too would the eye-catching presence of the scarlet *pendón*, embroidered with the coats-of-arms of the city, which unfurled over the group just as if it were a military procession.[69] The route was a direct one, its course significant. It ran from the Plaza Mayor along the causeway of Tacuba out to the *hermita*, or shrine, of San Hipólito, close to the exit of the city. This axis had been the principal ceremonial route of the Mexica city because it was the causeway toward Chapultepec, along which the Mexica *huei tlatoani* would enter the city at the close of a victorious campaign. After 1520, the route was vividly remembered by the participating conquistadores as the path of their panicked and humiliating retreat from the city on the Noche Triste, as they were driven out of the city by the Mexica. Retaking that same route, this time with measured and confident steps, heading toward the shrine that marked where Spaniards had fled, allowed the conquistador class to layer a new meaning onto the axis, reinscribing their panicked path of retreat with the eventual claim to victory, as if the weight of their feet could push down the Mexica city and its history below the surface of the soft and wet ground.[70] The procession was repeated the following morning, when a special mass was held, followed by the bullfights and lasso contests that happened in many festivals. In this particular one, the bullfight can be seen as revisiting yet again the battle and triumph over the city's indigenous peoples, the conflict between the two parties symbolized by the uneasy (and, barring tragic accident, predetermined) contest between matador and bull and played out within the more controlled space of the arena set up in the Plaza Mayor.

That the festival had the desired commemorative effect and can be presumed to have been absorbed into the meaning of the lived space is registered by accounts of it by the city's chroniclers. The long account written by the Franciscan Diego Valadés in the mid-1570s tells us of both cause and effect. The meaning of the event was explained, he tells us, in the sermons said on the masses of the two days, as the archbishop took the opportunities to remind those gathered of what had happened at the site. Having been present at many celebrations of San Hipólito (Valadés lived in Mexico City from 1543 to 1555 and likely visited many times up to 1571), Valadés uses his narrative of the present-day event of the festival of San Hipólito to offer a representation of the city's past space: the *pendón*, he tells us, was the same as that carried when the city was captured, the site of San Hipólito was to be found outside of the earlier Mexica city walls, and the two masses of thanksgiving that were said on the feast day "happened on the same

site where the most bloody battle had arisen, and where the most blood had been spilled, and where thousands of men had died."[71] Thus through the celebration of San Hipólito, the triumphal narrative of the Spanish victory was remembered and reenacted time and again in the collective life of the city. A few months earlier, Corpus Christi, which celebrated the more general triumph of the Eucharist over pagan religions, would offer its own preamble; in this feast, it was less the city's secular government that was put on display than the corporate structure of the city's populace in the great march of all the city's guilds, adding to the sense of collective identity of its residents and also leaving its traces on the urban grid.

While the triumphalist view of San Hipólito had its seeds in the celebrations sponsored by the city's *cabildo*, that view was also extended outward to the city's indigenous residents later in the sixteenth century. By the time Valadés witnessed the celebration, perhaps as early as 1543 or as late as 1571, the city's indigenous elites had been included in the procession, dressed in ceremonial costume. However, the representation of space that they likely heard was of an entirely different nature. In the masses said in the city's indigenous parishes on that day, they would have been treated to a Nahuatl song in honor of the feast day's saint. We are fortunate to have a cycle of feast day psalms written down by one of city's leading Franciscans, Bernardino de Sahagún. His collection includes four written for the feast of San Hipólito. The second of them explicitly connects the saint to the conquest of Tenochtitlan, and represents the resultant space of New Spain in alignment with the space of Israel, home to God's chosen people, as well as within the larger cosmic framework of heaven above and devils below:

SECOND PSALM

As through a miracle God saved the sons of Israel from the hands of the Egyptians, on the ninth day of the month of March,

just so, through a miracle, God saved us, the people of New Spain, from the hands of devils on St. Hippolytus' festive day.

And the children of Israel each year held a festival to celebrate the day of their deliverance. Just so is it required that we, the people of New Spain, each year observe the feast, because it is the festival of our deliverance; it is what pertains to our deliverance.

Our Lord God wrought a very mighty miracle for us

when those who pampered, who defended devils who were governing New Spain were conquered.

We were the devils' men, and the lords [and] rulers were the devils' guardians; they were the ones who loved them. And God sent His warriors so that the devils and their befrienders were conquered.

This miracle, by which we, we people of New Spain, were saved, was wrought on the feast day of God's beloved Saint Hippolytus. Let us be happy; let us take pleasure. Alleluia, alleluia.[72]

In this work, the Franciscans did not represent the space of New Spain as defined by the military defeat by the Spaniards, but as a space that had been delivered from the pagan devils who had once taken charge of the lords and ruler (and the text uses the words "in tetecuti in tlatoani" to name them). The terrible violence that the Spaniards were celebrating along the causeway is here suppressed, and instead the Franciscans open up a new representation of the urban space: one infused with the benefits of Christian salvation.

NAMING IN THE CITY

The civic celebration of San Hipólito offered an occasion to mark the history of the Spanish triumph over the lived spaces of the city by an important representation of space: the place-name. In the essay discussed in chapter 1, "Walking in the City," Michel de Certeau underscores their importance: "Proper names carve out pockets of hidden and familiar meanings. They 'make sense,' . . . disposed in constellations that hierarchize and semantically order the surface of the city, operating chronological arrangements and historical justifications."[73] Rare, but certainly important in the city, were these "historical justifications" that were applied to lived spaces that otherwise might be ungraspable as mental images, allowing urban residents to make sense of the city. One of these, the "Puente de Alvarado," is still extant in the city's toponymy, embedding the history of Pedro de Alvarado's death-defying leap onto a street corner (see figure 1.9).

But, in general, urban history was of little interest to the new Spanish settlers, and the names they bestowed on Mexico City in the two decades after the Conquest operated on two registers. If the post-Conquest city was a monster, seething with dirty waters and surrounded by unintelligible and hostile peoples, renaming it brought it

into conceptual alignment with other places; thus, the early Spanish inhabitants renamed places using the toponymy of Spain, adding "New" to the monikers to signal difference. Thus, "Nueva España," or "New Spain," the name given to the entire colony, allowed Spanish inhabitants to conceive of the territory as something theirs and familiar (Spain) while at the same time marking the singularity of their experience (New). But within the city itself, the earliest set of names we find Spanish residents implanting are not ones that insist on the likeness of the place to the familiar—there is no "New Venice" or "New Salamanca," as these are comparisons we find only in historical chronicles directed to an outside audience. Rather, the net of names Spanish residents threw out over the city insisted on individual possession; thus, in the *Actas de cabildo*, which largely ignores any preexistent indigenous toponymy, we have the "casas del marqués" (houses of the marquis) for the Cortés family residences, the "portales de Tejada" for the market arcades owned and built by the *audiencia* judge Lorenzo de Tejada (seated 1546–1553), and the "casa de Juan Cano" for Juan Cano's house. City streets bore relational names (as in "the street going from the Plaza to San Francisco"), and land grants made by the *cabildo* were named by the street and then by the names of adjacent lot owners, if they were Spanish men (women's names were almost never used). Indigenous owners, on the other hand, were, with rare exception, not named, their properties labeled simply "some Indian houses." Thus in the practices of naming registered in the *actas*, we see a web of individual Spanish possession being established in this unique register of the city's spaces.[74]

But if we look to native histories, we can see that key areas, like the one around San Hipólito, were inscribed with different names, and that they were used, as place-names often are, for mnemonic recall. In his narrative of the conquest of Tenochtitlan, the mestizo chronicler Diego Muñoz Camargo would describe a crucial moment of the war, when the besieged Spaniards and their allies attempted to escape from the Mexica city under the cover of night on the Noche Triste, but were exposed by the cries of an old woman. He tells it thus: as they made their way along the Tacuba causeway, nearing the eventual site of the shrine of San Hipólito, "an old woman seller, who was there at that hour to sell food to passing travelers, with a little stall, in Ayoticpac, which was where Juan Cano, the son-in-law of Moteuczoma built his houses, which today belong to Hernando de Ribadeneyra, which

were left to him by Juan de Esposa Salada, the old woman there, who must have been the devil himself, began to cry in a loud voice, 'Hey, Mexica—the imprisoned gods are leaving. What will you do, you careless men? Look, so they don't escape! Turn and kill them so they don't return and take your city again.'"[75] With her cries, the Mexica were rallied and at Ayoticpac they began to attack the escaping Spaniards. Ayoticpac is remembered here as a Mexica victory, and Muñoz Camargo also layers it with new meaning, connecting it to the names of its past and present-day owners. These were not unimportant people: Juan Cano had married the heiress doña Isabel Moctezoma, and they had a number of urban properties; the last owner mentioned, Hernando de Ribadeneyra, was a member of the Spanish *cabildo* beginning in 1573 and was at one point in charge of the storehouses of maize that provisioned the city; he is recorded as owning these houses on the Tacuba causeway in 1578.[76] In all likelihood, his was a grand house, an urban mansion that had its own supply of freshwater from Chapultepec, quite visible and known to people entering the city along the causeway, one of the city's main access points. Thus, Muñoz Camargo knew of Conquest history through its associations with contemporary buildings and kept these connections alive in his written account. Similarly, Chimalpahin would write about Ayoticpac also, linking it to the site of the convent of La Concepción and one of its longtime residents, doña Isabel Moctezoma, the daughter of doña Isabel and Juan Cano, showing the slightly different valences that the place carried in the seventeenth century.[77] Chimalpahin offers remembrance that points almost exclusively to the past, identifying one of the sites in this area as "Tolteca acalloco," or "canal of the Toltec," and specifies that two of Moteuczoma's sons were killed here during the same battle.[78]

Although the area around San Hipólito offers us Nahuatl and Spanish names and different sets of associations to both past events and present-day features, some areas were erased of their Nahuatl names. If the entire temple precinct had a name, we do not know it; when this site was cleared and leveled, it came to be known as the Plaza Mayor, or the principal plaza, a fact reflected in the extraordinary Map of Santa Cruz, in which it is simply named as "plaza." The indigenous neighborhoods, where Nahuatl was spoken, retained Nahuatl toponymy, by and large, and the associations that residents had with those names await study.

CONCLUSION

This chapter has taken stock of the extraordinary events unfolding in the two decades after the Conquest, as the once-evacuated island was repopulated and its urban rhythms reestablished. Other histories of the city have told of the actions of the group of Spaniards resident in the city's center, but I have focused on the presence of the indigenous rulers in the city, arguing for their importance in getting the city up and running during this time. Key to the city's success was the functioning of its markets, particularly the great Tianguis of Mexico that was reestablished in the island's southwest corner, allowing the city once known as Tenochtitlan to reclaim its position as a market hub.

While the reclaimed market was an indigenous bulwark, other spaces of the city were being claimed, and marked, by the Spanish conquistadores who lived in the city center. Most important was the feast of San Hipólito, marking the surrender of Cuauhtemoc and the fall of Tenochtitlan as an indigenous city. Spanish-led processions out from the Plaza Mayor followed the city's main causeway, formerly the main processional axis of the Mexica city. Practices give meaning to spaces, and with this yearly commemoration, the causeway that had once been the roadway upon which victorious Mexica armies returned home was now the route upon which Spanish conquistadores celebrated their military triumph.

Names were one vehicle for conveying the presence of the new Spanish ruling class in the city, but they were also a way of remembering its complicated past. In Sahagún's psalm quoted above, the conquered space is denoted "New Spain," showing us that naming could also offer the possibility of introducing an idealized landscape onto the foreign ground. However, the early Spanish residents were not the only dreamers. This task of conceiving a new representation of the space of the principal city of a country now called "New Spain" fell also to the indigenous nobility, and in the next chapter we will look at their role in imagining the city.

Huanitzin Recenters the City

While the island that Mexico City occupied was one space, its peoples lived under overlapping political jurisdictions, whose roles and powers shifted over the course of the sixteenth century. The Spanish *cabildo*, discussed in the last chapter, claimed domain over the central area and had jurisdiction over its Spanish residents, although it aspired to much more; surrounding it were the peoples and territories of the four parts, or *parcialidades*, that together were called Mexico-Tenochtitlan; to the north was Santiago Tlatelolco (see figure 4.2). All three centers boasted the same nexus of commerce, governance, education, and worship. (For the purposes of clarity, I'll refer to the two indigenous zones as Mexico-Tenochtitlan and Santiago Tlatelolco; I will refer to the larger urban constellation as Mexico City. Further nuances of the names for the city will be explored in chapter 7.) Both Santiago Tlatelolco and Mexico-Tenochtitlan had historic roots as pre-Hispanic *altepeme*, and both were products of strategic alliances between indigenous governors and the Franciscans.

As we saw in the last chapter, key in the city's post-Conquest reestablishment were the indigenous rulers who headed the indigenous *cabildo* of Mexico-Tenochtitlan and bore the title of "gobernador." Many of the *gobernadores* who followed don Juan Velázquez as ruler of the indigenous city, as seen in the genealogy in figure 4.7, were members of the Mexica royal house, and while their pre-Hispanic forebears once ruled an entire empire from their urban seat, after the Conquest they would move in a more restricted orbit around the city. In many histories of the city, they are barely mentioned, but as we saw, they played

a crucial role in rebuilding the indigenous-majority city. Continuing with construction projects like the ones initiated by Tlacotzin in 1522–1525, these rulers would build their government building (*tecpan*) near the Franciscan convent by the beginning of the 1540s; adjacent to it would be the Tianguis of Mexico, refounded in 1533 and occupying an expanse even larger than the Plaza Mayor itself. Although the office these rulers held was no longer that of the all-powerful *huei tlatoani* who had ruled the larger pre-Hispanic empire, as newly consecrated *gobernadores* they enjoyed considerable material benefits in the form of tribute goods still delivered to them by the city's indigenous population, which, following pre-Hispanic custom, were a repayment for their guardianship of the *altepetl*. But to focus only on the material trappings that the governorship brought these elites is to miss another powerful motivation for them to take on a role in the tumultuous post-Conquest period. Drawn from the ranks of the traditional ruling class, the men who would come to lead the city were educated and politically astute, their intellectual flexibility signaled by their ability to accommodate Spanish demands, particularly the all-important conversion to Christianity. It was they who would oversee the creation of a stable and productive social order in the wake of the trauma of battle. This was the great challenge that history had given to them.

So what was their vision of the city? And how did it materialize in the lived spaces of Mexico-Tenochtitlan? The actions of Tlacotzin in re-creating the great *tianguis* show evidence of conservative leadership with an added dose of self-interest, but records of his short-lived reign are

few. So instead, this chapter focuses on the first descendant of the Mexica *huei tlatoque* to be seated as *gobernador*, don Diego de Alvarado Huanitzin (r. 1537/1538–1541). Born before the Conquest, this Mexica princeling would have been imbued with Mexica conceptions of divine kingship, raised within a culture of noblesse oblige, where the ruler was father to his people, shading them like a great *ahuehuetl* tree. We find aspirations for Huanitzin's city expressed in two somewhat surprising formats: a manuscript page documenting the reign of his predecessor Moteuczoma and a religious feather painting, and these works will be the focus of this chapter.

THE ELECTION OF HUANITZIN

Huanitzin, unlike the rulers who had immediately preceded him, had impeccable Mexica credentials: he was the grandson of the emperor Axayacatl and son-in-law and nephew of Moteuczoma.[1] The Humboldt Fragment II underscores his legitimacy by showing him wearing the *xiuhhuitzolli*, the miter-like headdress that symbolized high authority, and sets him in contrast to the other rulers who followed Cuauhtemoc, who lack the headdress (see figure 4.6). Similarly, the Codex Aubin shows him dominating an entire page, folio 76v, wearing the appropriate cloak

and miter (figure 5.1). A count of his years in office, four turquoise disks, is set in front of him. In the Beinecke Map, which shows a line of five colonial-era rulers, Huanitzin begins the list, set at the top of figure 5.2, and the map's artists were careful to present him conservatively, wearing the traditional *xiuhhuitzolli*. A finely woven white cotton mantle wraps around his figure, and he is seated on the *tepotzoicpalli*, the high-backed reed seat of the *huei tlatoque*. Immediately above his figure are the four turquoise disks to show the length of his rule, similar to the depiction in the Codex Aubin. He does not appear in the Codex Mendoza, because this manuscript shows only the pre-Hispanic *huei tlatoque* along with the year count pertaining to their rule; however, a comparison to figure 1.4 shows how similar Huanitzin's portrayals are, in pose and dress, to those of Moteuczoma, his pre-Hispanic forebear.

While Huanitzin seems to first have been an advisor to the second *audiencia*,[2] or royal court, his later fortunes are intimately associated with those of another grandee, Viceroy Antonio de Mendoza, both men rising as the political fortunes of Hernando Cortés fell. Mendoza, a trusted

FIGURE 5.1. *Unknown creator, the reigns of don Diego Huanitzin and don Diego Tehuetzquititzin, Codex Aubin, fols. 76v–77r, ca. 1576–1608.* © Trustees of the British Museum.

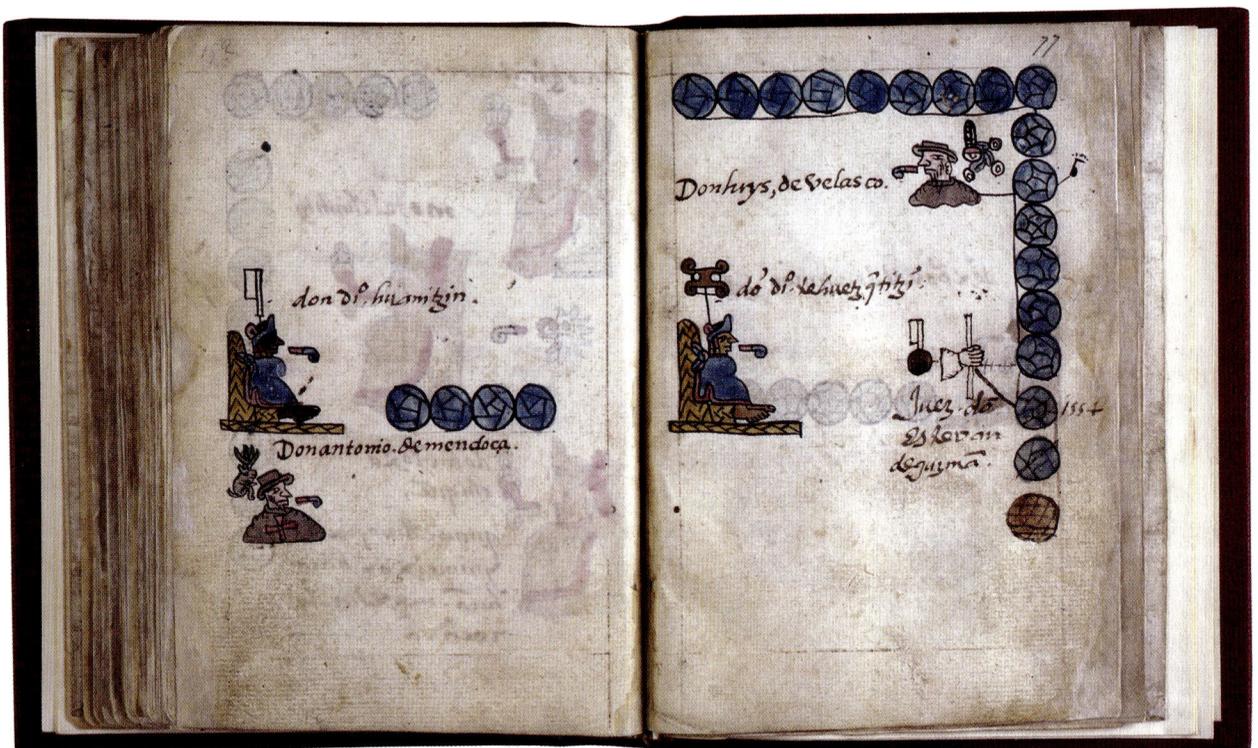

member of Charles V's court circle, was dispatched by the monarch to serve as the viceroy of New Spain, arriving in 1535. As the executive head of the government, who ruled in the king's stead, Mendoza was charged with building a centralized bureaucracy to represent the Crown's interests and to protect native charges from excessive exploitation. Unlike Cortés, who feared native rulers and did his best to undermine them, Mendoza was keenly aware of bloodline, that near-sacred Spanish ideal of *sangre*. He saw the importance of a strategy of governance that included indigenous rulers, which grew out of the second *audiencia*'s informal strategy of using native rulership in the city, particularly as a bulwark against the conquistador class.

As Mendoza entered the Plaza Mayor in mid-October of 1535, members of the local government were arrayed to meet him, including the second *audiencia*, the presidency of which Mendoza would assume, as well as the members of the Spanish *cabildo* (seated in the *ayuntamiento*), who had jurisdiction over Spanish lands in the central part of Mexico City and whose membership was drawn largely from the conquistador class. If the *cabildo* feared that Mendoza would continue to push back against their ambitions to control lands outside of the city as well as indigenous labor, as had the second *audiencia*, it was right to do so. One of his curtailments was territorial: Mendoza centralized the granting of lands in his office and limited the Spanish *cabildo*'s ability to grant lands outside of the city proper; within the city, Mendoza insisted that the *cabildo* keep a permanent record of grants in graphic form. He also stripped grants from conquistadores who failed to build on their lots appropriately.[3] But the most important curtailment was political. By once again allowing members of the Mexica royal house to be appointed rulers of Mexico-Tenochtitlan, Mendoza helped reestablish a strong indigenous authority within the city. A muscular native government offered a means of checking the power of the city's Spanish *cabildo* members, who vied with the large indigenous population for city lands, and the excesses of the *audiencia* judges, who benefited from tributary labor.[4]

Mendoza was deliberate in the reestablishment of the royal line; the year after he arrived, in 1536, the "noblemansteward" don Pablo Xochiquentzin, who had been appointed governor of Mexico-Tenochtitlan by Sebastián Ramírez de Fuenleal, died. Mendoza left the seat empty for at least a year, perhaps to better acquaint himself with the structure of the Mexica ruling house and the available candidates. Native histories are unclear on how long the seat

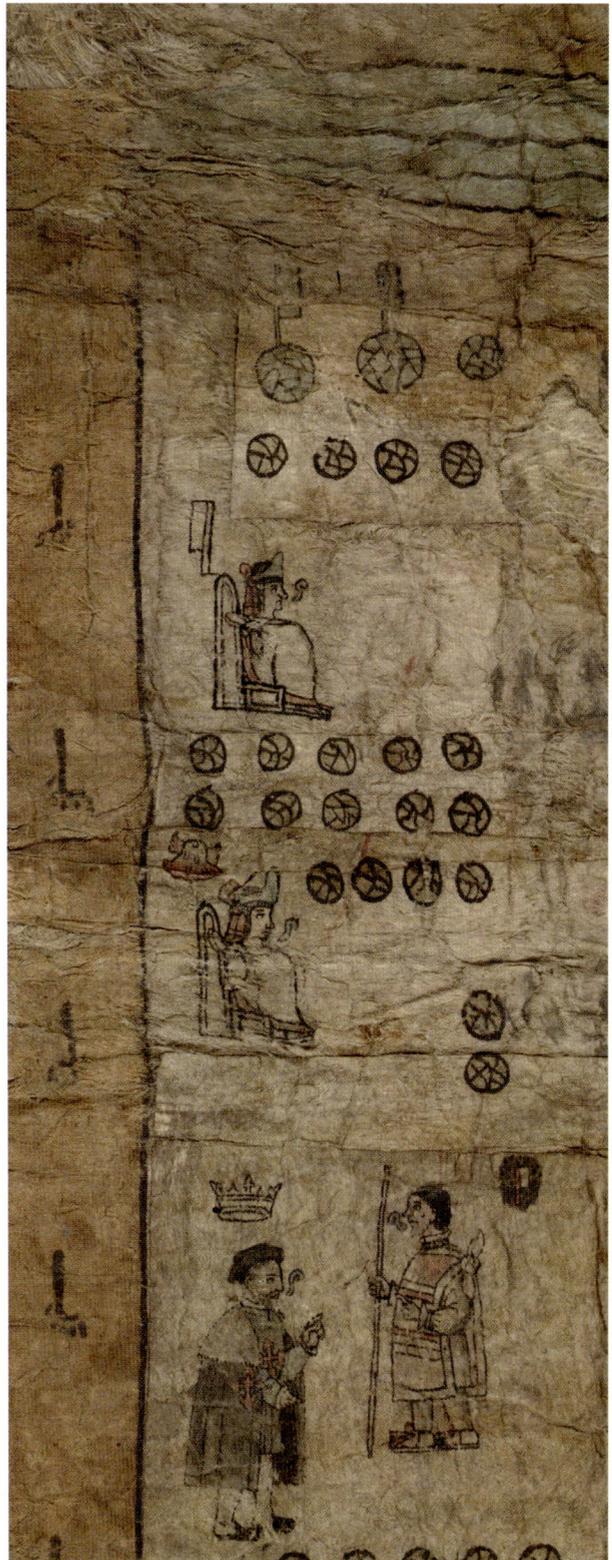

FIGURE 5.2. *Unknown creator, don Diego Huanitzin (top), don Diego Tehuetzquititzin (center), and Viceroy Luis de Velasco and don Esteban de Guzmán (bottom), detail, Beinecke Map, ca. 1565. Beinecke Rare Book and Manuscript Library, Yale University.*

remained vacant, but it seems that Mendoza's appointment of the new ruler, to whom he gave the title of "gobernador," came around 1537 or 1538.[5]

Who would the likely candidates have been? While the polygamous marriages of the Mexica elite had once produced no shortage of candidates, after the Conquest the pool would have been a limited one. It was the convention for a newly consecrated Mexica *huei tlatoani* to purge his competitors, and Cuauhtemoc, despite being named to a city under siege, seems to have behaved no differently in 1520.[6] Cortés adopted the same strategy by executing less-than-compliant rulers on the Honduras campaign. By the time of Mendoza's arrival, the best candidates (following the Spanish idea of legitimate bloodline) would have been two sons of the *huei tlatoani* Moteuczoma II, don Martín Cortés Nezahualtecolotzin and his younger brother don Pedro Moctezoma (the preferred spelling of the family name from the sixteenth century onward) Tlacahuepantli. Both survived the purges by Cuauhtemoc, but both left the city in the 1520s. Don Martín Cortés was in Spain as early as 1524 and was educated there by the Dominicans.[7] One chronicler tells us that he had the misfortune of traveling with a rival, don Hernando de Tapia, the son of don Andrés de Tapia Motelchiuhtzin, who ruled the city from 1526 to 1530, and Tapia poisoned him on the return trip from Spain.[8] Don Martín's brother, don Pedro Moctezoma, was taken to Spain with Cortés in 1528, and there he began his lifelong legal battle to maintain the prerogatives he felt were due to him by birthright, returning to Mexico only in 1541, by which point his politically formative years had been spent outside of the city. Some native sources hint that don Pedro Moctezoma was less than competent— perhaps an alcoholic—but what is abundantly clear is that his battles with the Spanish Crown consumed him, as he shuttled back to Spain, as did his son, who married a Spanish woman. Neither held a seat on the *cabildo* of post-Conquest Mexico-Tenochtitlan.[9]

In contrast, Huanitzin was an engaged intellectual and an astute politician who never, it seems, left the New World. We do not know the year that he was born, but he had survived the Conquest and also passed the even stronger acid test of his political skills, the deadly house-cleaning of potential rivals that happened on the ascent of Cuauhtemoc in 1520. And living in the Spanish camp as royal hostage from 1521 to 1525, including on the Honduras trip, gave him an opportunity to observe and to learn; it is certainly possible that he spoke Spanish as well as Nahuatl.[10] The internment during the Honduras campaign would also have allowed him to build relationships with other Mexica nobles who were also under lock and key; he would need their continued support in the actual process of governance. Upon the end of the campaign, he returned to the governorship of Ecatepec, a valley town, there joining other high-ranking native elites.[11] The daughters of Moteuczoma II whom the Spanish recognized as legitimate had been given grants of indigenous labor in the form of the *encomienda* here, and Huanitzin would marry one of their half sisters, doña Francisca. But he must also have maintained relations with powerful figures in Mexico City to be introduced to Mendoza. In the Beinecke Map of ca. 1565, it is Huanitzin who is listed as the first of the ruling line in a post-Conquest map, a choice that María Castañeda de la Paz has argued was likely meant to underscore an indigenous ruling line that was newly consecrated by viceregal authority (figure 5.2).[12]

With his ascent to the governorship of indigenous Mexico-Tenochtitlan some sixteen years after the city's conquest, Huanitzin, one of the highest-ranking members of the Mexica royal family, became like the city he ruled— shaped by a past that he was called upon to forget, and obliged to act in a place that had not been fully imagined. At the time he came to rule, Spanish colonists were growing more and more accustomed to calling the larger territory that stretched from the Atlantic to the Pacific "New Spain," a name that marked their aspirations to create a new place that carried with it the traces of their distant, transatlantic place of origin. Within Mexico City, the form of governance by *cabildo* echoed Spanish precedents. Huanitzin's project was the inverse. As the scion of a ruling family who had over generations raised the indigenous city out of the mud of the shallow lake and fashioned the island city into a sacred capital by carefully aligning its axes to the movement of the sun and the divinely saturated features of the surrounding landscape, he needed to reconstruct the elements that made Tenochtitlan such a conceptual center. His project was to create a Mexico-Tenochtitlan that maintained the latter, while contending with the irrefutable facts of its history: the city's sacred center had been taken over and made the seat of the Spanish government, and other sacred nodes in the urban fabric were being occupied by the city's Franciscans, as part of their mission to introduce Christianity to the city's indigenous residents, either by suasion or by force.

FIGURE 5.3. *Unknown creator*, The Mass of Saint Gregory, *feather mosaic, 1539. Musée des Jacobins, Auch, France.*

At the same time, he, like the *gobernadores* who followed him, needed to strike a delicate political balance between the viceroy and the judges of the *audiencia*, who protected him and the parts of the city he controlled from the more aggressively expansionist Spanish *cabildo*.

This said, the documentary record on Huanitzin and his reign is admittedly sparse, much of it cited above. We have no secure date for his accession to the seat in Mexico-Tenochtitlan. Through the 1530s, Franciscans were learning Nahuatl and setting it to the Latin alphabet; the training of native scribes followed, and early documents began to be produced in Nahuatl in the decade of 1535–1545, coinciding with Huanitzin's reign.[13] There is no known document exclusively authored by him. Thus, a rare artwork—the only one known that can be connected to Huanitzin's patronage—looms large in reconstructing the aspirations of his reign (figure 5.3). The work is an elaborate feather painting, or feather mosaic, the most highly regarded of all art forms in both pre-Hispanic and early post-Conquest Tenochtitlan.

HUANITZIN'S FEATHERWORK

The featherwork created under Huanitzin's patronage, *The Mass of Saint Gregory*, is an extraordinary one; to make it, indigenous artists took a black-and-white European printed image that had been imported into New Spain—in this case, an image of the vision of Christ that appeared to Pope Gregory I (ca. 540–604)—and copied it using feathers as their medium.[14] The work measures twenty-seven inches high and twenty-two inches wide and has been mounted on wood. As elaborated in texts and images, Pope Gregory I was confronted by a person who did not believe in the truth of the Transubstantiation, that is, that during the Mass the host is converted into the body of Christ. The pope responded by praying at an altar, at which point a vision of Christ appeared to him. In this featherwork image, the pope is at the altar with his back to the viewer, flanked by two tonsured concelebrants; the accouterments on the altar, such as the open book and the chalice in front of him, show him to have been not just at prayer, but saying the Mass. Behind the altar, we see the vision: the bleeding Christ rises from a rectangular stone tomb, the crucifix set behind him. Arrayed around the Christ are a set of twenty or so images—the arma Christi, mnemonic devices enabling the viewer to remember the events of the Passion and the Resurrection.

Because of the beauty and technical refinement of this work, it has been the object of intensive scrutiny.[15] Scholars have found a close source for it in a print created by Israhel van Meckenem around 1490 (figure 5.4); such copying from print models was a conventional way that indigenous artists made artworks for the new class of Catholic patrons and to adorn churches.[16] But most have looked at its central imagery in relation to its European printed source or its meaning in relation to papal politics, particularly the pope's promulgation of the bull Sublimus Dei in 1537, a bull that asserted in general terms the humanity of the indigenous peoples of the New World.[17] My concern here is the meaning of the work in relation both to Huanitzin's reign and to his spatial project for the city, and thus I will bracket off the fascinating discussions among scholars of European art about the meaning of the Gregorymass in its European context.[18]

The evidence connecting the featherwork both to Huanitzin and to the city comes from its unusual and singular frame; such a frame with text is not found in any European printed source of the Gregorymass. It reads: "Paulo III pontifici maxima en magna indiaru[m] urbe Mexico co[m]

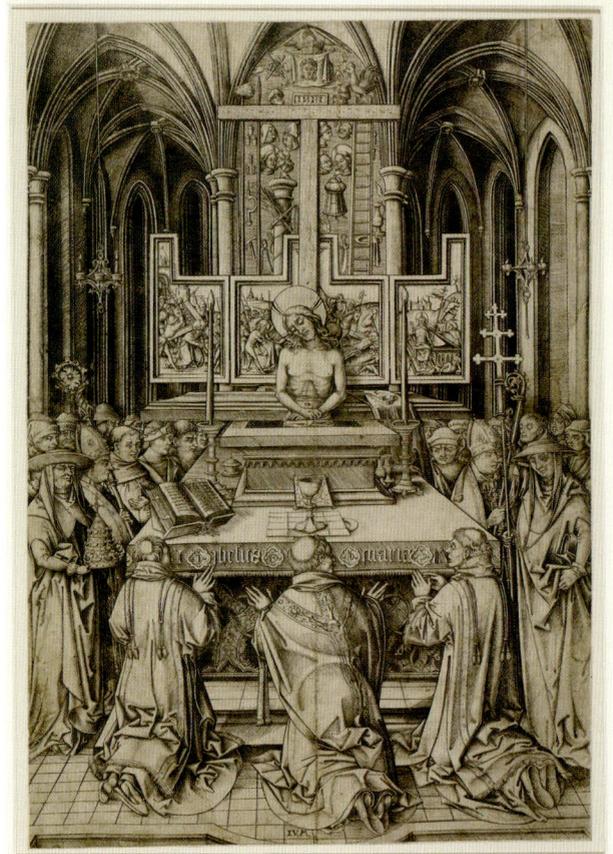

FIGURE 5.4. *Israhel van Meckenem (German)*, The Mass of Saint Gregory, *engraving, ca. 1490. © Trustees of the British Museum.*

posita d[omi]no Didaco goberna tore cura fr[atr]is Petri a Gante minoritae AD 1539" ([For] Paul III, pope, in the great city of the Indies, Mexico, this was composed [under] don Diego [Huanitzin], [its] governor, under the care of Friar Pedro de Gante, Franciscan, the year of our Lord, 1539).[19] Here, Huanitzin's name occupies the bottom border, set opposite the name of the pope, who has been assumed to be the intended recipient of this Mexican-made gift, an assumption underwriting the insertion of the initial "[for]" into the translation, a word that does not appear in the Latin text. The bottom line of text names Huanitzin as having "composita" the work, rather than "created" it, likely to signal his patronage rather than any original artistry.

Given that in 1539, the year of the work's creation, the city on the island had various intersecting identities (viceregal capital, indigenous *altepetl*, Spanish *ciudad*) and its political jurisdictions were still being sorted out, its name—what to call this city—was an unsettled affair. Thus the particular choice of words used to name it on a work associated with

Huanitzin is significant and offers us some notion not only of how he represented his domain, but also of the larger spatial horizon against which he set it. The framing text is written in Latin capitals, a text that commands the viewer's attention. Its use of overlapping letters is typical of engraved inscriptions on architecture, texts set prominently into the façades of buildings that commonly state patronage and date of construction. This "architectural text" along the edge of the featherwork describes the city over which Huanitzin ruled as "magna indiaru[m] urbe Mexico" (the great city of the Indies, Mexico). The use of the name "Mexico" is significant. At the time the work was made, Huanitzin held sway over only a part of the island city, the indigenous lands set around the Spanish-dominated nucleus, and this ring city was often referred to as "la gran ciudad de Tenochtitlan Mexico" or "la gran ciudad de Mexico Tenochtitlan" in other texts of the 1530s.[20] In contrast, "Mexico" could mean the entire island, encompassing both indigenous and Spanish political jurisdictions alike, as we will see more fully in chapter 7. It is this more expansive name that the featherwork employs, a "great city" that takes its name from the ethnic "Mexica" moniker. Significantly, the text does not use the term "Tenochtitlan," the name of the pre-Hispanic city. Moreover, the text also situates the city not in "New Spain," a name that implied its derivative European nature as well as its political identity as the seat of the viceroy of New Spain. Instead, the city of Mexico here is set against the horizon of the entire field of Spanish territories in the New World and beyond, as "the Indies" would be used also to describe Spain's foothold in Asia after midcentury.

The linkage of the text "magna indiaru[m] urbe Mexico" to Huanitzin as governor can be seen as a push-back against the aspirations of the Spanish cabildo to control the entire island, including the spaces of Mexico-Tenochtitlan; it also avoids situating that city within viceregal "New Spain," a political space under the control of the Spanish royal government, headed by the viceroy and the Real Audiencia.[21] The ambition to create a "magna indiaru[m] urbe Mexico" would be shared by the other figure named along the left side of the frame, the Franciscan Pedro de Gante, in residence in the San Francisco monastery from the time of its founding in 1525, who would be keenly aware of European ideologies of the "urbe." While the Franciscan projects for the city ran parallel to, and often intersected with, those of Huanitzin and other native gobernadores, they will be treated separately in the chapter that follows. If this work can offer something of how Huanitzin and Gante thought of the city in terms

of a magna indiaru[m] urbe Mexico, we have yet to discover the full extent of their vision, as captured in the featherwork as a representation of the urban space. Taking into account the spatial valences of featherworks, and reconsidering the status of this one as a gift from the perspective of Mexico-Tenochtitlan, this featherwork will reveal itself as a multifaceted representation of the city.

THE FEATHERED ICON AND THE GIFT

To the Mexica viewer and maker, import lay in the feather medium; in the pre-Hispanic period, feathers signified the spatial expanse of the tribute empire. And like other such feather paintings created in the colonial period, this one was created through the laborious application of thousands of feathers, often the brilliant plumage of birds that had been imported from the tropics, onto a paper substrate to create bold fields of color, or, as in this case, images. An indication of its importance is signaled by the Florentine Codex, which devotes long passages of its Nahuatl text to the art, as well as pages of illustrations, revealing the intricacies of an art form achieved only through extensive training.[22] Colonial observers could be unstinting in their praise of Mexica artists, and certainly were so for featherworkers, in particular for their ability to copy work with unerring precision.[23] Feather workshops were a common sight in the city at least through the 1570s; the writers of the Florentine Codex, created around 1570, declare that "whoever would like to see [the particularities of the craft] and understand them, will be able to see them with their own eyes in the houses of the craftsmen, which are in all areas of this New Spain, doing their craft."[24]

Other writers have analyzed the relationship of feathers to the sacrificial imagery depicted here and the solar qualities of the plumage; our interest, however, is in the spatial connotations of the featherwork.[25] It is likely that this featherwork The Mass of Saint Gregory came not just from the city named in its frame but from the very part of the indigenous city that was emerging as a new center in the 1530s, oriented around the monastery of San Francisco and the great Tianguis of Mexico (see figure 4.2). The presence of this craft specialty in this area of the city is signaled by a comment made by the Franciscan chronicler Torquemada, who mentions that San Francisco was built on "Moteuczoma's aviary," which may have been part of the garden complex that appears in the southwest of the city in the 1524 map that accompanied Cortés's Second Letter (see

figure 1.11).[26] This "aviary" may have been not a pleasure garden, but a holding pen for the most exotic birds to be used in featherworks. The Florentine offers another clue for locating the feather workshops in the city, saying that the featherworkers and the temple to their tutelary deity clustered in a neighborhood called Amatlan. Colonial records reveal no district named Amatlan in Mexico-Tenochtitlan, but a closely related name is that of Amanalco, which sat a few blocks to the southwest of San Francisco.[27] This would have mattered little to its intended recipient, the pope, but for its patrons, this featherwork may have been intimately connected to the new urban geography that was emerging in the southwest of the city. Within these feather workshops, elite featherworkers registered expansive creative agendas, well known in other works of early colonial art, where, within the framework provided by Christian iconography, they created works that were meaningful within older visual systems and material hierarchies.

The framing text begins with the name of Pope Paul III (r. 1534–1549), and while the text could be interpreted as a simple statement of papal domain over Mexico, it is more likely that the featherwork was intended as a gift, because it was sent to Europe at some point and is now in a European collection; scholars suspect it never reached its intended recipient.[28] Nonetheless, affixing his name to the frame of the sacred image, setting it opposite to that of the pope, Huanitzin also showed his embrace of Christianity, a testament of indigenous acceptance of the faith in the patronage of a work that adhered to orthodox iconography.

It is useful, also, to situate this work among other gifts sent to Europe traceable to Mexica leaders. Before the Conquest, as we saw in chapter 3, Mexica leaders often impressed lesser leaders through asymmetrical gifting, that is, presenting an inferior with a work he would be unable to reciprocate and thereby giving a public and social face to an otherwise intangible power relationship. At the time of the Conquest, Moteuczoma II, Huanitzin's father-in-law, engaged in such asymmetrical gifting on a number of occasions: upon hearing of the arrivals of the foreigners upon the Veracruz coast, he sent shields and featherworks, as well as a great "sun" of beaten gold and a "moon" of silver.[29] These gifts, in turn, were sent by Cortés to Charles V as evidence of Moteuczoma's subservience; once in Europe, they took on different meaning, becoming a measure of the extraordinary riches that a conquest, if successful, would yield. When witnessed by the artist Albrecht Dürer in 1520 as they were displayed in Brussels, he saw them as an indication of exotic craftsmanship, writing that "amongst them [were] wonderful works of art, and I marveled at the subtle ingenia of men in foreign lands."[30]

In their original Mexica framework, however, such extravagant gifts were gestures of excessiveness, meant in native terms to overwhelm the recipient, such goods materializing social relations in acts of competitive generosity.[31] In describing an earlier act of gifting to the Mexica *huei tlatoani* from the equally powerful ruler of Tetzcoco, Nezahualcoyotl, the Dominican historian Diego Durán wrote, "Nezahualcoyotl offered gifts: these were according to the position of the giver and that of the person for whom they were destined, and although the Relación, the written history [Durán's source for the information, also called the Crónica X], does not mention this, these presents were never less than gold jewelry, precious stones, ear ornaments, lip plugs, exquisite featherwork, shields, weapons, mantles, and beautifully worked breechcloths."[32] The Durán account first and foremost emphasizes the gift as a reflection of the giver, as well as revealing that the featherwork would have been among the expected items in such an elite gift. As such, the gifting of *The Mass of Saint Gregory* was an asymmetrical exchange, as the pope, as far as we know, had sent nothing to Huanitzin, and certainly nothing of such value and artistry. Huanitzin proclaimed his patronage in his name set boldly at the bottom of the frame.

The choice of a feathered work was not insignificant, especially one in which the thousands of tiny feathers were set on the surface to create, on one hand, the broad shimmering field of blue that creates the background, and on the other, the detailed parts of the image, like Gregory's surprised fingers, or the downward cast of Christ's eyes. The anthropologist Alfred Gell has discussed the "captivation" that such images exert on their viewers in the following terms:

> Where [works are] . . . made with technical expertise and imagination of a high order, which exploit the intrinsic mechanisms of visual cognition with subtle psychological insight, then we are dealing with . . . artifacts which announce themselves as miraculous creations. The "coming into being" of these objects is explicitly attended to, because their power partly rests on the fact that their origination is inexplicable except as a magical, supernatural, occurrence.

The attention that viewers pay to the miraculous artifact, Gell continues, "traps" them in a "logical bind" between

the ordinary, known world, "in which objects have rational explanations and knowable origins, and the world adumbrated in the picture, which defeats explanation.... This is captivation, the primordial kind of artistic agency." In the example of Trobriand canoe prows that Gell examines, he argues that these captivating objects were used as weapons when making overseas exchanges, "[demoralizing] the opposition because they cannot mentally encompass the process of its origination, just as I cannot mentally encompass the origination of a Vermeer."[33] Huanitzin would have known the attraction that feathered objects held for Europeans, with Cortés sending back shipments of feathered shields as early as 1522, and the attraction that the Mexica themselves had for feathered works, particularly feathered clothing, which points up their power of captivation on both sides of the Atlantic.[34] So not only was Huanitzin sending the pope a gift of overwhelming generosity, but its extraordinary manufacture marked it as one of overwhelming visual power.

In the featherwork *The Mass of Saint Gregory* we have begun to perceive how Huanitzin imagined New Spain, or rather, his domain, the great city of the Indies, from where he could dispatch captivating and extravagant (and perhaps even humiliating) gifts to an overseas pontiff. Its orthodox central iconography also offered a testament to his acceptance of Christianity. At the moment of the creation of this work, Huanitzin had particular reason for making public statements about his devotion as a Christian. Around the second year of Huanitzin's reign, Bishop Juan de Zumárraga, a Franciscan appointed to the highest religious post in the New World, was in the midst of a widespread anti-idolatry campaign. Many indigenous elites fell under suspicion of continuing in their old ways, and one of those accused, although never questioned by inquisitors, was Huanitzin himself.[35] After scores of interrogations, Zumárraga's investigation zeroed in on the ruler of nearby Tetzcoco, don Carlos Ometochtzin, who descended from Nezahualcoyotl and Nezahualpilli, the lords pictured in figures 3.2 and 3.3. Accused of the worship of pagan idols and of engaging in an adulterous and incestuous relationship with his niece Inés, don Carlos was found guilty and hauled to the Plaza Mayor of Mexico City for an auto-da-fé on November 30, 1539, a public spectacle that commanded the presence of the leaders of the native governments of Mexico-Tenochtitlan and Santiago Tlatelolco as witnesses. Huanitzin was thus one of those who heard the charges against his peer

proclaimed in both Spanish and Nahuatl; don Carlos was executed the following day.[36] While a group of Tlaxcalan elites had been executed for idolatry some ten years before, this was the first high-profile execution of a member of the native elite nobility, a man as well connected through family ties to other Nahua elites in the Valley of Mexico as the Habsburgs were interconnected in Europe. As Huanitzin's cousin by marriage was burned at the stake, Huanitzin's public acceptance of the Catholic faith and his display of that affiliation became both a political and a mortal necessity. It is in this year that the feather painting is dated.

As tempting as it may be to read the framing text as a secondary decorative element added to the central image, this response is likely a product of our modern response to picture frames as ancillary to the central work. It is worth recalling that somewhat later in the colonial period, picture frames were often more valuable than the works they held. In the indigenous context of the sixteenth century, frames were essential in providing key temporal and spatial contexts for the interior image. If we return once again to folio 2r of the Codex Mendoza, we see two frames. The first is an outer frame of fifty-one year counters to suggest a correlation between the length of Tenoch's rule and the near-sacred cycle of fifty-two. The second is an inner rectangular frame that is meant to be read as an abbreviated version of the water-surrounded island; it also establishes the outer boundary of the quadripartite space that connects, as we have seen, the city of Tenochtitlan to the sacred quincunx template (see figures 1.3 and 2.5). These frames are essential for interpreting the central image. In a similar fashion, the frame of the featherwork also establishes both space (*magna indiaru[m] urbe* Mexico) and time (AD 1539) for what unfolds in the central field. And what does appear is a miraculous vision of the crucified Christ. From the vantage of Catholic theology, of course, the coincidence is perfectly plausible given that the Christ is believed to be present wherever, and whenever, the Mass takes place. This framing of the sacred presence of the Christ within the city of Mexico, it must be emphasized, appears on a portable object. Thus, its patrons, named as Huanitzin and Pedro de Gante, projected their vision of the city outward toward an intended European and Christian public. By locating the presence of the Christ within a space identified as Mexico, Huanitzin and Gante thereby offered to the pope a vision of a decentered Christianity, with the Christ as equally present in Mexico as in Rome.

THE *TECPAN* AND THE
IMAGE OF THE RULER

The featherwork offers us an image that Mexica elites were projecting across the Atlantic and toward a European public. But they were also turned inward, toward their city, to the less glamorous (and less public) activity of rulership, activity most present to the urban historian through monumental architecture. Huanitzin was no different, and one of the most important actions of his reign was to build a *tecpan*, or government palace, a building that embodied indigenous authority for a local public, as well as an international one.

This *tecpan* was built on a plot facing the great Tianguis of Mexico and seems to have been constructed around 1541, the start of construction coinciding with, it seems, the very end of Huanitzin's reign. The date for the construction of this palace is inferred from the Map of Santa Cruz and a mention in the actas of the *cabildo* (see figures 2.8 and 4.8). This map has typically been dated to ca. 1555, based on its receipt in Europe; in the cartouche at the side, the Spanish royal cosmographer Alonso de Santa Cruz presents it as a gift to the Holy Roman Emperor Charles V. Charles's abdication in 1556 has served as the map's *terminus ante quem*. However, Edward Calnek has argued for an initial creation date of between 1537 and 1541, and close examination of the evidence from within the map shows two phases of the map's creation, one taking place before 1537 and the other, whose additions are clearly visible, taking place after. This reworking is typical of indigenous maps of Mexico City. In the first phase, buildings were sketched on the pale ground of the map, and paint was applied around them, leaving the buildings unpainted. This first phase included the central church that is named as an "iglesia mayor," as the Cathedral of Mexico was often called. In the second phase, buildings that had been added were made directly (and selectively) on the already-painted ground of the map and thus appear brown. Among the second-phase additions was the church of Santa Catalina, where construction, as Calnek points out, began in 1537; not included on the map is the Convent of the Concepción, which was begun in 1541.[37] Thus the first phase seems to antedate 1537, but it is no earlier than 1533, because the *tianguis* is shown in its post-1533 location. The second phase was carried out after 1537 and before the start of construction of the Convent of the Concepción in 1541.

The *tecpan* does not appear on the Map of Santa Cruz, suggesting that construction started in 1541 or after.

Instead, within the space of the *tianguis* is the hospital of San Lázaro—the traditional name given to the hospitals for lepers set on the outskirts of cities—across the street from where the *tecpan* would be built. San Lázaro seems to have been set on the opposite side of fortune's wheel as the *tecpan*; the Spanish town council records include no mention of San Lázaro after an entry of December 17, 1540, and some fifteen years later the *cabildo* registered complaints that lepers were wandering in the streets. I suspect that this hospital was torn down to make room for the new indigenous *tecpan*; a year and a half after the disappearance of San Lázaro from the *Actas de cabildo*, the *tecpan* is mentioned in the *actas* of September 1542.[38] By the time of this mention, Huanitzin had died, but the construction of the building noted in 1542 may have started during the dry season of 1541, at the end of his life.[39]

The Franciscan writer Diego Valadés would describe the architectural nexus of commerce, governance, and religion as part of the Franciscan urban project, but in his description of newly built evangelized cities, it is the indigenous *tecpan* that occupies pride of place. Valadés reports that, after justly dividing lands among the populace and giving a greater share to the indigenous nobles, the Franciscans carried out the following:

> Among these divisions, an intermediate area was reserved for commerce and the marketplace and public buildings were erected, such as the palace, which was called "house of the city," within which were a great number of patios and halls, which housed the public treasury, and where visitors were received. In the front of the building, towards the church and the public forum, there were portals on both the first and second stories. In the upper, higher, story were the senate and the cabildo, and justice was carried out. In the lower stories of more modest aspect, many dwellings and cells were to be found. Such buildings are built in the cities, of masonry and plaster, using enormous quantities of stone, and they were constructed following the models and styles of Spain. The church occupies the median zone, and is constructed with admirable art and elegance.[40]

What Valadés describes as the urban ideal could easily be San Juan Moyotlan, where the *tianguis* abutted the *tecpan*, a building that Valadés would have witnessed firsthand while living a block away in San Francisco from 1543 to 1555. What is remarkable is that he lists buildings for the indigenous governors before the Catholic church, one

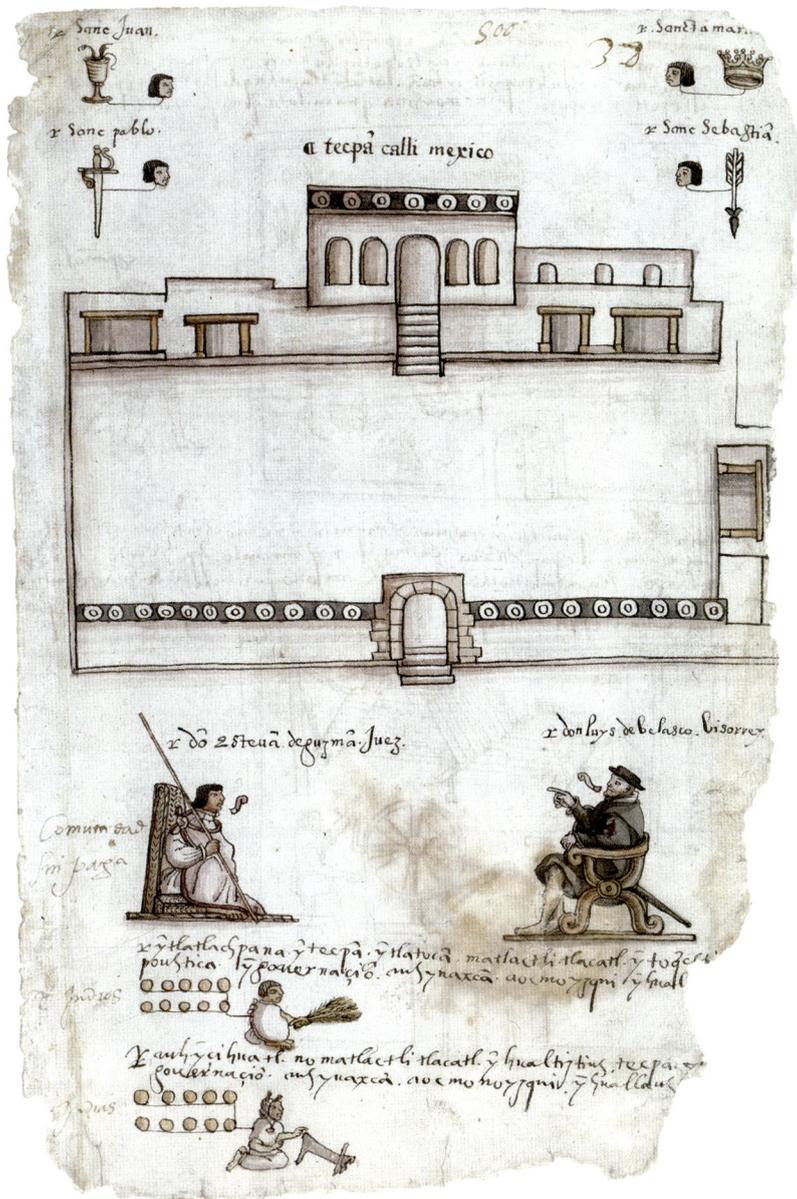

FIGURE 5.5. *Unknown creator, the* tecpan *of Mexico-Tenochtitlan, with don Esteban de Guzmán and Viceroy Luis de Velasco below, Codex Osuna, fol. 38r, ca. 1565.* © *Biblioteca Nacional de España.*

small indication of the political realities the Franciscans faced in the decades after the Conquest, as allegiances with native elites like Huanitzin were crucial to the fortunes of both, there and elsewhere.

The site of the *tecpan* from its construction until the nineteenth century was at the intersection of what is today Eje 1/Lázaro Cardenas and Izazaga, near the modern metro stop of Salto de Agua, and nineteenth-century photographs show it as having an arcaded façade; a detail from an 1867 plan of the city shows it as being a large building, set back from the street line (see figure 4.10). The earliest record of its appearance is to be found in the Codex Osuna, a manuscript compiled in 1565 as part of a

complaint by the indigenous rulers against the excesses of *audiencia* members; the circumstances of its creation are discussed at greater length in chapter 7. This manuscript includes a nearly full-page image of the *tecpan*, probably after a renovation carried out in about 1555 (figure 5.5). In the Codex Osuna, the street façade of the urban palace is a long wall, which the *tianguis* maps discussed in the last chapter reveal to have been about ninety yards long. It is shown decorated with a row of twenty disks, a symbol of *chalchihuitl*, or precious jade beads, a standard decoration that marked important indigenous buildings through the colonial period and known archeologically as far away as Oaxaca.[41] The Osuna shows this wall punctuated by an

arched doorway, with its masonry construction carefully detailed—the new (to the New World) building technology of arch and keystone, which was regarded with awe by the first generation of indigenous masons to use it.[42] This doorway leads to a large enclosed courtyard, dominated at one end by the government palace, which faces eastward. As represented here, the courtyard plaza was a highly controlled space, with one entrance from the street and no marked exit, except perhaps through the back of the *tecpan* itself. The architectural habit of enclosing special spaces with low walls had pre-Hispanic roots and was seen in its fullest expression in the Coatepantli, a great serpent wall that was built around the Templo Mayor.

The architecture of this building is not completely clear from the Osuna rendering, but comparison to the rendering of the *tecpan* of Santiago Tlatelolco, which lay a little more than a mile to the north, makes the design somewhat clearer (figure 5.6). A schematic rendering of this second *tecpan* appears in the Tlatelolco Codex, a native manuscript of ca. 1565; this building had the same walled courtyard, but above its arcaded portico, there was a second story, along with a second-story porch-like space. Similar elements appear in Mexico-Tenochtitlan's indigenous palace—a large walled courtyard and two-story building, with porch.[43] In the low-built city, the tall building would have been visible from a distance.

The front wall of the *tecpan* bordered the enormous *tianguis* to the east, and thus the two-story palace was always a visible presence in the busy marketplace; we have seen how indigenous lords might tax transactions in marketplaces, and considering this, the proximity of the *tecpan* to the *tianguis* was a practical choice, as well as a symbolic one, as all the goings-on within the *tianguis* would have been visible from the balcony of the two-story *tecpan*. Taking stock of the emergent indigenous city in 1541, twenty years after the Conquest, we see a shift of power toward the *parcialidad* of San Juan Moyotlan. Joining the great market there was the *tecpan*, then under construction. Nearby was the great chapel of San José de los Naturales, part of the complex of the monastery of San Francisco that had been moved there in 1525, and together these created a new center of gravity in the city. Their siting in Moyotlan gave them historical pedigree as home to Yopico, the *tlaxilacalli* that had been settled by one of the originating migrating clans of the Mexica and the temple that was the final stop on Mexica coronation rituals.

Almost certainly, the election of Moyotlan as preemi-

FIGURE 5.6. *The* tecpan *of Santiago Tlatelolco. Author drawing after* Codex Tlatelolco, *sec. 5.*

nent was meant to check the interests of other powerful clans of indigenous elites in the city. The parceling out of the different sections of the city to different indigenous elites effected under Cortés left the *parcialidades* in the hands of different indigenous families who built their respective palaces, as did the family of Juan Velázquez Tlacotzin, whose home was adjacent to the early *tianguis* also in Moyotlan (see figure 4.2).[44] Later lawsuits tell us why location was so important: in the pre-Hispanic period, the urban *altepetl* customarily supplied tribute labor to the leader (*tlatoani*) of the *altepetl*, and these patterns endured; establishing oneself as a *parcialidad* leader meant access to local labor. One such competitive clan was the Tapia family, who descended from don Andrés de Tapia Motelchiuhtzin, who had briefly been *gobernador*. His son, don Hernando de Tapia, was an interpreter for the *audiencia*, a position that gave him access to Spanish Crown officials, and at his death, he was a wealthy man.[45] He lived in a large urban palace in San Pablo Teopan that appears on the Map of Santa Cruz.[46] The ability of post-Conquest *gobernadores* to command indigenous labor is revealed in a lawsuit of 1576, after the powerful don Hernando died, when the community of San Juan Moyotlan charged that they had built a large palace for the Tapia family when Motelchiuhtzin, don Hernando's father, was governor (1526–1530) on the understanding that this was a community building, not one to be passed down to the Tapia heirs; the wealthy Tapia family countered that the building was, and always had been, their family palace.[47] The Map of Santa Cruz shows another urban palace in Teopan, this one belonging to "don Pablo,"

likely the palace of the third post-Conquest *gobernador*, don Pablo Xochiquentzin.[48] Another potential political force was don Pedro Moctezoma Tlacahuepantli, the son and heir of the pre-Conquest *huei tlatoani*, who was from San Sebastián Atzacoalco and died in his palace there, which was adjacent to the church.[49] Thus, by moving the center of the city to San Juan Moyotlan, and marking that spot with a *tecpan* that was and would continue to be an official building, not elite property, Huanitzin made clear the city had a new center.[50]

What was the ideological valence of the new *tecpan*? We can determine something of what it meant, at least in elite circles, by looking at the context of the rare image of the *tecpan* in the Codex Osuna and comparing it to a similar building that is represented in the third part of the Codex Mendoza (figures 5.5 and 5.7). In the Codex Osuna, the building is intimately connected to the idea of just indigenous rulership as it had evolved by midcentury; below it appear two figures, neatly balanced in the composition. On the left side is don Esteban de Guzmán, an indigenous noble from outside of Mexico City who was appointed as *juez-gobernador* (judge-governor) of Mexico-Tenochtitlan by the viceroy, allowing him to act in both a judicial and an executive capacity. He held office from 1555 to 1557. Facing him is the viceroy, don Luis de Velasco. Guzmán, who was not from the Mexica elite, is represented with the authority to rule by the large staff he carries in his hand, granted to him by the viceroy. Below is the foundation of indigenous labor, the sweepers and the tortilla makers, responsible for maintaining life in the *tecpan*, and their presence will be discussed at greater length in chapter 7 in the context of the 1550s. The architecture of this new colonial *tecpan*, seat of the *gobernadores*, bears a strong resemblance to the way palace architecture is represented in the Codex Mendoza. We have seen pages from the first two sections of this book, which tell the history of the city via the history of conquests of the *huei tlatoque*, and the tribute due from conquered regions (see figures 1.3, 1.4, and 3.1). The codex dates to the early 1540s, and given the highly trained Mexica scribes (*tlacuiloque*) who worked on it, its most likely place of creation was either in the Franciscan center of San José de los Naturales or in and around the *tecpan*, as these would have been the two most prominent places of scribal production in the indigenous city in the early 1540s (see figure 4.2). While the first two sections of the book have a number of manuscript cognates, the third section (folios 56v–71r)

is entirely unprecedented. Across sixteen folios, it offers an account of the different social stations within Mexica society, as well as the different stages of life for the Mexica individual; little mention of "idolatrous" religion or sacrificial practice is made, and instead, the reader emerges with a picture of a harmonious, well-organized, and hierarchical society, at whose head is the just ruler. The Codex Mendoza's ideal of this ruler is expressed most forcefully on folio 69r; it is one of only two pages in the manuscript dominated by a single large image, the other being the foundation of Tenochtitlan in 1325 on folio 2r, discussed previously (see figure 1.3). On folio 69r, we see the pre-Hispanic palace of Moteuczoma II, with the powerful *huei tlatoani* seated near the center of the page, high up in his second-story throne room. Flanking him are rooms for various leaders from nearby cities in the Valley of Mexico (the ruler of Tetzcoco would sit at the right). A stairway leads from the throne room to the chambers on the first level, and in these are the bureaucrats who run the state, judges and generals. As if to underscore a pacific moment of the state, the chamber where the council of war would meet is vacant, whereas the chamber for Moteuczoma's council (its members are like royal judges, its text tells us) houses four men discussing the problems of the commoners gathered at the bottom to make appeals.[51]

At the moment that the Codex Mendoza artists were working on creating this image of Moteuczoma's palace in the early 1540s, the building in the city that most closely resembled their rendering would have been steps from their atelier, to be found in the newly constructed *tecpan*. Both were axial structures, with a central stairway linking two stories, unusual among the low buildings of the city. Both had large interior patios surrounded by a wall and marked by entablature decorations of rings. And both representations were connected to images of indigenous political order.

In the Codex Mendoza, the pivot of this ordered world is the brilliant turquoise-garbed figure of Moteuczoma, who had been dead for almost two decades when the picture was painted but whose figure was emerging in the rhetoric of indigenous documents as the organizing figure of the just *república de indios* (Indian republic) that existed before the Conquest. Here, the order of his rule is conveyed by the building that he inhabits. But of course, this was painted around the time that Moteuczoma had been replaced by his son-and-law and nephew, Huanitzin, who, according to images in native manuscripts, also wore the

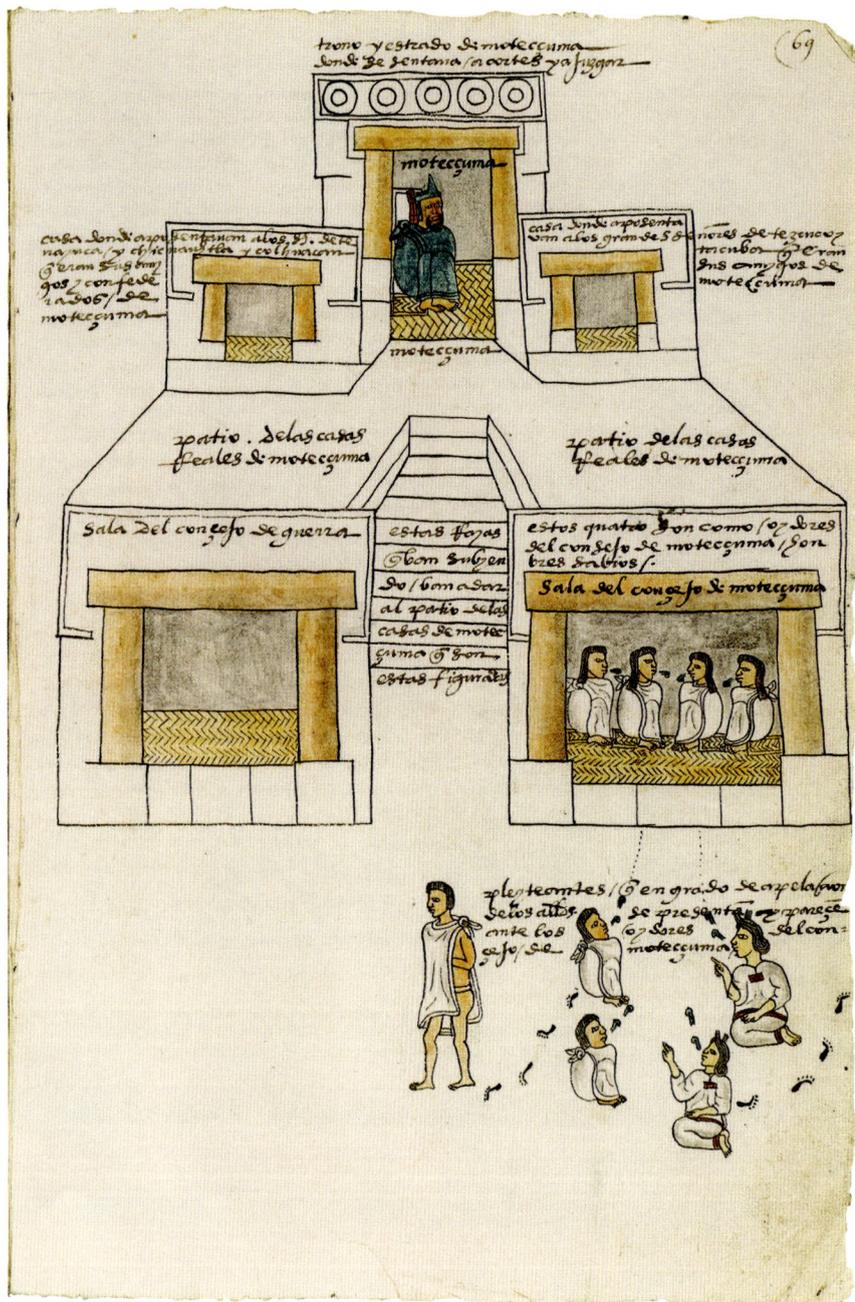

The image contains various handwritten Spanish annotations within the manuscript illustration, including labels such as "trono y estrado de moteccuma donde se sentaua en cortes y a juzgar," "moteccuma," "casa donde apesentaua," "patio de las casas reales de moteccuma," "sala del consejo de guerra," "sala del consejo de moteccuma," and "(69)."

FIGURE 5.7. *Unknown creator, Palace of Moteuczoma, Codex Mendoza, fol. 69r, ca. 1542. Bodleian Libraries, University of Oxford, Ms. Arch. Selden A1.*

imperial garb of the turquoise miter and brilliant cloak, showing his affiliation to this august line of indigenous rulership. The palace that Moteuczoma inhabits in the Codex Mendoza is a rendering of the past, but also an augur of the future, to be seen in the newly constructed and architecturally similar *tecpan*, which gave concrete and physical form in the changing city to the enduring presence of Mexica rulers.

To gauge the importance of this building within the urban fabric, it helps to recall that at the time of its completion, around 1542, there was no such equivalent palace for the viceroy in the center of the city, and there would not be for another twenty years. When Mendoza arrived in the city in 1535, he and the *audiencia* were housed in the so-called *casas viejas* (old houses), the former palace of Axayacatl.[52] And while the city's Spanish residents certainly would have orbited around the Plaza Mayor, where government functions and civic ritual took place, the vast majority of the city's residents were more likely to pass through or congregate in the southwest quarter, where the

great market with its selection of foodstuffs and goods was found. The Santiago Tlatelolco market would also have been a draw, particularly for those coming into the city from the north. In addition, the presence of San José de los Naturales and Santiago Tlatelolco, the city's two indigenous parishes, ensured that city residents were obliged to come there on Sundays and feast days as well.

Set in the indigenous nerve center of the city, this *tecpan* would have served as a billboard for the image of indigenous rulership. Two native accounts from the second half of the sixteenth century mention how the building featured a large banner showing a *tlatocamecayotl*, a list of the city's indigenous rulers, from Tenochtitlan's founders to the present, and at the base of this genealogy was the nopal cactus.[53] "Appreciated by all the people," the banner undoubtedly was set on the complex's outside wall.[54] Such a public image certainly underscored the historical legitimacy of the building's current resident, and the autochthonous nopal cactus recalled the deity Huitzilopochtli's command to found the city, and thus trafficked in the kind of public imagery that pre-Hispanic Mexica rulers had developed. It also connected the ruler's authority to this spot in the city, and after 1563 its façade seemed to offer a subtle riposte to the other royal palace within the city, this one occupied by the viceroy (see figure 4.3). This other palace was built like a fortress to protect it from a hostile public, and on its façade was written the name of a distant king, one who never set foot in his New World domains.[55]

CONCLUSION

While Huanitzin's reign was brief, he established a template to which other successful indigenous rulers of the city would adhere. The first element was acceptance of Christianity, seen in the orthodox imagery of *The Mass of Saint Gregory* that occupies the central field of the featherwork. The work's frame, linking his name to that of Pedro de Gante, testifies to his successful alliance with the city's Franciscans. Secondly, in possessing his own exalted pedigree, Huanitzin also behaved like a traditional Mexica ruler, likely wearing the garb of office that had signaled the divine election of his forebears. Within the city, he would have needed to marshal indigenous labor for new publicworks projects, like the *tecpan*, and the builders of this Mexica palace drew on a symbolic architectural vocabulary that underscored indigenous authority. And in sending extravagant (and perhaps humbling) gifts to the pope that featured wholly orthodox iconography, he set the city into a Christian, global network.

Underwriting Huanitzin's success, and kept to the sidelines through most of this chapter, was his alliance with the Franciscans, these brown-robed friars who arrived soon after the Conquest. After an initial three came, in 1524 a larger and more famous group of twelve Franciscans arrived, in number and aspiration mirroring Christ's first apostles. When Cortés welcomed the larger group into the city in June of 1524, the powerful conquistador fell to his knees, this act of submission making an impression on the assembled indigenous elites.[56] He then granted the friars a prime piece of real estate on the northeast corner of the Plaza Mayor, right on the ruins of the dismantled Templo Mayor. As a result of Cortés's favor, the Franciscans came to early dominance in the city as they quickly assumed the massive project of evangelization; in the years following them, the Dominicans and Augustinians would arrive, but their influence in the city's indigenous quarters was never as great.

By the end of May 1525, the Franciscans had abandoned their granted seat on the Plaza Mayor and moved to Moyotlan in the city's southwest, an area that Spaniard residents perceived at that moment as marginal and dangerous, but that would emerge as the nerve center of the indigenous city.[57] Keen political strategists, the Franciscans allied variously with the royal government and sometimes even with Cortés's heirs. Wherever they moved with the political currents, the Franciscans were often crucial supporters of the indigenous government as it pushed back against the ever-encroaching Spanish *cabildo* and non-Franciscan archbishops.

From their seat in the monastery of San Francisco, built a few blocks to the north of the *tecpan*, they would join with the city's indigenous residents in establishing a city of both mortar and metaphor. Like the indigenous elite, they would take up the charge to imagine Tenochtitlan anew, and they would link it to Rome, the city of Christian origin, and in this would follow the pattern of the city's Mexica founders, who had once created an idealized Tenochtitlan as the new Aztlan. Living in the monastery of San Francisco during these early decades following the Conquest was the friar named on the left margin of the featherwork frame, Pedro de Gante, founder of the great school of San José de los Naturales within San Francisco. He was a key figure in the development of the post-Conquest city, and we will turn to the Franciscan project in the next chapter.

CHAPTER 6

Forgetting Tenochtitlan

In 1579, almost a half century after the featherwork *Mass of Saint Gregory* was created in Mexico City, carrying something of the aspirations that its patron, don Diego de Alvarado Huanitzin, had for the city in its text and imagery, another representation related to Mexico City was being published in Europe by Franciscan writer Diego Valadés.[1] In the often-reproduced full-page engraving from Valadés's *Rhetorica christiana* (figure 6.1), we witness a vast enclosed courtyard meant to represent metaphorically the evangelizing project of the Franciscans, one of the three religious orders charged by the Spanish Crown with the conversion of New Spain's indigenous peoples. At center is a large architectural maquette representing the flawless primitive church, first founded in Rome, being carried into this "inovo indiarum orbe" (new world of the Indies) and borne aloft by Franciscan friars. Around them, within the vast enclosed courtyard, identified as "forum" by the top inscription, we see seven scenes of Franciscans teaching tightly packed groups of indigenous people and ministering to them during life's great passages: at bottom right, friars administer the sacraments of baptism and marriage; at top center, a burial is being held. Three more scenes of sacramental practices take place in the arcaded spaces at bottom, as we see confessions, communion, and extreme unction of the dying. The rigid symmetry of the composition, with temple at center, small domed buildings at the corners, and linear borders of trees set parallel to the perimeter walls, makes clear the order of this world and its inhabitants, as well as the spiritual authority of the Franciscans, who dominate their native charges.

This representation of space found its counterpart within the lived space of the Monastery of San Francisco, the great complex that the friars founded in 1525, soon after their arrival in Mexico City. San Francisco, like Valadés's ideal, had an enormous expanse of courtyard, its enclosing walls measuring some 200 yards by 150 yards. For all its activity, Valadés's print shows us very little permanent architecture—just the domed corner structures, the wall, and the great seven-naved arcade, where the majority of sacramental activities are concentrated, that runs along the bottom of the sheet (it has been turned outward toward the viewer to allow one to see the activities within). In its early days, San Francisco also had very few structures except for the great chapel of San José de los Naturales that lay within it, which the Franciscan chronicler Gerónimo de Mendieta described as "a chapel with seven naves, and seven corresponding altars, oriented to the east. The main altar, set at the top of steps, is in the center, with three altars on each side."[2] Within these naves, as in the image, the Mass was held and the sacraments dispensed to the enormous indigenous population of the city.

San Francisco was the nerve center of the Franciscan enterprise in the New World, not only home to many extraordinary religious men, but also a conceptual space that was symbolic of the larger Franciscan mission, whose contours are expressed in the Valadés image. The walled precinct underscored the perceived necessity of the separation of this Indo-Christian space from the rest of the world, and we see it inhabited in the print only by Franciscans and indigenous men and women. But of course, San Francisco

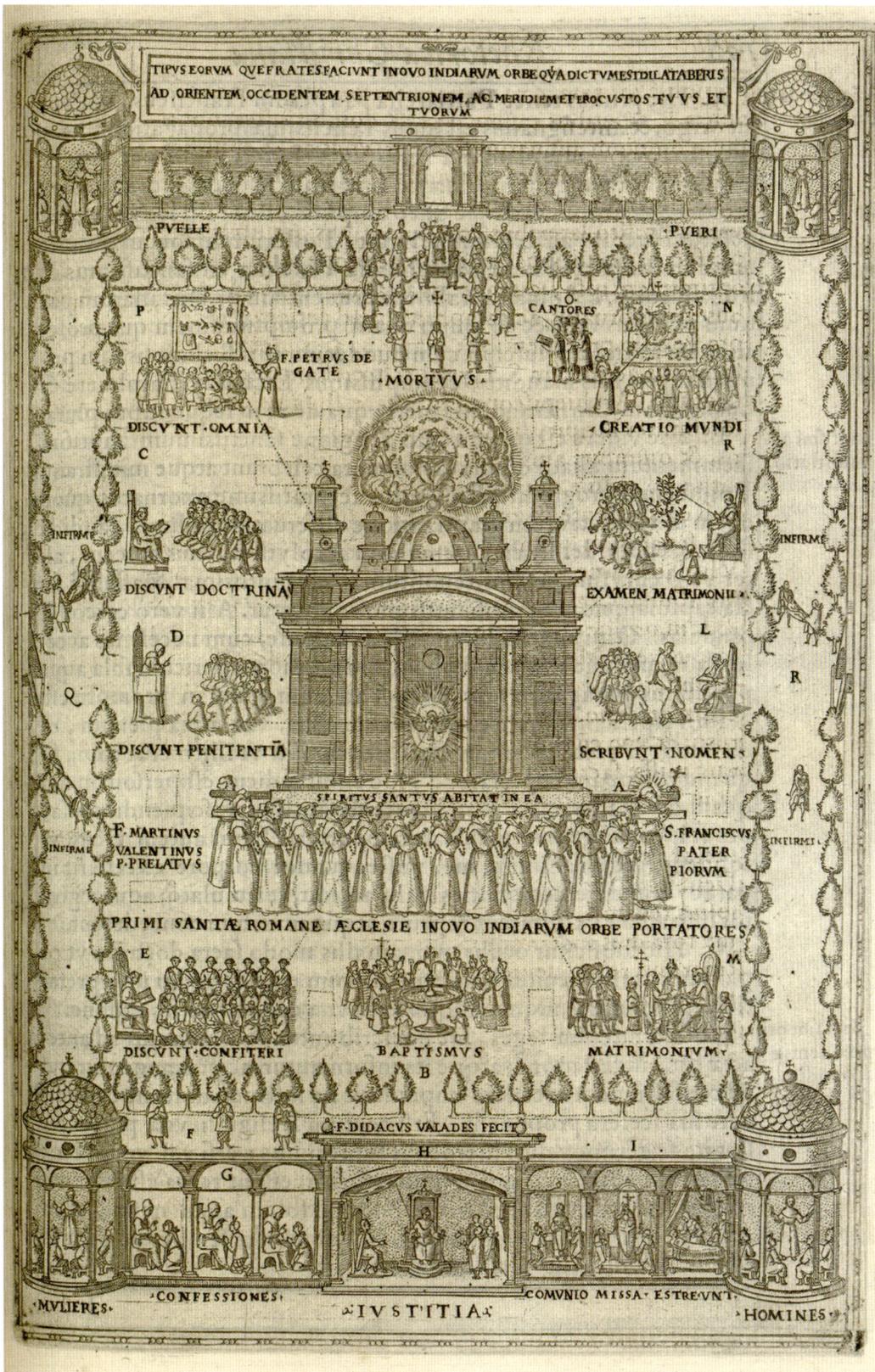

FIGURE 6.1. *Diego Valadés, the Monastery of San Francisco, from* Rhetorica christiana *(Perugia: Petrumiacobum Petrutium, 1579). Rare Books Division, New York Public Library, Astor, Lenox and Tilden Foundations.*

was never a world apart; it was just one node in the densely populated Mexico City. Nonetheless, from within its walls, Franciscans attempted to shape the city around them in its image. Their partners in the enterprise, as suggested in the last chapter, were often the indigenous elite, who were hardly the passive receiving audience pictured by Valadés, but rather had their own agendas. But this chapter centers on the Franciscans and their project for the city. It argues that they were gripped by the powerful representation of space that they found in another formerly-pagan-now-Christian city, Rome, and that they attempted to remake Mexico-Tenochtitlan in Rome's image. In the opening chapter of this book, I discussed Lefebvre's three intersecting spheres of space, and we saw the diachronic nature of lived space, as the past is continually reawakened in urban spaces through practices that range from the expressly commemorative to the quotidian. This range reflects the operation of individual human memory itself, whose powers of recall fall on a wide spectrum, on one end the intentional, on the other, the habitual.[3] The Franciscans were well aware of the powerful mnemonic pull that once-pagan Mexico-Tenochtitlan held for its residents, like the lodestone to the needle, and their efforts to remake the city entailed not only reshaping its lived spaces, but also reaching into the minds of its residents and making them forget pagan Tenochtitlan. Thus, we will be concerned not only with how the city was rebuilt in the image of Rome, but also with the model of mind and memory that allowed the Franciscans, particularly Pedro de Gante, to believe that Tenochtitlan could be forgotten and Rome remembered.

FRANCISCAN UTOPIAS

While the evangelizing project of the Franciscans was to spread through New Spain, the heart of their enterprise was in Mexico City, whose indigenous residents were assigned to a single Franciscan parish, San José de los Naturales, in 1525, just a year after the arrival of the famous twelve. Although initially given a privileged site by Hernando Cortés on the Plaza Mayor upon their arrival to the city in the spring of 1524, they made the decision in 1525 to move to the southwest and build their monastery in Moyotlan.[4] There, they would found what would become an enormous monastery, with an indigenous chapel and school, San José de los Naturales (see figure 4.2). The Franciscans' move to the southwest was perfectly in keeping with their sense of their mission in the New World:

the conversion of its native peoples in preparation for the millennium, which called them to turn away (and move away) from the corrupt world of the venal conquistadores and *cabildo* members who held sway around the refounded Plaza Mayor.[5]

However, the Franciscans' move would have appeared foolhardy to the conquistadores, who had settled in the center of the city; although it was only a few blocks, it took the friars out of the protective nucleus of Spanish power around the Plaza Mayor, out to its unstable margins, at a time when Spanish residents of the city were nervously awaiting an indigenous uprising. On this exposed urban frontier, where at night the friars could hear the noisy drumbeats and songs that they feared accompanied sacrificial rituals, the Franciscans seemed headed toward a swift martyrdom.[6]

But perhaps they were in less danger than some imagined. The Franciscans moved to the new site at the moment that most of the city's high-ranking Mexica elite were with Cortés on the long march to Honduras, which from October 1524 onward left a power vacuum in the indigenous city. And the compromised infrastructure, as well as uncertain provisioning, meant the Mexica were hardly ready to spearhead another war, or able to organize an insurrection among the surrounding *altepeme* without first repairing political relationships damaged by the war.

The Franciscan choice of this particular spot to found the large compound of San Francisco was decisive in the development of post-Conquest Mexico-Tenochtitlan. One practical reason for choosing the southwestern site was the presence of Moteuczoma's aviary and gardens in this part of the city. These areas would likely have featured large open spaces, which could be used as plazas for worship, and vacant spaces in the city's dense urban fabric here and elsewhere exerted a magnetic attraction to the Franciscans. By choosing an open site, Franciscans could avoid laborious removal and destruction of houses and buildings, which might rile the native populations. In addition, this site was close to one of the main freshwater supplies, the aqueduct from Chapultepec, and at the beginning of 1526, the Franciscans were granted their own generous allotment of water from the Chapultepec pipe.[7] One of the main canals of the city ran along the eastern perimeter of the monastery and then turned toward the west to run through the center of the convent, providing a flow of irrigation waters early in the city's history, as later maps of the city make clear. Water allowed the friars to plant orchards,

a source of food and drink; moreover, the canalizing of water through Franciscan convents seems to have been a trope, as Jaime Lara has pointed out, that evoked the flowing waters of Jerusalem.[8]

One of the first structures to be built in this space was the large open Chapel of San José de los Naturales, which was located in the eastern end of the site (see figure 6.2). In the 1550s, it was one of the largest and most elegant spaces in the city—much more so than the jerry-built Cathedral, which stood on the Plaza Mayor and served the Spanish residents of the city. As a testament to its importance, we find that the public Mass that was said to welcome the newly arrived Viceroy Luis de Velasco in 1550 was held at the Chapel of San José de los Naturales, the only space that could accommodate the city's crowds; a few years later the funeral ceremonies for Charles V were held there as well as the autos-da-fé of the Inquisition.[9] The Franciscan living quarters and church were nearby within the complex, likely in the western part of the site, but later construction has covered the traces of this early architecture, including the chapel. The southwest quadrant of the site seems to have been where the gardens were planted, taking advantage of the canal running through them; gardens continued to

thrive here into the nineteenth century, as we see in figure 6.2. This elegant map was created in the wake of the Liberal Reform Laws in the mid-nineteenth century, as urban cartographers were called upon to create detailed plans of ecclesiastic property that was to be seized by the state. Most of the dense architectural fabric we see in the plan was constructed in the eighteenth century, but some of the use patterns were established with its early sixteenth-century foundation: the concentration of architecture in the eastern part of the site (it was here that the Chapel of San José de los Naturales once stood) perhaps made use of much-earlier Mexica foundations, and the extensive orchards and gardens that dominate the southwest corner of the monastery at lower right were planted where adjacent canals once allowed a supply of irrigation water from the Laguna of Mexico as well as easy transport of produce to market.

The Franciscans imagined their monastery as the pivot

FIGURE 6.2. *Plano General del Convento de San Francisco, mid-nineteenth century. Top is oriented to the east. Mapoteca Orozco y Berro, 1459-OYB-725.C. Servicio de Información Agroalimentaria y Pesquera,* SAGARPA.

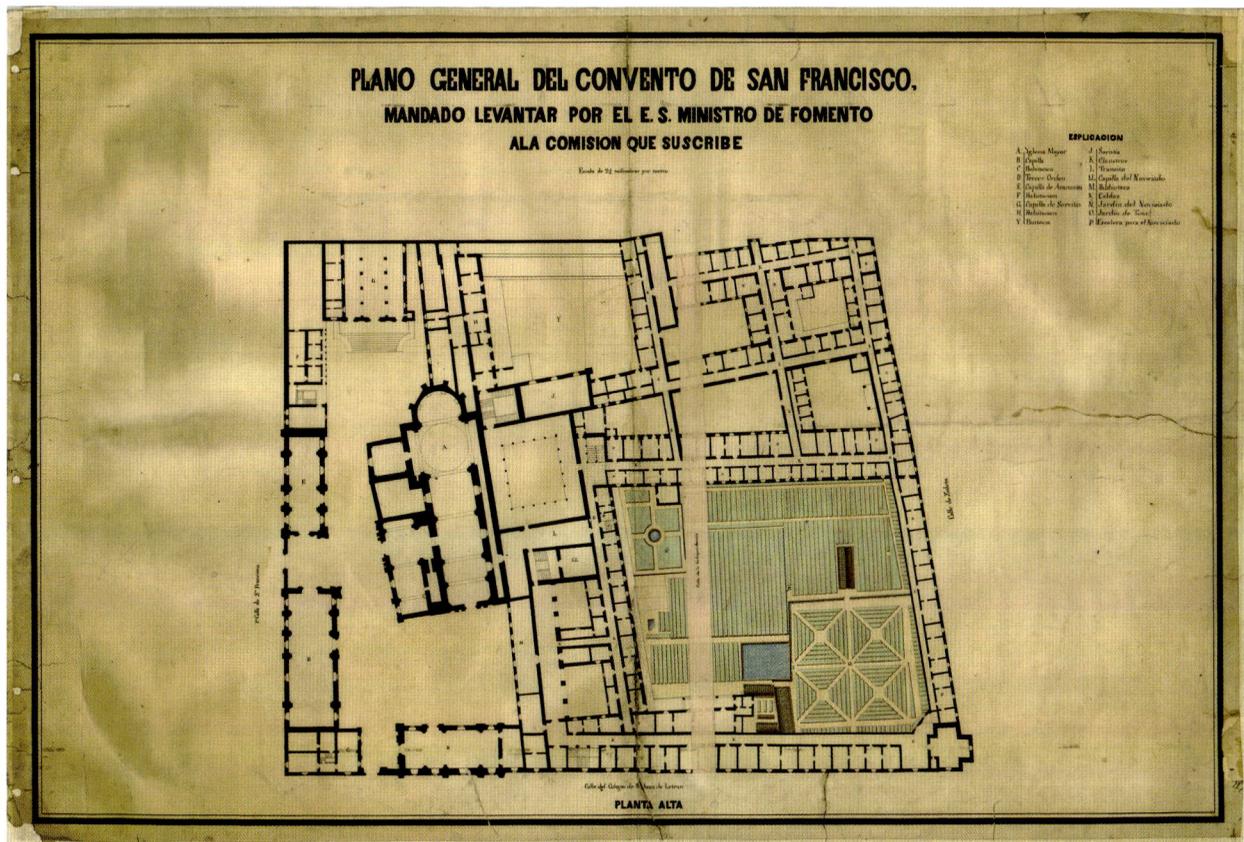

of the indigenous city, a new center in lieu of the Templo Mayor, and their project was aided immensely by the preexisting division of the city into its four component *altepeme*, which meant that urban Tenochtitlan was not structured like an atom, with a firm and central nucleus, but rather like a Venn diagram, where the center was the overlap of four autonomous units. Just like Cortés, who parceled out the city parts to indigenous lords, including don Juan Velázquez Tlacotzin, the Franciscans continued to respect the earlier structure. They established chapels in each of the four former *altepeme*, but maintained the Chapel of San José de los Naturales as the religious center of the indigenous city. In addition, dozens of smaller chapels would come to be built throughout the indigenous city and may have replaced local shrines maintained by the pre-Hispanic *tlaxilacalli*. This religious network also created opportunities for men and women within religious hierarchies. Thus the new quadripartite structure of Mexico-Tenochtitlan, where religious and political jurisdictions overlapped, carried forward and transformed the pre-Hispanic city.

Resident within San Francisco were some of the leading immigrant intellectuals in the Americas, including Pedro de Gante and Bernardino de Sahagún, who saw in the evangelization of the New World the great challenge of their age, so compelling that they would leave the security of family, friends, and comfortable employ to journey on a path that might lead—and sometimes did—to martyrdom. Within the city in the late 1530s, we can think of don Diego Huanitzin, Viceroy Antonio de Mendoza, and fray Pedro de Gante as the holy trinity of the emergent, post-Cortés city. Mendoza, although younger than Gante, was the political father of the enterprise, establishing royal authority across New Spain. With Mendoza's arrival, Huanitzin was recalled from his provincial seat of Ecatepec to be reborn as *gobernador* in the place his ancestors ruled as *tlatoque*, as we saw in the last chapter. Gante (ca. 1476/1485–1572), one of three Franciscans to arrive in New Spain in 1523, was the animating spirit. His name, which means "Ghent," marks his northern European origins (Ghent was part of Spain's extended empire in the Low Countries) and signals the international cast of the mendicants arriving in New Spain. But the bland geographic moniker does little to reveal Gante's remarkable qualities.[10] Born to a Flemish family, he was believed to be related to the emperor Charles V, the most powerful figure in Europe, as he was whispered to be the son of

Charles's grandfather, Holy Roman Emperor Maximilian. Throughout Charles's life, Gante had unique access to the emperor's ear; Gante would appeal directly to him to maintain royal support for the school of San José.[11] And upon Gante's death, Charles's son and heir, Philip II, was notified and reminded that Gante "was very close to your Christian father, and thanks to this, we [Franciscans] have been able to obtain many and great favors."[12] Gante's entry as a lay friar into the Franciscan order took him into the orbit of other powerful intellectuals: one of his companions in the New World mission was his fellow Flemish Juan Glapión, who had been *catedrático* (professor) at the University of Paris and confessor to Charles V.[13] Coming to settle in the newly conquered city just five years after its defeat, Gante was certainly among the first to occupy the newly founded monastery in Moyotlan, where he would live for forty-five years.[14] Quickly fluent in Nahuatl, he would write and publish the *Doctrina christiana en lengua mexicana* in 1553 as well as devise an ingenious "hieroglyphic" catechism for Nahuatl speakers.

Franciscan aspirations for New Spain were particularly idealist in envisioning it as comprising new Christian communities, populated only by indigenes, whose perceived lack of materialism and communal ethos made them ideal candidates for such utopias; the Franciscans' zeal in evangelizing was amplified by their belief that the conversion of the peoples of the New World was one of the necessary catalysts for the millennium, or Second Coming, when Christ would reappear in triumph.[15] But more specifically, Gante's aspirations for indigenous peoples and his regard for their capacities is reflected in the founding within San Francisco of the great school of San José de los Naturales, where he taught the sons of Mexica elites, as well as those from the surrounding regions, to read and write in Latin and the basics of the Christian faith. The school was also renowned for its training in the mechanical arts. It, like the chapel that served its new parishioners, was named after Saint Joseph, obedient and faithful husband of the Virgin Mary, as well as carpenter; the suffix *naturales* was a term that in its day simply meant "peoples of a place." In founding an evangelizing school in the ravaged city, Gante meant to put the city on a new trajectory; the utopia that was to be obtained within the walls of San Francisco through the catechizing of its youth was its future.

To create this future, Gante believed that the Mexica he gathered needed to disconnect themselves from their pagan past, as if the normal circuits of memory and remembrance

could and would be rewired. To this end, Gante took elite children into his school in San Francisco and then held them like captives, cutting them off from contact with their elders, "so that they would forget their bloody idolatries and excessive sacrifices."[16] The process of forgetting began with Gante himself. In a letter that he wrote to his fellow Franciscans in the province of Flanders in June 1529, only some six years after disembarking from Europe, he makes a startling admission: "I have forgotten my native tongue," he writes, "and thus I write to you in my new learned tongue of Spanish." He ends the letter with a closing in Nahuatl, his newest learned language: "Ca ye ixquich ma motenehua in tote[ou]h in totlatocauh in Jesu Cristo" (That is all. May he be mentioned, our God, our Lord, Jesus Christ), and adds a request that the letter be translated into Flemish and sent to his parents.[17] In forgetting Flemish after a six-year residence in Mexico-Tenochtitlan, Gante thus became like his native charges, who he believed would likewise "forget" the idolatrous history and the pagan city that was their birthright. Putting aside the question of whether one can forget a native tongue in six years, or a lifetime of religious practices over a few months, we can see that Gante's concern with memory and forgetting was not singular, as other Franciscans also wrote about how their evangelization efforts would cause indigenous people to "forget" their old practices. In place of these memories of idolatry, Franciscan evangelizers would retrain the native memory to retain Christian doctrine, using carefully constructed mnemonic techniques.

It is Gante who, along with Huanitzin, is named on the edge of the featherwork *Mass of Saint Gregory* (figure 5.3), discussed in the previous chapter. The main figure of the central field of that work, Pope Gregory the Great, may have had a particular appeal to Gante for his writings on evangelization; his work was certainly well known to Gante's disciple Valadés.[18] During his tenure as pope in the sixth century, Gregory spearheaded the evangelization of pagan Anglo-Saxon England, and in the letters he wrote to Mellitus, who was en route to England, Gregory sketched out a framework for pagan conversion that was at the forefront of the minds of church intellectuals as they faced the immense task of evangelization in the New World. The principles that he laid down offered much-needed guidance to the Franciscans a millennium later. Most compellingly, Gregory supported the reuse of shrines of a pagan religion, writing, "It is clear that the shrines of idols [*fana idolorum*] in the land should not be destroyed,

but rather that the idols that are in them should be. Let holy water be prepared and sprinkled in these shrines, and altars constructed, and relics deposited, because, as long as these shrines are well built, it is necessary that they should be transformed from the cult of demons to the service of the true God."[19] In the same letter, Gregory argued that if the shrines were not destroyed, just the idols, the former pagans would "flock with more familiarity to the places to which they are accustomed." Thus, Pedro de Gante may have been thinking about the lessons and guidance that Gregory offered in a land of novice Christians and perhaps the possibility of exchange between indigenous sacred categories and Catholic ones in sixteenth-century New Spain.

THE *RHETORICA CHRISTIANA* AND MEMORY

We know more about Gante's pedagogy, and the theory of mind that lay behind it, than that of any other priest in sixteenth-century New Spain because its principles were set down in a book written by his pupil and secretary, the Franciscan Diego Valadés. Born in 1533 in New Spain in the city of Tlaxcala, Valadés had obscure origins.[20] At about age ten, he was entrusted into Gante's care and lived in San Francisco from 1543 to 1555. Valadés learned to draw and paint there; in addition, he seems to have had a facility for language, and knew Spanish, Latin, Nahuatl, Tarascan, and Otomí. Indigenous languages were particularly useful to him after he was ordained at the age of twenty-two; he was the guardian of the Franciscan monastery in Tlaxcala, a Nahuatl-speaking region, and also worked on the northern frontier of New Spain evangelizing the Otomí-speaking Chichimecs. After some sixteen years as a Franciscan, Valadés left New Spain for the first time in his life to cross the Atlantic in 1571, when he traveled in Franciscan circles in Spain and France. By May of 1575, Valadés was in Rome, a member of the papal court, having been elected the General Solicitor of the Order.[21]

While in Rome, Valadés decided to write a book, the *Rhetorica christiana*, part instructional manual, part history, with the stated aim of making accessible the large body of work that existed on both rhetoric and mnemonic techniques for preachers, who might be prevented from acquiring the necessary books themselves due to their poverty.[22] In the work, he synthesized ideas about rhetoric and memory drawn from both classical (Cicero, Diomedes)

and Christian thinkers (Saint Thomas Aquinas, Ramón Llul) as a guide for the Christian orator.[23] For instance, he instructs the reader that there are two kinds of memory. One is natural: "Natural memory is that which has been imbedded into our minds and has been born at the same time as thought itself; it is one of the virtues of the soul that it can return to past things, to measure via them future things." The other is artificial: "Artificial memory is that which is strengthened by certain training and a system of discipline. As such, artificial memory consists of places and images, and is amplified by means of study."[24]

This distinction between a natural memory, which is drawn from experience (I remember burning my hand in the fire in January), and an artificial one, which is not gained from direct experience but is cultivated through study (I remember the Ten Commandments), is a commonplace in classical writings on memory. In fact, Valadés copied from, perhaps secondhand, the most important surviving classical treatise on memory, the *Rhetorica ad Herennium*, whose author is unknown. Compare the original Latin passage by Valadés on natural memory (translated above): "Naturalis est ea quae nostris animis insista est, et simul cum cogitatione nata," with the *Rhetorica ad Herennium*: "Naturalis est ea, quae nostris animis insita est et simul cum cogitatione nata." Or Valadés on artificial memory with the same text—here is the *Rhetorica ad Herennium*: "Artificiosa est ea, quam confirmat inductio quaedam et ratio praeceptionis," and here the original Latin of Valadés: "Artificialis est ea quam confirmat inductio quaedam, et ratio praeceptionis."[25] Valadés, like the *Rhetorica ad Herennium*, goes on in his text to outline the specific exercises that one can use to strengthen artificial memory, memory techniques that also fascinated other classical, and later, Christian, authors. His advice is meant both for preachers, so that they might hold in their heads entire Christian texts, and for novices who are learning the catechism.

While Valadés's rhetoric and memory texts are largely synthetic and derivative, the originality of his work is to be found in the specific examples of the application of these techniques from his own experience in the Franciscan missions of New Spain. We do not know if the Valadés book ever was put to use by preachers in New Spain or elsewhere. It was published in halves in 1579, the first half in Rome and the second in Perugia and bound together there. Few copies of this work exist today, but the copy of one of its plates used to decorate the frontispiece of the

second edition of the work of another, later, Franciscan, Juan de Torquemada, which was published in Madrid in 1723, suggests that it did have some circulation in Europe.[26]

While its impact on its contemporary audience may have been slight, the Valadés book is of great interest today, not only because it offers an eyewitness account of Pedro de Gante and his pedagogy, but also because it includes twenty-seven engravings, a number signed by Valadés; like the larger text, some of the engravings are somewhat clumsy reworkings of other prints, but a handful are unique in their depiction of specific practices in the New World. Among them is the rendering of the ideal Franciscan monastery discussed at the opening of this chapter (see figure 6.1). We can see the kind of training Valadés remembered (or perhaps imagined) from his years at San Francisco. The large open space of the courtyard, or *atrio*, is populated by clustered groups of indigenous men and women, who sit or gather at various stations of Christian instruction, where robed Franciscans tutor them on Christian sacraments—marriage, confession, and so on.

A specific connection to San Francisco is found at upper left, where Pedro de Gante points to a great cloth *lienzo*, or painting, upon which various symbols have been set, not letters or words, but mnemonic devices used to trigger remembrance in the mind of the neophyte viewer (figure 6.3). After establishing that his indigenous charges

FIGURE 6.3. *Diego Valadés, Pedro de Gante teaching in San Francisco, detail, the Franciscan Monastery, from* Rhetorica christiana (*Perugia: Petrumiacobum Petrutium, 1579*). *Rare Books Division, New York Public Library, Astor, Lenox and Tilden Foundations.*

have developed techniques for the cultivation of artificial memory through the use of images, Valadés tells us of the method that Franciscans developed to take advantage of their abilities: "The friars, having to evangelize the Indians, use figures [imagery] in their sermons that are noteworthy and previously unknown, in order to teach them the divine doctrine with greater perfection and objectivity. Towards this end, they have canvases upon which they have painted the principal points of Christian religion, such as the symbols of the apostles, the Ten Commandments, the Seven Deadly Sins, in descending order and with aggravating circumstances, the Seven Works of Mercy and the Seven Sacraments."[27] It is difficult to make out the objects on Gante's sheet, but the accompanying text tells us that they "discunt omnia" (discuss everything); some look like the arma Christi (a cloak, a sword), whose mnemonic nature dovetailed with mendicant modes of instruction. But they are more likely tools and products (a knife, a padlock), as Gante instructs natives in the mechanical arts that would be taught at San José, the school he founded, which stood, like the chapel with which it shared its name, within the larger precinct of San Francisco.

At other stations in the picture, unnamed Franciscans use similar methods of teaching via images—the friar at upper right points to more clearly recognizable imagery as he teaches the creation of the world (the image shows God the Father in a mandorla as the things of the newly created world take shape beneath him), and the friar beneath him points to a tree. Both of these tiny images are reworked as full-page images in the folios of the *Rhetorica* that follow, concordant with Valadés's goal of supplying helpful didactic materials to his readers. As Gante points to an image on the *lienzo* and Valadés describes and depicts mnemonic devices, they both reveal a particular theory of mind and memory that is worth exploring, given how it will come into play in Mexico City.

Valadés often describes knowledge as being "engraved" (*grabado*) on the mind—he shows a preacher using a pointer so that "se les graben mejor en la memoria" (they better engrave it into memory), and one of his included images is in fact an image of the human brain in cross section, with parts labeled, offering a concrete expression of the mind, created when the work's engraver took a smooth sheet of metal and cut in the design.[28] While he does not discuss forgetting, the model of the engraved mind that he proposes suggests that memory's traces can be actively removed, much as the engraver grinds down his plate, a

process very familiar to this author/artist of a book containing engraved plates.

His use of the mnemonic device also follows another model, again in classical treatises, wherein the mind is imagined as a storehouse, with the mnemonic image standing for a larger body of knowledge stored in the memory. For instance, Valadés tells his reader that to remember the Gospel of Matthew, one stores in one's mind an image of a columned building, with each of the columns of a different kind of stone, including porphyry and jasper, relating to different parts of the Gospel.[29] Such mnemotechnics were cultivated in Franciscan modes of instruction, which taught students how to create such pictorial images to store "artificial" memory—that is, ideas learned by instruction, a feat we are more likely now to term "rote memory" than "artificial," but they are much the same. This kind of teaching and mnemonic recall is commonplace in the classical-period *Ars Memorativa*, which recommends the use of constructed images to recall learned information thus stored in the warehouse of the mind. Most important in these exercises, and carried through to Valadés, is the construction of imagined spaces in which to lodge the mnemonic image—a spatialized practice that has been described as building "a memory palace." In fact, both memory storage and memory retrieval dealt with architectural spaces—the model of the warehouse and then the constructed "space" of the memory palace used in recall.

This brief introduction to ideas of mind and memory that Franciscans like Pedro de Gante and Valadés carried with them in the New World, particularly in memory that was envisioned as a broad space that could be stocked with images and a mind that is like an engraver's plate, is important to help understand their efforts at making Mexica forget their perceived idolatry and their concern with the urban spaces of Mexico City that, like the constructed memory palace, held the traces of these earlier (and now forbidden) religious practices. Because of this model of mind and memory, the Franciscans' reconstruction of the Mexica city happened on two fronts, interior and exterior. They would erase (*borrar*) the memories of idolatry from the minds of the city's residents, like a writer "unmakes the characters and figures formed on paper, or canvas, or another material"[30] or a craftsman grinds down a metal plate in preparation to re-engrave it. Using words borrowed from the printing process, Valadés intended to engrave these minds (*grabar*) with new, Christian teaching, learned in schools like San José, at the same time that

he reacquainted these minds with the goodness of God, a knowledge that was already imprinted on the soul. On the exterior, they would destroy the idolatrous shrines and temples, which carried the memory of past belief, from the spaces of the city. And they would then inaugurate a new Christian city, whose consecrated spaces could lead to knowledge of the true God.

ALLEGORIES OF ROME

This two-level project is made clear in Valadés's image of the courtyard, where, as we have seen, the interior actions of erasing/imprinting of minds are shown in the teaching of the gathered neophytes, a process parallel to that of engraving. At the center of the page, another image, an allegorical one, signals the exterior process of reshaping the sacred spaces of the Indo-Christian city (figure 6.1). Here, twelve men in the Franciscan habit line up along one side of a large maquette of a circular temple, bearing it upon their shoulders, and two more friars appear at front and back of this architectural palanquin. Two of the figures supporting the palanquin are identified in the text: the leading figure is Saint Francis himself, and bringing up the rear is Martín de Valencia (ca. 1474–1534), who headed the Franciscan order and the initial phases of the mission from his arrival in 1524, the year after Gante, until his death. He was prior of San Francisco in its earliest years, until moving to Tlaxcala in 1527. The other twelve figures are unnamed, but certainly are meant to represent the group of twelve Franciscans arriving in New Spain in 1524, the apostolic mission whose number echoed that of Christ's own apostles. The presence of Saint Francis as the leader of this group signals that this imagining is meant to show us an allegory—rather than a real event—of the mission into New Spain.

The architectural maquette that rests on their shoulders was likely inspired by architectural prints that Valadés saw in Europe, but seems to be providing an idea of a building rather than specifically rendering an existing one: it has a porch supported by four Doric columns and an unusual rounded pediment, while behind is the square-plan church with four towers arranged around a central dome. The plan vaguely evokes the plan of Saint Peter's as well as the Pantheon, a Roman temple whose classical façade was flanked by two towers (since removed) in the sixteenth century. Since he was living in Rome while composing the book, Valadés would have known both these buildings firsthand. The legend below explains that these Franciscans are the

carriers of the first Roman church into the Indies: "Primi santae romane aeclesie inovo indiarum orbe portatores." At the center of the church's portal is an image of the Holy Spirit, which animates the work of the evangelizing Franciscans, a Spirit that travels along small lines inscribed in the image toward the Franciscans, similar to Pentecost, when the Holy Spirit entered into the first apostles.

The combination of the classicized architecture and the twelve apostolic friars dovetails with the larger Franciscan equation between their New World church and the primitive Roman Catholic Church believed to have been established by Jesus and his apostles. As John Leddy Phelan notes, "All the mendicant chroniclers of the late sixteenth century were dazzled by the image of the Primitive Church." Phelan cites Vasco de Quiroga, bishop of Michoacán in the 1540s, who wrote of his inspiration "in the new primitive and reborn Church of this New World, a reflection and an outline of the Primitive Church in our known world in the Age of the Apostles."[31] In fact, from the first years of their entry into the New World, the Franciscans were careful to cultivate the connection between themselves and the twelve apostles, widely publicizing their arrival as a group of twelve in 1524 in image and text, obscuring the earlier arrival (in 1523) of a group of three. Those familiar with the tropes of the sixteenth-century Renaissance will recognize in Valadés's depiction of the "first Roman church" as a vaguely classical building the larger Renaissance interest in the present age as renovating the classical past, but within this lies a particularly Franciscan apostolic project for the New World, which intended to capture the purity and energy of the "primitive" church. But such a return to the past, primitive church entailed a blurring of the particular temporal moment captured in the engraving. This linkage of past and present is carried further in Valadés's label for the maquette, "primi santae romane aeclesie," an ambiguous phrase that may suggest that the building being carried into New Spain represents the early Christian church established in Rome or that it represents the Roman Catholic Church of Valadés's own day, headed by the pope.

The workings of memory allow it to be both at once, a primitive church of Rome in a present-day moment of global Catholicism. As a starting point, the maquette, since it is not a real building, opens up the semiotic field: it resembles the architecture of Rome; it also captures the kind of structures that Valadés's own treatise recommended constructing in the mind to remember sacred

texts—the temples of the Gospel described above, with their columns of porphyry and jasper. In the midst of a larger image that shows indigenous minds being engraved with new Christian knowledge, the central temple, with its ambiguous inscription, seems to be Valadés's attempt at creating a mental image allowing readers, particularly the preachers to whom it was addressed, to remember the primitive church of Rome in their contemporary work.

Recall, though, that the Franciscan project of remaking the city was both an internal and an external one, and the external process of "remembering" Rome may have been first carried out by Gante, Valadés's mentor, whose image appears in the upper left. While there is only fragmentary evidence of Gante's actions in the city of Mexico-Tenochtitlan after the Conquest, much of it suggests that Gante's great project for Mexico-Tenochtitlan was to create another Rome within this *inovo indiarum orbe*. Just as idolatry was supposedly being erased from the minds of the figures clustered at his feet in this courtyard, and Christian catechism or useful trades engraved, so too, with the destruction of the native temples, Rome was being inscribed onto the conquered city. In his early letter to his fellow Flemish friars, written in Spanish after forgetting his native tongue, Gante wrote, "I, due to the pity of God, and for His honor and glory, in this province of Mexico where I live, *which is another Rome*, with my industry and divine favor have constructed more than a hundred houses consecrated to the Lord, both churches and chapels" (italics mine).[32] While comparisons to ancient Rome were frequently employed in century-long debates around the justice of the Spanish Conquest in the New World, as David Lupher has discussed, it was not the Rome of the pagans that Franciscans were envisioning; rather it was Rome as a pagan space remade into a Christian one to which they aspired.[33]

BUILDING A NEW ROME

If the malleability of the mind made Tenochtitlan-as-Rome possible as an idea, how were the Franciscans to achieve it on the ground, in the lived spaces of Mexico-Tenochtitlan? When Cortés reassigned the lands within the Mexica ceremonial precinct, his tremendous will (and ego) allowed him to act as if no sacred city had existed there before; taking possession of the Mexica palaces was certainly a practical move but also indicates a belief that present possession erases past history. The Franciscans, and Gante, following Pope Gregory the Great, understood that the city they created needed to be both familiar (so converts would "flock" to familiar places) and transformed ("transformed from the cult of demons").[34] One of Gante's better-documented building projects, the chapel of San José de los Naturales, offers some indication of how these double (and on the surface, contradictory) goals could be achieved in a single building. The chapel was an enormous, seven-naved structure built at the east end of the complex, probably between 1547 and 1552. Six massive wooden columns dominated its great façade, defined its seven naves, and upheld its roof (figure 6.4). Such great interior spaces were unknown in pre-Hispanic architecture, which focused on mass rather than volume; the use of the barrel vault to span the great spaces was also unknown. But this transformed space was filled with the familiar. The columns supporting the roof were almost certainly made with *ahuehuetl* trees, the great native cedars that could provide the strong and straight supports the building called for and that, as we saw in chapter 3, grew in watery places like Chapultepec and were associated

FIGURE 6.4. *San José de los Naturales, reconstruction drawing of façade, from George Kubler,* Mexican Architecture of the Sixteenth Century *(New Haven: Yale University Press, 1948), figure 252, p. 330. Reproduced courtesy of the Kubler family.*

Sync Sebastian. los quatro barrios de mexico

Sanc pablo.

pro bisor bachiler mu ... nu

Comvacados años. por orden del bachiller moran provisor de ... en dios. hizieron las campanas. para ... la ... sant pablo ... ciudad los quales se pagaron de ... de y extrema ... entre los yndios y el virrey ni el arçobispo

Sanc Joseph

fray p.° degante

ancta maria

Sanc Juan

FIGURE 6.5. *Unknown creator, diagram of Mexico-Tenochtitlan, Codex Osuna, fol. 8v, ca. 1565. © Biblioteca Nacional de España, Madrid.*

with the figure of the Mexica ruler. In fact, a cross erected in San Francisco's *atrio* made of *ahuehuetl* stood outside the chapel, and this great tree had been dragged along the Tacuba causeway from Chapultepec, forested from the grove of sacred ancient trees that stood there.[35] However, these great columns were transformed, their memory traces redirected, as they were painted to look like jasper, the same kind of columns Valadés instructs readers to construct in their memory palaces to remember the Gospels.[36]

Evidence for this Franciscan process of "redirecting" pagan memory can be found in their approach to building in the four *altepeme*. It will be recalled that each of the *altepeme* that composed pre-Hispanic Tenochtitlan—Moyotlan, Teopan, Atzacoalco, and Cuepopan—had its own ceremonial complex, often set somewhere in the central zone. By about 1530, the Franciscans had occupied these four complexes and had their shrines at the tops of the temples dismantled.[37] Evidence suggests that they built Christian

chapels adjacent to three of the temples, and located the fourth not far from its corresponding former temple, with the temples serving as quarries of useful building materials. It was likely Gante who made the decision to do so, since he claimed to be active in the process of early chapel building, as Martín de Valencia, the other Franciscan leader, was resident in Tlaxcala during much of this time. All four of these original Franciscan sites, although rebuilt over time, survive in the city today (see figure 4.2). The archeologist Alfonso Caso first proposed that the churches of San Pablo Teopan, San Sebastián Atzacoalco, and San Juan Moyotlan had been built upon the sites of, or adjacent to, the old *altepetl* temple complexes, the stone being reused.[38] But perhaps even more attractive to the Franciscans were the voids of the precincts, those plazas that surrounded temple-pyramids, offering ready-made spaces within the dense urban fabric that could be easily reconfigured into church courtyards. Such transformations happened in other cities in New Spain and had theological sanction in the admonition of Pope Gregory to use pagan spaces. The spacious plazas that are seen on eighteenth-century maps around the parish churches of San Juan, San Pablo, and San Sebastián suggest that their antecedents were the open spaces of those *altepeme*'s temple plazas; and open spaces still exist around the chapels of San Juan and San Pablo today. Caso also argued that Santa María Cuepopan in the northwest, which has no recorded plaza, was not built over or adjacent to an *altepetl* temple, and its sixteenth-century (and modern) position was moved slightly.

The Franciscan vision for the religious order of the city was captured in a representation of the urban space, in diagram form, in the Codex Osuna, where we encountered the image of the *tecpan* in chapter 5. Here, on a page titled "Los quatro barrios de Mexico" (the four neighborhoods of Mexico City), we see the indigenous city of Mexico-Tenochtitlan in quincunx form (figure 6.5). On its surface, the text registers a complaint about the payment for three bells of San Pablo. But the images show something different. At the corners, the four *parcialidades* (parts of the city) are named and identified by small chapels: clockwise from top left we see San Sebastián, San Pablo, San Juan, and Santa María. Their positioning on the page corresponds to their location in space, oriented to the east, as can be seen by comparison to figure 4.2. If this is a kind of schematic map, the central pivot of this city is the great parish church of San José, which is set in the center, with the figure of Pedro de Gante set below, and below him,

the hieroglyphic name of Tenochtitlan. The Spanish city is nowhere to be seen.

THE NEW ROME

Rome was made present in these newly consecrated spaces through their names. José Rubén Romero Galván was the first modern scholar to understand that these four indigenous *altepetl* chapels had been named after four of the seven basilicas of Rome: three took their patron saints from the four major basilicas, San Juan de Letrán, Santa María la Mayor, and San Pablo Extramuros, and one from the three minor basilicas, San Sebastián (see figure 4.2).[39] The other major basilica in Rome is the papal basilica of Saint Peter (San Pedro). But what Romero Galván overlooked was that San Pablo Teopan was actually dedicated to Saint Peter *and* Saint Paul, confirmed by a very early source on Mexico City, which names the neighborhood as the "barrio de Sant Pedro e Sant Pablo."[40] Thus Mexico-Tenochtitlan was recast as a new Rome by carrying in it the patron saints of all four major basilica churches of Rome (San Juan, Santa María, San Pablo, San Pedro). The city, for its part, would cleave to the primitive Christian utopia that the early church once had hoped to achieve in Rome, at the time of the founding of the basilica churches.[41]

But what of indigenous participation in applying the Roman template? Were indigenous concerns reflected in these choices of patron saints? Both Romero Galván and Roberto Moreno de los Arcos have suspected an indigenous role in the choice of patron saints.[42] In particular, Moreno de los Arcos argued that the identities of the pre-Hispanic patron deities of the four *parcialidades* influenced the choice of the later Catholic patron saints. Certainly, recent archeology has revealed pre-Hispanic temples throughout Tenochtitlan. Evidence suggests that Moyotlan held a temple devoted to Xipe Totec.[43] And a round temple, the architectural form used for Quetzalcoatl temples, has been found at the present-day Pino Suarez metro station, which was excavated around the location of the southern causeway of Ixtapalapa, that is, on the accepted border between Moyotlan and Teopan. However, beyond this, we have no firm evidence for which deities were patrons of the *parcialidades*.

Our best evidence for the continuities between the pre-Hispanic religious landscape and the early colonial one comes from the festival calendar. If we take Motolinia's date of the early 1530s for the building of the *parcialidad*

chapels, we can reasonably assume that their patron saints were set around then, as well. By this time, the Honduras campaign was over and more indigenous elites were back in the city. Longer exposure would have led both Franciscans and Nahuatl-speaking elites to understand each other's language by then. Supporting evidence on the Franciscan side comes from their own claims to speak Nahuatl (and from the somewhat embarrassed apology for those, like Francisco de Soto, who never could master the tongue) and on the indigenous side, from the emergence of a group of translators, like don Hernando de Tapia, who worked for the Real Audiencia as an interpreter and was the son of Motelchiuhtzin.[44]

Among the Mexica, it may have been less important to find saints that correlated to pre-Hispanic deities than to maintain the festival calendar, which was pegged to fixed solar and celestial events (solstices and equinoxes in particular) and related agricultural cycles. As mentioned in chapter 4, as early as 1528 the Spanish *cabildo* celebrated the feasts of San Juan (June 24), Santiago (July 25), and the Assumption of the Virgin ("Santa María de Agosto" on August 15).[45] The indigenous city would also hold feasts on these days for San Juan Moyotlan (June 24), Santiago Tlatelolco (July 25), and Santa María Cuepopan (August 15). It does not seem that the indigenous nobility were using the celebrations as "cover" for pre-Hispanic practices that might be perceived as idolatrous; rather, it is more likely that by linking the *parcialidad* celebrations into festivals that already were important ones in the city's festival calendar, indigenous leaders were both integrating themselves into the new calendar and giving themselves an opportunity to show their importance, through the feasting, and the gift giving and dances that such feasts entailed. As such, the public life of the indigenous city quickly absorbed patron saints and their feast days, as happened across New Spain. Through the colonial period, funding for these local festivals—often quite high—came from indigenous treasuries, the *cajas de comunidades*.[46]

Moyotlan, the first among equals of the *altepeme* of Tenochtitlan, represents a more complex choice in its patron saint than the others. It had not one but two patron saints, San Juan Bautista (Saint John the Baptist) and San Juan Evangelista (Saint John the Evangelist), as did San Juan de Letrán, the Roman basilica from which its name was derived.[47] John the Baptist was a favored patron for Franciscan monasteries in New Spain, and his pairing with the Evangelist was not uncommon, either, given that the

two saints can be seen as emblems of the Franciscan sense of their mission in the New World. John the Baptist, of course, was a symbol of the beginning, in that the baptism he offered allowed human souls eternal life in Christ for the first time in the history of the world. John the Evangelist, on the other hand, was believed to be the author of that chronicle of End Times, the Book of Revelation, whose eschatology underwrote the Franciscans' own millennial views.[48] These two patron saints graced Moyotlan with two feast days: San Juan Bautista's (June 24) and San Juan Evangelista's (December 27). These feasts, both of them celebrated with great fanfare in Moyotlan, fell on nearly opposite sides of the solar year, each occurring within a week after a solstice. The twin feasts thus offered continuity with the pre-Hispanic festival calendar, which pivoted around solstice celebrations. Moyotlan's early summer feast (San Juan Bautista) was equally propitious within the Catholic liturgical calendar, falling into the stretch that began with Holy Week and ended around Corpus Christi. Into this arc of festival celebrations was that of the *parcialidad* of San Pablo Teopan, whose patron saints (again, double) were Saints Peter and Paul, whose single feast fell on June 29.[49]

While the dovetailing of indigenous and Spanish calendars offers a rationale for the choice of this particular Roman basilica for Moyotlan, such a rationale did not play a consistent role in the choice of the other feast days. Santa María Cuepopan's feast (August 15) fell during the indigenous month of Xocolhuetzi, an early harvest celebration, but not one of primary importance. The impulse for this choice may have been Franciscan devotion to the Virgin— one of the earliest monasteries they founded in Tlaxcala was likewise devoted to the Virgin of the Assumption. And the feast of Atzacoalco was that of San Sebastián (January 20), which fell around the beginning of the indigenous year or during the dangerous 5-day liminal period of the *nemontemi* at the end of the 360-day year, a time marked in the indigenous calendar not by feasting, but by a general retreat from festive life. Scholars have linked the worship of San Sebastián in other native communities to pre-Hispanic devotion to Xipe Totec, as both San Sebastián and Xipe's sacrificial victims were killed by arrow sacrifice, but in the city of Tenochtitlan, it is Moyotlan, not Atzacoalco, with more clearly discernable Xipe connections.

By midcentury, Moyotlan, with its two festivals set on either side of the year, had emerged politically as the center of the city. Not only was it the most populous *parcialidad*,

but it was adjacent to San Francisco, which contained the city's main indigenous center of worship in San José de los Naturales.[50] While Nahua polities traditionally rotated leadership positions among their component parts, San Juan Moyotlan's enduring preeminence is signaled by nomenclature: in early documents, all four indigenous *barrios* were typically named when a matter concerned the indigenous population, but by the end of the century, the entirety of Mexico-Tenochtitlan was typically referred to as San Juan Tenochtitlan, as if the saints of Moyotlan now stood for the whole. For instance, viceregal requests for drafts of indigenous labor after midcentury are typically addressed to San Juan Tenochtitlan and Santiago Tlatelolco, respectively. Moyotlan's favored status extended to its lacustrine ecology. Although the terrain was swampy (the name Moyotlan means "among the mosquitoes"), this part of the city abutted the relatively fresh Laguna of Mexico, and while still prone to floods, its position did allow for expansion by landfill as the population grew. The good quality of the soil is signaled by the presence of both Moteuczoma's and then later the Franciscans' gardens there. Moyotlan was well connected to the rest of the valley by both water and land—the causeways of Tacuba (formerly called Tlacopan) led to it, and eventually the causeways of Chapultepec and Piedad would be created to the west and to the south, further linking it to the valley around. And the accessibility of Moyotlan was certainly a reason that the great Tianguis of Mexico was built there in the pre-Hispanic period and was refounded on its initial site in 1533, thereby replacing the short-lived post-Conquest *tianguis* established by Juan Velázquez Tlacotzin along the Tacuba causeway.

CONCLUSION

By midcentury, the Indo-Christian city was consolidated in Moyotlan, centered around San José de los Naturales within San Francisco. The spacious *tecpan* down the street offered an architectural embodiment of the order of indigenous authority; it was also the center of a commercial hub centered on the great Tianguis of Mexico. Just as the older Templo Mayor had been set at the crossing of axes, so too was this center. Its east–west axis linked

San Juan to San Pablo Teopan; by 1532, this causeway of San Juan would extend farther east to reach the springs at Chapultepec. The north–south axis was defined by the artery that passed along the side of San Francisco and then nearby, to Santa María Cuepopan, to end up at Santiago Tlatelolco, this axis thus linking not only indigenous centers, but Franciscan ones as well. By the 1540s, that axis extended south to the new causeway of the Piedad, which linked the *tianguis* to the agricultural zones to the south, particularly Chalco.[51] The Map of Santa Cruz defines this as a principal artery by the presence of a figure walking to the left (or south), with a bundle over his arm, as well as by the conjoined brown and blue lines that show this was both a road and a canal (see figure 4.8). The importance of such visual and conceptual axes to the pre-Hispanic city was discussed in chapter 3, and their colonial continuance is treated in chapter 8. The image of this city as the organized Christian republic finds expression twice in the Codex Osuna; in both instances, the Christian symbols for the patron saints, themselves referring to a sacred Roman template, are presented as metaphors for the city. Such was the view from the *tecpan*.

But what about the view from deep inside the city? This chapter and the previous one have taken a new look at the sixteenth-century city, reorienting it so it centers on the pivot of the *tecpan* and the Franciscan complex, and we have explored the ideologies of the Franciscans and the city's first indigenous governor in imagining what this new city would be. We then turned to the physical building of the city beginning in the 1530s, as far as can reasonably be reconstructed, and we found that by the early 1540s, the new center of Moyotlan with *tecpan* and *tianguis* competed with the Plaza Mayor, around which the city's Spanish residents clustered. If we desire to take our analysis even further, moving away from the elite culture of the *gobernadores* like Huanitzin and the native historians, to seek some sense of the city as envisioned by its non-elite residents, the potters and salt carriers and weavers who formed the mainstay of the economy and the tributary class, we must move deeper into one of the principal surviving representations of space, the city's place-names, and these will be the subject of the next chapter.

CHAPTER 7
Place-Names in Mexico-Tenochtitlan

If we move upward from the city's southwest quarter, where we ended the last chapter, and take a view from the air, that captured in a map of 1628, we confront few traces of the indigenous sacred architecture that existed the century before (figure 7.1). We see the city from an oblique angle, as if viewed from a bird aloft to the city's west, and the city stretches out across the foreground, the dike of Ahuitzotl or San Lázaro limning its far edge, with Lake Tetzcoco extending beyond. While the landscape of lake and mountains would have been familiar to a viewer of 1500, the temple complexes that once dominated the ceremonial life of the city's four parts, Moyotlan, Teopan, Atzacoalco, and Cuepopan, had been recycled to build churches, the memory of them appearing in vacancy: the large *atrios* around San Pablo Teopan and San Sebastián Atzacoalco that replaced earlier ceremonial plazas are seen at the upper part of the eastern-oriented map. The new churches that replaced the temples and other religious monuments were carefully rendered by the map's author, Juan Gómez de Trasmonte (d. ca. 1647). Named in 1635 as *maestro mayor*, or official architect/city planner, Gómez de Trasmonte was one of the designers of the city's preeminent building, the Cathedral, which appears in the map's center. In this map (a lithographic copy is reproduced here of a now-lost original that he created), no explanatory glosses appear within the space of the city. Instead, tiny inscribed numbers appear adjacent to the larger buildings, indexes to the legends set in the map's two cartouches, one at lower left and the other dominating the upper part of the map. In this upper banner, the leftmost column lists

the larger monastic complexes by religious order (Franciscan, Augustinian, Dominican, Jesuit, Mercedarian, Carmelite), whereas on the right, buildings are grouped by type (convents, hospitals, parish churches, schools). This seventeenth-century representation of the city emphasizes the hierarchy of institutions that provided spiritual guidance, intellectual training, and corporeal succor to its residents, their presence woven into the grid of streets that comprised the ordered streets of the *traza*. The existence of the indigenous city that also occupied this space has been neglected by Gómez de Trasmonte, and upon the body of European architectural forms that we see within the city, he has drawn a veil of the Spanish names of Catholic saints.[1]

There is one exception to this linguistic effacement, and that is to be found in the name that stretches like a banner across the top: "La Ciudad de Mexico," which preserves the name the city's indigenous founders gave to the island that they created, the founders who also took that place-name to identify themselves (the Mexica, or "people of Mexico"). The origin and etymology of this Nahuatl name, "Mexico," is poorly understood; the Codex Aubin of 1576–1608 says that the Mexica had taken the name of their deity Mexitli, while more recently the linguist Gordon Whittaker has argued that it is a place-name contracted from words meaning "the center of the moon," with the "moon" referring to the surrounding lake.[2] Its pre-Hispanic adoption may date to after 1473, when Tenochtitlan's conquest of its northern neighbor on the island, Tlatelolco, called for a name to describe the entire island; or it may have been the name that the immigrants, once united in their era of

FIGURE 7.1. *Juan Gómez de Trasmonte, "Forma y Levantado de la Ciudad de México" (view of Mexico City), 1907 (based on 1628 map). Lithograph; published by Francisco del Paso y Troncoso, Florence.*

peregrination before 1325, used from the outset to name the island that Huitzilopochtli chose for them to settle.³

But on the Trasmonte map, "Mexico" functions like an adjective to the noun "ciudad," and the latter was of equal if not greater importance to the city's Spanish residents, who cared about such matters. "Ciudad" was a designation conferred by the Spanish Crown, better than "villa" or the less distinguished "pueblo." "Ciudad" both confirmed urban status and elevated a community to a place in the exclusive network of *ciudades* of imperial Spain; additionally, King Charles V had granted "la gran Cibdad" of Mexico a coat of arms in June of 1529, adding a visual marker of its status.⁴ If "Mexico" spoke to a particular and local identity of this place, "ciudad" spoke to its key position within an increasingly global network of urban centers. Thus, the royal Spanish cosmographer-chronicler Juan López de Velasco would count in 1570 only nine "ciudades" within the archbishopric of Mexico, most of them designated as such because of their Spanish population; indigenous

communities, which may have been larger in area and more populous than nearby Spanish ones, were nonetheless often designated as "pueblos."⁵

As we zoom in closer to the Trasmonte map, we are confronted with a spectacle of closeness and intimacy. We can see buildings clearly, their sharp façades and bluish roofs, the network of canals and aqueducts. But this is a fiction of knowledge: although we can see buildings, the streets are empty. The people, whose voices in Spanish or Nahuatl once filled the air, are silent. The people, who produced the spaces of this city both with their labor and through their movements, are absent. Our gaze, instead, is held high above the lived reality transpiring in the streets, the distance magnified by the time elapsed between Trasmonte's rendering and our viewing.

But one way of closing the temporal gap can be found in the proper names that city residents used to name (and therefore to represent) the urban spaces they inhabited, a process that Michel de Certeau calls "carv[ing] out pockets of hidden and familiar meanings." On this map, the presence and the voices of urban residents are transferred to a narrow register within the vast field of language—the names at the top that reflect, in part, the names that people used to designate certain places. Place-names, Certeau argues, "make sense" of the otherwise undifferentiated spaces of the urban body by providing a shared set of referents (if I were to say "Tianguis of Mexico" or "Plaza Mayor," you and I would both understand these as distinct places that offered distinct experiences).[6] And thus the proper nouns that residents used to name the city may be the best register of this process of "making sense." But at the same time that the Trasmonte map reveals some of the place-names, it forgets to include others: none of the city's Nahuatl names show up in its glosses, other than "Mexico." And it was Nahuatl, rather than Spanish, that the majority of the city's residents spoke through the sixteenth century, and it was in Nahuatl that most places were named.

The indigenous place-names of Mexico City have been a subject of interest to the city's historians since the eighteenth century, when they were considered as one of the few remaining traces of the earlier, pre-Hispanic city. But other than the bare fact of their survival, what can they tell us about the city? How can they be interpreted beyond what they say about the evident physical features of the place they name—be they Acalhuacan, the "place of the canoes," for a docking station, or Tullan, the "place of reeds," for a swampy locale? Is the simple description of topography the only way residents of the city "made sense" of the urbanscape? Certeau anticipates one pitfall of reading too much into place-names: "Those words . . . slowly lose, like worn coins, the value engraved on them," which is to say that even mosquito-bitten residents of Moyotlan (from the Nahuatl *moyotl*, "mosquito") might never have connected their afflictions with the name of the place. My goal in this chapter is to gain some insight into how city residents in the mid-sixteenth century understood their city, and in tracking that quarry, place-names are one of the best guides. But we must go beyond the simple question of etymology, that original "value engraved," and to do so, I offer a reading that shows how place-names are used in particular historical contexts, both as names and as graphic symbols. Doing so will give us a unique vantage onto the

historical shifts that were taking place in the city's political life in the 1550s and early 1560s. During these decades, the native *gobernadores* who succeeded don Diego de Alvarado Huanitzin (r. 1537/1538–1541) found their prerogatives increasingly curtailed by the Spanish *cabildo* and the royal government, at the same time that their support from below—those masses of commoners who once sustained them economically through tribute and politically through participation in the city's ceremonial life—was eroding. This chapter has two sections. First, as a way of establishing how closely names were linked to political concerns, I begin with a brief discussion of the changes in names of the island city to show how proper nouns were a way that ruling bodies articulated the space of their domain. In the second part, I turn away from etymology, the traditional means of interpreting names, to look instead at the way that written place-names were used in manuscripts of the period, arguing that their graphic presences came to stand for the social and ethnic groups in the capital city, and through them, we can meter their widening ruptures.

NAMES AND SHIFTING REFERENTS

It has long been understood that as the Spanish entered the New World, they used place-names as imaginative projections of what they hoped to find, or to create, in territories whose expanse they poorly understood and whose peoples were ciphers. Christopher Columbus, upon landing on a sandy beach, endowed this and everything beyond with the name "the Indies," thinking he had reached Asia. Even after it was apparent that the Americas were not part of Asia, "the Indies" was used to designate Spain's overseas possessions, into the nineteenth century. And within New Spain, the instability of name to referent was not just a feature of language in general, but rather a condition produced by colonization, where the aspirations of the colonizers mixed with an uncertainty about the nature and extent of the entities being named. This uncertainty, as well as the political stakes in the use of certain names, is revealed when we track the name of one place over time. Let us return to the place-name for the complex city that is our subject, the entity named "Ciudad de Mexico" in the Trasmonte map.

The use of the designation "ciudad" to describe Mexico City is first encountered in the letters that Hernando Cortés wrote back to the Crown; after he decided to re-found the city and set the government of New Spain upon the site of the Mexica capital, he called that place a "ciudad" and the

term was used thenceforth. Any question about its status as "ciudad" was put to rest with the royal confirmation of a coat of arms in 1529. The more elaborate title "Muy noble, insigne y muy leal Ciudad" (very noble, notable, and very loyal city) was granted by the Crown in 1548, and the Spanish *cabildo* saw it as cause for rejoicing when the official letter arrived from Valladolid.[7] The honor of the "ciudad" title was not exclusively a Spanish privilege, and Mexico was not alone in being an indigenous-majority *ciudad*: in the Valley of Mexico, Tetzcoco was named a "ciudad" in 1543, Xochimilco in 1559, and Tacuba (known as Tlacopan before the Conquest) in 1564.[8] Outside of the valley, Tlaxcala was also granted the title "La Leal Ciudad de Tlaxcala" and a coat of arms in 1535, this designation a reward for the services it rendered to the Spanish during the wars of conquest.[9] Thus, for indigenous and Spanish residents alike, the designation "ciudad" showed their importance within the emergent Spanish hierarchy of urban centers. Even though the designation of "ciudad" may have been construed to apply to the Spanish part of the city and used by its *cabildo* to describe its domain, the city's native government also wielded it. That it was not merely a substitute for, or even coincident with, the Nahuatl term "altepetl" is made clear by Nahuatl-language documents produced by the indigenous *cabildo* where the term "ciudad" remains untranslated, although on occasion it is attached to the term "altepetl."[10]

While "ciudad" had a standard and accepted meaning, as granted by the king, the three appellatives most closely associated with the city, "Tenochtitlan," "Tlatelolco," and "Mexico," did not.[11] Although we have no pre-Hispanic manuscripts or books from the city, the Teocalli of Sacred Warfare, discussed in chapter 2 (see figures 2.14 and 2.15), shows that the name "Tenochtitlan," represented glyphically on the back face of the Teocalli by a *nochtli* (prickly-pear cactus) that rises from the body of Chalchiuhtlicue, was used to represent the city or some part of it in the pre-Hispanic period. The Codex Mendoza confirms that a very similar glyphic form was used at the time of its creation, around 1542 (see figure 1.3). The glyphic sign most likely refers just to the southern part of the island city that we commonly think of as Tenochtitlan, because the political history that follows is concerned with those rulers who created an empire from Tenochtitlan, while the conquered Tlatelolco is shown as a separate entity in the page that chronicles its conquest. However, there is a slight uncertainty. On folio 2r of the Codex Mendoza, two of the tribal

leaders (Ocelopan and Xomimitl) who gather around the glyphic sign (they are shown at ten o'clock and four o'clock, respectively) are named in other accounts as Tlatelolco leaders.[12] Could the first page of the Codex Mendoza be referencing both Tenochtitlan and Tlatelolco in its opening image? We might recall that the Codex Mendoza was almost certainly created in Tenochtitlan, and when it was created, Tlatelolco was once again asserting its independence from Tenochtitlan. Thus the inclusion of Tlatelolco's leaders on its first page may register a post-Conquest attempt by Tenochtitlan's leaders to stake a claim to the entire island.

The names "Tenochtitlan" and "Tlatelolco" were first transliterated into the Latin alphabet in the letters of Cortés, albeit in somewhat bastardized form. Writing in the 1520s, Cortés was aware that the city had two parts, but he nonetheless referred to the entire location as "Temixtitan," his rendering of "Tenochtitlan" and a name that reflected the pre-Hispanic political dominance that Tenochtitlan held over its northern counterpart after the 1473 conquest. Thus, "Tenochtitlan" (no matter how it was spelled) by the early 1520s could either designate just the southern *altepetl* or be inclusive of Tlatelolco. An added layer of meaning comes with the addition of "Mexico." In his 1522 letter to Charles V, Cortés described the tribute-paying polities beyond the valley as the "provinicias de México y Temixtitan," and his use of the word "México" in this context is largely coincident with what in modern times we would consider the domain of the Triple Alliance, the three Nahuatl-speaking polities in the valley that headed a tribute empire. Cortés did not use "Mexico" as a name for the entire island or the city at this point. Neither did the Spanish *cabildo* members, who, following Cortés, used the name "la grand Cibdad de Temixtitan" beginning with their first records in 1524. By 1529, however, we find the Spanish *cabildo* using "la cibdad de temistitán méxico"—tacking on the second name. They do not explain their rationale for doing so, but it may be that they, like Cortés, understood "México" as a more expansive term. Their adoption of it went hand in hand with their attempt to control not only the island city, but also the area within fifteen leagues of it, an area that encompassed the larger valley and beyond. They continued to use this long form of the city's name (Temistitan-Mexico) until the mid-1530s, as did other bodies in the city, like the Real Audiencia and the Episcopal Inquisition. Over the course of the 1530s, the *cabildo* gradually dropped the use of "Temixtitan" or "Temistitan,"

and by 1545 "Ciudad de México" was the norm for the *cabildo*. Table 7.1 offers a selection of names used in ecclesiastical, royal, and local-government contexts. In the names, we can see two trends: in official, royal correspondence, issued from Spain, the city is called "Tenochtitlan Mexico" (the first term's variable spellings are shown in the table), and this name persists during the course of the century. But in a local Spanish context, as in the *cabildo* records, the use of "Tenochtitlan" (or its variants) drops from view by about 1540.

TABLE 7.1. *Changes in Mexico City nomenclature*

SOURCE/RECIPIENT	YEAR	NAME USED
Hernando Cortés, Second Letter to Charles V	1520	gran ciudad de Temixtitan [Timixtitan][1]
Cortés, Third Letter to Charles V	1522	ciudad de Temixtitan[2]
Cortés, Third Letter to Charles V	1522	provinicias de México y Temixtitan[3]
Cortés, Third Letter to Charles V	1522	Culúa[4]
Cortés, Fourth Letter to Charles V	1524	gran ciudad de Temixtitan[5]
Spanish *cabildo*	1524	grand Cibdad de Temixtitan[6]
Cortés, Fifth Letter to Charles V	1526	ciudad de Tenuxtitan[7]
Charles V to Spanish *cabildo*	1526	Cibdad de Temistitan Mexico[8]
Spanish *cabildo* to Charles V	1529	gran cibdad de temixtitan[9]
Spanish *cabildo*	1529	cibdad de temistitán méxico[10]
Cortés, letter to Charles V	1530	ciudad de México[11]
Spanish *cabildo*	1530	Cibdad de México[12]
Cortés, letter to Charles V	1532	gran ciudad de México[13]
indigenous nobles, letter to Charles V	1532	Cibdad de Mexico Tenuxtitan and Cibdad e barrio de Tenuxtitan Mexico y su comarca[14]
Bishop Ramírez de Fuenleal, head of second *audiencia*, letter to Charles V	1532	cibdad de Temistitlan Mexico con el Tatelulco[15]
Spanish *cabildo*	1533	Gran cibdad de tenuxtitan mexico[16]
Cortés, letter to Charles V	1534	gran ciudad de México[17]
audiencia to Spanish *cabildo*	1534	mexico Tenuxtitan mexico[18]
Charles V to Spanish *cabildo*	1534	cibdad de tenuxtitlan mexico[19]
Juan de Guzmán Itztlolinqui, letter to Charles V	1536	ciudad de Mexico and la cibdad de Temestitlan México[20]
Episcopal Inquisition	1536	grand Cibdad de Temistitán [also Temixtitán] Mexico[21]
Episcopal Inquisition	1536	grand Cibdad de Mexico[22]
Motolinia, *Historia*	1536	Gran ciudad de México[23]
Indian nobles, *probanza* [evidentiary statement] to Charles V	1539	gran cibdad de Tenuxtitlan México[24]
Episcopal Inquisition	1539	cibdad de México[25]

Spanish *cabildo*	1545	cibdad de México
Charles V to Spanish *cabildo*	1549	Ciudad de Temistitan Mexico[26]
Cervantes de Salazar, *Life in the Imperial and Loyal City of Mexico*	1554	Civitas Mexicus[27]
indigenous resident	1558	ciudad de Mexico[28]
indigenous *cabildo*	1563	ciudad de Mexico Tenochtitlan[29]
indigenous *cabildo*	1567	ciudad de Mexico Tenochtitlan[30]
Juan López de Velasco, *Geografía*	1570	ciudad de Tenustitan Mexico[31]
Philip II to Spanish *cabildo*	1571	themixtitlan mexico[32]
Fernando Alvarado Tezozomoc, *Crónica mexicayotl*	ca. 1600	gran ciudad de Mexico Tenochtitlan/ huey altepetl Ciudad Mexico Tenochtitlan[33]

[1] Cortés, *Cartas de relación*, 50.

[2] Cortés, *Cartas de relación*, various.

[3] Cortés, *Cartas de relación*, various. The referent is the territory of the Triple Alliance.

[4] Cortés, *Cartas de relación*, 110: "Que cuando este nombre de Culúa se dice, se ha de entender por todas las tierras y provincias de estas partes, sujetas a Temixtitlan." This translates as: "When this name Culúa is said, what is meant is all the lands and provinces of this region that are subject to Tenochtitlan," which suggests that the referent is the territory of the Triple Alliance.

[5] Cortés, *Cartas de relación*, 218.

[6] Bejarano, *Actas de cabildo*, March 8, 1524.

[7] Cortés, *Cartas de relación*, 283, 287.

[8] Bejarano, *Actas de cabildo*, August 23, 1526.

[9] Bejarano, *Actas de cabildo*, July 12, 1529.

[10] Bejarano, *Actas de cabildo*, September 10, September 20, 1529.

[11] Cortés, *Cartas de relación*, 300.

[12] Bejarano, *Actas de cabildo*, January 9, 1530.

[13] Cortés, *Cartas de relación*, 309.

[14] Pérez-Rocha and Tena, *La nobleza indígena*, 99–101.

[15] García Icazbalceta, *Colección de documentos para la historia de México*, 1:175.

[16] Bejarano, *Actas de cabildo*, August 1, 1533.

[17] Cortés, *Cartas de relación*, 317.

[18] Bejarano, *Actas de cabildo*, June 15, 1534.

[19] Bejarano, *Actas de cabildo*, September 11, 1534.

[20] Pérez-Rocha and Tena, *La nobleza indígena*, 103.

[21] González Obregón, *Procesos de indios idolatras y hechiceros*, 17, 53, 79.

[22] González Obregón, *Procesos de indios idolatras y hechiceros*, 1.

[23] Motolinia, *Historia de los indios de la Nueva España*, 14.

[24] Pérez-Rocha and Tena, *La nobleza indígena*, 125.

[25] González Obregón, *Proceso inquisitorial del Cacique de Tetzcoco*, 29. González Obregón, *Procesos de indios idolatras y hechiceros*, 99, written from Tlatelolco.

[26] Bejarano, *Actas de cabildo*, June 17, 1549.

[27] Cervantes de Salazar, *Life in the Imperial and Loyal City of Mexico in New Spain*, fol. 257r.

[28] Reyes García, Celestino Solís, and Valencia Ríos, *Documentos nahuas de la Ciudad de México del siglo XVI*, 74.

[29] Reyes García, Celestino Solís, and Valencia Ríos, *Documentos nahuas de la Ciudad de México del siglo XVI*, 101.

[30] Reyes García, Celestino Solís, and Valencia Ríos, *Documentos nahuas de la Ciudad de México del siglo XVI*, 89.

[31] López de Velasco, *Geografía y descripción universal de las Indias*, 2nd pt., 188.

[32] *Real cedula* (royal decree), reproduced in Bejarano, *Actas de cabildo*, October 26, 1571.

[33] Tezozomoc, *Crónica mexicayotl*, 4.

However, "Tenochtitlan" continued to be used among indigenous elites and within the indigenous government of the island, especially after Viceroy Antonio de Mendoza's formal appointment of Huanitzin to its governorship, around 1538. That "Tenochtitlan" meant a political jurisdiction covering just the southern part of the island was solidified by Viceroy Mendoza's appointment of the eponymous don Diego de Mendoza to the seat of Tlatelolco in 1549.[13] This appointment acknowledged the earlier divide between the two *altepeme* and offered a partial redress of Tlatelolco's politically subordinate position, which the skillful viceroy no doubt meant as an internal check to Huanitzin. In addition, the name "Mexico" is almost always included along with "Tenochtitlan" in indigenous records of the city. A letter written by indigenous nobles to Charles V in 1532 reveals something of how they envisioned the city at that point. They called the city the "Cibdad de Mexico Tenuxtitan," reversing the order of terms in use in Spanish documentation, a reversal that largely held through the century. However, in the same letter, they also employed a more expansive phrase, "Cibdad e barrio de Tenuxtitan Mexico y su comarca" (city and neighborhood of Tenochtitlan Mexico and its surrounding territory). "Ciudad," as explained above, was a marker of rank within the Spanish system, but the linking of the term with "barrio," "neighborhood," is significant because a *barrio* is a subsection of a larger urban conglomerate; thus, the nobles seem to be indicating that their domain, that doughnut city that

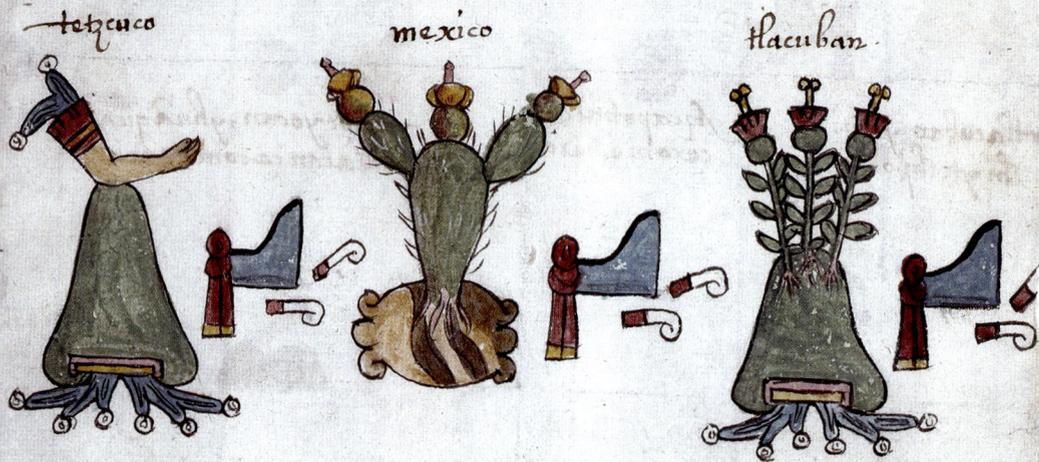

FIGURE 7.2. *Unknown creator, the former altepeme of the Triple Alliance, Codex Osuna, fol. 34r, ca. 1565.* © *Biblioteca Nacional de España.*

existed around the Spanish center, was both city and *barrio*. The naming acknowledges the political reality unfolding on the city streets: that the Spanish *cabildo* controlled the center of the island (although they never described the *traza* as a "barrio"), whereas indigenous nobility controlled only a portion, that is, their *barrio* named "Tenochtitlan Mexico." But the inclusion of "ciudad" also insists on the status of this *barrio*. In addition, "su comarca" expands its political reach. The city's nobility and its corporate bodies held extensive amounts of property off the island that was worked for their benefit, and the inclusion of "su comarca" in the appellative used by these indigenous elites is wielded like a boundary marker to stake out their continuing domain over this larger realm, a domain under constant erosion by Spanish appropriation.[14]

Another factor in the shifting terms had to do with Tenochtitlan-Tlatelolco rivalries. The rulers in post-Conquest Tenochtitlan still thought of Tlatelolco as within their domain, and we pick up signals as late as the seventeenth century that they wanted their sovereignty to continue. In the history of the city attributed to Fernando Alvarado Tezozomoc, Huanitzin's son, he uses the term "Mexico" to describe a people, the "tlacamexitin" (Mexi-people), or "yn mexica tepilhuan in tenochca tepilhuan" (the children of the Mexica, the children of the Tenochca).[15] Since one of his points, as a member of the ruling lineage of Tenochtitlan, is to argue against the independence of Tlatelolco, his use of "Mexica" is a strategic one meant to encompass the Tlatelolca. The conflation of the term "Mexico," meaning the larger tributary empire, with "Tenochtitlan" is also seen on the Codex Osuna, folio 34r (figure 7.2). While we have looked at pages from this book dealing with internal events in Mexico-Tenochtitlan in earlier chapters, this page is part of a document of separate origin included in the composite book, and shows the colonial-era status of the towns that were once part of the Triple Alliance. On its first page, the alphabetic text, written by a Nahuatl-speaking scribe, names these *altepeme* as "Tetzcuco [Tetzcoco]," "Mexico," and "Tlacuban [Tlacopan]." Each is flanked by a *xiuhhuitzolli*, the royal miter of indigenous rulership, but it is not used to show the high rank of these three *altepeme*, instead being included to signal that they are tributaries of the Spanish Crown (rather than held in *encomienda*), substituting the native "crown" for the more conventional rendering of a European one. The *altepetl* of Tetzcoco is topped by a bent arm and a water glyph to denote "Acolhua," the constituent ethnic group;

the *altepetl* of Tlacopan is depicted with three blooming stems, perhaps related to *tlacotl*, meaning "staff." Here as on other pictorial documents, "Mexico" is represented with the familiar glyph for "Tenochtitlan," there being no standard pictograph to represent the name "Mexico."

In fully alphabetic documents from the 1560s, a period from which more documentation survives, the formal documents issued by the native *cabildo* use "Mexico Tenochtitlan" along with "Ciudad." Although this term seems merely a version of the official "Tenochtitlan Mexico" used by the king in his missives to the Spanish *cabildo*, reading it next to documents produced in Tlatelolco, which refers to itself as "Ciudad [de] Mexico Santiago Tlatilolco,"[16] shows it to be a self-consciously limited term. In both cases the second term modifies and limits the first; that is, it refers to a political jurisdiction that extended only within the portion of "the Ciudad de Mexico" under the control of the *cabildo* seated in Tenochtitlan, versus the northern portion, under the domain of the *cabildo* seated in Santiago Tlatelolco.

So in the Spanish realm, "Ciudad de Mexico" coalesced because "Mexico" was from its first use by Cortés a more expansive territorial term than "Tenochtitlan"; the gradual adoption of "Mexico" within the Spanish *cabildo* reflects its grand (or even grandiose) territorial ambitions. But within the indigenous realm, different terms evolved to reflect the recasting of the political terrain. Facing the newly gained autonomy of Tlatelolco in the 1540s, the city's Mexica rulers, who once controlled the entire indigenous city, found themselves in control of only a part of the island, a political diminishment reflected in the name that they used, "Mexico-Tenochtitlan." And by the end of the 1530s, when the Spanish *cabildo* no longer favored its use, "Tenochtitlan" began to designate only that part of the island under indigenous control. This territory was even more limited by the recognition of Tlatelolco as a separate and largely equal indigenous territory within the island with its own government. So while "Tenochtitlan" and "Tlatelolco," within the indigenous context, were coming to have a more concretely identified spatial referent, the referent of "Mexico" is never completely spatial.

TLAXILACALLI IN MEXICO-TENOCHTITLAN

As we saw in our discussion of the pre-Hispanic city in chapter 3, Tenochtitlan was divided into four *altepeme*, which in turn had subdivisions called *tlaxilacalli*, and each

of these carried a name. These *tlaxilacalli* names were preserved in a ca. 1789 manuscript map by the great Enlightenment intellectual José Antonio Alzate, a map that lay dormant for over a century—never engraved or published during his lifetime or in the nineteenth century. When the archeologist Alfonso Caso encountered the single known version of it in Paris and redrew and published it in 1956 as part of his study "Los barrios antiguos de Tenochtitlan y Tlatelolco," he brought renewed attention to these subunits of the city and their nomenclature (figure 7.3). This map reconstructed the pre-Hispanic city, drawing on the names from the Alzate map and cross-checking and augmenting these with other historical sources. Key was a 1637 list of indigenous parishes that Caso found in the British

Museum, which allowed him to corroborate Alzate's identifications, as well as other land documents Caso's collaborator had found in the Archivo General de la Nación in Mexico.[17] Like Alzate, Caso assumed a conservative character for the place-names, so he assumed that the Nahuatl nomenclature belonged to the city's pre-Hispanic past. The study of the etymology of the place-names for linguistic ends was of lesser interest to him.[18]

For readers of the day, Caso's article revealed a theretofore-unknown social order and complexity of the pre-Hispanic city that existed within the framework of the known four-part division. Caso took the names that Alzate had plotted on the map and correlated the boundaries of the subdivisions to the modern streets of the city, marking their boundaries with colored lines on a modern map, the different colors corresponding to the four *parcialidades*, with a blue trapezoid at the map's center to mark the limits of the Spanish *traza*. He thus affirmed the spatial expanse of the hundred or so subdivisions, which he called "barrios." As the title of his article suggests, his interest was in the pre-Hispanic period, but since he used colonial documents

FIGURE 7.3. *Alfonso Caso, map of Tenochtitlan and Tlatelolco, showing the indigenous neighborhoods, from "Los barrios antiguos de Tenochtitlan y Tlatelolco,"* Memorias de la Academia Mexicana de la Historia *15 (1956). Reproduced courtesy of the Academia Mexicana de la Historia. Photograph General Research Division, New York Public Library, Astor, Lenox and Tilden Foundations.*

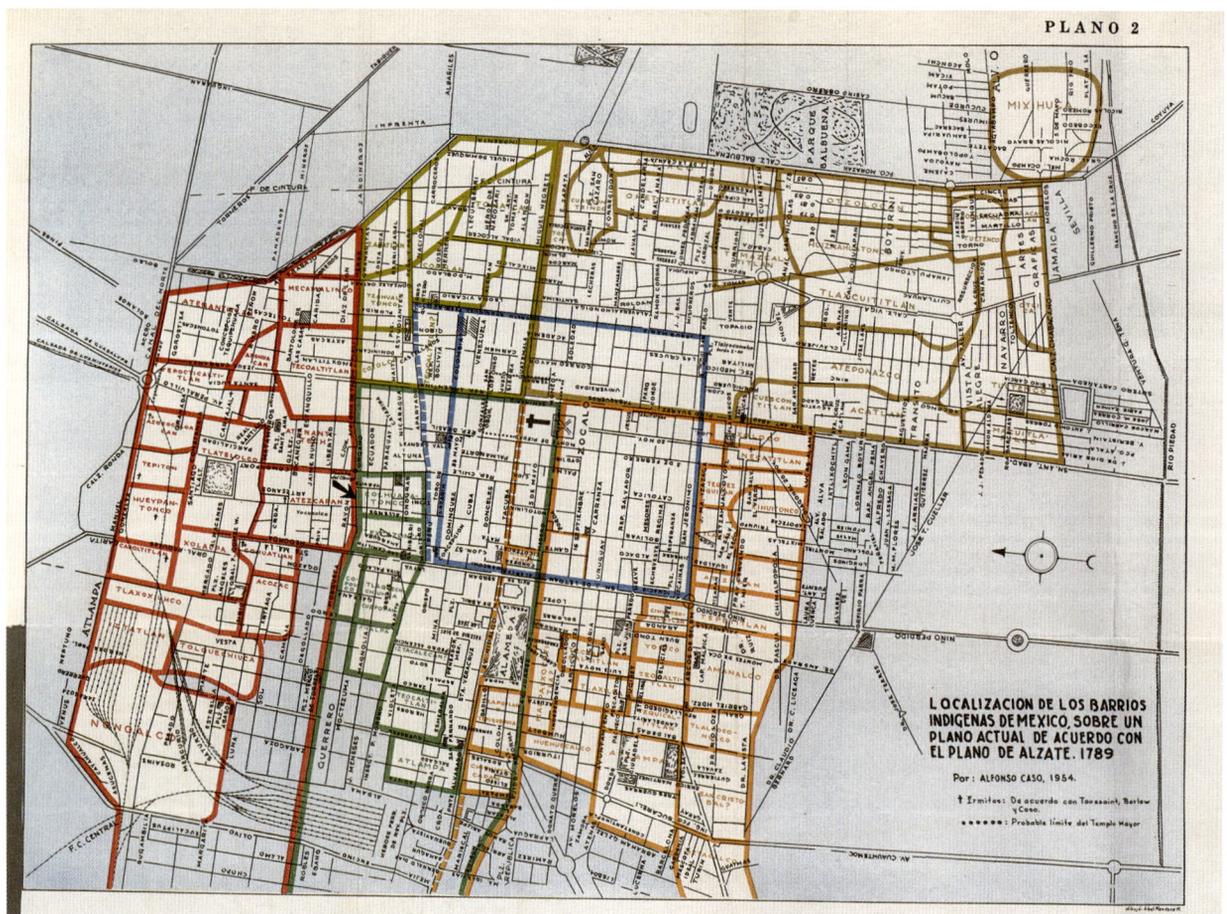

from the sixteenth and seventeenth centuries, he ended up offering strong evidence for the colonial endurance of the pre-Hispanic spatial and social categories in the city.

This study sparked other research, and scholars such as Luis Reyes García have since established not only that the units Caso called "barrios" endured, but also that they were better known in the sixteenth-century city as *tlaxilacalli*, a term discussed in chapter 3. More recently, Edward Calnek and Jonathan Truitt have taken up the names again, working even more extensively with the Nahuatl corpus of documents from the city to expand and refine the number of *tlaxilacalli* names.[19] But even more important is Truitt's finding that the *tlaxilacalli* were not extinguished by the Conquest or any time after, but rather, like the larger *parcialidades* that comprised them, took on the names of Catholic saints and endured into the nineteenth century.

The *tlaxilacalli* was the basic unit for collective identification within the city, one step up from the household and one step down from the *parcialidad*. The evidence that *tlaxilacalli* names were a crucial part of residents' sense of themselves in the city is attested to by the scores of Nahuatl legal documents that survive from the sixteenth-century city. While in Spanish documentation of the same place and period it is a commonplace to identify one's place of residence, such locational identifiers are often quite general, with "citizen of Mexico City" (*vecino de México*) being a frequently found identifier. But indigenous residents of the city were situated within a three-layer hierarchy, the indigenous city, its component *parcialidad* (a continuation of the four-*altepetl* pre-Hispanic city), and finally the *tlaxilacalli*, or neighborhood. These layers combined into a neat spatial package we can call "Mexico-Tenochtitlan," which can be roughly diagrammed as shown in table 7.2.

As encountered in legal documents, the classifications reflect the structure of the indigenous government of the colonial city as it developed by midcentury—the *gobernador* ruled the city of Mexico-Tenochtitlan, and under him were two *alcaldes* and then some twelve *regidores*, who were representatives of the *parcialidades*, with usually four from Moyotlan and two or three from each of the other parts.[20] Within the various *tlaxilacalli*, there were *alguaciles* (constables) to carry out justice. Such a political hierarchy was never separate from a religious one: up to the 1560s, all of the city's Nahua residents were officially parishioners of San José de los Naturales within San Francisco, but they were also served by (and served within) the churches of the four *parcialidades*. Many of the *tlaxilacalli* had their own small chapels for worship. Slight differences emerge between the expression of this hierarchy in Tlatelolco, which always held itself to be separate and equal to Tenochtitlan. Lacking the four-*parcialidad* division, Tlatelolco seems to have had two hierarchical levels: the first, the city of Santiago Tlatelolco (the complement to Mexico-Tenochtitlan), and the second, the *tlaxilacalli*. For instance, in a land-sale document of 1551, we find a local noble who describes himself thus: "I, don Baltazar Tlilancalqui, and my wife, Juana Tlaco, residents of this city of Mexico–Santiago Tlatelolco, our *tlaxilacalli* being Santa Ana Xopilco."[21]

But the ways the names of *tlaxilacalli* are used is revealing about the way the city residents represented themselves within this larger urban and social complex. *Tlaxilacalli* names are consistently appended to personal names, often linked by the word *chane*, which derives from the Nahuatl word for "home." Thus we find phrases like "nehoatl Ysaber Ana nican nichane San Juan Tlatilco" (I, Isabel Ana,

TABLE 7.2. *The three-layered political hierarchy in Mexico-Tenochtitlan*

MEXICO-TENOCHTITLAN															
San Juan Moyotlan				San Pablo Teopan				San Sebastián Atzacoalco				Santa María Cuepopan			
Tlaxilacalli	Tlaxilacalli	Tlaxilacalli	Tlaxilacalli	Tlaxilacalli	Tlaxilacalli	Tlaxilacalli	Tlaxilacalli	Tlaxilacalli	Tlaxilacalli	Tlaxilacalli	Tlaxilacalli	Tlaxilacalli	Tlaxilacalli	Tlaxilacalli	Tlaxilacalli

my home is here in San Juan Tlatilco) in a document of 1587 or "Agustin Tecpanecatl chane Tolpetlac" (Agustin Tecpanecatl whose home is Tolpetlac). Some documents transcribe first-person identifications and thus suggest the contours of actual speech, as in "nehuatl ni Martin de Lazaro Moyotla[n] nochan" (I, Martín de Lázaro, my home is Moyotlan).[22] Thus, at least in their encounters with the administrative system, the residents of the city thought about themselves in the context of *chane*.

While the Spanish translation of *chane* is consistently "vecino," some of its social meaning is lost in the English translation to "resident." The root word is *chantli*, or "home." Foreigners were called *hueca chane*, meaning "with faraway homes." But *chantli* had an important associated meaning: to "speak home" (*channonotza*) meant to "come to agreement in legal proceedings."[23] That is, *chantli* (like its English translation into "home") was also embedded in social accord and conveys that one is part of a larger social network. As expressed through the (admittedly formulaic) language of documents, the concept of *tlaxilacalli* appears to be as much about a social as a geographic entity. The boundaries that separated one *tlaxilacalli* from the next on both Alzate's and Caso's maps may have been more porous than their graphic expression suggests.[24]

WRITING SYSTEMS AND MEANINGS

Nahuatl place-names were important for self-identification of the indigenous populace throughout the sixteenth century and beyond. So how did place-names allow indigenous residents of the city to lay claim to this landscape, or to "make sense" of this city by naming it? A natural place to turn for answers would be indigenous maps of the city, where the place-names that we know from the Alzate map might be registered. However, other than the Map of Santa Cruz at Uppsala University, we know of no midcentury indigenous map of the entire city (see figure 2.8). And while the Santa Cruz map offers a wealth of pictographic place-names in the landscape *around* the city, none appear within the urban space at the center of the map; instead, within the city only alphabetic glosses appear. Indigenous maps of plots of land within the city do exist, particularly for the later part of the sixteenth century, and while they sometimes include indigenous place-names, many of these seem to be those of micro-areas, that is, urban plots. A case in point is figure 7.4, a small map from 1567 on a sheet of European paper, now attached to a lawsuit in the Archivo General de la Nación, Mexico. On the right, a two-room house is seen in plan, its walls marked in red pigment. The dimensions are carefully measured according to standard units, based on the *maitl*, "hand," and the *yollotl*, "heart." On the far right side, a three-*cemmatl* length (a measurement of about six feet, or the distance from foot to hand outstretched) is marked with symbols of hands, and along the top side, a length of three *cemmatl* and one *cenyollotli* (a measurement of half a *cemmatl*, that is, from outstretched fingertips to heart), is marked by three hands and a heart.[25] Inside the space of the house, the owners have glyphic names—the male, above, is identified by a banner (*panitl*), the female below with a stream of water (*atl*) grasped by a hand (*maitl*). A twisted cord shows the bond of marriage between them; the attached cross indicates the sanction of the union by the Catholic Church. The male head has been shaded gray to indicate that he is dead. In front of the house to the left are four fields, each marked with a *panitl*, the measure for twenty, and together, these fields probably measure 860 square yards, enough for a family plot. The place-name attached to the fields on their right border shows us reeds, or *tollin*.

The map, although quite simple, addresses one salient coda raised by Certeau: were place-names like "worn coins," worn smooth by use until rendered unremarkable? For instance, one might be born in San Francisco, but does one connect the name with the bird- and animal-loving saint who lies behind it, or instead is the name overlaid with a wealth of historical and personal associations? Such would be the conclusion that Certeau points to. However, the appearance on the map of a pictographic script to name both the householders and the field suggests that literate people in the Valley of Mexico may have been more attentive to etymologies because of the way that Nahuatl iconic script was written. This script first developed in the preHispanic period but continued to be used in documents produced in the colonial period, being very gradually displaced by alphabetic writing of Nahuatl introduced in the 1540s, but still used within the indigenous ambit through the century, as in this map. Maps made particular use of a subset within the larger world of iconic script of phonetic graphemes, or hieroglyphs, used to denote the names of persons and places, dates and quantities.[26] In the preHispanic period, such appellatives were not just confined to manuscripts but were also carved on public monuments, as we have seen with the names of Ahuitzotl and Moteuczoma in chapters 2 and 3, named on works where they were

FIGURE 7.4. *Unknown creator, map of the properties of Lázaro Pantecatl and Ana Tepi, ca. 1567. Archivo General de la Nación, Mexico, Tierras 20, pte. 1, exp. 3, fol. 256v.*

respective patrons. As described by the linguist Gordon Whittaker, Nahuatl script "consists of a powerful mix of (a) morpheme signs (morphograms), most of which represent words and are, accordingly, known as logograms or word signs, and of (b) phonetic signs (phonograms) employed in varying proportions according to the whims of scribes and the dictates of circumstance."[27]

In keeping with the general character of iconic scripts known worldwide, the signs used to convey words (logograms) are often images: a picture of a dog, *izquintli*, yielded a phonetic reading of *izquintli*, which we call a logogram because the sign (dog/*izquintli*) produces a reading of an entire word (*izquintli*). While phonetic readings that a sign produced were standard, the meaning was not, which is to say that the same sign could be read as a logograph or a phonograph or could produce a conventional reading. Thus, in some cases, as in the name "Huanitzin" (see figures 5.1 and 5.2), the sign of a banner was a phonograph, producing the phonetic reading of *panitl*, understood as *huanitl*. In fact, the banner most frequently functioned as phonogram, dropping its absolutive suffix of *-itl*, to convey *pan*, which when used as a suffix meant "upon."[28] In the map of figure 7.4, we see the four banners in the field and

they produce a conventional reading, as the banner is also the symbol for twenty, although bearing little relation to the word for twenty (*cempohualli*).

Turning to the personal names on the map in figure 7.4, reproduced in detail as figure 7.5, we see how Nahuatl scribes grappled with the influx of new Spanish names that were given to commoners upon their baptism. The alphabetic documents that accompanied this map identify the names of these two figures: he is Lázaro Pantecatl, and in rendering his name, the scribe has not included his Spanish name, "Lázaro," and has provided only the first syllable of his Nahuatl name, which means "resident of the place of the banners." The map includes the *panitl* sign used as a logograph for "banner." In contrast, for the name of his wife, Ana Tepi, the scribe has chosen to write only her Christian name, which is rendered with phonographs: a water symbol (*a[tl]*) is grasped by a hand (*ma[itl]*), yielding *a-ma*, or Ana, the *m* shifting to an *n* sound. Thus, in rendering appellatives such as place-names or personal names, like "Pantecatl" or

FIGURE 7.5. *Unknown creator, map of the properties of Lázaro Pantecatl and Ana Tepi, detail, ca. 1567. Archivo General de la Nación, Mexico, Tierras 20, pte. 1, exp. 3, fol. 256v.*

"Ana," Nahuatl scribes needed to be able to identify salient parts of a word to represent it either logographically or phonetically, as well as to know how many sounds could be left out or unrepresented and still allow the hieroglyph to be read; the reader, in turn, needed to be able to identify the images as the appropriate logogram or phonogram. So, as the Nahuatl script was employed, it called upon both readers and writers to wield a fairly refined sense of the underlying parts and meanings of words, an "etymological attitude" that is not demanded of readers and writers of phonetic scripts. In figure 7.4, in order to read the place-name that sits at the edge of the family fields (which could possibly be read as "Tullan," "Tulpan," or "Tultitlan"), a reader would have to first identify the pictorial sign (*tollin*) that was at its etymological root.

Because scribes had to strip down words to their etymological roots to represent them and readers had to build outward from etymology, it is unlikely that place-names as they continued to be written graphically became "worn coins." Table 7.3 presents a list of *parcialidades* and known *tlaxilacalli* names within Mexico-Tenochtitlan, along with proposed translations and/or etymologies. The first column lists one of the four *parcialidades* to which the *tlaxilacalli* belonged, the second gives the *tlaxilacalli* name, and the third offers a reading of the meaning or etymology of that name. The fourth and fifth columns are parallel data—in column four are corresponding names from other places with the same or similar etymology, and in column five are

those same corresponding place-names, this time written in iconic script. In only one case (Atlixyocan) are the data in columns four and five taken from Mexico-Tenochtitlan; in all other cases, the toponyms are simply comparative, taken from the names of conquered or tributary states outside of the city, for which we have better graphic evidence.

The etymologies of the names within the city are largely unsurprising, in that they follow the contours of the wider body of Nahuatl place-names: some names were topographically descriptive, meaning that they referred to salient landscape features or qualities, like the name "Moyotlan," for the mosquitos that bred in the city's swampy west, or "Acalcaltitlan," which means "next to the boats," likely for a docking station. Many of the names, not surprisingly for a water-ringed city, have aquatic references. Another subgroup refers to buildings or built structures, presumably ones that existed within the particular *tlaxilacalli*. "Teopan," for example, means "temple." And yet a third category refers to historical events that unfolded at a particular place. For instance, both "Mixiuca" (where women give birth) and "Temazcaltitlan" (next to the sweat baths) in the *parcialidad* of San Pablo Teopan relate to the history of foundation. As told in the *Crónica mexicayotl*, right before the vision of Huitzilopochtli's eagle, a woman named Quetzalmoyahuatzin gave birth there and, following the custom for postpartum women, was then bathed in a sweat bath; this chronicle also adds that the chapel of San Pablo Itepotzco was later erected on the spot.[29] So while in some few cases, the names index historical events, they are for the most part simply geographically descriptive. The list also shows us one of the mind-puzzling features of place-names: because of the scribal conventions described above, the way a name is rendered may have some, but not all, elements of the name as it was used by speakers. Thus historians and epigraphers have been most successful in decoding iconic place-names when an alphabetic list accompanies them, as in the Codex Mendoza.

THE BATTLE OF PROPER NOUNS

Creating table 7.3 meant drawing on place-names from outside the city for parallels because no comprehensive list of the city's *tlaxilacalli* written in iconic script comes down to us. In fact, there is no known comprehensive alphabetic list of the city's *tlaxilacalli* either—Caso, Calnek, and Truitt have cobbled theirs from a variety of sources, the most important one undoubtedly being Alzate's map.

TABLE 7.3. *Tlaxilacalli place-names*

PARCIALIDAD	TLAXILACALLI NAME	TRANSLATION	COMPARABLE PLACE-NAME, EPONYMOUS OR SIMILAR	GLYPH OF COMPARABLE PLACE NAME
?	Atezcapan	upon the water's surface	Atezcahuacan	
?	Atlampan	upon the water	Atlan	
?	Atlixyocan	translation unknown; from *atl* (water) and *ixtli* (eye)	Atlixyocan	
?	Axiuaca	from *atl* (water) and perhaps *xihuitl* (turquoise)		
?	Texcalcocolco	translation unknown		
?	Tlahuac	translation unknown		
?	Toltengo?	translation unknown		
San Juan	Acatlan (2 instances)	place of reeds	Acatepec	
San Juan	Acaztlan	place of the watering trough (*acaxitl*)		
San Juan	*Acolco*	place where the water bends (*coltic*)	Acocolco	
San Juan	Amanalco	at the lake		
San Juan	Atizapan	upon the chalk water		
San Juan	Atlampa	upon the water	Atlan	
San Juan	Aztacalco	house of the herons	Aztaquemecan	
San Juan	Chapultepec	grasshopper hill	Chapultepec	

PARCIALIDAD	TLAXILACALLI NAME	TRANSLATION	COMPARABLE PLACE-NAME, EPONYMOUS OR SIMILAR	GLYPH OF COMPARABLE PLACE NAME
San Juan	Chichimecapan	upon the Chichimec water		
San Juan	Cihuateocaltitlan	next to the women's temple	Cihuateopan	
San Juan	Cohuatlayauhcan	place of the curved serpent	Coatlayauhcan	
San Juan	Huehuecalco	house of the elders	Huehuetlan	
San Juan	Macpalxochititlan	next to the Macpalxochitl (a tree, *chiranthodendron pentadactylon*)		
San Juan	*Macuitlapilco*	translation unknown		
San Juan	Milpantongo	in the field (*milpa*)	Tecmilco	
San Juan	Moyotlan	among the mosquitoes		
San Juan	Necaltitlan	next to the house of ashes	Nextitlan	
San Juan	Oquitoco	translation unknown		
San Juan	*Popotlan*	next to the broom twigs (*popotes*)	Popotlan	
San Juan	Quauhchinanco	eagle woods	Cuauhtlan	
San Juan	Tecpancaltitlan	next to the *tecpan*-house	Tecpan	
San Juan	Tecuicaltitlan	next to the community house/ next to the workers' house		
San Juan	Teocaltitlan	next to the temple	Teocaltzinco	

PARCIALIDAD	TLAXILACALLI NAME	TRANSLATION	COMPARABLE PLACE-NAME, EPONYMOUS OR SIMILAR	GLYPH OF COMPARABLE PLACE NAME
San Juan	Tepatlan	translation unknown		
San Juan	Tepetitlan	next to the hills	Tepetitlan	
San Juan	Tequixquipan	upon the *tequesquite* (*tequixquitl*, a naturally occurring bicarbonate of soda)	Tequixquiac	
San Juan	*Terrazas*	translation unknown		
San Juan	*Tetacpilco*	translation unknown		
San Juan	Tianquiztenco	at the edge of the market	Xaltianquizco	
San Juan	Tlalcocomulco	where there are turns or depressions in the road		
San Juan	*Tlaliztacapa*	upon the salt/white earth (from *tlalli* [earth] and *iztac* [salt])	Tlaltizapan	
San Juan	Tlatilco	place of earth hills		
San Juan	*Tlatzcayacac*	translation unknown; from *tlatzcan* (cypress) and *yacac* (nose)	Huaxacac	
San Juan	Tlaucalpan	translation unknown		
San Juan	Tlaxilpan	translation unknown		
San Juan	*Totocalco*	place of the bird house	Tototepec	
San Juan	Tzapotla	sapote place	Zapotlan	
San Juan	Xacalpan	upon the hut (*xacalli*)		
San Juan	Xihuitonco	little grass/turquoise	Xiuhuacan	

PARCIALIDAD	TLAXILACALLI NAME	TRANSLATION	COMPARABLE PLACE-NAME, EPONYMOUS OR SIMILAR	GLYPH OF COMPARABLE PLACE NAME
San Juan	Xoloco	place of Xolotl	Xolotlan (glyph shows head of the deity Xolotl)	
San Juan	*Xometitlan*	next to the elder tree		
San Juan	Yaotlica	place of war	Yautlan (glyph shows shield and club)	
San Juan	Yopico	Yopi place	Yopico (glyph shows hat of the deity Yopi)	
San Juan	*Zacatlalmanco*	where there are grasses	Zacatla	
San Pablo	*Acaxhuacan*	translation unknown		
San Pablo	Amaxac	where the water divides	Amaxac	
San Pablo	Apepetzapan	translation unknown		
San Pablo	Ateponazco	where the water boils		
San Pablo	*Atlacolpan*	upon the watery bend		
San Pablo	Atlixco	upon the water		
San Pablo	*Atztahuacan*	translation unknown		
San Pablo	*Cochtocan*	translation unknown		
San Pablo	Cohuatlayauhcan	place of the curved serpent	Coatlayauhcan	
San Pablo	Continco	translation unknown		
San Pablo	Cuezcontitlan	next to the grainaries? (from *cuezcomatl* [grain])	Cuezcomatitlan	
San Pablo	*Huehuetlan*	place of the ancestors	Huehuetlan	

PARCIALIDAD	TLAXILACALLI NAME	TRANSLATION	COMPARABLE PLACE-NAME, EPONYMOUS OR SIMILAR	GLYPH OF COMPARABLE PLACE NAME
San Pablo	Huitznahuatl/ Iznahuatonco	small place of the south/spine speech (*huitz* is both "south" and "maguey spine")	Huitznahuac	
San Pablo	Iztacalco	in the house of salt	Iztacalco	
San Pablo	Mixiuca	where women give birth		
San Pablo	Ometochtitlan	next to "1 Rabbit"		
San Pablo	Otzolocan	place of caves	Oztoma	
San Pablo	Tecama	translation unknown	Tecamachalco, from *tetl* (stone) and *camachalli* (jaw)	
San Pablo	Temazcaltitlan	next to the sweatbaths	Temazcalapan	
San Pablo	Teocaltitlan	next to the temple	Teocaltzinco	
San Pablo	Teopan	place of the temple	Teopantlan	
San Pablo	Tepetlacalco	place of the *tepetla* (stone house)	Tepetlacalco	
San Pablo	Tepiton	big hill		
San Pablo	*Tequixquipan*	upon the tequesquite (*tequixquitl*, a naturally occurring bicarbonate of soda)	Tequixquiac	
San Pablo	Tezcamincan	translation unknown		
San Pablo	Tlacaltitlan	next to the people's house		
San Pablo	Tlachcuititlan or Tlachcontitca	where there is turf		

PARCIALIDAD	TLAXILACALLI NAME	TRANSLATION	COMPARABLE PLACE-NAME, EPONYMOUS OR SIMILAR	GLYPH OF COMPARABLE PLACE NAME
San Pablo	Tlachquac	place of the ballcourt	Tlachco (glyph shows a ballcourt in plan)	
San Pablo	Tlaliztacapan/ Tlalixtacapan	upon the salt/white earth (from *tlalli* [earth] and *iztac* [salt])	Tlaltizapan	
San Pablo	Tlatzontlacalpan	translation unknown; from *calpan* (upon the house)		
San Pablo	Toçanitla	translation unknown; from *toznene* (yellow parrot)	Toztlan	
San Pablo	*Tolpetlac*	reed-mat place		
San Pablo	Tultengo	end of the reeds/swamp	Tollan	
San Pablo	Tzoquipan/ Tzoquiapan	place of much mud		
San Pablo	Xoltenco	translation unknown; from *xo* (green) and *tenco* (at the edge or lip of)	Atenco	
San Sebastián	Acalcaltitlan	next to the boats (*acalli*, reduplicated)	Acalhuacan	
San Sebastián	Ahuatonco	little oak	Ahuatepec	
San Sebastián	Atexuca/Atlixocan	place of the surface of water (from *atl* [water] and *ixtli* [eye, or surface])		
San Sebastián	Atzacoalco	Translation unknown; from *atzacua* (water lock)	Atzacan	
San Sebastián	Çitlaltepec	hill of the star	Citlaltepec	
San Sebastián	Coatlan	place of the serpent	Coatlan	
San Sebastián	Cotolco	translation unknown		

PARCIALIDAD	TLAXILACALLI NAME	TRANSLATION	COMPARABLE PLACE-NAME, EPONYMOUS OR SIMILAR	GLYPH OF COMPARABLE PLACE NAME
San Sebastián	Cuitlauctonco	little excrement place	Cuitlahuac	
San Sebastián	*Iztacalco*	in the house of salt	Iztacalco	
San Sebastián	Teocaltitlan	next to the temple	Teocaltzinco	
San Sebastián	Tlamagascapan	priest river	Tlamacazapan	
San Sebastián	Tomatlan	place of the tomatoes		
San Sebastián	Tzacualco	place of the small hill/temple		
San Sebastián	Tzahualtonco	little spider web; place of the lepers		
San Sebastián	Xocototlan	place of the plums? (from *xocotetl* [plum])	Xocotla	
San Sebastián	Zacatlan	place of the grasses	Zacatla	
Santa María	Analpa	translation unknown		
Santa María	Apanohuayan	where the water passes	Cuauhpanoayan (glyph includes symbol for *cuahuitl*, "wood")	
Santa María	Atenantitech	water wall	Atenanco	
Santa María	Atlampa	upon the water	Atlan	
Santa María	Ayoticpac	upon the squash (*ayotli*) or tortoise (*ayotl*); or from *ayoh* (something that contains water)	Ayotlan	
Santa María	Cihuatlan	place of women	Cihuatlan	

PARCIALIDAD	TLAXILACALLI NAME	TRANSLATION	COMPARABLE PLACE-NAME, EPONYMOUS OR SIMILAR	GLYPH OF COMPARABLE PLACE NAME
Santa María	*Cohuatlan*	place of the serpent	Coatlan	
Santa María	*Colhuacalzinco*	little house of the *colhua* (ancestors/bent house)	Colhuatzinco	
Santa María	Colhuacatonco	little place where the water bends		
Santa María	*Colzuauhtepec*	bent/old hill		
Santa María	Copolco	translation unknown		
Santa María	Cuepopan	translation unknown		
Santa María	Iztacalecan	place of the salt house	Iztacalco	
Santa María	*Quauhtepeque*	hill of the woods/eagle	Cuahuacan	
Santa María	Teocaltitlan	next to the temple	Teocaltzinco	
Santa María	*Tezcacohuac*	translation unknown; from *tezcatl* (mirror) and *coatl* (serpent)	Tezcacoac	
Santa María	Tezcatzonco	the little mirror	Tezcatepetonco	
Santa María	*Tlacuechiuhcan*	translation unknown		
Santa María	*Tlalcozpan* (subunit of Teocaltitlan)	upon the yellow earth		
Santa María	Tlocalpan	translation unknown		
Santa María	*Tollan*	place of the reeds	Tollan	
Santa María	*Tolpetlac*	place of the reed mats		

SOURCES: *Tlaxilacalli* names are from Alfonso Caso, "Los barrios antiguos de Tenochtitlan y Tlatelolco"; Agustín de Vetancourt, *Teatro mexicano*; and Jonathan Truitt, "Nahuas and Catholicism in Mexico Tenochtitlan: Religious Faith and Practice and la Capilla de San Josef de los Naturales, 1523-1700." Translations other than my own are from Caso, "Los barrios antiguos de Tenochtitlan y Tlatelolco"; and Antonio Peñafiel, *Nombres geográficos de México*. All illustrations by author; comparable glyphs are from the Codex Mendoza, with the exception of Atlixyocan, from the Codex Osuna and Chapultepec, from Tira de la Peregrinación.

NOTE: Italicized names are identified in the cited sources not as *tlaxilacalli* but as *estancias* (small farms) or *huertas* (orchards).

And reading the names for etymology, as above, can show us what salient topographical features Nahua residents identified in the city around them, where important architecture was likely to stand, and in a few instances, the imprint of the city's history on its toponymy. But if we set aside the "etymological attitude" argued for above and consider that names may be little more than the smooth coins of Certeau, what interpretive possibilities are open to us?

The challenge comes from a manuscript housed at the University of Texas at Austin, known as the Genaro García 30, which on its dozen or so pages offers the richest known record of place-names written in iconic script from Mexico-Tenochtitlan. It is a fragmentary manuscript and was once part of a larger *juicio de residencia*, or internal investigation of an official's time in office, carried out in late 1553 or the early months of 1554. The subject of its investigation was the then-seated indigenous *gobernador* of Mexico-Tenochtitlan, don Diego de San Francisco Tehuetzquititzin (r. 1541–1554), who succeeded Huanitzin after the latter's death (see figure 4.7 for his genealogy). Such *residencias* were standard operations within Spanish government in that they offered a way for the Crown to maintain oversight of the officials in its government. They involved appointing a judge with broad authority to examine accounts and take testimony. In this case, the *residencia* was carried out by don Esteban de Guzmán, an indigenous judge from Xochimilco, a man trusted by the viceroy who later headed the government of Mexico-Tenochtitlan as *juez-gobernador* (1554–1557), a special title that conferred upon him both judicial and executive authority. Upon completing the *residencia* and writing down his findings, Guzmán would typically present his findings to the *audiencia*.[30]

The manuscript registers complaints lodged by the city commoners, who claimed that they had delivered goods to the *gobernador* but had not been paid for them. This is a surprising charge, given that commoners traditionally supported the indigenous nobility as part of the social contract of the *altepetl*. But by midcentury, no longer. The existing manuscript has three strata: it began as a purely pictographic register of the goods that the four *parcialidades* of the city claimed to have delivered to the government under Tehuetzquititzin, along with their respective values. These included piles of highly finished embroidery works, furniture made of woven reeds, and supplies of waterfowl and fish. In figure 7.6, we see the page devoted to the food delivered to the native *cabildo* by different subsections, likely *tlaxilacalli*, within the *parcialidad* of San Juan Moyotlan. For the food, the Moyotlan *macehualtin*, "commoners," received compensation, so those amounts are shown as well. For instance, for the fish delivered by Moyotlan, seen as the fish glyph at upper left, they were compensated six *pesos* (each *peso* is shown as a semispherical bowl with a hank of three knotted cords above to create a bundle) and seven *tomines* (an amount that is one-eighth of a *peso*, shown as a coin or counter), colored red. For the birds they delivered, shown by the glyph below the fish, they received one *peso*, four *tomines*, also colored red. Uncolored amounts on other pages are the unpaid debts claimed by the native community. This is the first stratum. The second stratum was added after the pictographic record was created. A scribe, writing in Spanish, wrote down the oral testimony that the pictographic account elicited from both the *gobernador* and the *macehualtin*; in figure 7.6, this is the script that appears above the payment of six *pesos*, seven *tomines* in the upper register. The third stratum was added when the whole was reviewed by a judge, who determined the veracity of the accounts and what was due to the commoners, setting his comments in the margin; on this page, this appears as the large, loose hand below the fish, which, in one word, notes that the debts have been absolved.

To identify the groups of commoners, the artists of the pictographic manuscript employed hieroglyphs. In figure 7.6, the one for Moyotlan, a mosquito topped by a net, is seen in the inset. Below it, however, other hieroglyphs appear—a cedar tree attached to a mask at lower left, a hill symbol (*tepetl*) attached to the glyph for teeth (*tlan*). These glyphs may be the names of their respective *tlaxilacalli*, or a smaller unit that Truitt has identified as a sub-*tlaxilacalli*, because very few of the hieroglyphs easily

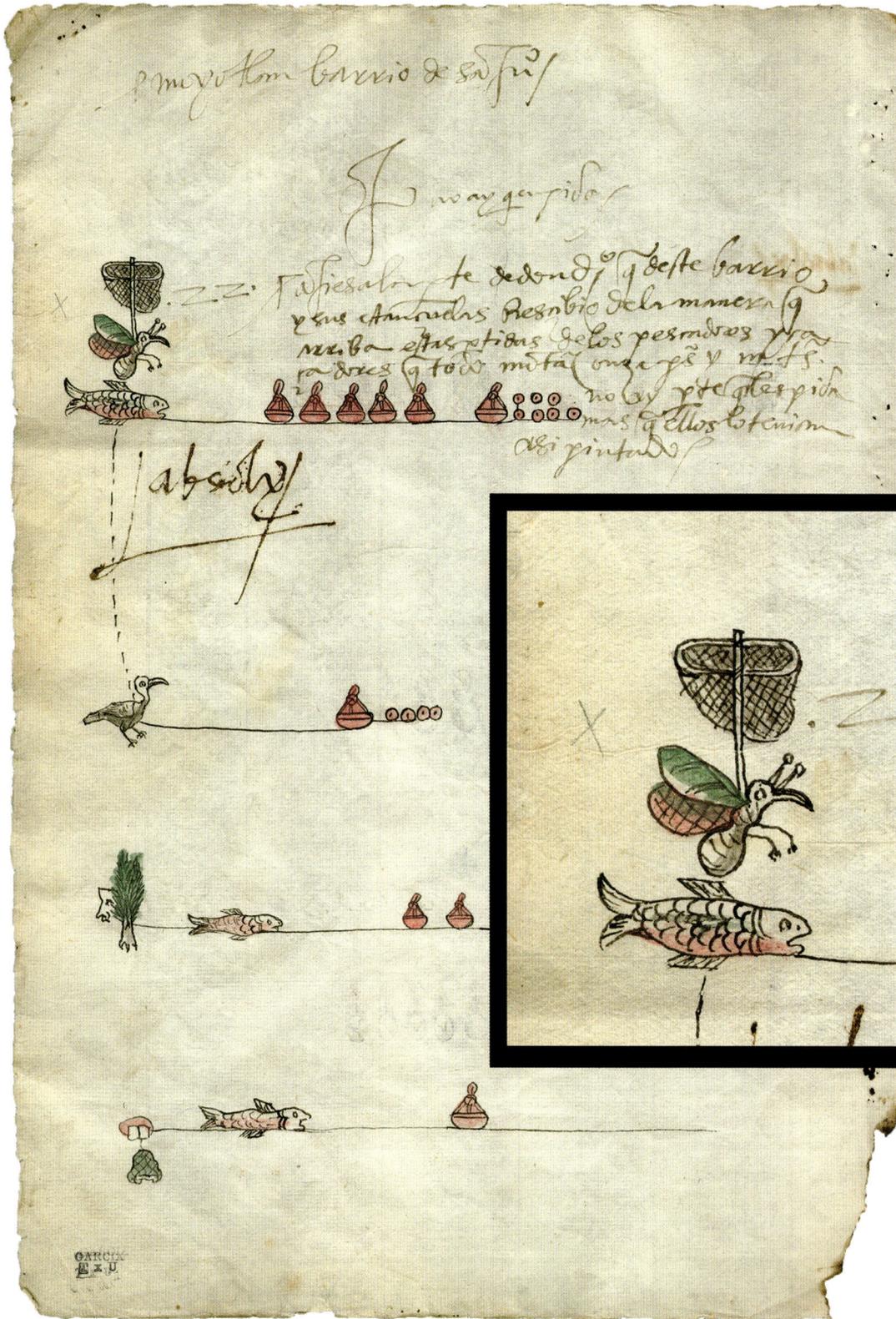

FIGURE 7.6. *Unknown creator, tribute from the* parcialidad *of San Juan Moyotlan, with place-name pictograph of Moyotlan inset in center right detail, Genaro García 30, fol. 3v, ca. 1553–1554. Nettie Lee Benson Latin American Collection, University of Texas Libraries, University of Texas at Austin.*

match up to known *tlaxilacalli* names. The full correlation of these glyphs to known groups or geographic locales awaits an exhaustive archival search to yield a more fine-grained description of the indigenous city.

But in the meantime, this source offers another opportunity. In one of his essays collected in *Of Grammatology*, Jacques Derrida offers a critique of Jean-Jacques Rousseau's idea that writing is simply parasitic upon the spoken language, or as Rousseau himself put it, "Writing is nothing more than the representation of speech." Rousseau's fundamental proposition inflected the work of linguists such as Ferdinand de Saussure, who posited that writing and other sign-making functions were properly subsumed within the science of linguistics, that is, the spoken word. Derrida argues the reverse, pointing out the numerous instances where writing gives a shape to and determines language; instructive is the example drawn from Saussure, where the misspelling of the proper name "Lefèvre" then occasions changes in the way the word is spoken. Derrida provocatively suggests that there should be a science of grammatology where the science of writing subsumes that of speech: "Since writing no longer relates to language as an extension or frontier, let us ask how language is a possibility founded on the general possibility of writing."[31]

While my purpose here is not to carry out a Derrida-inspired critique of the historiography or epistemology of Nahuatl writing, I want to follow through on a proposition that stems from Derrida's work. Let us consider the place-names on the page as signs that transmit the spoken word, and also allow that the function of such signs is not limited to their role as carriers of purely linguistic information. Such an approach is suggested by the tendency of Nahuatl place-names to "go beyond" a simple transcription of parts of the spoken word by including iconographical elements. The place-name "Tenochtitlan," from the Codex Mendoza, for example, is composed of an eagle (*cuauhtli*) on top of a cactus (*nochtli*) on top of a stone (*tetl*), but only the latter two elements figure in the place-name as spoken. With the devouring, yet unspoken, eagle, added to the place-name, we see a scribe who is using writing to do more than simply record the name; the written form becomes a means of linking the spoken toponym to a particular historical narrative about the foundation.

In a similar vein, let us question the relationship between a proper noun and its referent. By convention, proper nouns denote a single, unified referent: "Mexico" and "Moteuczoma II" refer, respectively, to a country bordered on the north by the Rio Grande and to one of the last Mexica emperors. But let me propose the idea that proper nouns may not *always* refer to an antecedent and unified signified. So no matter what kind of sign (logogram/phonogram) is used to represent the name of a place, let us not, by default, view that space, the referent for either written or spoken word, as a unified field or stable entity. We have already seen a related phenomenon of situational meaning in our examination of the names of Mexico City. Different groups within the city used the proper nouns "Mexico" and "Tenochtitlan," but the same terms could mean very different geographical and political entities. The distance between sign and signified might be even greater when we consider the use of two different scripts. For example, in looking at the map seen in figure 7.4, we encounter within it a graphic sign. When we read the alphabetic documents that accompany this map, we encounter the place-name "Tullan." We assume that these different scripts refer to the same entity, a field measuring about 860 square yards. But what if they don't? What if these different scripts point not to a unified underlying reality, but to distinct or differently understood ones?[32] We know, for instance, that the people of central Mexico held "Tula" to be a city whose high cultural achievements they inherited, as well as a place of ancient origin. What if the graphic place-name carried a host of meanings that the set of letters on the page ("t-u-l-l-a-n") did not? With this idea in mind, that different scripts—even those that "say" the same thing—may point to different referents, I now turn back to the place-names on Genaro García 30 to pay attention to how different scripts coexist and interact within the bounded space of each set of pages.

Folios 4v–7r are two once-adjoined pages (their order has been shuffled in modern times; figure 7.7). Page 4v has four sets of images, arranged roughly into four horizontal registers. In the top one, five turquoise disks show that these pages cover a five-year period. In the second one, two tribute-paying groups (they may be *tlaxilacalli*, although they are not named as such) within the *parcialidad* of Santa María Cuepopan have created some 60 *petates*, or woven reed mats, for the *gobernador*. These mats were typically used as coverings and as sleeping mats, and are represented by a rectangular glyph of bound reeds, with 3 *panitl* symbols at top, to make the count of 60. These mat makers have been paid for their wares, shown by the red counts on the facing page (folio 7r), which list a payment of 3 *pesos*, 6 *tomines* for the *petates*, that is, .5 *tomines* per mat. Below,

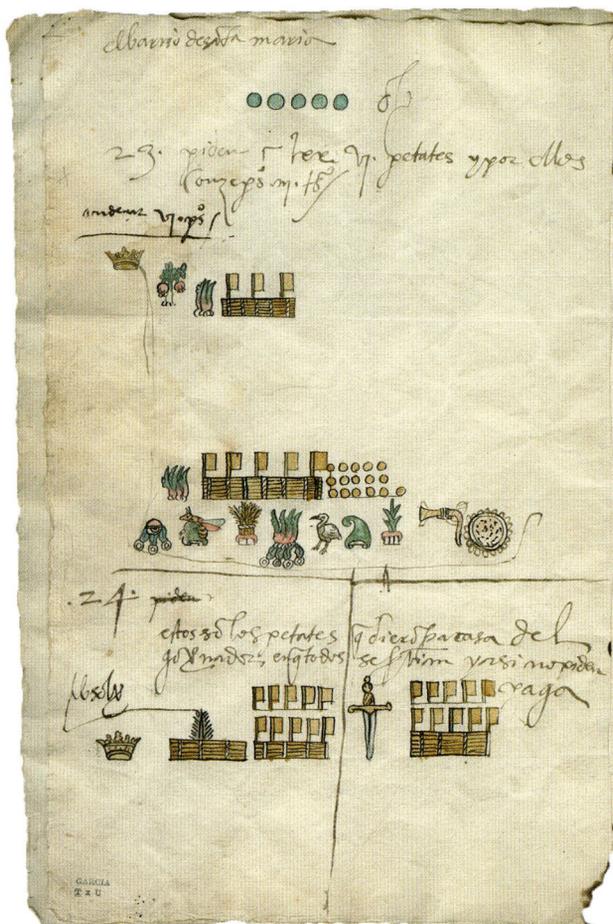

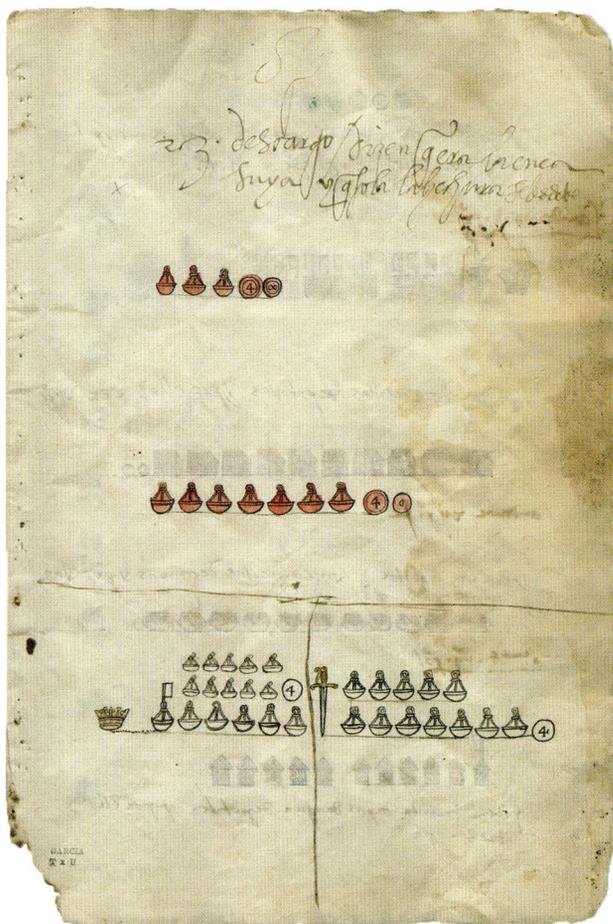

FIGURE 7.7. *Unknown creator, tribute from the* parcialidad *of Santa María Cuepopan, Genaro García 30, fols. 4v–7r, ca. 1553–1554. Nettie Lee Benson Latin American Collection, University of Texas Libraries, University of Texas at Austin.*

in the central register, ten other groups identified by place-name (including one named with *tollin*) have produced 116 long *petates* and the facing page says that they have been paid 7 *pesos*, 5 *tomines*, that is, .52 *tomines* per mat, receiving slightly more for each of these larger mats than the mat makers of the top register. The bottom register of the page is occupied by the goods for which communities have not been paid. On the left, Santa María Cuepopan is shown to have delivered 600 *petates*; the *petates* on the left are of slightly rougher quality, and the facing page gives their value as 35 *pesos*, 4 *tomines* (at .47 *tomines* a mat). At bottom right is the count for San Pablo Teopan, which has an unpaid balance for 200 mats, their value registered on the facing page at 12 *pesos*, 4 *tomines*, that is, exactly .5 *tomines* per mat.

Notable are the different kinds of writing that appear

on the pages; in addition to phonetic writing of Spanish, different iconic scripts are at work. For instance, the *parcialidad* of San Pablo Teopan is represented by a sword (the conventional symbol of Saint Paul, who was thus executed), and Santa María Cuepopan, by a crown (the symbol of Mary, Queen of Heaven), these signs being derived from attributes of the patron saints rather than having any relation to spoken language, be it Nahuatl or Spanish. On the page, they are colored with a uniform yellow pigment, as if to represent gold. In contrast, the often smaller and more visually complicated glyphs for the Nahuatl names of tributary groups, perhaps *tlaxilacalli*, are colored with three pigments: red (likely derived from cochineal), blue-green (which may have been derived from Maya blue), as well as the yellow. The same red pigment is used as color fill for the symbols (*pesos* and *tomines*) that show the government's payment of debts; the blue is used to fill in the year counts at the tops of the pages. Alphabetic writing is added in the spaces between the pictographs, and it gives voice to two parties: the native governmental officials, who contest the demand for payment, saying that the raw goods are theirs

FIGURE 7.8. *Unknown creator, tribute from the* parcialidades *of San Juan Moyotlan and San Pablo Teopan, Genaro García 30, fols. 5v–6r, ca. 1553–1554. Nettie Lee Benson Latin American Collection, University of Texas Libraries, University of Texas at Austin.*

and they only owe for the cost of manufacture, and the Spanish judge, who proclaims whether the debt has been absolved or not.

This work of 1553–1554 shows us, then, that distinct ways of writing coexisted on the pages of documents produced within the city and would seem to confirm the idea of an emergent bilingual empire created within New Spain. But this document reveals a distinction not just between the Nahuatl and the alphabetic writing used, in this case, to write Spanish but also within the signs themselves, where different orders of signs refer to the same (assumed) entity. We see this on folios 3v and 5v, which show two versions of the name of the *parcialidad* San Juan Moyotlan. At the top of folio 3v, and enlarged in the inset, we find the Nahuatl name "Moyotlan," represented here in iconic script, a mosquito (*moyotl*) with a net (*matlatl*) attached above it (figure 7.6). The net may reduplicate the initial *m* sound or may register a part of the name not included in the alphabetic rendering. When used in this context, "Moyotlan" identifies the *parcialidad* affiliation of the fishermen and hunters from Moyotlan who have delivered fish and birds.

At the top left of folio 5v (figure 7.8), we encounter Moyotlan named again, but here it is the chalice of Saint John the Baptist marking it; Saint John, as we know, was one of two patron saints of this *parcialidad*. And we see the name not connected to the producers, but instead connected to the unpaid goods received by the *gobernador*. In other words, while it is Moyotlan named on both of these pages, there are two ways of writing the name, one by rendering the Nahuatl name in iconic script, the other by rendering the saint's name with a symbol of the saint's attribute.

Could these names of what we assume is one place, when expressed differently, be pointing to the existence of two entities? Because these two renderings, on the surface naming the same place, in fact reflect two distinct concepts: "Moyotlan" (in iconic script) as point of group identification for fishermen and hunters and "Moyotlan"

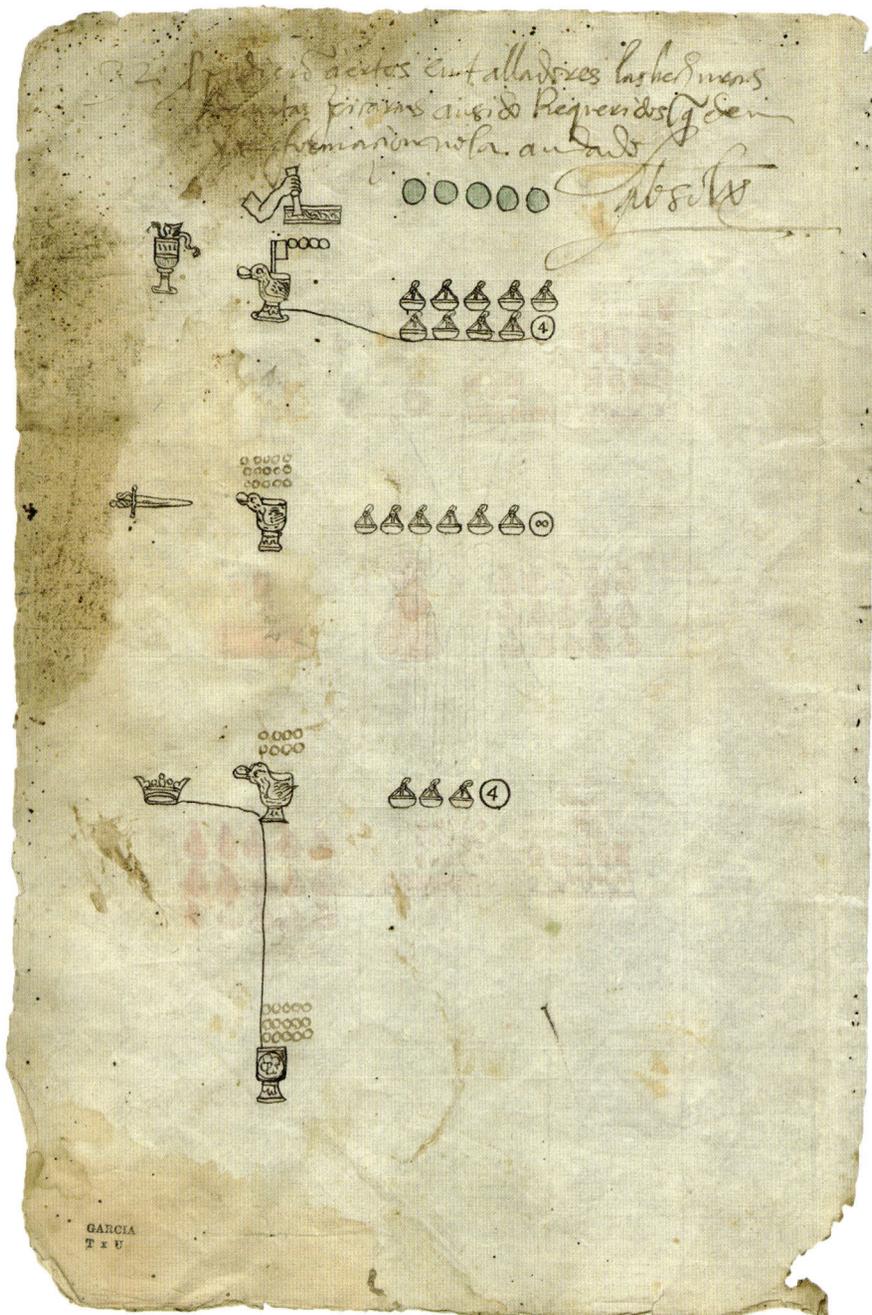

FIGURE 7.9. *Unknown creator, tribute paid by the sculptors of Mexico-Tenochtitlan, Genaro García 30, fol. 9v, ca. 1553–1554. Nettie Lee Benson Latin American Collection, University of Texas Libraries, University of Texas at Austin.*

(as the symbol of a saint) as collection point for tribute goods. What these pages seem to show is that "Moyotlan," as rendered here, is less a defined geographic entity than two very different social contracts. In one of these, people were connected by shared livelihoods in a shared space; in another, they were bound vertically to overlords, the connections between them materialized in a flow of goods that was increasingly a one-way current.

On two other pages, we see another tension between proper nouns (figures 7.9 and 7.10). Folios 9v and 10v show

the luxury goods produced by two groups: indigenous sculptors and indigenous painters, who use a distinct logogram to identify themselves at the top register of each page, below the count of turquoise years. The sculptors represent themselves with a small bent arm holding a sculptor's tool in front of a decorated band, while the painters represent themselves as an arm with a paintbrush, also in front of a decorated rectangle, presumably a sheet of paper. (The facing pages are either blank or missing and thus not reproduced here.) These artisans do not identify

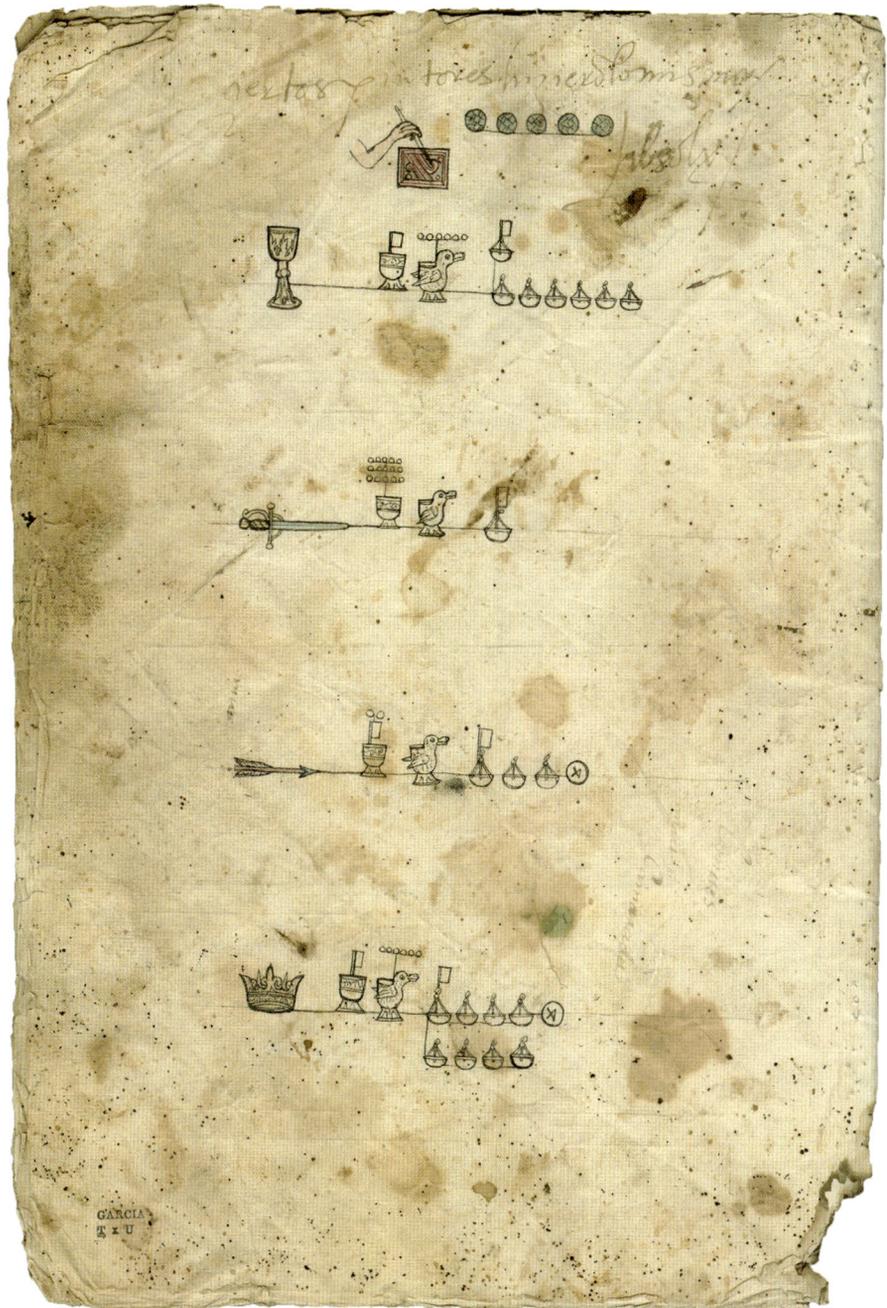

FIGURE 7.10. *Unknown creator, tribute paid by the painters of Mexico-Tenochtitlan, Genaro García 30, fol. 10v, ca. 1553–1554. Nettie Lee Benson Latin American Collection, University of Texas Libraries, University of Texas at Austin.*

themselves as belonging to one of the four *parcialidades*, as their symbol alone is set at the head of the page. Instead, it is the goods delivered, and again not paid for, that are connected with lines to the symbols of three of the four *parcialidades* (a facing page is incomplete because here we would expect the arrow of San Sebastián). In other words, the self-identifying marks of painters and sculptors are not linked to these particular Christian symbols of the *parcialidades*, where they may have resided, whereas the tribute delivered is.

These corporate identifications expressed by the icons of sculptors and painters—where native craftsmen and -women felt a sense of collective unity—had deep roots, and such social groups had many opportunities to maintain their strength in the colonial city. Sahagún's Florentine Codex tells us that the practitioners of certain crafts, like goldworkers and featherworkers, lived together in certain neighborhoods in the pre-Hispanic city and shared in the worship of a particular cult deity, with the goldworkers worshipping Xipe Totec, the featherworkers

Coyotlinahual.[33] Thus for some craftspeople, group identifications stemming from occupation and residence historically overlapped. In the post-Conquest city, Catholic religious sodalities dedicated to a saint or an object of devotion, called *cofradías*, began to consolidate as early as the 1530s, replacing pre-Hispanic cults. Since members often shared the same occupation, religious affiliations coincided with professional ones, as they had in the pre-Hispanic period. We will see the trajectories of the *cofradías* through the city streets in the next chapter. Another forum where the bonds of collective identification were forged was the marketplace, particularly the great Tianguis of Mexico, where craftsmen and merchants were grouped by type in stalls to sell their goods, which afforded them repeated and habitual face-to-face interactions with each other and with their buyers.

If we consider that Genaro García 30 offers us on its pages a representation of the city, its first strata and general organization created by a native scribe working for commoners complaining about abuses by the nobility, we can see how frequently indigenous hieroglyphs represent collectives of people whose communal identity was consolidated through their shared tribute obligations. The symbols of the saints that stood for the *parcialidades*, on the other hand, are aligned to the collection of that tribute, which was intended for the native *gobernador*. We can compare folios 4r–7r to a page from the Codex Mendoza, where tributary provinces are named along the edge of the page and the lists of the tribute that they were required to pay is pooled in the center of the page (figure 7.7 and see figure 3.1). But two crucial differences emerge: first, the Codex Mendoza opens with a visual statement about the divine origins of Tenochtitlan (see figure 1.3), an ideological statement that justified the extractive economic relationships that are expressed in the tribute section. Genaro García 30 is a fragmentary manuscript, but in its present state it lacks compelling ideological justification of the traditional transfer of goods detailed on its pages, perhaps an indication that conventional social bonds within the *altepetl* were fraying. Second is the presence of the other strata on the pages—the responses produced by the questioning of the indigenous judge don Esteban de Guzmán and the *gobernador* Tehuetzquititzin and the final responses by the Spanish judge. These show us quite visibly the shake-up in power relations within the city itself, where the native *gobernadores* were now expected to pay for the many goods they had once received for free. And now native *gobernadores* were no longer the last court of appeal in any political process, their traditional rights countermanded and curtailed by a new Spanish legal system.

TEHUETZQUITITZIN

But who exactly was the figure named as "don Diego" on the pages of Genaro García 30? And if the manuscript tells us something about indigenous commoners living in the city during his reign, and their dissatisfactions at delivering tribute to the *tecpan*, what can it tell us about him? Other historical sources reveal that, like his second cousin Huanitzin, Tehuetzquititzin was a political survivor as well as a member of the highest strata of the Mexica elite, being the grandson of the *huei tlatoani* Tizocic (see figures 4.7 and 5.2). He tenaciously made it through three years in captivity in Coyoacan and then the grueling expedition to Honduras, during which many other native leaders, like Cuauhtemoc, died or were killed. And like Huanitzin, such proximity to the conquistadores gave him an opportunity to observe them at close range as well as create alliances with the other elite Mexica also held captive. Upon Huanitzin's death, he was chosen, likely by Viceroy Mendoza himself, as the new *gobernador*. From the brief description offered by the historian Chimalpahin, we can see that Tehuetzquititzin followed in the traditional path of his *huei tlatoani* forebears and as part of his accession rituals he was bathed: "It was also at this time, in [this] year, that one went to Xochipillan where the people of Xochipillan were defeated. There don Diego Tehuetzquititzin went to be bathed as ruler."[34] Bathing was an important phase of the pre-Hispanic consecration rituals of the anointed ruler, and Tehuetzquititzin carried on that tradition; he also proved his prowess as a warrior, another crucial phase of Mexica consecration. However, Tehuetzquititzin did not initiate his own conquests, as his forebears had done. Instead, he joined Viceroy Mendoza's campaign against the northern Chichimecs in the 1540–1542 Mixtón war. Such a pattern—the anointment by ritual bathing, the waging of war—evokes the earlier rituals of the Mexica kings, at the same time that participation in a Spanish-led military campaign allowed Tehuetzquititzin to prove his loyalty to the Spanish Crown as well as to hit the road with Mendoza, then the most powerful man in New Spain.

Representations of Tehuetzquititzin in indigenous manuscripts adhere to the conventions used to show his predecessor Huanitzin. In the Codex Aubin, he is shown

in the same manner as Huanitzin, wearing the turquoise miter and turquoise cloak (see figure 5.1); in the Beinecke Map, he appears, like Huanitzin, with a turquoise miter and seated on the high-backed *tepotzoicpalli* (see figure 5.2). Also on the Codex Aubin page is the sign of what would be the greatest challenge of Tehuetzquititzin's rule: the terrible hemorrhagic fever epidemic, a disease known as *cocoliztli* that swept through New Spain in 1545–1548, followed by a lesser epidemic in 1550 of what was perhaps mumps.[35] The scale of death leaves its traces in the account of a judge of the *audiencia*, Alonso de Zorita, who served from 1556 to 1566, and who looked back on this period and recorded that "ten, fifteen, twenty years ago there were fewer farms, and there were many more Indians. . . . [Today] there is barely one third as many Indians."[36] Modern accounts estimate that as much as 80 percent of the native population died in the *cocoliztli* epidemic; in comparison, the Black Death in Europe killed 50 percent of the population, so "in absolute and relative terms the 1545 epidemic was one of the worst demographic catastrophes in human history."[37] In its wake, a food crisis erupted in Mexico City because so few were alive or well enough to work in the fields, and the self-interested response of the Spanish *cabildo* was to demand that more indigenous commoners be compelled to plant wheat and maize.[38]

The plagues exacerbated the trends of the extractive economy that had been created in the wake of the Conquest, where Spanish conquistadores and later arrivals looked to indigenous labor, granted to the Spaniards via *encomiendas*, to support themselves and their large households, as well as their business ventures.[39] Their interests were in direct conflict with those of native elites, like Tehuetzquititzin and other members of the native *cabildo*, for whom being a noble meant being wealthy. These native elites depended upon the classes beneath them to support their households and to maintain their status and did so by requiring tribute from the peasants who worked lands they held. Within Mexico City, native elites' access to indigenous labor was curtailed even more sharply as they lost properties and the tenant labor they once held outside of the city to the Crown or *encomenderos*, who held Crown grants of indigenous labor. Within the city, they had to compete with the labor demands made by religious orders (who relied on free indigenous labor in all their construction) and *repartimientos* (temporary grants of labor) given to the viceroy and the *audiencia*.

Tehuetzquititzin had to contend not only with

epidemics and their aftermath in the late 1540s, but also with the viceregal government, which was pushed by the royal Crown for even more revenues and began to aggressively curtail the prerogatives of all indigenous nobility by changing the pre-Hispanic tributary economy. Before the Conquest, commoners delivered maize or other goods, which were used, in part, to support rulers and their families; they also had labor obligations, often for works of benefit to the community. Land was also a key resource: noble families held lands that were worked for their benefit, and certain lands were set aside for the benefit of officeholders. But land seizures, first by conquistadores and later by the royal government, eroded the amount of tributary lands that supported elites (patrimonial lands) and native officeholders (*señorial* lands).[40] By midcentury, the royal government had put rulers in the valley on a salary, thereby cutting the amount that they were entitled to receive from the general tribute collection. At the same time, they curtailed the labor services that commoners would traditionally supply indigenous rulers.[41]

One indication that the indigenous *cabildo* under the leadership of Tehuetzquititzin was hard-pressed for resources is their decision in the late 1540s to erect a building with an arcade in the Tianguis of Mexico, a structure that would define its northeast corner. In all likelihood, they were envisioning this public work as a building whose income would benefit their community coffers, following the practice of the Spanish *cabildo* to construct storefronts on land it owned adjacent to the plazas of the city and rent them out; adding to the value were the arcaded spaces in front, another source of rental income.[42] The indigenous *cabildo* undoubtedly recognized the potential for profit if it constructed buildings of its own on the perimeter of the Tianguis of Mexico. But it lacked the necessary funds for the building and joined with the powerful dealmaker and judge of the *audiencia* Lorenzo de Tejada (seated 1546–1553) to build these shops with their sheltering arcade, with Tejada advancing the capital for the venture.[43] When the indigenous *cabildo* could not raise the money to repay him for the building, Tehuetzquititzin ceded the land as repayment, and the building was thenceforth known as the "Portales de Tejada."[44] Tehuetzquititzin's move is a revealing one, in that he and the native *cabildo* believed that it was possible to alienate the *tianguis* land to repay a communal debt. In other words, the land of the *tianguis* was no different than other lands within the *parcialidad*, where the native government was able, like its Spanish counterpart, to

grant the lands under its aegis. A careful businessman, well aware of legal niceties, Tejada sought additional confirmation for his new land grant from the Spanish *cabildo*, which he received on July 19, 1549.[45] Thus, what had begun as a work that would profit the indigenous *cabildo* ended up as a net loss of *tianguis* land.

While the extractive economy, with peasants supporting elites, had its roots in the pre-Hispanic era, in that period, disgruntled or overworked laborers had no exterior court of appeal over executive authority. But after the Conquest, the Crown established a legal system that provided one. Its presence is seen in the Genaro García 30, where the overseeing (but unnamed) judge (likely from the *audiencia*) writes down the summary judgment. In legal disputes, indigenous commoners could appeal to royal judges, who had jurisdiction over elites and commoners alike; by the end of the sixteenth century a separate court system was set up for them.[46] But by midcentury, popular discontent by Mexico-Tenochtitlan's tributary population could and would be channeled through the Spanish legal system. We find abundant evidence of it in the commoners' reaction to

largely untenable conditions erupting during Tehuetzquititzin's reign. In the Genaro García 30, city residents, aware that they now needed to be compensated for goods beyond the set level of tribute, made a plea to be paid for goods given to Tehuetzquititzin. Another document, the Codex Cozcatzin, reveals another face of the strained system. This work is a composite, drawn up probably in the late seventeenth century by an elite indigenous family from Tlatelolco who used it as part of an ongoing effort to claim political power in the polity. To this end, they ordered the copying of a number of earlier alphabetic-pictographic manuscripts by a native scribe, who brought together largely unrelated pictorial histories in a single document. One of them is a complaint of ca. 1572 presented to the *audiencia* by indigenous residents of Mexico City. They claimed that under the reign of Tehuetzquititzin, that is, over twenty years earlier,

FIGURE 7.11. *Unknown creator, textile tribute from the four parcialidades of Mexico-Tenochtitlan, Genaro García 30, fols. 8v–9r, ca. 1553–1554. Nettie Lee Benson Latin American Collection, University of Texas Libraries, University of Texas at Austin.*

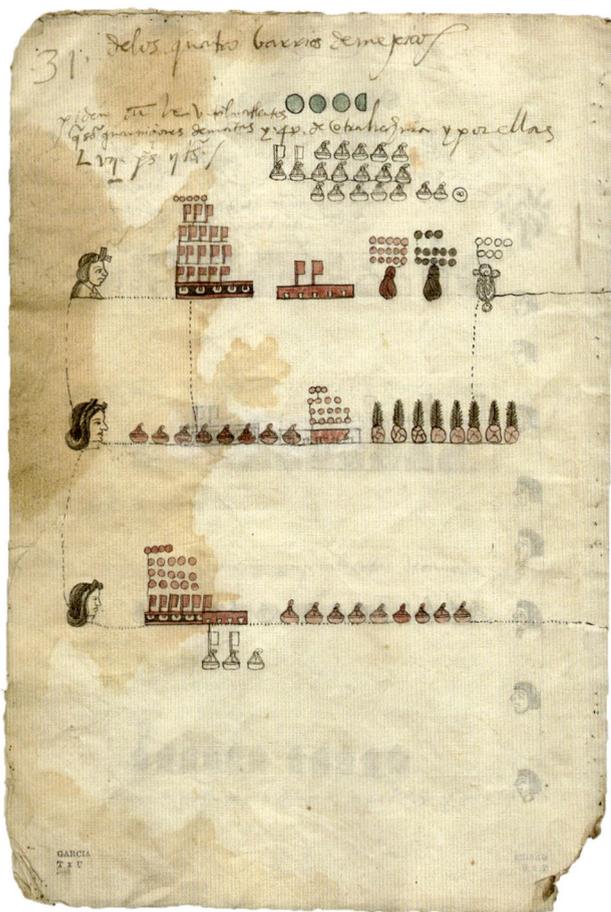

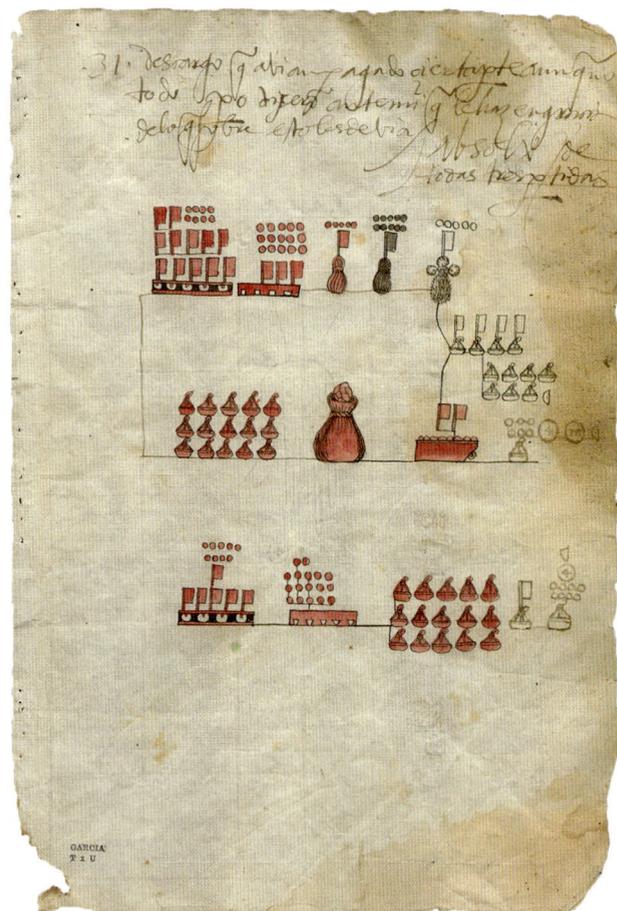

they had been despoiled of lands granted to them yet even earlier, in the mid-fifteenth century under Itzcoatl in the region around San Juan Ixhuatepec. As they put it, "The aforementioned don Diego [Tehuetzquititzin] tyrannically, with little fear of our Lord God, took the lands from us by force, throwing some of us into jail, driving others from their lands, and tormenting and visiting us with many other vexations."[47] We do not know Tehuetzquititzin's side of the story about this land parcel; these could have been patrimonial lands, farmed for him by dependents, who were making their own land grab.

Instead of writing off Tehuetzquititzin as simply an abusive ruler, caught with his hand in the till or bullying peasants off their lands, let us return to the Genaro García 30 and put it in the context of what we know of the early part of Tehuetzquititzin's reign, where we find him consecrated as closely as possible to the style of pre-Hispanic Mexica rulers, and living in San Pablo Teopan, as would his son Pedro Dionosio.[48] On folios 8v–9r of this document, the skilled women textile workers present their account of the goods delivered to the *gobernador*, which include 563 embroidered borders arranged in the page's three registers (figure 7.11). Such an embroidered border is frequently seen set as the border of capes that were for the exclusive use of elites, and the one produced in the largest quantity (365) on folio 8v has what is called a *tenixyo*, the eye border design; we see it worn by the Tetzcocan noble Tocuepotzin, whose elegant full-page portrait was included in the Codex Ixtlilxochitl (figure 7.12), and by Moteuczoma as he appears in the Humboldt Fragment II (see figure 4.6).[49] In its list of the cloaks that warriors were allowed to wear to mark their status, the Codex Mendoza reserved it for warriors who had taken three or four captives, but not one or two. These borders would undoubtedly have been sewn to the edge of a cloak or loincloth of another fabric to elevate its status, making it appropriate for elite wear. Also included in the goods delivered are hanks of thread, some dyed black, others red, and some spun with feathers, a laborious technique used to create feather-embedded cloth. The quantity of borders clearly indicates that these were not for the exclusive use of one person alone; as status markers, the amount was excessive for the *gobernador*'s entire household, which would certainly include people whose status proscribed the wearing of such elite garments.

So how are we to account for this large demand for very special and highly recognizable textiles? In accounts of the vibrant pre-Hispanic feasting culture of the Mexica rulers,

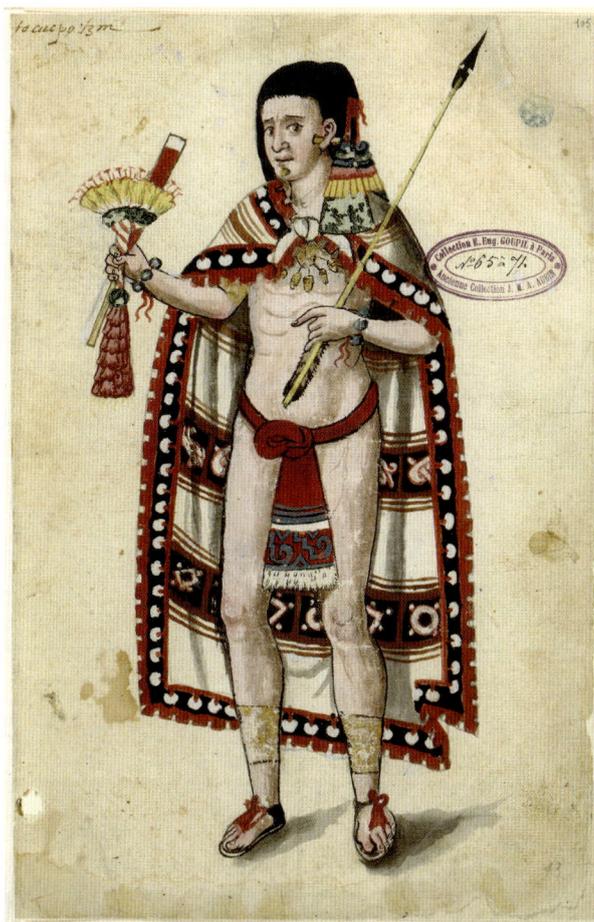

FIGURE 7.12. *Unknown creator, portrait of Tocuepotzin, Codex Ixtlilxochitl, fol. 105r, ca. 1580. Ms. Mexicain 65–71, Bibliothèque nationale de France, Paris.*

textiles were among the gifts given by the ruler as a way of cementing bonds between ruling elites. We should recall the account of ritual gifting between Nezahualcoyotl and Moteuczoma I, written by the Dominican Diego Durán and discussed in chapter 5, where the Tetzcocan ruler gave his Mexica counterpart presents of "gold jewelry, precious stones, ear ornaments, lip plugs, exquisite featherwork, shields, weapons, mantles and beautifully worked breechcloths."[50] Zorita echoes the Durán account of elite gifting, but emphasizes how feasts benefited a larger populace: "All that they [the indigenous wealthy merchants] gave went into a common fund that the ruler expended for the enjoyment of all on these festivals. When the festival had ended, the supreme ruler gave to the lesser lords, his vassals, and to the lords of neighboring towns who attended these festivals, rich cloaks and other presents."[51]

Two other sets of goods listed in the complaint of

Genaro García 30 can also be related to a culture of ceremonial feasting. The last pages of the document show the products that the painters and sculptors were making: elaborate painted cups and vessels (figures 7.9 and 7.10). One of the vessel types that both painters and sculptors participated in making is in the form of a bird, specifically a duck, a water bird common in the valley. The rendering of these vessels on the manuscript page bears similarity to a ceramic vessel, probably from the Valley of Mexico, now in the collection of the Metropolitan Museum in New York (figure 7.13). While the ceramic bird may represent a native turkey or vulture, based on the shape of its beak, its adornments are those of the water deities, and they include a goggle-eyed mask like the one that Tlaloc wears, a paper fan above its forehead (the *amacuexpalli*), and large rectangular earrings. This work, with its innovative form and careful ceramic work and slip technique, gives us an idea of the elegant objects that these feasts required and allows us to surmise the social bonds that their gifting cemented, as well as the latent water iconography.

We can pair Genaro García 30's tantalizing visual evidence of the elaborate elite feasting culture that Tehuetzquititzin maintained with other accounts, particularly a lawsuit brought by the native community of commoners who complained that they were unfairly taxed over the years, both by their own lords and by Spanish officials.[52] Most of their complaints concerned the delivery of fodder or building materials, but they also claimed around 1555 that they were forced to pay extra monies so the lords could celebrate the feast of San Pedro and San Pablo, the feast day of Tehuetzquititzin's *parcialidad*; the government countered years later by saying that such payments were entirely voluntary.[53] These payments show us the value of the symbolic economy that the feasting culture gave rise to, as well as the ways that elite celebrations were piggybacked upon a new cycle of Catholic ritual. And following our discussion of "competitive generosity" in chapter 5, we can see that feasts, whose traces we see in the Genaro García 30, were important venues for Tehuetzquititzin to consolidate the imperiled elite classes in the city, as well as build alliances with indigenous elites outside the city, thereby keeping up an expansive network of possible marriage partners of similar status.[54] The outcome of his efforts at social consolidation appears in a letter written May 2, 1556, two years after his death.[55] In it, the leaders of the main valley towns, from Tenochtitlan, Tetzcoco, Tlacopan, Tlatelolco, Coyoacan, Ixtapalapa, and Ecatepec, came together in

Tlacopan to ask the king to protect them from the *agravios e molestias* (aggravation and abuses) they received from the valley's resident Spaniards, and to appoint a protector to live full-time in the city and keep the king apprised of their situation. They went as far as suggesting the Dominican firebrand Bartolomé de las Casas for the position. Such elite alliances were not created overnight, and in this letter we find evidence that Tehuetzquititzin's feasting strategy succeeded in consolidating alliances between the often-quarrelsome leading families of the valley. The maintenance of this feasting culture was crucial for the social adherence of the city's native elite, at the same time that it was increasingly taxing to the shrinking tributary base.

ESTEBAN DE GUZMÁN AND THE *TECPAN*

Tehuetzquititzin is the last ruler for whom we have any record of consecration in the old style. With the departure of Viceroy Antonio Mendoza in 1550, Tehuetzquititzin lost the man with whom he had embarked on an internal conquest, most likely a key ally and protector. The appointment of Viceroy Luis de Velasco, who arrived in the city in 1550, brought a new era, and Tehuetzquititzin did not survive long. Velasco energetically took up the cause of tribute reform, and although his goal was often to protect indigenous charges against excessive exploitation by Spanish *encomenderos*, in the case of Mexico City, he also interceded between the city's population and their native lord. He made the extraordinary appointment of don Esteban de Guzmán, an indigenous man who had previously served the viceroy as a judge for indigenous affairs, to conduct the *residencia* investigation of the governorship of Tehuetzquititzin in 1553 or 1554. While Genaro García 30 was part of this inquiry, no final report ever seems to have been filed because this (relatively) long-seated ruler died during it. Velasco quickly named Guzmán as interim ruler in June of 1554, giving him the title "juez-gobernador."[56] But unlike earlier *gobernadores*, Guzmán had no connection to the Mexica ruling line or even with the city itself, instead coming from Xochimilco, a town some twelve miles to the south of Tenochtitlan. This appointment was a significant event in the valley, and its importance led it to be recorded in a number of native pictorial histories of the era.[57]

If we used the featherwork *The Mass of Saint Gregory* to give us an image of how Huanitzin, the city's first *gobernador*, imagined the city under his reign, we can derive a wholly different picture by looking at a manuscript about

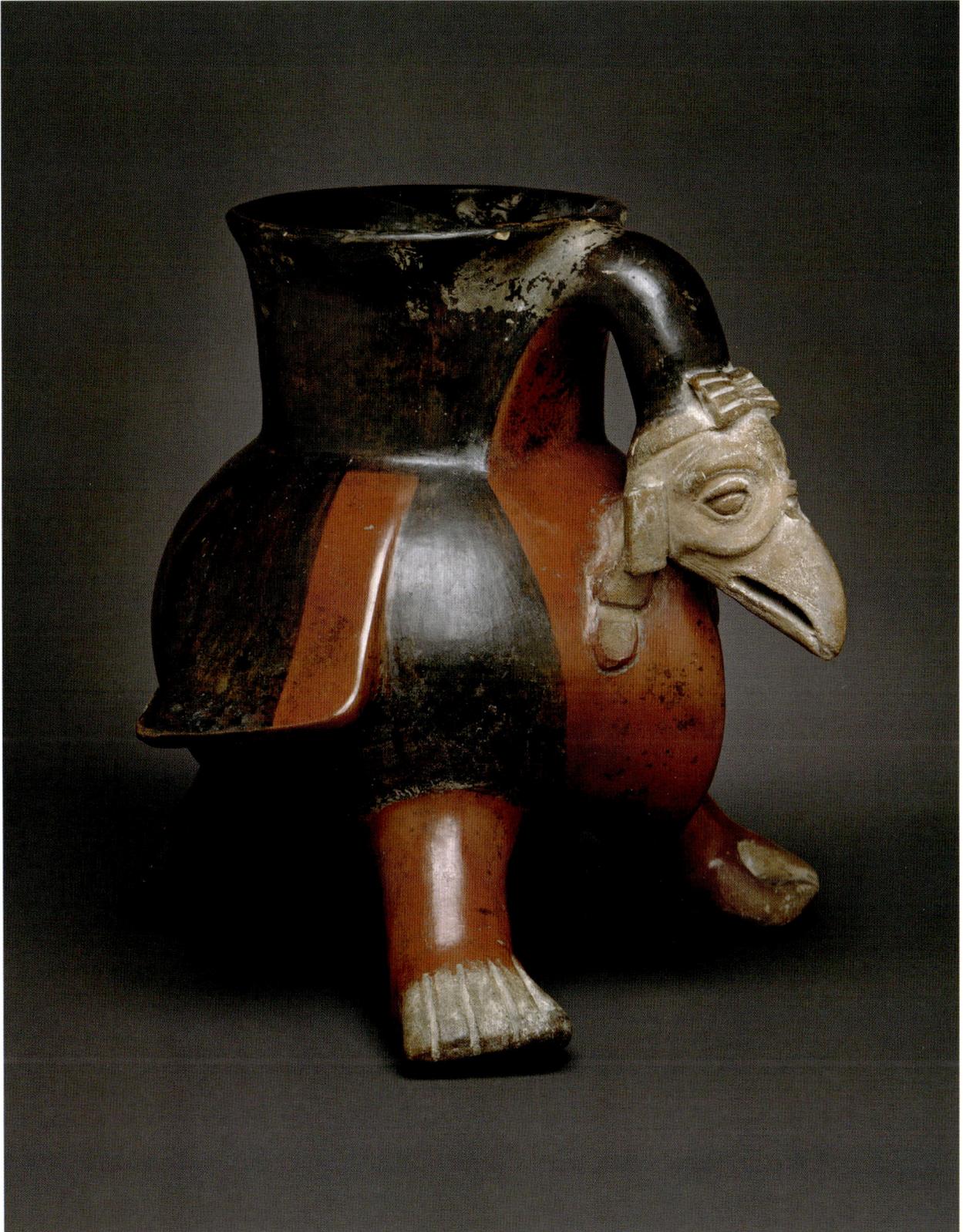

FIGURE 7.13. *Unknown (Aztec) creator, vulture vessel, fifteenth to early sixteenth century, Mexico. Ceramic, 8¾ in. (22¼ cm). © The Metropolitan Museum of Art, New York. Image source, Art Resource, New York.*

FIGURE 7.14. *Unknown creator, Viceroy Luis de Velasco and don Esteban de Guzmán (top), with complaint over tribute (below), Codex Osuna, fol. 1v, ca. 1565. © Biblioteca Nacional de España.*

the city in which Guzmán plays a starring role, the Codex Osuna. The codex, whose image of the *tecpan* we saw in relation to its construction under Huanitzin in chapter 5 (see figure 5.5), was compiled in 1565 during the official inquiry conducted by Gerónimo de Valderrama, whom Philip II had appointed to serve as general inspector (*visitador general de Nueva España*), a position with wide-ranging powers.[58] One of his charges was to organize and rationalize the system of tribute. His inquiry offered a forum for airing the long-simmering disputes within the city. One section of the Osuna was created at the behest of the city's indigenous governors to complain of abuses—usually unrecompensed labor and goods—that the city's indigenous residents had given to Crown officials. In other words, its content mirrors that of the Genaro García 30, but instead of commoners complaining about their indigenous overlords, we find those very indigenous lords complaining about their Spanish higher-ups. Those held responsible included Viceroy Luis de Velasco, and particular blame was placed on the judges of the *audiencia*, including Zorita.

Although dated to 1565, during the reign of Luis de Santa María Cipactzin (r. 1563–1565), this later lord is not depicted in the Codex Osuna. Instead, it is Esteban de Guzmán, who had ruled a decade earlier (r. 1554–1557), who appears twice in the manuscript. It is quite possible that this part of the Osuna was drawn up ca. 1555 and then the original, or a copy, was given to Valderrama a decade later during his investigation of abuses.[59] Folio 1v is the reverse of what is now the opening page of the document but originally was an internal page of a much longer compilation, as is revealed by the pagination, which runs from 463 to 501 (figure 7.14). This page registers a complaint from ten or so years before, that is, sometime around 1555, when Viceroy Velasco commanded that lime (a necessary ingredient for stucco, concrete, and whitewash) be brought into the city for repairs on the palace where the viceroy lived, as well as on the Chapultepec aqueduct that ran along the Tacuba causeway. While the text and images below show us the counters, the bags of lime, and the Chapultepec place-name that was their destination, the top of the page is dominated by an exchange between the viceroy, at left, seated in the curule chair used by Spanish officials, and Guzmán, standing at right, holding a staff of office of about six feet long. Both the men speak, their speech scrolls being the only application of a light blue, likely Maya blue, on the page; following a convention of this manuscript, Velasco speaks in a straight scroll to show

his Spanish words, whereas Guzmán's mouth emits the more elegant curled scroll of Nahuatl speakers. The visual trope of facing figures in a delimited space like this one has a long tradition in Mesoamerican pictorials to show alliances. The position of their hands—they each point toward the other with the index finger of their left hand—is often used in colonial manuscripts to show two figures in conversation.[60] Most interestingly, Guzmán's position does not convey submission (he is not kneeling), nor is he simply accepting an order, in which case his hand would more likely be downward turned, with his palm facing toward Velasco. While much suggests their equality, there are other elements that suggest an unequal balance of power between the two figures. First is the presence of Velasco's curule chair, a typical sign used to show a Spanish authority figure. Second is his sword, whose sheathed blade is visible behind the chair; the right to wear a sword was closely curtailed by law, and rarely do indigenous authority figures carry swords. Instead, they carry staffs. Another page in this manuscript makes this clear by showing indigenous deputies kneeling one at a time before Viceroy Velasco as they receive their staffs (figure 7.15). The staff in Guzmán's hand was also conferred upon him by the viceroy as a mark of his authority within a political hierarchy established by the Crown.[61]

These images in the Codex Osuna establish Guzmán as something of a New Man within the still-developing political hierarchy of the colony because this is one of the first images where a native governor is shown in relation to the viceroy—not a coincidence, but a sign that Guzmán was actively constructing a role for native leaders that underscored their relationship to royal power (see figures 5.5 and 7.14). To begin, he wears clothes that are modifications of Spanish clothing types: long pants with a long-sleeved and belted tunic covering his torso; Velasco, on the other hand, wears the costume of a court official: tight-fitting leggings under breeches and a kind of greatcoat covering all. But Guzmán also wears the most distinctive and expensive item of indigenous male dress, the *tilma*, "cloak." Other period portraits of Guzmán, such as the ones in the Plano Parcial and the Beinecke Map, show him to wear a cloak with a red border and red stripes, and a parallel example of a vividly striped cloak can be found worn by Tocuepotzin, a high-ranking Tetzcocan noble (see figures 4.5, 5.2, and 7.12). If the goal of the cloak was to distinguish him in a crowd, the deep cherry-red border or stripes set off against the fine white cotton (which may have even had

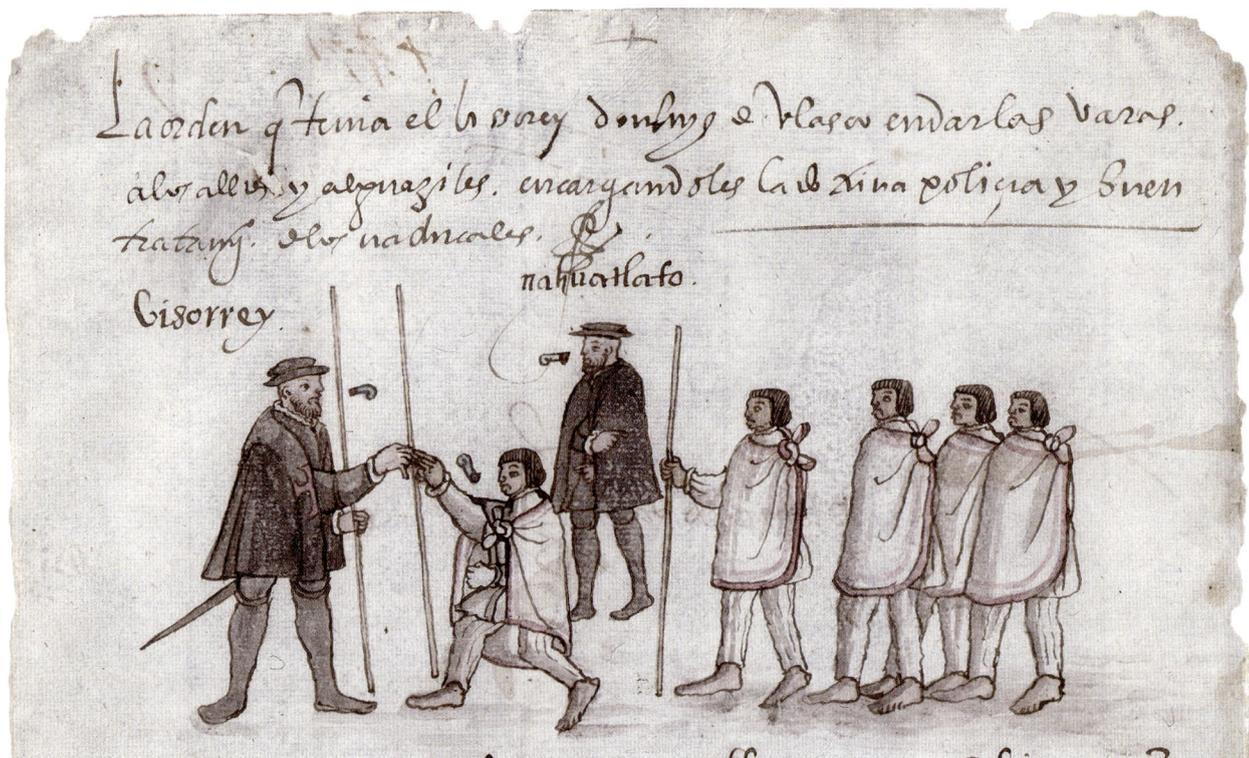

FIGURE 7.15. *Unknown creator, Viceroy Luis de Velasco deputizing the alguaciles, or indigenous constables, detail, Codex Osuna, fol. 9v, ca. 1565. © Biblioteca Nacional de España.*

feathers embedded in it) would have been quite visible. The relationship of the figures on the Osuna page in figure 5.5 is also significant because Guzmán appears consecrated by viceregal authority (holding the staff) at the same time that he is shown as an equal partner in the parley. A similar image on the Beinecke Map shows the pair in a position of even greater equivalence (see figure 5.2). Here, Guzmán, wearing the striped cloak, is standing with his staff, and opposite is the viceroy, also on foot. Both are speaking, and their pointing hands underscore their exchange. But a subtle visual difference is introduced: Guzmán stands at a slightly higher register than the viceroy, and his words are addressed not to the figure opposite him, but to the crown, that symbol of royal power worn only by the monarch, that floats above the viceroy's head.

The reading of the Osuna image can be further nuanced by the historical record, which makes it clear that despite his favor with the viceroy, Guzmán was no puppet. Instead, from the moment of being seated, he was active in defending certain prerogatives of the indigenous community. Soon after coming to office in 1554, he was joined by don Pedro Moctezoma Tlacahuepantli (d. 1570), the son of the pre-Hispanic emperor, in writing to the king directly to resist an attempt to put the city's indigenous *cabildo* under the exclusive control of a Spanish "protector."[62] The letter

argues that indigenous officials were both competent and loyal. Around the time of the writing of this letter, a new conflict erupted over the collection of tithes between city natives and the archbishop (and Dominican) Alonso de Montúfar, who, like Guzmán, assumed his post in 1554.[63] In another letter written to the king, in 1556, mentioned above as the fruit of Tehuetzquititzin's alliance building, Guzmán joined other native elites to ask the king for the special protector of indigenous interests.[64]

If the first image of Guzmán in the Codex Osuna shows him to be an actor within the political framework established by the king—albeit a resolutely indigenous one—a second rendering of Guzmán, on folio 38r of the manuscript, fills out what this indigenous world looked like (see figure 5.5). The top of the image is dominated by the indigenous *tecpan*, built at the end of Huanitzin's reign, and the similarity of its rendering to the earlier image of Moteuczoma's palace in the Codex Mendoza was discussed in chapter 5 (see figure 5.7). But let us consider it anew in the context of Guzmán's reign of 1554–1557 as *juez-gobernador*. He and Velasco are for the second time in

the manuscript pictured in conversation, but here Guzmán sits in the *tepotzoicpalli*, the high-backed seat made of woven reeds used by indigenous political authorities, and his long *tilmatli* obscures most of his Spanish-style clothing beneath, while the viceroy sits at a slightly lower level in the curule chair. Below them, breaking the symmetry of the page, is the complaint, written in Nahuatl: the ten male servants and ten female cooks for the indigenous *cabildo* have not been showing up for work. They are pictured as an indigenous man holding a broom and a woman kneeling at a *metate*, a stone used to grind prepared maize into the dough for tortillas. These figures have resonance beyond the obvious: the creation of maize dough was the female employ *par excellence*, such an essential activity for the sustenance of life that a Nahua creation myth told of the deities creating the human race from similar dough. Sweeping, likewise, was a world-ordering activity, and daily sweeping of spaces was necessary to remove any disordering filth, or *tlazolli*, that might have collected during the night.[65] The practice of vigorously sweeping church courtyards was singled out for admiration by the chronicler Mendieta, who, writing at the end of the sixteenth century, praised the practice as a sign of reverence for the sacred space of churches: "The old people value sweeping the churches, no matter how high-ranking they may be, following the custom of their ancestors in pagan times, who in sweeping showed their devotion, especially at a time they lacked the ability to join in warfare and battle."[66] Thus, these are not merely servants, but emblems of the near-sacred activities that keep the world in order, and they are aligned with the figure of Guzmán above.[67]

Unlike the Mendoza image of the palace of Moteuczoma, the *tecpan* is a vacant space in the center of the page in the image in figure 5.5, labeled "tecpan calli mexico"—that is, "palace house of Mexico." It is significant, given the slippage of names discussed above, that this seat of government does not have the modifying (and limiting) word "Tenochtitlan" included, even though the symbols of the patron saints of the four *parcialidades* that appear above clearly refer to the four parts of Tenochtitlan and do not include Tlatelolco. The puzzling emptiness of the *tecpan* can be read two ways: Guzmán was never seated as *gobernador*, nor was he a member of the Mexica ruling elite, and the artist may have seen him as someone who was "outside" the ruling circle. But the emptiness of the building can also be seen as visually establishing that the *tecpan* was a building belonging to the *office* of the governor, rather than

to any ruling family; recall the lawsuit of 1576, discussed in chapter 5, where a building that residents of San Juan Moyotlan had built was usurped by the Tapia family.[68] As part of bringing urban focus to the *tecpan*, Guzmán seems to have enlarged the building during his term in office.[69]

We have encountered the four Christian symbols for the four parts of the city, San Juan Moyotlan, San Pablo Teopan, San Sebastián Atzacoalco, and Santa María Cuepopan, in the Genaro García 30, where they are visually allied with tribute collection. Here in this Codex Osuna image, however, the same symbols are attached to tiny heads, exactly the same kind of anonymous faces that are used to designate peasant landholders in maps of the period. For instance, on the Beinecke Map, the fields that dominate the right side of the map each contain heads to designate the smallholder, and each is distinguished by a name written in iconic script to the right (figure 7.16). The same is to be seen in censuses of the period. But in the Osuna, the "commoner" head is identified with the Christian symbol of the *parcialidad*, a change from the Genaro García 30, where it is the names of the *tlaxilacalli* that represent the popular classes. If we were to read the space that is created on the page of the Codex Osuna as hierarchical layered space, at the bottom we would have the commoners and their essential labors; above them would be an equal partnership of indigenous and royal governance; above them would be the *tecpan*, symbol of indigenous political order; and above that, on the highest plane, would float the emblems of commoners and their Christian city, arranged in cartographic order.[70] A corresponding "map" of the city's sacred space is to be found on folio 8v, introduced in chapter 6, where we find five elements arranged in a quincunx, a typical arrangement of sacred spaces (see figure 6.5). Here, the city's only indigenous parish, San José de los Naturales, is the central pivot, with Pedro de Gante below it, and below him, the symbol of Tenochtitlan's name, represented as a *nochtli* cactus growing out of a stone. Around it are arranged the chapels representing the four *parcialidades*, to create a kind of shorthand map, with east, the sunrise direction, at the top.

So in the images of this section of the Codex Osuna we see an emergent image of the city with commoners organized into this four-part Christian republic. As *juez-gobernador*, Guzmán receives his authority from the king via the viceroy. At the same time, we can see further evidence of the widening crack in the social compact that we saw running through the pages of Genaro García 30;

FIGURE 7.16. *Unknown creator, the properties of smallholders, detail, Beinecke Map, ca. 1565. Beinecke Rare Book and Manuscript Library, Yale University.*

in the Codex Osuna, the sweepers and the tortilla makers are not showing up for work, and on the following pages, indigenous textile workers and orchard workers are charged with not paying their taxes to support the native government. But even this last point is given nuance by the Codex Osuna: most of the scofflaw *macehualtin* (commoners) are compelled to be so because their greedy Spanish employers refuse to free them and the textile workers are literally imprisoned within the workshop. And the starving of native governance is of detriment to all, a point made by Zorita, who was in office as an *audiencia* judge during the period spanned by these pages of the Codex Osuna and an outspoken defender of the "natural" lords and the logic of their rule. According to Zorita, "Under the old system of government [where native lords received generous tributary income], then, the whole land was at peace. Spaniards and Indians alike were content, and more tribute was paid, and with less hardship, because government was in the hands of the natural lords. This state of things

continued until some of their subjects began to persecute the lords in the manner aforesaid," that is, by complaints and lawsuits.[71]

In the general context of an appeal directed to Valderrama, as a representative of the king, the narrative told on the pages of the Codex Osuna seeks to reestablish the proper balance of power within the city—where native peoples are not required to render unpaid services to the viceroy or to members of the *audiencia*, but instead are required to give labor and tribute to their indigenous rulers (ironically, Zorita is one of the figures identified as receiving tribute goods without paying for them).[72] Such an idealized image of the proper order of the native city was pioneered, if not engineered, by Guzmán—its four equivalent (and Christian) *parcialidades* organized around a spacious and ordered civic center, the *tecpan*, and beneath it its indigenous ruler, who wields an authority that has both native sources (signaled by the *tepotzoicpalli*) and confirmation by a royal one (signaled by the staff he carries).

When the next ruler, don Cristóbal de Guzmán Cecetzin (no relation to don Esteban de Guzmán), took office in 1557, the conception of native rulership was shifting. Although Cecetzin had a perfect Mexica pedigree, as

a son of Huanitzin, we know nothing of his consecration. But we do know that like his father, he would expand and embellish the *tecpan*, a building that in Guzmán's imagery was associated with disinterested native governance. In 1557, soon after being seated, Cecetzin called on commoners to bring construction materials for city buildings (including some in the *tianguis*), which included 22 large stones "para portales" like those in the great arched doorway or portal we see in the *tecpan*'s outer wall in the Codex Osuna (figure 5.5).[73] In 1562, he undertook an ambitious expansion of the building, and the city's residents were allowed to go to forests around Cuauhximalpa to cut 200 *viguetas* (a beam about 20 feet long), 300 beams of 5 *brazas* (about 33 feet), and 500 planks of unspecified size for the building. While the quantity of wood was nowhere close to the 7,000 beams Cortés ordered for his house in Coyoacan a few decades earlier, it was still a great amount, at least 4,600 yards (not counting the planks).[74] Given that most of the architecture in the city was stone and adobe, the wood would have served for framing and roofing.

While the interior spaces of the *tecpan* served as meeting room, archive, and jail, the outside of the building offered two distinctive features, one of them connected to pre-Hispanic architecture. The building itself had a balcony, an elevated display space that allowed the standing ruler to address his people gathered in the plaza below; such balconies seem to have been part of pre-Hispanic palaces as well as the viceregal architecture of the city. It was on such a balcony, for example, that Moteuczoma was reportedly assassinated, an event captured in one native pictorial.[75] And a diary of life in the city in the 1560s describes the seated governor addressing a throng from the *tecpan* balcony, making himself visible at the same time as he set himself apart.[76]

The enclosed plaza was also found at the *tecpan* of Tlatelolco, and daily sweeping would have marked both of them as sacred spaces.[77] Crossing from the more mundane space outside into this plaza, indigenous city residents would muster for parades, and it was here that the *mitotes* would unfold, the ritualized dances that brought together performers, often members of the high indigenous nobility, dressed in feather costumes to perform. These *mitotes*, as we shall see briefly in the next chapter, were key sites for the enactment of indigenous political power within the urban sphere.

CONCLUSION

When analyzing the etymology of names of *tlaxilacalli* in the city, we can see initially that the names "made sense" by referring to historical events, as well as describing natural features or qualities within the city. Atlixyocan, which begins with the word *atl*, "water," was appropriately once a swampy place along the littoral of the island city. But in considering the written forms of names, we discovered them to be locales for the expression of collective identity, be it that of elites or that of the tribute-paying class. As we moved through the midcentury decades of the city, we saw some of the historical reasons for the unraveling of the social contract, with the combination of devastating epidemic diseases along with more pressure for revenue being put on an ever-smaller tribute base, those *macehualtin* caught in the middle. In turning to the Codex Osuna, we saw a new vision of the city and the role of native governance within it emerging. In the next chapter, we will turn to festival life in the city, particularly in the decades of the 1560s, to see how public processions and spectacle gave expression to these evolving ideologies of the urban space.

Axes in the City

In the last chapter, we looked at the way corporate identity was expressed in pictographic documents produced within Mexico City in the 1550s and 1560s, which revealed a growing tension between the city's elites and commoners. On one side, governing elites were struggling to hang on to their wealth as well as some of the traditional prerogatives that their status once afforded them and their families. On the other side, the vast number of indigenous city residents—the painters and the sculptors, the mat makers and the fishermen—were under increasing pressure not only from their own lords, but also from the ever-growing number of Spaniards in the colony for tribute goods and labor. A particular threat came from members of the royal government, who expected to be able to draw on and benefit from native labor despite the frequent injunctions issued by the Crown government in Spain. Not only would the indigenous lords complain about the "personal services" their communities were required to give to Spaniards, but also the commoners would complain of unpaid debts to them, like the 2,980 *pesos* the viceroy owed for five years' delivery of fodder.[1] Adding to the fractious situation of the 1550s and 1560s were the Crown's ongoing attempts to reform and rationalize tribute payments. The goal was not only to help its own financial situation but also to protect indigenous commoners from abuses by the powerful, be they *encomenderos* (holders of grants of indigenous labor), *corregidores* (Crown officials who oversaw regions about the size of counties), or their own indigenous leaders. Within Mexico City, the powerful classes with the potential to be exploiters included the judges of the royal court and the

viceroy, members of their families and their dependents, and indigenous elites and leaders of the mendicant orders. Mexico City was not a *corregimiento* (under the control of a *corregidor*), nor were its people held in *encomienda*, so these powerful interests were not directly in play.

Operating within this competitive political environment, where their prerogatives were under attack from above and below, the governors and ruling *cabildo* of Mexico-Tenochtitlan had good reason for public assertions of their relevance. They made themselves present to city residents in a variety of ways, the most obvious being through the vast array of public ceremonies that took place in the city, during which rulers participated in the practices that shaped the city's lived spaces as they had before the Conquest. One set of practices explicitly linked to the Spanish monarchy included the *entradas*, in which the newly appointed viceroy was officially welcomed into the city; the *jura*, or the taking of the oath of loyalty to a new king; and the celebrations and mourning that took place on the birth of a royal child, a royal marriage, or a royal death. Another set was the religious celebrations, some in honor of patron saints. Evidence from later periods shows us the enduring importance of the feast days of the patron saints of the *parcialidades* (San José, San Juan Bautista and San Juan Evangelista, San Pedro and San Pablo, San Sebastián, and the Virgen de la Asunción). Easter week and Corpus Christi were also the cause for general celebrations within Mexico-Tenochtitlan and across the city; the feast of San Hipólito drew the indigenous community out to the Tacuba causeway on August 12th and 13th. But of all

of these, perhaps the most interesting and least understood were the celebrations of accession that happened within Mexico-Tenochtitlan itself when the newly elected governor would take his seat within the *tecpan*.

Thus there were a multitude of occasions in which the native governor and *cabildo* members could don their colorful cloaks and make their way through the city, often preceded by a large procession composed of indigenous church leaders (*fiscales* and *cantores*) and other city dwellers, to the sound of musicians (playing trumpets and drums) and the explosions of fireworks. In his essay "Walking in the City," Michel de Certeau suggests that one way of imagining the urban conglomerate is to compare the city to language itself, wherein the paths of individuals walking or moving through the city are akin to speech acts.[2] Just as spoken language is performance and has no concrete existence beyond the instant that people speak, the city is likewise constituted by the movements of people as they move through and use its spaces, what Henri Lefebvre would designate "practice." While these essential and quotidian itineraries, like spoken language, are often lost to us, set beyond the horizon of the historical gaze into past space, we do have accounts of urban festivals that help us better understand the lived spaces of the city.

PROCESSIONS IN MEXICO CITY

Festivals and processions have also long been of interest to social historians since they are, as the historian Robert Darnton has described them, when "the city mak[es] itself visible to itself."[3] In the organized arrangement of participants, community leaders implicitly made public the unspoken and often otherwise unrecorded structure of the urban social order. Participants, in turn, internalized this order; once enacted, it became a feature of communal identity. In Spanish-sponsored processions in Mexico City, such as Corpus Christi, representatives of the city's indigenous populace went first, the distance between them and the Eucharistic host, which appeared near the procession's end, a sign of their low status; the order of this procession was firmly dictated by the Spanish *cabildo* in 1533.[4] That these matters were taken seriously by the residents of Mexico City is clearly seen in a sprawling lawsuit that refused resolution for over a decade in the 1570s and 1580s. *Gremios* (guilds of craftsmen) had their corresponding religious *cofradías* (religious sodalities), and they marched behind the banner of their *cofradía's* patron saint in procession.

In the 1570s, Mexico City's ironworkers protested that the *cofradía* of the shoemakers' guild had moved in front of them in the Corpus Christi procession; they argued that *they* deserved the place behind the tailors' guild because of the date of their establishment—that is, the procession was organized by one guild *cofradía* following another guild *cofradía*, but these in turn were arranged chronologically by the date of their establishment.[5]

Guilds were important to both the social and economic life of the city. Because of the rules of the painters' guild, for instance, aspiring artisans would work in apprenticeship for a number of years, before taking an exam that would allow them to reach the next level of *oficial*; becoming a master painter (*maestro*) came at the end of years of training and the successful completion of exams administered by the guild overseer.[6] And only as a master painter could a man set up his own independent workshop. The internal structure of guilds came to mirror the idealized order of hierarchical society segregated by caste; blacks and mulattos could advance only so far, and after 1568, indigenous painters were barred from creating images of saints and selling them to Spaniards, in effect demoting them to a lesser rank than their Spanish counterparts.

Thus guilds, with their regulated internal order, were microcosms of an idealized social order set at a small scale. The arrangement of them in a procession like Corpus Christi offers yet another representation of the city's social order at a somewhat larger scale. The order is worth parsing. If guilds' *cofradías* appeared in order of the dates of their foundation, then their procession offered, as shoemakers followed ironworkers, who followed tailors, a visual narrative of the city's history, told as the sequential coalescing of one artisanal industry after the next, like a derivative graph that tracked the increase in the city's population and range of manufactured products, decade after decade. Since guilds were represented as *cofradías*, the growing number of guilds, year after year, joining the parade also bore witness to the expansion of Catholic religious devotion.

But in indigenous Mexico-Tenochtitlan, religious processions followed a different logic, and they underscored, in turn, the presence of the indigenous government and the self-determined religious organization of the residents; in doing so, they represented the social geography of the city. A key source for processions in the sixteenth century is the *Historia eclesiástica indiana*, completed in 1596 by the Franciscan Gerónimo de Mendieta (1528–1604), who was resident at San Francisco after arriving in New

Spain in 1554; he devotes three chapters to his eyewitness accounts of the religious celebrations of the community of Mexico-Tenochtitlan that he saw, and participated in, in San Francisco.[7] (His younger Franciscan colleague, Juan de Torquemada [1564–1624], reproduces these chapters in his *Monarchia indiana* but swaps in details from what he saw at Santiago Tlatelolco.)[8] In discussing the festivities, Mendieta underscores the central importance of the seven-naved chapel of San José de los Naturales that sat within the larger walled compound of San Francisco, as did his colleague Diego Valadés (b. 1533), who wrote about the city some two decades earlier. San José served as the parish church to the city's indigenous community, "and within celebrated all the divine offices and feasts as in a Cathedral Church." In particular, Mendieta highlights the celebration of Holy Thursday. His *Historia* is not without argument: through it he sought to demonstrate the open-hearted acceptance of Christianity by the native population, implicitly rebutting critics who claimed that mendicant evangelization was a superficial affair; or as he puts it, "It is clearly visible that they are not like the Moors of Grenada, but true Christians." Beyond his larger rhetorical claim, Mendieta's account shows us the important role of native elites in the religious life of the city's indigenous population. In a description of Holy Thursday events he saw in 1595, he writes that the friars would first gather in the church of San Francisco and then process, presumably to the adjacent altar at San José. After the reading of the Gospel, twelve impoverished indigenous people, chosen for the occasion, would file out to three basins filled with hot, rose-scented water, where the priests would wash their feet, after which the indigenous lords would emerge bearing elegant mantles to clothe the twelve selected. The newly elevated poor would be led to a table laden with food that the lords had provided. Not only would these twelve be fed, but so too would other poor people invited to the feast. "It is a sight to see, the abundance of the food that the Indians have spread out in the patio, from food stewed in the pots or vessels that they use, and bread and fruit, so that all the poor were satiated that day."[9] Much of the symbolism of the ceremony is expressly Christian—the twelve people are like the twelve apostles who gathered with Jesus at the Last Supper, and their change in status, going from badly dressed and hungry to richly clothed and fed, recalls the Gospel passage where Jesus says, "Blessed be ye poor, for yours is the kingdom of God" (Luke 6:20). In washing their feet, the Franciscans engaged in a traditional

rite of Holy Thursday, the reenactment of Jesus's washing of the apostles' feet during the Last Supper, as told in John 13:1–17.

But the elegant clothes and feast provided by the lords are something that harken back to pre-Hispanic rites, as many of the important *veintena* celebrations of the ritual year featured similar feasting. Offering a compelling parallel are the *veintena* feasts of Tecuilhuitontli and Hueytecuilhuitl, the Small Feast of the Lords and the Large Feast of the Lords, which fell in June and July. The last feast was the most memorable, as the poor were invited in and served "tamales made of maize treated with lime; or else with some fruit, some tamales of maize blossoms; or with twisted ends, or sweetened with honey . . . and this feasting went on for seven days. And for this reason was this done—purely that the *tlatoani* might show benevolence to others by giving his bounty to his vassals."[10] Holy Thursday was not the only occasion of large-scale giving in the post-Conquest period, and historical records are punctuated with accounts of specific feasts in Mexico-Tenochtitlan that testify to indigenous patrons' largesse as well as the ubiquity of these events: in 1572, at the feast of All Souls, the city's indigenous community provided 5,000 loaves of bread, 3,000 to 4,000 wax candles, 25 *arrobas* of wine, a large number of hens and eggs, and great quantities of fruit; some of this was given to feed the resident friars, who numbered about 100 at the end of the century, but much was given out to the poor or those who asked, and this custom was repeated year after year.[11]

While Mendieta does not specify in his description of Holy Thursday or other religious celebrations that the food was a gift from the *tecpan*, the quantity of foods and organization of the delivery suggest that it was, especially since the lords are specified as giving away the mantles. Had the city's Spanish *cabildo* been regularly sponsoring such feasts, we would find clear evidence of payments made, as we do for the annual feast they sponsored for San Hipólito. For the native governors, the religious celebrations sponsored by the Franciscans at San José would have offered both a physical and social space for the continuance of practices of ceremonial feasting—those extravagant and impressive giveaways—that we have seen taking place mostly among elites. And these were not without political effect, as the native governors' ability to give away huge quantities of goods reaffirmed their status as recognized leaders and offered them a chance to reassert political relationships through such symbolic representations. For

instance, in 1588, the *gobernador* of Mexico-Tenochtitlan tried to compel Ixtacalco, an outlying town that was one of Mexico-Tenochtitlan's dependents off the island, to come and march in the Holy Thursday procession, an implicit reaffirmation of their dependent status.[12]

Mendieta continues with descriptions of the three processions that emerged from San José on Holy Thursday, on Good Friday, and then on Easter morning, the most sacred days of the Christian calendar:

On Holy Thursday, the procession of [the cofradía of] Veracruz was held, with more than two hundred thousand Indians as well as three thousand penitents, with two hundred twenty nine insignias of Christ and of His Passion. On Good Friday, the procession of [the cofradía of the Virgin of] Soledad was held, with more than seven thousand seven hundred adherents, by count, with insignias of the [Virgin of] Soledad. On the morning of the Resurrection, the procession of [the cofradía of] San José was held with two hundred and thirty beautiful golden platforms [*andas*] carrying images of Our Lord and Our Lady and other saints. Joining in the procession were all the members of both the cofradías mentioned above of Veracruz and Soledad (which is a great number) in great order and with wax candles in their hands; in addition to them, on all sides, innumerable numbers of men and women, almost all carrying wax candles.[13]

In the first part of the description, we find abundant evidence of what Mendieta is asking us to find: the unstinting embrace of Catholic practice by New Spain's indigenous peoples. The procession, with its multitude of sacred statues and images borne aloft above the slowly moving crowd, would have been familiar to any Spanish reader who had witnessed the urban festivals of Holy Week in Seville or Madrid. In fact, at another point in the narrative, Mendieta says that at the worship within one of the chapels of San José, this one devoted to San Diego, the traffic of devotees equaled that to his shrine in Alcalá, Spain.[14]

But the images in the Holy Week procession of Mexico-Tenochtitlan were of a different order. Some of them would certainly have been statues and likely ones made out of an interior armature of reed and finished with a papier-mâché-like exterior; Mendieta praises the work indigenous artisans did after encountering images from Flanders and Italy: "There was not a single retablo or image, as excellent that it might be, that they did not imitate or copy [*retraten*

y contrahagan]; whether it be in the round, of wood or of bone, they worked it so carefully and skillfully, and being so remarkable, they were sent to Spain, just as they sent the hollow crucifixes made of reed, that although are the size of a large man, even a child could carry one."[15] Also seen in New Spain, but likely not to be found in many European processions, were images made of feathers or clothed in feathers, whose gleaming, iridescent surfaces suggested their sacred quality. In his earlier account of Corpus Christi in the city of Tlaxcala, the Franciscan Motolinia offers this description: "The Most Holy Sacrament was processed, along with many crosses and platforms bearing the statues of saints. The drapes on the crosses and the decorations of the platforms were all of gold and feather-work, upon them many images fashioned of feathers and gold, which would be more highly prized in Spain than brocade. There were many banners of the Saints, and the Twelve Apostles dressed with in their insignia."[16] Some of these banners would have been made out of feathers, an art form praised by Mendieta.[17] Other sources testify to the public use of feathers in religious processions: in 1565 in Mexico City, the merchants' guild placed a great *quetzalapanecayotl*, or standard made of the gleaming feathers of the quetzal bird, over the supporting platform upon which a statue of San Francisco was carried.[18] Banners and images were also made of flowers, also noted with admiration by Mendieta: "And it is worth noting that just as these artisans make works of feathers, they also make other images, which are common and not so greatly esteemed, out of roses and flowers of diverse colors, and they do no more or less than create images of saints, and coats-of-arms, and placards, or anything that they want, fixing the petals of flowers and grasses with paste on a reed mat . . . and after they have been used in the churches for which they are made for use on holy days, Spaniards request them to place in their homes, as they are perfect and devout images."[19] Because the materials were so ephemeral and their use was constant, only a few sixteenth-century works of feathers survive from New Spain (none of flowers do); a work like the featherwork *The Mass of Saint Gregory*, discussed in chapter 5, was likely preserved because it left the country. Maize-paste crucifixes have fared better.

One featherwork banner survives in a Mexican collection (the Museo Nacional del Virreinato), and while its good state of preservation argues against its heavy processional use, it nonetheless gives us a sense of what was witnessed in these processions (figure 8.1). At 42 inches

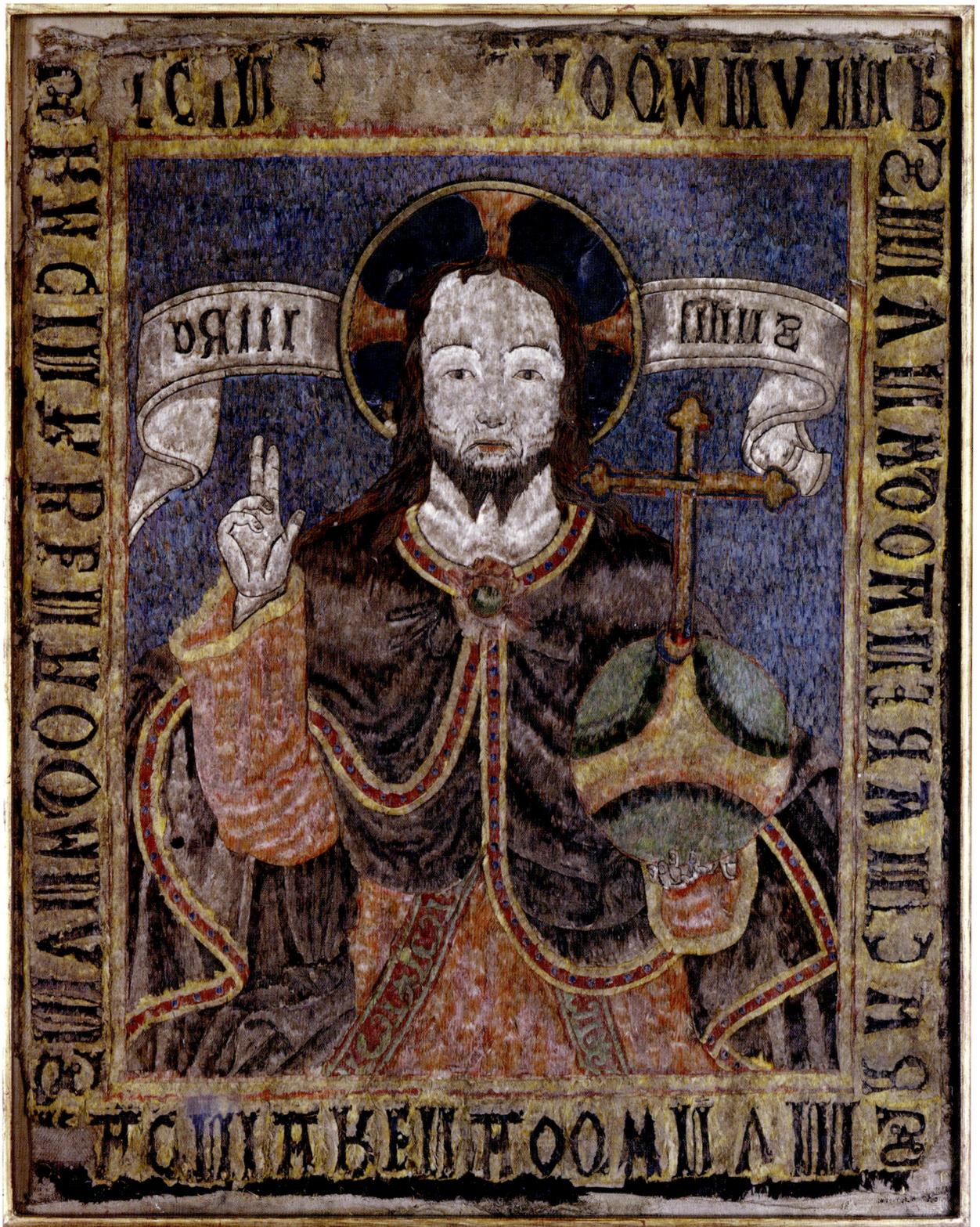

FIGURE 8.1. *Unknown creator, Salvator Mundi, feather mosaic, sixteenth century. Museo Nacional del Virreinato, Tepozótlan, Mexico. Reproduction authorized by the Instituto Nacional de Antropología e Historia.*

high by 35 wide, the work is quite large, and its imagery was drawn from a European print of the Salvator Mundi (Savior of the World), the figure of Christ holding an orb with a cross on top to symbolize his triumph over the globe. Even today, the work retains a shimmering quality imparted by the feathers used in its manufacture; these are densely packed on its *amatl*-paper surface. Typically, the less expensive feathers used in the lower layers would have been dyed, while those on the top layer were not. The feathers came from both local birds and ones found only in tropical zones of the country, like parrots and quetzals. The luminous turquoise-blue field that dominates the background invites comparison to *The Mass of Saint Gregory* (see figure 5.3); however, in contrast to the complex interaction of figures in the Gregorymass, this work was designed to have greater visual impact when seen from afar, with the gleaming white of the Christ's face set off against the dark frame of hair. The dramatic colors work to the same end: the purple cloak, set off with bands of red and gold; the brilliant red tunic edged in yellow; the turquoise background against the gold frame. While the broad framing text is so much like that of the Gregorymass that they could have been produced in the same workshop, in this case, the repeating text is not completely readable, written in an uncommon script. Even for literate viewers of the time, the letters here would have been for effect only. This, too, speaks to a kind of legibility from afar, as the text signified the Holy Word without needing to be actually read.

PROCESSIONAL ORDER AND SOCIAL COHESION

Just as the images that were carried in the processions had, on the surface, European imagery but were of indigenous facture and indigenous materials, so too were the *cofradías* that played a starring role in the organization and order of the Holy Week processions. These religious sodalities were established as early as the mid-1530s, funded and peopled by the Nahua residents of the city. Holy Thursday featured the oldest *cofradía*, that of Veracruz, whose cult object was the cross, which would have been fashioned of silver. Writing in 1595, Mendieta describes how the next day, Good Friday, was dominated by the *cofradía* of the Soledad de la Virgen (a version of Our Lady of Sorrows), which was one of the newest *cofradías* at the time of his writing, established in 1591, and the number of devotees thronging to the

procession suggests its immense and immediate popularity. On Easter itself, the most important day of the liturgical year, it was the *cofradía* of San José that went first, to be followed by Veracruz and Soledad.[20]

If the larger order of the processions of Holy Week was determined by perceived hierarchies of the Nahua *cofradías* of the city, we can also see evidence that the social geography of the city was on display at these public events. Mendieta underscores the presence in the procession of 230 platforms that were carried aloft, and upon them were set images of Jesus and Mary and other saints, "todas doradas y muy vistosas" (all guilded and brilliant). But where did all these images come from? Earlier in his history, Mendieta comments on the large number of images appearing in processions in New Spain in general, " . . . which are many in large towns, because in addition to those that the head town [*cabecera*] has, are those that hamlets or subject towns carry in," which tells us that political hierarchies as well as spatial concepts of center and periphery were given expression as the images of the towns subject to the head town were brought from their outlying homes to the more powerful center.[21] Within Mexico-Tenochtitlan, the same dynamic would have held. Some of the images would likely have been housed in San Francisco, or within the seven arches of the chapel of San José, but 230 is a large number of images, and many were certainly supplied by the neighborhood chapels, many if not all of these representing the city's *tlaxilacalli*, as well as subject towns from the surrounding valley. One indication of the alliance of a cult image with a particular chapel comes from the indigenous historian Chimalpahin, who writes of a moment in 1597 when the Franciscans, whose once-contested control of Santa María Cuepopan was firmly confirmed by royal order, took out the statue of "the precious lady Santa María who was kept at San José" and returned with her to Cuepopan.[22] Such circulation of the holy image was also a standard feature of Spanish practice; some months before this statue of the Virgin made her way back to Cuepopan, the Virgin of Remedios was brought for a ten-day stay at the Cathedral of Mexico before returning to her regular "home" in her shrine near San Bartolomé Naucalpan, about six miles to the west of the city.[23]

Mendieta also offers us an indication of the rules governing the order of the procession, writing of the general crowd that "they went ordered by their neighborhoods [*barrios*], according to the prominence, or lack of, that they

recognize among themselves, adhering to their ancient customs."[24] Here, as in the rest of Mendieta's text, "barrio" means one of the four *parcialidades* of the city; thus the forest (to us) of 230 images of the saints on golden platforms must have been to city residents a collection of individual trees, often quite recognizable and associated with particular chapels of the city, organized by the *parcialidad* that comprised them. We do not know how the sixteenth-century Nahua of the city ordered the *tlaxilacalli* within each *parcialidad*—whether the order represented in the procession would be the same as that registered in later tribute lists—but Mendieta's comment suggests a publicly known and performed order at the level of the *tlaxilacalli*. Following the cult icons in the procession were the members of the *cofradías*, who had their own emblems—the cross, a statue of the sorrowing Virgin—that were held aloft, and then finally the *parcialidades* of the city, probably organized as we find them in documents, with San Juan Moyotlan first, then San Pablo Teopan, San Sebastián Atzacoalco, and Santa María Cuepopan.

So, in the impressive public display, we can see not only what Mendieta meant it to show within the context of his larger *Historia*—the fervent and popular embrace of orthodox Catholicism by the indigenous people of New Spain's largest city, the former capital of its pagan empire (whose history is covered in the *Historia*'s early chapters)—but also evidence of how the city represented itself to itself in these important moments, the spectacle offering a visual crystallization of particular social orders (the *cofradías*) represented by their visual uniformity (members of the *cofradía* of Veracruz and the Soledad would wear or carry their respective insignias), whereas the other parts of the city (likely the *tlaxilacalli*) were represented by their plurality, each designated by a different cult image, but all contained and ordered within a larger structure established by the four-part city of ranked *parcialidades*.

Such public rituals have long been understood to contribute to the construction of collective memory. Maurice Halbwachs's foundational study of the topic emphasizes the role of public rituals in forging bonds of memory between individuals;[25] that is, the experience of an event by many individuals allows them to create a mental image of a past that they all share. To this end, Halbwachs underscores the role of commemorative events. For example, consider the washing of the feet that the Franciscans carried out on Holy Thursday within San Francisco. This theatrical event

provided the thousands of Nahua witnesses a shared experience, which they could remember and recall together. But it was not just any event: it was a restaging of an event from the Gospels. Thus, in remembering the foot washing in the days, months, or years after they saw it, the witnessing Nahua were recalling an event in 1595 as well as one that had happened long before, in Jerusalem of the first century. The repetition of the same foot-washing rite year in and year out created layered memories, thick with associations, all pointing back to an event in the past. Such repeated restaging thereby contributes to an individual's sense of history, and at the same time this enacted past can claim authority because of communal participation. "*Through* the appropriate *commemorabilia* I overcome the effects of anonymity and spatio-temporal distance and pay homage to people and events I have never known and will never know face-to-face," the philosopher Edward Casey has written, adding that *commemorabilia* "are always trans-individual in their scope and function."[26] Paul Connerton has taken Halbwachs's argument further in pointing out that, along with the *content* of a commemoration (such as the reenactment of the Passion of Christ), its *form*, specifically the employment of a ritual language and particular bodily gestures, brings meaning home to participants.[27] But all argue for the crucial role of public rituals and the sense of a past that is forged through them in giving coherence to the social order and to the individual's sense of existing within a longer historical stream.[28] Because it is through involvement with collective rituals invoking a shared history that individuals are transformed into members of a larger social group, memory, thought in classical models to pertain to the individual consciousness, moves out beyond the individual into the zone of the intersubjective.

But perhaps as important as their role of creating a shared sense of the past among the city's residents, rituals of reenactment and commemoration in the indigenous city served to shape the city's spaces—the sphere of practice giving meaning to lived space. Practices are found in the order that worshippers followed as they walked in processions that conformed to (and made visible) the established hierarchy of the *parcialidades*, or in the way that the bearers of the cult statues from both San Francisco and the city's various chapels arranged themselves as they gathered in the monastic courtyard for the Easter morning procession. In addition to reinforcing hierarchical order among the lived spaces of the city, such processions established and

reinforced the center and its relative periphery in the lived space of Mexico-Tenochtitlan. So at the same time that these gatherings represented the spaces beyond the walls of the compound, they also marked San Francisco and particularly the chapel of San José as of central importance to the city's emergent spatial orders.

As such, these rituals left a deep impression on the city's residents and in its lived spaces. It would be easy to discount a friar like Mendieta's description of the worshipping crowd, mustered on the page simply to bear witness to his rhetorical claim of the success of the evangelizing project. But two diaries written by indigenous chroniclers of life in the city, the anonymously authored *Anales de Juan Bautista* and the *Annals* of Chimalpahin, also underscore the impression religious festivals and processions made on city residents. Their transcription, translation, and publication at the hands of Luis Reyes García, Rafael Tena, James Lockhart, Susan Schroeder, and others have opened the doors of a once-remote and little-known Nahuatl archive and brought the texture of daily life of sixteenth-century and early seventeenth-century Mexico-Tenochtitlan to life. They are both filled with accounts of regular and episodic public celebrations, as well as irregularities in the known patterns. For instance, one of the many festivals that Chimalpahin describes for the year 1593 is Corpus Christi, and his entry of the first day of the feast, not untypical in length or detail, reads thus:

> Thursday the 17th of the month of June was when the Sacrament went in procession, but it could not be done, it could not make progress on the road; it went in procession only inside the cathedral, since it couldn't be taken out because it rained very much; the rain really pelted down, and it became very muddy. And the dancers prepared themselves well, in Mexico as well as Tlatelolco, and all the different tradespeople performed their acts of entertainment as separate groups; the reason it was done that way is that the Royal Audiencia along with the alcaldes ordinarios of the [Spanish] city and the corregidor mayor at the municipal building ordered it and set a big fine for whoever should not take part in the celebration; they would be punished by the officers of the law.[29]

In an entry of 1566, one of the anonymous chroniclers of the Anales de Juan Bautista describes the antics of people on Mardi Gras and the other days leading up to Ash

Wednesday but centers it in the indigenous city: "Here was the great performance, and all the players [*mahuiltiani*], gathered in the Tecpan and then went to circle around the Tianguis [of Mexico]. For three days they were in the market and the nobles rode on horseback: don Pedro Dionisio [the son of Tehuetzquititzin] and don Pedro de la Cruz also went to circle around the market, and on an old shelter that was erected in the market, they put on top of it a globe with the four winds."[30] Descriptions such as these reveal the lasting visual impact of such ephemeral practices on lived space, as well as the way that new representations of cosmic spaces—the globe and the four winds—were being integrated into them.

CHRISTIAN AXES IN MEXICO CITY

During Holy Week, San Francisco was the locus for celebrations; the presence of San José de los Naturales, the first and foremost parish church for the city's indigenous residents, made it a frequent hot spot within the urban fabric—often in complement to the great Tianguis of Mexico that lay only a few blocks to the south, for when the *tianguis* was emptied out on Sundays and feast days, San Francisco filled up.[31] Also of great importance were the chapels pertaining to each of the four *parcialidades*. In the pre-Hispanic city, great care had been taken, mostly across the fifteenth century, to construct the visual axes that tied the sacred architecture of the valley together and gave expression to political relationships.[32] These axes were visually unchanged in the sixteenth century. Standing on the hill of Tetzcotzinco, which had been shaped in as a miniature *altepetl* by the rulers of Tetzcoco, the colonial ruler of Tetzcoco, don Hernando de Pimentel, could see in 1557 across the valley as his forebears had done. From this hill, he could look to the other small hill that gave expression to the idea of the *altepetl*: Chapultepec. Visual axes also roped the larger environment into the built environment of the city, with the equinox sun still aligning itself with the Tacuba causeway, the city's main east–west axis. However, within the city itself, residents joining in ritual processions, often ones that traced a route from one hot spot to another, were actively renewing or creating anew axes of importance within the city.

Figure 8.2 highlights three important processional routes, each associated with a different set of commemorative events—the kind of commemorations that

were essential in creating a sense of shared history. The first established in the post-Conquest city was that of San Hipólito, discussed in chapter 4 and shown in figure 8.2, which offered urban residents a commemoration of the Spanish victory over Mexica armies. This event was recalled both in the sermon preached at the Mass and in the movement up and down the Tacuba causeway, the path of escape during the Noche Triste, when the Spanish and their allies were routed from the city. Another route was that taken on Easter Sunday, and this is also shown on the map; Chimalpahin, writing at the beginning of the seventeenth century, tells us that it had two starting points: one for indigenous participants at San Francisco and one for Spaniards at the church of Veracruz. These two points of origin served participants with a yearly reminder of their inclusion in one (and exclusion from the other) of the two "republics" within the city. Veracruz, which sat upon the Tacuba causeway, had been established as a parish in 1568, and through the colonial period it was understood as the entrance to the city; it was here that the Virgin of Remedios would be welcomed into the city in 1577 after her cult gained popularity due to the reputation of the statue of her as effecting "remedies" for various ills, such as lack of rain.[33] In addition, Veracruz was located near San Hipólito, that monument to Spanish victory. The two streams created by the two republics came together in the area of Ayoticpac, which marked an earlier moment in the city's history: it was here where an old woman seller had raised the cry to alert the Mexica that their enemies were escaping, a moment of

FIGURE 8.2. *Map of central Mexico City showing processional routes, by Olga Vanegas.*

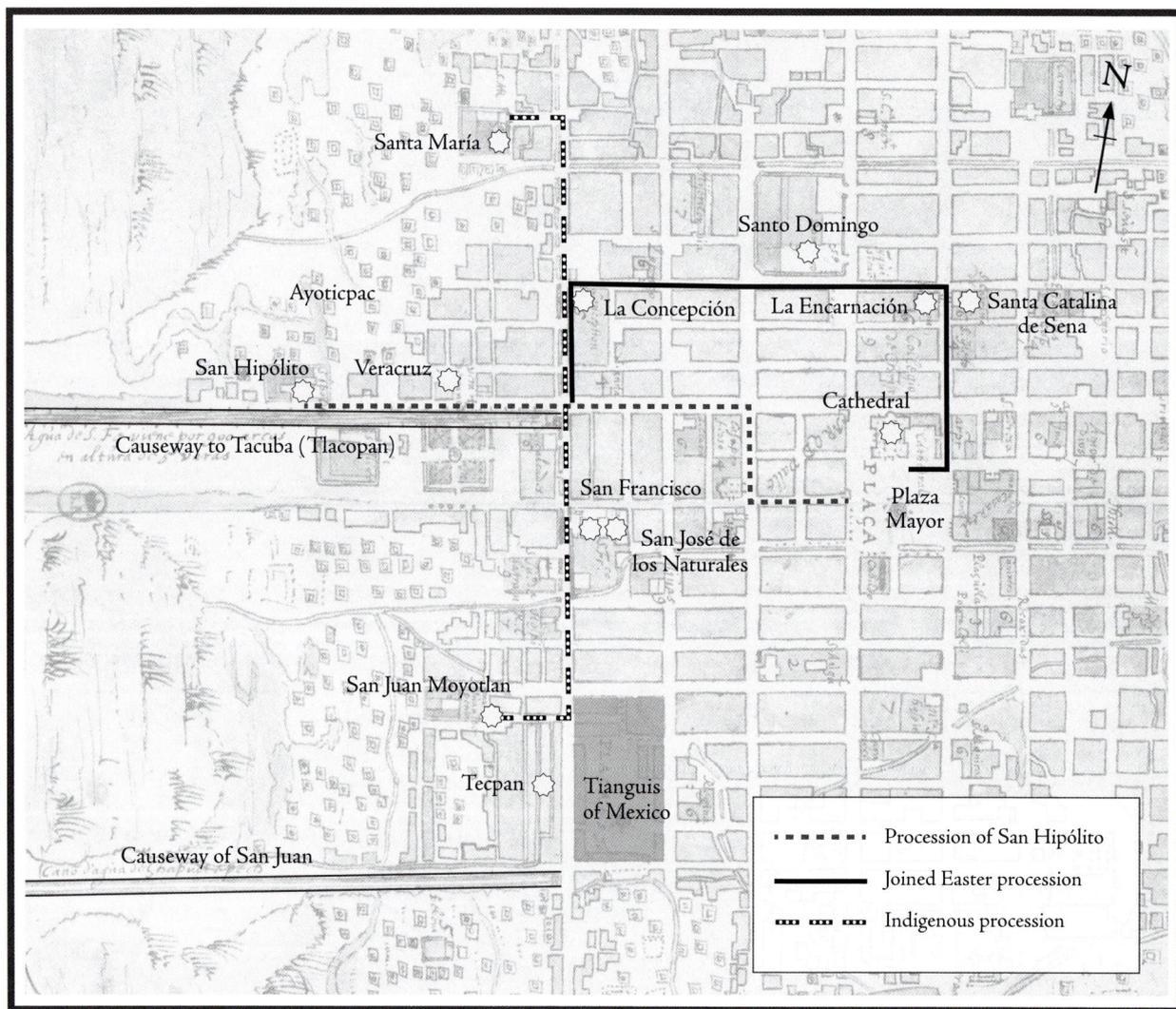

indigenous victory still remembered in the late sixteenth century.[34] The two republics made their way through the city, stopping at convents and a monastery along the way. The first stop was the first convent founded in New Spain, La Concepción (1540), and the second was Santo Domingo, the large monastery of the Dominicans, who were the second mendicant order to arrive in New Spain, after the Franciscans. From there, the procession passed by the convent of La Encarnación (since these were cloistered nuns, the procession did not enter), then to Santa Catalina de Sena (a cloistered order of Dominican nuns), before heading south to the Cathedral and the Plaza Mayor.[35] This route thus underscored very early religious foundations (La Concepción and Santo Domingo), the presence of the powerful religious orders in the city's urban fabric, and the centrality of the Cathedral.

The third set of routes seen in figure 8.2 were indigenous ones, cultivated by the Franciscans. Mendieta's *Historia* underscores that in addition to the Eastertime celebrations, the most important indigenous feasts were those of the Virgen de la Asunción (August 15) and San Juan Bautista (June 24), which were, not coincidentally, the feasts of the two *parcialidades* (Cuepopan and Moyotlan) that remained under Franciscan control at the time Mendieta was writing (San Pablo and San Pedro and San Sebastián, the patron saints of Teopan and Atzacoalco, do not figure in this account). The nineteenth-century map of San Francisco, within which San José was to be found, shows two principal entrances to this enormous complex (see figure 6.2, which is oriented to east at top). The one to the north is still in use today. The other entrance was along the west wall and led directly onto the north–south causeway, so upon leaving San José, the celebrants would head to the chapel of Santa María Cuepopan to the north or, in the south, to the plaza in San Juan Moyotlan where a small chapel to San Juan had been built. After 1594, this was also the site of the Clarist convent of San Juan de la Penetencia, and Mendieta describes Moyotlan as "where there is a nuns' convent of Santa Clara, in addition, it is the leading neighborhood [*barrio principal*] of Mexico City's Indians."[36] When the convent was moved to this site in 1594, leaders of the *parcialidad* stipulated that they be allowed to continue to celebrate their *fiestas y mitotes* (festivals and dances) in its plaza, affirming that the plaza of San Juan was an important site for indigenous celebrations.[37]

Causeways were raised roadways, so once upon these streets, the procession—noisy with musicians and fire-works—would be easily visible from lower-lying surrounding streets. Much of this north–south street was also what was called *una calle de agua*, that is, a street of water, and the wide canal running alongside it flowed south to the end of San Francisco and then turned to the east to cross the Plaza Mayor. This great north–south axis was marked, in the colonial period, by the sightline that ran from the tall cross made of a single trunk of a massive *ahuehuetl* tree that was set in the courtyard of San Francisco—visible for miles away—to the tower housing the bells of the monastery of Santiago Tlatelolco to the north and then on to the mountain of Cuauhtepec, where a sacred mountaintop shrine had been built in the pre-Hispanic period.[38] It was this same mountain where Mexica priests once journeyed on the ritual perambulation of the month of Atlcahualo, supplicating the rain deity Tlaloc for his life-giving waters through the tears of sacrificial children.[39] On the Assumption and the feast of John the Baptist, these axes may have been formally marked with great triumphal arches shading the route, arches made of "roses and adorned with trimmings and garlands of the same flowers."[40] The creation of these arches demanded enormous expenditures of labor, as did porting the flowers and greens from peripheral growing areas to this part of the urban center.[41] This north–south axis was crucial to the Franciscans as well, both physically and conceptually, because it linked the two Franciscan monasteries in the city—San Francisco and Santiago Tlatelolco, which lay barely a mile apart. From the 1550s into the 1570s, two of the great Franciscan intellectuals of the era were living and working along this axis, Pedro de Gante in San Francisco and Bernardino de Sahagún a mere thirty-minute walk to the north at Tlatelolco.[42]

In short, the lived spaces of the city were being layered with meaning through ritual practices; in particular, its axes were marked repeatedly by the ritual processions that took place following the annual religious calendar. As we saw in the rites of Holy Thursday, the indigenous rulers of Mexico-Tenochtitlan continued the age-old pattern of embedding themselves and their presence within the spaces of the city itself. As likely hosts of an impressive feast, they entwined themselves into orthodox celebrations of Holy Thursday. Having briefly established why ritual was so important in shaping the lived spaces of the city and helping coalesce collective identity, I will, in what follows, turn to some of the rituals of the indigenous government taking place in the 1560s into the 1580s that were played out in both formal and informal contexts (the procession,

the marketplace), in structured formats and unstructured eruptions (the swearing of the oath and the riot), to better understand the evolving spatial orders of the city and the connection of indigenous rule to it.

THE PROCESSION AND THE RIOT

Writing in the mid-1590s, Mendieta witnessed a city where Franciscan control of the indigenous peoples had eroded since its peak during the decades of the 1550s and 1560s, as other orders (Dominicans and Augustinians) had chipped away at this Franciscan stronghold. In their contest with the Franciscans, these other orders found an uneasy ally in Alonso de Montúfar, the reforming archbishop, whose arrival to the city in 1554 coincided with the death of the *gobernador* Tehuetzquititzin (r. 1541–1554). Montúfar, an irascible and widely disliked man, was a Dominican as well as the highest-ranking religious authority in the colony. Despite his own mendicant affiliation, he attempted to curb the power of the mendicant orders in general by prying the huge indigenous congregations from their control and putting them in the hands of parish priests (also called secular priests), who answered to the archbishop rather than to the head of an order. Within the city, his attempts at so-called secularization put him at odds with the powerful Franciscans, who controlled the city's indigenous parishes and with whom the Dominicans had a long history of strife.

Montúfar's first successful assault on Franciscan power in Mexico City involved removing the residents of the indigenous *barrio* of San Pablo Teopan, which lay in the city's southeast quadrant, from Franciscan control and turning them over to secular priests in 1562.[43] This was a slap in the face to the educated, erudite, and self-denying brown-robed friars; these new parish priests at San Pablo had no ties to the Franciscans. They also had the reputation of being badly educated, lacking indigenous languages, and being interested in worldly gain (they took no vow of poverty, as did the Franciscans). If we return to the idealized image of the city found in the Codex Osuna of 1565 seen in an earlier chapter (see figure 6.5), we now understand it to be a nostalgic one, as one branch of the perfect quincunx radiating from San José had recently been lopped off. Montúfar's plan to empower secular priests in indigenous Mexico-Tenochtitlan was, in the short term, an unsuccessful one, but his project to curb Franciscan holdings was not: San Pablo went from the hands of secular priests to those of Augustinians in 1575; San Sebastián was turned over to the Carmelites 1585 and remained under their control for over two decades before being ceded to the Augustinians in 1607.[44] And the arrival of the Jesuits in 1572 also threatened the Franciscans, as did their establishment of the school of San Gregorio in 1575, which would supersede the Franciscan school at Tlatelolco in the education of the native elite by the seventeenth century. Writing about these events at the end of the century, Mendieta would speak of the indigenous city, once unified under Franciscan control, in anthropomorphic terms: "Others have attempted, and perhaps some still attempt, to dismember even more this body."[45] So when the brown-robed Franciscans headed processions out of their monastery through the city streets to the indigenous churches under their charge in wake of the public "dismemberment" of 1562, they were making their control of these indigenous neighborhoods a public spectacle, asserting their presence in this urban body.

The struggle taking place in the 1550s and 1560s between the Franciscans and the archbishop was also about money, and both the indigenous uprisings we will see in this chapter played out against a glinting backdrop. From the time of the Conquest, the indigenous peoples of New Spain were exempt from the expected 10 percent tithe to support the Catholic Church, often levied on agricultural products, but they paid tribute to the Crown or to their *encomendero* and they manned the labor drafts (*repartimientos*) assigned to build churches and monasteries;[46] following custom, they provided food to the clergy and supported them through the portion of their tribute that went to their *caja de comunidad* (community coffers). Donations of alms were often quite substantial. In addition, many voluntarily served churches, but if they did so, they were exempt from paying tribute, as Charles Gibson notes. Montúfar, however, pushed for direct payments to the church via tithes, and understandably, native leaders resisted. Montúfar scored a partial victory in the wake of a judicial hearing in 1558; as Gibson explains, "Indians were not to pay tithes on native goods and native properties, but . . . they were liable in transactions involving either Spanish goods, such as cattle, wheat, and silk, or lands that had formerly belonged to Spaniards."[47] So by the time Montúfar began to take away mendicant parishes, he had already raised the ire of both Franciscans, who felt that an additional tax would turn native converts away from the church, and native leaders, who objected to another tax on their already-stressed native charges.

So Mexico City in the 1550s and 1560s was very much a

city where political and religious powers were in conflict. For their part, the indigenous governors operating out of San Juan Moyotlan were allied with the Franciscans in wanting to assert their power over the four parts of the city, at the same time that neither was assured of their hold. The contest over spiritual authority in the city overlapped with control of its spaces, a long-simmering feud that boiled over into the streets in August of 1569.

After the successful capture of San Pablo Teopan from the Franciscans, Montúfar turned his sights to Santa María Cuepopan. It was a strategic move: from the viewpoint of the indigenous city, Santa María was somewhat of an outlier. It was the smallest of the city's four indigenous neighborhoods and was not as central in the lives of the city's reigning elite. While the other *parcialidades* were solidly populated by Nahua, Cuepopan was home to the city's Otomí neighborhoods, an ethnic group with their own language; that the city's Zapotec community was ministered to by the church of Santo Domingo, which lay adjacent to Cuepopan, may speak to their presence in this *parcialidad* as well.[48] The church of Santa María, the only one of the four *parcialidades* to be named after a female figure, was architecturally distinct: the eighteenth-century (reconstructed 1731–1735) building that survives as a parish church today has an unusual circular apse, and its appearance in the Map of Santa Cruz of ca. 1537–1555 suggests that it followed a similar circular floor plan as far back as the sixteenth century.[49]

Cuepopan's liminality has pre-Hispanic roots. Its feminine associations may derive from its position in the west, as the Nahuatl word for "west" is *cihuatlampa*, or "woman land."[50] But even more vivid to city residents was its location on the border between Mexico-Tenochtitlan and Santiago Tlatelolco, polities that had been distinct, with separate ruling houses, until 1473, when Tenochtitlan conquered its northern neighbor and executed its ruler, a humiliation not forgotten through the sixteenth century. And after the Conquest, when Tlatelolco reasserted its independence from Mexico-Tenochtitlan, the canal of Tezontlale on Tlatelolco's southern border marked the division and ran close by the chapel of Santa María; skirmishes along this canal continued into the eighteenth century, giving one of bridges that crossed it the name "Bridge of the Wars."[51] While it is difficult to fully judge a fragmentary manuscript, in the Genaro García 30, discussed in the last chapter, many of the complaints against indigenous rulers seated in the Moyotlan *tecpan* come from Santa María Cuepopan.

The liminality of Santa María Cuepopan allows us greater insight into the political and religious importance of the procession that happened every year on its feast day, August 15. The route linked San Francisco to Santa María, and when the Franciscans, the indigenous *cabildo*, and the *cofradías* headed north along this axis, the indigenous hierarchy made itself visible once again to all the residents of the city. Starting at the *tecpan* in San Juan, the path of *cabildo* members would rope in the liminal Santa María. The reassertion of this indigenous and Franciscan axis, which ran north–south, was also important within the pattern of the larger festival life of the city. Just two days earlier, the city's residents would have marched along the perpendicular (east–west) axis of the Tacuba causeway to celebrate indigenous defeat in the feast of San Hipólito.[52]

But August 15, 1569, unfolded differently. From his seat in the Archbishop's Palace on the Plaza Mayor, Montúfar dispatched secular priests to hold Mass at Santa María, thereby occupying it on the most important day of that *parcialidad*'s ritual year. He was hardly naïve about what he was doing, and in anticipation of a confrontation, he sent the priests with two heavies: a constable of the court (*alcalde de corte*) and a diocesan judge (*provisor de arzobispado*). Coming from the plaza, they would have traveled down the Tacuba causeway, taking the same path that was taken in celebration of the indigenous defeat two days earlier.

At the same time Montúfar's men were mustering at the Cathedral, native leaders, brilliantly dressed in fine mantles and feather ornaments, were congregating in the city's southwest. They likely first came together at the *tecpan*, the seat of the government, where the wide plaza in front of the building was typically used for mustering. Passing through its arcaded portal, they made their way the short distance to San Francisco, which Montúfar described in a violent metaphor as lying only "a harquebus shot" away.[53] Upon reaching San Francisco, they entered to join sober, brown-clad Franciscans in the great chapel of San José, and waiting for them may have been a cult statue of the Virgin herself on her golden platform, as well as dozens if not hundreds of the sacred images that represented this faithful body politic. The procession emerged from San Francisco and turned right onto the north–south causeway toward Santa María, likely displaying an internal structure that mirrored that of the social fabric, as during Holy Week. This route also meant that they moved along one of the city's main canals. Normally the pacific movement of people would have mirrored that of the contained current

of water, but on this day, the crowd was riled up by the archbishop's threat to the established order and particularly his assault on their Franciscan leaders.

At Santa María, the two sides clashed: the indigenous procession from San Francisco surged like a deluge toward the chapel where Montúfar's minions were attempting to enter, hitting them with sticks, throwing stones at their heads, stealing their hats, tearing their clothing, and almost killing the constable.[54] As Montúfar's men were beaten out of Santa María, the Franciscans, reportedly, did nothing to intervene.

The way this event is normally interpreted, as in Robert Ricard's *Spiritual Conquest of Mexico*, the incident seems to be one scene in the larger drama of a churchly power struggle, where the Franciscans, belying the pacific nature of their founder, were marshaling all of their resources to keep the meddling bishop from encroaching on their indigenous stronghold. However, it is difficult today to treat the rebelling indigenous peoples as merely Franciscan pawns, given the large and growing evidence of indigenous agency.[55] The loss of Santa María would certainly have curtailed Franciscan access to some of Mexico City's indigenous population (and their labor) and interrupted an important spatial axis that they held in the city. But it was also important to the indigenous *cabildo*, which was closely allied with the Franciscans. By maintaining this axis, Franciscans and their indigenous allies kept open an important opportunity for an expression of their public face.

The tumult at Santa María was on its surface shocking to the archbishop because his representatives were beaten up, but it was also disturbing because an event that would, in normal circumstances, show the successful evangelization of the city's indigenous residents, and their devotion to the holy presence manifest in the image of Mary and other saints, became the very moment when they rejected the decisions of the church's hierarchy. Montúfar was outfoxed because the city's political leaders emerged not as seditious rabble-rousers, but as an organized and pious community manifesting their faith on the day appointed by the church's calendar. Their display of force had its desired effects: the Franciscans maintained their hold on Santa María until the eighteenth century.

THE OATH OF ALLEGIANCE OF 1557

Such processions, like the one that erupted in violence in 1569, were not the only spectacles in which the indigenous rulers appeared; other important forums were those events in which they showed their support for royal authority. One of the most important (and given the longevity of Charles V and Philip II, the two Habsburg rulers of New Spain in the sixteenth century, the rarest) of all royal ceremonies was the *jura*, or oath of allegiance to a new king, taken by all royal officials. News of the ascent of Philip II reached New Spain in 1557, and the official oath was held in Mexico City on June 6 of that year, and was celebrated with exceptional pomp. It is known to us because the artist of an indigenous pictorial, the Tlatelolco Codex, created in Mexico-Tenochtitlan's sister city, devoted an extensive visual description to the event; a brief account also appears in the city's *Actas de cabildo*.[56] The Tlatelolco Codex is an annals-style history, offering a timeline of events beginning in 1542 and ending in 1560. Vertical red lines divide the codex year by year; the year that concerns us, 1557, is elaborately rendered, and while it forms part of a longer strip, its artist, or artists, composed this section as a single, integral unit (figure 8.3). It shows a collection of events happening in the year 1557, arranged into four horizontal registers. At top left, in the uppermost register, is the figure of don Cristóbal de Guzmán Cecetzin (r. 1557–1562), who was seated as *gobernador* of the city in 1557 at the end of the term of don Esteban de Guzmán. Below his figure, the toponym of Tenochtitlan appears as a small cactus growing from a rock, and behind his head, his name is rendered hieroglyphically.[57] While this image may pertain to his seating as *gobernador*, the center of the page is devoted to the events of the oath for Philip II, which happened in June. Here, in the second, third, and fourth registers, we see indigenous and royal governments brought together to take the oath to the newly anointed king. The second register of the page is dominated by a raised platform, called a *cadalso*, measuring about thirty feet long and fifteen wide, that was erected for the occasion on the Plaza Mayor, outside the Cathedral's west door and opposite the royal palace, which sat to the west of the plaza at that time (it would move to the east in 1562). This was constructed by indigenous laborers, who also brought the adobe bricks.[58] On it, the highest-ranking Spanish officials of the royal government and the Catholic Church are seated, including Viceroy don Luis de Velasco (center left) and Archbishop Alonso de Montúfar, dressed in his red cape and archbishop's miter (center right).[59] The book in his hands, the open Gospel, will be the site of the most important moment of this ritual. Upon it, those gathered will swear an oath of allegiance to

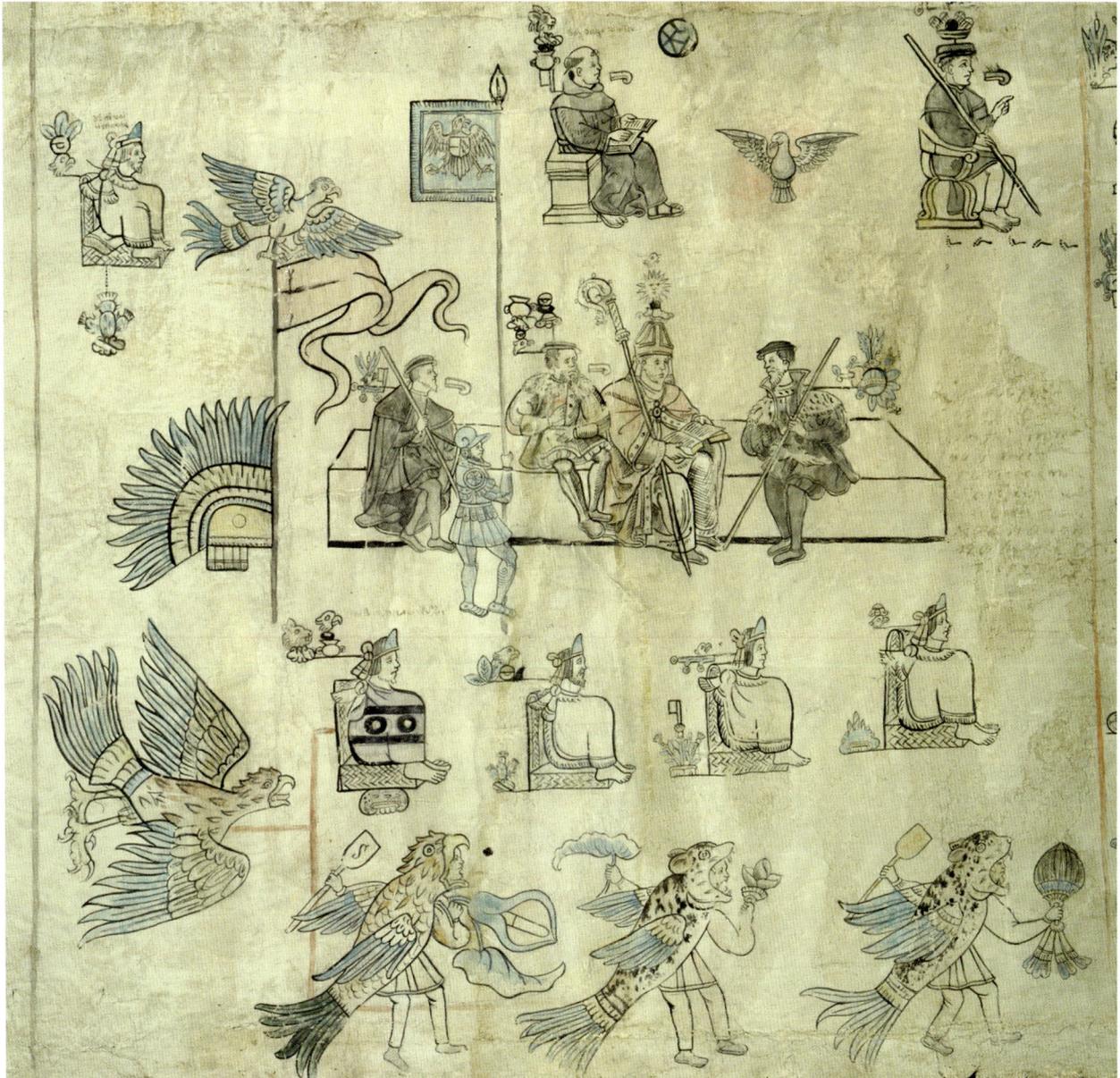

FIGURE 8.3. *Unknown creator, celebrations in honor of the* jura, *or oath of loyalty, to Philip II in 1557, Codex Tlatelolco, sec. 7, ca. 1565. Biblioteca Nacional de Antropología e Historia, Mexico. Reproduction authorized by the Instituto Nacional de Antropología e Historia.*

the new king, whose presence is represented by the banner, an eagle bearing his coat of arms, held aloft by an unnamed standard-bearer standing at left. To the immediate left of the banner is Alonso de Zorita, then president of the *audiencia*, or royal court, and at the far right end of the *cadalso* is Diego López de Montealegre, another royal judge and member of the *audiencia*, seated facing the left. Taken as a whole, this image is clearly a shorthand and highly edited version of what actually happened on the Plaza Mayor in 1557. Francisco Cervantes de Salazar reports that there were almost eight thousand indigenous dancers, and likewise, the *Actas de cabildo* records throngs on the plaza as witnesses and the participation of the city's Spanish *cabildo*,

whose members also took the oath, but they are omitted in this indigenous account.[60]

Instead, the bottom two registers of the page are dominated by a depiction of a joyous indigenous celebration of the oath of allegiance. The third register shows a gathering of the leaders of the former Triple Alliance, and joining them is the ruler of Tlatelolco, whose independence from Tenochtitlan had been reestablished, likely by Viceroy

Mendoza.[61] These four leaders offer an indigenous counterpart to the royal government seated above it. This third register begins on the left with the ruler of Tlatelolco, where we see don Diego de Mendoza Imauhyantzin; next to him to the right is the ruler of Tenochtitlan, Cecetzin, again; then follows Tlacopan, where we see don Antonio Cortés Totoquihuaztli, and finally, at the far right, is Tetzcoco, represented by don Hernando de Pimentel.[62] Glyphs that render their names, or parts of their names, are attached to their heads. And as in other manuscripts, they are seated on the traditional seat of authority, the *tepotzoicpalli*, with the glyphic toponyms of their polities connected to the bases of their seats. The artist renders them conservatively, in static profile, in contrast to the dynamic and unsettled postures of the figures seated above, a visual choice also made in other native manuscripts of the period.

Although we know that the celebration of the oath took place on the Plaza Mayor, and that standard protocol would call for the indigenous leader of Tenochtitlan, Cecetzin, to be preeminent, this manuscript from rival Tlatelolco shows the scene differently. Don Diego de Mendoza, the ruler of that polity, is shown in a position of greater prominence: his *tepotzoicpalli* is slightly larger than those of this three companions, and while they wear fringed *tilmatli* that are not decorated (although Totoquihuaztli's *tilmatli* is tinged a slight pink), his carries a band of bold black ring shapes, framed by two black bands, the same pattern that indigenous buildings of authority, like the *tecpan* of Mexico-Tenochtitlan, carried on their façades. Since don Diego was most likely the patron of this manuscript, his status here may have been enhanced at his request, a visual record of the jockeying for power that valley elites engaged in both before and after the Conquest.

We can read in this image the political subjugation of indigenous lords to their new Spanish masters seated above. But of course, the event was about everyone's—Spaniards' and indigenes' alike—subjugation to the newly anointed king. Notwithstanding, the fourth register, at the bottom of the page, makes it clear that this is a Nahua-inflected celebration carried out in the Spanish Plaza Mayor, translated into indigenous terms, just as the oath that these seated lords took was translated into Nahuatl. A meticulous depiction of an eagle is at the left of the scene, but this is no ordinary eagle. The body of this "eagle" is red, and the upper part of his wings and tail are yellow. The wing and tail feathers are blue-green. They are the same color as the feathers above in what appears to be either a quetzal-feather headdress, or a

quetzalpatzactli, a quetzal-feather back device, that here has been repurposed as a standard, attached to the pole holding the pennant that flies above the scene with yet another feathered bird affixed to its top.[63]

What we are witnessing in this eagle seems to be not any real bird, but an elaborate bird costume, very similar to the bird costume worn by the adjacent dancing figure, on the left of the fourth register, an indigenous man wearing a Spanish-style tunic over pants as well as closed shoes, whose face appears out of the beak of the costume. In front of him, to the right, are two other costumed figures, both dressed as winged ocelots. They carry objects in both their outstretched hands: the outermost figures carry a paddle-shaped object marked with an *s*, while the other objects are leaves, flowers, or feathers. The left figure carries an oversized blossom and leaf of the *huacalxochitl* flower, and the center figure, just its leaf. Such were the accouterments of ritual dances called *mitotes*: if we compare these figures to a scene of pre-Hispanic ritual dancers in the Florentine Codex in figure 8.4, we see a similarity to the figure at center left who carries the *huacalxochitl* flower and leaf. Three of the dancers in the Florentine carry bouquets of large-petal flowers (perhaps the *yolloxochitl*) that bear some resemblance to that carried by the central figure in the Tlatelolco Codex. The figure at right of the Tlatelolco Codex carries an oval red feather fan at whose base is a tight ring of blue feathers; from its handle, four pendants ending with feathers dangle.

FIGURE 8.4. *Unknown creator, dances of the merchants in honor of Huitzilopochtli, detail, Florentine Codex, bk. 9, ch. 8, fol. 30v, ca. 1575–1577. Florence, Biblioteca Medicea Laurenziana, Med. Palat. 219, c. 338v. By concession of the Ministry for Heritage and Cultural Activities; further reproduction by any means is forbidden.*

THE TRADITION OF THE MITOTE

The *mitote* (ceremonial dance) that we witness here was a tradition reaching back to the pre-Hispanic period; Diego Durán describes four days of dances that accompanied the investitures of rulers.[64] The word "mitote" comes from the Nahuatl root *itotia*, and Europeans seem to have adapted their word "mitote" from *mitotia*, meaning "it is danced."[65] Such dances had been particularly important in the consecration of a ruler, where they had a sacralizing function akin to bloodletting. They were also danced at pre-Hispanic religious events. Mendieta would write that "one of the most important things that there was in this country were the songs and dances, used to make sacred the feasts for their devils that they honored as gods."[66]

But these dances were not just past phenomena, and most sixteenth-century observers discuss them as eyewitnesses in no small part because the Franciscans, eager to capitalize on the rich pagan ceremonial life of their native charges, quickly created sanitized versions of both songs and their corresponding dances for Christian ritual use.[67] Mendieta offers an example. He praised the order and the beauty of the dances, which could involve thousands of people moving in time to the beat of two types of drums, the *huehuetl* and the *teponaztli*, and noted how dancing was a prized skill. One of the earliest Franciscan chroniclers, Motolinia, did the same: "Attired in white shirts and mantles and bedecked in feathers and with a bouquet of roses in their hands, the Indian lords and chiefs perform a dance and sing in their language the songs that solemnize the feast which they are celebrating. The friars have translated these songs for them and the Indian masters have put them into the meter to which the Indians are accustomed. The songs are graceful and harmonious. In many places the dancing and singing begin at midnight and numerous lights illumine the patios."[68] Writing in the late sixteenth century, Mendieta also discussed the costumes worn in these dances, which he witnessed: "At times they brought to the dance plaza cones of roses and of other flowers, or bouquets to carry in their hands, and garlands that they put on their heads, in addition to the costumes that they used in the dance, rich cloaks and feathered costumes, and others carried in their hands small beautiful feathers instead of bouquets."[69]

As we can see from these two accounts, written about sixty years apart, feathered costumes were a key element, in addition to music, of the performance of *mitotes* in the sixteenth century.[70] This connection had pre-Hispanic

roots. The Florentine Codex, for instance, tells us that one of the key roles of the featherworkers was to create the dance costume of Moteuczoma. And because of its role in dance costumes, feathered clothing continued to be made through the sixteenth century. The Florentine Codex, again, describes how in the 1570s, some feathered articles had fallen from fashion, but not so dance costumes: "Insignia borne on the back are made, with which there may be dancing; and all the dance array, gear, and ornaments: the quetzal feathers, head ornaments, bracelets for the upper arm with precious feathers, gold bands for the upper arm; fans—fans of heron, of red spoonbill, of troupial, of crested guan, of quetzal feathers; and hand banners, quetzal feathered hand banners with troupial feathers in alternating bands, heron feather banners, gold banners tufted with quetzal feathers at the tips."[71] Feathered costumes were prized by indigenous elites in the colonial period and were among the heirloom items that were designated in wills, objects passed down from generation to generation; in her research on indigenous costume, Justyna Olko has identified a number of feathered garments of different types named in wills.[72] Here in the Tlatelolco Codex, their importance is underscored by the red line that runs from the first image of the colored eagle, connecting it with the Tlatelolco ruler, don Diego de Mendoza, and the first two dancers (figure 8.3). The rarity of the costumes, as well as the skill of the dancers, made the *mitotes* special events, danced at official events, and while they could be sponsored by the mendicants, they were also performed under the sponsorship of the indigenous lords, as we see them here.

The *mitotes* were one way that indigenous governors fused ceremonial forms of the past into the new ones of the present. Some observers remained deeply suspicions of them. Cervantes de Salazar would write of indigenous dancers, "In the dance in which they would sing praises to the devil, they now sing praises to God, who is the only being worthy of praise. But they are so inclined to follow their ancient idolatry, and if there is no one around who understands their language, among the sacred orations they sing they mix in pagan songs, and to better cover up their damaging acts, they begin and end with words of God, interspersing pagan verses in low voices so as not to be heard, and raising their voices at beginning and end, when they say 'God.'"[73] Despite their suspect nature, the *mitotes* were at times embraced by Spanish royal officials, who called for them to be performed at civic rituals, particularly those that marked a transition in monarchial power

(such as the oath of allegiance sworn to the new king or the processional entry of the new viceroy into a city).[74]

But the particular rendering of the 1557 oath along with the *mitote* in the Tlatelolco Codex raises the question of whether in the sixteenth century the *mitotes* were understood as offering only "ritualized expressions of loyalty" to the Spanish monarch. We have seen, in chapters 3 and 5, that a traditional way of showing political alliances and associated political hierarchies among the pre-Hispanic rulers would have been through feasting or in gift giving. But the iconography of the *mitote* in the Tlatelolco Codex emphasizes the potency of rulers rather than political fealty. Consider the flowers that the dancers hold. The form of the *huacalxochitl* flower—here shown in dramatically enlarged form—was likened to the male sexual organ. Sahagún's informants wrote that women of the palace pleasured themselves with it, "therefore, they say, they were carnally guilty," and thus related to masculine potency. These flowers were carried by both rulers and war heroes, as well as by dancers.[75]

Military prowess was a key component of indigenous rulership, and many of the costumes and accouterments shown as part of the *mitote* performed for the oath were ones once specifically linked to a ruler's military exploits. The feathered fan carried by the front figure may be the *tlauhquecholecacehuaztli*, the "red spoonbill feather fan" depicted in the Florentine Codex and one of the gifts that valley rulers, assembled by the Mexica *huei tlatoani* to watch gladiatorial sacrifices on the successful completion of a war, carried in their hands, thus both an emblem of military victory and an example of Mexica largesse. This fan also resembles that carried by a *tequihua*, "seasoned warrior," who was among those entrusted to be "ambassadors and guides" (*enbaxadores* and *aldalides*) by the *huei tlatoani* in the pre-Hispanic period and who were represented in the Codex Mendoza (figure 8.5).

Indigenous audiences certainly remembered the prestige of feathered costumes in the mid-sixteenth century—in the Tlatelolco Codex, the earliest scenes, of ca. 1542, show the Tlatelolco warriors carrying feathered shields and wearing feathered ornaments in their hair, and one figure wears a short jerkin with an ocelot pattern, similar to the feathered jerkins in the Codex Mendoza (folios 22r and 32r) and the Codex Ixtlilxochitl (see figure 3.2). Since featherworks of all kinds were exceedingly precious, warrior costumes, once out of date, seem to have been repurposed into valuable dance costumes, in addition to

FIGURE 8.5. *Unknown creator, a tequihua, or seasoned warrior, carrying a fan, detail, Codex Mendoza, fol. 67r, ca. 1542. Bodleian Libraries, University of Oxford, Ms. Arch. Selden A1.*

being created anew, as the Florentine Codex reports.[76] For instance, the Codex Mendoza frequently shows ocelot costumes, complete with helmet-masks, in its tribute lists, their black spots set against a background of yellow (folios 20r, 21v, 23r, and 31r), white (folio 25r), blue (folios 29r, 37r, and 51r), or red (folio 54r). Such suits were made not from ocelot skin, but from *feathers*, carefully sewn into cotton backing, rachis by rachis, thousands of feathers, crafted to resemble the spotted pelt. One such yellow feathered costume, with its own *devisa*, "emblem," in the form of a giant bird with outstretched wings similar to that in the Tlatelolco Codex, can be seen in the upper left quadrant of a page from the Codex Mendoza, reproduced in figure 3.1. These elaborate, extraordinary suits were destined to be given to the highest-ranking of the Mexica military elite, as reward and public sign of their prowess in battle. They were also to be worn by these elite Mexica warriors into the next round of conquest battles, which in turn would bring

more territory and more such tribute into Tenochtitlan; thus they were intimately associated with the relentless cycle of Mexica military expansion.[77] In fact, the particular costumes shown in the Tlatelolco Codex, that of a colored eagle and an ocelot, were even more strongly linked to pre-Hispanic military prowess, as eagle and ocelot knights were the two most elite castes of warriors.[78]

Two of the dancers in the Tlatelolco Codex wear similar ocelot costumes over their heads and bodies, but they are different in that they are not full bodysuits, but are more like hooded (or headed) capes, draped over the shoulders. It is worth recalling that feathered suits were among the few seamed garments created by the pre-Hispanic Nahua, for in general, indigenous clothing was made of uncut cloth because cutting and seaming fabric weakens its overall structure. In these dance costumes, armholes with sleeves, the part of a garment most likely to wear out, do not appear, and instead, feather "wings" cover the seam where the armholes may have once been.

This scene in the Tlatelolco Codex, then, offers us valuable insight into the hybrid performance culture of Mexico City; on the surface, it renders the oath celebration with the pairing of two visually equivalent orders: above, the royal and church officials are seated on the raised platform, as they swear on the open book held by the archbishop, with turquoise speech scrolls marking the oaths emerging from their mouths; below, the indigenous *gobernadores* are seated on their individual *tepotzoicpalli*, but they are not shown taking the translated oath in Nahuatl, as no speech scrolls emerge. Instead, they are linked to the performers of the *mitote* that appear below. But here the conceptual alignment between the Spanish celebration and the indigenous one is pulled off axis by the timeworn associations of the *mitote* and the necessary feathered costumes. In the *mitote*, it was indigenous rulership being performed, with its overtones of potency and military prowess. Taking place in the Plaza Mayor, the 1557 *mitote* reasserted indigenous presence in this ancient sacred space.

ELITES VERSUS COMMONERS IN MEXICO-TENOCHTITLAN

The Tlatelolco Codex shows us the *mitote* being used in a particularly indigenous interpretation of the oath of allegiance, a continuance of one of the ways, in addition to public feasting and gifting, that rulers in the pre-Hispanic period made a public spectacle of their rule. And just like

a public feast, the *mitotes* became a flashpoint for the tensions between commoners in the city and the indigenous nobility. Such conflicts surface in the available record at moments when the Crown government called for some kind of investigation, as when Viceroy don Luis de Velasco sent the indigenous judge don Esteban de Guzmán to the *tecpan* in 1553 or 1554 to investigate reports of abuse by Tehuetzquititzin, as seen in chapter 7. When, nine or ten years later, in 1563, the Crown dispatched Gerónimo de Valderrama to serve as general inspector, his visit blew the top off the volcanic caldron of valley politics. All sectors of the city, from the most powerful *encomendero* down to humble Nahua bakers, vented their grievances; eventually his presence led to riot and insurrection. By 1564, the year after his arrival, a group of native commoners were in active pursuit of a lawsuit against the native officers of their *cabildo*, claiming that the *alcaldes* and *regidores* had abused their offices for self-enrichment and were leading lives of vice. Notably, two of the nineteen complaints they presented in 1564 had to do with *mitotes*:

> VII. Item, the seventh [charge] is that when the afore-named alcaldes and regidores perform their mitotes, they are accustomed to dress themselves in the suits and accouterments that their ancestors used to customarily wear and dress themselves when they performed idolatry and human sacrifice, and this cannot be permitted given the office they hold . . .
>
> XIII. Item, the thirteenth is that those aforenamed alcaldes and regidores demand during the [festival] season that a certain amount of money be collected from each craftsman in each of the parcialidades, so that they can make feathered costumes and other objects of feathers to be used in their mitotes. And each [feather] piece costs fifty or sixty pesos. And when the mitote is to be performed, they give or rent out these feathered [costumes] to single young men so that they might appear in the mitote and impress the women who come to see the dance, and those that rent [the costumes] give the alcaldes and regidores money and Castilian wine for the feast day, and they in turn distribute the money that they had collected from the commoners and the artisans.[79]

The charges were calculated ones, as are any in a lawsuit, specifically crafted to draw on actual events that would appeal to the sympathies and prejudices of the presiding judge. Item seven reveals two features of the *mitote*

performances: first, that the most valued costumes to be worn in their performance (that is, the ones worn by the native *cabildo* members) were recycled ones, a condition also suggested by the Tlatelolco Codex. Second, *mitotes* were not squeaky-clean entertainment; for the charge of idolatry to be made in the first place, the dances needed to already carry with them some taint. This particular valence is confirmed by periodic bans directed against the performance of *mitotes*, beginning in 1539.[80] Item thirteen allows us to see the expense of the contemporary costumes. An unskilled worker in a labor draft paid at the official rate would earn one-twelfth of a *peso* per day in 1560; skilled workers on the free market might earn as much as a *peso* a day.[81] Thus to buy a feathered costume to be used in a *mitote*, a peon would need to devote two years of his wages, and a highly skilled craftsman would need to devote two or three months of his. The item also allows us to peer behind the costumes that cover the anonymous performers in the Tlatelolco Codex and see something of their motivations. They were young men and being a *mitote* performer enhanced their status, certainly among the gathered women. But most interesting is the last part of the charge, because it connects the *mitotes* directly to the feasting and culture of largess that indigenous governors kept alive in the city. In controlling the performance and the costumes of the *mitotes*, the indigenous *cabildo* was also able to fund giveaways on feast days.

Some weeks after these charges were filed on July 4, 1564, with the *audiencia* judge Pedro de Villalobos, who was hearing the case, the indigenous *cabildo* finished their response, in which they, through their lawyer, Juan Caro, replied charge by charge to the accusers. Caro offered a firm rebuttal to the charge of idolatry:

> To the seventh item, I deny what it contains, for in their mitotes or in customary dances, my clients have never introduced deviations nor idolatrous acts nor anything contrary to Christian doctrine. . . . while my clients may take out some costumes, and though they may be akin to those of antiquity, for this one can neither be led to sin nor to a presumption of bad Christianity, for [they do so] only to make themselves joyful in their celebrations with songs that praise God and the Christian religion and all the saints, and curse the devil and their ancient ceremonies, with the approval of priests and others who administer Christian doctrine, the Catholic faith, following that which is generally done and customary among the natives

of New Spain in their celebrations and mitotes, without damage to the Christian religion nor to any person.[82]

The response essentially confirms what the accusation established, that is, that many of the costumes were old ones and thus once associated with the "idolatrous" practices of the pre-Hispanic period. However, Caro insists that they have been transformed by their context—they are now used only to praise God. Most important, however, is widespread acceptance of *mitotes* as part of Christian ritual, approved by the friars and performed throughout New Spain.

Caro's response to the thirteenth charge reveals little about the dancers, but does reaffirm the heirloom status of costumes:

> . . . my clients did not spend any contributions for feathered costumes, accouterments or similar items, which will be proved as truthful, given that they have kept some feathered items in their community [the *tecpan*] for their enjoyment and public festivals, and have had them for more than 25 years; thus one will find that they have not bought feathers nor shields for this purpose since then, using only those which have been in the aforementioned community [*tecpan*] for years. Nor have my clients demanded contributions for this reason or any similar one, nor will one find any order issued nor collection made for the aforementioned expense.[83]

The response underscores the role and status of the feathered garments. It makes clear that the community of Mexico-Tenochtitlan had held some featherworks in the *tecpan* for decades and that these were considered community property, brought out as part of community-sponsored festivals. That young, unmarried men were dancing also points to the dances as a form of social reproduction—learning the steps of the *mitote* was a refined and admired art, and this, like other kinesthetic skills, was passed down by the apprentice mimicking the master. However, the charges in the suit, combined with the presence of feathered items in elite wills, suggest that featherworks, once created and held as communal property, were increasingly becoming treated as personal property, with *cabildo* members renting out the costumes that they "owned" (notably, a charge they didn't respond to). Certainly such rentals would help augment their increasingly restricted salaries. In the reforms passed by Viceroy Martín Enríquez de Almanza

in the mid-1570s, the salary to be paid to an indigenous *alcalde* in nearby Tacuba (Tlacopan) was twelve *pesos* a year; *regidores* received only eight.[84] This clearly meant that indigenous *cabildo* members needed to find other ways to support themselves, as did Crown officials of the era. The resentment of the commoners bringing the charges was not over the use of the feathered costumes, or their expense, but rather that objects that they had paid for as community goods were being used to enrich public officials. This repositioning of symbolic items, once seen as communal property, into the private sphere of individual rulers was paralleled by the movement of once-communal goods, like land, into the domain of individual indigenous elites.[85]

If *mitotes* became flashpoints for the mounting tensions between commoners and elites, and the hijacking of once-communal costumes was the source of resentment, it is because they were an important expression of communal identity and its internal hierarchy. They were, as much as the procession, another way the community showed itself to itself. In leading the *mitote*, a pre-Hispanic ruler like Moteuczoma made public his role as leader of the *altepetl*; and we might imagine after the Conquest that the *gobernador* danced in a similarly key position, perhaps flanked by the two *alcaldes* and followed by *regidores* and then by the *alguaciles* (constables) of the four *parcialidades* to make visible the political hierarchies of the government. When Chimalpahin describes a *mitote* at the beginning of the seventeenth century, he tells us that it is don Hernando de Alvarado Tezozomoc, that is, Huanitzin's son and Moteuczoma's grandson, who would don the dance costume and lead the crowd.[86]

Descriptions of the colonial *mitotes* make clear why they should serve as such potent metaphors for that communal body. Mendieta describes the three or four thousand people who would come together to dance; each of the "songs" would be started by two masters, recalling the double leadership that the *huei tlatoani* and *cihuacoatl* provided for the *altepetl*, to be followed by a large chorus. "This great multitude," marvels Mendieta, "moved their feet together, the same as very skilled Spanish dancers. And more is that all the body, the head along with the arms and hands, moved in concert, measured and ordered, that not a single one varied, nor moved off the beat." The harmonious community that was forged kinesthetically in the *mitote* was also a means of social reproduction: "Many youngsters, and the sons of the lords, join the dance, some of them seven or eight, others as young as four or five, who dance with their parents."[87]

That the 1564 lawsuit would underscore that young men were eager to join the dance tells us that the commoners bringing the suit also understood its socially integrating function (although attributing the zeal of participants to sensual pursuits), and if we think beyond the spectacle of its performance, we can envision the apprenticeship of dance master and young disciple assuring the continuity of one generation to the next.

In the same context, the *tecpan* building, sometimes referred to simply as "la communidad" and presented as such in the Codex Osuna, would become equally contentious. The process of building *tecpans* was a communal enterprise, with labor being part of one's obligation to the community. But at the same moment that the *mitotes* were being contested, so was the *tecpan*. As part of the same lawsuit of 1564, the commoners protested that they had not been paid for their labor, either to maintain or to expand the *tecpan*. "They brought many large stones for the work being done at the cabildo-and-community house [the term for the *tecpan*], and each stone cost three *pesos*, and to pay for them, they [the native *cabildo*] collected a silver *real* from each Indian, and they were brought by dragging, an enormous amount of work, to put them in the cabildo-and-community house, and in bringing them, more than 500 Indians worked for more than eight days."[88] And as we shall see, the *tecpan* would bear the brunt of growing popular outrage.

DANCE AND RIOT

Just when the commoners of Mexico-Tenochtitlan were gathering testimony in support of their charges against the native *cabildo*, the seated *gobernador*, don Luis de Santa María Cipactzin, grandson of Ahuitzotl and resident of Moyotlan, celebrated his wedding, on June 4, 1564, to doña Magdalena Chichimecacihuatl.[89] They were married not in San Francisco but in Santo Domingo, and after the wedding, a merry procession complete with wind instruments made its way back toward the *tecpan*. A native account tells us of the events: "At the foot of the stairs, the people of the church gathered, the singers, and there they sang. When the bride entered, they began to dance. First they performed to the *chichimecayotl* song, and then they began the *atequilizcuicatl* [water-spreading song], and then the tlatoani [Cipactzin] himself danced. And in this he then painted his huehuetl drum, he gilded it. The lords and principales of the [surrounding] towns had come. And in the

thatched shelters around the outside of the Tecpan, there the old military guard [of eagle warriors] stood, and within the Tecpan, the Otomí guard danced for two nights."[90] This two-day celebration evokes those great celebrations staged by the Mexica *huei tlatoani*, complete with the eagle warriors and festive songs and attendant *mitotes*, whose music and movements we can only imagine from their evocative names, such as the "dance of the Chichimecs," the great nomadic warriors who were the progenitors of valley civilizations, and "the song of the spreading water." It was perhaps one of the few happy moments that Cipactzin would enjoy, because just a month and a half later, calamity struck Mexico-Tenochtitlan.

It came not in the form of one of the devastating plagues that had decimated the native population, nor even in the formal presentation of the charges made in the lawsuit; instead, it was a new form of tax levied on the indigenous population of New Spain, one coinciding with heightened internal tensions in the native city. Questions about, and quarrels over, tribute were endemic from the mid-1550s over which natives should pay (were elites exempt?), how much they should pay, and how it should be paid (in specie? in kind?). The indigenous lords of the Valley of Mexico considered tribute so burdensome that they appealed to the king in 1562 to suspend tribute payments for a decade.[91] So finally, when Gerónimo de Valderrama arrived to serve as general inspector, one of his first tasks was the reform of indigenous tribute payments. It was, in fact, probably the main charge the king gave to Valderrama, who, having previously served as head of the exchequer (*contador mayor de hacienda*), was an accountant rather than a jurist.[92] He based his reform on revised population figures, which promised heavier tribute assessments for Mexico City's indigenous people, to be made in cash. In this, he broke with long-standing practices of calling for payment by tribute in kind. News of the new tribute levies leaked out at the beginning of 1564, and when Cipactzin and the *cabildo* members heard of the changes, they did everything in their power to mitigate them, appealing time and again to the *audiencia*. The Franciscans found them equally objectionable; Mendieta drew a parallel between Valderrama's count and the census of King David (2 Samuel 24), which "must not have pleased God" because in response, "He sent another pestilence to his people," and indeed, another epidemic had broken out that year.[93]

The protests were to no avail. So on Thursday, July 13, less than two weeks after they had been hit with a lawsuit

accusing them of incompetence and venality, Cipactzin and the *cabildo* members, along with Juan Caro, their attorney, gathered on the balcony of the *tecpan*. Below them, in the plaza, were leaders and residents of the four *parcialidades*, who had been waiting months to hear the result of the negotiations, some of whom would have known about, if not been party to, the lawsuit. In front of this hostile crowd, Cipactzin then announced the new levies they would face in the future, tribute money that would support not only the Spanish government, but also the indigenous government itself, which was to receive about half of the levy. The crowd's discontent found a spokesman in Miguel Teicniuh, who called out, "In all this time that we negotiated, for six months we contested in vain, for now there's nothing to be done, they have not heard our pleas. And here," he said, likely gesturing toward Cipactzin, who stood on the *tecpan*'s balcony, "is the lord of all of you—do you think he did anything on your behalf? Perhaps he neglected you, or didn't take care of this community."[94]

When Teicniuh finished speaking, the riled crowd began to riot. Cipactzin shouted over their heads to gathered musicians to begin playing their wind instruments, as if to remind all those gathered of the joyful and pacific event of his wedding, when they had played in this same space some six weeks before. The music did nothing. From below, more local leaders raised their voices in dissent, the crowd joined in with their yells, old women wept, and then the throng erupted. A native official entered the crowd to calm it and was nearly torn limb from limb. Hearing the noise of the crowd in the *tecpan* patio, the market sellers in the adjacent Tianguis of Mexico thronged toward the nearby building, adding to the tumult. Cipactzin was able to escape, so the swelling crowd vented their fury on the architectural mass of the *tecpan* itself, throwing stones at the upper part of the building and attacking what was clearly a symbol of native authority, the row of rings and flower border on the roofline.[95]

Cipactzin is often scourged in histories as an ineffective leader, but he also faced an era of impossible demands—struggling to hold on to the time-honored means of expressing his authority at the same time that the Spanish Crown government was increasingly pressing in on elite prerogative in the indigenous city. And he did not give up. Although thrown in jail when he was unable to collect the new tributes (*gobernadores* were also responsible for delivery of tribute to the royal treasury), he and his *cabildo* mounted a counterattack on one of the causes of

the citizenry's growing poverty: the exorbitant demands by members of the Crown government on the peoples of Mexico-Tenochtitlan. He issued a searing complaint to Valderrama about the demands for goods and services that the viceroy and the judges of the *audiencia* had been making on his people for the past decade—those loads of lime and stone for their houses, the cartloads of fodder for their horses, the fruit for their tables. This complaint comes down to us in the form of the Codex Osuna, the pictorial source for much of what we know about the city from 1555 to 1565. Ironically, the Osuna precisely mirrors the complaints about him and his *cabildo* launched by commoners in the 1564 lawsuit.

Cipactzin's complaint would have an effect. Viceroy Velasco would escape any censure, as he died of a lingering illness at the end of July 1564, two weeks after the *tecpan* riot. But Valderrama eventually would suspend two of the six judges of the *audiencia* (Villanueva and Vasco de Puga) from their offices and push another (Zorita) to resign and return to Spain at the beginning of 1566.[96] Not long after, the city's royal government and the Spanish *cabildo* were sucked into another political maelstrom as Martín Cortés, the conquistador's son, who returned to New Spain in 1563, fomented a coup d'état, which was uncovered in the summer of 1566. These events—with their marquee actors—playing out on the Plaza Mayor eclipsed the tragedies unfolding in the *tecpan*. On May 24, 1565, Cipactzin emerged, alone, on the same balcony from which he had announced the crushing tributes the previous year. He screamed "as if possessed by the devil," and his raving went on through the night. He would die at the end of the year.[97]

CONCLUSION

This chapter has shown the multifold ways that spaces were marked in Mexico-Tenochtitlan, from the movement of sacred images in processions, to decorous *mitotes* in the *tecpan*, which in turn defined axes, urban hot spots, and peripheries in relation to the center. We have also seen how the indigenous rulers in the *tecpan* connected their person and their rule to these spaces, often working in tandem with the Franciscans. In the giveaways of feasts and the feathered costumes of the *mitotes*, we have seen how these very rulers carried the festival culture of the pre-Hispanic *altepetl* into the seventeenth century. But one of the most important roles of pre-Hispanic rulers was the manipulation of water, which was essential for the maintenance of the *altepetl* within the singular watery environment of the Valley of Mexico, and it is to water that we return in the next chapter.

Water and *Altepetl* in the Late Sixteenth-Century City

On June 28, 1575, an extraordinary event took place within the main hall of the *ayuntamiento* building, which occupied the south side of Mexico City's main plaza.[1] That morning, members of the Spanish *cabildo*, among them wealthy and powerful citizens of this New World capital, had gathered for their regular semiweekly meeting to discuss some of the affairs of the city under their control: the organization of festivals, particularly San Hipólito; the regulations of city slaughterhouses; the cleaning and paving of streets. But interrupting the normal course of affairs was a letter from the viceroy, Martín Enríquez de Almanza (r. 1568–1580); after it was read, into the large meeting hall walked some unusual guests, men who rarely entered through these portals. They were the leaders of the *cabildo* of Mexico-Tenochtitlan, the indigenous government that controlled the four *parcialidades*, that indigenous ring city of the island. At their head was don Antonio de Valeriano, who claimed descent from lineages of the great *huei tlatoque* of the pre-Hispanic period, and he was flanked by the indigenous government's two *alcaldes*, don Martín de la Cruz and don Martín Hernández, along with a host of other nobles and government officials, whose numbers likely included the ten or so *regidores* representing the four *parcialidades*. These men rarely appeared in front of this body, so it was a ceremonious occasion. To the untutored, their dress would simply have marked them as members of the *república de indios*, but to knowledgeable viewers it would have been rich with symbols of their office. For most of them, it almost certainly included the native *tilmatl* (cloak), worn over their shoulders and knotted in front, made of

fine white cotton spun with rabbit hair or feathers, dyed and patterned in some cases and embroidered with the *tenixyo* design of brilliant cherry-red thread at its edge, one of the signal markers of elite clothing (see figure 7.12).

Some of the members of the Spanish *cabildo* may have known Valeriano; the viceroy certainly did, as this governor of Mexico-Tenochtitlan appealed directly to him in managing the indigenous city's affairs. Valeriano was well known in other circles; he was a great favorite of the city's powerful Franciscans, had worked with Bernardino de Sahagún on the creation of the Florentine Codex, and had taught Nahuatl to Juan de Torquemada, whose chronicle *Monarchía indiana* is still an indispensable source for Mexican history. Gerónimo de Mendieta, the Franciscan who was the careful observer of the festivals examined in the last chapter, would speak of him highly, offering him as an argument for the value of educating indigenous elites, one of the results being that they proved better rulers: "And of this we have a good example among us in don Antonio Valeriano, the Indian governor of Mexico City, who emerged [from Franciscan schools] with command of Latin, logic and philosophy and he then followed those priests who were his teachers, named above, in studying grammar in the college [of Santa Cruz, housed in Santiago Tlatelolco] for a number of years and taught young priests in that monastery and after was elected to be the governor of Mexico and he has ruled in that city a little less (I don't know if more) than thirty years, in all affairs that pertain to the Indians and has met with great approval from the viceroys and has been an example for the Spanish."[2] In his

Annals, the Nahua historian Chimalpahin would describe him as "a sage and a scholar" (*tlamatini momachtiani*), using a term, *tlamatini*, that was reserved for elders possessing extraordinary wisdom and judgment who provided counsel for following generations.[3] The historian of the Spanish *cabildo*, Francisco Cervantes de Salazar, would write in 1554 of how the indigenous students at the Franciscan school of Santa Cruz "have a teacher of their own nationality, Antonio Valeriano, who is in no respect inferior to our grammarians. He is well trained in the observance of Christian law and is an ardent student of oratory."[4] In addition to Latin, Valeriano spoke and wrote Spanish fluently. He had been appointed to the governorship after a difficult interregnum of some eight years; the death of his third cousin don Luis de Santa María Cipactzin (r. 1563–1565) in December 1565 coincided with the crisis provoked when Martín Cortés, the son of the conquistador, attempted to seize power as king of New Spain. Arriving to a city in chaos, Viceroy Gastón de Peralta (r. 1566–1568) had begun the practice of appointing outsiders to rule in Mexico-Tenochtitlan. Viceroy Enríquez, however, returned to the tradition first established by Viceroy Mendoza of choosing members of the highest Mexica elite, appointing Valeriano to the post in 1573. Like Huanitzin, who had also been Mendoza's appointment, Valeriano had impeccable Mexica credentials. His great-grandfather was Axayacatl, and Valeriano was born in Azcapotzalco, where his family held power. His wife, doña Isabel de Alvarado Moteuczoma, was almost certainly born in Tenochtitlan and was the granddaughter of Moteuczoma II and daughter of Huanitzin (see figure 4.7).[5] And in reaching almost to the end of the sixteenth century, Valeriano's reign would rival in its length that of Moteuczoma II, who was seated at its dawn.

In the *cabildo* meeting that morning, Valeriano delivered a request that the native community of Mexico-Tenochtitlan be allowed to build an aqueduct from Chapultepec along the causeway of San Juan, one that would reach the great *tianguis* at the city's southwestern corner and supply Moyotlan and from there be carried on an east–west route to reach San Pablo Teopan. The main reason that Valeriano gave was a simple one: this area of the city was ill-supplied with Chapultepec's waters. This was true, given that the one existing aqueduct, the same one that had served the pre-Hispanic city, fed the city's north and center, running as it did along the Tacuba causeway to feed the fountain in the Plaza Mayor. While a *tianguis* fountain to serve the southwestern quadrant had been contemplated since

1558, it had never come to fruition.[6] To further convince the *cabildo*, Valeriano put more chips on the table: all the labor and stone would be provided by his government; they would also pay half the salary of the Spanish *maestro* to oversee this public work; and the water would benefit not only the city's indigenous, but also the numerous Spanish residents who lived in these quadrants of the city.[7] The catch was that the city would use monies from the *sisa de vino*, a temporary tax on wine, to pay for the lime, a crucial ingredient for masonry. Lime was expensive, costing about 4.5 *pesos* per *cahiz* (an amount measuring about 12 *fanegas*, or 18 bushels; indigenous workers measured lime by *cargas*, or the amount an individual could carry, which was half a bushel),[8] and by the end of the work, 8,628 *cahizes* would be required, with 44,122 *pesos* paid out by the Spanish *cabildo* alone for the project—this at a time when a skilled indigenous artisan might earn a *peso* a day.[9] The anticipated expense for lime alone might normally have led the extraordinary request from indigenous leaders to be shrugged off by the Spanish *cabildo*, which would need to approve such a large infrastructure project. This one, however, had the powerful viceroy's backing, so it would have been hard to refuse. And approve it the *cabildo* did.

This event and the aqueduct that was built over the next seven years to deliver water to the Tianguis of Mexico often merit a small note in accounts of the city's colonial water supply, overshadowed by a much longer and eventually successful project to bring water in from the distant springs of Santa Fe.[10] But when set within the larger sweep of indigenous governance in the city and its role in supplying water to the city residents—a role that showed its sacred dimensions in the creation of the Acuecuexco aqueduct under Ahuitzotl in 1499—the building of the aqueduct can be seen as having crucial importance to both the practical and ideological exercise of indigenous governance in the city. Moreover, setting this aqueduct in relation to two earlier (and failed) aqueduct projects is revealing. These are the 1564–1570 revival of the Acuecuexco aqueduct and the subsequent attempt, beginning in 1571, to build an aqueduct from Santa Fe. In addition, when we see it within the context of the ecological and social challenges that city residents faced in the 1560s and 1570s, particularly the devastating epidemics and food shortages that seized the city beginning in the mid-1570s, we can better understand the second aqueduct of Chapultepec as the signal monument that it was.

To underscore the continuing importance of water to

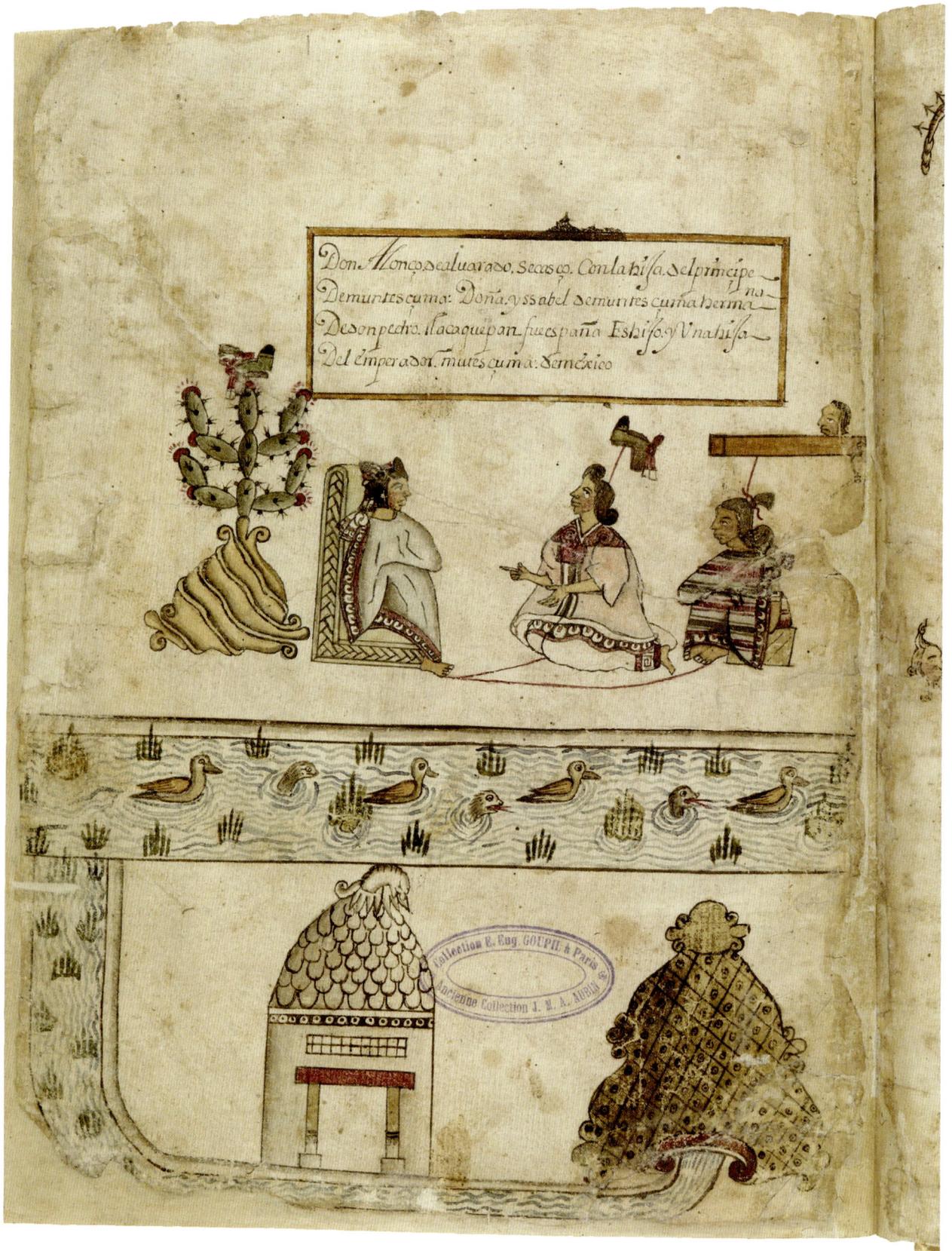

FIGURE 9.1. *Unknown creator, Moteuczoma II and his children, Codex Cozcatzin, fol. 10bis–r, seventeenth century. Ms. Mexicain 41–45, Bibliothèque nationale de France, Paris.*

the *altepetl*, both as an idea and for the practical functioning of the city, it is worth turning to a page in the seventeenth-century Codex Cozcatzin, which includes a complaint about don Diego de San Francisco Tehuetzquititzin (r. 1541–1554), discussed in Chapter 7. Another section of this document is a history of the *huei tlatoque* of Mexico-Tenochtitlan, and it begins with an image of the last pre-Hispanic ruler, Moteuczoma II, and two of his children, doña Isabel Moctezuma and don Pedro Moctezuma Tlacahuepantli (figure 9.1).[11] Moteuczoma II is seated on the high-backed *tepotzoicpalli*, and behind him is a hill glyph, marked with the nopal cactus, part of the hieroglyphic name of Tenochtitlan. In its highest branches hangs the turquoise miter, the "crown" of Mexica rulers, as well as part of the name glyph of Moteuczoma himself. Moteuczoma's body is covered in a white *tilmatli*, marked on its edges with the *tenixyo* border. His daughter, above whose head is set the Moteuczoma name glyph, wears a *huipil* with a similar border, and behind her, her brother don Pedro wears a striped cloak with the *tenixyo* border. Never holding office, don Pedro is seated on a low stool. The glyph for his Nahuatl name (understood here as Tlaca-*cua*pantli) appears connected to his head, where the head of a person (*tlaca*) sits upon (*pan*) a beam of wood (*cua-huitl*). Below is a schematic landscape. At the lower right corner is the familiar *tepetl* symbol, marked with volutes on the side to show its stony character and a large stone (*tetl*) at the top. The diamond-and-dot pattern, here filled with pigment, is old iconography used to show the rough skin of Tlaltecuhtli, the earth deity whose sacrifice brought about the world as the Nahua knew it. It is comparable to the patterns seen in the map reproduced in figure 2.18. From a cave-like opening at the bottom of the hill, a stream of water (*atl*) emerges, the necessary element to show that this is an *altepetl*, evoking the origin of the streams at the foundation of Tenochtitlan. As this stream flows along the bottom of the page and then up its left side, it changes from symbol to landscape, appearing like a canal on the left. In the center of the page, it takes on more characteristics of the lake, growing with reeds and hosting water birds, water snakes, and a furry animal that might be a nutria, all neatly ordered within a horizontal band. To the left of the *tepetl* symbol in the bottom register is an indigenous-style building, with red posts and lintel around the central doorway, and the disk pattern that marked special buildings is seen on the entablature, the same pattern that we have seen decorating the *tecpan* of Mexico-Tenochtitlan.

Since this document is a historical chronicle meant to support doña Isabel's noble genealogy, on first glance, there seems to be no particular need to include these images of *altepetl*, indigenous building, and water on the page. But seen in light of the document's larger rhetorical claims—a statement about the historical roots and argument for the necessity of indigenous rulers—the ordered watery environment is linked into this nexus of ideas, in the same way that a more famous opening image, that of the Codex Mendoza, was (see figure 1.3). Symbols for the *altepetl* often show it as a hill glyph with a stream of water emerging from the bottom, like the glyph of Chapultepec in the Codex Aubin (see figure 1.7); however, in the case of the Codex Cozcatzin, the life-giving water from the base of the *altepetl* feeds a hydraulic system of canals and lakes. And as we have seen, this system was not mere symbol, but once existed in and around the city, where the Mexica rulers over time manipulated the surrounding salty lakes and springs to provide freshwater to the city residents. The linkage of *altepetl*, rulership, and the supply of water in a seventeenth-century manuscript shows its indelibility through time, and in this chapter we will see how its endurance was fostered by a ruler of Mexico-Tenochtitlan who sought once again to provision the city with freshwater from the miraculous source of Chapultepec.

THE CONQUISTADORES AND THE WATER SYSTEM

The manipulation of the Valley of Mexico environment and the transformation of the Laguna of Mexico from salt water into fresh was the result of experiments that spanned centuries among the valley peoples. But with the Conquest, the control of the system fell into the hands of the city's new Spanish inhabitants, who made the major decisions about the resources to be devoted to its infrastructure. The Spanish *cabildo* of Mexico City was mostly concerned with expanding the wealth and prerogatives of its members and *vecinos* (citizens), and thus it neglected crucial infrastructure maintenance, no doubt resulting in part from a poor understanding of the function of the waterworks. As a result, the indigenous labor drafts that historically had been devoted to the constant upkeep demanded by the waterworks—the cleaning of the canals, the maintenance of causeways and dikes, the monitoring of water levels in different parts of the lake, and the corrective openings and closings of dams—were siphoned off to the building

projects within the city, which included the Cathedral, San Francisco, Santo Domingo, San Agustín, and Cortés's palaces, as well as palaces for other Spanish residents. And when devoting labor to the waterworks was unavoidable, as it would become in 1555, the Spanish *cabildo* avoided paying for it, pushing responsibility for the waterworks onto the already overburdened backs of native rulers.

Another reason for the neglect can be traced to the conquistadores' Spanish birthright: Cortés and most of his men were from the bleached plains of Extremadura, where occasional stands of live oaks clustered together against the throbbing summer sun. To them, Tenochtitlan, a lacustrine city built to embrace the water, was entirely foreign. As Richard Boyer has argued, the Spaniards imported not only their customs but also their cultural landscape into the Valley of Mexico and attempted to re-create their dry homeland there.[12] By midcentury, the first of many projects to dry up the city had been proposed in the Spanish *cabildo*; the process would take centuries, but by the beginning of the twentieth, the lakes would be largely gone.

Their own deadly experience with the city's lakes and canals during the wars of conquest, described in chapter 4, helped set the stage for later Spanish hostility to the surrounding lakes. As a result, in the decades after the Conquest, the Spanish government's concerns about water were closely linked to its worries about indigenous insurrection. For instance, in 1537, to enhance the security of the city, Viceroy Mendoza proposed that the city be walled and that the Tacuba causeway be widened and a fort built at its entrance. Part of the goal of this ambitious proposal, were it carried out, was to transform the city's relationship with the surrounding water, and it reveals the startling blindness of Spanish officials to the necessary coexistence of city and lake. Indigenous residents were to be cleared from a band of land around the city (presumably the laguna, which was a source of agricultural water as well as an absorptive area for flood prevention), and this would be leveled and filled; all the canals that ran through the city (and carried the water out during the rainy season, thus preventing floods) would be filled, except for two or three, which would be lined with mortared stone (thereby reducing their absorptive capacity). In the wake of the Chichimec rebellion, which began in 1540, and the ensuing Mixtón war, Spanish fears of an indigenous uprising grew more acute. In April of 1541, the viceroy and the *cabildo* went into high gear to protect the city from indigenous insurrection, retrofitting two palaces in the city so that

women and children could take shelter in them. They also extended the street that passed by San Francisco so that it reached the western lakeshore, thus providing another exit from the city.[13] A year later, in May 1542, the *cabildo* was planning to build a fortress at Chapultepec, openly recognizing the tactical disadvantage it faced when having to fight on the island city rather than on the dry land of the lakeshore. By 1545, the *cabildo* was fielding a radical proposal to clear the city's entrance and exit to the city by filling in a huge swath of the laguna, everything that lay between the causeway running from Tlatelolco to Tacuba on the north, to the causeway of San Juan, which ran by the Tianguis of Mexico toward Chapultepec (figure 9.2).[14] The proposal makes two points clear. First, the Spanish failed to recognize that the surrounding swampy areas in the laguna and the lake, which could capture, hold, and absorb rain water and runoff, were the city's best protection from floods. Second, water levels were indeed low through the 1540s as the result of a great drought; otherwise, such a proposal would have hardly been feasible, nor would the apparent ease with which Spanish officials could build roads to run across the western laguna.[15]

Cultural attitudes made themselves felt in the vast campaign of building that the Spaniards sponsored in the city, and these too had unprecedented impact on the surrounding lakes. In order to support the foundations of their new stone churches and houses, Spanish builders used wooden pilings to compensate for the swampy subsoil, thereby creating ceaseless demand for wooden beams—it was not untypical for the *cabildo* to allow the harvesting of hundreds of wooden beams from the surrounding forests so the conquistadores could build their houses. Already by 1533, the *cabildo* was moving against the illicit cutting of wood, so deforestation had proceeded rapidly.[16] In addition, the conversion of grasslands to pasture for the cattle, sheep, and goats that the Spaniards brought into a land with no native ruminants led to erosion. The stripping of forests and grasslands dramatically decreased the absorptive capacity of these lands. Thus, when the rainy season came, rain waters poured into the lakes with increasing violence. The natural world was an increasingly fearsome place, and the residents of Mexico City knew it.

In the sections that follow, we will first look at two related problems: increasing the city's freshwater supply and the colonial rebuilding of the dike system. I will begin by sketching out the systemic problems that caused a terrible shortage of freshwater in the city and then turn to

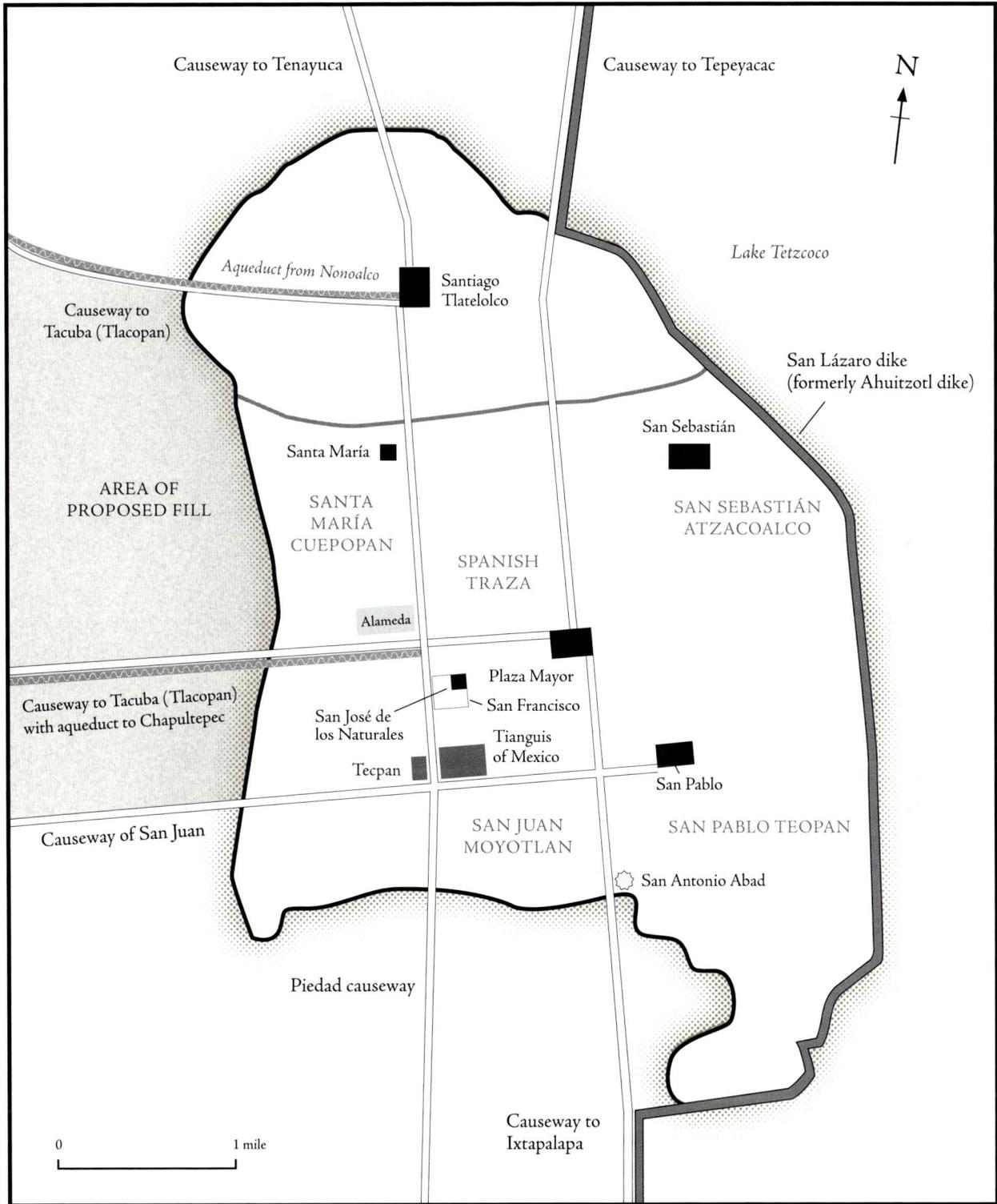

Causeway to Tenayuca

Causeway to Tepeyacac

N

Aqueduct from Nonoalco

Santiago
Tlatelolco

Lake Tetzcoco

Causeway to
Tacuba (Tlacopan)

San Lázaro dike
(formerly Ahuitzotl dike)

Santa María

San Sebastián

AREA OF
PROPOSED FILL

SANTA
MARÍA
CUEPOPAN

SAN SEBASTIÁN
ATZACOALCO

SPANISH
TRAZA

Alameda

Plaza Mayor

Causeway to Tacuba (Tlacopan)
with aqueduct to Chapultepec

San José de
los Naturales

San Francisco

Tianguis
of Mexico

Tecpan

San Pablo

Causeway of San Juan

SAN JUAN
MOYOTLAN

SAN PABLO TEOPAN

San Antonio Abad

Piedad causeway

0 1 mile

Causeway to
Ixtapalapa

FIGURE 9.2. *Map of Mexico City showing proposal to fill the laguna, ca. 1545, by Olga Vanegas.*

some of the solutions that were proposed and carried out, many of them with roots in indigenous experience.

THE SHORTAGE OF FRESHWATER

As we saw in chapter 3, pre-Hispanic Tenochtitlan had suffered acutely at times from a scarcity of freshwater, and freshwater was always a valued resource. The project of the Acuecuexco aqueduct under Ahuitzotl of 1499 tells us that the densely populated city of that epoch needed more water. Yet the city under Ahuitzotl's successor, Moteuczoma, seemed to function well enough just by using Chapultepec water and by drawing on the springs that existed within the city itself. So the lack of water resources was not entirely crippling to the pre-Hispanic city, even for the large populations of the first two decades of the sixteenth century, when Tenochtitlan is estimated to have had 150,000 residents. One reason was certainly the careful husbanding of potable water; the city was largely supplied by water sellers who delivered potable water by canoe, so households had a limited supply of freshwater. And the gradual desalinization of the laguna meant that canal water from it could be used to nurture crops.

It was only after the Conquest that the problem of freshwater scarcity escalated rapidly. This need is surprising given the presumed overall drop in the city's post-Conquest population as the result of both the war and epidemic diseases, a drop that should have diminished the demand for water after 1521. But all evidence shows that it did not. Why was this so? The unprecedented demands by new Spanish residents on the water supply are well chronicled in the *Actas de cabildo*: grants for orchards given along the Tacuba causeway siphoned off needed potable water for agricultural use even before it reached the city. And the mills being constructed to grind wheat in and around Tacuba, on the lake's western edge, put another strain on water resources. In addition, after freshwater coming over the Tacuba causeway reached the entrance to the city at the edge of Alameda park, it flowed into underground pipes. City residents and institutions were given grants of water from these pipes, allowing them a constant flow of freshwater, a stark contrast to the parsimonious use that canoe delivery encouraged. But another cause, less obvious to Spanish observers, was having long-term and devastating consequences.

The breaching of the Nezahualcoyotl dike during the wars of conquest and the subsequent neglect of the Ahuitzotl dike meant that water resumed its natural flow eastward, toward the salty Lake Tetzcoco. A drought in the two decades following the Conquest reduced the freshwater feeding the laguna, so the western side of the city, where sweet water was once trapped in the laguna by the system of dikes, began to dry out. Any backflow from Lake Tetzcoco coming in during the rainy season would have increased the salinity of these crucial wetlands. In addition, the loss of forest cover of the surrounding hills and mountains and resulting erosion in the slopes around the valley silted up the laguna.[17] So overall, what had once been a freshwater reservoir to the west of the city became a shallow, salty swamp. Evidence for the drying out of the western laguna in the mid-1530s comes from various sources. During the second *audiencia*, when Bishop Sebastián Ramírez de Fuenleal headed the government (January 1531 to April 1535), the desiccated lake area around the city emitted a foul odor, which was blamed for the outbreaks of epidemic disease; the proposal of 1545 to fill in the laguna and make it dry ground also indicates low water levels continuing through the 1540s. While indigenous agriculturalists, like those pictured in the Plano Parcial de la Ciudad de México (figure 4.4), had reason to be concerned about the dramatic loss of agricultural wetlands, Spanish leaders were most concerned with maintaining sufficient canal levels so that canoes could continue to move goods and provision the city, which was made difficult when even the canals that were cut into the lakebeds ran dry. Thus Spanish policies differed dramatically from earlier indigenous ones. They wanted to fill the system from the north with just enough water to help keep canoes afloat, a strategy that helped to feed the salty Lake Tetzcoco but did little for the wetlands of the laguna. Thus, so that canoe traffic could move, Ramírez de Fuenleal requested that the waters of the Cuauhtitlan river and waters from the Asumba (Otumba) spring be allowed to freely flow into Lake Xaltocan.[18] Two decades later, Viceroy Mendoza, in a similar vein, mandated that a canal be built so that the freshwater river of Cuauhtitlan would be diverted farther north to Lake Zumpango, thereby increasing the northern lake levels and buoying canoes into Lake Tetzcoco, but not attending to the sweet-salty balance.[19]

As discussed in chapters 2 and 3, Tenochtitlan had always been a marginal growing environment, given that a salty lake originally surrounded it. But the construction of the dikes transformed the waters in the Laguna of Mexico by trapping the freshwaters flowing into the system from

the west and gradually sluicing out the salt (see figure 2.7). The laguna was not sweet enough for drinking, but it was sufficient for irrigation, as evidenced by the number of *chinampas* in the city that availed themselves of water from the canals. Instead of following indigenous precedent, maintaining a sweet laguna and using its water that flowed into the city's canals as irrigation water, the city's Spanish residents instead used valuable drinking water from Chapultepec for irrigation and for other low purposes. For instance, city residents were known to wash animals and their clothes with water from the Chapultepec aqueduct.[20] In 1598, the Dominicans who staffed the Inquisition complained that their well water had given out, so they requested a supply of water from the pipes bringing freshwater in from Chapultepec so that they could clean out prison cells.[21] Moreover, city residents were often incautious about maintaining the cleanliness of the canals, and their treatment of the canals as open sewers rendered them further unfit for irrigation or the vast range of uses to which nonpotable water could be put. This situation is abundantly attested to in the *actas*, and a few examples will suffice to make the larger point. In one of its early dictates notable for its sangfroid, from 1527, the Spanish *cabildo* banned dumping dead animals in the canals, as well as dead *Indians*—a prohibition clearly meant to address an existing problem. In another telling instance, the *cabildo* granted a lot to a tanner along a canal running into the city. Tanneries around the world are notorious for both their foul odor and the noxious liquids they emit (a by-product of the decomposition of the hides and the substances—lye, urine, dung—used to preserve them); this canal flowed directly into the urban core, entering near the Tianguis of Mexico, carrying its fetid contents into the heart of the indigenous city.[22] Slaughterhouses were also a source of foul odor and contamination, and they were situated on canals, with the flow used to dispose of blood and feces.[23] Thus the water that once had some agricultural use was quickly polluted, and the city was ever more dependent upon the limited supply of freshwater coming in from the Chapultepec canal as well as any available well water.

By the 1560s, the crisis in the supply of freshwater had reached new proportions, and, rather than working to restore the laguna as a source of agricultural and nonpotable water, the city's Spanish government responded by seeking new freshwater sources to supply the city. From the Conquest until this point, all of Mexico City's freshwater had come from a large collector built at the base of the springs of Chapultepec. As we saw in chapter 3, a weir that lay between two low-lying structures regulated the pre-Hispanic reservoir; the water flowed out from this structure into an aqueduct that ran along the lakeshore and then along the causeway of Tacuba to enter the city (see figure 3.5). The discovery of a large Tlaloc statue near the pre-Hispanic collector tells of the practical and ritual nature of this building. While the aqueduct's pipes had been destroyed by Cortés during the Conquest, they were repaired shortly after as part of the early reconstruction projects of the city.[24] Also early in the colonial period, another collector was built within the perimeter of the pre-Hispanic one, with higher walls meant to increase the pressure of the water so that it could flow more forcefully into the aqueduct and thence into the city. The numerous rebuildings of this collector, each time within the perimeter of the previous, each time with a smaller area and presumably with higher walls, were meant to keep up the necessary water pressure to supply the city.[25]

When the waters from Chapultepec arrived to the island along the causeway of Tacuba, a collection point allowed water porters in canoes to pass by in the canal beneath and fill ceramic vessels to distribute the water to markets or to households; this was the same site as a later fountain called the Tlaxpana, which existed into the nineteenth century. The water continued onward along the Tacuba causeway toward the city, arriving at another collection point adjacent to the Alameda; at the end of the colonial period, the elegant fountain here was called la Mariscala. But along the way into the city, more and more parties clamored for its use. Beginning in the 1520s, the *cabildo* had made significant grants for orchards along this watery artery, and these orchard owners had pipes, sometimes legal ones created with the permission of the *cabildo* and sometimes not, to draw water into their valuable crops. The *obrero mayor* (overseer of public works) was frequently called in to repair the clay pipe that would be broken by those wishing to avail themselves of the water inside.[26] By 1532, the *cabildo* began prohibitions of drawing irrigation water for orchards from the Chapultepec pipe.[27]

Water problems surfaced more acutely in 1564, when, in April, the scarcity of water was so great that the *cabildo* joined with the judge Villalobos, a member of the Real Audiencia, to look at the possibility of bringing in water from the abundant springs of Santa Fe; funding the work was the *sisa de carne*, the temporary tax imposed for special projects like this one, on the sales of meat.[28] While

Santa Fe's water was highly regarded as being clean and healthful, it lay beyond Chapultepec to the west. This land was initially not under the city's control, instead being the domain of the powerful priest Vasco de Quiroga, who had founded in 1532 an indigenous community based on ideas of Thomas More's *Utopia* and who was initially unwilling to allow Mexico City's long reach into his protected domain.[29] Moreover, powerful landholders and mill owners (among them the Cortés family and the judge Lorenzo de Tejada, the same judge who owned the shops and arcades in the *tianguis*) held or had held lands in this area, and the *cabildo* was unwilling to disrupt their valuable water supplies.[30]

In light of the high political costs of such a waterwork, the *cabildo* decided to pursue a second project. By August of 1564, the *cabildo* was considering tapping the springs of Acuecuexco, near Churubusco (the colonial-period bastardization of the name Huitzilopochco) to the south of the city. This new project, called the Churubusco aqueduct, was in fact a very old one, because it entailed drawing on the springs that had once been tapped to provision the city under Ahuitzotl, in 1499. But as described in chapter 3, the springs were so abundant that their water began to flood the Mexica city, and Ahuitzotl ordered that the collector be dismantled. (This was not the first planned revival of the Mexica aqueduct; a similar project had been proposed and then abandoned in 1527.)[31] In the intervening years, the conduit into the city that had once run along the causeway of Ixtapalapa had fallen into disrepair.

In 1564, the city's builders calculated, as had the Mexica before them, that in order to reach the city anew, the water from the springs would need to fill a collector that would create enough pressure to force the water to go down the Ixtapalapa causeway and to enter the city from the south, following the route of the Acuecuexco aqueduct. The springs lay a little over five miles from the Plaza Mayor, requiring a shorter distance for the water to travel and making the Churubusco project more feasible than bringing water from distant Santa Fe. Clearly the amount of water in the springs was still abundant, as noted by some of the architects brought in to evaluate the plan, who also added that other nearby springs could supplement the water supply to the collector, should this one prove insufficient.[32] In addition, the project was supported by Gerónimo de Valderrama, who virtually led the government after the death of Viceroy Luis de Velasco in July 1565 had left New Spain without its traditional head. Valderrama lent the *cabildo* the necessary 1,000 *pesos* to pay for the oil and rope

it needed to import from Spain for the waterworks, which arrived in September of 1566.[33]

By April 1565, the project had progressed to the point of the construction of a large collection tank in Churubusco, made of thick masonry to withstand the pressure of the water contained in it. Momentum continued when the new (and briefly serving) viceroy, Gastón de Peralta, threw his support behind the project, agreeing to allocate the *sisa de carne* toward the costs of the new aqueduct and fountain in January of 1567.[34] But there was an underlying unease about the project, revealed by the number of times the *cabildo* dispatched its experts to measure and re-measure the grade and the force of the water. At least one *cabildo* member was concerned about the overall stability of the ground for such a project, as well as its ability to withstand the seismic tremors that were frequent in Mexico City.[35] So it is not entirely surprising that when Viceroy Martín Enríquez arrived in November 1568, he put the brakes on the project, asking for yet another study to be carried out shortly after his arrival. In May of 1570, he ordered that still another measurement of the water's force be taken.[36] Evidently, this round of measurement failed to convince him of the aqueduct's plausibility, because by the end of 1571, he had turned the government's attention toward Santa Fe as the most likely source for the city's water.[37]

The attempt to bring water from Santa Fe consumed the attention of the city's builders as well as its tax revenue through much of the early 1570s, a project admirably chronicled by Raquel Pineda Mendoza.[38] The plan was to set the aqueduct atop an enormous arcade that would carry the water from the springs of Santa Fe and nearby Cuajimilpa toward Chapultepec, where the water would flow into the already constructed eastern aqueduct that ran along the Tacuba causeway, thus saving the expense of a new system of arteries to feed the city. But the inexperience of the builders led to an unmitigated disaster. While the city spent 27,855 *pesos* and 5 grams of gold on tools and materials, much of it from the *sisa de vino*, diverting lime to the project (which halted other construction works), it was wasted money. In February of 1573, a commission sent out by the *cabildo* discovered that the slope that the arcade provided to the aqueduct had been badly calculated, so that water backed up and overflowed its course en route, and more than fifty arches were badly aligned.[39] A nasty lawsuit ensued, as the *cabildo* went after Miguel Martínez, one of the *maestros*, or experts, of the project, impounding his goods and throwing him in jail.[40] Thus the second great

aquatic lifeline was a failure. While Gerónimo López, then the *cabildo's obrero mayor*, attempted to reignite support (and funds) for the project at the end of 1573, he failed to do so.[41]

So when Valeriano and the other indigenous officials entered the *cabildo* room, their Spanish peers had just paid for two similar projects and witnessed the abandonment of one, the Acuecuexco/Churubusco aqueduct, and the collapse of the other, the Santa Fe aqueduct. In light of these failures, Valeriano's proposal was an audacious one—and perhaps even an insulting one to the *cabildo's* members, who had spent the last decade putting time and money into water projects that did nothing to mitigate the city's freshwater crisis. It was certainly unwelcome: this canal would draw on water from the already stressed supplies of Chapultepec and deliver it to a traditionally indigenous neighborhood; moreover, the *cabildo's* contribution was to be the valuable and limited commodity of lime. The cost of lime was an enormous part of any building project; the greatest percentage of the 28,000 or so *pesos* that went to the failed Santa Fe aqueduct was spent on lime. In 1565, the limited quantities of lime available meant that during the building of the Churubusco cistern, the then *obrero mayor*, Francisco Mérida de Molina, had to ask to divert lime from the construction of the Cathedral in order to use it on the waterworks.[42] Thus, supplying lime to this indigenous project would hamstring the *cabildo's* own chosen infrastructure work. But the viceroy seems to have thrown his weight behind it; in fact, the decision to issue a *real cédula* (royal command) to allow the *sisa* to be spent on getting water to the city in 1573 coincided with the appointment of Valeriano, and the Viceroy's intention may have been to back an indigenous project, so for the *cabildo* to vote it down would have been out of the question.[43]

INDIGENOUS KNOWLEDGE AND THE DIKE SYSTEM

If numerous Spanish engineers had failed, not once but twice, in the quest to bring more water into the city, why did Valeriano and the native *cabildo* think they could succeed? Was this a foolhardy quest, given the difficulties of moving water across the valley? One might assume that the rupture of the Conquest and the diminishment of indigenous power in the city would have led to the erosion of technological knowledge, but there is abundant evidence of the continuing role that indigenous experts played in

managing the valley's water system, although many of the great disruptions were beyond their ability to control.

A case in point is the 1555 project to rebuild the Ahuitzotl dike (a dike that subsequently took on the name "San Lázaro dike" because of the church and hospital for lepers rebuilt on the east side of the city in the 1570s) under Viceroy Luis de Velasco.[44] As we have seen, in the first decade or two after the Conquest, lake levels around the city were extremely low. One reason was that Cortés ruptured the Nezahualcoyotl dike in order to get his brigantines close to the city for his attack; another, a general drought. But silt, deforestation, and construction of new causeways within the laguna (which impeded the flow of water) were proceeding apace. The city's first great flood crisis hit in the wake of the 1555 rainy season, when the city experienced flooding so severe that the Spanish *cabildo* complained in October that the city was almost underwater. Viceroy Luis de Velasco was compelled to move quickly. Velasco called on his own advisors as well as the indigenous nobility when the surging waters posed a threat to the city, asking them for their opinions. In October or November of 1555, the lords of Mexico-Tenochtitlan, Tacuba, and Tetzcoco gathered together, as they had done as heads of the pre-Hispanic Triple Alliance in consecrations and feasting and as they continued to do in the colonial period and as they would do in the great celebration of the oath of allegiance of 1557, described in chapter 8. Santiago Tlatelolco, which had been under the control of Tenochtitlan before the Conquest, had a seat at the table as well. They advised that the building of a dike like the one that had existed before would protect the city. In recalling the meeting some months later, Juan Aquiaguacatl, a noble from the *parcialidad* of San Pablo, said, "The aforementioned lords [of Mexico-Tenochtitlan, Santiago Tlatelolco, Tacuba, and Tetzcoco] came together and spoke together about it and this witness was one of them and they resolved after having spoken, that the best and fastest solution would be to build the dike, which used to exist, for protection from the lake and they gave this reply to his Excellency the Viceroy."[45] At the end of the consultation process, the viceroy decided to follow the lords' advice and rebuild the old Ahuitzotl dike that had run along the eastern perimeter of the city, stretching from the causeway of Tepeyacac to that of Ixtapalapa, a dike whose maintenance had been neglected since the Conquest—note how Juan Aquiaguacatl says that "it *used to* exist, for protection" (italics mine). Its neglect was entirely understandable, as falling lake levels made it seem

of limited utility; moreover, its stones were of great value to construction projects in the city and invited pillaging, as stone for building was scarce on the island. As before, the dike was meant to protect the city from the inflow of salty waters from Lake Tetzcoco, but in its reincarnation it was to serve as a first line of defense for the city, rather than, as previously, a companion to the longer Nezahualcoyotl dike (which was never rebuilt) and a means of amplifying the freshwater zone around the city.[46]

This testimony comes from a witness in a lawsuit brought by the *audiencia* against the *cabildo* for its intransigence in refusing to pay for the dike building. In it, the indigenous witnesses discuss a proposal to restore only one of the dikes for flood protection, rather than the fuller double-dike system that pertained under the pre-Hispanic Mexica. But we know that such an understanding of the role of the twin dikes was alive in the late-1530s from the Map of Santa Cruz. This map was updated over time, as discussed in chapter 5. While the urban center represents the city in the late 1530s and early 1540s, the dike system shown captures an earlier point in time. It shows the functioning of the twin dikes (of Ahuitzotl and Nezahualcoyotl), which is contrary to evidence from colonial sources that suggest that the Nezahualcoyotl dike, after being breached in the Conquest, was not repaired.[47] In contrast, the Map of Santa Cruz shows the city with both the dikes fulfilling their intended roles, with the inner dike running along the perimeter of the city and the intact outer dike running parallel, creating a band of water in between. The difference between the waters is shown with pigment, where sweet water is an indigo blue and salty water a greenish pigment, seen in figure 2.9. Thus, when the map was made, its artist was aware of the purpose of the once-functioning dikes, that is, to keep out the salty (green) water from Lake Tetzcoco and create a band of sweet (blue) water between the dikes to the east of the city. While the Map of Santa Cruz almost certainly had left the city by the 1550s, the native leaders gathered in 1555 may have had a similar map as a reference. The indigenous witnesses repeatedly mention that Viceroy Velasco asked for *pinturas antiguas*, the conventional term for native manuscripts, to show the solution to flooding and that the native leaders had brought them along.[48]

By November of 1555, the viceroy had also called upon the rulers of the former Triple Alliance, including don Esteban de Guzmán, who was then *juez-gobernador* of Mexico-Tenochtitlan, to drum up the necessary labor from the towns under their aegis, an indication that indigenous labor was still very much controlled by native lords at that time. Velasco would deputize an indigenous man named Baltásar Acatliapanecatl to carry a staff of office called the *vara de justicia*, and go to the towns controlled by Mexico-Tenochtitlan and round up a labor force. We have seen in the Codex Osuna how central the granting of this long staff was to indigenous authority at midcentury (see figure 7.15); Velasco soon had a labor draft of six thousand indigenous workers under his command.[49]

The construction project to rebuild the San Lázaro dike was a massive and divisive one, pitting the *audiencia* and the viceroy (who at this point favored projects that had an indigenous pedigree) against the Spanish *cabildo* members (who wanted to drain the lake entirely). The *cabildo* churlishly rebuffed Velasco's request to help supply the labor, food, and tools necessary for the work—the traditional role that the sponsoring government had adopted in the pre-Hispanic period. Thus this enormous burden, as workers would be required to carry their own food or else pay local women to make their tortillas, was shifted either to the indigenous government or to the workers themselves. The Spanish *cabildo*'s response shows that they were less than eager to start paying for labor that once they had benefited from for free. Since the pre-Hispanic period, the *cabildo* members argued, the city's commoners had worked to create and maintain all the city's public works. To change the *cabildo*'s role now, they argued, would make indigenous laborers less likely to work gratis in the future. Moreover, they claimed that they lacked the resources, and accused the city's indigenous residents of being rich and idle most of the time.[50]

Such a charge came on the heels of don Esteban de Guzmán's investigation of the tribute paid to the native governor don Diego de San Francisco Tehuetzquititzin, discussed in chapter 7. When the ambitious and grasping Spanish officials on the *cabildo*—some of them without *encomiendas* of their own—witnessed the quantities of food and luxury goods being delivered to native lords of the city, they might have had reason to think the city's indigenous community had untold stores of wealth (see figures 7.6 to 7.11). What they did not realize, or perhaps did not choose to register, was that the goods like those we see in the Genaro García 30—those cups and vessels, the luxury fabrics being delivered—were the lifeblood of the symbolic economy that enabled social hierarchies that could muster six thousand workers with a single call. Nor

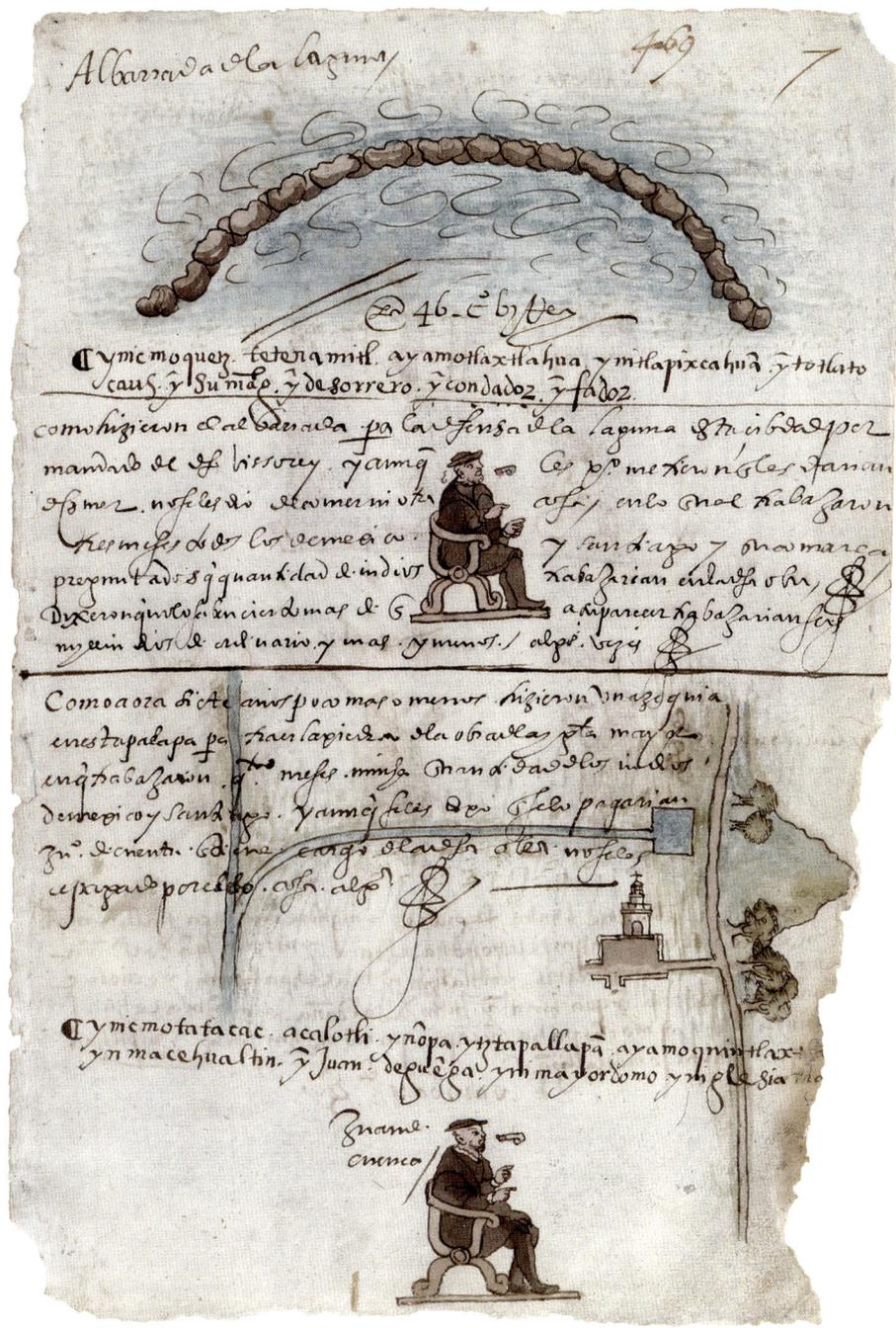

FIGURE 9.3. *Unknown creator, the rebuilding of the dike of San Lázaro (top), Codex Osuna, fol. 7r, ca. 1565. © Biblioteca Nacional de España.*

was it convenient to recognize, or perhaps even possible to see, for these men who comprised the Spanish *cabildo*, men with limited engineering skills if any at all, that the complicated system of waterworks developed across the fifteenth century would take an enormous allocation of labor and money to maintain as it had been designed.

The nonpayment for indigenous labor used to create the dike still rankled a decade later in Mexico-Tenochtitlan, as we see in the Codex Osuna. On folio 7r, the page is divided in half by a horizontal line (the bottom half relates to a different matter), and the top half is divided again (figure 9.3). In the upper quadrant is a brown arc, composed of oval shapes, some with an internal undulating double line. These are modified versions of the traditional symbol for stone (*tetl*) and are meant to show the curving stone dike. Although we think of this dike as abutting the land on one side, the image shows blue water on both sides of the dike, perhaps to capture the conditions at the time of its creation,

when the dike was pushed out into the flooded expanse of the eastern part of the city. Below the dike and the water, a Spanish official—almost certainly Viceroy Luis de Velasco, who spearheaded the project—is seated in a curule chair, his hand pointing in a gesture of command, and a red and blue speech scroll appears in front of his mouth. The texts, written in both Nahuatl and Spanish, amplify the meaning of the image, giving voice to the complaint of Mexico-Tenochtitlan's indigenous community. They read thus (my translations from Nahuatl are in italics and from Spanish are in roman):

> *Although the dike was built, they have not yet paid, his overseers [of] our lord the Viceroy, the treasurer, the accountant, the lawyer.* This is how they built the wall that protected this city from the laguna, that was ordered to be built by the viceroy, and although they were promised that they would be fed and other things paid for, for all they worked for three months, all those from Mexico and Santiago [Tlatelolco] and its surrounding area. When they [witnesses] were asked what number of Indians would have worked on the aforementioned project, they said that they weren't certain, but by their estimations six thousand Indians had normally worked, sometimes more, sometimes less.[51]

Such an undertaking was a massive one—for six thousand laborers to work effectively and create the dike within three months would have required an operating hierarchy and would have gone well beyond what indigenous commoners in the city were normally expected to contribute to infrastructure projects headed by the native governors. And it would have required a know-how of dike building, certainly not as complicated as the construction of a new waterworks, but technological knowledge nonetheless.

Almost a decade after the rebuilding of the San Lázaro dike in 1555, indigenous engineering knowledge of a higher level was brought to bear on the more complicated attempted revival of the Acuecuexco-Churubusco aqueduct, which would have entailed building a cistern high and strong enough to propel water forcefully into an aqueduct and installing that aqueduct at a sufficient slope to allow the water to keep its momentum as it moved northward to the city. The *Actas de cabildo* reveal indigenous roles in this revival of the project. Within the halls of the Spanish *cabildo*, one of the key arguments in favor of the Churubusco aqueduct was that it had once worked, as originally built by the pre-Hispanic Mexica. And in the initial forays to see if the quantity and force of the water was sufficient, indigenous experts were included in the measuring process. Viceroy Enríquez's opposition to the project followed the results of a measurement carried out in May of 1570, when three members of the *cabildo* went out, along with a notary and an interpreter, with three *indios oficiales que entiendan de pesar*, that is, skilled indigenous men with the greatest expertise in measuring the force of water and the grade of a waterworks; it was they who delivered an expert opinion on the feasibility of the aqueduct. And a decade later, when floods once again threatened the city in 1580, it was *indios antiguos* (very old Indians) who were called in to help figure out a solution to the problem.[52]

As in other forums, the projects of the city's indigenous peoples were entwined with those of the Franciscans, who were also deeply interested in questions of water and water engineering, for both practical and symbolic reasons.[53] The knowledge of the two parties was exchanged and enriched within places like San José de los Naturales and Santiago Tlatelolco. Fray Francisco de las Navas (d. 1578), who was guardian of the monastery of Santiago Tlatelolco and a fluent Nahuatl speaker, was called on by the Spanish *cabildo* to offer his expert opinion on the Acuecuexco-Churubusco waterworks in 1566, along with another Franciscan consultant, Fray Francisco de Tembleque. Both were described by the Spanish *cabildo* as "people of much professional experience and with similar waterworks serving to carry water in the manner of this one."[54] Tembleque was also the engineer of the great aqueduct of 156 arches that carried water from Zempoala some twenty-eight miles to the town of Otumba, north of Mexico City, perhaps the most important hydraulic work of sixteenth-century New Spain, finished ca. 1557.[55]

THE CHAPULTEPEC AQUEDUCT AND THE PLAGUE

Antonio de Valeriano's ambitious 1575 project to build an aqueduct from Chapultepec would do nothing to stem the overall environmental degradation of the valley, but it would be a lifeline to the traditionally indigenous neighborhoods of San Juan Moyotlan and San Pablo Teopan. We have little idea of what this second Chapultepec aqueduct cost the indigenous community in labor, tools, and support; our scant record of its costs comes from the *Actas de cabildo*'s grudging payments for the necessary lime. And

grudging they were; the Spanish *cabildo* needed to be prodded by viceregal directive again and again to allocate the necessary funds. All told, the 44,122 *pesos* it paid out for the second Chapultepec aqueduct was double the 27,855 it spent from the *sisa* funds on the disastrous Santa Fe project of 1571–1573, and 88 percent of this was specifically described as payments for the lime alone.[56]

Perhaps the best indication of Valeriano's resolve—and his ability as a leader—becomes evident when we set the construction project against its historical backdrop. In June of 1576, just a year after the aqueduct project began, came the first report of *cocoliztli*, a hemorrhagic fever, which had been the cause of the 1545 epidemic that was blamed on the foul odors from the lakebed. The city was convulsed by this second epidemic that would claim about 45 percent of the population during its two-year rampage.[57] The chronicler Mendieta, who lived in the city then, wrote, "In the year 1576, another general pestilence arrived, and an enormous number of people died all over, and it caused a flow of blood, like the other epidemics, and appeared like typhus."[58] His younger colleague, Juan de Torquemada, may have just arrived in New Spain at the time of this epidemic, and it left a vivid picture in his memory:

In the year 1576, under the Viceroy don Martín Enríquez, the native Indians survived an epidemic and pestilence that lasted more than a year. It was so great that it almost ruined and destroyed the whole country, leaving the Indies, which we call New Spain, nearly depopulated. It was a terrible thing to see the people who died, because the thing was that some were dead, and others about to die, and no one had the health or the strength to be able to cure one or bury another. In the cities and large towns, they opened great ditches, and from morning to night, the ministers did nothing else but carry corpses, dump them in, and cover them with dirt when the sun went down, with none of the solemnity with which the dead are usually buried, because there was not enough time and too many corpses.[59]

The disease almost uniquely infected the indigenous population, so the stresses we see that increased the impact of the disease—shortages of freshwater and food, overwork of the labor force—would have been even more acute after. Indeed, Chimalpahin reports that this epidemic was followed by yet another in 1579: "And this was when there was a sickness again (blood came from our noses). The sickness really raged; many people died."[60] Even within the Spanish *cabildo*, whose members were often dismissive of problems in the native *parcialidades*, there were calls as late as 1581 to suspend public works until the native population had fully recovered from the 1576 *cocoliztli* epidemic, which, of course, would have stopped work on the new Chapultepec aqueduct.[61] Mendieta, writing about the effects of plagues, was amazed at how enduring the Mexican *altepetl* was, in describing the response of indigenous peoples in Jalisco. Unlike other peoples in the world, they did not flee into the countryside when plague struck, instead staying together in their *altepetl*—only within the *altepetl* would they be assured a decent burial and not die like animals.[62]

The *cocoliztli* epidemic is reflected in the payments made by the Spanish *cabildo* for lime, our only meter at present of building activity; the project began in July of 1575 with 3,000 *pesos* of lime, and the next lime payment was not until January of 1579 (figure 9.4). In this year, the pace of the project picked up again, and in spite of disease and food shortages, the aqueduct project went forth. So did another great indigenous enterprise in the city, the painting of the Florentine Codex, where the native *tlacuiloque* shut themselves up in the school of Santa Cruz within the monastery of Santiago Tlatelolco as the plaza outside was trenched to contain the corpses left in the plague's wake.[63]

The promise of that early summer day in June of 1575 when Valeriano and other elites gathered to deliver their request to the Spanish *cabildo* took years to bear fruit, but nonetheless can be seen in the lithograph of the Trasmonte

FIGURE 9.4. *Payments made by the Spanish* cabildo *of Mexico for lime for the Chapultepec aqueduct, 1575–1582.*

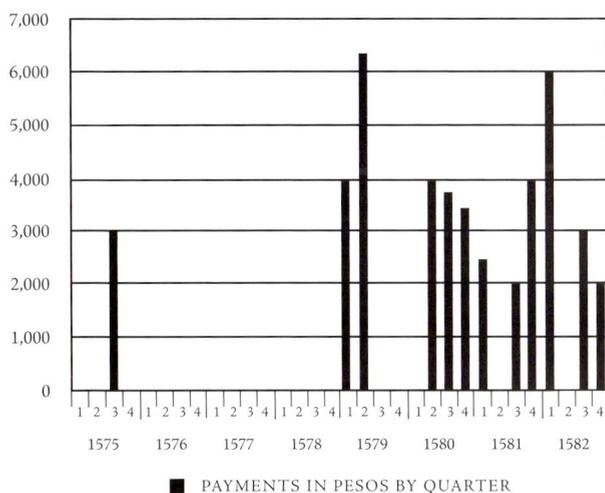

PAYMENTS IN PESOS BY QUARTER

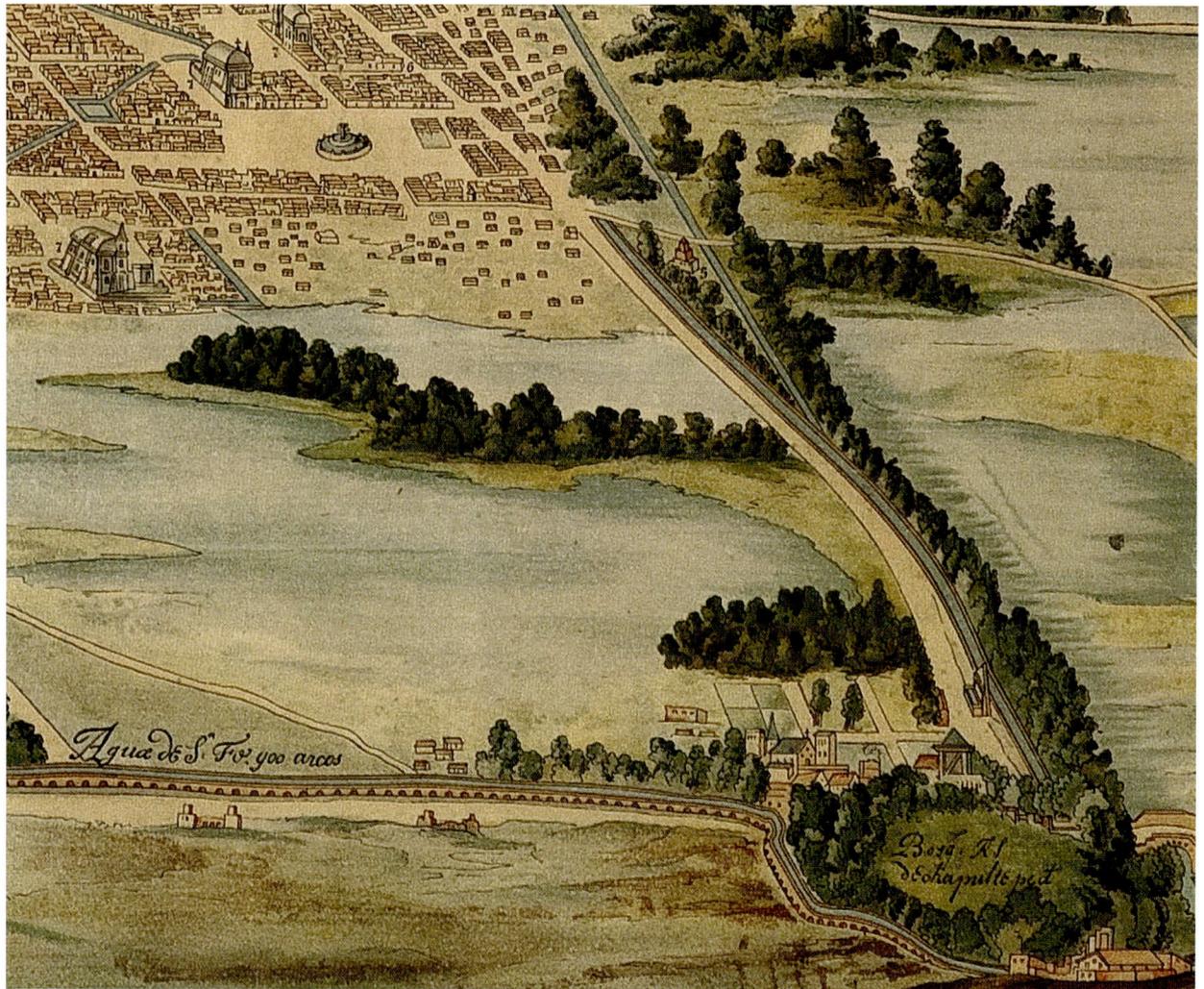

FIGURE 9.5. *Juan Gómez de Trasmonte, the Chapultepec aqueduct, at right, with the Tianguis of Mexico in the upper left, detail, "Forma y Levantado de la Ciudad de México" (view of Mexico City), 1907 (based on 1628 map). Lithograph; published by Francisco del Paso y Troncoso, Florence.*

map (see figure 7.1). This map is dominated at the bottom by the long arcade, completed in 1620, that finally brought water from the faraway springs in Santa Fe, delivering it to the fountain on the edge of the Alameda and from there into the extant network of underground pipes that had been granted to only a few of the city's favored citizens.[64] A text on the map emphasizes the achievement: "Agua de Santa Fe. 900 arcos." But at the right of the map, one can make out a second aqueduct, an open-air canal, running along the causeway that linked Chapultepec to San Juan Moyotlan, edged by a thin line, perhaps to show the raised masonry (figure 9.5). At the edge of the city, it disappears, pulled underground by another network of pipes. The first reappearance of the water is quite close to the place of its underground canalization; in the great nearby plaza of the Tianguis of Mexico, a round fountain dominates the space; it may have replaced an earlier construction, which was a simpler fountain, seen marked by the circle at the

center of figure 4.9. The *tecpan* is not singled out on the Trasmonte map—it was more concerned with the city's buildings and waterworks than the activities of its residents—but it would have faced off against the fountain, whose waters began to flow in December of 1582.[65] The inaugural event was memorable to the chronicler Chimalpahin, who wrote of the waters breaking through: "12 Rabbit year 1582. In this year, on the 22nd of the month of July, on the feast day of Santa María Magdalena, was when the aqueduct reached San Juan. And on the 31st of the month of December water ran in the fountain in the marketplace; at that time the fountain that is in the marketplace was

inaugurated. [The work on the aqueduct and fountain] took six years to finish."[66]

This fountain and its flowing waters would have been visible to Antonio de Valeriano as he stood on the second-floor balcony of the *tecpan* and looked toward the east, much the same way that the sacred pools, evoking the primordial sites of foundation and fed from the Chapultepec springs, were visible as his great-grandfather Axayacatl looked eastward from his palace on the city's great sacred precinct. In Axayacatl's epoch, the adjacency of water source and sacred mountain (as the Templo Mayor was conceived to be) was held to be a symbol of the sacred *altepetl*, that "water hill" that signified an autonomous community throughout central Mexico. Looking northward from the *tecpan* porch, Valeriano could see the markers of the city's Franciscan axis that ran from south to north, from the great cross carved of a sacred *ahuehuetl* tree in the patio of San Francisco all the way to the bell towers of the Franciscan monastery of Santiago Tlatelolco. Here, Tlatelolco's *gobernador* and *cabildo* leaders had been busy constructing their own *cistern* (called a *caja de agua*) adjacent to their market, Franciscan monastery, and *tecpan*. Excavations of that site by Salvador Guilliem Arroyo have revealed this Tlatelolco cistern to have been a magical place, filled as it was with mural paintings. Visible by those who approached it to fill their ceramic jugs, the paintings limned a watery paradise, replete with abundant fish and aquatic life below the line painted to show the surface of the water. Above the painted waterline, fishermen and boaters availed themselves of nature's bounty.[67] As would befit a water source adjacent to the Franciscan church, the cross of Christian salvation was painted at one end, entwining Christological symbols with images of a watery utopia. We do not know whether the original fountain of Mexico-Tenochtitlan boasted of such glorious paintings, but we can imagine that the swirling pool of freshwater alone was rich with meaning for those drawn to it, evocative both of the city as Christian paradise and of a water-rich *altepetl*.

VALERIANO AND THE TIANGUIS OF MEXICO

During Valeriano's term of office, the Spanish *cabildo* sought to expand its jurisdiction over the city's spaces by approving grants and land transfers within it, as it had with earlier rulers. But Valeriano's role in resisting their incursion into one of the key indigenous spaces of the city, the Tianguis of Mexico, is worth attending to, because arguments presented as part of a lawsuit show him articulating indigenous communal rights to urban land and offer a corrective to Charles Gibson's contention that markets slipped from indigenous control by around the 1540s.[68]

Documents of the 1560s show that the indigenous governors were overseeing land transfers within the space of the *tianguis* into that decade and beyond, signaling that it was a space that they controlled. But not without contest from the city's Spanish *cabildo*, who, as seen in chapter 4, were eager to assert their jurisdiction over the city's land. In February of 1560, the Spanish *cabildo* was asked by a city resident, Juanes de Lugo, for a grant of land in the *tianguis*, but the members refused because they were planning to occupy this space with shop buildings, which, like other such properties they held in the city, could be used for rental income.[69] Lugo's wife, who was indigenous, then appealed to the native *cabildo*, which at that time was headed by the *gobernador* Cecetzin, for a *tianguis* grant, which she was given. The Spanish *cabildo* then angrily complained to the viceroy that the native governor, in making such grants, was usurping the viceroy's authority (for the native *cabildo*'s authority stemmed from his, and this grant did not have his express approval), as well as its own, for it had claimed jurisdiction over the *tianguis* as part of the city lands under its control.

The Spanish *cabildo* revealed, in this lawsuit, its continuing desire for control of both the island's space and all its peoples. It took the opportunity the suit represented to request high-handedly that the viceroy do away with both autonomous indigenous governments of Mexico-Tenochtitlan and Santiago Tlatelolco. In their stead, it suggested that the viceroy name two indigenous officials from each *altepetl* to serve as *regidores* on the Spanish *cabildo*. Given that the *cabildo* typically had twelve *regidores* to begin with, this request would have had the effect of robbing the indigenous residents of the city of an autonomous government and stripping indigenous leaders of almost all of their royally recognized power. The request was not granted. Later that year, the Spanish *cabildo* again asserted its right over the *tianguis* land by giving permission to a glassmaker to build a portal in front of his house, which sat on the *tianguis*, proclaiming the portal a public space, that is, one under its domain.[70]

If the land of the *tianguis* was contested, so was the regulation of commerce within it. The following year, in 1561, the viceroy issued an order giving the Spanish *alguacil*

de tianguis broad powers to enforce the regulated prices as well as to punish miscreants in the Tianguis of Mexico as well as in the other indigenous markets.[71] But the fact that this order came from the viceroy, rather than the cabildo, is revealing. Had the commerce of the Tianguis of Mexico been, like that of the Plaza Mayor, clearly under the cabildo's jurisdiction, then the cabildo could have dispatched the alguacil itself (he was, after all, an employee). The viceroy's intervention suggests either that the cabildo had been doing such a poor job of running the place that he had to step in, or that the Spanish cabildo's jurisdiction over commerce in the Tianguis of Mexico was uncertain to begin with.[72]

More than two decades later, in 1588, the indigenous cabildo continued to claim jurisdiction over the lands of the Tianguis of Mexico, by refusing a Spaniard the right to build on a small parcel he claimed to own, the lot measuring fifteen by seven varas, or about forty feet by twenty feet; as part of this lawsuit, one of the maps of the tianguis discussed in chapter 4 was created (see figure 4.9). The indigenous cabildo based its claim both on ownership of long standing, as well as on the brick-and-mortar evidence that the tianguis presented. A witness stated that "it is well known that the community and its government [of Mexico-Tenochtitlan] have no other communal goods left, of all that our ancestors once held and possessed in this city, other than the tianguis."[73] The cabildo made the point more clearly some years later, in 1601, when another Spaniard attempted to build within the Tianguis of Mexico, and they, and the witnesses they summoned, testified that all the land within the tianguis belonged to the native community.[74] One witness, Tómas Gabriel de los Angeles, a resident of San Juan who was sixty-three years old, testified that "all the ground that is built in the Tianguis [of Mexico] is and always has been the property of the community of Mexico and it has always been seen as and possessed by [the community], as long as this witness has known, peacefully and without contest of any other person. And when this witness was about ten years old [that is, around 1550], during the time when an Indian named don Diego de San Francisco [Tehuetzquititzin] was governor [of Mexico-Tenochtitlan], this witness saw him divide the land [of the tianguis] among the Indian craftsmen so that they would hold the aforementioned land." Another witness added that to pay for the use of these spaces, these craftsmen would send tortillas.[75] It is clear from the indigenous testimony in this case that the tianguis lands were leased by the native cabildo, but never fully alienated.

In contrast, the man contesting the native cabildo's right to control tianguis lands, a Spaniard named Diego Arias, argued that any right the cabildo may have had had ceased long before and that the land had been owned, and sold, outright. In other words, the tianguis was private, not communal, property. Such clashes, between an indigenous understanding of communally held land and a Spanish understanding of land as private property, were constant in the valley. While some Spaniards who occupied property around the Tianguis of Mexico joined the native cabildo in their suit, the rationale presented by the latter was distinct. Valeriano's government argued that indigenous (and communal) possession was established by the creation of the space: "For the good of the community, we had laid out in a square [quadrar] the tianguis. . . . Now both Spaniards and naturales buy and sell all kinds of products in it and the Tianguis is well-laid out, well-proportioned and square [bien trazada e proporcionada e quadrada], its only flaw being there is not enough space for such a large congregation of people, with hardly any room for all the naturales and Spaniards."[76]

In arguing that the tianguis was communal property that they controlled, the members of the cabildo of Mexico-Tenochtitlan, led by Valeriano, carried forward a pre-Hispanic category of communal land, but appropriated the idea of the "traza," the same idea that their counterparts on the Spanish cabildo used to exert their hold on urban space. In other words, to claim that the market was "trazado" was not just to say it had been planned, its stalls laid out in order; it was to use exactly the same language, and method, that the occupants of the Spanish city used to stake their claim on the island from the time of Alonso García Bravo, the conquistador who laid out the Spanish traza at the center of the city in the mid-1520s.

Representations of the space of the tianguis employ a similar visual rhetoric of order. If we turn back to the map of the Tianguis of Mexico, filled as it is with Nahuatl glosses, we cannot be unimpressed with the regularity and lucidity of its layout, based on blocks of four and five, with slight extensions in some, so that within its framework, it could accommodate all sizes of vendors (see figures 4.11 and 4.12). There is some evidence to suggest that the original of this map (known only in the copy reproduced here) was created during Valeriano's reign. While an early inventory calls it a work of 1531, this date is clearly in error: the Tianguis of Mexico was not reestablished at this site until 1533, and three architectural features appear on it whose

dates are known to be after 1531 (the *tecpan* of ca. 1542, the Portales de Tejada of ca. 1549, and the fountain of ca. 1585), allowing us to assign a *terminus post quem* to the original of the mid-1580s.[77] The extensive use of Nahuatl (rather than Spanish) and limited use of loan words suggest that we are still dealing with a sixteenth-century document.

A likely moment for the creation of the original map is mid-October of 1589, when Viceroy Álvaro Manrique de Zúñiga, marqués de Villamanrique (r. 1585–1590), responded to indigenous complaints about the disorder in the Tianguis of Mexico and sent the *alcalde ordinario* of the city's Spanish *cabildo*, Gonzalo Gómez de Cervantes, to the *tianguis* to resolve the problem by reorganizing space in the market, and "put in order all Indian women and all the others within the traza of the market so that they are grouped together, and not interspersed with those selling other types of merchandise."[78] Eighteen days later, the viceroy again dispatched Gómez de Cervantes to resolve a complaint brought by the indigenous marketwomen who sold blankets.[79] In designating certain blocks to certain products and grouping like products together, this map seems to arise from some moment of market organization. Its use of Nahuatl texts and hieroglyphs is significant, for it means that, if created to address the 1589 complaint, Gómez de Cervantes was unlikely to have created the map of the market himself to organize and assign plots to vendors, for it is in Nahuatl, not Spanish. Instead, he likely turned to a native scribe to draw up the proposed plan and may also have left the map in the hands of the native leaders—the ones who would have understood Nahuatl and its glyphic representations—for them to carry the organization out.

As represented in this map, the *tianguis* is an ordered place with sellers grouped by wares, their plots shown as "trazado"—that is, laid out in organized fashion. In its quadripartite, bounded space, it also evokes cosmic models that left their imprint on folio 2r of the Codex Mendoza (see figure 1.3). On this map as well, the façade of the *tecpan* is poorly drawn, but its imposing presence is still registered in the upper left. We see the row of large disks that marked important buildings in the city running along its cornice. Also visible is the arched portal to the *tecpan*'s internal plaza that lay directly opposite the southwest entrance of the *tianguis*. Anyone entering from the south or west, including most likely all the traffic from the canoes from the southern docks and the carts coming along the causeway of San Juan, would need to pass alongside it before entering the *tianguis*. Given the traffic to the market, the

adjacent *tecpan* was where most city residents and those coming in from outside regions would encounter civic architecture. Its exterior wall was decorated with a banner showing the indigenous *gobernadores*, another way of reminding the urban public of the presence of native rulers. The *tecpan*, of course, likely first constructed in the 1540s, had been updated and rebuilt over time, but the visual language it employed of the retaining wall, marked with disks of "preciousness" at the top, was known throughout central Mexico as a marker of the palaces of indigenous rulers. The addition of the arched doorway shows the mastery of a relatively new technology, the keystone. Not only was the market in the same location as it had been in the Mexica city but also the sensual experiences it offered—the sights of the piles of chilies, the bright whiplash of cochineal-dyed embroidery, the odors of fish and ground tobacco—gave individuals an enduring connection to the memories of the city's past and a link to its spatial history. These deep and complex meanings that lived space carried help us better understand why the native *cabildo* was able to risk bitter lawsuits in order to insist on its dominance in the space of the *tianguis*.

CONCLUSION

In bringing a canal of water into the Tianguis of Mexico, Valeriano would not only provision the city's residents, but also restore the image of the *altepetl* once found in the Templo Mayor, where a straight canal bearing freshwater from Chapultepec ran all the way into the temple precinct and filled the pools there, making the ceremonial center a microcosm of the larger *altepetl*.[80] He did so against enormous odds, as the plague of *cocoliztli* devastated the population of Mexico-Tenochtitlan, with its effects, like food shortages and other aftershock plagues, continuing for the life of the aqueduct project. Valeriano's relationships with the Franciscans, reaching back to long before he entered the *tecpan*, ensured him the backing of powerful supporters in the city; his relationships with Viceroy Enríquez and subsequent viceroys were also mutually accommodating. For instance, despite Viceroy Enríquez's reforms to indigenous offices, whereby officeholders were to receive a salary and little other compensation, Valeriano was granted by him and successive viceroys the labor of four peons to work his fields.[81] But if we take the view from the *tecpan* and the *tianguis*, one reason for Valeriano's long rule might have been his careful manipulation of powerful symbols, like

that of the *altepetl* and the ordered *tianguis*, at the same time that he ensured a practical benefit from community projects, like a new source of freshwater and the protection of communal resources. He seems also to have avoided the divisiveness sparked by the feasts and *mitotes* sponsored by his predecessors. He was so highly regarded that even after he was deaf and infirm from age, he kept hold of his office for a twenty-six-year term (1573–1599), which ran from 3 House to 3 Reed, occupying an auspicious half century in the native calendar.[82]

Valeriano left few gorgeous monuments for posterity—there are no known featherworks that named him as patron, nor buildings, like the *tecpan*, that were an enduring presence in the urbanscape, for it was torn down in the nineteenth century. One of his great achievements, the canal from Chapultepec, has been overshadowed by its transformation in the eighteenth century into an impressive arcade running into the city, parts of which survive today. Nearby, the vast space of the *tianguis* and the *tecpan* courtyard exist no longer. The area is still a market hub, with the new Mercado de San Juan filling much of the space of the patio of the old *tecpan*; the Tianguis of Mexico, badly compromised by the floods of the seventeenth century, was eventually turned over to the city's powerful Basque community, who in 1772 built a great school there, Las Vizcaínas, whose long façade (made possible by the vacant space held open in the city's increasingly dense fabric by the *tianguis*) is still one of the city's architectural gems.[83]

Instead, today one is more likely to encounter Valeriano in one of the dozens of pedestrian documents that exist in Mexico City's Archivo General de la Nación, his signature affixed to proceedings of land transfers between indigenous parties and Spanish residents, one of the many bureaucratic functions that the indigenous *cabildo*, seated in the *tecpan*, had as its responsibility. One sale of 1592 was given particular attention by the *cabildo* because it involved an indigenous widow, Mariana, who was offered 100 *pesos* for her land and its houses in the *tlaxilacalli* of San Hipólito Teocaltitlan by a Spanish resident of the city, Luis de Cevallos.[84] In conformity with the law, such transfers of land out of indigenous hands needed approval of the indigenous *cabildo*. The area was near the parish of Veracruz, which was adjacent to the Alameda, to the north of the causeway

of Tacuba, an area of expanding Spanish settlement. Because of the value of the property and the potential transfer of land from indigenous into Spanish hands, Valeriano mandated that both an auction and a *pregón* be carried out, a *pregón* being a daily public announcement by a crier over a specified length of time, usually over thirty days. The crier, a man named Diego Aztaxochitl, would appear in public spaces throughout the city and announce the news of the sale, the details of the property, and the offered price; a *pregón* such as this one gave indigenous buyers a chance at the property, as well as Spanish ones who were willing to pay a higher price. The crier's trajectory wended its way through the indigenous city, a one-man civil procession that crisscrossed the key public areas of San Juan Moyotlan and Santa María Cuepopan, the two *parcialidades* adjacent to the sale property, his itinerary marking the lived spaces. Each day (save Sundays and holidays) was punctuated with a *pregón* in Nahuatl (and perhaps in Spanish as well) about the impending sale and the current price; after a month, when the public crier's announcement had time to travel mouth to mouth throughout the city, competing bids started to come in, each one to be matched by Cevallos. At Yaoltica, in San Juan Moyotlan, the price was pushed to 120 *pesos*; by the time the crier made his way to the *tianguis*, some thirteen days later, the price was 160; at the end of the thirty *pregones*, which were carried out over almost two months, the price the widow Mariana received was double the initial offer. Valeriano signed off on the deal.

It is not hard to see, in the figure of the crier Diego Aztaxochitl, the extended presence of the *gobernador* in the streets of the city (whose Nahua subjects still called him a *tlatoani*, at whose root is *tlatoa*, meaning "to speak"), making public and transparent the workings of the city government, as it oversaw the legitimacy of such a sale, as well as garnering the best price for its indigenous seller and giving indigenous buyers a chance at it, too. That presence extended beyond the *tecpan*, where many of the maps and documents that recorded such land transfers would be kept. It moved outward in the crier's near-daily trajectories through the city streets. His itinerary marked the lived spaces of the city at the same time that the Nahuatl words carried along by his voice made the *gobernador* present to all who were listening.

CHAPTER 10

Remembering Tenochtitlan

ZUAZO: Now here is the plaza. Look carefully, please, and note if you have ever seen another equal to it in size and grandeur.

ALFARO: Indeed, none that I remember; and I don't think that its equal can be found in either hemisphere. Good heavens! How level it is and how spacious! How gay! How greatly embellished by the superb and magnificent buildings that surround it on all sides! What order! What beauty! What a situation and location! Truly, if those colonnades that we are now facing were removed, it could hold an entire army.

ZUAZO: The reason for the great size of the plaza is to prevent goods from being offered for sale in other places. For whereas in Rome there was a market-place for swine, one for vegetables, another for cattle, the Livian market, the Julian market, the Aurelian market and the one for delicacies, this one market-place is for all the people of the City of Mexico. In this one market-place weekly market days were established; here the auctions are held; here is found whatever there is for sale; and to this place the merchants of the whole province bring and import their wares. To this market-place also, to sum it up, flow in whatever things are most desirable in Spain.[1]

In this imaginary dialogue created in 1554 by Francisco Cervantes de Salazar between two characters who walk through the streets of Mexico City, they arrive at the great main plaza of the city and are unabashed in their admiration of its size; Alfaro, a new arrival, is unable to find anything like it in the cities cached in his memory. His companion, Zuazo, offers the markets of ancient Rome as a comparison, but they are divided by type, whereas here, all the goods from home and abroad are put on display in one place. The dialogue, a Latin primer for students at the newly founded university that lay not far off the Plaza Mayor, is one of the few written descriptions of the city from this midcentury period, and it neatly captures the pride of the emergent Creole class in their city, whose markets rival and transcend a pagan Roman model and bring together "the most desirable" goods of the transatlantic trade. As an early literary work about the city, it has been an influential representation of the urban space of the New World capital, the characters' trajectory through the city establishing an order that begins in the Spanish Plaza Mayor and moves outward, its narrative structure following their itinerary, establishing the city's center and relative peripheries.

This dialogue also captures some of the difficulty that city residents had in establishing a horizon against which to situate Mexico City, a place that European writers, looking to the New World from across the Atlantic, set somewhere within the vague outlines of that region that maps called "America." The market of Zuazo's "Mexico," for instance, hovers between the Roman markets of the classical past and the markets of the future, with vast quantities of goods coming from near and far to be displayed upon its paved expanse. For Habsburg rulers concerned with centralizing their power and funding European ambitions, Mexico City's main plaza *was* the future, with transatlantic and transpacific goods representing the growing reach of their overseas empire. Within this plaza, they would offer an architectural reminder of their own presence by buying

the palace constructed by Cortés along the eastern edge of the main plaza in the 1560s to serve as the seat of the viceroy, that royal doppelganger. It would be reworked over three centuries to "forcefully [assert] the presence and persistence of kingly authority in New Spain"[2] (figure 4.3). By the end of the sixteenth century, the Spanish Habsburgs would seize on the model it offered of a spacious central plaza defined by orderly architecture as a metaphor for the order and centrality of royal power beyond Mexico City. They took this prototype, one developed on the periphery, and carried it back to the center. Beginning in the 1580s, a spacious main plaza, also called the Plaza Mayor, began to be constructed in Madrid, echoing that of the American capital, whose "order and regularity . . . symbolized the good government the Spanish Habsburgs wished to impart to all of Spain."[3]

Mexico City, and its process of becoming a place where royal authority was inscribed on plaza and building alike, paralleled that of the earlier and coterminous Mexica city of Tenochtitlan, which had been reclaimed from the shallow swamps around an island in Lake Tetzcoco as its people fashioned an ideal *altepetl* modeled on Aztlan, their place of origin. They understood the surrounding environment to be filled with divine presences that made themselves manifest in the fall of rain and the sweep of the tides; controlling the excesses of that environment was a constant battle, one likened to warfare both in representations of the city and in practice. If colonial Mexico City was a conquered city, so was its predecessor, Tenochtitlan, but the battle waged and fitfully won was against the surrounding lakes. Seizing the lead in the battles, both against enemy states and against the ever-encroaching lake, was the *altepetl* leader, or *huei tlatoani*. Just as his later Habsburg counterparts would increasingly mark Mexico City with their presence, both in the figure of the viceroy and in the architecture of its center, the Mexica *tlatoani* used representations to anneal his person to that of the *altepetl* as a whole. Thus the manipulations of the surrounding environment that were necessary to create and then maintain the *altepetl*—the watery hill and ideal human community—were credited to this leader.

Most histories of the city have assumed that the Mexica historical trajectory ended with the Conquest, as if the deaths of the *huei tlatoque* Moteuczoma and then Cuauhtemoc were equivalent to the death of Tenochtitlan. But it did not, as can be seen otherwise on a number of fronts. When powerful indigenous men were reseated as

rulers of Mexico-Tenochtitlan, it was they who rebuilt the city, reestablishing freshwater supplies and marketplaces and a new government center. Indigenous knowledge and technologies also continued to inform water management in the sixteenth-century city. The indigenous ideology of the *altepetl* was no less a force than the imported European ideology of *civitas* in the sixteenth-century city, and the former, like the surrounding lakes and groundwater springs, was constantly welling up and flooding through the sixteenth-century city.

Spanish conquerors would destroy the *altepetl* temples but perhaps the most dramatic injury to the *altepetl* was not the Conquest itself, but the gradual denial of the first of the two essential Nahua ideas in the word *altepetl*: *atl*, "water." Spaniards and Creoles, their idea of an ideal city forged in bone-dry Extremadura, had little tolerance for the watery world that was modeled on Aztlan, and their vision of Mexico City as a flood-free city, which meant a water-free valley, led to the agonizing *desagüe* (literally, the "de-watering" of the city) over the next four centuries. By the early nineteenth century, Alexander von Humboldt would point out that the pre-Hispanic verdure of the valley environment had given way to arid plains resembling those of Tibet and the great salt plains of Central Asia.[4] For better and worse, the space of Mexico City was shaped by a constant interplay between the ideal—manifested in verbal and visual representations—and realized actions.

This was true within the indigenous spheres of the city, as the discussion of the representations of the urban spaces in the previous chapters has shown. Because if Spanish residents struggled to find a horizon against which to situate Mexico City, so too did its indigenous rulers in the colonial period, and this horizon was both a global one and a local one. Some of this struggle was captured in the featherwork produced under don Diego Huanitzin, the only known work of art we can attribute to his patronage, which aimed, in part, to find a place for Mexico City within the new framework of a global Christian empire. Later, his successor, don Esteban de Guzmán, would situate indigenous rule in the city, as represented through the *tecpan*, in relation to the power hierarchy established by the viceroy. Surely the other sixteenth-century native *gobernadores* did more along these lines—like creating the banner representing the line of native governors that hung from the *tecpan*, preserved only via its description in native accounts—but the vagaries of history and the systematic disenfranchisement of indigenous peoples by the colonial

state have meant that very little of *their* city has survived. This book has tried to focus attention on that which has.

To do so has meant not only closely scrutinizing the objects we use to understand the past, but also shifting the frameworks employed and questioning the metaphors that have shaped the city's history. Taking into account the presence of the city's indigenous residents who vastly outnumbered their Spanish neighbors has meant moving away from thinking of the city only as the product of its elite political class or as existing only in architecture. Instead, paying attention to the urban practices, be they the actions of building dikes and walking (now ephemeral) processional routes, and granting them a role in the creation of the lived spaces of the city has been a way to bring attention to indigenous presences in the city. Nonetheless, representations have always been in the foreground of our picture of fifteenth- and sixteenth-century Tenochtitlan and Mexico City, given how their agendas—battling ones after the Conquest—shaped both the lived spaces of the city and its subsequent historical representations.

If the Mexica city of Tenochtitlan offered to its indigenous residents comforting reminders of their seamless integration into the larger cosmic order in both its layout and its animating rituals, its Spanish conquerors saw the indigenous city around them as a bloodstained place, where the "idolatrous" ritual they witnessed or heard gossiped about in their terrified encampments was like a poison, seeping up through the city's soils and through the cracks in the walls. Once the Conquest was over and the city reoccupied, the markers of this perceived idolatrous past were to be dismantled, the temples destroyed and the "idols" cast from the altars. The conquistadores hoped that the past of the city could be forgotten, and later the Franciscans hoped, even believed, the same. They targeted its symbolic architecture, razing the *altepetl* pyramids along with the great Templo Mayor, its useful stone piled nearby to be recut for the *parcialidad* churches and the Cathedral. As the city's leading evangelizers, the Franciscans were even more concerned with individual memories, and thus they sought also to reach into the minds of the city's indigenous residents and make them forget Tenochtitlan as the condition for creating a new Christian republic on its spaces.

This historical amnesia was doubled in the histories of the city written after the Conquest, with the emphasis on Spanish exploits and the reliance on Spanish narratives. This pattern would continue through the sixteenth century. Cervantes de Salazar was hired as the Spanish *cabildo's*

historian, and in his dialogue above, for instance, nothing in the verbal narration of the city suggests that it had a deep Mexica history before the Spanish Conquest. In fact, the market Zuazo describes in the opening quote with such eloquence was, in fact, a very minor market for most of the city's residents, holding mostly expensive and imported goods in the sixteenth century. Instead, the city's lifeblood flowed through the great indigenous markets, particularly the Tianguis of Mexico, that were to be found on the city's western side, appearing only later in this same dialogue. To be aware of indigenous presence is thus to confront the powerful metaphor of indigenous erasure, an erasure that was established in the first historical accounts of the city (Cortés's letters) and carried forth by the city's Franciscan evangelizers and in its official Spanish histories.

In creating a new narrative about Mexico City that shows its historic connections to pre-Hispanic Tenochtitlan and the importance of indigenous Mexico-Tenochtitlan to its sixteenth-century identity, I have been compelled by the challenge posed by Michel de Certeau, who asks those of us thinking about the urban form to move from flying, with its distance, to the point of view of the walker, moving along created and creative itineraries within the city. And I have been aided by the schema of Henri Lefebvre, who posits three intersecting spheres that constitute space: the representations of space; lived space; and practice. While Certeau takes up the figure of the walker in synchronic time, in the actual experience of lived space, human memory adds the diachronic. Thus cities are inescapably marked by their pasts, pasts embedded in the layout of streets and the presence of buildings, with traces of calamitous events—the stain of the high-water mark, the jagged scar of the seismic convulsion—indeed, for city residents, time loops back on itself in the patterned repetitions of city life, of festival and market. And ceremony. The work of human memory meant that the city's spaces were layered with historical deep associations that even the bloody battles of conquest could not blot out; they were like those cluttered memory palaces of classical theory that Franciscans imported into New Spain, their mnemonic traces difficult to obscure. This metaphor of city as memory palace sets continuity over rupture and allows me some leave to trace a through line from the pre-Hispanic period to the sixteenth century, in an attempt to bridge the traditional historical cleavage that has rent pre-Hispanic Tenochtitlan apart from viceregal Mexico City.

In fact, rather than flying or walking, the experience

of a city is perhaps better likened to swimming, where a straight trajectory forward or backward through space is one option, but so is a vertical plunge downward to move back in time. We have seen that place-names can serve like buoys in an aquatic environment, floating on the surface but always anchored to the bottom, to a point in deep time, as if by the ropes of memory. At the same time, the underwater landscape that determines their surface location is always changing, just as the contours of history are being remade like the bottom of the sea, as tectonic plates shift and underwater storms drive through. For the urban historian, the water is constantly rising, and while we float on its surface, past moments of a place are lost to us below, while new ones are being created.

With a new history of the city discovered in these depths, let us return to the representation of present-day Mexico City that is perhaps the best known to its residents—the metro map—with a new appreciation of the meanings carried by the urban body (see figure 1.12). Along the oldest line of the system (line 1, colored pink), where we encountered traces of Mexica Tenochtitlan in the stations of Pantitlan and Chapultepec, we now find yet another monument to the indigenous manipulation of water: "Salto de Agua" is set at the site of the life-giving *tianguis* fountain engineered under the city's extraordinary sixteenth-century leader Antonio de Valeriano. Crossing through it is the newish line 8 (dark green), inaugurated in 1994, which runs along the great indigenous-Franciscan axis of the city that ran from the *tecpan* in San Juan Moyotlan to San Francisco and ends right near Santa María Cuepopan. In 1604, Balbuena likened the city, rising from the ashes of the Conquest, to a phoenix, and it bears recalling that in Ovid's telling, the phoenix is one of the few creatures that "reproduces itself," the offspring a clone of the parent. The parent of Mexico City was Tenochtitlan, and the birthright can no longer be denied.

Notes

CHAPTER 1

1. Includes Tlatelolco; from Edward Calnek, "Tenochtitlan-Tlatelolco: The Natural History of a City."

2. Jean-Noel Biraben and Didier Blanchet, "Essay on the Population of Paris and Its Vicinity since the Sixteenth Century"; Seville figures from 1534 from Ruth Pike, "Population Trends: The Demographic Revolution of Seville"; John A. Marino, *Becoming Neapolitan: Citizen Culture in Baroque Naples*, 9; Christopher Hibbert, *Rome, the Biography of a City*, 156, 161.

3. Hernando [Hernán] Cortés, *Letters from Mexico*, trans. Anthony Pagden, 266, 270.

4. Bartolomé de las Casas, *The Devastation of the Indies: A Brief Account*, trans. Herma Briffault, 64.

5. Robert Barlow, "Some Remarks on the Term 'Aztec Empire.'"

6. Bernardo de Balbuena, *La Grandeza Mexicana*.

7. Michael J. Schreffler, *The Art of Allegiance: Visual Culture and Imperial Power in Baroque New Spain*, 9–35.

8. Frances F. Berdan and Patricia Rieff Anawalt, eds., *The Codex Mendoza*.

9. Henry B. Nicholson, "The History of the Codex Mendoza"; Jorge Gómez Tejada, "Making the 'Codex Mendoza,' Constructing the 'Codex Mendoza': A Reconsideration of a 16th Century Mexican Manuscript."

10. Elizabeth Hill Boone, *Stories in Red and Black: Pictorial Histories of the Aztecs and Mixtecs*, 65–70, 197–237.

11. Paul Ricoeur, *Memory, History, Forgetting*, trans. Kathleen Blamey and David Pellauer, 209–227.

12. Charles Dibble, ed. and trans., *Códice Aubin: Historia de la nación mexicana: Reproducción a todo color del códice de 1576*.

13. Richard L. Kagan and Fernando Marías, *Urban Images of the Hispanic World, 1493–1793*, 9–11.

14. Robert J. Mullen, *Architecture and Its Sculpture in Viceregal Mexico*, 4.

15. Federico Navarrete Linares, *Los orígenes de los pueblos indígenas del valle de México*, 25.

16. Henri Lefebvre, *The Production of Space*, trans. D. Nicholson-Smith, 85, 31.

17. Michel de Certeau, *The Practice of Everyday Life*, trans. Steven Rendall, 92–93.

18. Certeau, *The Practice of Everyday Life*, 93.

19. Certeau, *The Practice of Everyday Life*, 96.

20. Lefebvre, *The Production of Space*, 45.

21. Lefebvre, *The Production of Space*, 39, 46.

22. Lefebvre outlines them as follows: "1. *Spatial practice*, which embraces production and reproduction, and the particular locations and spatial sets characteristic of each social formation. Spatial practice ensures continuity and some degree of cohesion. In terms of social space, and of each member of a given society's relationship to that space, this cohesion implies a guaranteed level of *competence* and a specific level of *performance*. 2. *Representations of space*, which are tied to the relations of production and to the 'order' which those relations impose, and hence to knowledge, to signs, to codes, and to 'frontal' relations. 3. *Representational spaces*, embodying complex symbolisms, sometimes coded, sometimes not, linked to the clandestine or underground side of social life, as also to art (which may come eventually to be defined less as a code of space than a code of representational spaces)." Lefebvre, *The Production of Space*, 33.

23. Anthony F. Aveni, *Skywatchers*, 33.

24. Edward Calnek, "El sistema de mercado en Tenochtitlan."

25. Andrés Lira González, *Comunidades indígenas frente a la ciudad de México*.

26. Sonia Lombardo de Ruiz, *Atlas histórico de la ciudad de México*.

27. Edward S. Casey, "Remembering as Intentional" and "Place Memory," in *Remembering: A Phenomenological Study*.

28. Gaston Bachelard, *The Poetics of Space*, trans. M. Jolas.

29. Maurice Halbwachs, *On Collective Memory*, ed. and trans. Lewis A. Coser; Paul Connerton, *How Societies Remember*.

30. Lefebvre, *The Production of Space*, 73.

31. Luis González Aparicio, *Plano reconstructivo de la región de Tenochtitlan*; Ángel Palerm, *Obras hidráulicas prehispánicas en el sistema lacustre del Valle de México*.

32. Alain Musset, *D'eau vive à l'eau morte*; Gabriel Espinosa Pineda, *El embrujo del lago*.

33. Charles Gibson, *The Aztecs under Spanish Rule*.

34. James Lockhart, *The Nahuas after the Conquest: A Social and Cultural History of the Indians of Central Mexico, Sixteenth through Eighteenth Centuries*.

35. William F. Connell, *After Moctezuma: Indigenous Politics and Self-Government in Mexico City, 1524–1730*. María Castañeda de la Paz, "Historia de una casa real: Origen y ocaso del linaje gobernante en México-Tenochtitlan"; María Castañeda de la Paz, "El Plano Parcial de la Ciudad de México: Nuevas aportaciones en base al estudio de su lista de tlatoque"; Emma Pérez-Rocha and Rafael Tena, *La nobleza indígena del centro de México después de*

la Conquista; Perla Valle, *Ordenanza del señor Cuauhtémoc*, trans. Rafael Tena.

36. Ethelia Ruiz Medrano, *Reshaping New Spain: Government and Private Interests in the Colonial Bureaucracy, 1531–1550*; Ethelia Ruiz Medrano, "Fighting Destiny: Nahua Nobles and Friars in the Sixteenth-Century Revolt of the Encomenderos against the King," in Ethelia Ruiz Medrano and Susan Kellogg, eds., *Negotiation within Domination: New Spain's Indian Pueblos Confront the Spanish State*, 45–77; Felipe Castro Gutiérrez, ed., *Los indios y las ciudades de Nueva España*.

37. Edmundo O'Gorman, "Reflexiones sobre la distribución urbana colonial de la ciudad de México"; Alfonso Caso, "Los barrios antiguos de Tenochtitlan y Tlatelolco."

38. See also Roberto Moreno de los Arcos, "Los territoriales parroquiales de la Ciudad Arzobispal"; José Rubén Romero Galván, "La Ciudad de México, los paradigmas de dos fundaciones"; Anthony F. Aveni, Edward E. Calnek, H. Hartung, "Myth, Environment, and the Orientation of the Templo Mayor of Tenochtitlan."

39. Calnek, "Tenochtitlan-Tlatelolco"; Edward Calnek, "Tenochtitlan in the Early Colonial Period"; Edward Calnek, "Settlement Pattern and Chinampa Agriculture at Tenochtitlan."

40. Barbara E. Mundy, "Mapping the Aztec Capital: The 1524 Nuremberg Map of Tenochtitlan, Its Sources and Meanings"; on the economic organization of the empire, Frances Berdan, *The Aztecs of Central Mexico: An Imperial Society*.

41. Lockhart, *The Nahuas after the Conquest*, 20.

42. Emily Umberger, "Renaissance and Enlightenment Images of Aztec Sacrificial Stones."

43. Alejandro Alcántara Gallegos, "Los barrios de Tenochtitlan: Topografía, organización interna y tipología de sus predios"; Jonathan Truitt, "Nahuas and Catholicism in Mexico Tenochtitlan: Religious Faith and Practice and la Capilla de San Josef de los Naturales, 1523–1700"; Richard Conway, "Lakes, Canoes, and the Aquatic Communities of Xochimilco and Chalco, New Spain."

44. Population data from Instituto Nacional de Estadística y Geografía, online at http://cuentame.inegi.org.mx/monografias/informacion/df/poblacion/. Metro data from "Sistema de Transporte Colectivo—Metro de la Ciudad de México," available online at http://www.metro.df.gob.mx/.

45. On Pantitlan, see Margarita Carballal Staedtler and María Flores Hernández, "El Peñón de los Baños (Tepetzinco) y sus alrededores: Interpretaciones paleoambiéntales y culturales de la porción noroccidental del Lago de Texcoco," 258–264; Bernardino de Sahagún, *Florentine Codex: General History of the Things of New Spain*, bk. 2, ch. 20, 43–44, and bk. 2, ch. 25, 84.

CHAPTER 2

1. González Aparicio, *Plano reconstructivo*.

2. Correlation from Domingo Francisco de San Antón Muñón Chimalpahin Quauhtlehuanitzin, *Codex Chimalpahin: Society and Politics in Mexico Tenochtitlan, Tlatelolco, Texcoco, Culhuacan, and Other Nahua Altepetl in Central Mexico*, ed. and trans. Arthur J. O. Anderson and Susan Schroeder, 1:105.

3. Cortés, *Letters from Mexico*, 102.

4. Karl A. Wittfogel, *Oriental Despotism: A Comparative Study of Total Power*, 27, 59.

5. Alonso de Molina, *Vocabulario en lengua castillana y mexicana y mexicana y castellana*, fol. 8v (Nahuatl), fol. 67r (Spanish).

6. Richard F. Townsend, *State and Cosmos in the Art of Tenochtitlan*, 43.

7. Townsend, *State and Cosmos*, 28.

8. Arild Hvidtfeldt, *Teotl and Ixiptlatli: Some Central Conceptions in Ancient Mexican Religion*.

9. Cantares Mexicanos, fols. 22v–23r, translated in Angel María Garibay K., *Historia de la literatura náhuatl*, 1:160. My translation of Garibay's Spanish.

10. Domingo Francisco de San Antón Muñón Chimalpahin Quauhtlehuanitzin, "Historia Mexicana," from "Codex Chimalpahin," unpublished translation by John B. Glass, in my possession. Another translation, less poetic, is to be found in Chimalpahin, *Codex Chimalpahin*, 1:27.

11. Alfredo López Austin, "Cosmovision," 1:268; Alfredo López Austin, "Los juegos de la esencias," in *Tamoanchan y Tlalocan*.

12. López Austin, "Cosmovision," 268–274; Johanna Broda, "El culto Mexica de los cerros de la Cuenca de México," 53.

13. Eduardo Matos Moctezuma, "Symbolism of the Templo Mayor," 188–189.

14. Sahagún, *Florentine Codex*, bk. 3, ch. 1, 1–4.

15. Aveni, Calnek, and Hartung, "Myth, Environment, and the Orientation of the Templo Mayor."

16. Sahagún, *Florentine Codex*, bk. 11, ch. 12, 247.

17. Chimalpahin, *Codex Chimalpahin*, 1:87.

18. Joaquín García Icazbalceta, ed., "Historia de los Mexicanos por sus pinturas," 3:246, 249.

19. Diego Durán, *The History of the Indies of New Spain*, ed. and trans. Doris Heyden, 32, tells of sacrifice in Tepetzinco; the heart was thrown to where the foundation took place, in a place called Tlacocolmolco. The date varies according to different sources. For instance, Chimalpahin,
Codex Chimalpahin, 1:89, dates it as 1 House (1285).

20. Chimalpahin, *Codex Chimalpahin*, 1:97. Also, Fernando Alvarado Tezozomoc, *Crónica mexicayotl*, trans. Adrián León, 52–54.

21. García Icazbalceta, "Historia de los Mexicanos," 3:246, 249.

22. Chimalpahin, *Codex Chimalpahin*, 1:101. The account of the foundation found in Durán, *History*, 40, which describes a spring flowing from the rock, and I use this to understand the Nahuatl account as describing streams.

23. María Elena Bernal-García and Ángel Julián García Zambrano, "Introducción" in *Territorialidad y paisaje en el altepetl del siglo XVI*, ed. Federico Fernández Christlieb and Ángel Julián García Zambrano, 20.

24. Chimalpahin, *Codex Chimalpahin*, 1:103.

25. Durán, *History*, 35.

26. Carballal Staedtler and Flores Hernández, "El Peñón de los Baños," 218–256.

27. Palerm, *Obras hidráulicas prehispánicas*; González Aparicio, *Plano reconstructivo*.

28. Bernal Díaz del Castillo, *The True History of the Conquest of New Spain*, ed. Genaro García and trans. Alfred Percival Maudslay, vol. 2, ch. 92, p. 73; Jeffrey R. Parsons, *The Last Saltmakers of Nexquipayac, Mexico: An Archaeological Ethnography*.

29. Teresa Rojas Rabiela, "Ecological and Agricultural Changes in the Chinampas of Xochimilco-Chalco"; Teresa Rojas Rabiela, ed., *La agricultura chinampera: Compilación histórica*; Jeffrey R. Parsons, Mary H. Parsons, Virginia Popper, and Mary Taft, "Chinampa Agriculture and Aztec Urbanization in the Valley of Mexico."

30. González Aparicio, *Plano reconstructivo*, 35–38.

31. Jeffery R. Parsons, "The Aquatic Component of Aztec Subsistence: Hunters, Fishers and Collectors in an Urbanized Society."

32. Rojas Rabiela, "Ecological and Agricultural Changes."

33. Palerm, *Obras hidráulicas prehispánicas*; González Aparicio, *Plano reconstructivo*; Teresa Rojas Rabiela, "Obras hidráulicas coloniales en el Norte de la Cuenca de México (1540–1556) y la Reconstrucción de la Albarrada de San Lázaro (1555)"; Valle, *Ordenanza del señor Cuauhtémoc*.

34. Carballal Staedtler and Flores Hernández, "El Peñón de los Baños." See also summary of excavations in Margarita Carballal Staedtler and María Flores Hernández, "Hydraulic Features of the Mexico-Texcoco Lakes during the Postclassic Period."

35. Durán, *History*, 110–111.

36. Fernando de Alva Ixtlilxochitl, *Obras históricas*, ed. Edmundo O'Gorman, 1:445. A later source credits "el tolteca amanteca [Huexo]

tzincatl" (Toltec artisans from Huexotzinco) for the construction, Valle, *Ordenanza del señor Cuauhtémoc*, 154, 155.

37. Ross Hassig, *Aztec Warfare: Imperial Expansion and Political Control*, 58–60, calculates that Tenochtitlan, at the height of its population, could have fielded an offensive army of at most about 43,000 men.

38. Motolinia [Motolínía], or Toribio de Benavente, *Historia de los indios de la Nueva España*, ed. Edmundo O'Gorman, 147.

39. Juan de Torquemada, *Monarquía indiana*, vol. 1, bk. 2, 158.

40. Carballal Staedtler and Flores Hernández, "El Peñón de los Baños." See also Robert Barlow, "El plano mas antiguo de Tlatelolco."

41. In Carballal Staedtler and Flores Hernández, "El Peñón de los Baños," 259, the authors suggest that the northern part of the dike existed as a "wall of stone" running from El Coyoco to El Peñón de los Baños before 1428.

42. Torquemada, *Monarquía indiana*, vol. 1, bk. 2, 158.

43. Eloise Quiñones Keber, *Codex Telleriano-Remensis: Ritual, Divination, and History in a Pictorial Aztec Manuscript*, fol. 32v.

44. Carballal Staedtler and Flores Hernández, "El Peñón de los Baños," especially 148–151; see also González Aparicio, *Plano reconstructivo*, 34–35.

45. González Aparicio, *Plano reconstructivo*, 34.

46. Carballal Staedtler and Flores Hernández, "El Peñón de los Baños," 259–261.

47. Margarita Carballal Staedtler and María Flores Hernández, "Las calzadas prehispánicas de la isla de México"; Torquemada, *Monarquía indiana*, vol. 1, bk. 2, 158. See also Carballal Staedtler and Flores Hernández, "Hydraulic Features of the Mexico-Texcoco Lakes," 164–167.

48. Archivo General de la Nación, Mexico, Tierras 917, exp. 1, fol. 23, Mapoteca 0881.

49. Carballal Staedtler and Flores Hernández, "El Peñón de los Baños," 145; Carballal Staedtler and Flores Hernández, "Hydraulic Features of the Mexico-Texcoco Lakes," 167.

50. Gibson, *The Aztecs under Spanish Rule*, 225.

51. Sigvald Linné, *El Valle y la Ciudad de México en 1550: Relación histórica fundada sobre un mapa geográfico, que se conserva en la biblioteca de la Universidad de Uppsala, Suecia*; Miguel León Portilla and Carmen Aguilera, *Mapa de México Tenochtitlan y sus contornos hacia 1550*.

52. Manuel Toussaint, Federico Gómez de Orozco, and Justino Fernández, *Planos de la Ciudad de México*; Linné, *El Valle y la Ciudad de México*.

53. Diana Magaloni Kerpel, "Painters of the New World: The Process of Making the Florentine Codex"; Diana Magaloni Kerpel, "The Traces of the Creative Process: Pictorial Materials and Techniques in the Beinecke Map."

54. Henry B. Nicholson quoting don Juan Bautista de Pomar in "Religion in Pre-Hispanic Central Mexico," 408.

55. Nicholson, "Religion in Pre-Hispanic Central Mexico." The term "vertical stratification" is from table 2, between pp. 408 and 409.

56. Richard F. Townsend, "The Renewal of Nature at the Temple of Tlaloc"; Anthony F. Aveni, "Mapping the Ritual Landscape: Debt Payment to Tlaloc during the Month of Atlcahualo."

57. Sahagún, *Florentine Codex*, bk. 1, ch. 4, 2.

58. Sahagún, *Florentine Codex*, bk. 11, ch. 12, 247.

59. Henry B. Nicholson and Eloise Quiñones Keber, *Art of Aztec Mexico: Treasures of Tenochtitlan*, 72.

60. Sahagún, *Florentine Codex*, bk. 1, ch. 11, 6–7.

61. Sahagún, *Florentine Codex*, bk. 11, ch. 12, paras. 1–3, 247–251.

62. Édouard de Jonghe, "Histoyre du Mechique: Manuscrit français inédit du XVIe siècle" (my translation), 29; see also Angel María Garibay K., *Teogonía e historia de los mexicanos: Tres opúsculos del siglo XVI*, 69–120.

63. Alfonso Caso, *El teocalli de la guerra sagrada: Descripción y estudio del monolito encontrado en los cimientos del Palacio nacional*, 62.

64. Emily Umberger, "Montezuma's Throne," 33.

65. William Landon Barnes, "Icons of Empire: The Art and History of Aztec Royal Presentation," 363.

66. Caso, *El teocalli de la guerra sagrada*, 57.

67. Mary Ellen Miller, "A Re-examination of the Mesoamerican Chacmool."

68. Caso, *El teocalli de la guerra sagrada*, 60.

69. Jonghe, "Histoyre du Mechique," 29.

70. Edward S. Casey, *Getting Back into Place: Towards a Renewed Understanding of the Place-World*.

71. García Icazbalceta, "Historia de los Mexicanos," 3:248.

72. Leonardo López Luján, *The Offerings of the Templo Mayor of Tenochtitlan*, trans. Bernard R. Ortiz de Montellano and Thelma Ortiz de Montellano.

73. Chimalpahin, *Codex Chimalpahin*, 1:101.

74. Sahagún, *Florentine Codex*, bk. 2, app., 178.

75. María Elena Bernal-García, "The Dance of Time, the Procession of Space at Mexico-Tenochtitlan's Desert Garden," 73–74.

76. López Luján, *The Offerings of the Templo Mayor*, 82–83, suggests that the main temple could have been constructed on top of the original springs.

77. Sahagún, *Florentine Codex*, bk. 2, app., 178.

78. Sahagún, *Florentine Codex*, bk. 11, ch. 12, 250.

CHAPTER 3

1. Louis Marin, *Portrait of the King*, trans. Tom Conley.

2. Molina, *Vocabulario*, Nahuatl to Spanish, fol. 95v, gives the definition as "imagen de alguno, sustituto, o delegado" (the image of someone, a substitute, or delegate). The longer exploration of the term by Hvidtfeldt shows its sacred qualities. Hvidtfeldt, *Teotl and Ixiptlatli*.

3. Díaz del Castillo, *True History*, vol. 2, ch. 88, 41.

4. Díaz del Castillo, *True History*, vol. 2, ch. 88, 40–41.

5. Sahagún, *Florentine Codex*, bk. 9, ch. 21.

6. Thomas A. Lee Jr. and Carlos Navarrete, eds., *Mesoamerican Communication Routes and Cultural Contacts*.

7. Cortés, *Letters from Mexico*, 103–104.

8. Sahagún, *Florentine Codex*, bk. 9, ch. 20.

9. See Berdan and Anawalt, eds., *The Codex Mendoza*, vol. 3 (facsimile): for feathered suits as tribute, fols. 19r–55r; for warriors in feathered costumes, fols. 64r, 65r, 67r.

10. Eduardo Matos Moctezuma and Felipe Solís Olguin, eds., *Aztecs*, 449.

11. Jacqueline de Durand-Forest, ed., *Codex Ixtlilxochitl: Bibliothèque national, Paris (Ms. Mex. 55–710)*.

12. Durán, *History*, 356.

13. Patricia Rieff Anawalt, "A Comparative Analysis of the Costumes and Accoutrements of the Codex Mendoza"; Patricia Rieff Anawalt, "The Emperors' Cloak: Aztec Pomp, Toltec Circumstances"; Carmen Aguilera, "Of Royal Mantles and Blue Turquoise: The Meaning of the Mexican Emperor's Mantle"; Barnes, "Icons of Empire," 56–85.

14. Sahagún, *Florentine Codex*, bk. 10, ch. 14.

15. Sahagún, *Florentine Codex*, bk. 6, ch. 5, 21–24. Translations of individual words from Molina, *Vocabulario*.

16. Lockhart, *The Nahuas after the Conquest*, 20–28.

17. Caso, "Los barrios antiguos de Tenochtitlan y Tlatelolco"; Truitt, "Nahuas and Catholicism in Mexico Tenochtitlan."

18. Kartunnen gives the spelling as "tlahxillacalli"—she gives no etymology, but *calli* is "house," and *xillantli* is "womb," a word with metaphorical freight of origin; Frances Karttunen, *An Analytical Dictionary of Nahuatl*, 271. Current Nahua scholars favor the orthography *tlaxilacalli* and its treatment as a subunit of the *altepetl*, replacing an earlier generation's preference for the term *calpolli*. See Caterina Pizzigoni,

Life Within: Local Indigenous Society in Mexico's Toluca Valley, 1650–1800, 6. Luis Reyes García insists on a difference between *tlaxilacalli* and *calpolli* in "El término calpulli en documentos del siglo xvi," in Luis Reyes García, Eustaquio Celestino Solís, and Armando Valencia Ríos, *Documentos nahuas de la Ciudad de México del siglo XVI*, 21–68. In contrast, Lockhart, like Pizzigoni, sees the terms as relatively interchangeable, preferring *calpolli* for its recognizability. Lockhart, *The Nahuas after the Conquest*, 16.

19. Tezozomoc, *Crónica mexicayotl*, 74.

20. Pedro Carrasco, *The Tenochca Empire*, 94.

21. Richard Adams, *Prehistoric Mesoamerica*, 404.

22. Motolinia, *Historia*, 84.

23. González Aparicio, *Plano reconstructivo*.

24. René Acuña, ed., "Relación de San Juan Teotihuacan," in *Relaciones geográficas del siglo XVI*, 7:235–236.

25. Richard F. Townsend, "Coronation at Tenochtitlan"; Townsend, "The Renewal of Nature." The Tlillan temple and Yopico temple are mentioned in the coronation of Tizocic, in Durán, *History*, 297–298. Durán notes in his *Book of the Gods and Rites and the Ancient Calendar* that Tlillan was a place he knew as a child growing up in Mexico City, where he locates it as "contiguous [to the house] of Acevedo at the intersection of [the house of] Don Luis de Castilla" (217); the volume's editors, Doris Heyden and Fernando Horcasitas, pinpoint this in the modern city at the corner of República de Brasil and Justo Sierra.

26. Carlos Javier González González, "La ubicación e importancia del Templo de Xipe Tótec en la parcialidad tenochca de Moyotlan." Evidence for the flow of Chapultepec's water along this axis is provided by water pipes discovered in salvage archeology and discussed in Ricardo Armijo Torres, "Arqueología e historia de los sistemas de aprovisionamiento de agua potable para la ciudad de México durante la época colonial: Los acueductos de Chapultepec y Santa Fe," 33–37.

27. Durán, *History*, 343.

28. Durán, *History*, 357.

29. Durán, *History*, 322, 406.

30. Marcel Mauss, *The Gift: The Form and Reason for Exchange in Archaic Societies*, trans. Ian Cunnison, 37–38.

31. Alfred Gell, *Art and Agency: An Anthropological Theory*, 20.

32. Townsend, *State and Cosmos*, 28.

33. Susan Toby Evans, "Aztec Royal Pleasure Parks: Conspicuous Consumption and Elite Status Rivalry."

34. Esther Pasztory, *Aztec Art*, 129–133.

35. Luis González Obregón, using information drawn from Alfredo Chavero, described five canals, used for transport of urban goods, crossing the pre-Hispanic city, three of them running in an east–west direction, two north–south. Luis González Obrégon, "Reseña histórica," 1:35–36.

36. López Luján, *The Offerings of the Templo Mayor*.

37. Durán, *History*, 67–68.

38. Durán, *History*, 80.

39. Chimalpahin, *Codex Chimalpahin*, 1:235; Ixtlilxochitl, *Obras históricas*, 1:444.

40. Michel Graulich, ed., *Codex Azcatitlan*, 115n73.

41. Durán, *History*, 242.

42. Chimalpahin, *Codex Chimalpahin*, 1:46–47.

43. Durán, *History*, 320.

44. Rubén Cabrera C., "Informe de las excavaciones en el bosque de Chapultepec."

45. Ignacio Alcocer, *Apuntes sobre la antigua México-Tenochtitlan*, 14.

46. Cabrera C., "Informe de las excavaciones."

47. Cabrera C., "Informe de las excavaciones"; see also Manfred Sasso Guardia, "El acueducto prehispanico de Chapultepec"; Durán, *History*, 21, 242–243; Patrick Hajovsky, "Without a Face: Voicing Moctezuma II's Image at Chapultepec Park, Mexico City."

48. Durán, *History*, 362.

49. Sahagún, *Florentine Codex*, bk. 8, ch. 1, 2; César Lizardi Ramos, "El manantial y el acueducto de Acuecuexco." Lizardi Ramos identified a number of springs clustering at the northern edge of Los Reyes Quiáhuac, today part of Mexico City near Coyoacan.

50. Durán, *History*, 361–366.

51. Lizardi Ramos, "El manantial y el acueducto de Acuecuexco," found some traces of the aqueduct leading to the causeway.

52. The route of the aqueduct is established in Durán, *History*, 369; Lizardi Ramos, "El manantial y el acueducto de Acuecuexco," 229, identifies Huitzilan as on the site of the Hospital de Jesús.

53. Durán, *History*, 369.

54. Durán, *History*, 367.

55. Durán, *History*, 367–368.

56. Durán, *History*, 378.

57. Gell, *Art and Agency*, 135.

58. Durán, *History*, 378.

59. Luis González Obregón, ed., *Procesos de indios idolatras y hechiceros*, 116.

60. Lizardi Ramos, "El manantial y el acueducto de Acuecuexco."

61. Alcocer, *Apuntes sobre la antigua México-Tenochtitlan*, 96–100; Lizardi Ramos, "El manantial y el acueducto de Acuecuexco"; Charles R. Wicke, "Escultura imperialista mexica: El monumento de Acuecuexcatl de Ahuízotl"; Eloise Quiñones Keber, "Quetzalcóatl as Dynastic Patron: The Acuecuexatl Stone Reconsidered"; Barnes, "Icons of Empire," 297–333.

62. Barnes, "Icons of Empire," 309.

63. Barnes uses the presence of the fan-and-flap back hanging to argue that Ahuitzotl is dressed for a celebration dedicated to Atlatonan, a deity "closely related to Chalchiuhtlicue," Barnes, "Icons of Empire," 312.

64. Barnes, "Icons of Empire," 310.

65. On Quetzalcoatl imagery of the sculpture, see Emily Umberger, "Notions of Aztec History: The Case of the Great Temple Dedication," 96, and Emily Umberger, "Aztec Sculptures, Hieroglyphs, and History," 98–105, 127–132.

66. Its original site was discussed by Alcocer, *Apuntes sobre la antigua México-Tenochtitlan*, and more recently by Emily Umberger, "Monuments, Omens, and Historical Thought: The Transition from Ahuitzotl to Motecuhzoma II."

67. There is little agreement about what kind of building this would have been associated with. Wicke, in "Escultura imperialista mexica," 60, following Alcocer, *Apuntes sobre la antigua México-Tenochtitlan*, 96, thinks it decorated a temple devoted to Toci, an earth deity, built along the causeway. Quiñones Keber, "Quetzalcóatl as Dynastic Patron," argues that the work was part of a Quetzalcoatl temple complex that lay along the Ixtapalapa causeway and that its imagery underscores the relationship between Quetzalcoatl and Ahuitzotl.

68. Durán, *History*, 370.

69. Pasztory, *Aztec Art*, 127; Umberger, "Aztec Sculptures, Hieroglyphs, and History," 129–132, 157–164; Emily Umberger, "Antiques, Revivals, and References to the Past in Aztec Art," 74; Umberger, "Monuments, Omens, and Historical Thought."

70. Efraín Castro Morales, *Palacio Nacional de México: Historia de su arquitectura*. See also Caso, *El teocalli de la guerra sagrada*. Caso does not discuss placement at length; he writes simply that it was discovered in 1926 "en los cimientos del torreón sur del Palacio nacional" (in the foundations of the southern tower of the National Palace, p. 7). This location is confirmed in the map published by Eduardo Matos Moteuczoma, ed., *Trabajos arqueologicos en el centro de la Ciudad de México (Antología)*.

71. This was first identified as Moteuczoma's name glyph by Umberger, "Aztec Sculptures, Hieroglyphs, and History," 66–71. See also the discussion in Umberger, "Montezuma's Throne," 22–27, as well as Patrick Hajovsky, "On the Lips of Others: Fame and the Transformation of Moctezuma's Image."

72. Henry B. Nicholson, "The Chapultepec Cliff Sculpture of Motecuhzoma Xocoyotzin"; Ursula Dyckerhoff, "Xipe Totec and the War

Dress of the Aztec Rulers"; Colin McEwan and Leonardo López Luján, eds., *Moctezuma: Aztec Ruler*, 81; Hajovsky, "Without a Face."

73. Durán, *History*, 298.

74. Durán, *History*, 125.

CHAPTER 4

1. Francisco López de Gómara, *Cortés: The Life of the Conqueror by His Secretary*, ed. and trans. Lesley Byrd Simpson, 264.

2. Rafael Tena, ed. and trans., *Anales de Tlatelolco*, 119.

3. Díaz del Castillo, *True History*, vol. 4, ch. 156, p. 187.

4. Tena, *Anales de Tlatelolco*, 119.

5. For instance, Agustín de Vetancourt, "Tratado de la ciudad de Mexico," in *Teatro Mexicano*, fol. 1.

6. José Ignacio Mantecón Navasal and Manuel Toussaint, *Información de méritos y servicios de Alonso García Bravo, alarife que trazó la ciudad de México*; Ana Rita Valero de García Lascuráin, *La ciudad de México-Tenochtitlán: Su primera traza, 1524–1534*; Lucía Mier y Terán Rocha, *La primera traza de la ciudad de México, 1524–1535*; Guillermo Porras Muñoz, *El gobierno de la ciudad de México en el siglo XVI*.

7. Motolinia, *Historia*, tratado 1, ch. 1, 16.

8. Rodolfo Acuña-Soto et al., "Megadrought and Megadeath in 16th Century Mexico."

9. Motolinia [Motolinía], or Toribio de Benavente, *Motolinía's History of the Indians of New Spain*, ed. and trans. Francis B. Steck, 271.

10. On the debates over where to build the Spanish capital, see Porras Muñoz, *El gobierno de la ciudad de México*, 17–19; Valero de García Lascuráin, *La ciudad de México-Tenochtitlán*, 64–73.

11. Inga Clendinnen, "'Fierce and Unnatural Cruelty': Cortés and the Conquest of Mexico."

12. Gibson, *The Aztecs under Spanish Rule*, 381.

13. Edward Calnek, "The Localization of the 16th-Century Map Called the Maguey Plan"; María Castañeda de la Paz, "Sibling Maps, Spatial Rivalries: The Beinecke Map and the Plano Parcial de la Ciudad de México"; Castañeda de la Paz, "El Plano Parcial de la Ciudad de México."

14. Gibson, *The Aztecs under Spanish Rule*, 378.

15. López de Gómara, *Cortés*, 160.

16. López de Gómara, *Cortés*, 160–163.

17. Díaz del Castillo, *True History*, vol. 2, ch. 92, p. 71; Cortés, *Letters from Mexico*, 104.

18. Sahagún, *Florentine Codex*, bk. 11, ch. 11.

19. Ignacio Bejarano, ed., *Actas de cabildo de la ciudad de México*, August 26, 1524, mentions the appointment of someone to guard the "agua que viene de Chapultepec" (water that comes

from Chapultepec), revealing that the rebuilding of the aqueduct was one of the earliest public works projects in the post-Conquest city.

20. Chimalpahin, *Codex Chimalpahin*, 1:169, gives this succession.

21. Archivo General de la Nación, Mexico, Tierras 24, exp. 3, fol. III.

22. Cortés, *Letters from Mexico*, 263.

23. Cortés, *Letters from Mexico*, 321; López de Gómara, *Cortés*, 323, also names his appointment; don Pedro Moctezuma Tlacahuepantli (the son of the pre-Hispanic emperor) was named to another district. The evidence for Tlacotzin's appointment to Moyotlan is circumstantial, because his son don Geronimo had a large house in that district that he inherited from his mother and was a resident of that *barrio*. Archivo General de la Nación, Mexico, Tierras 24, exp. 3, fol. 140. Kubler, *Mexican Architecture of the Sixteenth Century*, 1:45, says he was assigned San Antonio Abad, but this is clearly a misunderstanding, as this was not one of the four parts of the early city.

24. It is described as "tianguis de la casa de Juan Velazquez" (market of the house of Juan Velazquez) in Bejarano, *Actas de cabildo*, May 22, 1524; after his death, it is described as the "tianguis que era de Juan Velazquez" (market that was Juan Velazquez's) in Bejarano, *Actas de cabildo*, May 20, 1526.

25. On Cuitlahua, see Chimalpahin, *Codex Chimalpahin*, 1:165.

26. Dibble, *Códice Aubin*, 62.

27. In Archivo General de la Nación, Mexico, Tierras 24, exp. 3, a lawsuit of 1569 uses the word *tlaltenamitl* for the dikes.

28. Cortés, *Letters from Mexico*, 323, tells us there were two native markets in the city, the other to be found where the Indians lived, presumably Tlatelolco.

29. Archivo General de la Nación, Mexico, Tierras 1735, exp. 2, fols. 117, 118, and 121, published in Arthur J. O. Anderson, Frances Berdan, and James Lockhart, *Beyond the Codices*, 146–149.

30. Robert Haskett, *Indigenous Rulers: An Ethnohistory of Indian Town Government in Colonial Cuernavaca*; Ruiz Medrano and Kellogg, eds., *Negotiation within Domination*.

31. López de Gómara, *Cortés*, 339; Cortés, *Letters from Mexico*, 366, makes the same point.

32. López de Gómara, *Cortés*, 339.

33. Pérez-Rocha and Tena, *La nobleza indígena*, 99–102.

34. Chimalpahin, *Codex Chimalpahin*, 1:169, notes his quick appointment.

35. Bejarano, *Actas de cabildo*, May 31, 1526, notes the return of Cortés; in the *acta* for June 28, 1526, Cortés named Alonso de Grado "visitador general" (a position with general

oversight) to amend problems with Indians, and at this moment, when Cortés reasserted his involvement in the city's affairs, he may have appointed the new governor.

36. García Icazbalceta, "Historia de los Mexicanos," 255, also tells us that Motelchiuhtzin (whom he also calls "Viznagual" [or Huitznahual]) was sent out to greet Cortés before his arrival into Tenochtitlan, so he was likely the first high-ranking Mexica lord Cortés ever met; this source also credits Cortés with the appointment of Motelchiuhtzin, 256, while underlining that he was not a nobleman, 260. Motelchiuhtzin's pre-Hispanic role is clarified by Bernal Díaz del Castillo, who reports that he was Moteuczoma's steward, "a great Cacique to whom we gave the name of Tápia and he kept the accounts of all the revenue that was brought to Moteuczoma, in his books which were made of paper which they call *amal*, and he had a great house full of these books." Díaz del Castillo, *True History*, vol. 2, ch. 91, p. 64.

37. Chimalpahin, *Codex Chimalpahin*, 1:171.

38. Chimalpahin, *Codex Chimalpahin*, 1:171.

39. Ruiz Medrano, *Reshaping New Spain*, esp. 24–32.

40. Pérez-Rocha and Tena, *La nobleza indígena*, 99–102; Chimalpahin, *Codex Chimalpahin*, 1:171; García Icazbalceta, "Historia de los Mexicanos," 256.

41. Chimalpahin, *Codex Chimalpahin*, 1:169, 171.

42. Bejarano, *Actas de cabildo*, December 19, 1533; in these minutes of the meeting, one of the councilmen, Gonzalo Ruiz, presented a summary of testimony given before the royal court, the *audiencia*, about the move of the *tianguis*, and his summary makes it clear that the market was being returned to where it once was. Dibble, *Códice Aubin*, 63, also reports a *tianguis* being established in 1533.

43. It is sometimes called the "Tianguis de San Lázaro" because the church of San Lázaro stood on the site into the 1540s, and some kind of shrine may have existed there through the sixteenth century. See Archivo General de la Nación, Mexico, Indios 4, exp. 194, and Hospital de Jesus 296, exp. 4, where a public announcement is made "en San Lazaro junto al tiangues" (at San Lázaro, next to the market) in 1592; this document is also reproduced in Reyes García, Celestino Solís, and Valencia Ríos, *Documentos nahuas de la Ciudad de México*, 304; Domingo Francisco de San Antón Muñón Chimalpahin Quauhtlehuanitzin, *Annals of His Time*, ed. and trans. James Lockhart, Susan Schroeder, and Doris Namala, 37, also refers to it as such.

44. Dibble, *Códice Aubin*, 65.

45. Jorge Olvera Ramos accepts that the Plaza

Mayor market was as important in the sixteenth century as in the seventeenth, but there is little direct evidence to support this point, except for the description of *cabildo* historian Francisco Cervantes de Salazar, *Life in the Imperial and Loyal City of Mexico in New Spain*, trans. Minnie Lee Barrett Shepard, 41–42 (quoted at the beginning of chapter 10). Jorge Olvera Ramos, *Los mercados de la Plaza Mayor en la Ciudad de México*. For instance, Henry Hawks does not mention a market in the Plaza Mayor in his 1572 report on New Spain's commerce. Henry Hawks, "A Relation of the Commodities of Nova Hispana," 545–553. On the role of floods in relocating the markets, see Archivo General de la Nación, Mexico, Indios 12, 1st pte., exp. 236, fol. 148, and 2nd pte., exp. 68, fol. 199.

46. The evidence for their daily operation is indirect: a 1595 order that Indians that sell in the *tianguises* of the plazas of Santiago, San Juan, and San Hipólito refrain from doing so after mass on Sundays and on feast days would have been unnecessary if they did not run on these days (Archivo General de la Nación, Mexico, Indios 6, 2nd pte., exp. 1063, fol. 289); Hawks, "A Relation of the Commodities of Nova Hispana."

47. Vasco de Puga, *Provisiones, cedulas, instrucciones de su Magestad . . .* , 2:148, 188–189, 248–249. More on viceregal attempts at provisioning the city is covered in Gibson, *The Aztecs under Spanish Rule*, 355; Pedro de Gante is mentioned in Olvera Ramos, *Los mercados de la Plaza Mayor*, 60.

48. In Francisco del Paso y Troncoso and Silvio Arturo Zavala, eds., *Epistolario de Nueva España, 1505–1818*, 15:162–165 (doc. 876).

49. Dibble, *Códice Aubin*, 63.

50. Cervantes de Salazar, *Life in the Imperial and Loyal City of Mexico*, 57; Kubler, *Mexican Architecture of the Sixteenth Century*, 1:205.

51. Martha Fernández, "Convento de Nuestra Señora de Regina Coeli," in Armando Ruiz, ed., *Arquitectura religiosa de la ciudad de México*, 170.

52. Olvera Ramos, *Los mercados de la Plaza Mayor*, 68.

53. In personal communication with me in 2012, Jonathan Truitt underscored the preeminence of women in the marketplace; also confirming their preeminence are orders specifically directed to indigenous female sellers (named as "indias") in Archivo General de la Nación, Mexico, Indios 4, exp. 4; Indios 6, exp. 79; Indios 6, exp. 234.

54. Jacqueline de Durand-Forest, "Cambios económicos y moneda entre los aztecas"; Janet Long-Solís, "El abastecimiento de chile en el mercado de la ciudad de México-Tenochtitlan en el siglo XVI"; Lockhart, *The Nahuas after the Conquest*, 185–198. Given the fidelity of copies to their originals in other works of the collection

of Lorenzo Boturini Benaduci (1702–1755), I trust that the copy of the map of the *tianguis* is an equally faithful copy of the now-lost original. This copy seems to have been made under the direction of the collector Aubin, because the word "effacé," meant to mark an effaced area on the original, also appears, written in the same hand, on a copy he commissioned of the Codex en Cruz (see Charles E. Dibble, ed., *Codex en Cruz*, atlas, 68–69). This leads me to suppose that Aubin, while in Mexico in the 1830s, was looking at the original of the *tianguis* map when he wrote his comment ("effacé") on the copy. While Aubin took the copy to France, the original may have remained in Mexico.

55. Elinor G. K. Melville, *A Plague of Sheep: Environmental Consequences of the Conquest of Mexico*.

56. In the Codex Santa Anita Zacatlalmanco, indigenous leaders of the city of the later sixteenth century wear hats. Codex Santa Anita Zacatlalmanco, 71.1878.1.2970: Manuscrit Mexico, Musée du quai Branly.

57. Woodrow Wilson Borah, *Silk Raising in Colonial Mexico*.

58. Gibson, too, notes the "conservatism of Indian material culture" in the markets in the valley in *The Aztecs under Spanish Rule*, 353, commenting further on "the absence of European tools, hardware, glass, and clothing, all which lay beyond the ordinary Indian's needs or economic opportunities."

59. Joaquín Aguirre and Juan Manuel Montalbán, *Recopilacion compendiada de las leyes de Indias, aumentada con algunas notas que no se hallan en la edicion de 1841 . . .* , 407. Archivo General de la Nación, Mexico, Tierras 35, exp. 2, fol. 133r.

60. Mier y Terán Rocha, *La primera traza*, 133.

61. " . . . dejando a los indios sus propriedades." Aguirre and Montalbán, *Recopilacion compendiada de las leyes de Indias*, 407.

62. Bejarano, *Actas de cabildo*, September 19, 1533. Barbara E. Mundy, "Pictography, Writing, and Mapping in the Valley of Mexico and the Beinecke Map," in Mary Miller and Barbara E. Mundy, eds., *Painting a Map of Sixteenth-Century Mexico City: Land, Writing and Native Rule*, 42–48.

63. Bejarano, *Actas de cabildo*, January 5, 1526.

64. See references in Archivo General de la Nación, Mexico, Mercedes 5, which outline the powers of the Spanish *alguacil* and other directives. Traditionally, indigenous governors and their *tianguizhuaque* (market overseers) controlled markets. Lockhart, *The Nahuas after the Conquest*, 185–198.

65. Land grants are covered in Mier y Terán Rocha, *La primera traza*.

66. Henri Delacroix, *La religion et la foi*, quoted in Halbwachs, *On Collective Memory*, 88n4.

67. Bejarano, *Actas de cabildo*, July 31, 1528.

68. On the cost of the *pendón*, see Bejarano, *Actas de cabildo*, March 9, 1528; trumpets are mentioned in Bejarano, *Actas de cabildo*, August 27, 1529; the pattern of the celebration is set out in Bejarano, *Actas de cabildo*, August 11, 1529, and the description varies slightly in its timing from that described by Diego Valadés, *Retórica Cristiana*, trans. Tarsicio Herrera Zapién, 467–469, who includes a long description, probably as he witnessed it. It is also described in Cervantes de Salazar, *Life in the Imperial and Loyal City of Mexico*, 69.

69. After 1535, the *regidor* who led the procession was accompanied by the viceroy and the head of the *audiencia*, thereby putting on display the structure of city government, as it would develop.

70. On other rituals, see Linda Curcio-Nagy, *The Great Festivals of Colonial Mexico City: Performing Power and Identity*.

71. Valadés, *Retórica Cristiana*, 467–469.

72. Arthur J. O. Anderson, trans., *Bernardino de Sahagún's "Psalmodia Christiana" (Christian Psalmody)*, 244–245.

73. Certeau, *The Practice of Everyday Life*, 104.

74. A smaller set of names is used for new Spanish constructions; thus, we find the Atarazanas, or the "docks," at the eastern limit of the city; this name appears even in Nahuatl documents.

75. In René Acuña, ed., "Descripción de la ciudad y provincia de Tlaxcala," in *Relaciones geográficas del siglo XVI*, 4:253.

76. Bejarano, *Actas de cabildo*, January 1, 1573; January 1, 1575; August 1, 1578; January 29, 1582.

77. Chimalpahin, *Annals of His Time*, 71, 81, 169, 241, 299.

78. Chimalpahin, *Codex Chimalpahin*, 1:159.

CHAPTER 5

1. Tezozomoc, *Crónica mexicayotl*, 164.

2. Evidence for this is found in Archivo General de las Indias, Seville, Justicia 232, charge 2: documentation of the *visita* (visit of oversight) of Vasco de Quiroga, in which one of the witnesses is "don Diego, indio principal of the barrio of San Juan, who states that he is more than 50 years old." Quoted in Ruiz Medrano, *Reshaping New Spain*, 24.

3. Gibson, *The Aztecs under Spanish Rule*, 271–273.

4. On contests between city Indians and the *cabildo* over lands reserved for the common good, called *ejidos* in Spanish, just in the decade of 1534–1544, see Bejarano, *Actas de cabildo*,

April 24, 1534; April 30, 1535; July 6, 1536; April 10, 1537; June 15, 1537; March 19, 1538; June 18, 1540; May 23, 1542; the clash between native *gobernadores* and *audiencia* judges midcentury is to be found in Vicenta Cortés Alonso, ed. and trans., *Pintura del gobernador, alcaldes y regidores de México: Códice Osuna.*

5. Chimalpahin, *Codex Chimalpahin*, gives both the date of 6 House, or 1537, in the Gregorian calendar (2:41) and the date of 7 Rabbit, or 1539 (1:41). If we accept the native span as the correct count (6 House–7 Rabbit), then he acceded somewhere between the end of January 1537 and the end of January 1539.

6. Castañeda de la Paz, "Historia de una casa real"; Tezozomoc, *Crónica mexicayotl*, 161; on the housecleaning by Cuauhtemoc, Tezozomoc, *Crónica mexicayotl*, 163–164.

7. Pérez-Rocha and Tena, *La nobleza indígena*, 38–39, give his biography.

8. Tezozomoc, *Crónica mexicayotl*, 151, says that the assassin was Motelchiuhtzin himself, but Castañeda de la Paz, "Historia de una casa real," 5, clarifies that it was his son.

9. Pérez-Rocha and Tena, *La nobleza indígena*, 29–35, for biography; Chimalpahin, *Codex Chimalpahin*, 1:149, says Pedro Moctezoma was native of San Sebastián Atzacoalco, where his son don Martín Motlatocazoma was born. Castañeda de la Paz, "Historia de una casa real," 5–6, discusses the reasons that Pedro Moctezoma was not elected to power. See also Amaya Garritz, "Ejectutoria a favor de don Diego Luis Moctezuma: Testamento del príncipe Pedro Moctezuma."

10. Pérez-Rocha and Tena, *La nobleza indígena*, 41–42, 99–102.

11. Tezozomoc, *Crónica mexicayotl*, 164.

12. Castañeda de la Paz, "Sibling Maps, Spatial Rivalries."

13. James Lockhart, "Postconquest Nahua Society and Culture Seen through Nahuatl Sources," in *Nahuas and Spaniards: Postconquest Central Mexican History and Philology*, 12.

14. See for instance Peter W. Parshall, *The Woodcut in Fifteenth-Century Europe*; Peter W. Parshall and Rainer Schoch, *Origins of European Printmaking: Fifteenth-Century Woodcuts and Their Public*.

15. Elena Isabel Estrada de Gerlero, Donna Pierce, and Clare Farago, "Mass of Saint Gregory," offers a summary of the literature.

16. Pablo Escalante Gonzalbo, *Los Códices mesoamericanos antes y después de la conquista española*, 103–199.

17. Gerlero, Pierce, and Farago, "Mass of Saint Gregory," 97–98.

18. For instance, Peter W. Parshall, "Imago Contrafacta: Images and Facts in the Northern Renaissance"; Caroline Walker Bynum,

"Seeing and Seeing Beyond: The Mass of Saint Gregory in the Fifteenth Century"; Esther Meier, "Ikonographische Probleme: Von der Erscheinung Gregorii' aur 'Gregormesse.'"

19. Translation modified from Gerlero, Pierce, and Farago, "Mass of Saint Gregory," 96.

20. For example, Pérez-Rocha and Tena, *La nobleza indígena*, 99, 101, 103, 105, 125.

21. The government of Santiago Tlatelolco was ruled independently by don Diego Mendoza (named after the viceroy), beginning in 1549. On the Santiago Tlatelolco rulers, see María Castañeda de la Paz, "Filología de un 'corpus' pintado (siglos xvi–xviii): De códices, techiloyan, pinturas y escudos de armas"; Castañeda de la Paz, "Historia de una casa real," 5n20; Rebeca López Mora, "El cacicazgo de Diego de Mendoza Austria y Moctezuma."

22. Sahagún, *Florentine Codex*, bk. 9, ch. 21, 93–97.

23. Gerónimo de Mendieta, *Historia eclesiástica indiana*, ed. Joaquín García Icazbalceta, bk. 4, ch. 13, 410.

24. Feather workshops are mentioned in the Spanish text of the Florentine Codex, which has been published as Bernardino de Sahagún, *Historia general de las cosas de Nueva España*, ed. Alfredo López Austin and Josefina García Quintana, 2:582 (bk. 9, ch. 21).

25. Alessandra Russo, "Plumes of Sacrifice: Transformations in Sixteenth-Century Mexican Feather Art"; Alessandra Russo, "Image-plume, temps reliquaire? Tangibilités d'une histoire esthétique"; Louise M. Burkhart, "The Solar Christ in Nahuatl Doctrinal Texts of Early Colonial Mexico."

26. Torquemada, *Monarquía indiana*, vol. 1, bk. 3, ch. 26, 303; Josefina Muriel, "En torno a una vieja polémica: erección de los primeros conventos de San Francisco en la ciudad de México, siglo XVI," 8.

27. Caso, "Los barrios antiguos de Tenochtitlan y Tlatelolco," 12–13. There is another Amanalco in Santiago Tlatelolco that may also have been a site for featherworking, since the Florentine mentions that the featherworkers' neighborhood is adjacent to that of the long-distance traders, or *pochteca*, who lived in Tlatelolco in the pre-Hispanic period. But Santiago Tlatelolco was not ruled by Huanitzin, so the origins of this featherwork were more likely in the workshops within his domain.

28. Collection history is covered in Gerlero, Pierce, and Farago, "Mass of Saint Gregory."

29. García Icazbalceta, "Historia de los Mexicanos," 254.

30. Albrecht Dürer, *Diary of His Journey to the Netherlands, 1520–1521*, 53–54.

31. Mauss, *The Gift*; E. M. Brumfiel,

"Materiality, Feasts, and Figured Worlds in Aztec Mexico."

32. Durán, *History*, 124.

33. Gell, *Art and Agency*, 68–69, 71.

34. Cortés's gift shipments discussed in Alessandra Russo, "'Everywhere in This New Spain': Extension and Articulation of an Artistic World."

35. In October of 1539, Culoa Tlapisque, a high priest of Culhuacan, told inquisitors that Huanitzin was in league with the keepers of the sacred bundle of Huitzilopochtli; González Obregón, *Procesos de indios idolatras y hechiceros*, 123–124. In January of 1540, perhaps to incur favor with Bishop Zumárraga, Huanitzin turned over to the Inquisition one Martín, who had in his possession some gold jewels and costumes, including "un moscador de pluma" (a feather fan) that belonged to Martín Ocelotl, a convicted idolator; González Obregón, *Procesos de indios idolatras y hechiceros*, 49. See Patricia Lopes Don, *Bonfires of Culture: Franciscans, Indigenous Leaders, and the Inquisition in Early Mexico, 1524–1540*.

36. Luis González Obregón, ed., *Proceso inquisitorial del Cacique de Tetzcoco*, 102–103. Alessandra Russo also discusses the featherwork as a response to the auto-da-fé in "Recomposing the Image: Presents and Absents in the Mass of Saint Gregory, Mexico-Tenochtitlan, 1539," a work that came to my attention while this book was in press.

37. Calnek, "Tenochtitlan-Tlatelolco," 153–155.

38. Bejarano, *Actas de cabildo*, January 29, 1552; September 5, 1542. Both San Lázaro and the "tiánguiz de los mexicanos," but not the *tecpan*, are described on this site in García Icazbalceta, "Historia de los Mexicanos," 244, a document dating to around 1534.

39. My early dating of the *tecpan* contradicts the text of the *Códice Cozcatzin*, a late seventeenth-century manuscript copied from earlier material. It records that the *tecpan* was built and the market was established in 10 Rabbit (1554). However, this is not a completely reliable source, as we know that the market mentioned in the text was established in 1533. Ana Rita Valero de García Lascuráin, *Los códices de Ixhuatepec: Un testimonio pictográfico de dos siglos de conflicto agrario*, 126.

40. Valadés, *Retórica Cristiana*, 475.

41. James Kirakofe, "Architectural Fusion and Indigenous Ideology in Early Colonial Teposcolula"; Susan Toby Evans, "The Aztec Palace under Spanish Rule: Disk Motifs in the Mapa de México de 1550 (Uppsala Map or Mapa de Santa Cruz)."

42. Torquemada, *Monarquía indiana*, vol. 3, bk. 16, ch. 2, 212.

43. Carlos Flores Marini, "El tecpan de

Tlatelolco"; Justino Fernández and Hugo Leight, "Códice del Tecpan de Santiago Tlatelolco (1576–1581)."

44. Cortés, *Letters from Mexico*, 321.

45. Emma Pérez-Rocha and Rafael Tena, "Parecer de la Segunda Audiencia sobre una petición de varios principales de la Ciudad de México al emperador Carlos V, México, 18 de junio de 1532," in *La nobleza indígena*, 101–102; will in Archivo General de la Nación, Mexico, Tierras 37, exp. 2. I thank Edward Calnek for bringing this document to my attention and sharing his summary transcription.

46. Bejarano, *Actas de cabildo*, June 3, 1542; Pérez-Rocha and Tena, *La nobleza indígena*, 39–40.

47. Archivo General de la Nación, Mexico, Tierras 37, exp. 2.

48. Linné, *El Valle y la Ciudad de México en 1550*.

49. Garritz, "Ejecutoria a favor de don Diego Luis Moctezuma," 34–35.

50. Moyotlan was the most populous *barrio* in the sixteenth and into the early seventeenth century, Torquemada, *Monarquía indiana*, vol. 3, bk. 15, ch. 16, 36; Caso, "Los barrios antiguos de Tenochtitlan y Tlatelolco," 50–59.

51. Gómez Tejada, "Making the 'Codex Mendoza,'" 295–306.

52. Kubler, *Mexican Architecture of the Sixteenth Century*, 190.

53. The Anales de Juan Bautista records that the work was painted in 1566 and put up on the *tecpan* on Easter Sunday, Luis Reyes García, ed. and trans., *¿Cómo te confundes? ¿Acaso no somos conquistados? Anales de Juan Bautista*, 146, 147. The work (or one like it) remained there; Chimalpahin also records such a banner in 1594 in *Annals of His Time*, 49.

54. Reyes García, *Anales de Juan Bautista*, 147.

55. See the discussion of the viceroyal palace in Schreffler, *The Art of Allegiance*, 13.

56. Mendieta, *Historia eclesiástica indiana*, 211.

57. Muriel, "En torno a una vieja polémica," 5. In Bejarano, *Actas de cabildo*, May 2, 1525, the Franciscans are still occupying a seat near the Plaza Mayor; on June 2, 1525, the *cabildo* records mention "San Francisco el Nuevo," on the new site.

CHAPTER 6

1. Diego Valadés, *Rhetorica christiana ad concionandi, et orandi vsvm accommodata, vtrivsq[ue] facvltatis exemplis svo loco insertis . . .*; edition cited: Diego Valadés, *Retórica Cristiana*, trans. Tarsicio Herrera Zapién.

2. Mendieta, *Historia eclesiástica indiana*, bk. 4, ch. 20, 435.

3. Casey, *Remembering*, 48–64.

4. Mendieta, *Historia eclesiástica indiana*, bk. 4, ch. 18, 222.

5. Torquemada, *Monarquía indiana*, vol. 3, bk. 5, ch. 16, 36.

6. Mendieta, *Historia eclesiástica indiana*, bk. 4, ch. 20, 227.

7. Bejarano, *Actas de cabildo*, January 23, 1526.

8. Jaime Lara, *City, Temple, Stage: Eschatological Architecture and Liturgical Theatrics in New Spain*.

9. Mendieta, *Historia eclesiástica indiana*, bk. 4, ch. 20, 434.

10. Ignacio Márquez Rodiles, *La utopía del renacimiento en tierras indígenas de América: Pedro de Gante, Vasco de Quiroga, Bernardino de Sahagún*; Pedro Vásquez Janiero, *Fray Pedro de Gante: El primero y más grande maestro de la Nueva Espana*; Ernesto de la Torre Villar, *Fray Pedro de Gante: Maestro y civilizador de América*; Mendieta, *Historia eclesiástica indiana*, bk. 5, pt. 1, ch. 18, 607–611.

11. See Gante's letter to Charles V in 1532, reproduced in Ernesto de la Torre Villar, *Fray Pedro de Gante: Maestro y civilizador de América*, 79–81.

12. Torre Villar, *Fray Pedro de Gante*, 11.

13. Francisco Morales, "Pedro de Gante (1490–1572)," in *Enciclopédia franciscana*, http://www.franciscanos.org/enciclopedia/pgante.html.

14. In his letter of 1529, Gante says he lived in Tetzcoco for three years, that is, from 1523 to 1526, and after a brief stay in Tlaxcala, went to Mexico City. Thus, he was likely in the city around 1526, right after the time of the refoundation of the monastery. Torre Villar, *Fray Pedro de Gante*, 71–75.

15. John Leddy Phelan, *The Millennial Kingdom of the Franciscans in the New World*.

16. Gante to Philip II, June 23, 1558, reproduced in Torre Villar, *Fray Pedro de Gante*, 105–113; quote from 107.

17. Gante to fellow priests in Flanders, June 27, 1529, reproduced in Torre Villar, *Fray Pedro de Gante*, 71–75; quote from 75 (my translation).

18. Herbert L. Kessler, "Gregory the Great and Image Theory in Northern Europe during the Twelfth and Thirteenth Centuries." Valadés's *Rhetorica christiana* lists Gregory as one of its sources and quotes the pope's writings throughout.

19. Pope Gregory, Epistle 11.56, translated and quoted in George Demacopoulos, "Gregory the Great and the Pagan Shrines of Kent," 388–389.

20. The long-accepted claim that Valadés was the illegitimate son of a conquistador who joined Cortés in the siege of Tenochtitlan and his mother an indigenous noblewoman is rejected by Gerardo Ramírez Leal, "Fray Diego Valadés y los Indios," 12–17.

21. Esteban Palomera, introduction to Valadés, *Retórica Cristiana*, vii–xlviii; Don Paul Abbott, *Rhetoric in the New World: Rhetorical Theory and Practice in Colonial Spanish America*, 45.

22. Valadés, *Retórica Cristiana*, 31.

23. Linda Baez Rubí, *Mnemosine novohispánica: Retórica e imágenes en el siglo XVI*; Frances Yates, *The Art of Memory*.

24. Valadés, *Retórica Cristiana*, 225. In my translation to English, I have modified the Spanish translation of Herrera Zapién with the Latin translation of Caplan, cited below.

25. From English translation by Harry Caplan, *Ad C. Herennium: De ratione dicendi (Rhetorica ad Herennium)*. See also Abbott, *Rhetoric in the New World*.

26. Torquemada, *Monarquía indiana*, vol. 3, frontispiece.

27. Valadés, *Retórica Cristiana*, 237.

28. Valadés, *Retórica Cristiana*, quote on 481.

29. Valadés, *Retórica Cristiana*, 257.

30. *Diccionario de Autoridades* (Madrid: Joachin Ibarra, 1726–1739), 655.

31. Phelan, *The Millennial Kingdom*, 47.

32. Gante to fellow priests in Flanders, June 27, 1529, reproduced in Torre Villar, *Fray Pedro de Gante*, 74.

33. "Estos Mexicanos fueron en esta tierra como en otro tiempo los Romanos" (These Mexicans occupied this country as in another time, the Romans occupied theirs), Motolinia, *Historia de los Indios de Nueva España*, tratado 3, ch. 4, published in Joaquin García Icazbalceta, ed., *Colección de documentos para la historia de México*, 1:180; David A. Lupher, *Romans in a New World: Classical Models in Sixteenth-Century Spanish America*.

34. Demacopoulos, "Gregory the Great," 388–389.

35. Torquemada, *Monarquía indiana*, vol. 1, bk. 3, ch. 26, 313.

36. Francisco Cervantes de Salazar, *Tumulo Imperial de la gran ciudad de México*, fol. 2r. Torquemada, *Monarquía indiana*, vol. 1, bk. 3, ch. 26, 298, writes of the real columns of jasper in Moteuczoma's aviary, which once stood on the spot where the Franciscan monastery was founded, so another possibility is that the jasper columns came from a Mexica building and were repurposed. I thank Byron Hamann for supplying a copy of the *Tumulo Imperial*.

37. Motolinia says that residents began erecting the first indigenous churches around 1530, and in the Códice franciscano, it is this order that takes credit for building them. See Joaquín García Icazbalceta, *Códice franciscano, siglo XVI*; Muriel, "En torno a una vieja polémica."

38. Caso aligns the pre-Hispanic *teocalli* (temples) of San Pablo and San Sebastián with the later churches; he suggests the *teocalli* of

Cuepopan was near present-day San Fernando, and that of San Juan was near the plaza of San Juan. See Caso, "Los barrios antiguos de Tenochtitlan y Tlatelolco," 11, 19, 27, 30. Short of urban excavation, it will be difficult to prove or discredit this claim. See, however, Saúl Pérez Castillo, "La equidistancia de algunos elementos urbanos de origen prehispánico, localizados dentro de los límites que tenían las ciudades de Tenochtitlan y Tlatelolco."

39. Romero Galván, "La ciudad de México." The other minor basilicas are San Lorenzo and Santa Cruz de Jerusalem. Other sites in the early city were soon given these "leftover" names. A church of San Lorenzo appears in the city in the 1530s adjacent to the *tianguis*, but disappears from that site, to reappear as the leper hospital on the eastern side of the city in the 1580s.

40. García Icazbalceta, "Historia de los Mexicanos," 3:248; see also Luis Chávez Orozco, ed., *Códice Osuna: Reproducción facsimilar de la obra*, 48.

41. Other writers have argued for the precedence of Jerusalem, which was undoubtedly a general model used throughout New Spain. Antonio Rubial García, "Civitas Dei," 34.

42. Romero Galván, "La ciudad de México," 13–32; Moreno de los Arcos, "Los territoriales parroquiales de la Ciudad Arzobispal." While Moreno de los Arcos assigned colors, year signs, and deities to the four parts of the city, drawing from a generic central Mexican template, his particular associations are not corroborated by any Mexica source on the city.

43. González González, "La ubicación e importancia del Templo de Xipe Tótec."

44. Mendieta, *Historia eclesiástica indiana*, bk. 5, pt. 1, ch. 19, 611; life of Hernando de Tapia to be found in Pérez-Rocha and Tena, *La nobleza indígena*, 40.

45. Bejarano, *Actas de cabildo*, July 31, 1528.

46. Lira González, *Comunidades indígenas*, 42–43, 316–319.

47. That Moyotlan had two patron saints is confirmed in Archivo General de la Nación, Mexico, Indios 344, fol. 96, which also discusses other locally important feasts.

48. Joaquín Montes Bardo, *Arte y espiritualidad franciscana en la Nueva España, siglo XVI: Iconología en la provincia del Santo Evangelio*, 247–248.

49. Chávez Orozco, *Códice Osuna*, 48: "Los dias de San Pedro y San Pablo, que es la vocación del dicho barrio" (The [feast] days of Saint Peter and Saint Paul, which is the devotion of the neighborhood). The source document is Archivo General de la Nación, Mexico, Civil 644. However, this appellation does not survive in midcentury documents, where it is simply called San Pablo.

50. Caso, "Los barrios antiguos de Tenochtitlan y Tlatelolco," 50–59, gives tributary population counts for early seventeenth-century *tlaxilacalli*. Torquemada, *Monarquía indiana*, vol. 3, bk. 15, ch. 16, 36, also names it as the most populous of the four parts in the 1520s.

51. Torquemada, *Monarquía indiana*, vol. 1, bk. 3, ch. 26, 300, writing ca. 1605, describes this as "new." He also mentions the causeway containing an aqueduct built to bring water from Chapultepec, whose construction is discussed in chapter 9.

CHAPTER 7

Material in this chapter was adapted from Barbara E. Mundy, "Place-Names in Mexico-Tenochtitlan," *Ethnohistory* 61, no. 2 (Spring 2014): 329–355.

1. Roberto L. Mayer, "Trasmonte y Boot: Sus vistas de tres ciudades mexicanas en el siglo XVII."

2. According to Whittaker, "The city name might seem to have several possible etymologies, but only one works well: an assimilated form of *me:tz-xic-co*, meaning 'in (-co) the centre (xic-; literally, navel) of the moon (me:tz-). The exact equivalent is found in Otomi for the Aztec capital. And we know that a *cc* cluster can become 'c (hc) in Nahuatl dialect. Cf. *tt: itta* 'see', which is now *i'ta* (ihta) in most dialects. So the Mexica are not so much the people of Mexi (even if they liked this folk etymology) as the people from the centre of the moon (lake = Metztliapan, today Lake Texcoco)." Personal communication, 2012.

3. On shifts in toponymy, see Gordon Whittaker, "The Study of North Mesoamerican Place-Signs," 18–20.

4. Bejarano, *Actas de cabildo*, June 7, 1529. The word "ciudad" was often spelled "cibdad" in the sixteenth century.

5. The network of *ciudad/pueblo* preserved the indigenous geopolitics, in part, as important indigenous centers (Cholula, Tlaxcala) were granted the title of "ciudad," although in Velasco's text the term "pueblo de indio" is affixed. In this network were the emergent network of "ciudades de españoles" (México, Puebla), whose Spanish populations, although often dwarfed by indigenous counterparts, heavily counted toward their city status. See Juan López de Velasco, *Geografía y descripción universal de las Indias*, 2nd pt., 186.

6. Certeau, *The Practice of Everyday Life*, 91–110.

7. Bejarano, *Actas de cabildo*, June 17, 1549.

8. Gibson, *The Aztecs under Spanish Rule*, 32.

9. Charles Gibson, *Tlaxcala in the Sixteenth Century*, 165.

10. Reyes García, Celestino Solís, and Valencia Ríos, *Documentos nahuas de la Ciudad de México*.

11. George Kubler, "The Name Tenochtitlan," surveys the Spanish literature, but Kubler did not have access to the Nahuatl corpus.

12. Tezozomoc, *Crónica mexicayotl*, 76.

13. Valero de García Lascuráin, *Los códices de Ixhuatepec*, 46.

14. Tenochtitlan held a number of off-island properties through the colonial period. Gibson, *The Aztecs under Spanish Rule*, 47.

15. Tezozomoc, *Crónica mexicayotl*, 3, 5.

16. Reyes García, Celestino Solís, and Valencia Ríos, *Documentos nahuas de la Ciudad de México*, 84.

17. British Museum Mss. Cat. Add. 13994. Many place-names were written down as part of the names of different chapels in the city by the religious chronicler Agustín de Vetancourt, whose interest was in documenting Catholic parishes in his contemporary city. That he knew so many of them in a book published in 1698 signals their endurance nearly two centuries after the Conquest. Vetancourt, *Teatro mexicano*, pt. 4, tratado 2, 42–43.

18. For more on the relation between the Caso and Alzate maps, see Barbara E. Mundy, "Place-Names in Mexico-Tenochtitlan."

19. Calnek, "Tenochtitlan-Tlatelolco"; Truitt, "Nahuas and Catholicism in Mexico Tenochtitlan."

20. The evolution of this government is treated in Connell, *After Moctezuma*, 13–21.

21. The text reads "Ca yn nehoatl don Balthazar Tlilancalqui yoan nonamic Juana Tlaco tichaneque yn inpan in ciudad Mexico Sanctiago Tlatilulco totlaxilacaltia Sancta Ana Xopilco." My translation; the document is Archivo General de la Nación, Mexico, Tierras 49, exp. 5, and is reproduced with Spanish translation in Reyes García, Celestino Solís, and Valencia Ríos, *Documentos nahuas de la Ciudad de México*, 187.

22. Reyes García, Celestino Solís, and Valencia Ríos, *Documentos nahuas de la Ciudad de México*, 201, 80, 93.

23. R. Joe Campbell, *A Morphological Dictionary of Classic Nahuatl*, 61–62.

24. I have been unable to find evidence of public rogations, or circumambulations, that would have defined the boundaries of the *tlaxilacalli* within the urban fabric.

25. Victor M. Castillo Farreras, "Unidades nahuas de medida."

26. Hanns J. Prem, "Aztec Writing"; Gordon Whittaker, "The Principles of Nahuatl Writing," 48–49, 52.

27. Gordon Whittaker, "Nahuatl Hieroglyphic Writing and the Beinecke Map," 138. An exception might be the chalice of Saint John the Evangelist, which is usually shown

containing a serpent, but in Genaro García 30 is shown with a winged serpent.

28. While Nahuatl had long and short vowels, the pictographic writing system ignored them. Thus "pāmitl" (banner), with its long *a*, could be used as a phoneme for "pan" (upon), with a short *a*.

29. Tezozomoc, *Crónica mexicayotl*, 61.

30. The *residencia* of Guzmán is mentioned in Chimalpahin, *Codex Chimalpahin*, 2:177, and in Tezozomoc, *Crónica mexicayotl*, 175.

31. Rousseau, quoted in Jacques Derrida, *Of Grammatology*, trans. Gayatri Chakravorty Spivak, 27; Saussure discussed in "Linguistics and Grammatology," in *Of Grammatology*, 27–73; Derrida, *Of Grammatology*, 41, 52.

32. Derrida develops a related set of ideas in "The End of the Book and the Beginning of Writing," in *Of Grammatology*, 6–26.

33. Sahagún, *Florentine Codex*, bk. 9, esp. chs. 14–19, pp. 63–85.

34. This translation found in Chimalpahin, *Codex Chimalpahin*, 1:173. Many indigenous leaders of central Mexico joined Antonio de Mendoza in this campaign against the Chichimecs. See Joaquín García Icazbalceta, ed., "Relacion de la jornada de don Francisco de Sandoval Acazitli," in *Colección de documentos para la historia de México*, 2:307–332.

35. Epidemics summarized in Peter Gerhard, *Geografía histórica de la Nueva España 1519–1821*, trans. Stella Mastrangelo, 23.

36. Alonso de Zorita, *Life and Labor in Ancient Mexico: The Brief and Summary Relation of the Lords of New Spain*, ed. and trans. Benjamin Keen, 212.

37. Acuña-Soto et al., "Megadrought and Megadeath in 16th Century Mexico."

38. Bejarano, *Actas de cabildo*, June 21, 1546.

39. Ruiz Medrano, *Reshaping New Spain*.

40. See the discussion in Castañeda de la Paz, "Sibling Maps, Spatial Rivalries."

41. According to María Castañeda de la Paz, from 1551 indigenous lords were obliged to pay the laborers who worked their lands (personal communication, 2009). The shift in support is detailed by Gibson, *The Aztecs under Spanish Rule*, 185–188.

42. See, for instance, Bejarano, *Actas de cabildo*, November 11, 1533. This case is to be found in Archivo General de la Nación, Mexico, Tierras 35, exp. 2, and is an earlier lawsuit folded into a later one.

43. The career of Tejada is covered in Ruiz Medrano, *Reshaping New Spain*. A *juicio de residencia* is to be found in Archivo General de Indias, Seville, Justicia 260.

44. Archivo General de la Nación, Mexico, Tierras 35, exp. 2, fol. 62.

45. Bejarano, *Actas de cabildo*, July 19, 1549.

46. Woodrow Wilson Borah, *Justice by Insurance: The General Indian Court of Colonial Mexico and the Legal Aides of the Half-Real*.

47. The text reads: "El dicho don Diego tiránicamente con poco temor de Dios nuestro señor nos las quito por fuerza, algunos echando en la cárcel, a otros desterrados y otros dándoles tormentos y otras muchas molestias." Codex Cozcatzin, fol. 9v. The Codex Cozcatzin has been published by Ana Rita Valero de García Lascuráin in *Los códices de Ixhuatepec: Un testimonio pictográfico de dos siglos de conflicto agrario*. Some historians have mistakenly said the complaint was filed against the governor of Tlatelolco, but if this were the case, the complainants would have identified themselves as from Tlatelolco, not Mexico. The correct attribution is to be found in López Mora, "El cacicazgo de Diego de Mendoza Austria y Moctezuma," 232. The group of documents is also discussed by Castañeda de la Paz, "Filología de un 'Corpus' pintado."

48. Castañeda de la Paz, "Historia de una casa real," 14, names Dionosio as being from San Pablo. Chimalpahin, *Annals of His Time*, 301, says Tehuetzquititzin is from San Pablo.

49. Bernardino de Sahagún, *Primeros memoriales*, trans. Thelma Sullivan, facsimile, 55v; Eduard Seler, "Ancient Mexican Attire and Insignia of Social and Military Rank," 3:3–61, esp. 5–16.

50. Durán, *History*, 124.

51. Zorita, *Life and Labor in Ancient Mexico*, 188–189.

52. Connell, *After Moctezuma*, 22–54.

53. Chávez Orozco, *Códice Osuna*, 48, III. The source is Archivo General de la Nación, Mexico, Civil 644.

54. For instance, the daughter of don Andrés de Tapia Motelchiuhtzin, the *gobernador* of Mexico from 1526 to 1530, married the native *gobernador* of Izcuincuitlapilco, a town to the south of Actopan, Hidalgo. Archivo General de la Nación, Mexico, Tierras 46, exp. 4.

55. Reproduced in Pérez-Rocha and Tena, *La nobleza indígena*, 199–200.

56. The Codex Aubin notes that Guzmán "habrían de investigar a don Diego" (would have to investigate don Diego [Tehuetzquititzin]), Dibble, *Códice Aubin*.

57. Guzmán appears in the ruler list of the Plano Parcial de la Ciudad de México; the Codex Aubin notes his accession, as does the Tira de Tepechpan. Lori Boornazian Diel, *Tira de Tepechpan: Negotiating Place under Aztec and Spanish Rule*.

58. Pilar Arregui Zamorano, *La Audiencia de México según los visitadores, siglos xvi y xvii*; Gerónimo Valderrama, "Cartas del licenciado Jerónimo Valderrama y otros documentos

sobre su visita al gobierno de Nueva España, 1563–1565."

59. The Codex Osuna, created under the auspices of the native *cabildo* and governors, shows them at their best; Cortés Alonso, *Pintura del gobernador, alcaldes y regidores de México: Códice Osuna*. Complaints by the native community that Guzmán's reforms were never carried out are alluded to in Archivo General de la Nación, Mexico, Civil 644, reproduced in Chávez Orozco, *Códice Osuna*, 13, 47, 49, 56.

60. Escalante Gonzalbo, *Los Códices mesoamericanos*, 286–292.

61. Cortés Alonso, *Pintura del gobernador, alcaldes y regidores de México: Códice Osuna*, fol. 9v.

62. Pérez-Rocha and Tena, *La nobleza indígena*, 192.

63. These monies would directly benefit the church, rather than, as was the existing case, having Indians pay tribute to the Crown, from which funds to support the Crown were extracted. The native position is clear: tithing would have been an addition to their tax burden. Also, the mendicants, headed by the Augustinian theologian Alonso de Vera Cruz, argued vociferously to the king that the collection of tithes would destroy native faith in the church. Magnus Lundberg, *Unification and Conflict: The Church Politics of Alonso de Montúfar, O.P., Archbishop of Mexico, 1554–1572*, 155. Guzmán certainly knew of these disputes—Vera Cruz preached publicly on the danger of tithes, and the native leaders themselves were asked for their opinions on the matter by the Crown in 1556. Their responses are in Archivo General de la Nación, Mexico, Justicia 160, cited in Lundberg. The tithes seem not to have been imposed. Lundberg, *Unification and Conflict*, 158–159.

64. Pérez-Rocha and Tena, *La nobleza indígena*, 191–200.

65. On sweeping, see Louise M. Burkhart, *The Slippery Earth: Nahua-Christian Moral Dialogue in Sixteenth-Century Mexico*, 117–125.

66. Mendieta, *Historia eclesiástica indiana*, bk. 4, ch. 18, 429.

67. George Kubler points out the sacred and ritual nature of building activities, giving the construction of the *tecpan* at Santiago Tlatelolco as an example: "Using the symbols and expressions of Christianity, the Indians attempted to identify their work with religious behavior." Kubler, *Mexican Architecture of the Sixteenth Century*, 1:157. The construction of the Mexico City *tecpan* was punctuated by similar rituals. See Reyes García, *Anales de Juan Bautista*, 155.

68. Archivo General de la Nación, Mexico, Tierras 37, exp. 2. I thank Edward Calnek for bringing this document to my attention.

69. The Codex Cozcatzin tells us that the *tecpan* was built under don Esteban de Guzmán, but I suspect this late text refers to a rebuilding of the structure. Valero de García Lascuráin, *Los códices de Ixhuatepec*, 126.

70. A similar reading of the space of the flat page as hierarchical levels is to be found in Codex Vaticanus A (also known as Codex Ríos). Pedro de los Ríos, *Codex Vaticanus 3738 der Biblioteca apostolica Vaticana: Farbreproduktion des Codex in verkleinertem Format*, fols. 1v–2r.

71. Zorita, *Life and Labor in Ancient Mexico*, 116–117; complaint about the poverty of "natural" lords on 198.

72. Wiebke Ahrndt, "Alonso de Zorita: Un funcionario colonial de la Corona española," in Alonso de Zorita, *Relación de la Nueva España*, ed. Ethelia Ruiz Medrano, Wiebke Ahrndt, and José Maríano Leyva; Ethelia Ruiz Medrano, "Proyecto político de Alonso de Zorita, oidor en México," in Zorita, *Relación de la Nueva España*.

73. Chávez Orozco, *Códice Osuna*, 43.

74. Chávez Orozco, *Códice Osuna*, 116–117.

75. *Lienzo de Tlaxcala*, 2:15.

76. Reyes García, *Anales de Juan Bautista*, 214–217.

77. Mendieta, *Historia eclesiastica indiana*, bk. 4, ch. 18, 429.

CHAPTER 8

Material in this chapter was adapted from Barbara E. Mundy, "Indigenous Dances in Early Colonial Mexico City," in *Festivals and Daily Life in the Arts of Colonial Latin America, 1492–1850*, edited by Donna Pierce (Denver: Denver Art Museum, 2014), 11–30.

1. Pérez-Rocha and Tena, *La nobleza indígena*, 253–255; Chávez Orozco, *Códice Osuna*, 49.

2. Certeau, *The Practice of Everyday Life*, 91–110.

3. Robert Darnton, *The Great Cat Massacre: And Other Episodes in French Cultural History*, 120.

4. Bejarano, *Actas de cabildo*, June 10, 1533.

5. Archivo General de la Nación, Mexico, Civil 708, exp. 4; the order of the guilds is revisited almost a century later in Archivo General de la Nación, Mexico, Indiferente Virreinal, caja 5283, exp. 72.

6. Francisco de Barrio Lorenzot, *Ordenanzas de gremios de la Nueva España*, ed. G. Estrada.

7. Mendieta, *Historia eclesiástica indiana*, bk. 4, chs. 18–20.

8. José Alcina Franch, "Juan de Torquemada, 1564–1624," 267.

9. Mendieta, *Historia eclesiástica indiana*, bk. 4, ch. 19, 434 (first two quotations); bk. 4, ch. 21, 436.

10. Sahagún, *Florentine Codex*, bk. 2, ch. 27, 92–93; Inga Clendinnen, *Aztecs: An Interpretation*, 66–67.

11. Mendieta, *Historia eclesiástica indiana*, bk. 4, ch. 17, 423–424.

12. It was an obligation they tried to escape; Archivo General de la Nación, Mexico, Compañia de Jesús I-14, exp. 414, fols. 2032–2033.

13. Mendieta, *Historia eclesiástica indiana*, bk. 4, ch. 20, 437.

14. Mendieta, *Historia eclesiástica indiana*, bk. 4, ch. 20, 435.

15. Mendieta, *Historia eclesiástica indiana*, bk. 4, ch. 12, 404.

16. Motolinia, *Historia de los indios de la Nueva España*, tratado 1, ch. 15, 61.

17. Mendieta, *Historia eclesiástica indiana*, bk. 4, ch. 12, 405.

18. Reyes García, *Anales de Juan Bautista*, 320–321.

19. Mendieta, *Historia eclesiástica indiana*, bk. 4, ch. 12, 406.

20. Truitt, "Nahuas and Catholicism in Mexico Tenochtitlan," 180–182; on Soledad, 190; Mendieta, *Historia eclesiástica indiana*, bk. 4, ch. 21, 436–437. Motolinia, writing in the late 1530s, discusses the *cofradía* of Veracruz, which counted men and women as its members. Motolinia, *Motolinía's History of the Indians of New Spain*, 113; Barry D. Sell, Larissa Taylor, and Asunción Lavrin, *Nahua Confraternities in Early Colonial Mexico: The 1552 Nahuatl Ordinances of Fray Alonso de Molina, OFM*.

21. Mendieta, *Historia eclesiástica indiana*, bk. 4, ch. 19, 431. See also Pedro Oroz, *The Oroz Codex: The Oroz Relation, or Relation of the Description of the Holy Gospel Province in New Spain, and the Lives of the Founders and Other Noteworthy Men of Said Province, Composed by Fray Pedro Oroz, 1584–1586*, ed. and trans. Angelico Chavez.

22. Chimalpahin, *Annals of His Time*, 60–61.

23. Rosario Inés Granados Salinas, "Mexico City's Symbolic Geography: The Processions of Our Lady of Remedios."

24. Mendieta, *Historia eclesiástica indiana*, bk. 4, ch. 20, 437.

25. Halbwachs, *On Collective Memory*. The idea presents a contradiction: how can memory transcend or escape its normal seat within individual consciousness to become something shared *among* individuals—that is, an intrapsychic phenomenon? The philosopher Edward Casey offers a solution in his discussion of commemoration: "On the psychoanalytic paradigm, to be mental or psychical at all is to arise from identifications with others. However unconscious they may be, memories of these identifications will be commemorative of these same others by furnishing inward memorials of them and of the acts by which identifications were first formed. Far from being exceptional, such memories come to provide the memorial infrastructure of the mind itself; taken together, they at once reflect and further the mind's own inherent alterity." Casey, *Remembering*, 244.

26. Casey, *Remembering*, 218–219.

27. Connerton, *How Societies Remember*.

28. Halbwachs, *On Collective Memory*, 88.

29. Chimalpahin, *Annals of His Time*, 43.

30. Reyes García, *Anales de Juan Bautista*, 142–143.

31. The royal government, no doubt pushed by the city's religious orders, attempted to ban the *tianguis* on Sunday and on feast days so that the city's indigenous people would show up at church. Archivo General de la Nación, Mexico, Indios 6, 2nd pte., exp. 1063, fol. 289.

32. González Aparicio, *Plano reconstructivo*.

33. Ana Lorenia García, "Parroquia de la Santa Veracruz," in Ruiz, *Arquitectura religiosa de la ciudad de México*, 237.

34. Acuña, "Descripción de la ciudad y provincia de Tlaxcala," in *Relaciones geográficas del siglo XVI*, 4:253.

35. Chimalpahin, *Annals of His Time*, 81.

36. Mendieta, *Historia eclesiástica indiana*, bk. 4, ch. 21, 436–437.

37. Archivo General de la Nación, Mexico, Indios 6, 1st pt. exps. 341 and 344, quote from fol. 96r; Jacqueline Holler, "Conquered Spaces, Colonial Skirmishes: Spatial Contestation in Sixteenth-Century Mexico City."

38. The acquisition of bells was a signal distinction for the city's indigenous parishioners. Tlatelolco's bells are recorded as being a gift from their *gobernador*, don Diego de Mendoza, in the *Códice de Tlatelolco*. Xavier Noguez and Perla Valle, *Códice de Tlatelolco*, fol. 1.

39. Anthony Aveni, "Aztec Astronomy and Ritual," 155–156.

40. Motolinia, *Motolinía's History of the Indians of New Spain*, 141.

41. Barbara E. Mundy, "Moteuczoma Reborn: Biombo Paintings and Collective Memory in Colonial Mexico City."

42. For Sahagún's life and work, see Miguel León Portilla, *Bernardino de Sahagún, First Anthropologist*; John Frederick Schwaller, ed., *Sahagún at 500: Essays on the Quincentenary of the Birth of Fr. Bernardino de Sahagún*.

43. A study awaits of the indigenous politics behind this secularization, including the role of the powerful Tapia family, descendants of Motelchiuhtzin (r. 1526–1530), whose paterfamilias, Hernando de Tapia, an interpreter for the *audiencia*, lived in the *barrio* and was buried in San Pablo after his death around 1555. His will is to be found in Archivo General de la Nación, Mexico, Tierras 37, exp. 2, 78v–94v.

I thank Edward Calnek for bringing this to my attention.

44. Gerhard, *Geografía histórica de la Nueva España*, 22–26.

45. Mendieta, *Historia eclesiástica indiana*, bk. 4, ch. 20, 435.

46. Starting in the 1550s, the viceroy mandated that *repartimiento* workers be paid a daily wage, but as Gibson shows, these wages were a fraction of those offered on the free market. Gibson, *The Aztecs under Spanish Rule*, 249–252.

47. Gibson, *The Aztecs under Spanish Rule*, 121, 123.

48. For Otomí residence, see Vetancourt, *Teatro mexicano*, pt. 4, tratado 2, 43. Zapotec presence in the city may have been diffuse; they are discussed in Matthew D. O'Hara, *A Flock Divided: Race, Religion, and Politics in Mexico, 1749–1857*. See also Archivo General de la Nación, Mexico, Indios 11, exp. 122.

49. Ana Lorenia García, "Santa María la Redonda," in Ruiz, ed., *Arquitectura religiosa de la ciudad de México*, 233.

50. While *cihuatlampa* is translated as "west" in Alonso de Molina's *Vocabulario* of 1571, the same source translates *sur* (south) into the Nahuatl as "cihuatlampa" and "huitztlampa." That *cihuatlampa* could be both "south" and "west" signals that Nahua directions were not as neat as the points on the Western compass (east–west, that is) and that the direction of the setting sun, which can be to the west or toward the south, depending on the season, might have been a direction. Molina, *Vocabulario*.

51. José María Marroqui, *La Ciudad de México, contiene el origen de los nombres de muchas de sus calles y plazas . . .* , 2:496–497.

52. This procession was at that moment a loaded one, as the *cabildo* had implicitly supported the overthrow of the Spanish monarchy in favor of local rule under Luis Cortés and the Ávila brothers, so their civic ritual carried a seditious taint. Lesley Byrd Simpson, *Many Mexicos*, 119–126. Barbara E. Mundy, "Crown and Tlatoque: The Iconography of Rulership in the Beinecke Map," in Miller and Mundy, *Painting a Map of Sixteenth-Century Mexico City*. Ethelia Ruiz Medrano, "Fighting Destiny: Nahua Nobles and Friars in the Sixteenth-Century Revolt of the Encomenderos against the King," in Ruiz Medrano and Kellogg, *Negotiation within Domination*, 45–77.

53. Alonso de Montúfar, *Descripción del arzobispado de México hecha en 1570 y otros documentos*, ed. Luís García Pimentel, 271.

54. Account comes from Montúfar, *Descripción del arzobispado de México*.

55. Robert Ricard, *The Spiritual Conquest of Mexico: An Essay on the Apostolate and the Evangelizing Methods of the Mendicant Orders in New Spain, 1523–1572*, trans. Lesley Byrd Simpson, 251, puts battles on the streets of Mexico City in the context of the larger fight between religious and seculars. See also Lundberg, *Unification and Conflict*.

56. Bejarano, *Actas de cabildo*; Perla Valle, "La Lámina VIII del Códice de Tlatelolco. Una propuesta de lectura." The discussion of the *mitotes* in the Tlatelolco Codex is adapted from Barbara E. Mundy, "Indigenous Dances in Early Colonial Mexico City," in Donna L. Pierce, ed., *Festivals and Daily Life in the Arts of Colonial Latin America: Papers from the 2012 Mayer Center Symposium at the Denver Art Museum*.

57. Whittaker, "Nahuatl Hieroglyphic Writing and the Beinecke Map," 138.

58. Chávez Orozco, *Códice Osuna*, 137.

59. Noguez and Valle, *Códice de Tlatelolco*.

60. Francisco Cervantes de Salazar, *Crónica de la Nueva España*, ed. Manuel Magalón, vol. 1, book 4, ch. 7, 315.

61. Castañeda de la Paz, "Filología de un 'corpus' pintado," 79.

62. The presence of Tlacopan's ruler at the *jura* is evidence of his loyalty to the Crown and was later invoked in a request to the Crown for exemption from tribute. Archivo General de las Indias, Seville, Justicia, leg. 1029, no. 10, discussed in Amos Megged, "Cuauhtémoc´s Heirs," 363–364. The presence of these same four rulers also appears in Bejarano, *Actas de cabildo*, June 4, 1557.

63. The base element of the Tlatelolco Codex looks like a headpiece, and many pages of the Codex Mendoza show similar feathered ensembles as if headdresses (see for instance, fols. 24r, 26r, 28r, 30r, 32r, 34r, 37r, 40r, 43r, 45r, 49r, 52r, and 54r), but fols. 23r and 65r show them as back elements, and the Florentine Codex also suggests that the *quetzalpatzactli* was worn on the back; Sahagún, *Florentine Codex*, bk. 8, ch. 12, pp. 33–35. See the recent discussion of the famous feather headdress of Moteuczoma in Sabine Haag et al., eds., *El Penacho del México Antiguo*.

64. Durán, *History*, 321–322, 405–406.

65. Karttunen, *An Analytical Dictionary of Nahuatl*, allows for *i'totiliztli* for "a dance," but the attested forms in both Molina and Sahagún are another nominative form, *mototiliztli*. See Molina, *Vocabulario*, and R. Joe Campbell, *Florentine Codex Vocabulary*.

66. Mendieta, *Historia eclesiástica indiana*, bk. 2, ch. 31, 140.

67. Anderson, *Bernardino de Sahagún's "Psalmodia Christiana,"* xvii–xxv.

68. Motolinia, *Motolinía's History of the Indians of New Spain*, 141.

69. Mendieta, *Historia eclesiástica indiana*, bk. 2, ch. 32, 142–143.

70. Miguel León Portilla, "La música en el universo de la cultura náhuatl."

71. Sahagún, *Florentine Codex*, bk. 9, ch. 20, 91, 92 (quotation).

72. Justyna Olko, *Turquoise Diadems and Staffs of Office: Elite Costume and Insignia of Power in Aztec and Early Colonial Mexico*.

73. Cervantes de Salazar, *Crónica de la Nueva España*, 1:135.

74. See Linda Ann Curcio-Nagy, *The Great Festivals of Colonial Mexico City*.

75. Jeanette Favrot Peterson, *The Paradise Garden Murals of Malinalco: Utopia and Empire in Sixteenth-Century Mexico*, 93; Sahagún, *Florentine Codex*, bk. 11, ch. 7, para. 10, 208, and bk. 9, fol. 30v. An image of the flower, in bk. 9, fol. 30v, appears in the Florentine Codex online at http://www.wdl.org/en/item/10096/zoom/#group=2&page=682&zoom=1.0793¢erX=0.6908¢erY=0.7468.

76. The Anales de Juan Bautista also reports the use of military ware for the dances. Reyes García, *Anales de Juan Bautista*, 164–165.

77. Durán, in his *History*, describes the elaborate feathered costumes that elite warriors wore into the field of battle, writing that they were "clothed head to foot with all the richness conceivable," 184.

78. Sahagún, *Florentine Codex*, bk. 9, ch. 2, 6.

79. Chávez Orozco, *Códice Osuna*, 14–15.

80. Archivo General de la Nación, Inquisition 303, exp. 54, describes the bishop's banning of a "baile de indios" (dance of the Indians) called the *tumteleche* for its idolatrous connections. Anderson, *Bernardino de Sahagún's "Psalmodia Christiana,"* xviii, summarizes ecclesiastical prohibitions.

81. Gibson, *The Aztecs under Spanish Rule*, 250.

82. Chávez Orozco, *Códice Osuna*, 35.

83. Chávez Orozco, *Códice Osuna*, 36.

84. Archivo General de la Nación, Mexico, Indios 1, exp. 11.

85. Castañeda de la Paz, "Sibling Maps, Spatial Rivalries," 53–74.

86. Chimalpahin, *Annals of His Time*, 66–67.

87. Mendieta, *Historia eclesiástica indiana*, bk. 2, ch. 32, 141–142.

88. Chávez Orozco, *Códice Osuna*, 87.

89. Chávez Orozco, *Códice Osuna*, 82, names him as a "resident of San Juan" when he was *alcalde* in 1556.

90. Reyes García, *Anales de Juan Bautista*, 196–197.

91. Pérez-Rocha and Tena, *La nobleza indígena*, 253–255.

92. Arregui Zamorano, *La Audiencia de México según los visitadores*, 74–75.

93. Mendieta, *Historia eclesiástica indiana*, bk. 4, ch. 36, 515.

94. Reyes García, *Anales de Juan Bautista*, 213, 214–215.

95. Reyes García, *Anales de Juan Bautista*, 216.

96. María Justina Sarabia Viejo, *Don Luis de Velasco, virrey de Nueva España, 1550–1564*; Ernesto de la Torre Villar, "Apuntamientos en torno de la administración pública y gobierno civil y eclesiástico en el siglo XVII," 250, confirms that Valderrama removed Luis de Villanueva Zapata and Vasco de Puga; they appealed to the Council of the Indies and were eventually reinstated; also see Arregui Zamorano, *La Audiencia de México*, 74–80. In 1560 the *audiencia* had six members (Zorita, Villalobos, Orozco, Vasco de Puga, Ceynos, and Villanueva)—the desired number seems to have been eight. See Ralph H. Vigil, *Alonso de Zorita: Royal Judge and Christian Humanist, 1512–1585*, 179. Reyes García, *Anales de Juan Bautista*, 135, also mentions that Villanueva and Puga were stripped of their staffs of office in January 1566.

97. Reyes García, *Anales de Juan Bautista*, 319.

CHAPTER 9

1. Reconstructed from Bejarano, *Actas de cabildo*, June 28, 1575.

2. Mendieta, *Historia eclesiástica indiana*, bk. 4, ch. 15, 416.

3. Chimalpahin, *Annals of His Time*, 140–141.

4. Cervantes de Salazar, *Life in the Imperial and Loyal City of Mexico*, 62.

5. Castañeda de la Paz, "Historia de una casa real." Chimalpahin, *Annals of His Time*, 192–193, gives Valeriano's wife's name.

6. Chávez Orozco, *Códice Osuna*, 117.

7. Bejarano, *Actas de cabildo*, June 28, 1575.

8. "Cargas" are specified in the indigenous complaint that comprises the Codex Osuna. Cortés Alonso, *Pintura del gobernador, alcaldes y regidores de México: Códice Osuna*. In that document of 1564, lime is valued at 4 *pesos*, 3 *tomines* per *cahiz*; a decade later, the *cabildo* pays anywhere from 4.5 to 5 *pesos* per *cahiz*. See Bejarano, *Actas de cabildo*, December 23, 1580; December 30, 1580.

9. Figures taken from Bejarano, *Actas de cabildo*, 1575–1583.

10. José Luis Bribiesca Castrejón, "El agua potable en la Republica Mexicana"; Raquel Pineda Mendoza, *Origen, vida y muerte del acueducto de Santa Fe*.

11. The framed cartouche that appears above was probably an addition made to create a fictional genealogy for the Mendoza Austria y Moctezuma family, who commissioned the work as part of their claim of the *cacicazgo* of Tlatelolco. See Castañeda de la Paz, "Filología de un 'Corpus' pintado." The Codex Cozcatzin has been published by García Lascuráin in *Los códices de Ixhuatepec*.

12. Richard Everett Boyer, "Mexico City and the Great Flood: Aspects of Life and Society, 1629–1635."

13. Bejarano, *Actas de cabildo*, October 5, 1537; July 5, 1541. The street that ran westward from San Francisco was still under construction in 1546; see entry for June 17, 1546.

14. Bejarano, *Actas de cabildo*, May 16, 1542; April 20, 1545.

15. It was the drought that led people of the valley to make offerings on Mount Tlaloc around 1539, which was revealed during the trial of don Carlos Ometochtzin. León García Garagarza, "The 1539 Trial of Don Carlos Ometochtli and the Scramble for Mount Tlaloc."

16. Bejarano, *Actas de cabildo*, January 10, 1539; October 27, 1533.

17. Boyer, "Mexico City and the Great Flood," 17–20.

18. Archivo General de las Indias, Seville, Patronato 181, reproduced in Emma Pérez-Rocha, *Ciudad en peligro: Probanza sobre el desagüe general de la ciudad de México*, 36 (fol. 994r); Martín Suchipanecatl blamed the odor for the *cocoliztli* epidemic, 52 (fol. 1002v).

19. Pérez-Rocha, *Ciudad en peligro*, 36 (Archivo General de las Indias, Seville, Patronato 181, fol. 994r). See also the analysis in Rojas Rabiela, "Obras hidráulicas coloniales." The long-term *desagüe* project—to drain the lakes entirely—is discussed in Vera Candiani, "The Desagüe Reconsidered: Environmental Dimensions of Class Conflict in Colonial Mexico."

20. Bejarano, *Actas de cabildo*, July 3, 1528; January 18, 1574.

21. Archivo General de la Nación, Mexico, Indiferente Virreinal, caja 6311, exp. 15, fols. 1r–3r; Bejarano, *Actas de cabildo*, May 15, 1598.

22. Bejarano, *Actas de cabildo*, April 3, 1527; June 6, 1542. The canal is referred to by the old designation of San Lázaro, also used for the Tianguis of Mexico since the church of San Lázaro once stood there.

23. Bejarano, *Actas de cabildo*, March 1, 1543; January 12, 1573.

24. Bejarano, *Actas de cabildo*, July 21, 1525.

25. Sasso Guardia, "El acueducto prehispánico de Chapultepec"; Cabrera C., "Informe de las excavaciones."

26. For example, Bejarano, *Actas de cabildo*, October 12, 1528, and February 14, 1530.

27. Bejarano, *Actas de cabildo*, January 21, 1532.

28. Bejarano, *Actas de cabildo*, April 24, 1564.

29. Pineda Mendoza, *Origen, vida y muerte*, 52–53, argues that the city was able to acquire the land by 1564.

30. Bejarano, *Actas de cabildo*, August 25, 1564; on the Tejada empire, see Ruiz Medrano, *Reshaping New Spain*.

31. Bejarano, *Actas de cabildo*, August 12, 1527.

32. Bejarano, *Actas de cabildo*, August 25, 1564.

33. Payment, for "aceite and estopa," Bejarano, *Actas de cabildo*, March 8, 1565; arrival on September 30, 1566.

34. Bejarano, *Actas de cabildo*, January 17, 1567.

35. See Luis de Castilla's complaint in Bejarano, *Actas de cabildo*, July 12, 1566.

36. Bejarano, *Actas de cabildo*, May 26, 1570.

37. Bejarano, *Actas de cabildo*, December 7, 1571.

38. Pineda Mendoza, *Origen, vida y muerte*.

39. Cost is from Pineda Mendoza, *Origen, vida y muerte*, 108; on the failure, see 109–121. Bejarano, *Actas de cabildo*, August 21, 1573.

40. Pineda Mendoza, *Origen, vida y muerte*, 121–126.

41. Bejarano, *Actas de cabildo*, October 19, 1573; November 11, 1573.

42. Bejarano, *Actas de cabildo*, December 31, 1565.

43. Archivo General de la Nación, Mexico, Indiferente Virreinal (Obras Públicas), caja 6311, exp. 015.

44. A chapel of San Lázaro, it will be recalled, sat adjacent to the Tianguis of Mexico site in the 1530s to the 1540s; the new site is mentioned in Bejarano, *Actas de cabildo*, August, 23, 1571; Rojas Rabiela, "Obras hidráulicas coloniales," 101–105.

45. Testimony of Juan Aquiaguacatl, February 13, 1556, in Pérez-Rocha, *Ciudad en peligro*, 46 (Archivo General de las Indias, Seville, Patronato 181, fol. 998v).

46. Rojas Rabiela, "Obras hidráulicas coloniales," 102.

47. Pérez-Rocha, *Ciudad en peligro*.

48. See, for instance, testimony of Francisco Atlaucal (Archivo General de las Indias, Seville, Patronato 181, fol. 997v), of Juan Aquiaguacatl (fol. 999v), and of Martín Suchipanecatl (fol. 1001v) in Pérez-Rocha, *Ciudad en peligro*, 42, 46, and 50.

49. Chávez Orozco, *Códice Osuna*, 120–121; Archivo General de la Nación, Mexico, Mercedes 4, fols. 256v–257r; Pérez-Rocha, *Ciudad en peligro*, 25, on its success.

50. Bejarano, *Actas de cabildo*, November 11, 1555.

51. Cortés Alonso, *Códice Osuna*, fol. 7r.

52. Bejarano, *Actas de cabildo*, August 25, 1564; May 26, 1570; January 18, 1580.

53. Lara, *City, Temple, Stage*.

54. Bejarano, *Actas de cabildo*, July 12, 1566; on Navas, see Georges Baudot, *Utopia and History in Mexico: The First Chronicles of Mexican Civilization (1520–1569)*.

55. Kubler, *Mexican Architecture of the Sixteenth Century*, 1:117. More recently, see Carlos

González Lobo, "La obra de Fray Francisco de Tembleque en la región de Zempoala-Ozumba."

56. Santa Fe figures from Pineda Mendoza, *Origen, vida y muerte*, 108; Chapultepec figures from Bejarano, *Actas de cabildo*, 1575–1583.

57. Acuña-Soto et al., "Megadrought and Megadeath in 16th Century Mexico."

58. Mendieta, *Historia eclesiástica indiana*, bk. 4, ch. 36, 515.

59. Torquemada, *Monarquía indiana*, bk. 5, ch. 22, 642.

60. Chimalpahin, *Annals of His Time*, 26–27.

61. Bejarano, *Actas de cabildo*, January 9, 1581.

62. Mendieta, *Historia eclesiástica indiana*, bk. 4, ch. 36, 519.

63. Sahagún, *Historia general de la cosas de Nueva España*, bk. 10, ch. 27, p. 635.

64. Pineda Mendoza, *Origen, vida y muerte*, 41–45.

65. Bejarano, *Actas de cabildo*, September 24, 1582. Later upkeep was charged to native coffers. Archivo General de la Nación, Mexico, Indios 5, exp. 958, fol. 316 [246]v.

66. Chimalpahin, *Annals of His Time*, 26–29.

67. Salvador Guilliem Arroyo, "La pintura mural de la caja de agua del Imperial Colegio de la Santa Cruz de Santiago Tlatelolco"; Salvador Guilliem Arroyo, "La caja de agua del Imperial Colegio de la Santa Cruz de Tlatelolco."

68. Gibson, *The Aztecs under Spanish Rule*, 355. For support, Gibson points to Archivo General de la Nación, Mexico, Mercedes 1, fol. 116r; Mercedes 5, fols. 223r–223v; as well as Cervantes de Salazar.

69. Archivo General de la Nación, Mexico, Tierras 35, exp. 2.

70. Bejarano, *Actas de cabildo*, February 19, 1560, and November 4, 1560.

71. Archivo General de la Nación, Mexico, Mercedes 5, fols. 223r–223v.

72. This case, where the Spanish *cabildo* asserted its rights over the Tianguis of Mexico, was similar to the claims it made in a lawsuit of 1564, where it claimed indigenous lands to the east of the island as "ejidos," or common land. Archivo General de la Nación, Mexico, Tierras 20, 2nd pte., exp. 7. Pablo Escalante Gonzalbo, "On the Margins of Mexico City: What the Beinecke Map Shows," in Miller and Mundy, *Painting a Map of Sixteenth-Century Mexico City*, 106.

73. Archivo General de la Nación, Mexico, Tierras 35, exp. 2, fol. 148v. The suit is complicated because at this point, in 1588, the native *cabildo* found itself arguing for the invalidity of the actions taken by the selfsame *cabildo* in 1560, the later members claiming it had no right to alien communal land to private individuals. The early sale is mentioned briefly in Rebeca López Mora, "Entre dos mundos: Los Indios de los barrios de la ciudad de México, 1550–1600."

74. Archivo General de la Nación, Mexico, Tierras 70, exp. 4, fols. 209–211. The role of the Franciscans in the *tianguis* is yet to be explored. In this same suit, the wealthy Juana Mocel, who made her will in 1596, had a number of properties within the *tianguis* that she had bought from the Franciscans.

75. Archivo General de la Nación, Mexico, Tierras 70, exp. 4, fols. 212–218.

76. Archivo General de la Nación, Mexico, Tierras 35, exp. 2, fol. 148v.

77. John B. Glass, with Donald Robertson, "A Census of Native Middle American Pictorial Manuscripts," no. 332, pp. 209–210.

78. Archivo General de la Nación, Mexico, Indios 4, exp. 4. Gómez de Cervantes's election is in Bejarano, *Actas de cabildo*, January 1, 1589.

79. Archivo General de la Nación, Mexico, Indios 4, exp. 52.

80. Bernal-García, "The Dance of Time."

81. Archivo General de la Nación, Mexico, Indios 3, exp. 510.

82. On Valeriano's illness, Chimalpahin, *Annals of His Time*, 58–59. Although Valeriano officially left office in 1599, he needed the aid of a lieutenant for almost the last three years, one indication of how important making it to the half-century mark was, Chimalpahin, *Annals of His Time*, 140–143. He still appeared at public events in 1601 and died in 1605, Chimalpahin, *Annals of His Time*, 72–73, 84–85.

83. Ana Lorenia Garcia, "Capilla del Colegio de San Ignacio de Loyola (Vizcainas)," in Ruiz, *Arquitectura religiosa de la ciudad de México*, 243; Josefina Muriel, ed., *Los vascos en México y su colegio de las Vizcainas*.

84. The sale of the widow Mariana's lands to Luis de Cevallos is transcribed in Reyes García, Celestino Solís, and Valencia Ríos, *Documentos nahuas de la Ciudad de México*, 298–315. Original document is Archivo General de la Nación, Mexico, Hospital de Jesus, leg. 298, exp. 4.

CHAPTER 10

1. Cervantes de Salazar, *Life in the Imperial and Loyal City of Mexico*, 41–42. Translation slightly modified with information from William Smith, "Forum," in *A Dictionary of Greek and Roman Antiquities* (London: John Murray, 1875), accessible online at http://penelope.uchicago.edu/Thayer/E/Roman/Texts/secondary/SMIGRA*/Forum.html.

2. Schreffler, *The Art of Allegiance*, 38.

3. Jesús Roberto Escobar, *The Plaza Mayor and the Shaping of Baroque Madrid*, 4.

4. Alexander von Humboldt [Alejandro de Humboldt], *Ensayo político sobre el reino de la Nueva España*, ed. Juan A. Ortega y Medina, 29.

Bibliography

Abbott, Don Paul. *Rhetoric in the New World: Rhetorical Theory and Practice in Colonial Spanish America.* Columbia: University of South Carolina Press, 1996.

Acuña, René, ed. *Relaciones geográficas del siglo XVI.* 10 vols. Mexico City: Instituto de Investigaciones Antropológicas, Universidad Nacional Autónoma de México, 1986.

Acuña-Soto, Rodolfo, David W. Stahle, Malcolm K. Cleaveland, and Matthew D. Therrell. "Megadrought and Megadeath in 16th Century Mexico." *Emerging Infectious Diseases* 8, no. 4 (April 2002). wwwnc.cdc.gov/eid/article/8/4/01-0175_article.htm.

Adams, Richard. *Prehistoric Mesoamerica.* 3rd ed. Norman: University of Oklahoma Press, 1977.

Aguilera, Carmen. "Of Royal Mantles and Blue Turquoise: The Meaning of the Mexican Emperor's Mantle." *Latin American Antiquity* 8, no. 1 (1997): 3–19.

Aguirre, Joaquín, and Juan Manuel Montalbán. *Recopilación compendiada de las leyes de Indias, aumentada con algunas notas que no se hallan en la edición de 1841 . . .* Madrid: I. Boix, 1846.

Alcántara Gallegos, Alejandro. "Los barrios de Tenochtitlan: Topografía, organización interna y tipología de sus predios." In *Historia de la vida cotidiana en México,* vol. 1, *Mesoamérica y los ámbitos indígenas de la Nueva España,* edited by Pablo Escalante Gonzalbo, 167–198. Mexico City: Colegio de México and Fondo de Cultura Económica, 2004.

Alcina Franch, José. "Juan de Torquemada, 1564–1624." In *Handbook of Middle American Indians,* vol. 13, *Guide to Ethnohistorical Sources,* pt. 2, edited by R. Wauchope, H. Cline, and J. B. Glass, 256–275. Austin: University of Texas Press, 1973.

Alcocer, Ignacio. *Apuntes sobre la antigua México-Tenochtitlan.* Tacubaya, Mexico: Instituto Panamericano de Geografía e Historia, 1935.

Alvarado Tezozomoc, Fernando. *Crónica mexicayotl.* Translated by Adrián León. Mexico City: Universidad Nacional Autónoma de México, 1992.

Anawalt, Patricia Rieff. "A Comparative Analysis of the Costumes and Accoutrements of the Codex Mendoza." In *The Codex Mendoza,* 4 vols., edited by Frances F. Berdan and Patricia Rieff Anawalt, 1:103–150. Berkeley: University of California Press, 1992.

———. "The Emperors' Cloak: Aztec Pomp, Toltec Circumstances." *American Antiquity* 55, no. 2 (April 1990): 291–307.

Anderson, Arthur J. O., trans. *Bernardino de Sahagún's "Psalmodia Christiana" (Christian Psalmody).* Salt Lake City: University of Utah Press, 1993.

Anderson, Arthur J. O., Frances Berdan, and James Lockhart. *Beyond the Codices.* Los Angeles: University of California Press, 1976.

Armijo Torres, Ricardo. "Arqueología e historia de los sistemas de aprovisionamiento de agua potable para la ciudad de México durante la época colonial: Los acueductos de Chapultepec y Santa Fe." Bachelor's thesis, Escuela Nacional de Arqueología e Historia, Mexico, D.F., 1994.

Arregui Zamorano, Pilar. *La Audiencia de México según los visitadores, siglos xvi y xvii.* 2nd ed. Mexico: Universidad Nacional Autónoma de México, 1985.

Aveni, Anthony F. "Aztec Astronomy and Ritual." In *Moctezuma's Mexico: Visions of the Aztec World,* edited by Davíd Carrasco and Eduardo Matos Moctezuma, 149–158. Niwot: University Press of Colorado, 1992.

———. "Mapping the Ritual Landscape: Debt Payment to Tlaloc during the Month of Atlcahualo." In *Aztec Ceremonial Landscapes,* edited by Davíd Carrasco, 58–73. Niwot: University Press of Colorado, 1999.

———. *Skywatchers.* Rev. ed. Austin: University of Texas Press, 2001.

Aveni, Anthony F., Edward E. Calnek, and H. Hartung. "Myth, Environment, and the Orientation of the Templo Mayor of Tenochtitlan." *American Antiquity* 53, no. 2 (April 1988): 287–309.

Bachelard, Gaston. *The Poetics of Space.* Translated by M. Jolas. Boston: Beacon Press, 1994.

Baez Rubí, Linda. *Mnemosine novohispánica: Retórica e imágenes en el siglo XVI.* Mexico City: Universidad Nacional Autónoma de México, 2005.

Balbuena, Bernardo de. *La Grandeza Mexicana.* 4th ed. Mexico City: Editorial Porrúa, 1985.

Barlow, Robert. "El plano mas antiguo de Tlatelolco." In *Obras de Robert H. Barlow,* vol. 2, *Tlatelolco: Fuentes e Historia,* edited by J. Monjarás-Ruiz, E. Limón, and M. C. Paillés. Mexico City: Instituto Nacional de Antropología e Historia, 1989.

———. "Some Remarks on the Term 'Aztec Empire.'" *The Americas* 1, no. 3 (January 1945): 345–349.

Barnes, William Landon. "Icons of Empire: The Art and History of Aztec Royal Presentation." PhD diss., Tulane University, 2009.

Barrio Lorenzot, Francisco de. *Ordenanzas de gremios de la Nueva España.* Edited by G. Estrada. Mexico City: Secretaría de Gobernación, Dirección de Talleres Gráficos, 1920.

Baudot, Georges. *Utopia and History in Mexico: The First Chronicles of Mexican Civilization (1520–1569)*. Translated by Bernard R. Ortiz de Montellano and Thelma Ortiz de Montellano. Niwot: University Press of Colorado, 1995.

Bejarano, Ignacio, ed. *Actas de cabildo de la ciudad de México*. Mexico City: Aguilar e hijos, 1889.

Berdan, Frances. *The Aztecs of Central Mexico: An Imperial Society*. Case Studies in Cultural Anthropology. New York: Holt, Rinehart and Winston, 1982.

Berdan, Frances F., and Patricia Rieff Anawalt, eds. *The Codex Mendoza*. 4 vols. Berkeley: University of California Press, 1992.

Bernal-García, María Elena. "The Dance of Time, the Procession of Space at Mexico-Tenochtitlan's Desert Garden." In *Sacred Gardens and Landscapes: Ritual and Agency*, edited by Michel Conan, 69–114. Dumbarton Oaks Colloquium on the History of Landscape Architecture 26. Washington, DC: Dumbarton Oaks, 2007.

Bernal-García, María Elena, and Ángel Julián García Zambrano. "Introducción." *Territorialidad y paisaje en el altepetl del siglo XVI*, edited by Federico Fernández Christlieb and Ángel Julián García Zambrano, 13–28. Mexico City: Universidad Nacional Autónoma de México, Instituto de Geografía, Fondo de Cultura Económica, 2006.

Biraben, Jean-Noel, and Didier Blanchet. "Essay on the Population of Paris and Its Vicinity since the Sixteenth Century." *Population: An English Selection* 11 (1999): 155–188.

Boone, Elizabeth Hill. *Stories in Red and Black: Pictorial Histories of the Aztecs and Mixtecs*. Austin: University of Texas Press, 2000.

Borah, Woodrow Wilson. *Justice by Insurance: The General Indian Court of Colonial Mexico and the Legal Aides of the Half-Real*. Berkeley: University of California Press, 1983.

———. *Silk Raising in Colonial Mexico*. Ibero-Americana 20. Berkeley: University of California Press, 1943.

Boyer, Richard Everett. "Mexico City and the Great Flood: Aspects of Life and Society, 1629–1635." PhD diss., University of Connecticut, 1973.

Bribiesca Castrejón, José Luis. "El agua potable en la Republica Mexicana." *Ingeniería Hidraulica en México*, pt. 1: 12, no. 2 (April–June 1958): 69–82; pt. 2: 12, no. 4 (October–December, 1958): 51–62; pt. 3: 13, no. 1 (January–March 1959): 29–38.

Broda, Johanna. "El culto Mexica de los cerros de la Cuenca de México." In *Graniceros: Cosmovisión y meteorología indígenas de Mesoamérica*, edited by Johanna Broda and Beatriz Andrea Albores Zárate, 49–90. Mexico City: Institutos de Investigaciones Históricas, Universidad Nacional Autónoma de México; Zincantepec, Mexico: El Colegio Mexiquense, 1997.

Brumfiel, E. M. "Materiality, Feasts, and Figured Worlds in Aztec Mexico." In *Rethinking Materiality: The Engagement of Mind with the Material World*, edited by E. DeMarrais, C. Gosden, and C. Renfrew, 225–237. Cambridge: McDonald Institute for Archaeological Research, University of Cambridge, 2004.

Burkhart, Louise M. *The Slippery Earth: Nahua-Christian Moral Dialogue in Sixteenth-Century Mexico*. Tucson: University of Arizona Press, 1989.

———. "The Solar Christ in Nahuatl Doctrinal Texts of Early Colonial Mexico." *Ethnohistory* 53 (Summer 1988): 234–256.

Bynum, Caroline Walker. "Seeing and Seeing Beyond: The Mass of Saint Gregory in the Fifteenth Century." In *The Mind's Eye: Art and Theological Argument in the Middle Ages*, edited by J. F. Hamburger and A.-M. Bouché, 208–240. Princeton: Princeton University Press, 2006.

Cabrera C., Rubén. "Informe de las excavaciones en el bosque de Chapultepec." Unpublished report, Archivo técnico del Instituto Nacional de Antropología e Historia, 311.41 (1975).

Cabrera C., Rubén, María Antonieta Cervantes, and Felipe Solís Olguín, "Excavaciones en Chapultepec, México, D.F." *Diario del Campo*, Suplemento 36 (October–December, 2005), 34.

Calnek, Edward. "The Localization of the 16th-Century Map Called the Maguey Plan." *American Antiquity* 38, no. 1 (1973): 190–195.

———. "Settlement Pattern and Chinampa Agriculture at Tenochtitlan." *American Antiquity* 37, no. 1 (1972): 104–115.

———. "El sistema de mercado en Tenochtitlan." In *Economía política e ideología en el México prehispánico*, edited by Pedro Carrasco and Johanna Broda, 97–114. Mexico City: Centro de Investigaciones Superiores del Instituto Nacional de Antropología e Historia, 1978.

———. "Tenochtitlan in the Early Colonial Period." *Acts of the XLII International Congress of Americanists* 8, 1976 (1979): 35–40.

———. "Tenochtitlan-Tlatelolco: The Natural History of a City." In *El Urbanismo en Mesoamérica/Urbanism in Mesoamerica*, vol. 1, edited by W. T. Sanders, A. G. Mastache, and R. H. Cobean, 149–202. Mexico City: Instituto Nacional de Antropología e Historia; University Park: Pennsylvania State University, 2003.

Campbell, R. Joe. *Florentine Codex Vocabulary*. 1997. Accessible at http://www2.potsdam.edu/schwaljf/Nahuatl/florent.txt.

———. *A Morphological Dictionary of Classic Nahuatl*. Madison, WI: Seminary of Hispanic Medieval Studies, 1985.

Candiani, Vera. "The Desagüe Reconsidered: Environmental Dimensions of Class Conflict in Colonial Mexico." *Hispanic American Historical Review* 92, 1 (2012): 5–39.

Caplan, Harry, trans. *Ad C. Herennium: De ratione dicendi (Rhetorica ad Herennium)*. Cambridge: Harvard University Press, 1954. Online at http://www.utexas.edu/research/memoria/Ad_Herennium_Passages.html.

Carballal Staedtler, Margarita, and María Flores Hernández. "Las calzadas prehispánicas de la isla de México." *Arqueología* 1 (1989): 71–80.

———. "Hydraulic Features of the Mexico-Texcoco Lakes during the Postclassic Period." In *Precolumbian Water Management: Ideology, Ritual and Power*, edited by Lisa J. Lucero and Barbara W. Fash, 155–170. Tucson: University of Arizona Press, 2006.

———. "El Peñón de los Baños (Tepetzinco) y sus alrededores: Interpretaciones paleoambiéntales y culturales de la porción noroccidental del Lago de Texcoco." Unpublished report, Archivo técnico del Instituto Nacional de Antropología e Historia, 8–101 (1989).

Carrasco, Pedro. *The Tenochca Empire*. Norman: University of Oklahoma Press, 1999.

Casas, Bartolomé de las. *The Devastation of the Indies: A Brief Account*. Translated by Herma Briffault. Baltimore: Johns Hopkins University Press, 1992.

Casey, Edward S. *Getting Back into Place: Towards a Renewed Understanding of the Place-World*. 2nd ed. Bloomington: Indiana University Press, 2009.

———. *Remembering: A Phenomenological Study*. 2nd ed. Bloomington and Indianapolis: Indiana University Press, 2000.

Caso, Alfonso. "Los barrios antiguos de Tenochtitlan y Tlatelolco." *Memorias de la Academia Mexicana de la Historia* 15 (1956): 7–62.

———. *El teocalli de la guerra sagrada: Descripción y estudio del monolito encontrado en los cimientos del Palacio nacional*. Mexico City: Talleres Gráficos de la Nación, 1927.

Castañeda de la Paz, María. "Filología de un 'corpus' pintado (siglos xvi–xviii): De códices, techiloyan, pinturas y escudos de armas." *Anales del Museo de América* 17 (2009): 78–97.

———. "Historia de una casa real: Origen y ocaso del linaje gobernante en México-Tenochtitlan." *Nuevo Mundo Mundos Nuevos, Debates* (January 2011). Published

online at http://nuevomundo.revues
.org/60624?lang=en.

———. "El Plano Parcial de la Ciudad de
México: Nuevas aportaciones en base al
estudio de su lista de tlatoque." In *Símbolos
de poder en Mesoamérica*, edited by Guilhem
Olivier Durand, 393–426. Mexico City:
Instituto de Investigaciones Históricas and
Instituto de Investigaciones Antropológicas,
2008.

———. "Sibling Maps, Spatial Rivalries: The
Beinecke Map and the Plano Parcial de la
Ciudad de México." In *Painting a Map of
Sixteenth-Century Mexico City: Land, Writing
and Native Rule*, edited by Mary E. Miller
and Barbara E. Mundy, 53–73. New Haven:
Beinecke Rare Book and Manuscript Library,
2012.

Castillo Farreras, Victor M. "Unidades nahuas
de medida." *Estudios de cultura náhuatl* 10
(1972): 195–223.

Castro Gutiérrez, Felipe, ed. *Los indios y las
ciudades de Nueva España*. Mexico City:
Universidad Nacional Autónoma de México,
Instituto de Investigaciones Históricas, 2010.

Castro Morales, Efraín. *Palacio Nacional de
México: Historia de su arquitectura*. Mexico
City: Museo Mexicano, 2003.

Certeau, Michel de. *The Practice of Everyday
Life*. Translated by Steven Rendall. Berkeley:
University of California Press, 1984.

Cervantes de Salazar, Francisco. *Crónica de la
Nueva España*. 2 vols. Edited by Manuel
Magalón. Madrid: Atlas, 1971.

———. *Life in the Imperial and Loyal City of
Mexico in New Spain*. Translated by Minnie
Lee Barrett Shepard. Austin: University of
Texas, 1953.

———. *Tumulo Imperial de la gran ciudad de
México*. Mexico City: Antonio de Espinosa,
1560.

Chávez Orozco, Luis, ed. *Códice Osuna: Repro-
ducción facsimilar de la obra*. Mexico City:
Ediciones del Instituto Indigenista Intera-
mericano, 1947.

Chimalpahin Quauhtlehuanitzin, Domingo
Francisco de San Antón Muñón. *Annals of
His Time*. Edited and translated by James
Lockhart, Susan Schroeder, and Doris
Namala. Stanford: Stanford University Press,
2006.

———. *Codex Chimalpahin: Society and Politics
in Mexico Tenochtitlan, Tlatelolco, Texcoco,
Culhuacan, and Other Nahua Altepetl in Cen-
tral Mexico*. 2 vols. Edited and translated by
Arthur J. O. Anderson and Susan Schroeder.
Norman: University of Oklahoma Press, 1997.

Clendinnen, Inga. *Aztecs: An Interpretation*.
New York: Cambridge University Press, 1991.

———. "'Fierce and Unnatural Cruelty': Cortés

and the Conquest of Mexico." *Representations*,
no. 33 (Winter 1991): 65–100.

Connell, William F. *After Moctezuma: Indigenous
Politics and Self-Government in Mexico City,
1524–1730*. Norman: University of Oklahoma
Press, 2011.

Connerton, Paul. *How Societies Remember*.
Cambridge and New York: Cambridge
University Press, 1989.

Conway, Richard. "Lakes, Canoes, and the
Aquatic Communities of Xochimilco and
Chalco, New Spain." *Ethnohistory* 59, no. 3
(2012): 541–568.

Cortés, Hernando [Hernán]. *Cartas de relación*.
Edited by Manuel Alcalá. Mexico City:
Editorial Porrúa, 1983.

———. *Letters from Mexico*. Translated by
Anthony Pagden. New Haven: Yale Univer-
sity Press, 1986.

Cortés Alonso, Vicenta, ed. and trans. *Pintura
del gobernador, alcaldes y regidores de México:
Códice Osuna*. Madrid: Ministerio de Edu-
cación y Ciencia, 1973.

Curcio-Nagy, Linda. *The Great Festivals of
Colonial Mexico City: Performing Power and
Identity*. Albuquerque: University of New
Mexico Press, 2004.

Darnton, Robert. *The Great Cat Massacre: And
Other Episodes in French Cultural History*.
New York: Basic Books, 2000.

Demacopoulos, George. "Gregory the Great and
the Pagan Shrines of Kent." *Journal of Late
Antiquity* 1, no. 2 (Fall 2008): 375–391.

Derrida, Jacques. *Of Grammatology*. Translated
by Gayatri Chakravorty Spivak, corrected ed.
Baltimore: Johns Hopkins University Press,
1997.

Díaz del Castillo, Bernal. *The True History of
the Conquest of New Spain*. 5 vols. Edited
by Genaro García. Translated by Alfred
Percival Maudslay. London: Hakluyt Society,
1908–1916.

Dibble, Charles E., ed. *Codex en Cruz*. 2 vols.
Salt Lake City: University of Utah Press,
1981.

———, ed. and trans. *Códice Aubin: Historia de
la nación mexicana: Reproducción a todo color
del códice de 1576*. Madrid: Ediciones J. Porrúa
Turanzas, 1963.

Diel, Lori Boornazian. *Tira de Tepechpan: Nego-
tiating Place under Aztec and Spanish Rule*.
Austin: University of Texas Press, 2008.

Durán, Diego. *Book of the Gods and Rites and
the Ancient Calendar*. Edited and translated
by Fernando Horcasitas and Doris Heyden.
Norman: University of Oklahoma Press, 1971.

———. *Historia de las indias de Nueva España e
islas de la tierra firme*. 2 vols. Edited by Angel
María Garibay K. Mexico City: Editorial
Porrúa, 1984.

———. *The History of the Indies of New Spain*.
Edited and translated by Doris Heyden. Nor-
man: University of Oklahoma Press, 1993.

Durand-Forest, Jacqueline de. "Cambios
económicos y moneda entre los aztecas."
Estudios de cultura náhuatl 9 (1971): 105–124.

———, ed. *Codex Ixtlilxochitl: Bibliothèque
national, Paris (Ms. Mex. 55–710)*. Fontes
rerum Mexicanarum 8. Graz, Austria: Akade-
mische Druck- und Verlagsanstalt, 1976.

Dürer, Albrecht. *Diary of His Journey to the
Netherlands, 1520–1521*. Introduction by J.-A.
Goris and G. Marlier. Greenwich, CT: New
York Graphic Society, 1971.

Dyckerhoff, Ursula. "Xipe Totec and the War
Dress of the Aztec Rulers." In *The Symbolism
in the Plastic and Pictorial Representations
of Ancient Mexico: A Symposium of the
46th International Congress of Americanists,
Amsterdam, 1988*, edited by Jacqueline de
Durand-Forest and Marc Eisinger, 139–148.
Bonn: Holos, 1993.

Escalante Gonzalbo, Pablo. *Los Códices meso-
americanos antes y después de la conquista
española*. Mexico City: Fondo de Cultura
Económica, 2010.

Escobar, Jesús Roberto. *The Plaza Mayor and
the Shaping of Baroque Madrid*. Cambridge
and New York: Cambridge University Press,
2004.

Evans, Susan Toby. "The Aztec Palace under
Spanish Rule: Disk Motifs in the Mapa de
México de 1550 (Uppsala Map or Mapa de
Santa Cruz)." In *The Postclassic to Spanish-
Era Transition in Mesoamerica*, edited by
Susan Kepecs and Rani T. Alexander, 13–34.
Albuquerque: University of New Mexico
Press, 2005.

———. "Aztec Royal Pleasure Parks: Conspicu-
ous Consumption and Elite Status Rivalry."
*Studies in the History of Gardens and Designed
Landscapes* 20 (2000): 206–228.

Fernández, Justino, and Hugo Leight.
"Códice del Tecpan de Santiago Tlatelolco
(1576–1581)." *Investigaciones Históricas* 1, no. 3
(April 1939): 243–264.

Flores Marini, Carlos. "El tecpan de Tlatelolco."
Anales del Instituto de Investigaciones Estéticas
10, no. 37 (1968): 49–54.

García Garagarza, León. "The 1539 Trial of Don
Carlos Ometochtli and the Scramble for
Mount Tlaloc." In *Mesoamerican Memory:
Enduring Systems of Remembrance*, edited
by Amos Megged and Stephanie Wood,
193–214. Norman: University of Oklahoma
Press, 2012.

García Icazbalceta, Joaquín. *Códice franciscano,
siglo XVI*. Mexico City: Editorial Salvador
Chávez Hayhoe, 1941.

———, ed. *Colección de documentos para la*

historia de México. 2nd ed. 2 vols. Mexico City: J. M. Andrade, 1858–1866.

———, ed. "Historia de los Mexicanos por sus pinturas." In *Nueva colección de documentos para la historia de México*, vol. 3, 228–263. Mexico City: Imprenta de Francisco Diaz de Léon, 1891.

Garibay K., Angel María. *Historia de la literatura náhuatl*. 2 vols. Mexico City: Editorial Porrúa, 1953–1954.

———. *Teogonía e historia de los mexicanos: Tres opúsculos del siglo XVI*. Mexico City: Editorial Porrúa, 1979.

Garritz, Amaya. "Ejecutoria a favor de don Diego Luis Moctezuma: Testamento del príncipe Pedro Moctezuma." *Históricas: Boletín del Instituto de Estudios Historicos* 37 (January–April 1993): 34–35.

Gell, Alfred. *Art and Agency: An Anthropological Theory*. Oxford and New York: Clarendon Press, 1998.

Gerhard, Peter. *Geografía histórica de la Nueva España 1519–1821*. Translated by Stella Mastrangelo. Mexico City: Universidad Nacional Autónoma de México, 1986.

Gerlero, Elena Isabel Estrada de, Donna Pierce, and Clare Farago. "Mass of Saint Gregory." In *Painting a New World: Mexican Art and Life, 1521–1821*, edited by D. Pierce, R. Ruiz Gomar, and C. Bargellini, 94–102. Denver: Frederick and Jan Mayer Center for Pre-Columbian and Spanish Colonial Art at the Denver Art Museum, 2004.

Gibson, Charles. *The Aztecs under Spanish Rule*. Stanford: Stanford University Press, 1964.

———. *Tlaxcala in the Sixteenth Century*. New Haven: Yale University Press, 1952.

Glass, John B. "A Survey of Native Middle American Pictorial Manuscripts." In *Handbook of Middle American Indians*, vol. 14, *Guide to Ethnohistorical Sources*, pt. 3, edited by R. Wauchope, H. Cline, and J. B. Glass, 3–80. Austin: University of Texas Press, 1975.

Glass, John B., with Donald Robertson. "A Census of Native Middle American Pictorial Manuscripts." In *Handbook of Middle American Indians*, vol. 14, *Guide to Ethnohistorical Sources*, pt. 3, edited by R. Wauchope, H. Cline, and J. B. Glass, 81–252. Austin: University of Texas Press, 1975.

Gómez Tejada, Jorge. "Making the 'Codex Mendoza,' Constructing the 'Codex Mendoza': A Reconsideration of a 16th Century Mexican Manuscript." PhD diss., Yale University, 2012.

González Aparicio, Luis. *Plano reconstructivo de la región de Tenochtitlan*. Mexico City: Instituto Nacional de Antropología e Historia, 1973.

González González, Carlos Javier. "La ubicación e importancia del Templo de Xipe Tótec en la parcialidad tenochca de Moyotlan." *Estudios de cultura náhuatl* 36 (2005): 47–65.

González Lobo, Carlos. "La obra de Fray Francisco de Tembleque en la región de Zempoala-Ozumba." *Bitacora Arquitectura* (2011): 44–53.

González Obregón, Luis, ed. *Proceso inquisitorial del Cacique de Tetzcoco*. Publicaciones del Archivo General de la Nación. Mexico City: E. Gómez de la Puerte, 1910.

———, ed. *Procesos de indios idolatras y hechiceros*. Publicaciones del Archivo General de la Nación. Mexico City: Guerrero Hermanos, 1912.

———. "Reseña histórica." In *Memoria de las obras del desague del Valle de México*. 2 vols. Mexico City: Junta Directiva del Desague, 1902.

Granados Salinas, Rosario Inés. "Mexico City's Symbolic Geography: The Processions of Our Lady of Remedios." *Journal of Latin American Geography* 11 (2012): 145–173.

Graulich, Michel, ed. *Codex Azcatitlan*. Paris: Bibliothèque Nationale de France, Société des Américanistes, 1995.

Guilliem Arroyo, Salvador. "La caja de agua del Imperial Colegio de la Santa Cruz de Tlatelolco." *Estudios de cultura náhuatl* 38 (January 2007): 15–32.

———. "La pintura mural de la caja de agua del Imperial Colegio de la Santa Cruz de Santiago Tlatelolco." *Anales del Museo de América* 15 (2007): 39–53.

Haag, Sabine, Alfonso de Maria y Campos, Lilia Rivero Weber, and Christian Feest, eds. *El Penacho del México Antiguo*. Altenstadt, Germany: ZKF Publishers; Vienna, Austria: Kunsthistorisches Museum; Mexico City: Instituto Nacional de Antropología e Historia, 2012.

Hajovsky, Patrick. "On the Lips of Others: Fame and the Transformation of Moctezoma's Image." PhD diss., University of Chicago, 2007.

———. "Without a Face: Voicing Moctezuma II's Image at Chapultepec Park, Mexico City." In *Seeing across Cultures in the Early Modern World*, edited by Dana Leibsohn and Jeanette Favrot Peterson, 171–192. Surrey: Ashgate, 2012.

Halbwachs, Maurice. *On Collective Memory*. Edited and translated by Lewis A. Coser. Chicago: University of Chicago Press, 1992.

Haskett, Robert. *Indigenous Rulers: An Ethnohistory of Indian Town Government in Colonial Cuernavaca*. Albuquerque: University of New Mexico Press, 1991.

Hassig, Ross. *Aztec Warfare: Imperial Expansion and Political Control*. Norman: University of Oklahoma Press, 1995.

Hawks, Henry. "A Relation of the Commodities of Nova Hispana." In *The principall nauigations, voiages and discoueries of the English nation . . .*, by Richard Haklyt. London: George Bishop and Ralph Newberie, 1589.

Hibbert, Christopher. *Rome, the Biography of a City*. New York: Penguin, 1987.

Holler, Jacqueline. "Conquered Spaces, Colonial Skirmishes: Spatial Contestation in Sixteenth-Century Mexico City." *Radical History Review* 99 (Fall 2007): 107–120.

Humboldt, Alexander von [Alejandro de]. *Ensayo político sobre el reino de la Nueva España*. Edited by Juan A. Ortega y Medina. Mexico City: Editorial Porrúa, 1966.

Hvidtfeldt, Arild. *Teotl and Ixiptlatli: Some Central Conceptions in Ancient Mexican Religion*. Copenhagen: Munksgaard, 1958.

Ixtlilxochitl, Fernando de Alva. *Obras históricas*. 2 vols. Edited by Edmundo O'Gorman. Mexico: Universidad Nacional Autónoma de México, Imprenta Universitaria, 1985.

Jonghe, Édouard de. "Histoyre du Mechique: Manuscrit français inédit du XVIe siècle." *Journal de la Société des Américanistes de Paris*, n.s. 2 (1905): 1–41.

Kagan, Richard L., and Fernando Marías. *Urban Images of the Hispanic World, 1493–1793*. New Haven and London: Yale University Press, 2000.

Karttunen, Frances. *An Analytical Dictionary of Nahuatl*. Austin: University of Texas Press, 1983.

Kessler, Herbert L. "Gregory the Great and Image Theory in Northern Europe during the Twelfth and Thirteenth Centuries." In *A Companion to Medieval Art*, edited by Conrad Rudolph. Blackwell Publishing, 2006. Blackwell Reference Online, accessed July 21, 2010.

Kirakofe, James. "Architectural Fusion and Indigenous Ideology in Early Colonial Teposcolula." *Anales del Instituto de Investigaciones Estéticas* 66 (1995): 45–84.

Kubler, George. *Mexican Architecture of the Sixteenth Century*. 2 vols. New Haven: Yale University Press, 1948.

———. "The Name Tenochtitlan." *Tlalocan* 1 (1944): 376–377.

Lara, Jaime. *City, Temple, Stage: Eschatological Architecture and Liturgical Theatrics in New Spain*. Notre Dame, IN: University of Notre Dame Press, 2004.

Lee, Thomas A., Jr., and Carlos Navarrete, eds. *Mesoamerican Communication Routes and Cultural Contacts*. New World Archaeological Foundation Papers 40. Provo, UT: New World Archaeological Foundation, 1978.

Lefebvre, Henri. *The Production of Space*. Translated by D. Nicholson-Smith. Oxford, UK, and Cambridge, MA: Blackwell, 1991.

León Portilla, Miguel. *Bernardino de Sahagún, First Anthropologist.* Translated by M. J. Mixco. Norman: University of Oklahoma Press, 2002.

———. "La música en el universo de la cultura náhuatl." *Estudios de cultura náhuatl* 38 (January 2007): 129–163.

León Portilla, Miguel, and Carmen Aguilera. *Mapa de México Tenochtitlan y sus contornos hacia 1550.* Mexico City: Celanese Mexicana, 1986.

Lienzo de Tlaxcala. In *Antigüedades mexicanas publicadas por la Junta Colombina de Mexico en el cuarto centenario del descubrimiento de América.* 2 vols. Edited by Alfredo Chavero. Mexico City: Oficina Tipográfica de la Secretaria de Fomento, 1892.

Linné, Sigvald. *El Valle y la Ciudad de México en 1550: Relación histórica fundada sobre un mapa geográfico, que se conserva en la biblioteca de la Universidad de Uppsala, Suecia.* Stockholm: Ethnographical Museum of Sweden, 1948.

Lira González, Andrés. *Comunidades indígenas frente a la ciudad de México.* 2nd ed. Mexico City: El Colegio de México, 1995.

Lizardi Ramos, César. "El manantial y el acueducto de Acuecuexco." *Historia Mexicana* 4, no. 2 (October–December 1954): 218–234.

Lockhart, James. *The Nahuas after the Conquest: A Social and Cultural History of the Indians of Central Mexico, Sixteenth through Eighteenth Centuries.* Stanford: Stanford University Press, 1992.

———. *Nahuas and Spaniards: Postconquest Central Mexican History and Philology.* UCLA Latin American Studies, vol. 76, Nahuatl Series 3. Stanford: Stanford University Press; Los Angeles: UCLA Latin American Center Publications, University of California, Los Angeles, 1991.

Lombardo de Ruiz, Sonia, with Yolanda Terán Trillo. *Atlas histórico de la ciudad de México.* Edited by Mario de la Torre. Mexico City: Smurfit Cartón y Papel de México, 1996.

Long-Solís, Janet. "El abastecimiento de chile en el mercado de la ciudad de México-Tenochtitlan en el siglo XVI." *Historia Mexicana* 34, no. 4 (April–June 1985): 701–714.

Lopes Don, Patricia. *Bonfires of Culture: Franciscans, Indigenous Leaders, and the Inquisition in Early Mexico, 1524–1540.* Norman: University of Oklahoma Press, 2010.

López Austin, Alfredo. "Cosmovision." In *The Oxford Encyclopedia of Mesoamerican Culture: The Civilizations of Mexico and Central America,* edited by Davíd Carrasco, 1:268–275. New York: Oxford University Press, 2001.

———. *Tamoanchan y Tlalocan.* Mexico City: Fondo de Cultura Económica, 1994.

López de Gómara, Francisco. *Cortés: The Life of the Conqueror by His Secretary.* Edited and translated by Lesley Byrd Simpson. Berkeley: University of California Press, 1964.

———. *Historia general de las Indias y vida de Hernán Cortés.* Edited by Jorge Gurría Lacroix. Caracas: Biblioteca Ayacucho, 1979.

López de Velasco, Juan. *Geografía y descripción universal de las Indias.* Biblioteca de Autores Españoles 248. Edited by Marcos Jiménez de la Espada. Madrid: Atlas, 1971.

López Luján, Leonardo. *The Offerings of the Templo Mayor of Tenochtitlan.* Translated by Bernard R. Ortiz de Montellano and Thelma Ortiz de Montellano. Albuquerque: University of New Mexico Press, 2005.

López Mora, Rebeca. "El cacicazgo de Diego de Mendoza Austria y Moctezuma." In *El cacicazgo en Nueva España y Filipinas,* edited by Margarita Menegus Bornemann and Rodolfo Aguirre Salvador, 203–287. Mexico City: Centro de Estudios sobre la Universidad, Universidad Nacional Autonoma de México, and Plaza y Valdés editores, 2005.

———. "Entre dos mundos: Los indios de los barrios de la ciudad de México, 1550–1600." In *Los indios y las ciudades de Nueva España,* ed. Felipe Castro Gutiérrez, 57–77. Mexico City: Universidad Nacional Autónoma de México, Instituto de Investigaciones Históricas, 2010.

Lundberg, Magnus. *Unification and Conflict: The Church Politics of Alonso de Montúfar, O.P., Archbishop of Mexico, 1554–1572.* Uppsala: Swedish Institute of Missionary Research, 2002.

Lupher, David A. *Romans in a New World: Classical Models in Sixteenth-Century Spanish America.* Ann Arbor: University of Michigan Press, 2003.

Magaloni Kerpel, Diana. "Painters of the New World: The Process of Making the Florentine Codex." In *Colors between Two Worlds: The Florentine Codex of Bernardino de Sahagún,* edited by Louis A. Waldman, 46–76. Florence: Villa I Tatti, 2012.

———. "The Traces of the Creative Process: Pictorial Materials and Techniques in the Beinecke Map." In *Painting a Map of Sixteenth-Century Mexico City: Land, Writing and Native Rule,* edited by Mary E. Miller and Barbara E. Mundy, 75–90. New Haven: Beinecke Rare Book and Manuscript Library, 2012.

Mantecón Navasal, José Ignacio, and Manuel Toussaint. *Información de méritos y servicios de Alonso García Bravo, alarife que trazó la ciudad de México.* Mexico City: Imprenta Universitaria, 1956.

Marin, Louis. *Portrait of the King.* Translated by Tom Conley. Minneapolis: University of Minnesota Press, 1988.

Marino, John A. *Becoming Neapolitan: Citizen Culture in Baroque Naples.* Baltimore: Johns Hopkins University Press, 2011.

Márquez Rodiles, Ignacio. *La utopía del renacimiento en tierras indígenas de América: Pedro de Gante, Vasco de Quiroga, Bernardino de Sahagún.* Puebla, Mexico: Benemérita Universidad Autónoma de Puebla and Universidad de las Américas, 2001.

Marroqui, José María. *La Ciudad de México, contiene el origen de los nombres de muchas de sus calles y plazas . . .* 2nd ed. 3 vols. Mexico City: J. Aguilar Vera, 1900–1903.

Matos Moctezuma, Eduardo. "Symbolism of the Templo Mayor." In *The Aztec Templo Mayor: A Symposium at Dumbarton Oaks, 8th and 9th October 1983,* edited by Elizabeth Hill Boone, 185–209. Washington, DC: Dumbarton Oaks, 1987.

———, ed. *Trabajos arqueologicos en el centro de la Ciudad de México (Antología).* Mexico City: Secretaria de Educación Pública, Instituto Nacional de Antropología e Historia, 1979.

Matos Moctezuma, Eduardo, and Felipe Solís Olguin, eds. *Aztecs.* London: Royal Academy, 2003.

Mauss, Marcel. *The Gift: The Form and Reason for Exchange in Archaic Societies.* Translated by W. D. Halls. Abingdon: Routledge, 1990.

Mayer, Roberto L. "Trasmonte y Boot: Sus vistas de tres ciudades mexicanas en el siglo XVII." *Anales del Instituto de Investigaciones Estéticas* 87 (2005): 177–198.

McEwan, Colin, and Leonardo López Luján, eds. *Moctezuma: Aztec Ruler.* London: British Museum Press, 2009.

Megged, Amos. "Cuauhtémoc's Heirs." *Estudios de cultura náhuatl* 38 (January 2007): 345–385.

Meier, Esther. "Ikonographische Probleme: Von der Erscheinung Gregorii' aur 'Gregormesse.'" In *Das Bild der Erscheinung: Die Gregormesse im Mittelalter,* edited by A. Gormans and T. Lentes. Berlin: Dietrich Reimer Verlag, 2007.

Melville, Elinor G. K. *A Plague of Sheep: Environmental Consequences of the Conquest of Mexico.* Cambridge: Cambridge University Press, 1994.

Mendieta, Gerónimo de. *Historia eclesiástica indiana.* 2nd ed. Edited by Joaquín García Icazbalceta. Mexico City: Editorial Porrúa, 1993.

Mier y Terán Rocha, Lucía. *La primera traza de la ciudad de México, 1524–1535.* 2 vols. Mexico City: Universidad Nacional Autónoma Metropolitana, Fondo de Cultura Económica, 2005.

Miller, Mary Ellen. "A Re-examination of the Mesoamerican Chacmool." *Art Bulletin* 67, no. 1 (March 1985): 7–17.

Miller, Mary Ellen, and Barbara E. Mundy, eds. *Painting a Map of Sixteenth-Century Mexico City: Land, Writing and Native Rule*. New Haven: Beinecke Rare Book and Manuscript Library, 2012.

Molina, Alonso de. *Vocabulario en lengua castellana y mexicana y mexicana y castellana*. Mexico City: Editorial Porrúa, 1977.

Montes Bardo, Joaquín. *Arte y espiritualidad franciscana en la Nueva España, siglo XVI: Iconología en la provincia del Santo Evangelio*. Jaén: Universidad de Jaén, 1998.

Montúfar, Alonso de. *Descripción del arzobispado de México hecha en 1570 y otros documentos*. Edited by Luís García Pimentel. Mexico City: J. J. Terrazas, 1897.

Morales, Francisco. "Pedro de Gante (1490–1572)." *Enciclopédia franciscana*. Online at http://www.franciscanos.org/enciclopedia/pgante.html.

Moreno de los Arcos, Roberto. "Los territoriales parroquiales de la Ciudad Arzobispal." *Gaceta Oficial del Arzobispado de México* (September–October 1982): 151–182.

Motolinia [Motolinía], or Toribio de Benavente. *Historia de los indios de la Nueva España*. Edited by Edmundo O'Gorman. Mexico City: Editorial Porrúa, 1969.

———. *Motolinía's History of the Indians of New Spain*. Edited and translated by Francis B. Steck. Washington, DC: American Academy of Franciscan History, 1960.

Mullen, Robert J. *Architecture and Its Sculpture in Viceregal Mexico*. Austin: University of Texas Press, 1997.

Mundy, Barbara E. "Indigenous Dances in Early Colonial Mexico City." In *Festivals and Daily Life in the Arts of Colonial Latin America, 1492–1850*, edited by Donna Pierce, 11–30. Denver: Denver Art Museum, 2014.

———. "Mapping the Aztec Capital: The 1524 Nuremberg Map of Tenochtitlan, Its Sources and Meanings." *Imago Mundi* 50 (1998): 1–22.

———. "Moteuczoma Reborn: Biombo Paintings and Collective Memory in Colonial Mexico City." *Winterthur Portfolio* 45, no. 2/3 (Summer/Autumn 2011): 161–176.

———. "Place-Names in Mexico-Tenochtitlan." *Ethnohistory* 61, no. 2 (Spring 2014): 329–355.

Muriel, Josefina. "En torno a una vieja polémica: Erección de los primeros conventos de San Francisco en la ciudad de México, siglo XVI." *Estudios de Historia Novohispana* 6 (1978): 1–15.

———, ed. *Los vascos en México y su colegio de las Vizcaínas*. Mexico City: Instituto de Investigaciones Históricas, CIGATAM, 1987.

Navarrete Linares, Federico. *Los orígenes de los pueblos indígenas del valle de México*. Mexico City: Universidad Nacional Autónoma de México, 2011.

Nicholson, Henry B. "The Chapultepec Cliff Sculpture of Motecuhzoma Xocoyotzin." *El México antiguo* 9 (1961): 379–442.

———. "The History of the Codex Mendoza." In *The Codex Mendoza*, 4 vols., edited by Frances F. Berdan and Patricia Rieff Anawalt, 1:1–12. Berkeley: University of California Press, 1992.

———. "Religion in Pre-Hispanic Central Mexico." In *Handbook of Middle American Indians*, vol. 10, *Archaeology of Northern Mesoamerica*, pt. 1, edited by R. Wauchope, G. F. Eckholm, and I. Bernal, 395–446. Austin: University of Texas Press, 1971.

Nicholson, Henry B., and Eloise Quiñones Keber. *Art of Aztec Mexico: Treasures of Tenochtitlan*. Washington, DC: National Gallery of Art, 1983.

Noguez, Xavier, and Perla Valle, eds. *Códice de Tlatelolco*. Mexico City: Secretaría de Relaciones Exteriores, 1989.

O'Gorman, Edmundo. "Reflexiones sobre la distribución urbana colonial de la ciudad de México." *Boletín del Archivo General de la Nación* 9, no. 4 (1938): 787–815.

O'Hara, Matthew D. *A Flock Divided: Race, Religion, and Politics in Mexico, 1749–1857*. Durham, NC: Duke University Press, 2010.

Olko, Justyna. *Turquoise Diadems and Staffs of Office: Elite Costume and Insignia of Power in Aztec and Early Colonial Mexico*. Warsaw: Polish Society for Latin American Studies and Centre for Studies on the Classical Tradition, University of Warsaw, 2005.

Olvera Ramos, Jorge. *Los mercados de la Plaza Mayor en la Ciudad de México*. Mexico City: Cal y Arena and Centro de Estudios Mexicanos y Centroamericanos, 2007.

Oroz, Pedro. *The Oroz Codex: The Oroz Relation, or Relation of the Description of the Holy Gospel Province in New Spain, and the Lives of the Founders and Other Noteworthy Men of Said Province, Composed by Fray Pedro Oroz, 1584–1586*. Edited and translated by Angelico Chavez. Washington, DC: Academy of American Franciscan History, 1972.

Palerm, Ángel. *Obras hidráulicas prehispánicas en el sistema lacustre del Valle de México*. Mexico City: Secretaria de Educación Pública, Instituto Nacional de Antropología e Historia, 1973.

Parshall, Peter W. "Imago Contrafacta: Images and Facts in the Northern Renaissance." *Art History* 16, no. 4 (December 1993): 554–579.

———. *The Woodcut in Fifteenth-Century Europe*. Washington, DC: National Gallery of Art, 2009.

Parshall, Peter W., and Rainer Schoch. *Origins of European Printmaking: Fifteenth-Century Woodcuts and Their Public*. Washington, DC: National Gallery of Art; New Haven: Yale University Press, 2005.

Parsons, Jeffery R. "The Aquatic Component of Aztec Subsistence: Hunters, Fishers and Collectors in an Urbanized Society." In *Arqueología e historia del Centro de México: Homenaje a Eduardo Matos Moctezuma*, edited by L. López Luján, D. Carrasco, and L. Cué, 241–256. Mexico City: Instituto Nacional de Antropología e Historia, 2006.

———. *The Last Saltmakers of Nexquipayac, Mexico: An Archaeological Ethnography*. University of Michigan Museum of Anthropology Anthropological Papers 92. Ann Arbor: University of Michigan, 2001.

Parsons, Jeffrey R., Mary H. Parsons, Virginia Popper, and Mary Taft. "Chinampa Agriculture and Aztec Urbanization in the Valley of Mexico." In *Prehistoric Intensive Agriculture*, edited by I. S. Farrington, 49–96, British Archaeological Reports S232. Oxford: British Archaeological Reports, 1985.

Paso y Troncoso, Francisco del, and Silvio Arturo Zavala, eds. *Epistolario de Nueva España, 1505–1818*. 16 vols. Mexico City: Librería Robredo de J. Porrúa, 1939–1942.

Pasztory, Esther. *Aztec Art*. New York: Abrams, 1983.

Peñafiel, Antonio. *Nombres geográficos de México*. Mexico City: Oficina Tipográfica de la Secretaria de Fomento, 1885.

Pérez Castillo, Saúl. "La equidistancia de algunos elementos urbanos de origen prehispánico, localizados dentro de los límites que tenían las ciudades de Tenochtitlan y Tlatelolco." *Revista del Centro de Investigación, Universidad La Salle* 4 (2000): 19–24.

Pérez-Rocha, Emma. *Ciudad en peligro: Probanza sobre el desagüe general de la ciudad de México*. Mexico City: Instituto Nacional de Antropología e Historia, 1996.

Pérez-Rocha, Emma, and Rafael Tena. *La nobleza indígena del centro de México después de la Conquista*. Mexico City: Instituto Nacional de Antropología e Historia, 2000.

Peterson, Jeanette Favrot. *The Paradise Garden Murals of Malinalco: Utopia and Empire in Sixteenth-Century Mexico*. Austin: University of Texas Press, 1993.

Phelan, John Leddy. *The Millennial Kingdom of the Franciscans in the New World*. 2nd ed. Berkeley and Los Angeles: University of California Press, 1970.

Pike, Ruth. "Population Trends: The Demographic Revolution of Seville." In *Seville from Aristocrats and Traders: Sevillian Society in the Sixteenth Century*. In *The Library of Iberian Resources Online*. http://libro.uca.edu/aristocrats/aristocrats1.htm.

Pineda Mendoza, Raquel. *Origen, vida y*

muerte del acueducto de Santa Fe. Mexico City: Instituto de Investigaciones Estéticas, Universidad Nacional Autónoma de México, 2000.

Pizzigoni, Caterina. *Life Within: Local Indigenous Society in Mexico's Toluca Valley, 1650–1800.* Stanford: Stanford University Press, 2013.

Porras Muñoz, Guillermo. *El gobierno de la ciudad de México en el siglo XVI.* Mexico City: Universidad Nacional Autónoma de México, 1982.

Prem, Hanns J. "Aztec Writing." In *Handbook of Middle American Indians, Supplement,* vol. 5, *Epigraphy,* edited by Victoria Reifler Bricker, 53–69. Austin: University of Texas Press, 1992.

Puga, Vasco de. *Provisiones, cedulas, instrucciones de su Magestad . . . 1563.* 3 vols. Reprint, edited by Joaquín García Icazbalceta. Mexico City: José María Sandoval, 1879.

Quiñones Keber, Eloise. *Codex Telleriano-Remensis: Ritual, Divination, and History in a Pictorial Aztec Manuscript.* Austin: University of Texas Press, 1995.

———. "Quetzalcóatl as Dynastic Patron: The Acuecuexatl Stone Reconsidered." In *The Symbolism in the Plastic and Pictorial Representations of Ancient Mexico: A Symposium of the 46th International Congress of Americanists, Amsterdam, 1988,* edited by Jacqueline de Durand-Forest and Marc Eisinger. Bonn: Holos, 1993.

Ramírez Leal, Gerardo. "Fray Diego Valadés y los Indios." In *Acerca de Fray Diego Valadés: Su Retórica cristiana,* edited by Bulmaro Reyes Coria, Gerardo Ramírez Leal, and Salvador Díaz Cíntora, 9–32. Mexico City: Universidad Nacional Autónoma de México, 1996.

Reyes García, Luis, ed. and trans. *¿Cómo te confundes? ¿Acaso no somos conquistados? Anales de Juan Bautista.* Mexico City: Biblioteca Lorenzo Boturini, Insigne y Nacional Basílica de Guadalupe, Centro de Investigaciones y Estudios Superiores en Antropología Social, 2001.

Reyes García, Luis, Eustaquio Celestino Solís, and Armando Valencia Ríos. *Documentos nahuas de la Ciudad de México del siglo XVI.* Mexico City: Archivo General de la Nación, 1996.

Ricard, Robert. *The Spiritual Conquest of Mexico: An Essay on the Apostolate and the Evangelizing Methods of the Mendicant Orders in New Spain, 1523–1572.* Translated by Lesley Byrd Simpson. Berkeley: University of California Press, 1966.

Ricoeur, Paul. *Memory, History, Forgetting.* Translated by Kathleen Blamey and David Pellauer. Chicago: University of Chicago Press, 2004.

Ríos, Pedro de los. *Codex Vaticanus 3738 der Biblioteca apostolica Vaticana: Farbreproduktion des Codex in verkleinertem Format.* Graz, Austria: Akademische Druck- und Verlagsanstanstalt, 1979.

Rojas Rabiela, Teresa, ed. *La agricultura chinampera: Compilación histórica.* Mexico City: Universidad Autónoma Chapingo, 1993.

———. "Ecological and Agricultural Changes in the Chinampas of Xochimilco-Chalco." In *Land and Politics in the Valley of Mexico: A Two Thousand Year Perspective,* edited by H. R. Harvey, 275–290. Albuquerque: University of New Mexico Press, 1991.

———. "Obras hidráulicas coloniales en el Norte de la Cuenca de México (1540–1556) y la Reconstrucción de la Albarrada de San Lázaro (1555)." *Ingeneria* 2 (1981): 98–115.

Romero Galván, José Rubén. "La Ciudad de México, los paradigmas de dos fundaciones." *Estudios de historia novohispana* 20 (1999): 13–32.

Rubial García, Antonio. "Civitas Dei." *Anales del Instituto de Investigaciónes Estéticas* 72 (1998): 34.

Ruiz, Armando, ed. *Arquitectura religiosa de la ciudad de México, siglos XVI al XX.* Mexico City: Asociación del Patrimonio Artístico Mexicano, 2004.

Ruiz Medrano, Ethelia. *Reshaping New Spain: Government and Private Interests in the Colonial Bureaucracy, 1531–1550.* Boulder: University Press of Colorado, 2006.

Ruiz Medrano, Ethelia, and Susan Kellogg, eds. *Negotiation within Domination: New Spain's Indian Pueblos Confront the Spanish State.* Boulder: University Press of Colorado, 2010.

Russo, Alessandra. "'Everywhere in This New Spain': Extension and Articulation of an Artistic World." *Source: Notes in the History of Art* 29, no. 3 (Spring 2010): 12–17.

———. "Image-plume, temps reliquaire? Tangibilité d'une histoire esthétique." In *Tradition et temporalités des images,* edited by Giovanni Careti, François Lissarague, Jean-Claude Schmitt, and Carlo Severi. Paris: Ecole des Hautes Études en Sciences Sociales, 2009.

———. "Plumes of Sacrifice: Transformations in Sixteenth-Century Mexican Feather Art." *Res: Anthropology and Aesthetics* 42 (Autumn 2002): 226–250.

———. "Recomposing the Image: Presents and Absents in the Mass of Saint Gregory, Mexico-Tenochtitlan, 1539." *Synergies in Visual Culture / Bildkulturen im Dialog: Festschrift für Gerhard Wolf,* edited by Manuela De Giorgi, Annette Hoffmann, and Nicola Suthor, 465–481. Munich: Wilhelm Fink Verlag, 2013.

Sahagún, Bernardino de. *Florentine Codex:*

General History of the Things of New Spain. 13 vols. (Cited by original book number.) Translated by Arthur J. O. Anderson and Charles E. Dibble. Santa Fe, NM: School of American Research and University of Utah, 1950–1963.

———. *Historia general de las cosas de Nueva España* [Florentine Codex]. 2nd ed. 2 vols. Edited by Alfredo López Austin and Josefina García Quintana. Mexico City: Consejo Nacional para la Cultura y las Artes and Editorial Patria, 1989.

———. *Primeros memoriales.* Translated by Thelma Sullivan. Norman: University of Oklahoma Press, 1997.

Sarabia Viejo, María Justina. *Don Luis de Velasco, virrey de Nueva España, 1550–1564.* Seville: Escuela de Estudios Hispano-Americanos, 1978.

Sasso Guardia, Manfred. "El acueducto prehispánico de Chapultepec." Master's thesis, Escuela Nacional de Antropologia e Historia, Mexico, 1985.

Schreffler, Michael J. *The Art of Allegiance: Visual Culture and Imperial Power in Baroque New Spain.* College Park: Pennsylvania State University Press, 2007.

Schwaller, John Frederick, ed. *Sahagún at 500: Essays on the Quincentenary of the Birth of Fr. Bernardino de Sahagún.* Berkeley: Academy of American Franciscan History, 2003.

Seler, Eduard. "Ancient Mexican Attire and Insignia of Social and Military Rank." In *Collected Works in Mesoamerican Linguistics and Archeology,* edited by Frank. E. Comparato. Culver City, CA: Labyrinthos, 1993.

Sell, Barry D., Larissa Taylor, and Asunción Lavrin. *Nahua Confraternities in Early Colonial Mexico: The 1552 Nahuatl Ordinances of Fray Alonso de Molina, OFM.* Berkeley: Academy of American Franciscan History, 2002.

Simpson, Lesley Byrd. *Many Mexicos.* 3rd ed. Berkeley: University of California Press, 1952.

Tena, Rafael, ed. and trans. *Anales de Tlatelolco.* Mexico City: Consejo Nacional para la Cultura y las Artes, 2004.

Torquemada, Juan de. *Monarquía indiana.* 1723. 3 vols. Mexico City: Editorial Porrúa, 1986.

Torre Villar, Ernesto de la. "Apuntamientos en torno de la administración pública y gobierno civil y eclesiástico en el siglo XVII." *Estudios de Historia Novohispana* 8 (1985): 243–264.

———. *Fray Pedro de Gante: Maestro y civilizador de América.* Mexico City: Seminario de Cultura Mexicana, 1973.

Toussaint, Manuel, Federico Gómez de Orozco, and Justino Fernández. *Planos de la Ciudad de México.* XVI Congreso Internacional de Planificación y de la Habitación. Mexico

City: Instituto de Investigaciones Estéticas de la Universidad Nacional Autónoma, 1938.

Townsend, Richard F. "Coronation at Tenochtitlan." In *The Aztec Templo Mayor*, edited by Elizabeth Hill Boone, 371–409. Washington, DC: Dumbarton Oaks, 1987.

———. "The Renewal of Nature at the Temple of Tlaloc." In *The Ancient Americas: Art from Sacred Landscapes*, edited by Richard Townsend, 171–185. Chicago: Art Institute of Chicago, 1992.

———. *State and Cosmos in the Art of Tenochtitlan*. Studies in Pre-Columbian Art and Archaeology 20. Washington, DC: Dumbarton Oaks, 1979.

Truitt, Jonathan. "Nahuas and Catholicism in Mexico Tenochtitlan: Religious Faith and Practice and la Capilla de San Josef de los Naturales, 1523–1700." PhD diss., Tulane University, 2008.

Umberger, Emily. "Antiques, Revivals, and References to the Past in Aztec Art." *Res: Anthropology and Aesthetics* (1987): 62–105.

———. "Aztec Sculptures, Hieroglyphs, and History." PhD diss., Columbia University, 1981.

———. "Montezuma's Throne." *Arara* 8 (2010): 1–45.

———. "Monuments, Omens, and Historical Thought: The Transition from Ahuitzotl to Motecuhzoma II." *Smoking Mirror* 16, no. 3 (November 2008): 2–6.

———. "Notions of Aztec History: The Case of the Great Temple Dedication." *Res: Anthropology and Aesthetics* 42 (Autumn 2002): 86–108.

———. "Renaissance and Enlightenment Images of Aztec Sacrificial Stones." *Source: Notes in the History of Art* 29, no. 3 (Spring 2010): 18–25.

Valadés, Diego. *Retórica Cristiana*. Translated by Tarsicio Herrera Zapién. Mexico City: Universidad Nacional Autónoma de México, Fondo de Cultura Económica, 1989.

———. *Rhetorica christiana ad concionandi, et orandi vsvm accommodata, vtrivsq[ue] facvltatis exemplis svo loco insertis . . .* Perugia: Petrumiacobum Petrutium, 1579.

Valderrama, Gerónimo. "Cartas del licenciado Jerónimo Valderrama y otros documentos sobre su visita al gobierno de Nueva España, 1563–1565." In *Documentos para la historia del México colonial*, vol. 7, edited by France Vinton Scholes and Eleanor B. Adams. Mexico City: Editorial Porrúa, 1961.

Valero de García Lascuráin, Ana Rita. *La ciudad de México-Tenochtitlán: Su primera traza, 1524–1534*. Mexico City: Editorial Jus, 1991.

———. *Los códices de Ixhuatepec: Un testimonio pictográfico de dos siglos de conflicto agrario*. Mexico City: Centro de Investigaciones y Estudios Superiores en Antropología Social y Colegio de San Ignacio de Loyola Vizcaínas, 2004.

Valle, Perla. "La Lámina VIII del Códice de Tlatelolco. Una propuesta de lectura." *Dimensión Antropológica* 2 (1994). Online at http://www.dimensionantropologica.inah.gob.mx/?p=1556.

———. *Ordenanza del señor Cuauhtémoc*. Translations by Rafael Tena. Mexico City: Gobierno del Distrito Federal, 2000.

Vásquez Janiero, Pedro. *Fray Pedro de Gante: El primero y más grande maestro de la Nueva Espana*. Mexico City: Editorial Porrúa, 1995.

Vetancourt, Agustín de. *Teatro mexicano*. Mexico City: Editorial Porrúa, 1982.

Vigil, Ralph H. *Alonso de Zorita: Royal Judge and Christian Humanist, 1512–1585*. Norman: University of Oklahoma Press, 1987.

Whittaker, Gordon. "Nahuatl Hieroglyphic Writing and the Beinecke Map." In *Painting a Map of Sixteenth-Century Mexico City: Land, Writing and Native Rule*, edited by Mary E. Miller and Barbara E. Mundy, 137–158. New Haven: Beinecke Rare Book and Manuscript Library, 2012.

———. "The Principles of Nahuatl Writing." *Göttinger Beiträge zur Sprachwissenschaft* 16 (2009): 47–81.

———. "The Study of North Mesoamerican Place-Signs." *Indiana* 13 (1993): 9–38.

Wicke, Charles R. "Escultura imperialista mexica: El monumento de Acuecuexcatl de Ahuízotl." *Estudios de cultura náhuatl* 17 (1984): 51–62.

Wittfogel, Karl A. *Oriental Despotism: A Comparative Study of Total Power*. New Haven and London: Yale University Press, 1957.

Yates, Frances. *The Art of Memory*. Chicago and London: University of Chicago Press, 1966.

Zorita, Alonso de. *Life and Labor in Ancient Mexico: The Brief and Summary Relation of the Lords of New Spain*. Edited and translated by Benjamin Keen. 1963. Reprint, Norman: University of Oklahoma Press, 1994.

———. *Relación de la Nueva España*. Edited by Ethelia Ruiz Medrano, Wiebke Ahrndt, and José Maríano Leyva. Mexico City: Cien de Mexico, 1999.

Index

Note: Italic page numbers refer to figures and tables.

Acachinanco, 64

Acatliapanecatl, Baltásar, 200

Acolhua, 37, 52, 55

Acuecuexatl stone, 67–69, 67

Acuecuexco: aqueduct of, 64–67, 65, 68, 69, 70, 71, 191, 196, 198, 202, 216n52, 216n67; springs at, 53, 61, 198

agency: attribution of, 60, 65; indigenous agency in colonial period, 15; of indigenous peoples, 180; and Nahua concepts of *teotl* and *teixiptla*, 60–61, 66–67, 69, 71; of sacred bundles, 66–67; spatial agency of Mexica rulers, 59–61

ahuehuetl (cypress tree), 32, 33, 63–64, 71, 100, 123–124, 177, 205

Ahuitzotl (r. 1486-1502): and Acuecuexatl stone, 67–69, 67; and Acuecuexco aqueduct, 64–65, 69, 191, 196; and aquatic infrastructure, 37, 38–40, 41, 41, 64, 191, 196, 198; Barnes on, 216n63; coronation of, 59, 62; dike of, 38–41, 41, 69, 75, 128, 129, 199–202; feather costumes of, 55; flow of water connected with figure of ruler, 24; monuments created under, 71; name glyph for, 138; performances of, 53; in Plano Parcial de la Ciudad de México, 77, 79; processions of, 59, 60; and Quetzalcoatl, 69, 216n67; rule of, 52; as *teixiptla* of Chalchiuhtlicue, 67–68, 69

Alcántara Gallegos, Alejandro, 18

altepeme (city-states): and aquatic infrastructure, 45; ceremonial centers of, 18, 57; *ciudades* compared to, 131; in Codex Osuna, 134, 135; as ideal physical space, 30, 31, 33–34, 210; as ideal political space, 15, 30–34, 51, 210; indigenous *gobernadores* as guardians of, 99; Mexica's search for, 30–34, 51; and

Mexico-Tenochtitlan, 99, 118, 124–125; Nahua political ideologies of, 10; residents supporting local nobility, 52; as result of actions of rulers and ethnic groups, 10; and roots of Santiago Tlatelolco, 99; and succession of Mexica rulers, 57; temple complexes of, 124–125, 220–221n38; Templo Mayor as model for, 15, 50, 51, 205, 207; within Tenochtitlan, 18; Tlaloc worshipped in, 42; *tlatoque* as metonym for, 3, 7, 8, 9, 10; translation as water hill, 10, 23, 51, 193, 205, 210; and tributary labor, 110, 149; and Triple Alliance of 1428, 20–21, 37, 61; and wars of Spanish Conquest, 75

Alvarado, Pedro de, 14, 14, 96–97

Alvarez, J. M., Plano de la Ciudad de México, 88, 88, 89, 109

Alzate, José Antonio, 136, 138, 140

Amanalco, 106, 219n27

Amatlan, 106

Anales de Juan Bautista, 175, 220n53, 224n76

Anales de Tlatelolco, 72

anamnesis, 14

aquatic infrastructure: Acuecuexco aqueduct, 64–67, 65, 68, 69, 70, 71, 216n52, 216n67; and agriculture, 17, 37, 39; building outward into lake, 39; canals of, 17, 23, 28, 34, 38, 41, 53, 55, 61, 64, 65, 66, 70, 72, 75, 77, 80, 84, 193, 194, 197, 216n35; Chapultepec aqueduct, 23, 51, 53, 58, 59, 61–63, 63, 64, 72, 75, 80, 94, 97, 116, 191, 216n26, 217n19; and *chinampas*, 17, 34, 34, 35; dikes of, 15, 35, 36, 37, 38, 39, 40–42, 41, 52, 58, 64, 69, 75, 81, 193, 194, 196, 197, 199–202; Durán on, 37; effect of Spanish Conquest on, 38, 39, 75–77, 86, 210; and Franciscans, 202; and indigenous *cabildo* of Mexico-Tenochtitlan, 190–191, 199, 226n65; indigenous technologies of, 73, 199–202, 210;

maintenance of, 193; in Map of Santa Cruz, 39–42, 40, 41; and metro system, 23; Mexica rulers connected with, 27, 39, 40, 42, 45, 51, 53, 71; of post-Conquest cities, 9; of pre-Conquest cities, 15, 16; and Spanish *cabildo*, 193–194, 196, 197–203; and Tlacaelel, 62

Aquiaguacatl, Juan, 199–200

Arias, Diego, 206

Aristotle, 14

Armijo Torres, Ricardo, 216n26

Ars Memorativa, 121

artists, indigenous: copying from print models, 104, 105, 173; Dürer on, 106; Florentine Codex on, 155–156; and guilds, 169; pigments used by, 40–41; and processions, 171; spatial templates of, 49; tribute paid by painters in Genaro García 30, 154–155, 155, 160; tribute paid by sculptors in Genaro García 30, 154–155, 154, 160. *See also* feathers and featherwork

Atarazanas, 218n74

Atzacoalco: as *altepetl*, 18, 57, 73, 128; and dike of Nezahualcoyotl, 38. *See also* San Sebastián Atzacoalco

audiencia. *See* Real Audiencia (royal court)

Augustinians, 113, 178

Ávila brothers, 224n52

Axayacatl (r. 1468–1481): descendants of, 100, 191, 205; palace of, 76, 112; in Plano Parcial de la Ciudad de México, 77, 79; rule of, 52

axes: alignment with sun, 102; of built environment, 15; Christian axes, 175–178, 212; of Mexico-Tenochtitlan, 127; and Oath of Allegiance of 1557, 180–182; and processions, 24, 58–59, 94, 95–96, 98, 169–171, 173–180, 189; streams as, 33, 51; and Templo Mayor, 127; and *tianguis*, 86, 88; visual and conceptual importance of, 127

Ayoticpac, 97, 176–177

ayuntamiento ("city hall"), 77, 101
Azcapotzalco, 37, 61, 75, 191
Aztaxochitl, Diego, 208
Aztec Empire: Map of, 21, 22, 37, 53; and Triple Alliance of 1428, 20–21, 37, 52, 55, 61, 64, 75
Aztlan, in Tira de la Peregrinación, 26–27, 26, 31

Balbuena, Bernardo de, 2, 3, 212
Barnes, William, 46, 67–68, 216n63
barrios (neighborhoods), 133, 135, 136–137, 174. See also tlaxilacalli (neighborhoods)
Basque community, 208
Beinecke Map: pigments used by indigenous artists, 40–41; ruler list, 100, 101, 102, 139, 156, 157, 163–164; smallholders, 165, 166
Bejarano, Ignacio, 217n19, 217n24, 217n35, 217n42, 218n69, 220n57
Biombo Portraying a View of the Palace of the Viceroy in Mexico City, 2, 2, 13, 18, 24, 86
Boturini Benaduci, Lorenzo, 218n54
Boyer, Richard, 194
Bridge of the Wars, 179
built environment: and architectural history, 9, 11; construction by indigenous laborers, 73; as lived space, 13; and place-names, 97, 218n74; post-Conquest sharing features with pre-Conquest Tenochtitlan, 73; representations of Mexica rulers in, 52; spatial continuities of, 17, 125–126; survival of, 9, 18; visual axes of, 15

cabildo (indigenous town council): and aquatic infrastructure, 191, 199, 226n65; arcade in Tianguis of Mexico as rental income for, 157, 205; and building of tecpan, 108, 187; indigenous elites of, 99, 102, 157, 164, 168, 169; and indigenous lands, 94, 208; jurisdiction of, 205, 206, 226n73; and mitotes, 185–186, 187; payment of members, 187; and processions, 179, 180; structure of, 15; and Tianguis of Mexico, 93, 207, 226n73; and tribute system reform, 188–189; use of "ciudad," 131, 135
cabildo (Spanish town council): Actas de cabildo, 86, 97, 108, 180, 181, 196, 197, 202; and aquatic infrastructure, 193–194, 196, 197–203; ayuntamiento as meeting place of, 77; building methods of, 194; and ceremonial practices, 94, 95–96, 126, 218n70; Cervantes de Salazar as historian of, 211; and Chapultepec fortress, 194; on epidemics, 203; expansionism of, 103, 105; and food crisis in Mexico City, 157; and Franciscans, 113, 116; and indigenous gobernadores, 130; jurisdiction of, 99, 105, 205–206, 226n72; and Laguna of Mexico's fill project, 194; and land grants, 93, 94, 97, 101; and Mendoza as viceroy, 101; payments made for lime for Chapultepec aqueduct, 203, 203; and place-names, 97, 131, 132, 135; and processions, 169; relationship with indigenous government, 113; and religious festivals, 170; and ritual of reenactment, 95; Spanish

precedents for, 102; storefronts constructed for rental income, 157; structure of, 15; Tejada's land grant from, 158; and Tianguis of Mexico, 80, 84, 86, 93, 94; and Valeriano's request to build Chapultepec aqueduct, 191
Cabrera C., Rubén, 63
cajas de comunidades (indigenous treasuries), 126, 178
Calendar Stone, 69
Calnek, Edward, 17, 108, 137, 140
Cano, Juan, 97
Cantares Mexicanos, 28
Caplan, Harry, 220n24
Carballal Staedtler, Margarita, 38, 39, 215n41
Carmelites, 178
Caro, Juan, 186, 188
Carvallo, Cristóbal de, Map of the Tianguis of Mexico, 86, 87, 88, 89, 204, 206
Casas, Bartolomé de las, 1, 3, 160
Casey, Edward, 174, 223n25
Caso, Alfonso: Map of Tenochtitlan and Tlatelolco, 17, 136–137, 136, 138, 221n17; on Teocalli of Sacred Warfare, 45, 48, 216n71; and tlaxicalli, 140; on tributary population counts, 221n50; on use of pre-Hispanic temples in post-Conquest churches, 124–125, 220–221n38
Castañeda de la Paz, María, 15, 102, 219n8, 219n9, 222n41
Castro Gutiérrez, Felipe, 15
Cathedral of Mexico: building project of, 76–77, 108, 117, 194, 199, 211; and processions, 173, 177, 179; and Trasmonte's "Forma y Levantado de la Ciudad de México," 128
Catholic Church: architecture of churches, 73; art patrons of, 104; disputes over tithes, 164, 178, 222n63; festivals of, 94, 95–96, 169; and Liberal Reform Laws, 117; and secularization, 178–180, 223n43, 224n55. See also Christian conversion; Franciscans
Catholic patron saints: circulation of holy image, 173–174; and cofradías, 156, 169, 173, 223n20; and feast day psalms, 96; feasts of, 95–96, 168; indigenous role in choice of, 125–126; and place-names of Mexico City, 73; and place-names of Mexico-Tenochtitlan, 125, 137, 152, 153, 156, 165; and Trasmonte's "Forma y Levantado de la Ciudad de México," 128, 129
causeways: Ahuitzotl dike, 39–42, 41, 75; arable land with Tenochtitlan, 39; bridges spanning breaks in, 18, 75; Chapultepec causeway, 85, 86, 127; construction of, 15, 37–39, 40, 41, 52, 71; in Covarrubias's View of the Valley of Mexico, 25, 25; and creation of Laguna of Mexico, 37; as dikes, 35, 58; and Laguna of Mexico, 37; lived spaces of, 58, 73; maintenance of, 193; in Map of pre-Hispanic Tenochtitlan and Tlatelolco, 16, 17, 38; in Map of Tenochtitlan from Cortés's Second Letter, 17, 18, 40; Mexica escaping

Spanish Conquest along, 72; Mexicaltzinco causeway/dike, 35, 37; Nezahualcoyotl dike, 38–42, 41, 75, 215n41; Piedad causeway, 86, 127, 221n51; processions along, 21, 58, 177; San Juan causeway, 86, 88, 127, 191, 194, 207; separating altepeme of Tenochtitlan, 18, 57; Spanish construction of houses along, 94, 97; Tepeyacac causeway, 37–39, 40, 58, 69; and wars of Spanish Conquest, 75. See also Ixtapalapa causeway; Tacuba causeway; Tlacopan causeway
Cecetzin, Cristóbal de Guzmán (r. 1557–1562): in Codex Tlatelolco, 180, 181, 182; as gobernador, 77, 166–167, 205; in Plano Parcial de la Ciudad de México, 77, 79
Cerro de la Estrella, 35
Certeau, Michel de: on cities as space, 10–12; on city as lived practice, 11, 12; on imaginary totalizations of cities, 10–12; on paths of walking, 169, 211; on place-names, 96, 130, 138; on representations of city, 10–11
Cervantes de Salazar, Francisco, 181, 183, 191, 209, 211, 218n45
Cevallos, Luis de, 208, 226n84
chacmool with Tlaloc mask, 42, 42, 47–48
Chalchiuhtlicue (female water deity): and Acuecuexatl stone, 67, 68; and Acuecuexco aqueduct, 65–66, 68; on back face of Teocalli of Sacred Warfare, 47–49, 47, 50, 51, 70, 131; in Codex Borbonicus, 43–44, 44, 65, 66, 67; conquest of, 45, 47–49, 50, 51; floods associated with, 43–44; lakes and streams associated with, 42, 47; movement of groundwater associated with, 43–44, 49, 50, 51; and origin histories, 45; stone sculptures of, 42–43, 43, 44, 47, 48, 51; teixiptla of, 66, 67–68, 69
Chalco: city, 35, 37, 127; lake, 35, 39, 41
Chapultepec: as altepetl model, 51, 61, 175; Botanical Garden of, 69; causeway of, 85, 86, 127; ceremonial buildings adjacent to aqueducts, 69; in Codex Aubin, 9, 9, 31, 61; as conceptual model for lived spaces, 31; fortress of, 194; freshwater aqueducts from, 23, 51, 53, 58–59, 61–63, 63, 64, 72, 75, 80, 94, 97, 116, 163, 191, 197, 202–205, 203, 204, 207, 208, 216n26, 217n19; freshwater springs of, 23, 31, 61–64, 71, 75, 127, 197, 205; glyph of, 9, 9, 31, 193; history of, 23; Map of, 63, 63, 71, 197; Mexica rulers' associated with, 61, 62–64, 71; and processions, 60; representations of, 61; and San Juan causeway, 86, 88; sculptures on, 23, 61–62, 62, 63, 70, 71, 80; and tales of Mexica migration, 50, 61, 71; in Tira de la Peregrinación, 30–31, 31, 61, 70; and Tlacopan causeway, 58; water for Tenochtitlan from, 23, 51, 53, 61–62
Charles V (king of Spain, r. 1519–1557): coat of arms for Mexico City, 129; Cortés's letters to, 1, 10, 17, 27, 75, 131, 211; funeral ceremonies

at Chapel of San José de los Naturales, 117; and Gante, 118; and Glapión, 118; indigenous nobles' letter to, 133; length of reign, 94; longevity of rule, 180; and Map of Santa Cruz, 108; and Mendoza, 100–101; and Moteuczoma II's gift, 106; recall of Cortés, 83

Chavero, Alfredo, 216n35

Chichimecacihuatl, Magdalena, 187

Chichimecs, 83, 119, 156, 194, 222n34

Chimalpahin Quauhtlehuanitzin, Domingo de San Antón Muñón: on Ayoticpac, 97; on banner showing list of indigenous rulers, 220n53; on Chapultepec aqueduct, 204; Codex Chimalpahin, 31–32, 34; on epidemic, 203; on images of saints, 173; on *mitotes*, 187; on Motelchiuhtzin, 83; on processions, 175, 176; on Tehuetzquititzin, 156; on Valeriano, 191; on Xochiquentzin, 83

Chimalpopoca (r. 1417–1427), 61

chinampas (raised beds): and Acuecuexco aqueduct, 64; and canals, 34, 35, 38, 77, 84, 197; construction of, 35, 52; and effect of Conquest on lake system, 75; and floods, 43; as intensive agriculture, 35; in Map of Tenochtitlan from Cortés's Second Letter, 17–18, 17; Map showing *chinampas*, 34, 34; post-Conquest abandonment of, 72; post-Conquest use by indigenous peoples, 77, 80; salty lakes threatening, 35; in Xochimilco, 71

Cholula, 25–26

Christian conversion: and Franciscans, 24, 102–103, 106, 113, 114, 116, 118, 119, 120, 121, 122, 175, 180, 211; and Gregory I, 119; and Huanitzin, 106, 107, 113; and indigenous *gobernadores*, 99; and religious festivals, 170, 171; and representation of urban space, 96

Christian iconography: and axes, 175–178, 212; and featherwork, 106, 107

Churubusco aqueduct, 198, 199, 202

Cihuacoatl (female deity), 58

Cipactzin, Luis de Santa María (r. 1563–1565): death of, 191; as *gobernador*, 77, 163, 187, 189; in Plano Parcial de la Ciudad de México, 77, 79; wedding celebration of, 187–188

cities: biological metaphors of, 3; locating of, 9–10; as metaphor, 3–5, 7–9; social space of, 10; as space, 10–14. *See also* Mexico City; Mexico-Tenochtitlan (indigenous ring city); Tenochtitlan

ciudades: indigenous centers granted status of, 133, 221n5; Spanish political ideologies of, 10, 104, 129, 130–131, 133, 135

civitas, ideology of, 210

Coatepantli, 110

Coatepec (serpent hill): Birth of Huitzilopochtli in the Florentine Codex, 29, 30, 48, 51, 61; as main pyramid at Tenochtitlan, 26, 29, 30, 51

Coatlicue, 29, 69

Codex Aubin: annals history of Tenochtitlan and Mexico City, 8–9, 10; arrival at

Chapultepec, 9, 9, 31, 61, 193; death of Cuitlahua, 8, 8, 81; on Guzmán's accession, 222n57; and lived spaces, 37; on origin of Nahuatl name, "Mexico," 128; as pictographic-alphabetic manuscript, 13; reigns of Huanitzin and Tehuetzquititzin, 100, 100, 139, 156–157

Codex Borbonicus: Chalchiuhtlicue, 43–44, 44, 65, 66, 67; *tonalamatl* calendar in, 65

Codex Borgia, world tree, 48, 48

Codex Boturini. *See* Tira de la Peregrinación

Codex Cozcatzin: Moteuczoma II and his children, 192, 193, 225n11; on *tecpan*, 223n69; on Tehuetzquititzin, 193

Codex en Cruz, 218n54

Codex Fejérváry-Mayer: quincunx motif in, 34, 107; world diagram, 33, 34, 48, 107

Codex Ixtlilxochitl: portrait of Nezahualcoyotl, 55, 56, 184; portrait of Nezahualpilli, 56, 56, 62, 83, 107; portrait of Tocuepotzin, 159, 163, 190

Codex Mendoza: ambiguous presentation of dates in, 7–8; and *cihuacoatl* glyph, 81; on clans of Tenochtitlan, 58; cloaks listed in, 159; on conquests of Mexica rulers, 45; feathered ensembles, 184, 224n63; the foundation of Tenochtitlan, 4–5, 4, 7, 8, 11, 32, 34, 35, 46–47, 48, 49, 51, 107, 111, 131, 156, 193, 207; and glyph of Tenochtitlan, 65, 131, 151; and indigenous pictography, 3, 4, 5, 13, 140; on Itzcoatl, 37; Mexica scribes creating, 3–4, 8, 111; on Mexica society, 111; palace architecture presented in, 111; palace of Moteuczoma, 111–112, 112, 164, 165; as pictographic-alphabetic manuscript, 13, 140; as pictorial history of city, 3, 4–5, 7–8, 9, 24; place-names in, 49–50, 49, 131; pre-Hispanic *huei tlatoque* in, 100; the reign and conquests of Moteuczoma II, 5, 6, 7, 7, 8, 45, 100, 111; symbol for *tianquiztli* in, 12, 12; *tequihua*, or seasoned warrior, 184, 184; tribute from Tochtepec, 53, 54, 55, 111, 156, 184; tributes demanded by Mexica rulers, 53

Codex Osuna: diagram of Mexico-Tenochtitlan, 124, 125, 165, 178; former *altepeme* of the Triple Alliance, 134, 135; and Esteban de Guzmán, 163–167; and indigenous rulers, 163, 222n59; and legal disputes, 163, 165–166, 189, 225n8; as pictographic-alphabetic manuscript, 13; and San Lázaro dike, 201–202, 201; *tecpan* of Mexico-Tenochtitlan, 109–110, 109, 111, 125, 127, 163–164, 165, 167; Viceroy Luis de Velasco and don Esteban de Guzmán, 162, 163, 164–165; Viceroy Luis de Velasco deputizing the *alguaciles*, 163, 164, 200

Codex Santa Anita Zactlalmanco, 218n56

Codex Telleriano-Remensis, and dike of Nezahualcoyotl, 38

Codex Tlatelolco: and bells of monasteries, 223n38; and *mitotes*, 181, 183–185, 186; and Oath of Allegiance of 1557, 180–182, 181,

183, 184, 224n63; as pictographic-alphabetic manuscript, 13; and *tecpan* of Santiago Tlatelolco, 110, 110

Codex Vaticanus A, 223n70

Códice Cozcatzin, 219n39

cofradías (religious sodalities): and Catholic patron saints, 156, 169, 173, 223n20; and processions, 169, 171, 173–175, 179

Columbus, Christopher, 130

Connell, William, 15

Connerton, Paul, 14, 174

Conway, Richard, 18

Copil, 31–34, 47, 50

Copilco, 23

Corpus Christi, feast of, 94, 95, 96

Cortés, Hernando: and aquatic infrastructure, 197, 199; Charles V's recall of, 83; Cuauhtemoc's surrender to, 3, 95; fall of, 100; and Franciscans, 113, 116; gifts of feathered works, 106, 107; Honduras campaign of, 82, 83, 84, 102, 116, 126, 156; and indigenous elites, 82, 101; letters to Charles V of Spain, 1, 10, 17, 27, 75, 131, 211; on markets, 81, 217n28; metro station named after, 20; and Mexico City as "ciudad," 130–131, 135; and Mexico City's governance, 82–83, 95, 217n35; and Moteuczoma II, 21, 45, 53, 77, 106; palaces built for, 73, 76, 94, 167, 194, 210; parceling out lands of Tenochtitlan, 72, 110, 118, 123; place-names in letters of, 131, 135; residences of, 76, 97; and siege of Tenochtitlan, 75; Tenochtitlan's destruction described by, 1, 9; Third Letter, 1; on Tianguis of Mexico, 80; and Juan Velázquez Tlacotzin, 81, 82, 118; and Triple Alliance of 1428, 21. *See also* Map of Tenochtitlan from Cortés's Second Letter

Cortés, Luis, 224n52

Cortés, Martín, 189, 191

Cortés Totoquihuaztli, Antonio, 182

cosmovision, 28–29, 31, 45, 50, 175

Costa Rica, 55

Council of the Indies, on Spanish *cabildo*'s right to apportion land, 93

Covarrubias, Luis, *View of the Valley of Mexico*, 25–26, 25, 28, 29

Coyoacan, 20, 35, 64, 76, 86

Coyolxauhqui (female lunar deity), 29, 30, 33–34, 45, 48

Coyotlinahual (deity), 156

Cuauhtemoc (Mexica emperor) (r. 1520–1525): captivity of, 76; Cortés's hanging of, 20, 82, 156, 210; in Humboldt Fragment II, 82, 83, 100; metro station named after, 20; in Plano Parcial de la Ciudad de México, 77, 79; purging of competitors, 102; surrender of, 3, 14, 20, 72, 95, 98; and Juan Velázquez Tlacotzin, 81

Cuauhtepec, 25

cuauhxicalli (eagle vessel), 68

Cuepopan: as *altepetl*, 18, 57, 58, 73, 128; *teocalli*

130, 131–133; Plano de la Ciudad de México, 88, *88*, 89, 109; Plano Parcial de la Ciudad de México, 77, *78, 79*, 196; population of, 18; post-Conquest reestablishment of, 73, 99; and processions, 94–96, 169–171, 173, 175–178, *176*; reallocation of lands within, 81; rebuilding of, 24, 80, 99; and representations of space, 11, 13, 15; sixteenth-century built environment of, 15, 17; as Spanish *ciudad*, 104; Spanish narratives of, 24; Spanish occupation of, 17, 72–73, 76; Spanish population of, 76–77, 86; Spanish residents of, 94, 95–97, 98, 99, 112, 113, 116, 117, 127, 211; spatial continuities between pre- and Post-Conquest periods, 15, 17, 18, 73, 125–126, 212; street sign, *14, 14*, 96; temporal continuity of, 10, 13; *traza* of, 72, 73, *73*, 77, 93, 94, 128. See also Mexico-Tenochtitlan (indigenous ring city); Plaza Mayor, Mexico City

Mexico-Tenochtitlan (indigenous ring city): canals of, 24, 80, 116–117, 177; Caso's Map of Tenochtitlan and Tlatelolco, 17, 136–137, *136*, 138, 221n17; in Codex Osuna, *124*, 125, 165, 178; elites versus commoners in, 168, 185–187; Franciscan development of, 116–119; genealogy of rulers, 83, *84*, 99, 156, 191; Huanitzin's spatial project for, 104; indigenous government of, 15, 18, 73, 77, 82–84, 86, 98, 99, 100–102, 108, 133, 137, 156, 167, 168, 177–178, 188, 190–191, 194, 199, 200–207, 208, 210; indigenous rulers of, 18, 24, 101, 102, 103–107, 111, 116, 137, 156, 163, 166–167, 169, 180–185, 189; and indigenous scribal production, 111; layers of indigenous residency in, 137, *137*; lived spaces of, 18, 24, 99–100, 116; markets of, 80–81; monumental architecture of, 108; name of, 105; off-island properties of, 135, 221n14; *parcialidades* of, 18, 72, 99, 110, 118, 125–126, 136–137, 140, 149, 151–154, 156, 159, 165, 166, 168, 174, 175, 177, 179, 187, 188; placement of sacred architecture, 18; place-names of, 18, 24, 97, 125, 127, 133, 135–140, 151; political jurisdiction of, 104, 118; as pre-Hispanic *altepetl*, 24, 99, 104; and processions, 169–170; in quincunx form, 125, 165, 178; Rome as Franciscan model for, 107, 113, 114, 116, 122–127, 209; sacred centers of, 102; as San Juan Tenochtitlan, 127; spatial continuities of, 15, *16*, 17, 18, 125–126, 212; *tlaxilacalli* of, 17, 135–138, *136*; *tlaxilacalli* place-names, 140, *141–149*, 149, 151–156; urban geography of, 106. See also Tianguis of Mexico

Mexitli (deity), 128

Miller, Mary Ellen, 48

mitotes (ritual dances): and Cipactzin, 188; costumes of, 182, 183, 184, 185–186, 187, 189, 224n76, 224n77; and elites versus commoners in Mexico-Tenochtitlan, 185–187; and indigenous political power, 167, 208; and lived spaces, 59; and Oath of Allegiance of 1557, 183–185; origin of word, 183, 224n65; periodic banning of, 186, 224n80; tradition of, 177, 183–185

Mixtón war, 156, 194

Mocel, Juana, 226n74

Moctezoma, Isabel (daughter of Isabel Moctezoma and Juan Cano), 97

Moctezoma, Isabel (daughter of Moteuczoma II and wife of Juan Cano), 97, *192, 193*

Moctezoma Tlacahuepantli, Pedro, 102, 110, 111, 164, *192, 193*, 217n23, 219n9

Molina, Alonso de, 27, 215n2, 224n50, 224n65

Montúfar, Alonso de, 164, 178–180, *182*

More, Thomas, 198

Moreno de los Arcos, Roberto, 125, 221n42

Motelchiuhtzin, Andrés de Tapia (r. 1526–1530): and assassination of Nezahualtecolotzin, 219n8; and Cortés, 217n36; descendants of, 102, 110, 126, 223n43; as *gobernador*, 77, 110; in Humboldt Fragment II, *82, 83*; and marriage, 222n54

Moteuczoma, Isabel de Alvarado (wife of Antonio Valeriano), *84*, 191

Moteuczoma Ilhuicamina (Moteuczoma I) (r. 1440–1468): agency of, 60; and aquatic infrastructure, 38, 61–62; and gifting, 159; military campaigns in Chalco region, 35; and *mitotes*, 187; monuments of, 52, 53, 60; performances of, 53; in Plano Parcial de la Ciudad de México, 77, *79*; portrait carved on Chapultepec hill, 62, *62*, 70, 80; Tlacaelel as *cihuacoatl* of, 80; and tribute goods, 55

Moteuczoma Xocoyotzin (Moteuczoma II) (r. 1502–1520): and aquatic infrastructure, 196; architectural works of, 58; assassination of, 167; asymmetrical gifting of, 106; aviary of, 23, 105–106, 116, 220n36; in Codex Cozcatzin, *192, 193*, 225n11; in Codex Mendoza, 5, *6*, 7, 8, 111; conquests of, 5, 70; coronation of, 59; and Cortés, 21, 45, 53, 77, 106; costumes of, 70–71, 83, 111–112, 183; death of, 7, 8, 9, 72, 210; descendants of, 83, 97, 100, 102, 191; descriptions of, 53; *encomiendas* assigned to children of, 81, 102; flow of water connected with figure of ruler, 24; gardens of, 127; headdress of, 20–21, 53; in Humboldt Fragment II, *82, 83*, 159; icon in metro map, *20, 20*, 21, 23; and Motelchiuhtzin, 217n36; name glyph of, 138, *193*, 216n71; palace in Codex Mendoza, 111–112, *112*, 164, *165*; palaces of, 21, 23, 69–70, 76; Palacio Nacional built on foundations of palace, 69; performances of, 53; in Plano Parcial de la Ciudad de México, 77, *79*; portrait carved on Chapultepec hill, 23, *64*, 70–71, *70*, 216n71; procession on Ixtapalapa causeway to greet Spanish conquistadores, 58, 71, 72; as referent, 151; rule of, 52; and sacred bundle of Huitzilopochtli, 66; and Teocalli of Sacred Warfare, 45–49, *46, 47*, 69; Juan Velázquez Tlacotzin as *cihuacoatl* under, 80; and urban complexes, 58; urban features constructed by, 21, 23

Motlatocazoma, Martín, 219n9

Motolinia (Toribio de Benavente), 73, 126, 171, 183, 220n37, 223n20

Moyotlan: as *altepetl*, 18, 57, 58, 73, 110, 128; festivals of, 126–127; market of, 73, 75, 110; and place-names, 130; Temple of Xipe Totec at Yopico, 71, 125, 126; and Juan Velázquez Tlacotzin, 81, 110, 217n23. See also San Juan Moyotlan

Mullen, Robert, 9

Muñoz Camargo, Diego, 97

Nahuas: and agency, 60–61; clothing of, 185; confraternities, 18; family ties of elites, 107; origin histories of, 45; and quadripartite scheme, 5

Nahuatl language: and alphabetic writing, 138–139, 152–153; and Codex Aubin, 8; etymology of "Mexico" in, 128; and feast day psalms, 96; in Florentine Codex, 29, 105; Franciscans' knowledge of, 126; Franciscans setting in Latin alphabet, 103; Gante's fluency in, 118, 119; goods in Tianguis of Mexico expressed in, 90, *91–92, 93*, 206, *207*; meaning of Tenochtitlan in, 1–2, 27; as metaphoric language, 28; and Oath of Allegiance of 1557, 182; period texts of, 13; and place-names of Mexico City, 73, 97, 130; and place-names of Mexico-Tenochtitlan, 97, 136, 137, 138–140, 151; and Valadés, 119. See also pictography

Nahuatl speakers: cosmovision of, 28–29; and directions, 179, 224n50; on divine election of rulers, 83; intensive agriculture of, 35, 77; and lived spaces, 18; as nomads settling in Chapultepec, 23; opposition in literary tradition, 27; and place-names, 140, 149, 151–156; Spanish knowledge of, 126; in *tianguises*, 93; in Valley of Mexico, 26

Nahuatl-speaking women, representations of, 13

Naples, Italy, sixteenth-century population of, 1

National Autonomous University (UNAM), 20

Navarrete, Frederico, 10

New Fire celebration, 71

New Spain: architectural history of viceregal period, 9; emergent bilingual empire, 153; governance of, 83; Huanitzin's conception of, 107; Mendoza as viceroy of, 101; Mexico City as home of viceroy of, 2, 20, 95, 104, 105, 113; Mexico City as viceregal capital of, 20, 104, 105, 118, 210, 211; naming of, 82, 97, 98, 102; processions in, 94–95; referents of place-names in, 130; and representation of space aligned with Israel, 96

Nezahualcoyotl (ruler of Tetzcoco): and aquatic infrastructure, 37–38, 40, 41, *41*, 62, 75;

bloodletting, 45, 67, 68, 183; and Chapultepec, 59; for coronations, 58, 59, 71; and deity costumes, 56; and priests' costumes, 66; and processions of Mexica rulers, 58; Spanish civil rituals, 14, 94–96, 98, 168, 218n69; and tribute goods, 55. *See also* mitotes (ritual dances); sacrifice

Rojas Rabiela, Teresa, 35

Rome, Italy: as model for Mexico-Tenochtitlan, 107, 113, 114, 116, 122–127, 209; sixteenth-century population of, 1; Valadés in, 119–120

Romero Galván, José Rubén, 125

Rousseau, Jean-Jacques, 151

Ruiz, Gonzalo, 217n42

Ruiz Medrano, Ethelia, 15, 82

sacred bundles, agency of, 66–67, 71

sacrifice: and Acuecuexatl stone, 68; heart sacrifice, 48; self-sacrifice of Mexica rulers, 69. *See also* human sacrifice

Sahagún, Bernardino de: on Chalchiuhtlicue, 44; on Coatlicue, 29; and feast day psalms, 96, 98; on indigenous artists, 155–156; on markets, 80, 82; on *mitotes*, 184, 224n65; as resident of Monastery of San Francisco, 118; and Santiageo Tlatelolco, 177; and Valeriano, 190. *See also* Florentine Codex

Salvator Mundi, feather mosaic, 171, 172, 173

San Antonio Abad, 64, 217n23

San Cosme, 58

San Francisco, monastery of: *ahuehuetl* tree in courtyard, 177, 205; centrality of, 175; extension of street passing by, 194, 225n13; Franciscan living quarters of, 117; Franciscans' utopian vision for, 116–119; Gante in residence at, 105, 113, 118, 122, 177, 220n14; gardens of, 117, 127; images of Catholic saints in, 173; lived space of, 114; Mendieta residing at, 169–170; and Moteuczoma's aviary, 105–106; Plano General, 117, 117, 177; residents of, 118; site of, 110, 113, 116; as symbolic of Franciscan mission, 114, 116; and Tianguis of Mexico, 86; in Valadés's *Rhetorica christiana*, 114, 115. *See also* San José de los Naturales

San Gregorio, school of, 178

San Hipólito: civil celebration of feast of, 14, 95–96, 98, 168, 170, 190; procession of, 176–177

San José de los Naturales: autos-da fé of the Inquisition, 117; Chapel of, 110, 114, 117, 117, 118, 123, 125, 127, 170, 173, 175, 177, 179; founding of, 116; as Gante's building project, 123; indigenous scribes of, 111; and Nahua confraternities, 18, 118; parish of, 113, 116, 137, 165, 170; and processions, 170, 171; reconstruction drawing of façade from George Kubler, 123, 123; school of, 18, 113, 118–119, 121–122

San Juan, feast of, 95, 126

San Juan causeway, 86, 88, 127, 191, 194, 207

San Juan de la Penetencia convent, 177

San Juan de Letrán, 125, 126

San Juan Moyotlan: and aquatic infrastructure, 202, 204; churches of, 125, 126, 177; feasts of, 126; Franciscans in, 113, 116, 177, 179; market of, 85, 108, 110, 127; name glyph for, 149, 150, 153, 153; patron saints of, 126, 221n47; population of, 126–127, 220n50, 221n50; power as center of Mexico-Tenochtitlan, 110–111, 113; and processions, 174; Spanish naming of, 73; tribute in Genaro García 30, 150, 153–154, 153, 165; Valadés on, 108. *See also* Moyotlan

San Lázaro dike, 199, 200–202, 201, 225n44

San Lázaro hospital, 108, 199, 221n39

San Lorenzo basilica, 221n39

San Pablo Extramuros, 125

San Pablo Teopan: and aquatic infrastructure, 202; *atrios* of, 128; churches of, 125; indigenous government of, 199; and Map of Santa Cruz, 110–111; patron saints of, 126, 221n49; and processions, 174; and secular priests, 178, 179; Spanish naming of, 73; *teocalli* of, 220n38; tribute goods from, 152, 153; tribute in Genaro García 30, 153, 153; water supply of, 191; Xochiquentzin's palace in, 110. *See also* Teopan

San Sebastián Atzacoalco: *atrios* of, 128; churches of, 125, 220n38; feast of, 126; Pedro Moctezoma's palace in, 110; and processions, 174; and secular priests, 178; Spanish naming of, 73; *teocalli* of, 125, 220n38. *See also* Atzacoalco

Santa Catalina church, 108

Santa Catalina de Sena, 177

Santa Cruz, Alonso de, 108

Santa Cruz de Jerusalem basilica, 221n39

Santa Fe springs, 191, 198, 203, 204

Santa María Cuepopan: church of, 125, 179; feast of, 126; and Franciscans, 173, 177, 179, 180; liminality of, 179; and north-south axis, 127; and processions, 174, 179–180; Spanish naming of, 73; tribute in Genaro García 30, 151–152, 152, 156. *See also* Cuepopan

Santa María la Mayor, 125

Santiago, feast of, 95, 126

Santiago Tlatelolco: bells of monastery, 177, 205, 223n38; Caso's Map of Tenochtitlan and Tlatelolco, 136–137, 136; cistern of, 205; as "ciudad," 135; feast of, 126; featherworking of, 219n27; and Franciscans, 177; indigenous government of, 15, 107, 137, 199, 205, 219n21, 219n27; as indigenous zone, 99, 113; market of, 85, 86, 113, 218n46; and north-south axis, 127; as pre-Hispanic *altepetl*, 99; and San Juan causeway, 86; Spanish naming of, 73; *tlaxilacalli* of, 137; viceregal requests for indigenous labor, 127. *See also* Tlatelolco

Santo Domingo, monastery of, 176, 177, 179, 187, 194

Saussure, Ferdinand de, 151

Schroeder, Susan, 175

sculptural representation: Acuecuexatl stone, 67–69; agency of, 60, 66, 71; on Chapultepec hill, 23, 61–62, 63, 70, 71, 80; deity images on live rock, 69, 70

Sebastian, Saint, 168

Simpson, Lesley Byrd, 224n55

Soto, Francisco de, 126

southern lakes, 35, 40, 59

space: Aristotelian and Ptolemaic conceptions modified by Christianity, 11; cities as, 10–14; meanings of, 10. *See also* lived spaces; representations of space; spatial practices

Spaniards: and aquatic infrastructure, 75, 194, 210; conquistador class, 3, 20, 38, 58, 72, 73, 75, 81, 83, 94, 95, 98, 101, 116, 156, 157, 193–194, 196, 211; fears of indigenous uprising, 194; indigenous elites collaborating with authorities, 82; indigenous elites competing with authorities, 81; interactions with indigenous peoples, 41; and place-names, 98; processions of, 94–96, 98; as residents of Mexico City, 94–97, 98, 209–210

Spanish Conquest: and aquatic infrastructure of Tenochtitlan, 38, 39, 75–77, 86, 210; arrival in Valley of Mexico, 37; and changes in place-names, 73, 75, 97; and Codex Aubin, 8; and Codex Mendoza, 7; and comparisons to ancient Rome, 123; and Cuauhtemoc's surrender, 72; and death of Tenochtitlan, 3; and destruction of Tenochtitlan, 18, 20; and feast of San Hipólito, 95–96, 98; and indigenous government, 15; and Ixtapalapa causeway, 71, 72; monumental architecture of, 9; siege of Tenochtitlan, 72, 75; wars of, 73, 75–76, 77, 81, 97, 116

Spanish Crown, 15, 102, 110, 114

Spanish historical narratives: on aquatic infrastructure, 37, 38; and death of Tenochtitlan, 1, 3, 72, 211; and feast of San Hipólito, 95–96; indigenous histories as source material, 37; and Mexica deities, 42; on Mexico City, 24, 211

Spanish language: and Codex Mendoza, 4, 8; and Florentine Codex, 29; and Gante, 119; goods in Tianguis of Mexico expressed in, 91–92, 93; period texts of, 13; and place-names in Mexico City, 96–97, 130; and Valadés, 119

Spanish missions, 73

spatial practices: and continuity between Mexico-Tenochtitlan and Mexico City, 18, 24, 73, 211; diachronic nature of, 14; and habitual memory, 14, 116; and intersection of spatial spheres, 59; Lefebvre on, 11, 12, 169, 213n22; and representations of space, 29; in Tenochtitlan, 53; visibility of, 13

spatial spheres: intersection of, 59, 116, 211; Mexica rulers' understanding of, 53, 55–61, 71; and relation of center to periphery, 86, 173, 175, 210. *See also* lived spaces; representations of space; spatial practices

state: early modern ideas of, 3; Foucault on, 11
Street signs, 14, *14*, 96
Sublimus Dei (1537), 104

Tacuba (city), 131
Tacuba causeway: and *ahuehuetl* trees, 124; and
 Chapultepec aqueduct, 163, 191, 197, 198; as
 east-west axis, 86, 175, 179; and feast of San
 Hipólito, 168, 176, 179, 224n52; and freshwater
 supply, 196; and markets, 80; and processions,
 95; and Ribadeneyra, 97; widening of, 194. *See
 also* Tlacopan causeway
Tapia, Hernando de, 83, 102, 110, 126, 219n8,
 223n43
Tarascan language, 119
tecpan of Mexico-Tenochtitlan (palace of
 indigenous government): architecture of,
 110, 111, 112, 113, 167; banner showing list
 of indigenous rulers, 113, 207, 210, 220n53;
 building of, 99, 108, 109, 110, 113, 187, 207,
 219n39; and Chapultepec aqueduct, 204, 205;
 in Codex Osuna, 109–110, *109*, 111, 125, 127,
 163–164, 165, 167; destruction of, 208, 210–211;
 disk pattern of, 193, 207; and elites versus
 commoners, 187; façade of, 182; featherworks
 in, 186; ideological valence of, 111, 165; and
 image of ruler, 108–113, 166; interior spaces
 of, 167; in Map of Tianguis of Mexico, 89,
 89, 108, 206, 207; in Plano de la Ciudad de
 México, *88*, 109; and processions, 175, 179,
 187; and religious festivals, 170; and riot over
 tribute system reform, 188, 189; site of, 108,
 109, 112–113; and Tianguis of Mexico, 85, 86,
 93, 99, 108, 110, 127, 206, 207
tecpan of Santiago Tlatelolco, 110, *110*, 167,
 222n67
Tecuilhuitontli, feast of, 170
Tehuantepec, conquest of, 56, 59
Tehuetzquititzin, Diego de San Francisco
 (r. 1541–1554): in Beinecke Map, *101*, 102, 156,
 157; in Codex Aubin, 100, *100*, 139, 156–157;
 and Cortés's capture of Olid, 82; death of,
 178; as *gobernador*, 77, 149, 156–160, 164, 185,
 193, 200, 206; Esteban de Guzmán's *residencia*
 investigation of, 160; in Humboldt Fragment
 II, *82*, 83; *juicio de residencia* of, 149, 156; and
 place-names, 24, 149; in Plano Parcial de la
 Ciudad de México, 77, *79*; and tribute goods,
 149, 200
Teicniuh, Miguel, 188
teixiptla: and Acuecuexco aqueduct, 66; and
 agency, 61, 66, 67, 69, 71; Ahuitzotl as
 teixiptla of Chalchiuhtlicue, 67–68, 69; of
 Chalchiuhtlicue, 66, 67–68; performances
 of, 53, 215n2; pluralistic nature of, 71; of Xipe
 Totec, 71
Tejada, Lorenzo de, *88*, 97, 157–158, 198
Teloloapan, conquest of, 59
Tembleque, Francisco de, 202
Temple of Yopico, 58, 71

Templo Mayor: agency of, 31, 60; and *altepetl*
 concept, 15, 51, 205, 207; and axes, 127; cached
 offerings in, 61; as ceremonial center, 18, 57, 58,
 207; and Chalchiuhtlicue, 42, 51; Coatepantli
 of, 110; as Coatepec in miniature, 29, 49, 61; in
 Covarrubias's *View of the Valley of Mexico*, 29;
 and Coyolxauhqui, 48; Franciscans building
 on ruins of, 113; and Huitzilopochtli, 30; lived
 space of, 29, 30; in Map of Tenochtitlan from
 Cortés's Second Letter, *17*, 18; as microcosm
 of larger cosmic order, 50–51; Monastery
 of San Francisco replacing, 118; pools of, 51;
 post-Conquest destruction of, 50; shrines
 of, 58; solar alignment of, 30; and Teocalli of
 Sacred Warfare, 45–46, 51; and Tlaloc, 30,
 42, 43, 76
Tena, Rafael, 15, 175
Tenoch (tribal leader), 5, 7, 37, 107
Tenochtitlan: Aztlan as model of, 27–28, 31, 32,
 113, 210; canals of, *17*, 23, 28, 34, 38, 39, 41, 53,
 55, 61, 64, 65, 66, 70, 72, 75, 77, 80, 84, 193,
 194, 197, 216n35; central ceremonial precinct,
 17–18, *17*, 25, 29, 57, 58, 123; clans of, 58; as
 complex *altepetl*, 18, 24, 26, 37, 38, 57, 60, 135;
 Covarrubias's *View of the Valley of Mexico*,
 25, *25*, 28; creation of, 26, 27–28; death of,
 1, 2–3, 7, 8, 9, 15, 24, 72, 210, 211; erasure of
 indigenous Tenochtitlan, 18, 24, 116, 123, 211;
 floods of, 23, 28, 33, 38, 39, 43, 45, 69, 75, 194;
 foundation in Codex Mendoza, 4–5, *4*, 7,
 8, 11, 32, 34, 35, 37, 46–47, 48, 49, 51, 107, 111;
 freshwater of, 33–34, 35, 38, 39, 41, 52, 53,
 71, 75; glyph for, 5, *47*, 65, 131, 135, 151, 165,
 180, 193; and histories of Spanish Conquest,
 72; hydraulic environment of, 23, 27, 50;
 indigenous government of, 18; indigenous
 Tenochtitlan's endurance, 3, 18; lived spaces
 of, 15, 26, 27, 29, 31, 35, 41, 52; looting during
 Spanish Conquest, 72; Map of pre-Hispanic
 Tenochtitlan and Tlatelolco, *16*, 17, 38, 51,
 57, 58, 61, 69; Map of Tenochtitlan from
 Cortés's Second Letter, 17–18, *17*, 28, 39, 58,
 61, 105–106; markets of, 55, 80; meaning
 in Nahuatl language, 1–2; monumental
 architecture of, 30; mountains surrounding,
 25–26, 28, 31; naming of, 37; place-names
 of, 48–49; population of, 35, 64, 80, 215n37;
 primordial landscape of, 50; quadripartite
 sociopolitical arrangement of, 18, 57, 58, 107,
 118; and representations of space, 24, 27, 33,
 39–40, 41, 45, 211; salt lake surrounding, 23;
 sixteenth-century population of, 1; as space,
 10; Spanish siege of, 72, 75, 98, 102; specialized
 trades in, 52; survival of built environment,
 9, 18; temples of, *17*, 25–26, 60, 124–125, 128,
 220–221n38; tributary regions of, 37; and
 Triple Alliance of 1428, 20, 37; water control
 in, 27, 34–35, 37–41, 43, 48, 53, 71, 75–77, 189,
 194, 196, 210. *See also* Mexico City; Mexico-
 Tenochtitlan (indigenous ring city)

Teocalli of Sacred Warfare: and cosmic template,
 50, 52; in foundation of Spanish royal palace,
 77; and glyph of Tenochtitlan, *47*, 65, 131;
 imagery of, 45–51, *46*, *47*, 69; location of,
 69–70, 216n70; as replica of Templo Mayor,
 46–47, 51
teocallis (temples), 28, 57, 124–125, 220–221n38
Teopan: as *altepetl*, 18, 57, 58, 73, 128. *See also* San
 Pablo Teopan
Teotihuacan, pilgrimages to, 58
teotl: and Acuecuexco aqueduct, 65–66; and
 agency, 60–61, 69, 71; of Chalchiuhtlicue, 65,
 66; concept of, 28, 53, 60–61, 69; pluralism
 of, 42
Tepanec, 37, 52, 61
Tepetzinco: as *altepetl* model, 51, 61; battle of
 Huitzilopochtli and Copil, 31–32; hot springs
 of, 58; human sacrifice at, 214n19; and tales of
 Mexica migration, 50
Tepeyacac causeway, 37–39, 40, 58, 69
Tepi, Ana, 139, *139*, 140
Tetzcoco: as *altepetl*, 51, 135; as "ciudad," 131;
 Gante living in, 220n14; Nezahualcoyotl as
 ruler of, 37, 38, 55, 106; and Triple Alliance
 of 1428, 20, 37, 61; and wars of Spanish
 Conquest, 75. *See also* Lake Tetzcoco
Tetzcotzinco, as *altepetl* model, 62, 175
Tezcatlipoca (creator deity): dismemberment
 of, 45; Mexica rulers as vessels of, 57; Mexica
 rulers dressed as, 68
Tezozomoc (Azcapotzalco ruler), 61
Tezozomoc, Fernando de Alvarado, 83, 135, 187
Tianguis de Juan Velázquez, 80, 81, 85, 217n23
Tianguis de San Juan, 85, 218n46. *See also*
 Tianguis of Mexico
Tianguis de San Lázaro, 217n43
tianguises (markets): and canals, 35, 84; and
 Chapultepec aqueduct, 191; closing for
 processions, 175, 223n31; and collective
 identification, 156; continuities with pre-
 Conquest markets, 73, 75; domestication
 of foreign goods, 82, 93; as essential to
 survival of city, 80, 98; and foodstuffs, 85,
 86; freshwater as commodity of, 80; as
 indigenous space, 93, 94; lived spaces of, 73;
 and north-south axis, 127; and relations of
 center to periphery, 86; structure of, 80; tax
 collection on marketed goods, 81; *tianguis*
 land used to repay communal debt, 157–158;
 Tlacotzin's re-creation of, 99, 127; water
 supply of, 191
Tianguis of Mexico: accessibility of San
 Juan Moyotlan, 127; and axes, 86, 88;
 Carvallo's Map, 86, *87*, 88, 89, 204, 206;
 and Chapultepec aqueduct, 204–205; and
 collective identification, 156; contested space
 of, 93–94; court cases concerning, 93, 94;
 daily operation of, 86, 88, 218n46; diagram of,
 88, 89, 90, *90*, 206, 207; and Espinosa's and
 Alvarez's Plano de la Ciudad de México, 88,

88; and floods, 208; and Franciscans, 226n74; and freshwater supply, 197, 207; *gobernadores'* role in, 84, 86; goods in, 88–90, *91–92*, 93; and indigenous communal rights to urban land, 205–207, 208; and indigenous material culture, 93, 218n58; as indigenous space, 86, 98, 105; López de Gómara's description of, 80; Map of, 88–89, *89*, 94, 206, *207*; in Map of Santa Cruz, 84–85, *85*, 86, 94; name of, 84, 85, 217n43; physical features of, 86, 88–90, 93, 99; pre-Hispanic site of, 84; and processions, 175; and representations of space, 206–207; and *tecpan* of Mexico-Tenochtitlan, 85, 86, 93, 99, 108, 110, 112–113, 127; and Valeriano, 205–207

Tianguis of San Hipólito, 85, 86, 218n46

tianguizhuaque (market overseers), 218n64

tianquiztli (market): glyph for, 12, *12*, 82; as lived space, 60

Tira de la Peregrinación: Arrival at Chapultepec, 30–31, *31*, 61, 70; Departure from Aztlan, 26–27, *26*, 31; Huitzilopochtli's election of Tenochtitlan, 27–28

Tira de Tepechpan, and Esteban de Guzmán's accession, 222n57

tithes, disputes over, 164, 178, 222n63

Tizocic (r. 1481–1486), 52, 156

Tlacaelel (brother of Moteuczoma I), 62, 80

Tlachihuatepetl, 26

Tlaco, Juana, 137

Tlacocomulco, 50

Tlacopan (city): as *altepetl*, 135; as "ciudad," 131; and Triple Alliance of 1428, 20, 37, 61. *See also* Tacuba (city)

Tlacopan causeway: and Chapultepec aqueduct, 51, 63, 64, 80, 94; contested meanings of, 94; and Moyotlan, 127; and processions, 58–59. *See also* Tacuba causeway

Tlacotzin, Juan Velázquez: and aquatic infrastructure, 81; as *cihuacoatl*, 80–81, 82; in Codex Aubin, *8*, 81; construction projects of, 99; and Cortés, 110, 118; death of, 77, 82; as *gobernador*, 77, 82, 83, 84, 99–100; in Humboldt Fragment II, 81, *82*; palace of, 110; *tianguis* established by, 99, 127

Tlahuac, 20

Tlaloc (rain and agricultural deity): *chacmool* with Tlaloc mask, 42, *42*, 47–48; impersonators of, 48, *48*, 68; and origin histories, 45; and processions, 177; sculpture at aqueduct of Chapultepec, 63, 197; and Templo Mayor, 30, 42, *43*, 76; water associated with, 42, 48, 160, 225n15

Tlaltecuhtli (earth deity), 45, 48, *49*, 49, 50, 193

tlapalli (pigment), 80

Tlatelolco: as *altepetl*, 57, 73; and aquatic infrastructure, 39; in Covarrubias's *View of the Valley of Mexico*, 25, *25*; creation of, 26; independence of, 181; looting during Spanish Conquest, 72; Map of pre-Hispanic Tenochtitlan and Tlatelolco, *16*, 17, 38, 51,

57, 58, 61, 69; markets of, 86; post-Conquest market of, 217n28; pre-Hispanic market of, 80; Tenochtitlan's conquest of, 128, 131, 133, 135, 179. *See also* Santiago Tlatelolco

tlatoque (supreme leaders): and aquatic infrastructure, 39; in Codex Mendoza, 100, 111; as deity delegates, 56–57; descendants of, 83, 99, 100, 110, 118, 156; feathers associated with, 55, 56; and festivals, 170; and gifting, 106, 184; jade beads associated with, 21, 82; as metonym for city-state, 3, 7, 8, 9, 10, 18; processions of, 58, 94, 95, 188; and spatial agency, 59–61; in Tenochtitlan, 18, 52–53, 210

Tlaxcala (city), 107, 119, 125, 131, 171

tlaxilacalli (neighborhoods): boundaries of, 138, 221n24; and *chane* or home, 137–138; chapels of, 137, 221n17; Franciscan chapels replacing local shrines maintained by, 118; and images of saints, 173; of Mexico-Tenochtitlan, 17, 135–138, *136*; and migrating clans of Mexica, 110; orthography of, 215–216n18; place-names of, 140, *141–149*, 149, 151–156, 167; and processions, 174; shrines of, 58; social and spatial dimension of, 57–58; tributary population of, 221n50

Tlaxpana fountain, 197

Tlilancalqui, Baltazar, 137

Tlillan (shrine), 58

Tochtepec, tribute goods from, 53, 54, 55, 111

Toci (earth deity), 216n67

Tocuepotzin (Tetzcocan noble), 159, *159*, 163

Toluca, conquest of, 70–71

Torquemada, Juan de: on dike construction, 39; on epidemics, 203; on Laguna of Mexico, 38; on Moteuczoma's aviary, 105, 220n36; on Piedad causeway, 221n51; on population, 221n50; processions, 170; and Valadés, 120; and Valeriano, 190

Townsend, Richard, 28

transport networks: and aquatic infrastructure, 41; and canals, 23, 35, 38, 41, 77, 84, 196, 197; and canoes, 23, 38, 41, 77, 84, 197, 207; of post-Conquest cities, 9

Trasmonte, Juan Gómez de, "Forma y Levantado de la Ciudad de México," 128, 129–130, *129*, 203–204, *204*

traza (grid plan): and Caso's Map of Tenochtitlan and Tlatelolco, 136; and Plaza Mayor, 73, *73*, 77, 93, 94; Spanish *cabildo's* control of, 135, 206; and Spanish *cabildo's* land grants, 93; and Trasmonte's "Forma y Levantado de la Ciudad de México," 128, 129

tributary labor: and leader of *altepetl*, 110, 149; and Real Audiencia judges, 101

tributary states, of Mexica, 37, 52, 53, 55–56, 60, 71, 80, 81, 86, 135, 221n14

tribute goods: in Codex Mendoza, 53, 54, 55, 111, 156; in Codex Osuna, *162*, 163, *164–165*; in Genaro García 30, 149, *150*, 151–152, *152*, 153, 156, *158*, 159, 165; and indigenous government

of Mexico-Tenochtitlan, 156, 157, 168; and Mexica rulers, 20–21, 52, 53, 55–56, 60, 81, 99, 157; and Tehuetzquititzin, 149

tribute system, reform of, 166, 167, 168, 188–189

Triple Alliance of 1428: *altepeme* of, 20–21, 37, 61; and Azcapotzalco, 75; in Codex Osuna, *134*, 135; leaders of, 52, 55, 64, 181–182, 199, 200, 224n62

Truitt, Jonathan, 18, 137, 140, 149, 218n53

Tula (city), 69, 151

Tzutzumatzin (Coyoacan ruler), 64

Umberger, Emily, 45–46, 47, 67, *67*, 216n71

urban plots, Map of, 138, 139–140, *139*, 151

Valadés, Diego: on civic celebrations, 95–96, 218n69; family background of, 119, 220n20; and Gregory I, 119, 220n18; on indigenous elites, 116; Monastery of San Francisco, from *Rhetorica christiana*, 114, *115*, 120, *120*, 122; as resident of Monastery of San Francisco, 119; *Rhetorica christiana*, 114, 119–123, *124*, 220n18; on San José de los Naturales, 170; on *tecpan*, 108

Valderrama, Gerónimo de, 163, 166, 185, 188–189, 198, 225n96

Valencia, Martín de, 122, 125

Valeriano, Antonio (r. 1573–1599), 24, 190–191, 199, 202–208, 212, 226n82

Valle, Perla, 15, 35

Valley of Mexico: Covarrubias's *View of the Valley of Mexico*, 25–26, *25*, 28, 29; geography of, 23, 25; Map of, *xii*, 23, 35, 58, 61, 63; Map of major dikes, 35, *36*, 37, *38*, 39, 40, 58, 64, 69, 75, 197; post-Conquest cities in, 9; pre-Conquest cities of, 15; shallow lakes of, 15, 34–35; and Triple Alliance of 1428, 20–21, 52; war in, 37, 52

van Meckenem, Israhel, *The Mass of Saint Gregory*, engraving, *104*, 104

Vargas Betancourt, Margarita, 15

vecinos (property-owning residents), 76–77

veintena (monthly feasts). *See* festival calendar

Velasco, Juan López de, 129, 221n5

Velasco, Luis de (r. 1550–1564): and aquatic infrastructure, 200, 202; in Beinecke Map, *101*, 102, 163–164; in Codex Osuna, *109*, 111, *162*, 163, 163–164, *164–165*, *164*, *165*, 200; in Codex Tlatelolco, 180, *181*; death of, 198; and legal disputes, 163, 185, 199; public mass at Chapel of San José de los Naturales, 117; and tribute system reform, 189; as viceroy, 160

Vera Cruz, Alonso de, 222n63

Vetancourt, Agustín de, 221n17

Villalobos, Pedro de, 186, 197

Villanueva Zapata, Luis de, 189, 225n96

Virgin Mary: cult statue of, 179, *180*; Mary, Queen of Heaven, 152; Soledad de la Virgen, 173; Virgin of Guadalupe and Tepeyacac shrine, 37–38; Virgin of Remedios, 173, 176; Virgin of the Assumption, 95, 126, 168, 177

vulture vessel, 160, *161*

water: and cosmovision, 28–29, 31; deities associated with, 23, 42–45; drought of 1540s, 194, 196, 225n15; flow of water connected with Mexica rulers, 24, 27, 38, 71, 189, 193; ideologies of, 27–28, 34; and indigenous government of Mexico-Tenochtitlan, 190–191, 194; and lived spaces, 39–42; and place-names, 49–50; and post-Conquest drought, 75, 196; in representations of space of Tenochtitlan, 27, 28, 32–35, 214n22; and search for ideal *altepetl*, 30–34; sources of, 61–67; Spanish distrust of, 75, 194; streams as connective axes, 33, 51; taxonomy of, 44; and Templo Mayor, 50, 51; and Teocalli of Sacred Warfare, 45–49; types of, 44; water control in Tenochtitlan, 27, 34–35, 37–41, 43, 48, 53, 71, 75–77, 189, 194, 196, 210. *See also* aquatic infrastructure; hydraulic environment

Whittaker, Gordon, 128, 139, 221n2
Wicke, Charles R., 216n67
Wittfogel, Karl, 27, 35
women, indigenous, and Tianguis of Mexico, 88, 218n53
World Tree, 48, *48*
Wyman, Lance, 20

Xico (city), place-name of, 49, *49*
Xipe Totec (patron deity of Mexica rulers; deity of springtime and regeneration), 57, 58, 70–71, 125, 126, 155

xiuhuitzolli (turquoise miter), 62, 100, 111
Xiuhtecuhtli (solar deity), 34, *34*
Xochimilco: city of, 18, 35, 37, 71, 131, 160; lake of, 35, 39, 41
Xochiquentzin, Pablo Tlacatecuhtli (r. 1530–1536): death of, 101; as *gobernador*, 77, 83, 84, 94; and indigenous lands, 94; palace of, 111; in Plano Parcial de la Ciudad de México, 77, *79*
Xomimitl (arrow foot), 58, 131

Yopico, 58, 71, 110, 216n25

Zapotecs, 179, 224n48
Zócalo. *See* Plaza Mayor, Mexico City
Zorita, Alonso de, 157, 159, 163, 166, 181, *181*, 189
Zumárraga, Juan de, 76, 83, 107, 219n35